GRAND COMPLICATION

VO

WATCHES INTERNATIONAL

THE ORIGINAL ANNUAL OF THE WORLD'S WATCH COMPLICATIONS AND MANUFACTURERS®

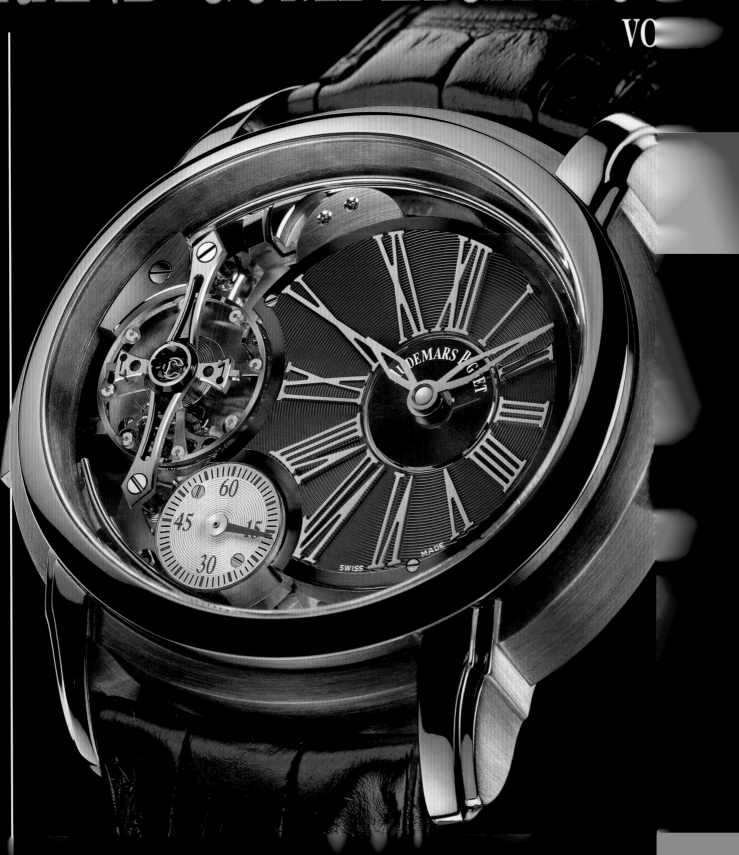

GRAND COMPLICATIONS®

THE ORIGINAL ANNUAL OF THE WORLD'S WATCH COMPLICATIONS AND MANUFACTURERS®

SPECIAL CALENDAR EDITION

First published in the United States in 2011 by

TOURBILLON INTERNATIONAL
A MODERN LUXURY MEDIA COMPANY

7 West 51st Street, 8th Floor
New York, NY 10019
Tel: +1 (212) 627-7732 Fax +1 (312) 274-8418
www.modernluxury.com/watches

PUBLISHER
Caroline Childers

EDITOR IN CHIEF
Michel Jeannot

CHIEF EXECUTIVE OFFICER
Lew Dickey

PRESIDENT
Michael Dickey

EXECUTIVE VICE PRESIDENT AND CO-CHIEF OPERATING OFFICER
John Dickey

EXECUTIVE VICE PRESIDENT AND CO-CHIEF OPERATING OFFICER
Jon Pinch

CHIEF FINANCIAL OFFICER
JP Hannan

GENERAL COUNSEL
Richard Denning

In association with **RIZZOLI** INTERNATIONAL PUBLICATIONS, INC.

300 Park Avenue South, New York, NY 10010

ISBN: 978-0-8478-3600-0

COVER: MILLENARY HAND-WOUND MINUTE REPEATER WITH AP ESCAPEMENT (AUDEMARS PIGUET)

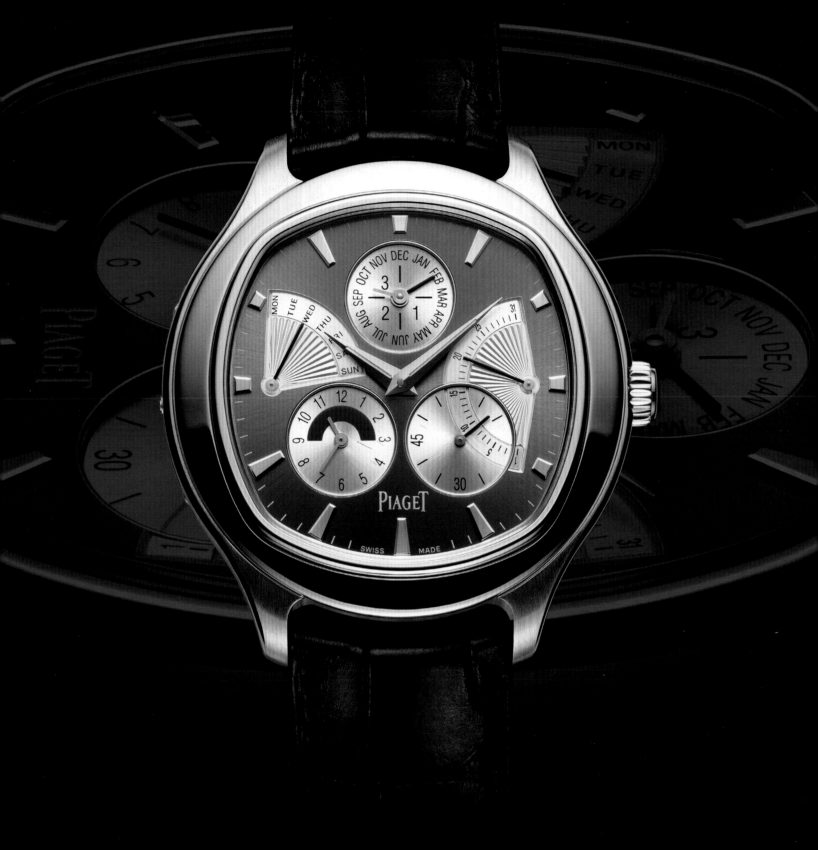

AP
AUDEMARS PIGUET
Le maître de l'horlogerie depuis 1875

JULES AUDEMARS
PERPETUAL CALENDAR

The *Jules Audemars Perpetual Calendar* watch is a masterpiece of miniaturisation developed on the basis of the extra-thin self-winding Calibre 2120 and the 2802 module. The entire mechanism is indeed just 4 millimetres thick. Intended to reproduce the intricacies of our calendar by displaying the cadence of the minutes, hours, days, date and months, this complex movement also smoothly handles the irregularity of 30- and 31-day months as well as the leap-year cycle. The calendar module is designed to require no correction before March 1st 2100, a date when the Gregorian calendar will imply an adjustment – exactly the kind of detail true connoisseurs will appreciate.

Pink gold case, brown or silvered dial, applied pink gold hour-markers, pink gold hour and minute hands.

AUDEMARS PIGUET LE BRASSUS (VALLÉE DE JOUX) SWITZERLAND, TEL +41 21 845 14 00

www.audemarspiguet.com

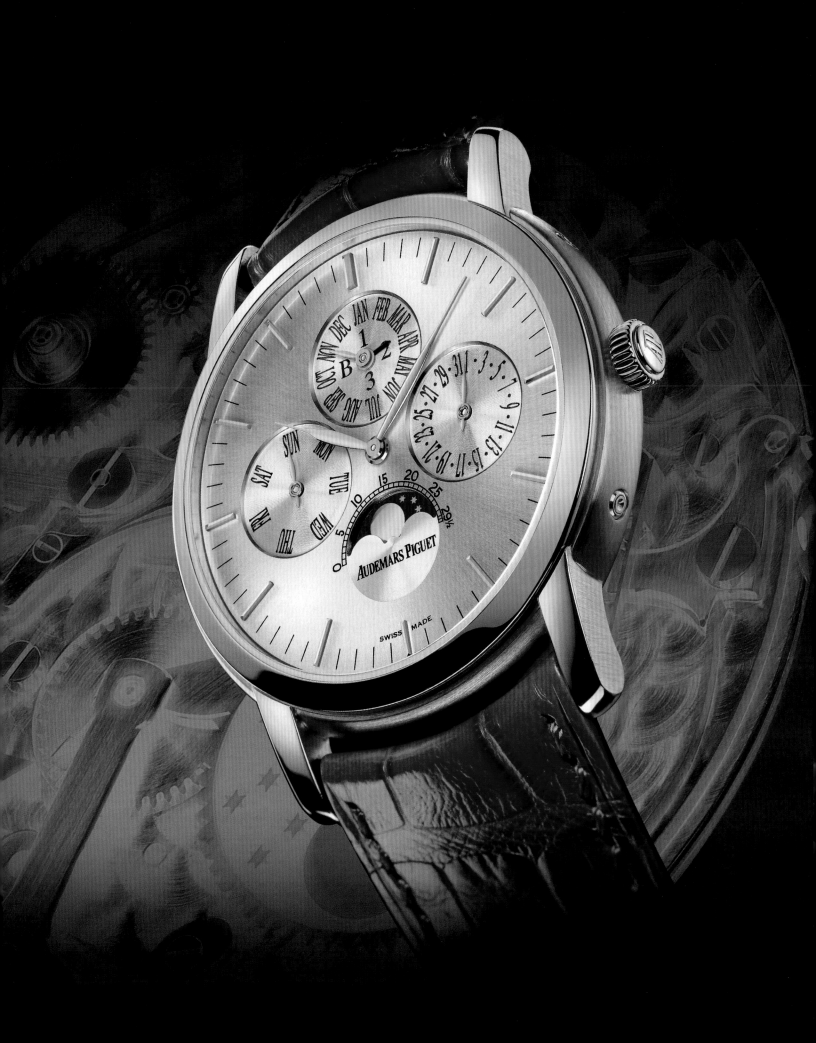

Letter from the President

All in the timing

In today's harried world, time is a luxury. Nowhere is this more evident than in the world of high-end timepieces, which have gained in popularity even as other time-telling devices have become ubiquitous.

It is an absolute pleasure to be afforded the opportunity to join an editorial conversation that stimulates, provokes, and engages a readership—one that Modern Luxury Media and its portfolio of upmarket city magazines covering the nation's top luxury markets so brilliantly facilitates. And it is a downright thrill to announce Dickey Publishing's acquisition of the country's largest city magazine publisher.

Dickey Publishing looks forward to working closely with the dedicated and talented team at Modern Luxury Media to build upon the success this great company has worked tirelessly and creatively to achieve in its first decade. While no one can predict what the future will bequeath, I can tell you without hesitation that Dickey Publishing shares Modern Luxury's commitment to producing best-in-class publications and to partnering closely with our valued clients to maximize their return on investment and brand activation.

I am especially pleased to be able to help introduce the latest edition of *Grand Complications*, with its focus on the most elite echelon of complicated mechanical timepieces. *Grand Complications* will be available for the first time this year online as a digital edition, and we will also be producing a version especially for the iPad. This multimedia approach is fitting for these elite timepieces, as one element of their immense appeal is their portability. One element—but there are many more. The immense care and skill brought to bear on these investment pieces reflects both the proud, searching history of technological leaps and a future full of equally impressive developments. I join connoisseurs in marveling at the perfection of these pieces: brilliantly conceived, aesthetically striking, technologically astute, and precisely engineered.

The sheer number of functions—and the inventive ways they can be displayed—described in these pages can boggle the mind, if you let it. The mechanical wonders herein are all the more admirable for fitting in the palm of one's hand—or rather, on one's wrist.

In the spirit of distinction, enjoy the issue.

Michael Dickey

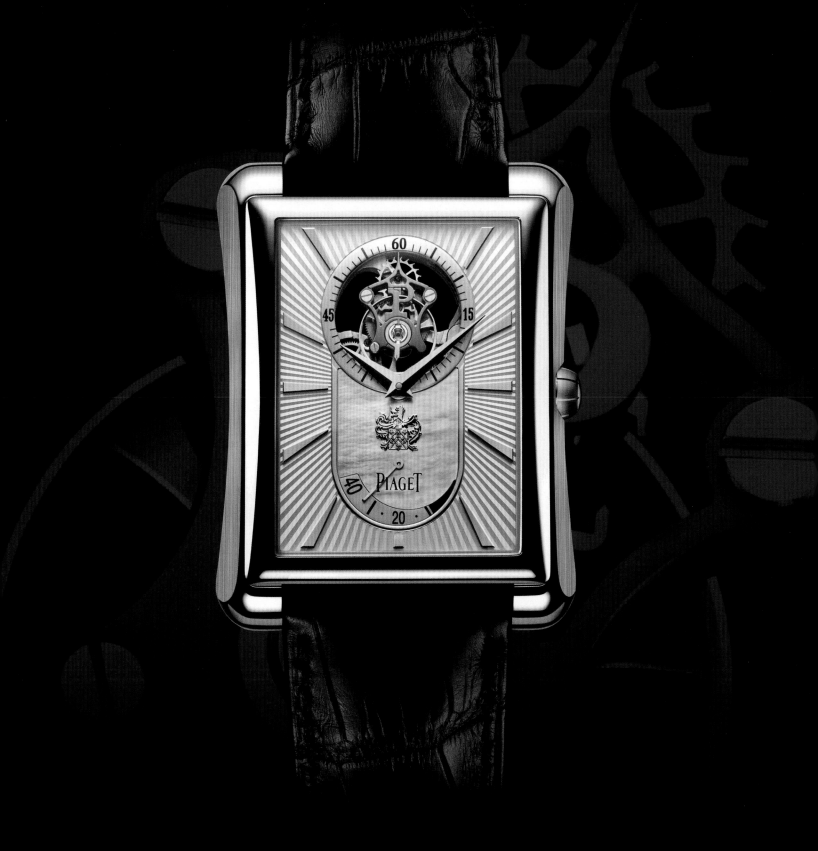

PIAGET EMPERADOR
Piaget Manufacture movement 600P
Mechanical hand-wound tourbillon
World's thinnest shaped tourbillon
3.5mm thickness
White gold, sapphire case-back
Boutique exclusivity

PIAGET

www.piaget.com

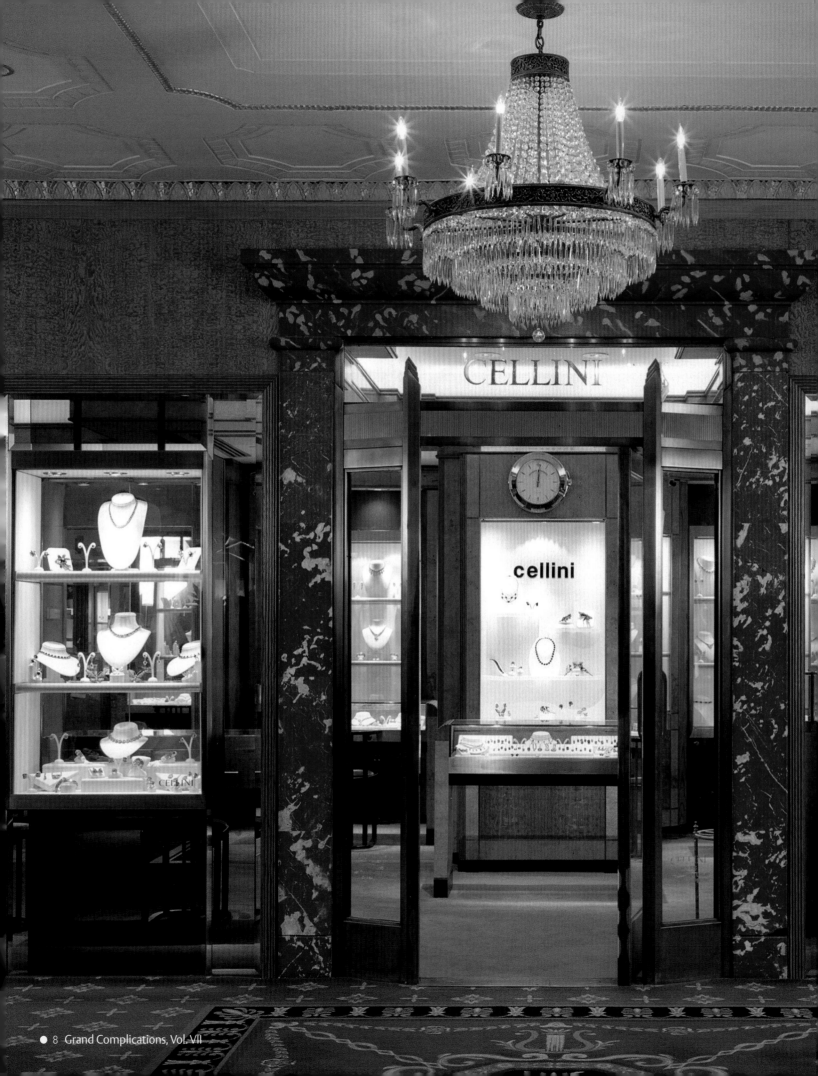

cellini

A New York City institution for more than a generation, Cellini Jewelers exceeds even the highest expectations with an impeccable collection of timepieces and jewelry that reflects a deep appreciation for the rareness of both handmade authenticity and natural beauty.

"Our considerable range is what sets us apart," says Cellini Jewelers President Leon Adams. "We carry an in-depth selection of the world's finest watches and a truly extensive array of jewelry. We believe it's important to have many choices, and an opportunity to select from a broad spectrum of pieces."

DEEP FOCUS

An extraordinary gathering of historic and emerging watchmakers finds a home at Cellini where it serves as the foundation for one of the world's largest and most prestigious collections of mechanical timepieces.

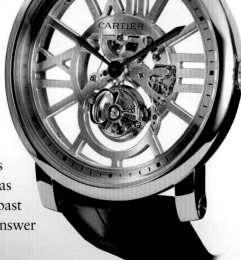

Dedicated watch enthusiasts have long cherished the unparalleled selection of timepieces Cellini offers. "If we believe enough in a brand to carry it, we do our best to carry the entire collection; not just every model, but more importantly, every metal that model is made in. Very few can say that," Adams says.

To help collectors navigate the eccentricities of high horology, Cellini's watch experts are as well versed in emerging trends as they are in past traditions and welcome the opportunity to answer your questions.

FACING PAGE
Cellini's flagship store was established in 1977 at the Hotel Waldorf-Astoria.

ABOVE
The Rotonde Skeleton Tourbillon is part of Cartier's new Fine Watchmaking collection, which is available on the East Coast exclusively at Cellini and Cartier.

LEFT
Cellini offers rings with natural fancy pink, yellow and white diamonds in platinum and 18-karat gold.

"We carry an in-depth selection of the world's finest watches and a truly extensive array of jewelry," Adams says. "We believe it's important to have many choices, and an opportunity to select from a broad spectrum of pieces."

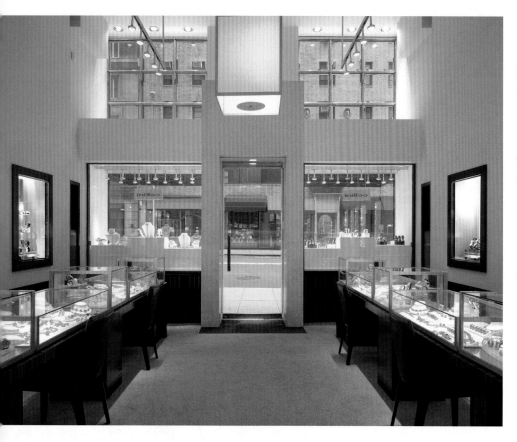

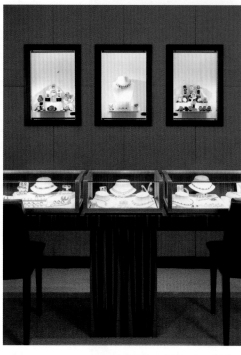

ABOVE AND LEFT
Cellini's second boutique was established in 1987 at the epicenter of the world's most elite shopping district.

FANTASTIC DISCOVERY

Along with the range of its watch collection, Cellini's dedication to rarity appeals to savvy connoisseurs who value exclusivity.

"You can walk into Cellini and see watches you won't see anywhere else," Adams says. "Beyond the best-known watchmakers, we also showcase some of the more exotic brands like Maîtres du Temps, Jean Dunand, Parmigiani, H. Moser, and just this year, Ludovic Ballouard's Upside Down watch."

In a nod to its reputation as an influential tastemaker, Cellini is also the only location on the East Coast where you can see Cartier's new Fine Watchmaking Collection other than Cartier's New York boutique.

GUIDED BY PASSION

More than just a bastion of high horology, Cellini has also cultivated a diverse collection of jewelry that ranks among the finest in New York City. Cellini is among an elite coterie of jewelers that specialize in exotic jewels, exhibiting an ambitious assortment that ranges from natural fancy color diamonds and alexandrite to Burmese rubies and Kashmir sapphires. "The same competitive spirit that drives our clients to demand the best from themselves is what inspires us to maintain such a high standard," Adams says.

For exceptional glamour, nothing outshines the supreme splendor of a bespoke setting. Cellini's gemologists and designers combine expertise with imagination to create jewelry tailored exclusively to your unique style, whether you are looking for a unique engagement ring or a one-of-a-kind necklace. "Because we have the experience and selection, the possibilities are endless," Adams says.

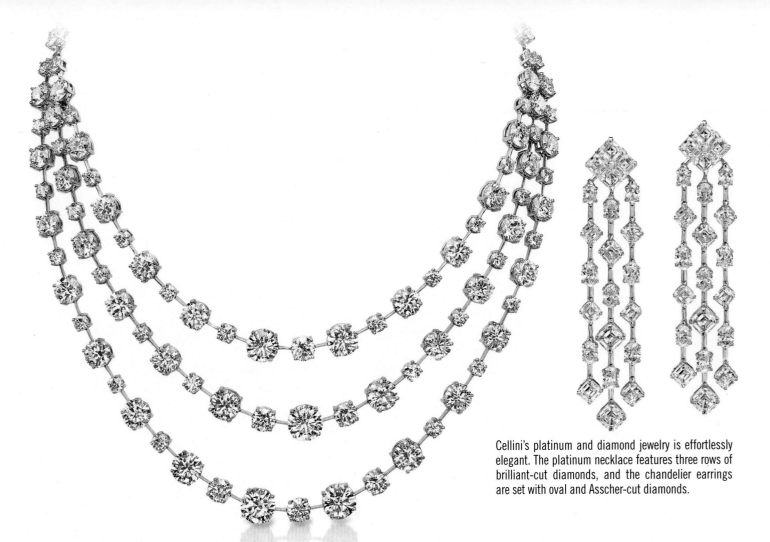

Cellini's platinum and diamond jewelry is effortlessly elegant. The platinum necklace features three rows of brilliant-cut diamonds, and the chandelier earrings are set with oval and Asscher-cut diamonds.

HANDLE WITH CARE

To maintain the beauty of your jewelry and extend the longevity of your watches, regular care is essential. Cellini invites you to visit our Waldorf-Astoria and Madison Avenue boutiques where our specialists stand ready to assist you.

Jewelry devotees will be able to relax as our experts scrutinize each stone's setting and evaluate the reliability of each clasp before returning the piece to you immaculately cleaned. Watch enthusiasts can rest assured that when the time comes every four years to service your mechanical timepiece that a master watchmaker will care for your watch as if it were their own.

Whether *haute couture* or *haute horlogerie* fuels your passion, come to Cellini and discover the best of both worlds.

BRANDS CARRIED

A. Lange & Söhne	IWC Schaffhausen
Audemars Piguet	Jaeger-LeCoultre
Bell & Ross	Jean Dunand
Cartier	Maîtres du Temps
Chopard	Panerai
De Bethune	Parmigiani
DeWitt	Piaget
Franck Muller	Richard Mille
Girard-Perregaux	Roger Dubuis
Guy Ellia	Ulysse Nardin
H. Moser & Cie.	Vacheron Constantin
Hublot	

CELLINI

Hotel Waldorf-Astoria • 301 Park Avenue at 50th Street
New York, NY 10022 • 212-751-9824

509 Madison Avenue at 53rd Street
New York, NY 10022 • 212-888-0505

800-CELLINI • www.CelliniJewelers.com

J 12

RÉTROGRADE MYSTÉRIEUSE

CHANEL

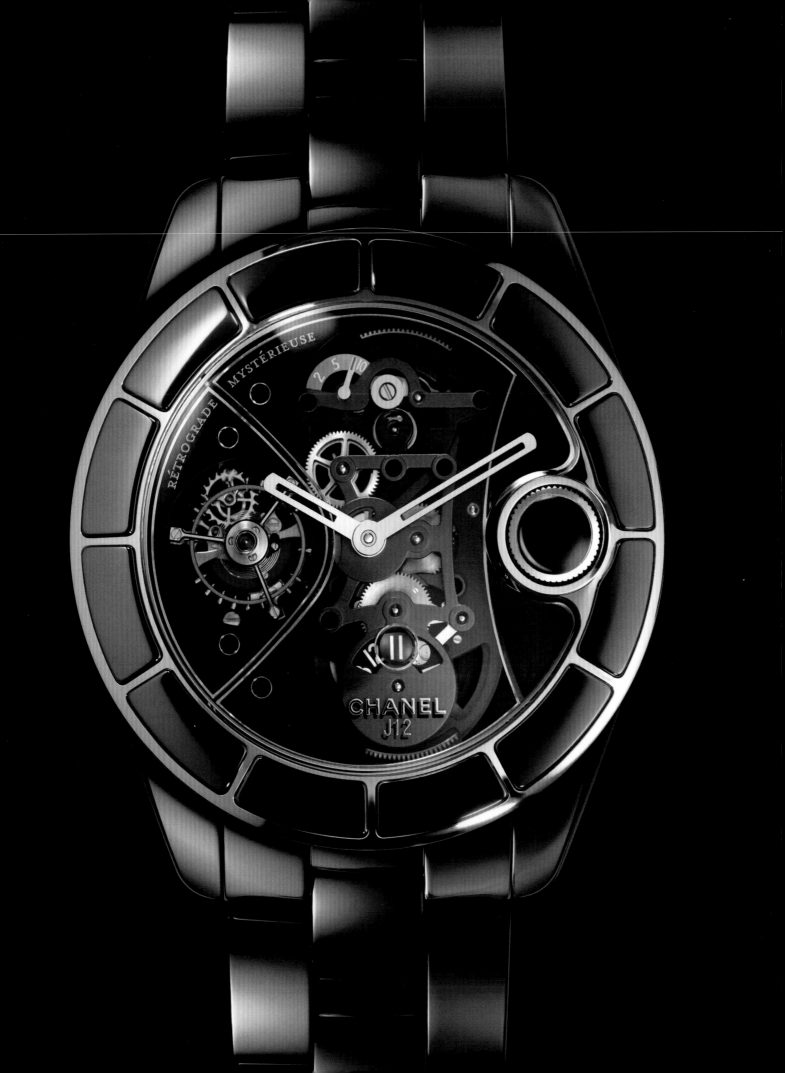

Letter from the Publisher

A Gripping Event

The watch industry is like a television series: it captivates and hooks us. The mechanism is implacably efficient. Episode 1 takes place in January, at the Salon International de la Haute Horlogerie in Geneva, and is not to be missed, since there is no repeat broadcast. The event sets the scene, introduces the main characters and provides the key elements of a scenario that will keep the audience spellbound throughout the season. Who will be the sales hero in 2011? Which challenges will brands have to face? What about the love affair between China with its magnificent dowry and its global suitors?

April brings a change of set and of actors, with the second episode shot at BaselWorld. The second branch of the family comes on the scene and, just like its Geneva-based cousins, is determined to keep viewers waiting with bated breath. The cogs are well oiled and highlight the skill of the scriptwriters who have honed their preparations: a sprinkling of glamour, a hint of suspense stretching over 10 days, and an array of stunning complications. High-caliber actors are the order of the day, and any guest star appearances are a good token of the series' success.

However, some do not necessarily get the audience they expect, and in the past couple of years there were more flops then hits, with the plot summed up in a single word: crisis. Some were prepared to admit that watchmaking was bound to follow a cyclical ratings curve, and now that the storm is past, most will agree that the collateral damage affected everyone, including those at the top of the bill. The season that kept watchmaking hearts beating at more vibrations per hour than ever is fortunately behind us.

2011 will doubtless bring further spectacular turns of events, and we can count on the industry's innate creativity in maintaining fast-paced action during the upcoming episodes.

Caroline Childers

RICHARD MILLE
A RACING MACHINE ON THE WRIST

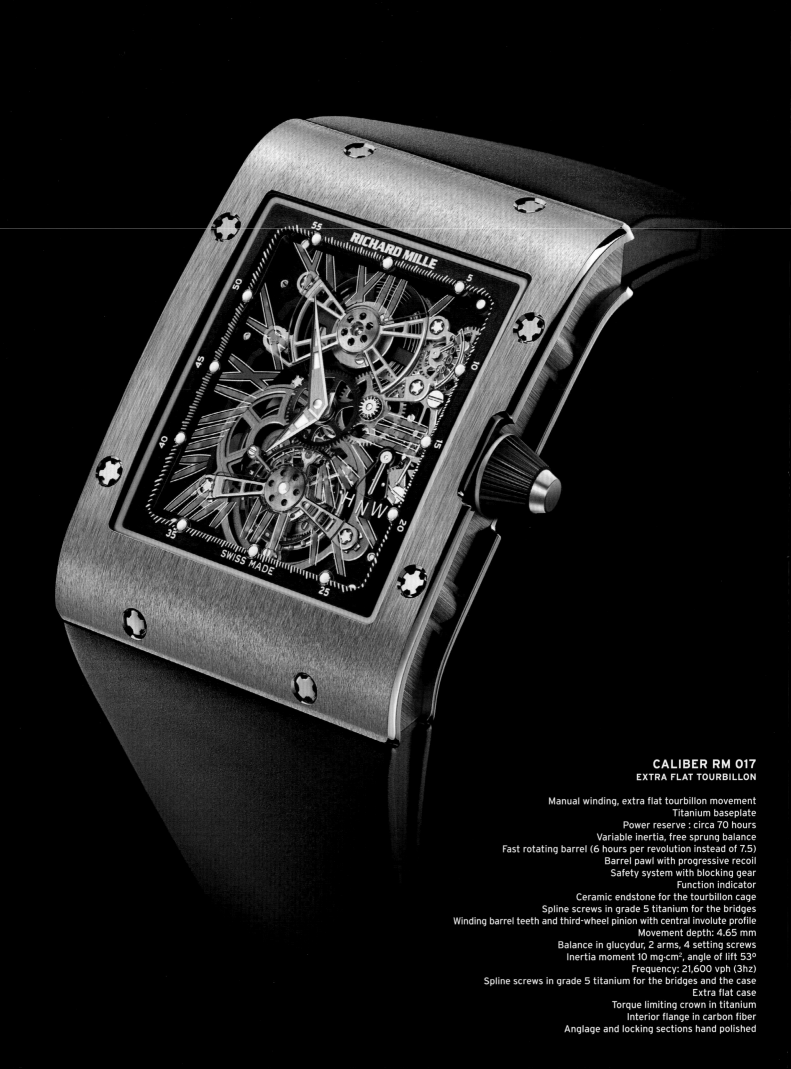

CALIBER RM 017
EXTRA FLAT TOURBILLON

Manual winding, extra flat tourbillon movement
Titanium baseplate
Power reserve : circa 70 hours
Variable inertia, free sprung balance
Fast rotating barrel (6 hours per revolution instead of 7.5)
Barrel pawl with progressive recoil
Safety system with blocking gear
Function indicator
Ceramic endstone for the tourbillon cage
Spline screws in grade 5 titanium for the bridges
Winding barrel teeth and third-wheel pinion with central involute profile
Movement depth: 4.65 mm
Balance in glucydur, 2 arms, 4 setting screws
Inertia moment 10 mg·cm², angle of lift 53°
Frequency: 21,600 vph (3hz)
Spline screws in grade 5 titanium for the bridges and the case
Extra flat case
Torque limiting crown in titanium
Interior flange in carbon fiber
Anglage and locking sections hand polished

Letter from the Editor in Chief

Beware of systemic paralysis

"The Swiss watch industry is fundamentally healthy!" This statement is bandied about by various top managers in the sector based on the latest statistics, as 2010 did indeed end with export figures of more than 16 billion Swiss francs, not far from the historical record set in 2008. The over 22% year-on-year increase was substantially boosted by Asian demand, with Hong Kong single-handedly accounting for almost one-fifth of Swiss watch exports.

The upturn is also confirmed on the employment side. After shedding 4,200 jobs in 2009—or 7.9% of its overall numbers—the watch industry is hiring left, right and center. Big names such as Cartier, TAG Heuer and Breguet are swamping headhunters and employment agencies with demands and several hundred positions are still open.

Against this backdrop, the 2011 is definitely off to an auspicious start. Wherever haute horology is on show—whether at the Salon International de la Haute Horlogerie (SIHH) or at BaselWorld, the booths are packed and the crowds flock in. Nonetheless, there is a cloud on this horizon.

In 2004, the powerful boss of the Swatch Group, Nicolas G. Hayek, who passed away in June 2010, had reached an agreement with the Swiss Competition Commission (Comco) with a view to definitively ceasing delivery of movement blanks to brands outside the group. The vast majority of the some four million mechanical watches made each year in Switzerland is indeed driven by one of the basis products offered by ETA, a subsidiary company of the Swatch Group.

This agreement came into force on January 1, 2011. The seven-year lead-time imposed by the Comco was intended to enable the establishment of one or several alternatives. While efforts to verticalize production have indeed been made by certain brands or groups, one must admit that there are still not a lot of options out there in terms of movement makers. We have seen a number of initiatives—meeting with varying degrees of success—in the peak segment, but there is no real industrial-scale alternative in place to serve the business as a whole. The best-placed operators are currently only able to meet a fraction of the demand.

In terms of its know-how and the quality of its watches, the Swiss watch industry is undoubtedly a flourishing sector. The financial crisis it has recently experienced will soon be no more than an unpleasant memory. It must however be careful not to allow a form of systemic paralysis to creep in and undermine its future.

Michel Jeannot

IWC.
The future of watchmaking since 1868.

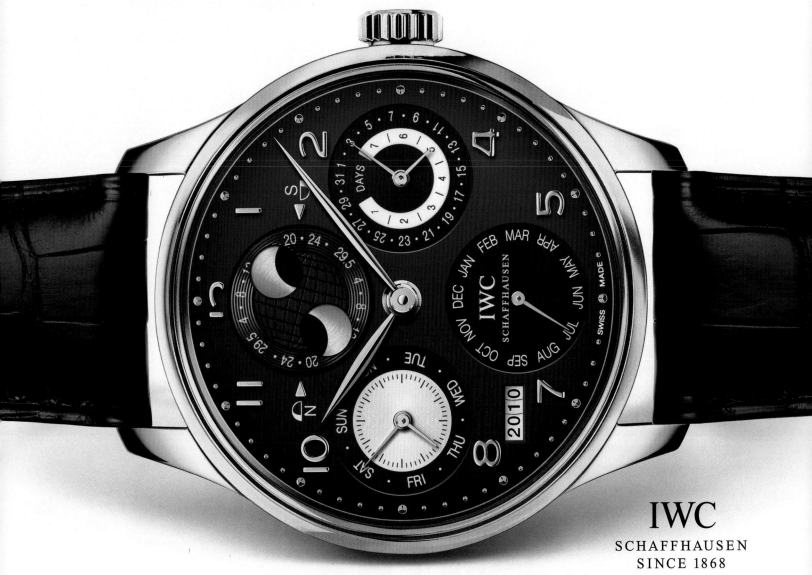

IWC
SCHAFFHAUSEN
SINCE 1868

The future's safe.

Portuguese Perpetual Calendar. Ref. 5021: One thing at IWC always remains the same: the desire to get even better. Here is one of the finest examples, with the largest automatic movement manufactured by IWC, Pellaton winding and a seven-day power reserve. The perpetual calendar shows the date and moon phase and is mechanically programmed until the year 2499. In short: a watch that has already written the future. **IWC. Engineered for men.**

Mechanical IWC-manufactured movement | Pellaton automatic winding system | 7-day power reserve with display | Perpetual calendar (figure) | Perpetual moon phase display | Antireflective sapphire glass | Sapphire-glass back cover | Water-resistant 3 bar | 18 ct white gold

IWC SCHAFFHAUSEN BOUTIQUES

9490C BRIGHTON WAY
BEVERLY HILLS, CA 90210
TEL. 310-734-0520

THE PALAZZO HOTEL
CASINO LEVEL, LAS VEGAS
TEL. 702-650-0817

FOR ADDITONAL INFORMATION OR TO REQUEST A CATALOG, PLEASE CALL 1-800-432-9330 OR VISIT OUR WEBSITE, WWW.IWC.COM

◗arije

Arije provides everyone who walks through its doors with the utmost in personalized service and acts as a congenial liaison between luxury watchmakers and their exclusive clientele.

For 30 years, Arije has been a fixture in the City of Lights, reinventing the aesthetic codes of jewelry and watchmaking. The first shop was established on rue Pierre Charron in the Golden Triangle of Paris, the section bordered by the avenue des Champs-Elysées, avenue Marceau and avenue Montaigne. Due to its extraordinary success and near-legendary status among Parisian watch aficionados, a sister store opened on avenue George V, a stone's throw away. The same year, 2009, Arije leapt even more emphatically into its expansion, opening two boutiques in Cannes and one in London as well.

The shops in Cannes, both on the Promenade de la Croisette—close to the esteemed Film Festival—enchant and soothe with marble-inflected interiors similar to the store in London. Taupe and chestnut accents on the walls and floor induce a state of relaxation and echo the sand just steps away on the beach. In a Paris location, the aura of luxury is tangible, and the walls themselves seem to exude golden light. A third approach, seen on the ground floor, combines the clean, simple lines of the taupe interior and the extravagance of Paris's "Golden Triangle" in a sleek modern design. Recessed displays devoted to the likes of Rolex and Audemars Piguet beckon to the passer-by, and immaculate white couches around delicate flames reinterpret the conversation pit for an upscale clientele.

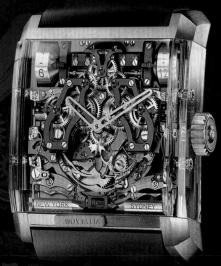

Répétition Minute Zephyr (Guy Ellia)

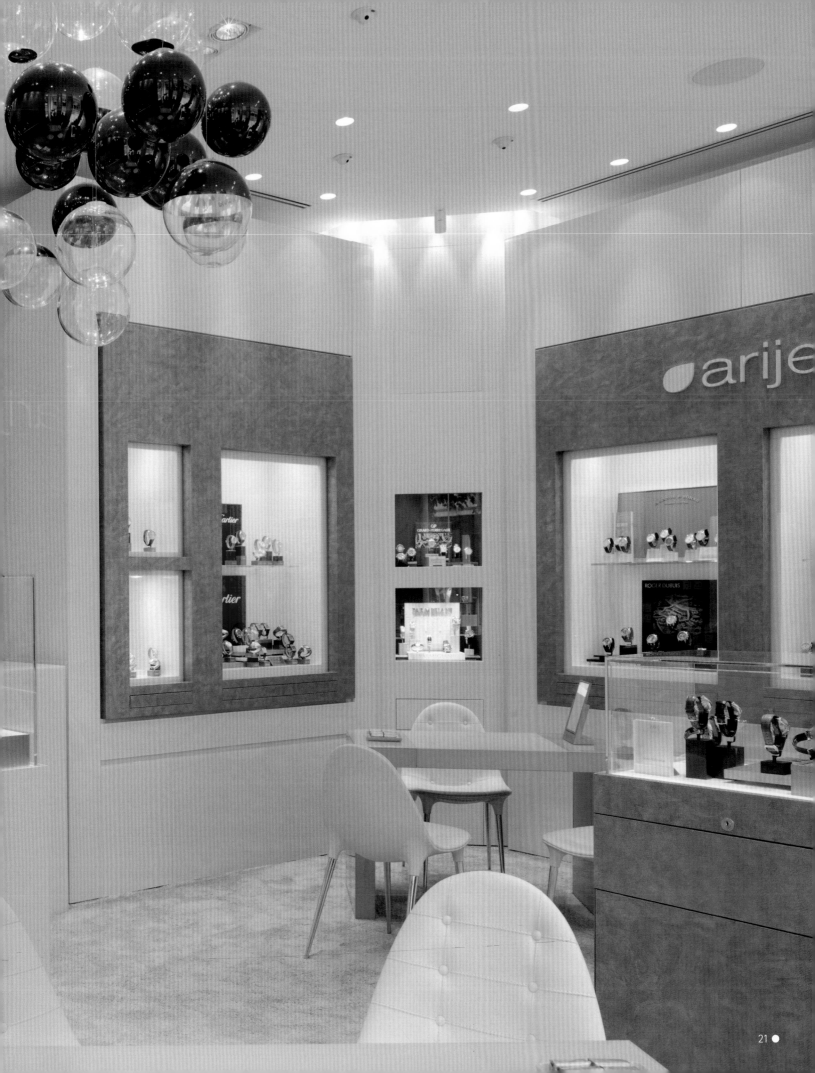

To wander inside an Arije boutique is like stumbling into a magical world made of gold and light. Five boutiques in three different cities—Paris, London and Cannes—all follow a distinct blueprint of luxury while developing their own identities.

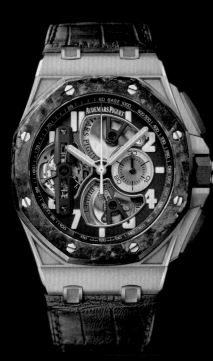

Royal Oak Offshore Hand-wound

The décor of Arije's boutiques, however, is only the beginning of a brand-new experience. One of the reasons for Arije's standing is its uncanny ability to predict trends in the watchmaking world. Of course, high quality is hardly a trend, and Arije carries the most prestigious names in the industry, names like Audemars Piguet, Breguet, Cartier, Chopard, IWC, Rolex, Vacheron Constantin, etc. The selection of watches, as well as a bent for daring, unpredictable haute jewelry, has built a reputation for Arije predicated on combining tradition and modernity. Major watch companies partner with Arije to showcase the latest word in exclusive series and limited editions.

This dedication is evident in the welcome the customer receives from Arije's staff. Acting as a congenial liaison between the highest-end watchmakers and their exclusive clientele, Arije provides everyone who walks through its doors with the utmost in personalized service. Of course, the relationship between the customer and the boutique is far from over once the watch lover happily holds his or her new Rolex or Audemars Piguet in hand.

DateJust Lady (Rolex)

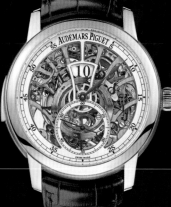
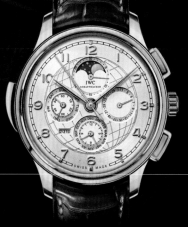
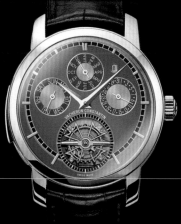

Time Space Quantième Perpétuel
(Guy Ellia)

Skeleton Manual Winding Repeater with Jumping Hour (Audemars Piguet)

Portuguese Grand Complication
(IWC)

Patrimony Traditionnelle Calibre 2755 (Vacheron Constantin)

Each shop dedicates a portion of its qualified staff to customer service. Handpicked watchmakers and reparation experts are approved by most major horological brands, where they undergo regular training. For the most delicate operations on the most complicated pieces, timepieces go to the ultra-modern servicing center at the boutique on Avenue George V. Just as a sapphire caseback reveals the workings of a watch, a glass window separates the servicing center from the rest of the boutique, allowing customers to observe the high-tech, high-precision work of consummate watchmaking professionals.

Of course, Arije would not be Arije without the spirit and efforts of Carla Chalouhi, its CEO. Daughter of Arije's founder, a cosmopolitan business-woman with her finger on the pulse of the watch industry, Carla is at the heart of it all, the woman behind the watches.

BRANDS CARRIED

A. Lange & Söhne** Girard-Perregaux** Roger Dubuis***
Audemars Piguet** Glashütte* Rolex*
Baume & Mercier** Guy Ellia** TAG Heuer*
Bell & Ross* Harry Winston* Tudor*
Blancpain* Hautlence** Ulysse Nardin**
Breguet* Hublot* Vacheron
Cartier** IWC** Constantin*
Chanel* Jaeger-LeCoultre* Van Cleef
Chaumet* Jaquet Droz* & Arpels**
Chopard* Montblanc* Zenith*
Cvstos* Omega*
de Grisogono* Panerai* * Paris
Dior* Parmigiani** * London
Ebel* Piaget** * Cannes
Franck Muller** Pierre Kunz*

ARIJE

PARIS
50 rue Pierre Charron - Tel +33 (0)1 47 20 72 40
30 avenue George V - Tel +33 (0)1 49 52 98 88

LONDON
165 Sloane Street - Tel +44 (0)20 7752 0246

CANNES
50 boulevard de la Croisette - Tel +33 (0)4 93 68 47 73

SAINT-JEAN-CAP-FERRAT
Grand-Hôtel du Cap-Ferrat • 71 boulevard du Général de Gaulle - Tel +33 (0)4 93 76 50 24

www.arije.com
contact: shop@arije.com

Rotonde Tourbillon Squelette
(Cartier)

23 ●

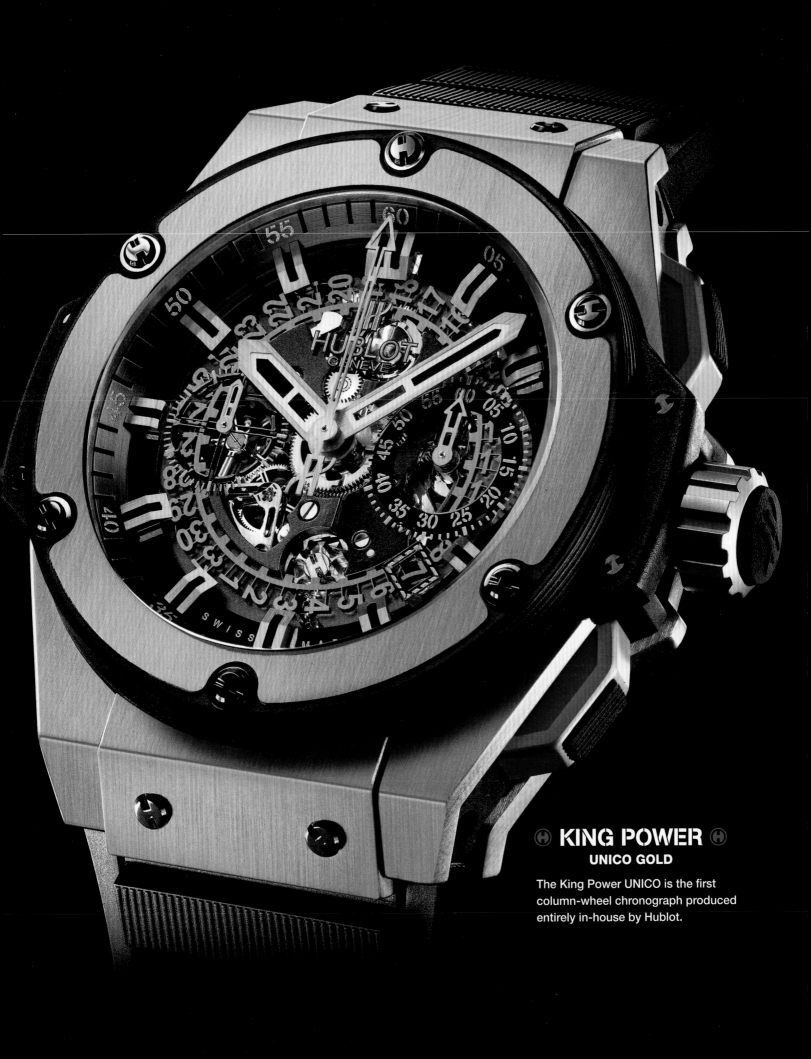

GRAND COMPLICATIONS®

THE ORIGINAL ANNUAL OF THE WORLD'S WATCH COMPLICATIONS AND MANUFACTURERS®

TOURBILLON INTERNATIONAL
A MODERN LUXURY MEDIA COMPANY
ADMINISTRATION, ADVERTISING SALES, EDITORIAL, BOOK SALES

7 West 51st Street, 8th Floor • New York, NY 10019
Tel: +1 (212) 627-7732 Fax: +1 (312) 274-8418

PUBLISHER
Caroline Childers

EDITOR IN CHIEF
Michel Jeannot

EDITORS
Claire Loeb
Elise Nussbaum

VICE PRESIDENT OF PRODUCTION
Meg Eulberg

ART DIRECTOR
Mutsumi Hyuga

VICE PRESIDENT OF MANUFACTURING
Sean Bertram

CONTRIBUTING EDITORS
Fabrice Eschmann
Scott Hickey
Mike Segretto

VICE PRESIDENT OF AUDIENCE DEVELOPMENT
Eric Holden

TRANSLATIONS
Susan Jacquet

DIRECTOR OF INFORMATION TECHNOLOGY
Scott Brookman

COORDINATION
Caroline Pita

SALES ADMINISTRATOR
Chris Balderrama

WEB DISTRIBUTION
www.modernluxury.com/watches

PHOTOGRAPHERS
Photographic Archives
Property of Tourbillon International, a Modern Luxury Media Company

MODERN LUXURY MEDIA

CHIEF EXECUTIVE OFFICER
Lew Dickey

PRESIDENT
Michael Dickey

EXECUTIVE VICE PRESIDENT AND CO-CHIEF OPERATING OFFICER
John Dickey

EXECUTIVE VICE PRESIDENT AND CO-CHIEF OPERATING OFFICER
Jon Pinch

CHIEF FINANCIAL OFFICER
JP Hannan

GENERAL COUNSEL
Richard Denning

⊙Westime

For more than two decades, family-owned and operated Westime has distinguished itself as the ultimate retail destination for finding extraordinary watches. Year after year, Westime earns the return business of discriminating clients from around the world who value Westime's superior service and watch selection.

Westime's two elegant boutiques make watch shopping a true VIP experience. At the Westime Los Angeles location, which is a 6,000-square-foot showroom adjacent to the Westside Pavilion, clients will find a wide range of watches representing every price point. Here, expansive showcases, comfortable seating arrangements and two specialty boutiques make browsing easy and personal. Two master watchmakers are on site at all times, and they have state-of-the-art equipment at their disposal to provide fast service and repairs. In Beverly Hills, Westime's intimate multi-level boutique resides at the heart of the city's most glamorous shopping district. Here, watch collectors and those following the latest fashion trends will find the most sought-after timepieces in the world.

Westime prides itself on offering highly regarded and rare watches from the most acclaimed watch brands. Limited editions, unique pieces, and even custom models created exclusively for Westime take pride of place in the boutiques' showcases. Westime is frequently selected by brands to carry their most complicated timepieces on an exclusive basis.

**Royal Oak Offshore
Grand Prix
(Audemars Piguet)**

From day one, Westime has also dedicated itself to seeking the new guard in haute horology by presenting the finest creations of contemporary watchmakers. Three brands stand powerfully for the new watchmaking vanguard. Richard Mille is regarded as the master of materials that are redefining the vocabulary of luxury; Greubel Forsey hails as the tourbillon revolutionary; and URWERK has emerged as the king of kinetic sculpture.

Throughout the year, Westime hosts unique customer events to introduce preferred clients to the newest watches, as well as the visionaries behind these complicated creations. The company is also a proud supporter of charities and their local fund-raising events. And the boutiques' multi-lingual staff members are dedicated to providing the ideal service to their clients—from explaining the specifics of complications, to hand-delivering a watch across the country.

Westime is owned by a third-generation watch connoisseur with a passion for mechanical timepieces and a true love of the business. With Greg Simonian, a member of the family's fourth generation, leading the business, Westime's horizons are expanding. During 2011, Westime will open a new flagship location on Sunset Boulevard, and continue to offer an even greater selection of watches and luxurious accessories.

Westime offers highly regarded and rare watches from the most acclaimed watch brands, displaying limited editions, unique pieces, and even custom models created exclusively for Westime in its showcases.

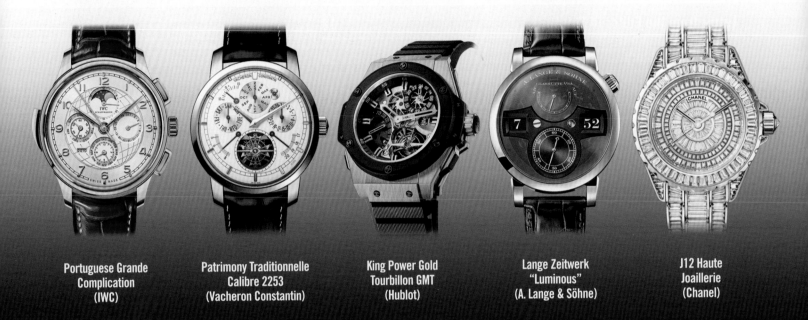

Portuguese Grande Complication (IWC)

Patrimony Traditionnelle Calibre 2253 (Vacheron Constantin)

King Power Gold Tourbillon GMT (Hublot)

Lange Zeitwerk "Luminous" (A. Lange & Söhne)

J12 Haute Joaillerie (Chanel)

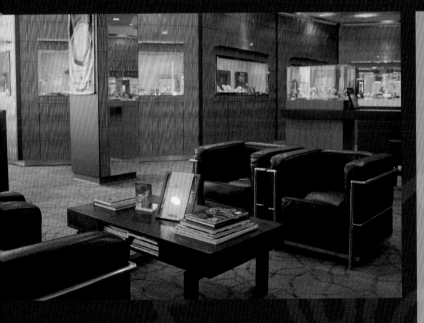

WESTIME

10800 West Pico Blvd., #197 • Los Angeles, CA 90064

tel: 310-470-1388 • fax: 310-475-0628

254 North Rodeo Drive • Beverly Hills, CA 90210

tel: 310-271-0000 • fax: 310-271-3091

www.westime.com

BRANDS CARRIED

A. Lange & Söhne	HD3
Alain Silberstein	Hermès
Audemars Piguet	Hublot
Bell & Ross	Ikepod
Blancpain	IWC Schaffhausen
Breguet	Longines
Breitling	Ludovic Ballouard
Buben & Zörweg	MB&F
Chanel	MCT
Chopard	Milus
Concord	Nixon
DeWitt	Omega
Ebel	Richard Mille
FP Journe	Roland Iten
Franck Muller	Romain Jerome
Frédérique Constant	TAG Heuer
Girard-Perregaux	Tiffany & Co.
Glashütte Original	Tissot
Graham-London	URWERK
Greubel Forsey	Vacheron Constantin
Guy Ellia	Vertu
Hamilton	Zenith
Harry Winston	

Summary

THE SIMPLICITY OF INNOVATION.

LUMINOR 1950 TOURBILLON GMT
Hand-wound mechanical Tourbillon
movement P.2005 calibre, three spring
barrels, second time zone with 12/24 h
indicators, 6-day power reserve.
Titanium case 47 mm Ø.
Titanium buckle.

PANERAI

Our collection of mechanical calibres, all made in-house, is unique in the world with unparalleled breadth in shape, design and level of complication: for every watch its own calibre. Throughout our 175-year history, we have produced over 1,000 different calibres. Out of the 60 calibres in creation today, the most exceptional are shown here. Absolute leadership in the history of fine watchmaking.

YOU DESERVE A REAL WATCH.

CAN SHOW YOU THIS.

Web Site Directory

A. LANGE & SÖHNE	www.alange-soehne.com		**LONGINES**	www.longines.com
AUDEMARS PIGUET	www.audemarspiguet.com		**PANERAI**	www.panerai.com
BELL & ROSS	www.bellross.com		**PARMIGIANI**	www.parmigiani.ch
BLANCPAIN	www.blancpain.com		**PATEK PHILIPPE**	www.patek.com
BREGUET	www.breguet.com		**PIAGET**	www.piaget.com
BVLGARI	www.bulgari.com		**REBELLION TIMEPIECES**	www.rebellion-timepieces.com
CHANEL	www.chanel.com		**RICHARD MILLE**	www.richardmille.com
CHRISTOPHE CLARET	www.claret.ch		**ROGER DUBUIS**	www.rogerdubuis.com
DE GRISOGONO	www.degrisogono.com		**STÜHRLING ORIGINAL**	www.stuhrling.com
DeWITT	www.dewitt.ch		**TAG HEUER**	www.tagheuer.com
DIOR HORLOGERIE	www.diorhorlogerie.com		**ULYSSE NARDIN**	www.ulysse-nardin.com
FRANCK MULLER	www.franckmullerusa.com		**URWERK**	www.urwerk.com
FRÉDÉRIQUE CONSTANT SA	www.frederique-constant.com		**VACHERON CONSTANTIN**	www.vacheron-constantin.com
GLASHÜTTE ORIGINAL	www.glashuette-original.com		**ZENITH**	www.zenith-watches.com
GUY ELLIA	www.guyellia.com			
HARRY WINSTON SA	www.harrywinston.com		RELATED SITES	
HUBLOT	www.hublot.com		**BASELWORLD**	www.baselworld.com
IWC SCHAFFHAUSEN	www.iwc.com		**SIHH**	www.sihh.ch
JACOB & CO	www.jacobandco.com		AUCTION HOUSES	
JAEGER-LeCOULTRE	www.jaeger-lecoultre.com		**CHRISTIE'S**	www.christies.com
JEAN DUNAND	www.jeandunand.com		**SOTHEBY'S**	www.sothebys.com

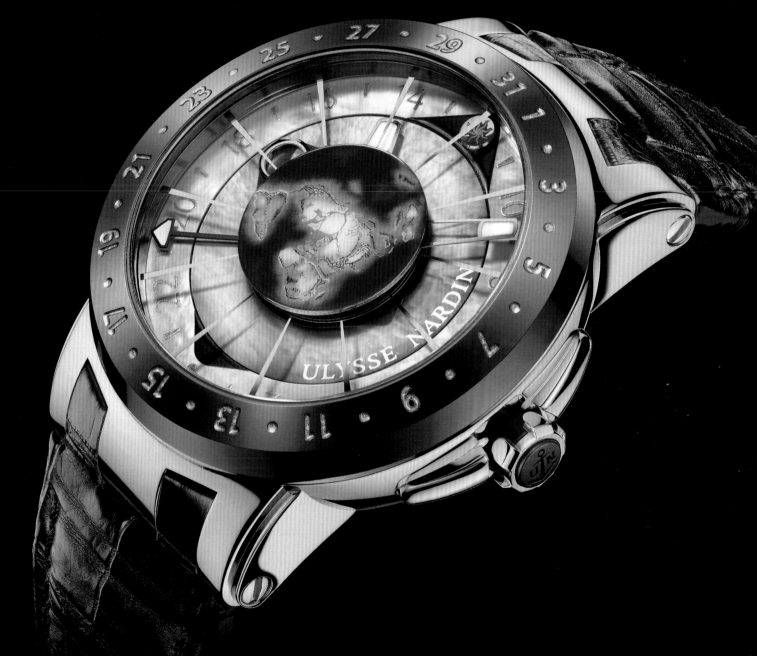

Moonstruck

Astronomical wristwatch. Self-winding.

Moon phases. 18 ct rose gold case. Water-resistant

to 100 m. Leather strap with folding buckle.

Limited Edition of 500 pieces.

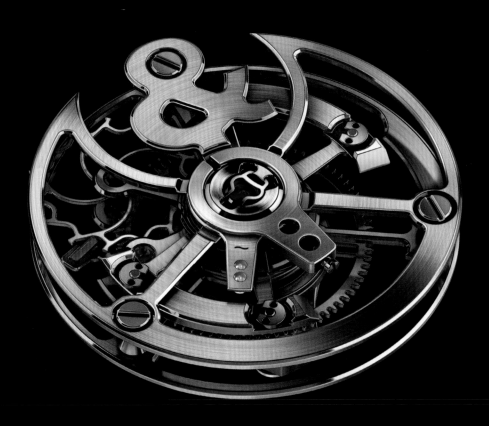

TIME INSTRUMENTS

BR INSTRUMENT MINUTEUR TOURBILLON · 44 X 50MM · HOURS, MINUTES AND SMALL SECONDS
MINUTEUR TIMER WITH FLYBACK FUNCTION (2 GRADUATIONS: MINUTES AND 1/10TH OF
HOURS) · 3-DAY POWER RESERVE INDICATOR · 18K SATIN-POLISHED PINK GOLD CASE
BELL & ROSS INC. 1.888.307.7887 · INFORMATION@BELLROSSUSA.COM · E-BOUTIQUE: WWW.BELLROSS.COM

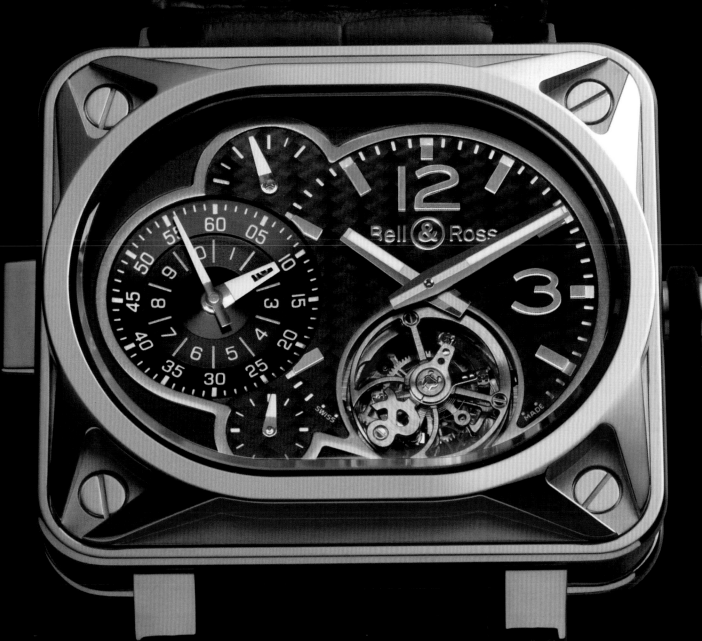

Index

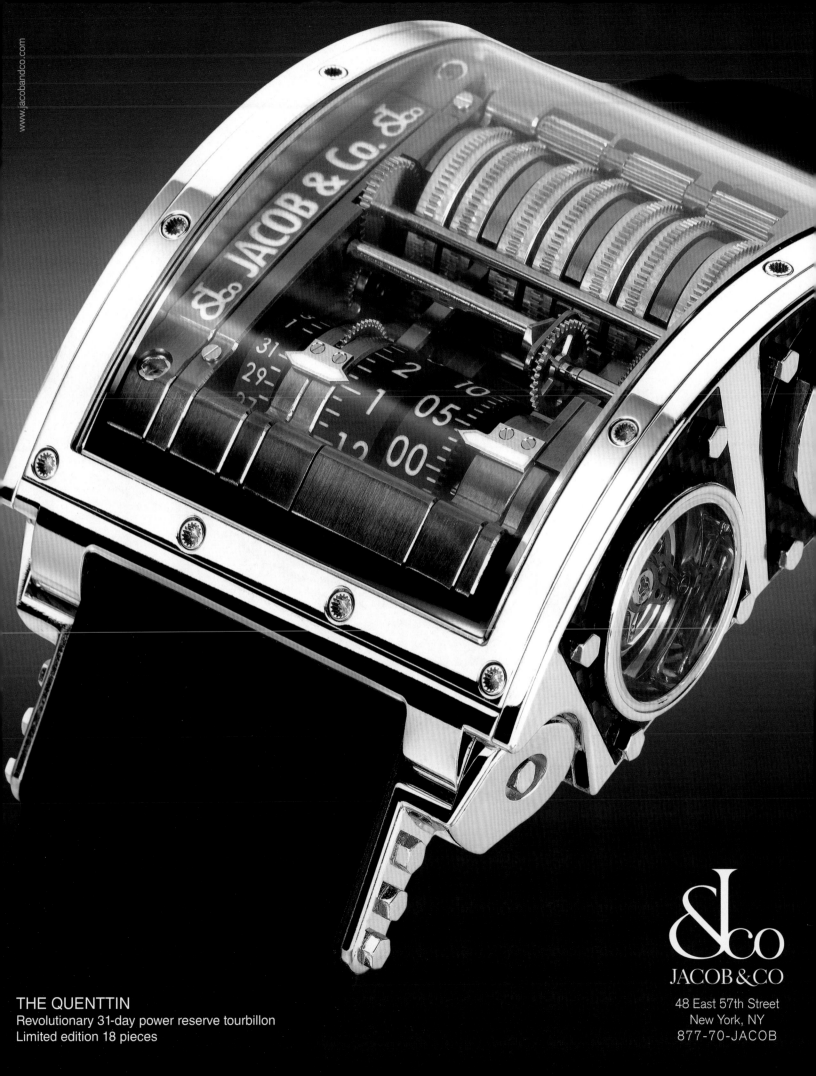

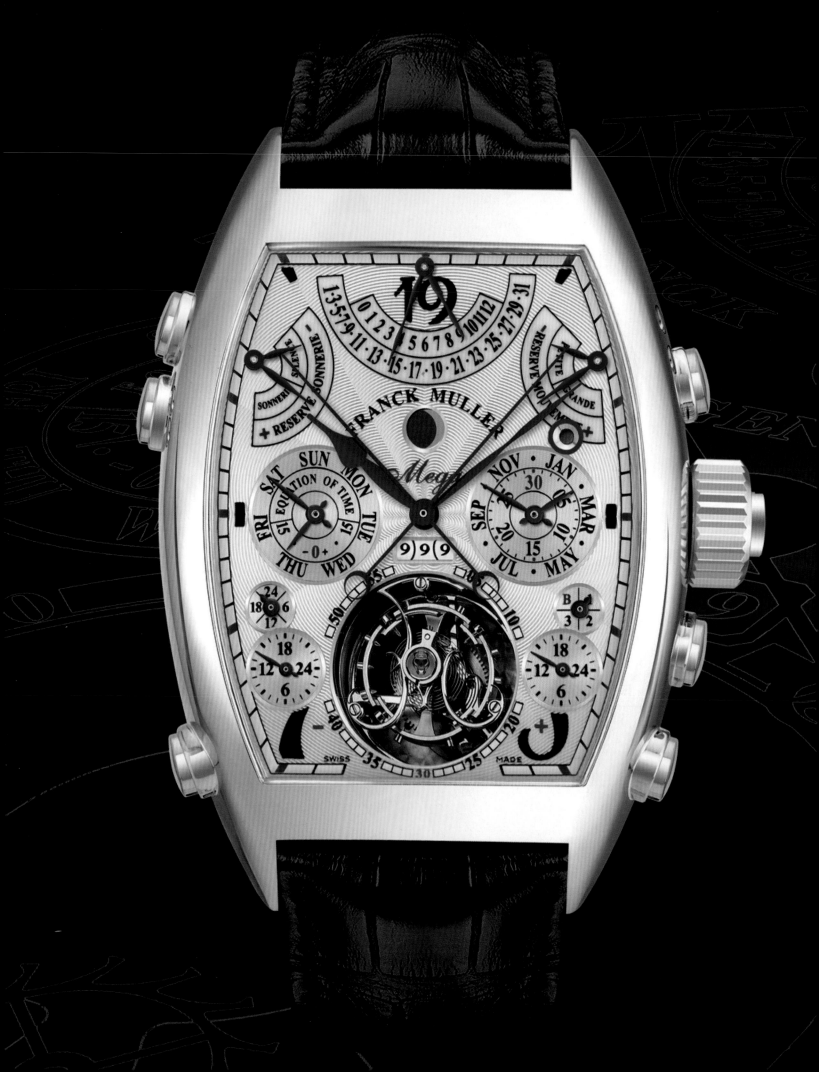

FRANCK MULLER

GENEVE

AETERNITAS
MEGA

THE MOST
COMPLICATED WATCH IN THE WORLD

Master of complications

Index

PARMIGIANI

HERITAGE IN THE MAKING

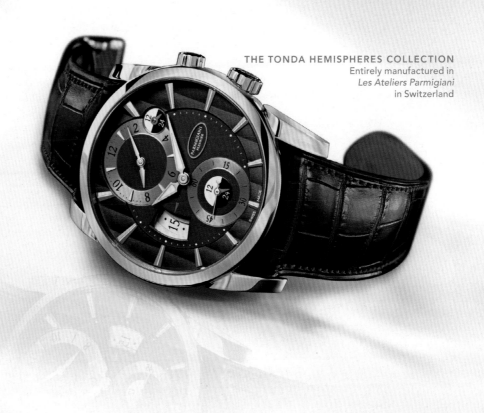

150 YEARS

MASTERING SPEED FOR 150 YEARS

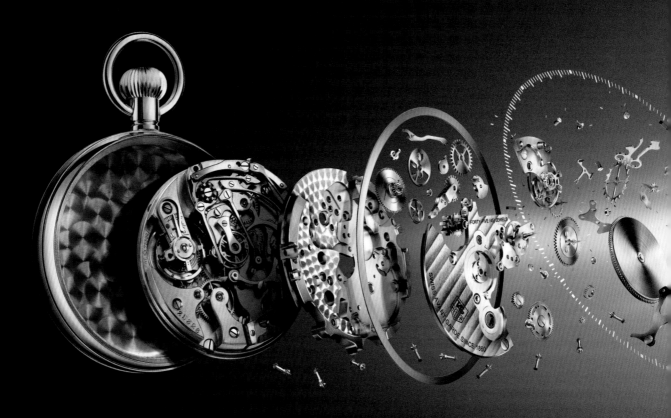

Grand Prix d'Horlogerie de Genève

Prize of La Petite Aiguille • 2010

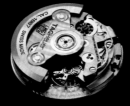

TAG Heuer Calibre 1887

Invented in 1887 by Edouard Heuer, reengineered in our new in-house Calibre 1887, the oscillating pinion enables our CARRERA chronograph to start in less than 2/1000th of a second.

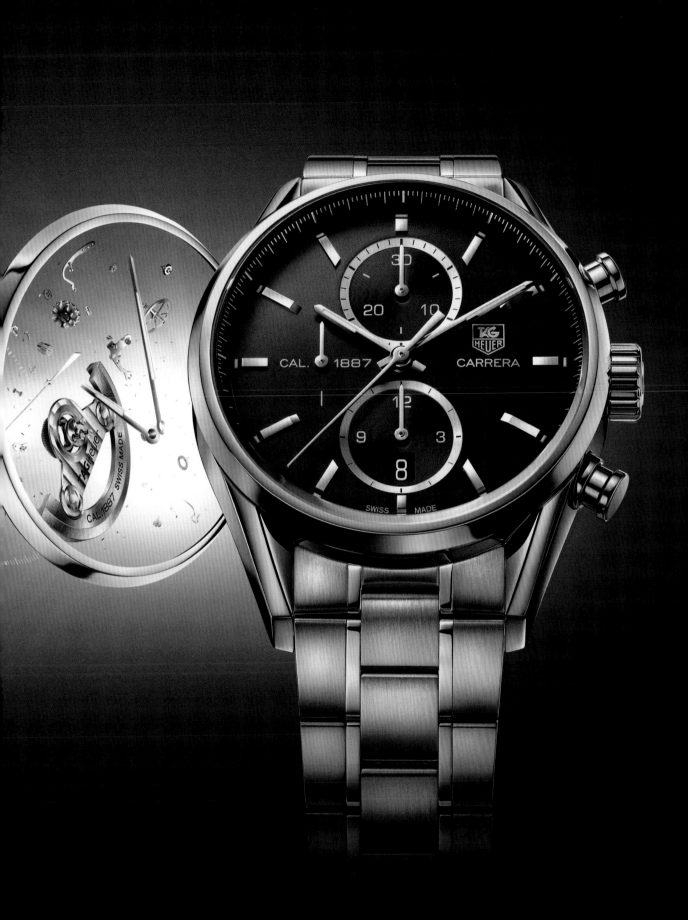

SWISS AVANT-GARDE SINCE 1860

Index

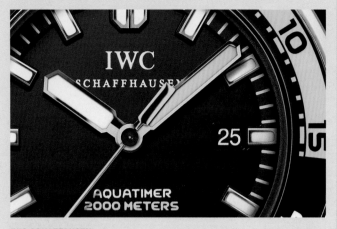

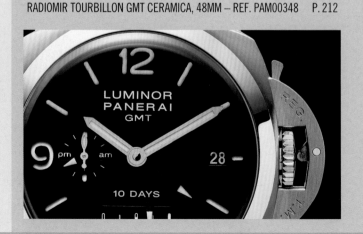

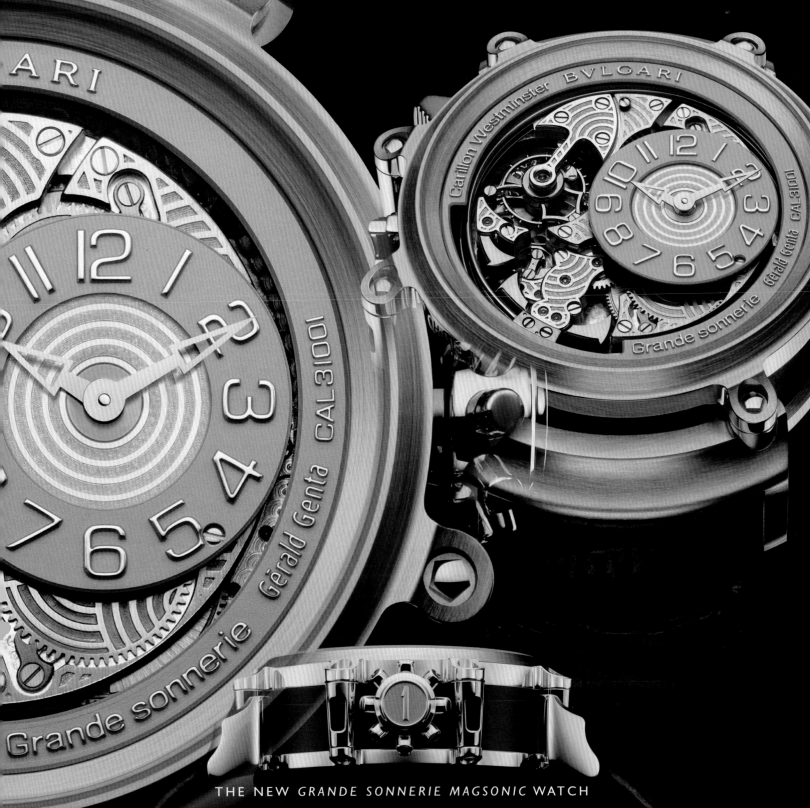

BVLGARI

THE NEW *GRANDE SONNERIE MAGSONIC* WATCH

GRANDE SONNERIE, WESTMINSTER CHIME, GRAND AND LITTLE STRIKE ON FOUR GONGS, MINUTE REPEATER AND TOURBILLON.
MANUAL WINDING MOVEMENT, GG 31001 CALIBER, COMPOSED OF 632 COMPONENTS ENTIRELY CRAFTED BY THE BVLGARI
MANUFACTURE DE HAUTE HORLOGERIE IN LE SENTIER. PERLAGE AND ENGRAVED WAVE PATTERN MADE BY HAND.
48 HOURS OF POWER RESERVE FOR THE MOVEMENT AND 24 HOURS FOR THE STRIKING MECHANISM DISPLAYED THROUGH
THE TRANSPARENT BACK CASE. PATENTED 18 KT PINK GOLD CASE CONSTRUCTION USING SOUND AMPLIFIER MAGSONIC® ALLOY.
SKELETONIZED OFF-CENTERED GOLD AND SAPPHIRE DIAL. ALLIGATOR STRAP WITH 18 KT PINK GOLD FOLDING BUCKLE.

ATLANTA · BAL HARBOUR · BEVERLY HILLS · BOCA RATON · CHEVY CHASE
CHICAGO · DALLAS · HONOLULU · HOUSTON · LAS VEGAS · NEW YORK
SAN FRANCISCO · SCOTTSDALE · SHORT HILLS · SOUTH COAST PLAZA · BVLGARI.COM

Meccanico dG
A TECHNICAL MASTERPIECE

With its double analogue and mechanical digital display, this watch from de Grisogono asserts itself as one of the most exceptional contemporary haute horlogerie models. Its highly sophisticated movement called for years of development, but this marvel of precision is not reserved exclusively for connoisseurs of horological techniques. The accurate and constantly repeated choreography performed by its gear trains, cams and microsegments generates extraordinary emotion and fascinating poetry that can be sensed by everyone. This majestic performance is set off to its best advantage within a case featuring imposing yet elegant lines.

The heart of the watch beats to the tune of a hand-wound mechanism composed of 651 parts, all hand-assembled by the company's most skilled and experienced watchmakers. The analogue display of the hours and minutes is located in the upper part of the dial, while the lower area features a mechanical digital display indicating a second time zone. The latter reveals tens of hours, single hours, tens of minutes and single minutes thanks to the action of mobile microsegments driven by a set of 23 cams combined with gears plus a triggering/synchronisation device. The vertical segments are 4.55 mm high and the horizontal ones have a display length of 1.80 mm. Each segment has four faces: two visible faces opposite each other with coloured inserts and two invisible faces, also opposite. One or more segments rotate 90° to turn one time indication into the next. The

jump is instantaneous, while anywhere from 1 to 12 segments move, depending on the time being displayed.

Each year, the digital function is activated 518,400 times and sets 285 million parts into motion.

This exceptional movement lends its full value to this timepiece that is inventing a new watchmaking language. Limited edition of 177 pieces.

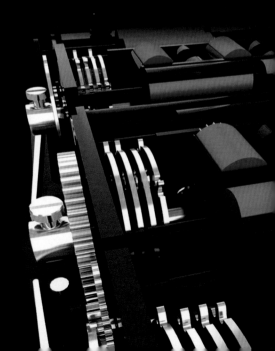

de GRISOGONO
GENEVE

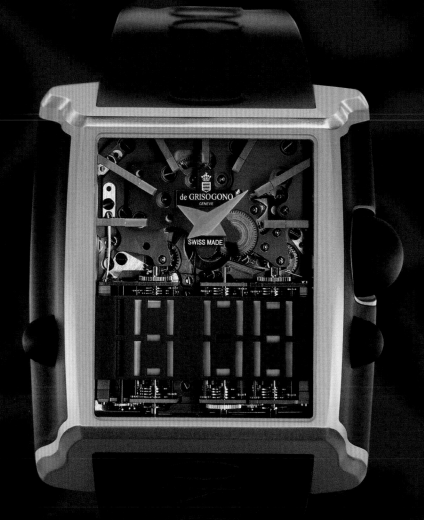

meccanico dG

Limited Edition of 177 pieces

Grand Prix d'Horlogerie de Genève

Public Prize · 2009

THE FIRST MECHANICAL WATCH IN THE WORLD WITH A DUAL ANALOGUE AND DIGITAL DISPLAY

MECCANICO dG IN TITANIUM AND RUBBER CASE, HANDWINDING MECHANICAL MOVMENT
WITH DUAL TIME AND MECHANICAL DIGITAL SECOND TIME ZONE

www.degrisogono.com

Index

ROGER DUBUIS

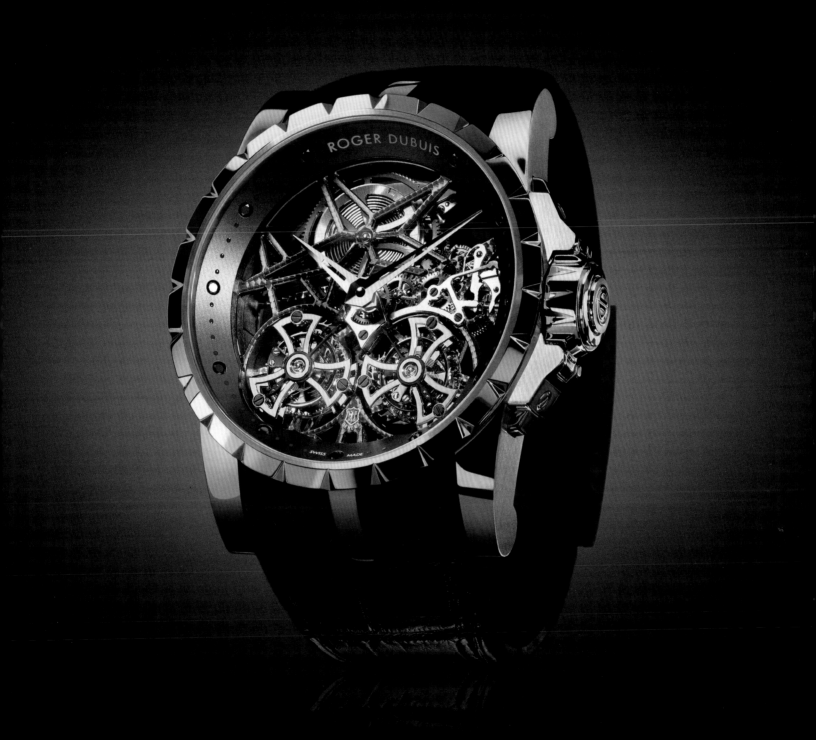

EXCALIBUR RD01SQ — SKELETON DOUBLE FLYING TOURBILLON

The Poinçon de Genève quality hallmark reflects highest accomplishments in horological art and craftsmanship. 100% of the ROGER DUBUIS watches bear this seal of excellence.

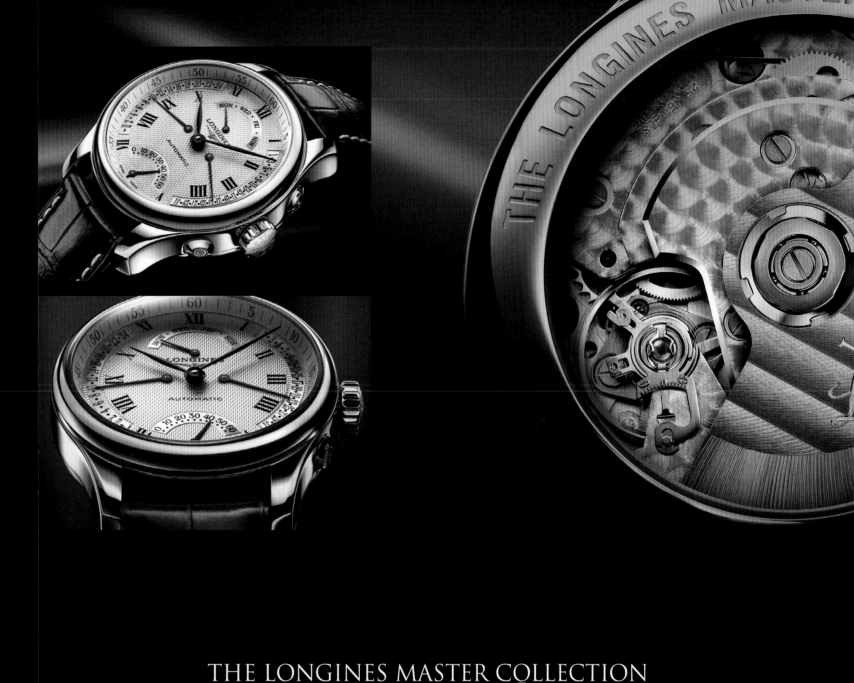

THE LONGINES MASTER COLLECTION
retrograde

Over the years, Longines has dedicated numerous efforts to perfecting the mechanical measurement of time. A creator of horological movements, the Saint-Imier-based firm has nevertheless also assured that a touch of added refinement always forms a part of its creations. Longines has always regarded elegance as being the fundamental underlying principle in both the arrangement of the watch calibre and in the aesthetics of the final watch. Faithful to the almost 180 years of its watchmaking tradition, Longines has today realised a synthesis between its technical and aesthetic heritage in the creation of a new flagship timepiece representing its collection of horological tradition: The Longines Master Collection Retrograde.

Index

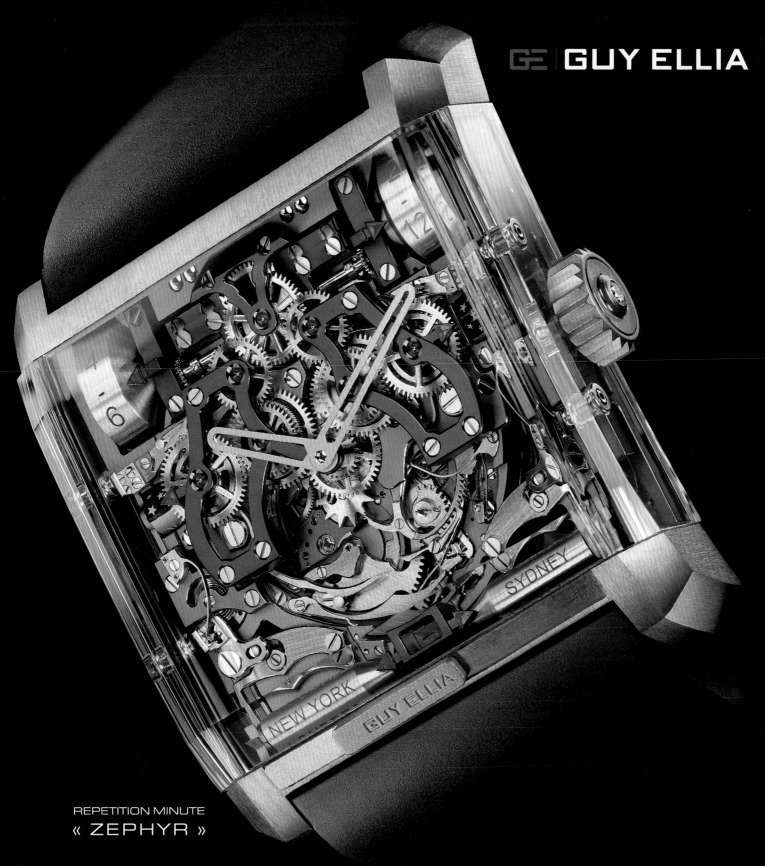

GE | **GUY ELLIA**

REPETITION MINUTE
« ZEPHYR »

Calendars

Hours, minutes and seconds are now considered basic functions of a watch and any indications other than these are referred to as "complications". However, well before counting minutes, seconds, and now even fractions of a second, humankind began by measuring time in days, months, years and sometimes even larger units, and the path towards finer divisions was to prove both lengthy and sinuous.

Mechanical horology kept pace with this evolution, and there were clocks and subsequently pocket-watches featuring various calendar indications (date, day, month, etc.) even before the appearance of the minute hand (late 17th century) and the seconds hand (late 18th century).

Over the centuries, calendar indications established themselves as one of the most useful functions a timepiece could offer, and they called upon all the ingenuity of the finest horologers who concerned themselves with resolving the various issues raised by the Gregorian calendar—starting with the variable lengths of months and the periodic return of February 29th.

Today, despite the omnipresent indications of the date, day, month and year appearing on countless daily objects (diaries, computers, cell phones, etc.), calendar watches are still very much in vogue. From a simple date window to the highly complex perpetual calendar, along with large date displays, day/date subdials and complete calendars, they offer a vast range of different expressions and varying degrees of complication. We have even witnessed in recent years the growing popularity of a new type, known as the "annual calendar." Mechanisms are consistently fine-tuned to offer ever-increasing security, reliability and user-friendliness. In design, variety is the order of the day, with a broad palette of display modes (apertures, hands, rollers, retrograde systems, etc...); transparency-based approaches that are often very original; and appearances matching all tastes ranging from the most classic to the most daring.

Such is the rich world we are inviting you to explore, with an overview of the history of the calendar, technical details regarding the various types of calendar watches, and a panoramic look at the main trends characterizing contemporary production.

A BRIEF HISTORY OF THE GREGORIAN CALENDAR

The Gregorian calendar was not made in a day. It is the result of extensive borrowing, as well as numerous influences, adjustments and corrections over the centuries. And even today, when it has asserted itself as the main official worldwide reference, it co-exists with a broad variety of systems that have maintained their religious and cultural importance.

The sky is often said to be our first clock. It was indeed by observing nature that human beings noticed a certain number of identical phenomena that were repeated at regular intervals, which enabled them to measure time, devise calendar systems and organize religious, political and civil activities.

The most evident unit of time is the alternating pattern of days and nights, as well as the visible movement of the sun across the sky, from sunrise through its zenith and on to sunset. But other periodic occurrences were also soon observed, the most obvious being the lunar cycle lasting around 29 days and which gave rise to the concept of the month (as is reflected in the etymological similarity between the words moon/month in English and Mond/Monat in German). Other phenomena spanning a longer period were also perceived, such as the regular return (in temperate climates) of the seasons over a cycle of around 365 days (corresponding to a complete revolution of the Earth around the sun), as well as the sun's variable height at its zenith, and the displacement of its sunrise and sunset locations on the horizon, which also follows a rhythmical cycle. These various observations resulted in the definition of a year.

It was on this double month-and-year basis that most civilizations developed their various types of calendar, some of which were extremely complex. The main difficulty stemmed from the fact that the lunar month does not correspond to a whole number of solar days and that the solar year does not contain a whole number of lunar months—which means that these units are not mutually divisible. The lunar cycle actually lasts 29 days, 12 hours, 44 minutes and 2.8 seconds (or 29.53 days), whereas the real duration of the so-called "tropical" or astronomical year is 365 days, 5 hours, 48 minutes and 45.2606 seconds (or 365.242190517 days). Some civilizations favored the lunar cycle (such as for the Muslim calendar), while others attempted to reconcile the two systems (lunisolar calendars, such as the Gregorian calendar).

FROM THE FERTILE CRESCENT TO THE GAULS

The very first calendars were generally of the lunar type. As populations became less nomadic, the rhythm of the year and the seasons, often linked to farming activities, became more important and an effort was made to devise calendars combining lunar and solar cycles. In the third millennium BC, the Sumerians already used a year comprising 12 months of 30 days each, with various intercalary months to compensate for the discrepancies. Mesopotamia also witnessed the invention of the sexagesimal numbering system, which led to dividing the day into 12/24 hours, the hour into 60 minutes and the minute into 60 seconds. In the Egyptian calendar, the year comprised 365 days with 12 months of 30 days each, plus five days added on at the end of the year—which led to a progressive regression in relation to the solar year. The Egyptian year began at the summer solstice (the start of the Nile floods), and the month was divided into three ten-day periods.

In Ancient Greece, while calendars were of the lunisolar type, with various intercalary methods, there were almost as many systems as there were cities. Nonetheless, Greek astronomers had already achieved an extremely high degree of sophistication in their calculations, particularly regarding the exact duration of the tropical year. The years were generally named after the magistrates in charge at the time, or numbered in relation to the first Olympic Games, held in 776 BC. The Celts also had some extremely complex calendar systems, traces of which have been found in, for example, the famous Coligny calendar displayed in the Gallo-Roman Museum on Fourvière (Lyon, France). This Gaulish calendar written in letters and Roman numerals features a cycle of five 12-month years with alternate 29 and 30-day months, to which two intercalary months were added, one at the start of the first year, and one in the middle of the third.

JULIAN CALENDAR

The Roman calendar, inspired by the Egyptian calendar, underwent a number of evolutions. In the Republican era, the year comprised 365 days (12 lunar months) with an intercalary month of varying length added once every two years to compensate for its lag behind the solar calendar. Until 153 BC, the year began in March, which marked the resumption of farming and military activities, which explains the names of the months of September (derived from septem, meaning seven), October (eight), November (ninth) and December (tenth), which have been maintained to this day despite subsequent calendar reforms.

Although the system of intercalary months was not applied in a sufficiently rigorous manner, particularly in the age of civil wars, it gave rise to various abuses perpetrated by the priests and magistrates responsible for the calendar. In the first century BC, Julius Caesar, in his capacity as "grand pontiff," decided to reform the calendar by enlisting the services of a Greek astronomer. The first measure adopted was to realign the Roman year with the tropical year. A 12-month year was instated, comprising alternating 31 and 30-day months apart from February, which had 29 (hence a total of 365 days), and every four years an intercalary day was to be added between February 24th and 25th. In the initial version of the so-called Julian calendar, which came into force in 46 BC, the month of August had 30 days, September 31, October 30, November 31 and December 30. In 44 BC, the senate decided to honor Julius Caesar, who had just been assassinated, by giving his name to the seventh month of the year, which thus became Julius (hence July). In 8 BC, the same homage was paid to the first emperor Augustus, to whom the following month was dedicated and named Augustus (August). But as this month had only 30 days, the Emperor could not decently be given a month shorter than that devoted to his illustrious predecessor, and so the month of August was lengthened to 31 days, which in turn meant September therefore had 30 days, October 31, November 30 and December 31, while February was shortened to just 28. And so it was that two tributes paid to famous Romans added to the complexity of the calendar system—and that of the task of future horologers.

In the Roman system, the month was divided into three unequal parts with three fixed points: the Kalends (1st day of the month)—hence the word calendar; the Nones (the 5th or the 7th); and the Ides (13th or the 15th). The date indication was counted backwards from the following point of reference. Our May 2nd, for instance, was referred to as the "6th day before the Nones of May."

The calendar was also punctuated by countless feast days as well as by alternating auspicious and ill-fated days. The year itself was named either after the consuls in power; or starting from the founding of Rome (754, 753 or 750 BC); or, more rarely, from the expulsion of the kings (509 BC). It was under the influence of Christianity, from the 3rd century onwards, that months were divided into seven-day weeks, based on the seven-day Biblical account of creation in Genesis). In the 6th century, the year of the birth of Jesus Christ was officially fixed as marking the start of the Christian era. Towards the end of the Middle Ages, days of the month began to be numbered from 1 to 28, 29, 30 or 31, and the leap-year day was then added at the end of February.

THE GREGORIAN CALENDAR

The Julian year, with its average length of 365.25 days, was slightly longer than the mean tropical year (365.24219 days), and thus fell one day behind every 134 years. This lag became ever more apparent over the centuries, and the mobile day of Easter, for example, was coming ever closer to summer. That was why Pope Gregory XIII decided in the late 16th century to "adjust" the Julian calendar. The first measure was to eliminate the ten-day difference with the tropical year by moving directly from Thursday October 4th 1582 to Friday October 15th 1582. To avoid this lag occurring in the future, the decision was also taken to eliminate three leap years every 400 years. To achieve this, it was decreed that the secular or century years (ending with 000) of which the first two numbers were not divisible by four would henceforth be deprived of February 29th (which is why the year 2000 was a leap year, whereas 2100, 2200 and 2300 will not be leap years). It is worth noting, however, that there is still a one-day error over a 3,000-year period despite this reform. While the Gregorian calendar was rapidly adopted by the main Catholic countries, it met with more resistance in Protestant and Orthodox nations that were not so inclined to obey papal decisions. Many countries did not officially adopt it until the 19th or the 20th century, and the monastic republic of Mount Athos, in Greece, still lives according to the Julian calendar.

THE REVOLUTIONARY CALENDAR

In 1793, the French revolutionaries decided to break with the ancien régime and with Christianity by abolishing the Gregorian calendar and replacing it with a new system—which proves the symbolic power a calendar may carry. The start of the Republican era was fixed on September 2nd 1792. The revolutionary year comprised 12 months of 30 days each, along with five or six extra days called "sans-culottides" and which began on September 22nd or 23rd (the autumn equinox). Months were given poetic names relating to the weather or to farming activities (Brumaire, Ventôse, Fructidor, etc.).

LEFT ABOVE

This pocket-sized silver sundial was an 18th-century French aid to travelers. Incredibly, the dial was both portable and universal. The small octagonal plate was engraved with concentric hour scales for different latitudes and had a compass inset. The central stylus folded down for compactness and was adjustable according to latitude.

LEFT

Square-shaped clock with horizontal dial. The case, made of gilded brass, has openings on two sides to allow the sound of the alarm to pass. The silver dial displays Roman numerals from I to XII, repeated inside with Arabic figures from 13 to 24. The central disc is for the alarm-setting.

They were divided into three ten-day periods that were named according to their numerical order: primidi, duodi, tridi, etc. The decision was even taken to give each day of the year its own name borrowed from a fruit, an animal or a tool: October 2nd was christened Potato, October 29th Black Salsify, November 5th Turkey Cock, November 30th Pickax, December 28th Manure and January 10th Plaster Stone! Following on from this, the revolutionaries also replaced—albeit briefly—the duodecimal system by a decimal system that involved a day divided into ten hours, hours divided into ten minutes and minutes divided into ten seconds. The Republican calendar was rescinded in 1806.

PRE-COLUMBIAN CALENDARS

The grand civilizations of what is now Latin America had also developed various calendars. The Mayas had a very complex system combining several calendars: one religious with a 260-day year and the other civilian with a 365-day year, as well as various cycles and counting modes. The Aztecs simultaneously used a sacred 260-day divinatory calendar, a civil solar calendar of around 365.25 days, and a 584-day Venus-based calendar.

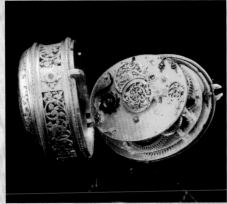

CALENDARS IN THE GLOBAL ERA

Today, in our "global village," the Gregorian calendar has established itself as the international benchmark, at least as far as everything related to civilian activities, transport and trade exchanges. But it continued to co-exist with other sometimes very ancient systems governing religious life and the cadence of traditional feast days. Followers of Islam use the Muslim lunar calendar (also called the Islamic or Hegerian calendar) in which the year is composed of 12 months of 29 or 30 days each. This Muslim year is 11 days shorter than the Gregorian year, which explains why the dates of Ramadan fall progressively earlier each year. It is based on direct human observation of the new moon that signals the start of the month, so different locations observe different starting dates. Moreover, the Hegira (the Muslim era) begins in 622 AD. According to the lunisolar Jewish (or Hebraic) calendar, which uses lunar months and solar years, months begin with the new moon and last 29 to 30 days. So as to keep pace with the solar rhythm, a 13th month is added to the year at certain intervals. The seven-day week begins on Sunday and the start of the calendar is equivalent to the year 3761 BC. The Chinese calendar is also of the lunisolar type, with seven intercalary months added over a 19-year cycle. The months begin with the new moon and the Chinese New Year falls between January 21st and February 20th. Among the many other systems used around the world, one might also mention the Thai lunar calendar, the Saka calendar (in India, Pakistan and Bali), the various Hindu calendars, and the "Julio-Gregorian" Berber calendar.

CENTER

Signed in 1557 and attributed to German watchmaker Christoph Schissler, this instrument presents a multiplicity of ingenious devices. It contains a map of central and western Europe and another of the world, a dictionary of geographic names, and a horizontal sundial with four scales for latitudes.

TOP AND ABOVE RIGHT

An oval-shaped astronomical watch made of silver and brass. Movement signed Marc Girard à Blois, France, beginning of the 17th century. Mr. Girard's watch belongs to this relatively numerous series of oval watches, which were fashionable from the last quarter of the 16th century until 1630.

FROM SKY TO DIAL

The very first medieval monumental clocks (particularly the 14th- and 15th-century cathedral clocks) already displayed a number of astronomical indications, some of which were related to the calendar. The astronomical clock on Strasbourg Cathedral, in France, was built between 1547 and 1574 and features a number of complications, including a perpetual calendar displaying the mobile feast days over a hundred-year period. The famous "Zytglogge" (Clock Tower) in Bern, Switzerland (1530) is distinguished by—apart from its animated figurines—an astronomical dial displaying the time, day, date, month, Zodiac sign and moonphase. Calendar displays appeared at a relatively early stage on pocket-watches—well before the minutes and seconds hands. From the late 16th century onwards, certain astronomical watches showed the time, the date, the day the week, the month (with its length) as well as the moonphases and Zodiac signs. Calendar watches subsequently proved a great success, but they were nonetheless merely "simple calendars" requiring manual adjustment after each month with less than 31 days, meaning five times a year. It was not until the late 18th century that the so-called "perpetual calendars" were developed, taking account of the variable lengths of the months and of the leap-year cycle. A complete perpetual calendar was included in the famous "Marie-Antoinette" watch by Breguet, which was completed in 1827. Throughout the 19th century, the perpetual calendar established itself as one of the most useful and sought-after complications. The 1920s saw the emergence of the first perpetual calendar wristwatches representing authentic feats of miniaturization. In 1945, Rolex claimed the launch of the first wristwatch with date window, the Datejust, which a few years later was fitted with a magnifying glass to facilitate reading of the date. The date window subsequently became a classic feature of "simple" calendar watches. In the 1980s, with the rebirth of mechanical watchmaking, the perpetual calendar made a spectacular comeback as a symbol of technical mastery and expertise, and all the major brands were keen to perfect this already highly sophisticated mechanism. The start of the new millennium has witnessed the breakthrough of a complication that was curiously rare until then, the annual calendar, which is more practical than the simple calendar, but less complex and less expensive than the famous perpetual calendars.

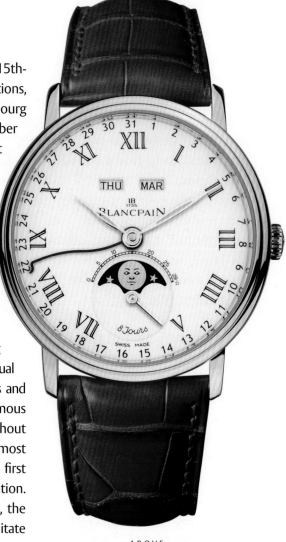

ABOVE

Available in a limited edition of 275 pieces, the Villeret Complete Calendar 8 Jours from Blancpain is powered by the automatic-winding 6639 caliber.

BELOW

Le Brassus in the 19th century, home of Audemars Piguet, Blancpain, Breguet and many other watchmakers.

THE ABC's OF CALENDAR WATCHES

CALENDAR

The word "calendar" is derived from the Latin word calendae (calends), the day of the Roman months when accounts were due or the first day of the month. In horology, several types of calendar mechanisms appear in various timepieces.

SIMPLE CALENDAR

This is the name given to a calendar systematically indicating 31 days per month. It is the most elementary and customary form of the calendar. A simple calendar must be manually adjusted on the first day of months following a month with less than 31 days, meaning five times a year (March 1st, May 1st, July 1st, October 1st and December 1st). A simple calendar generally shows only the date, but may also display additional information (day, month), as well as all the main calendar information (complete calendar).

How does it work?

The simple calendar mechanism operates by means of a reducing gear train activated via the hour wheel. It moves one notch forward with every two turns of the hour wheel (24 hours). The display appears either on a disc bearing the date, or via a hand fixed to the 31-day star. Subsidiary indications (day, month) operate according to the same principle.

COMPLETE CALENDAR

A complete calendar looks very much like a perpetual calendar, in that it displays the date, the day, the month and generally the moonphase. But it does not take account of the varying lengths of the months. Like a simple calendar, it must therefore be corrected at the end of all months with less than 31 days, meaning five times a year.

ANNUAL CALENDAR

The annual calendar—mid-way between the simple calendar and the perpetual calendar—automatically recognizes all months of 30 and 31 days, but does not take account of the duration of the month of February. It must therefore be corrected once a year, on March 1st. Annual calendars generally operate with the help of a wheel and pinion system of the same basic type as that driving the simple calendar, but considerably more complex.

LEAP-YEAR (OR SEMI-PERPETUAL) CALENDAR

The leap-year calendar, sometimes referred to as semi-perpetual, takes account of the variable lengths of 30- and 31-day months, as well as the 28 days of February, but not of the February 29th of leap years. It must therefore be corrected every four years, on March 1st.

PERPETUAL CALENDAR

The perpetual calendar is a highly sophisticated mechanism that not only recognizes months of 30 and 31 days, but also the 28 days of February and the quadrennial return of February 29th. It therefore possesses a mechanical "memory" of 1,461 days and theoretically requires no manual intervention. It does not however take account of the Gregorian correction relating to secular or century years (see above on the history of calendars) and must be corrected for every secular year of which the first two figures are not divisible by 4—as will for instance be the case in 2100.

How does it work?

The perpetual calendar is distinguished from other types of calendar by the presence of a highly sophisticated toggle (or multiple-lever) system that pivots on its axis to drive the various displays. The indications may be displayed by discs or hands. In addition to showing the date, the day and the month, generally complemented by moonphase, many perpetual calendars also show the year number and/or the leap-year cycle.

SECULAR OR CENTURY CALENDAR

The secular of century calendar takes account of the Gregorian correction made to years ending with 00. This extremely complex and rare calendar appears only on a handful of ultra-complicated watches (see Multi-Complications chapter).

LARGE DATE

The so-called "large date" system is not only distinguished by its oversized date display. It also involves a mechanism that is somewhat more complex than a usual date window. This device is generally composed of two discs: one for the tens and the other for the units. The discs are sometimes placed side by side and one on top of the other (with the upper disc featuring cut-out sections in such instances).

CALENDAR-CHANGE MODES

There are several possible change modes for the date (and other calendar indications), depending on whether the mechanism is of the "dragging" kind (involving a progressive transition that takes around two hours), "semi-instantaneous" (around one and a half hours) or "instant" (with a jump at exactly midnight). The instant change is of course the most complex to achieve, since it simultaneously affects several indications.

MANUAL CORRECTIONS

Calendar watches are all equipped with devices serving to manually adjust or correct the calendar indications. When it comes to a straightforward date aperture, the crown generally serves this purpose, whereas on more complex watches, corrector pushers or buttons on the side of the case are used to perform these rapid adjustments. It is well worth remembering that on these watches, particularly perpetual calendars, it is strictly prohibited to correct the calendar during the hours just before midnight, when the change mechanisms are already in action, since any such adjustments might damage the movement. In order to enhance both user-friendliness and security, certain firms have developed mechanisms that may be adjusted at any time.

WATCHES WITH DATE DISPLAYS

There are countless watches that simply indicate the date. The most widespread form of this display is a small window, generally placed at 3, 6 or 9 o'clock. For variety and to enliven certain designs, watchmakers have also developed more original presentation modes, particularly through windows showing several numbers at once, as well as openworked or transparent dials revealing the date disc. Another major trend is for pointer-type date displays in centrally positioned or offset versions. Retrograde displays are also in fashion, with some of them featuring quite astonishing compositions.

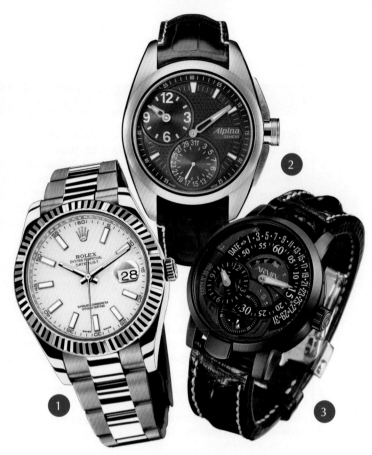

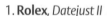

1. Rolex, *Datejust II*

A modern version of the archetypal date window watch, the Oyster Perpetual Datejust II by Rolex is distinguished by its instant date change and by its famous "Cyclope" magnifying lens that enlarges the numeral two and a half times.

2. Alpina, *Club Regulator Manufacture*

The Alpina Club Regulator Manufacture combines a regulator-type display (central minutes, hours at 10 o'clock) with a pointer-type date display occupying the entire lower part of the dial.

3. Armin Strom, *Armin by Armin Strom*

With its central minutes and offset hours, the Armin by Armin Strom reinterprets the historical regulator dials. Its date is displayed by a retrograde hand in the upper part of the dial.

4. Bulgari, *Octo Bi-Retro Steel Ceramic*

The Bulgari Octo Bi-Retro Steel Ceramic, from the Gérald Genta collection, combines an innovative design with a sophisticated mechanism. The jumping hours and retrograde minutes are complemented by a retrograde date moving across a 180° arc of a circle at 6 o'clock.

5. Universal Genève, *Microtor Cabriolet*

Universal Genève reinterpreted one of its great classics in creating this Microtor Cabriolet featuring a reversible case, a patented automatic winding system and a curved date display.

6. Ellicott, *Majesty*

On the Majesty watch by Ellicott, the openworked dial reveals the date disc with its series of numbers, as well as the meticulous construction of the self-winding movement with its 70-hour power reserve.

7. Movado, *Red Label Museum Calendomatic*

Inspired by a model launched in 1946, the Red Label Museum Calendomatic by Movado combines the famous understated black Museum dial with an original date display by means of a rotating disc bearing red Roman or Arabic numerals.

8. Vacheron Constantin, *Quai de l'Ile Date Self-Winding*

On the Quai de l'Ile Date Self-Winding watch by Vacheron Constantin, the date appears on a disc visible through a semi-transparent dial created using state-of-the-art secure printing technologies.

9. a.b.art, *Serie OA*

On the Serie OA by a.b.art—a brand with German origins, now made in Switzerland—the date is indicated by a colored dot running around the dial.

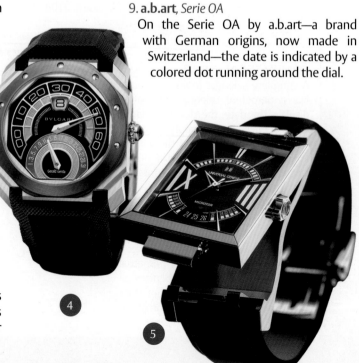

10. **IWC**, *Portuguese Tourbillon Mystery Retrograde*

IWC associates several different complications on this Portuguese Tourbillon Mystery Retrograde watch with a flying tourbillon that appears to be levitating against a dark background at 12 o'clock, and a retrograde date running over a semicircular arc between 9 and 6 o'clock.

11. **Vulcain**, *Anniversary Heart Automatic Calendar*

On the Anniversary Heart Automatic Calendar watch by Vulcain, the metallized sapphire dial provides a tantalizing glimpse of the date disc as well as the famous Cricket alarm movement now appearing in an automatic version.

12. **Roger Dubuis**, *Excalibur Bi-retrograde jumping date*

Stylistic exercise and technical feat: on this powerful Excalibur model by Roger Dubuis, the retrograde date display is divided into two symmetrical zones on either side of the 12-6 o'clock axis.

13. **Jaquet Droz**, *Date Astrale Nacre Noire*

On its Date Astrale Nacre Noire, Jaquet Droz, an expert in original displays, offers a retrograde date indication by means of a diamond sliding from 10 and 5 o'clock.

14. **Oris**, *Big Crown Pointer Date*

Launched in 1938, the Oris Pointer Date calendar system with central hand equips various models by the brand, including the Oris Big Crown Pointer Date, equipped with an oversized crown intended for pilots.

15. **Cartier**, *Calibre de Cartier*

Equipped with the first 100% Cartier mechanical self-winding movement, the Calibre de Cartier watch combines the brand's characteristic large Roman numerals with a date display showing three numbers at once.

LARGE DATE DISPLAYS

Highly prized for their readability as well as their original touch, "large date" displays are becoming increasingly sought-after in recent years, whether appearing alone on the dial or associated with other complications. Several well-known brands have taken an interest in this ingenious mechanism, improving both its running and its reliability.

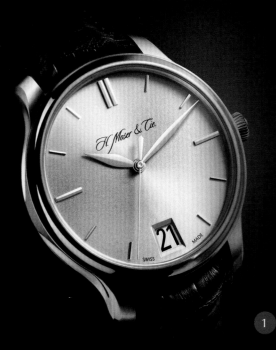

1

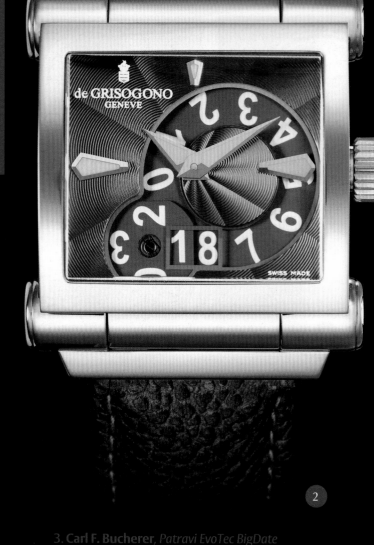

2

1. H. Moser & Cie, *Monard Date*

Based on two superimposed discs, the large date display on the Monard Date by H. Moser & Cie is also distinguished by its patented Double Pull Crown system, which avoids the user accidentally changing the time when simply seeking to adjust the date.

2. de Grisogono, *Instrumento Grande Open Date*

The Instrumento Grande Open Date by de Grisogono is distinguished by its highly original design and its visible calendar is characterized by two different-sized discs jointly forming the date.

3. Carl F. Bucherer, *Patravi EvoTec BigDate*

Carl F. Bucherer pays tribute to women with this Patravai EvoTech BigDate model featuring a self-winding in-house movement, an elegant cushion-shaped case, a refined dial and a large offset date at 11 o'clock.

4. A. Favre & Fils, *Phoenix 10.1 Quantième à Grand Affichage Rotatif*

On the Phoenix 10.1 Quantième à Grand Affichage Rotatif by A. Favre & Fils, the units numerals remain immobile, while a red arrow (for the dates from 1 to 9) or the 1, 2 or 3 o'clock numeral moves to indicate the date.

5. A. Lange & Söhne, *Grande Lange 1 Luminous*

Large date displays are closely associated with A. Lange & Söhne. A specialist in this type of display, the German brand uses its patented system on several models, including the Grande Lange 1 Luminous with an offset hours/minutes dial.

3

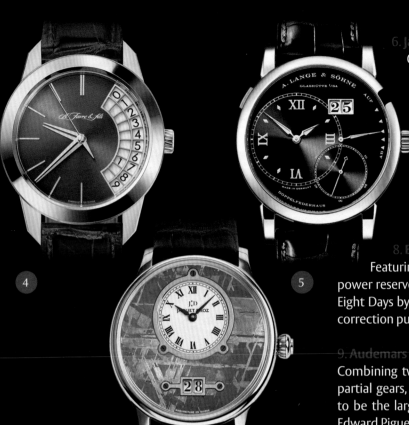

6. Jaquet Droz, *Grande Date Météorite*

On the Grande Date Météorite by Jaquet Droz, the large double date window is majestically enthroned in the lower part of the dial, while the hours and minutes appear in an offset subdial at 12 o'clock.

7. Epos, *Grande Date Verticale*

Featuring superimposed date windows and a crown at 12 o'clock, the Grande Date Verticale by Epos boasts several original characteristics combined with a dial graced with refined contrasts.

8. Eterna, *Madison Eight Days*

Featuring an elegant tonneau-shaped case, an eight-day power reserve and the patented Spherodrive system, the Madison Eight Days by Eterna displays its large date at 2 o'clock, with a fast correction pusher that may be used 24 hours a day.

9. Audemars Piguet, *Edward Piguet Tourbillon Large Date*

Combining two superimposed discs and an ingenious system of partial gears, the display created by Audemars Piguet is intended to be the largest on the market. Witness this ultra-sophisticated Edward Piguet Tourbillon Large Date model.

10. Tudor, *Glamour Double Date*

In this retro-chic Glamour Double Date model, "Rolex's little sister" Tudor combines a self-winding movement, small seconds at 6 o'clock and an imposing large date display at 12 o'clock.

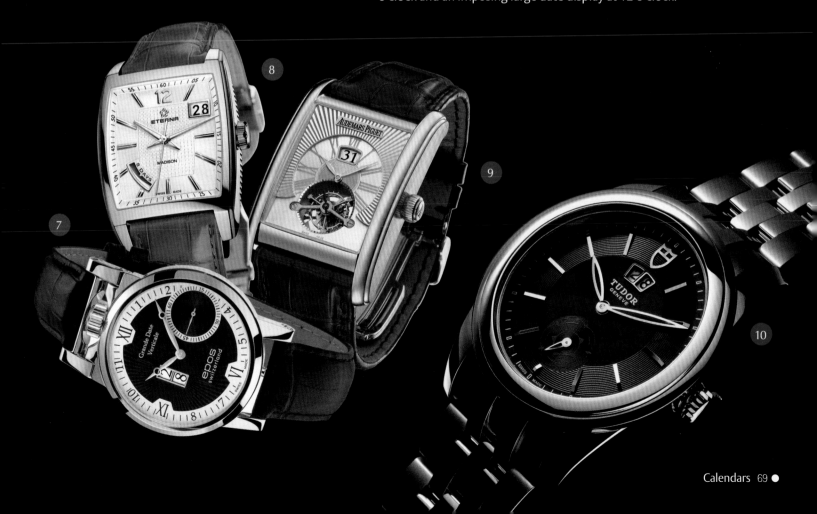

DAY / DATE OR MONTH / DATE WATCHES

The date indication is sometimes complemented by the day of the week, and sometimes by the month. The most widespread solution consists of two apertures placed "in line," meaning side by side, at 12, 3, 6 and 9 o'clock. But here too, watchmakers give free rein to their inventiveness and offer a fine range of pointer-type displays and retrograde indications. Most of these timepieces feature the names and abbreviations of the days and months in English, but some brands also enable purchasers to personalize the display in a given language.

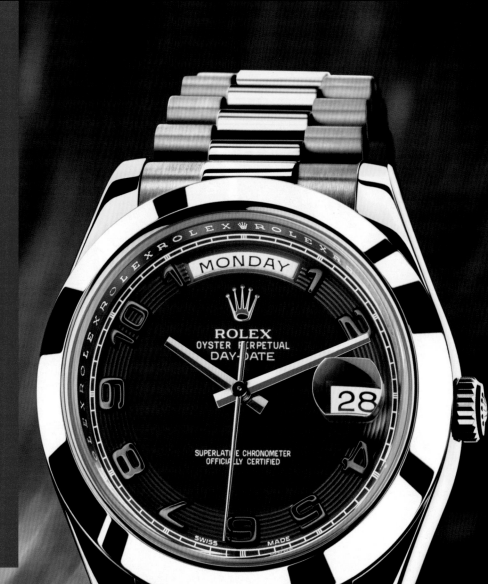

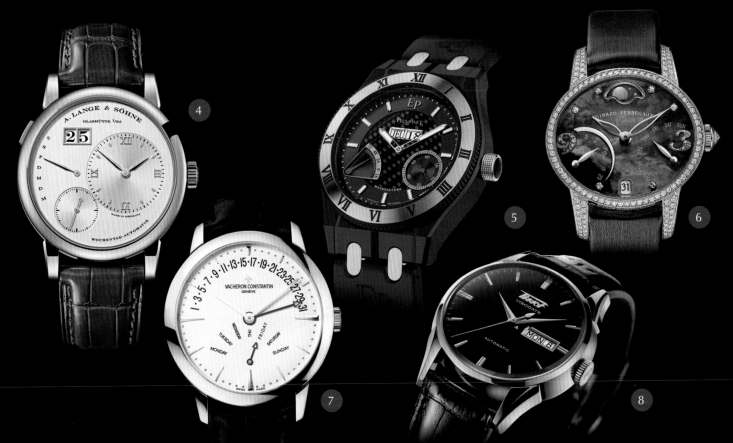

1. **Rolex**, *Oyster Perpetual Day-Date II*

A worthy heir to the first wristwatch to spell out the entire name of the day (launched in 1956), the Rolex Oyster Perpetual Day-Date II offers a choice of 26 languages for this indication.

2. **Vacheron Constantin**, *Quai de l'Ile Day-Date and Power Reserve*

Transparency is the name of the game on the Quai de l'Ile Day-Date and Power Reserve watch by Vacheron Constantin, which displays the day and date by means of two pointer-type subdial displays.

3. **Longines**, *Master Collection Retrograde*

A festival of retrograde displays enlivens the Master Collection Retrograde by Longines, showing the date between 1 and 5 o'clock and the date at 12 o'clock, complemented by equally retrograde dual time-zone and small seconds indications.

4. **A. Lange & Söhne**, *Lange 1 Daymatic*

A. Lange & Söhne's signature patented large date and offset hours/minutes subdial are combined on this Lange 1 Daymatic with a retrograde day indication running over an arc on the left-hand side of the dial.

5. **Pequignet**, *Morea Royal Triomphe*

Equipped with a self-winding in-house movement, the Morea Royal Triomphe by the French brand Pequignet displays the day and date through an oversized double window at 12 o'clock.

6. **Girard-Perregaux**, *Cat's Eye Bi-retro Jewelry*

The resolutely feminine Cat's Eye Bi-retro Jewelry watch by Girard-Perregaux, graced by an elegant oval case, displays the moonphase along with the date in a window at 6 o'clock and a retrograde day indication in the right-hand part of the dial.

7. **Vacheron Constantin**, *Patrimony Contemporaine Retrograde Day and Date*

Vacheron Constantin has created a highly original display on this Patrimony Contemporaine Retrograde Day and Date watch, with the date appearing on an arc of a circle between 9 and 3 o'clock and the day on another arc between 8 and 4 o'clock.

8. **Tissot**, *Visodate 1957 Automatic*

A re-edition of an innovative model from the 1950s, the Visodate 1956 Automatic by Tissot displays the day and the date through a double window at 3 o'clock.

9. **Maurice Lacroix**, *Les Classiques Jours Rétrogrades Automatique*

This Les Classiques Jours Retrogrades Automatique watch by Maurice Lacroix combines a large date at 12 o'clock with a retrograde day display at 6 o'clock.

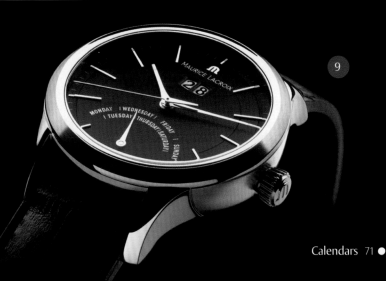

WEEKS OF THE YEAR

The week-number indication, a calendar indication that is mostly useful for business people and long-term planners, is a fairly rare item in the classic watchmaking repertoire but has recently appeared on several noteworthy models.

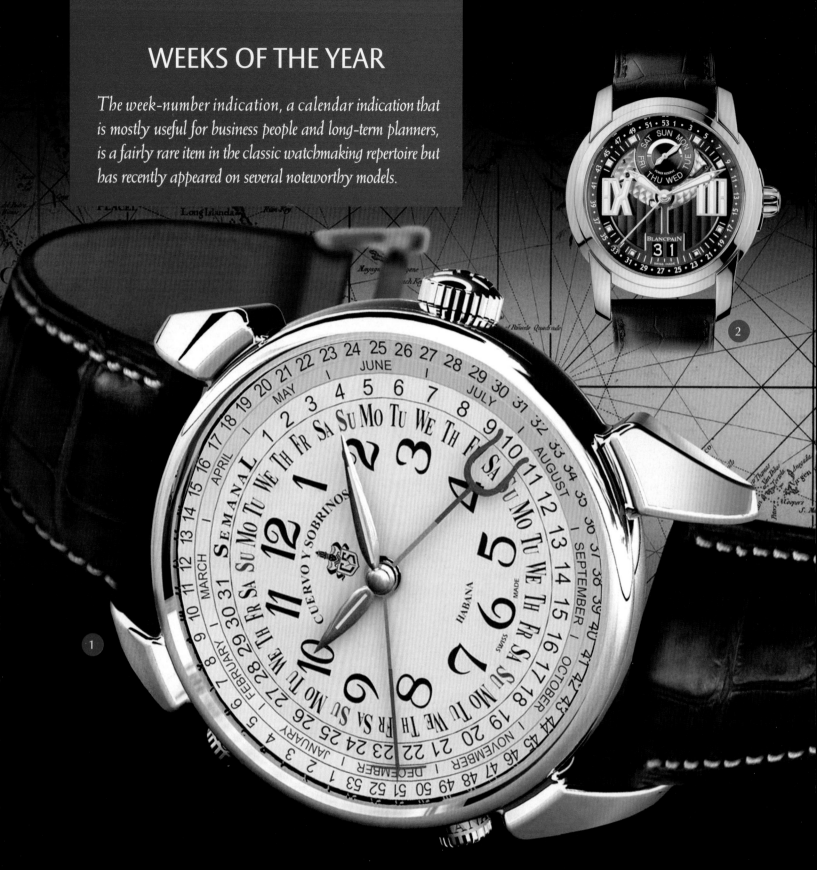

1. Cuervo y Sobrinos, *Historiador Semanal*

The Cuban-based Cuervo y Sobrinos brand reinterprets one of its highly successful 1940s models with this Historiador Semanal with multiple rings and quadruple calendar display. The week and month numbers (on the outside) are indicated by the dedicated hand moving around the dial circumference, while the date and date are displayed by a double-tipped hand, with all indications adjustable via the crowns at 8 and 10 o'clock.

2. Blancpain, *L-evolution Semainier Grande Date*

Endowed with an eight-day power reserve, the self-winding L-evolution Semainier Grande Date model by Blancpain displays the day of the week by means of a central hand pointing to the scale surrounding the dial. The calendar is completed by an oversized date display at 6 o'clock and a pointer-type day indication at 12 o'clock.

1. Girard-Perregaux, *Vintage 1945 Square Triple Calendar*
A play on geometry is the keynote of the Vintage 1945 Square Triple Calendar by Girard-Perregaux, which displays the date around a circle in the center of the quadrangular dial, as well as the day and month in two in-line apertures.

2. Baume & Mercier, *Classima Executives XL Chronograph and Complete Calendar*
Combining two very useful complications, the Classima Executives XL Chronograph and Complete Calendar by Baume & Mercier displays the date by means of a central hand, along with the day, month and moonphase through apertures.

3. Blancpain, *Phase de Lune Demi-Savonnette*
The Phase de Lune Demi-Savonnette by Blancpain is distinguished by several technical breakthrough developments in terms of the calendar, including an adjustment system that can be used at any time, and correctors discreetly placed beneath the case lugs.

4. Girard-Perregaux, *1966 Complete Calendar*
Sublimated by the gleaming metal of its palladium case, the pure dial of the Girard-Perregaux 1966 Complete Calendar features twin in-line day and month apertures, along with a pointer-type date display and a moonphase at 6 o'clock.

5. Jaeger-LeCoultre, *Master Calendar*
The large central date hand and the day/month windows slightly offset towards the upper part of the dial give the Master Calendar by Jaeger-LeCoultre an extremely dynamic touch, accentuated by the fan-shaped power reserve display at 12 o'clock.

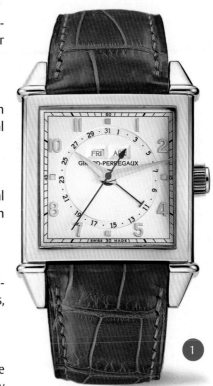

COMPLETE CALENDARS

With their date/day/month indications, generally associated with a moonphase display, complete calendars look very much like perpetual calendars at first glance, but they call for much more frequent manual interventions, and are therefore far less expensive. From classic styling to contemporary reinterpretations, there is a fine variety of designs liable to satisfy all manner of tastes.

PERPETUAL CALENDARS: CLASSIC DESIGNS

Representing the ultimate form of calendar watch, the famous perpetual calendars take account of the variable lengths of months as well as the quadrennial occurrence of February 29th. They are characterized by their multiple displays (date, day, month, leap-year cycle), generally enriched by moonphases. In their most classic version, they generally feature three or even four subdials arranged symmetrically in relation to the dial enter. But this restrained elegance sometimes conceals technical developments that considerably enhance the user-friendliness and the security of these ultra-sophisticated mechanisms.

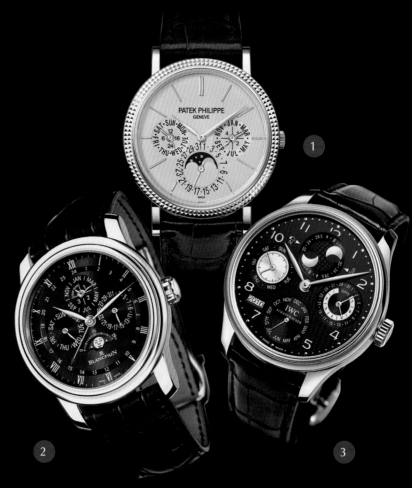

1. Patek Philippe, Ref. 5139

The Patek Philippe perpetual calendar, one of the most famous timepieces from the Geneva-based manufacturer, is distinguished by its ultra-thin self-winding movement and its understated yet readable dial.

2. Blancpain, *Perpetual Calendar with Under-Lug Correctors*

On its Perpetual Calendar with Under-Lug Correctors, Blancpain has developed an original system serving to integrate the correctors within the four bracelet lugs, on the wrist side. A press of the finger is enough to correct the date, day, month, leap-year cycle or moonphase display.

3. IWC, *Portuguese Perpetual Calendar*

Known as a great IWC specialty, the perpetual calendar is given a new interpretation in this Portuguese Perpetual Calendar watch featuring a midnight blue dial on an elegant background against which the displays of the date, day, month and moonphases (in both hemispheres) stand out with admirable clarity, along with the four-digit year number.

4. Jaeger-LeCoultre, *Master Grande Tradition Tourbillon à Quantième Perpétuel*

Jaeger-LeCoultre has combined two major complications in its Master Grande Tradition Tourbillon à Quantième Perpétuel, featuring three subdials with date/day/month subdials, as well as the four-digit year number appearing in the center of the month window.

5. Audemars Piguet, *Jules Audemars Perpetual Calendar*

Equipped with an ultra-thin self-winding caliber, the Jules Audemars Perpetual Calendar model by Audemars Piguet is a perfect example of a classic and yet timeless design. The leap-year cycle appears in the center of the month subdial.

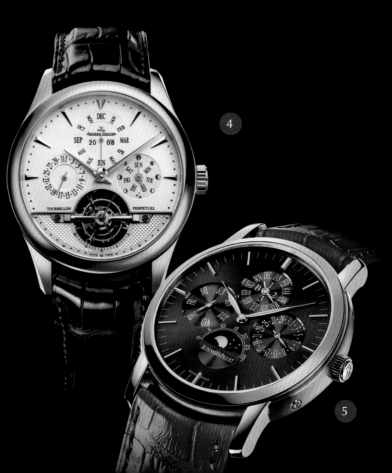

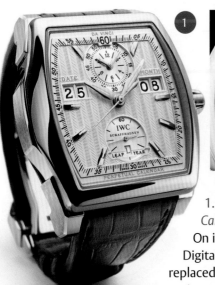
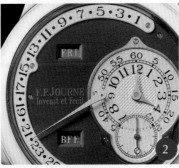
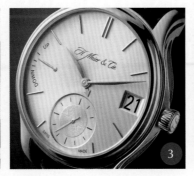
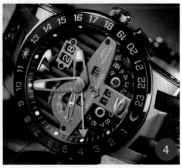

1. IWC, *Da Vinci Perpetual Calendar Digital Date and Month*
On its Da Vinci Perpetual Calendar Digital Date and Month, IWC has replaced the traditional subdials by two twin apertures indicating the double-digit month and date.

2. F. P. Journe, *Octa Perpétuelle*
The extremely original dial of the Octa Perpétuelle by F.P. Journe, with its offset hours, minutes and seconds, gives a starring role to the central retrograde hand, along with two day and month windows.

3. H. Moser & Cie, *Perpetual 1*
H. Moser & Cie offers an unusual and extremely restrained take on the perpetual calendar. The month is displayed by a small central hand pointing to one of the twelve hour markers—such as 5 standing for May. The calendar may be adjusted forwards or backwards at any time.

4. Ulysse Nardin, *El Toro*
The El Toro model by Ulysse Nardin stands out not only for its exceptional outward appearance, but also for its correction system serving to adjust either forward or backward all the various calendar indications – which are themselves synchronized with the central hours hand that is adjustable by pressing a + or - pusher.

5. Patek Philippe, *Ref. 5207*
Featuring day/date/month windows arranged around the arc of a circle, Ref. 5207 by Patek Philippe (with minute repeater and tourbillon) is distinguished by its mechanism enabling instant change of all the calendar indications at precisely midnight.

6. Ventura, *v-tec Alpha*
A perpetual calendar equipped with a quartz movement naturally does not represent the same technical feat as a mechanical movement, but it may give rise to some highly original designs, such as the v-tec Alpha by Ventura, featuring digital hours/minutes/seconds and date/month/year displays on two separate lines.

7. Breguet, *Classique 7717BA*
On this self-winding Classique watch by Breguet, the pointer- or window-type displays are lined up along the same vertical axis, against the brand's characteristic guilloché dial.

PERPETUAL CALENDARS: NEW VISUAL ARRANGEMENTS

The design of perpetual calendars enables brands to play with various aesthetic arrangements in order to make their models stand out from traditional dials. The trend is towards a number of apertures placed either in a straight line or around the arc of a circle. Watchmakers also enjoy combining pointer- and window-type displays in sometimes highly original compositions, a sophisticated aesthetic approach that is associated with a number of technical accomplishments.

PERPETUAL CALENDARS: RETROGRADE AND ROLLER

How can one enliven a perpetual calendar model? By choosing a retrograde-type mechanism for one or several of the calendar indications, with a hand moving across the arc of a circle before jumping back to its point of departure (see the Retrograde Mechanisms and Jumping Hours chapter). Another, much rarer, option is that of roller-type indications. This quest for originality paves the way for all manner of fanciful visual touches calling for a superlative degree of technical mastery.

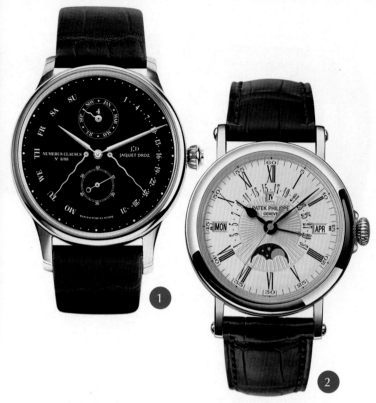

1. Jaquet Droz, *Perpetual Calendar*
Jaquet Droz, known for its consistently original designs, offers a Perpetual Calendar model with double retrograde display occupying the entire upper part of the dial, with days on the left and the date on the right.

2. Patek Philippe, *Ref. 5159*
The Ref. 5159 perpetual calendar with retrograde date from Patek Philippe has an "officer's style" case with a back protected by a hinged cover.

3. Parmigiani Fleurier, *Toric Corrector*
Equipped with a minute repeater and a pusher enabling instant correction of all the calendar and moonphase functions, the Toric Corrector by Parmigiani Fleurier displays the retrograde date on the arc of a circle running from 8 to 4 o'clock.

4. Jean Dunand, *Shabaka*
The ultra-sophisticated Shabaka watch by Jean Dunand is equipped with a minute repeater striking on a cathedral chime, and is also distinguished by its roller-type display of the perpetual calendar indications, all of which jump instantly at midnight.

5. Maîtres du Temps, *Chapter Two*
The Chapter Two watch, created by Daniel Roth, Roger Dubuis and Peter Speake-Marin for the Maîtres du Temps brand, displays the months and days spelled out on two rollers—complete with two correctors housed on the caseback.

6. Piaget, *Emperador Coussin Perpetual Calendar*
The Emperador Coussin Perpetual Calendar by Piaget, driven by an ultra-thin in-house movement, features two fan-shaped retrograde day and date displays. An additional 24-hour dual time zone display enables the wearer to travel around the world without disturbing the date indications.

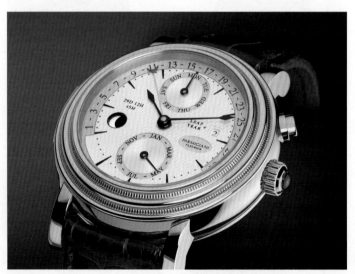

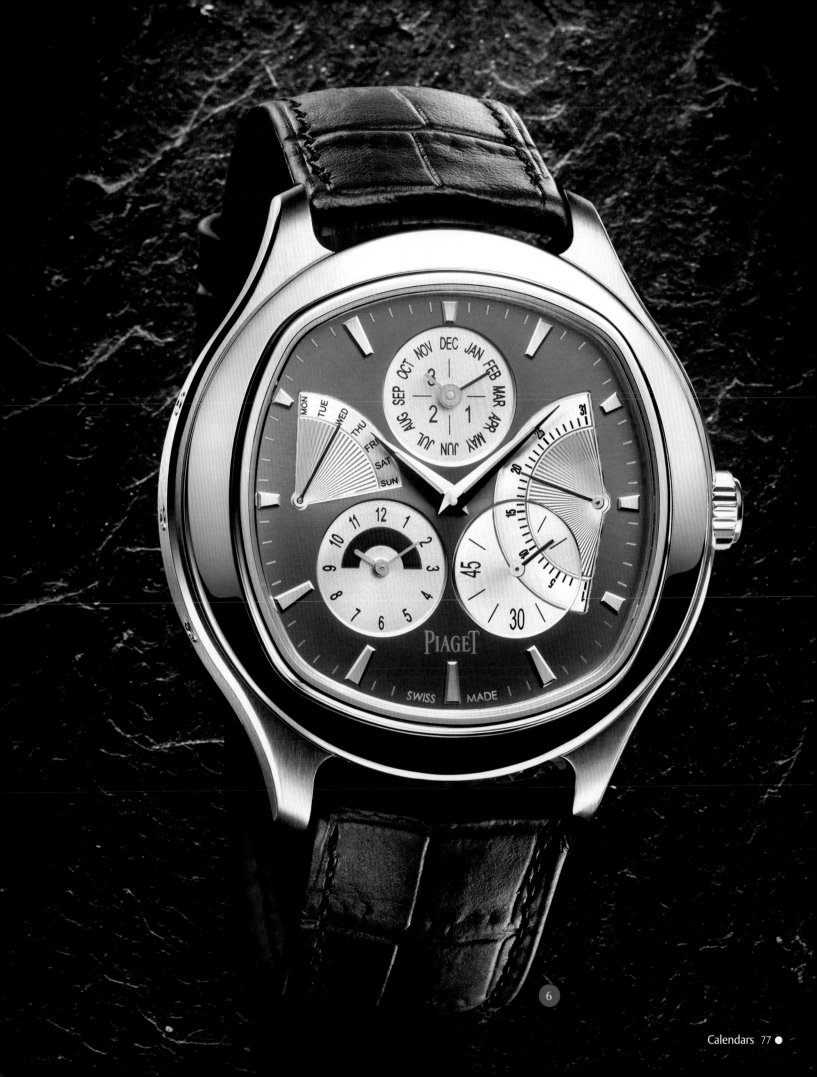

PERPETUAL CALENDARS: THE TRANSPARENT APPROACH

Visible mechanisms are all the rage in the watch industry at the moment. After introducing sapphire crystal casebacks on virtually all their complicated models, brands are vying with other to find ingenious means of revealing all or part of the movement through the dial side. Perpetual calendars are no exception, and there is a vast range of models with openworked dials, skeletonized movements or transparent dials that now hide almost nothing of their inner mysteries, at least in visual terms. These spectacular stagings are often matched by some exceptional technical feats accomplished behind the scenes.

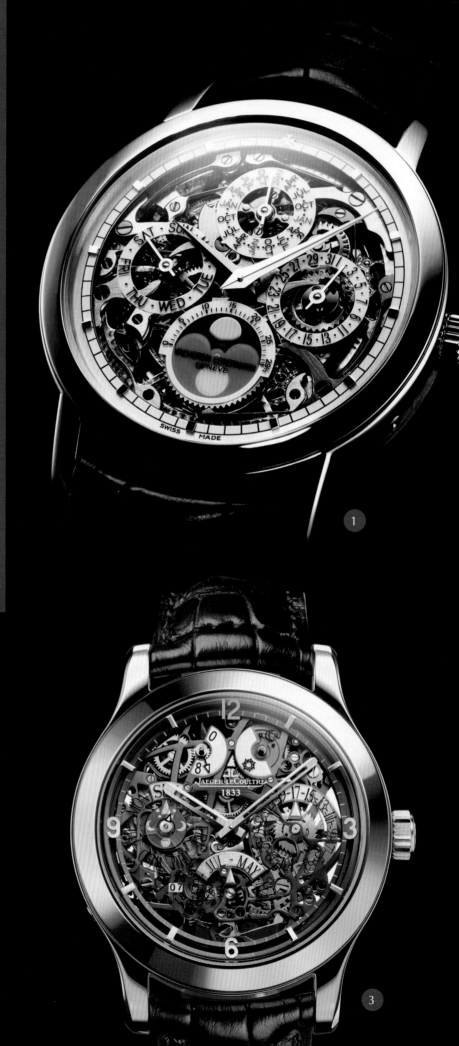

1

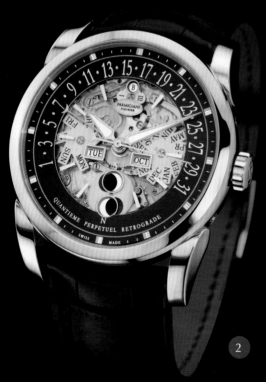

2

3

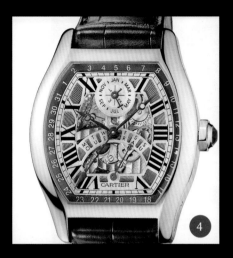

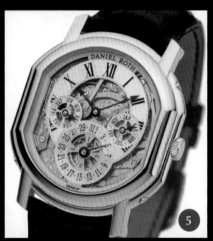

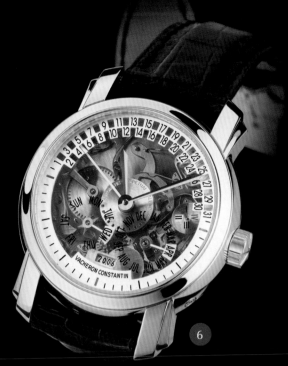

1. Vacheron Constantin, *Patrimony Traditionnelle Skeleton Perpetual Calendar*

Genevan watch manufacturer Vacheron Constantin provides an ethereally light version of the perpetual calendar in its Patrimony Traditionnelle Skeleton Perpetual Calendar, with its entirely openworked and engraved movement.

2. Parmigiani Fleurier, *Tonda 42 Retrograde Perpetual Calendar*

On the Tonda 42 Retrograde Perpetual Calendar by Parmigiani Fleurier, the abbreviations of the day and month appear on two discs featuring original shapes and visible through the transparent dial.

3. Jaeger-LeCoultre, *Master Eight Days Perpetual SQ*

The Master Eight Days Perpetual from Jaeger-LeCoultre, endowed with an eight-day power reserve, is shown here in a dazzling skeletonized version featuring daringly curved bridges echoing the lines of longitude and latitude.

4. Cartier, *Tortue Perpetual Calendar*

Equipped with an in-house movement, the Tortue Perpetual Calendar by Cartier combines various types of display—including a central pointer-type date indication and a retrograde day running from 8 to 4 o'clock—appearing on an openworked dial.

5. Daniel Roth, *Instantaneous Perpetual Calendar*

The Instantaneous Perpetual Calendar by Daniel Roth is distinguished by its system ensuring the instant jump of all calendar indications at midnight: its self-winding movement is partially visible through the openworked dial.

6. Vacheron Constantin, *Malte Retrograde Perpetual Calendar Openface*

Vacheron Constantin has equipped its Malte Retrograde Perpetual Calendar Openface watch in platinum with a double sapphire crystal. Transparent subdials with white rotating "pallets" serve to indicate the day, month and leap-year cycle painted in black on one of the sapphire crystals.

7. Patek Philippe, *Ref. 5104 Grande Complication*

On the Ref. 5104 Grande Complication model by Patek Philippe, the days, months and the leap-year cycle number are printed directly on the sapphire crystal dial and dark "pallets" highlight the appropriate white transfer by contrast.

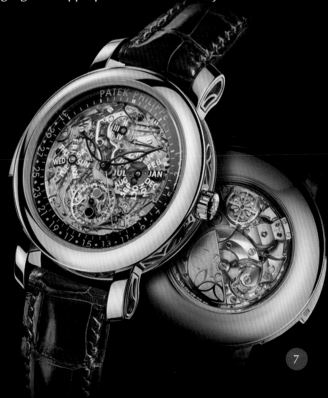

ANNUAL CALENDARS

If one were to name one particular rising star among calendar watches, the one that springs to mind is the extremely clever annual calendar. Less complex than a perpetual calendar, it enables brands to create watches that are more affordable and simpler to operate, while providing a degree of user-friendliness far superior to simple calendars in that they require just one correction per year. The last few years have brought a flourishing spate of annual calendar models featuring a great variety of displays and designs, as well as occasionally associating this complication with other useful functions.

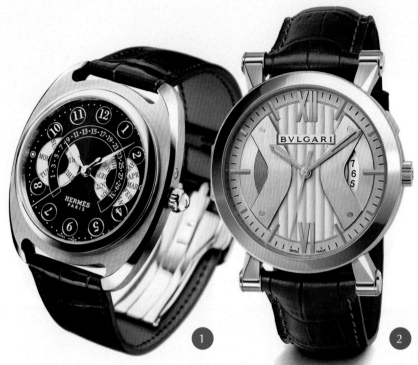

1. Hermès, *Dressage Annual Calendar*
The Dressage Annual Calendar watch by Hermès, with its exclusive Vaucher Manufacture Fleurier movement, is distinguished by its pointer-type 270° retrograde date display and its two visible day and month discs.

2. Bulgari, *Sotirio Bulgari*
The Sotirio Bulgari annual calendar watch by Bulgari plays on geometrical effects with its 225° retrograde date display, along with day and month windows opening onto discs that are partially visible thanks to a deliberately transparent effect.

3. Girard-Perregaux, *1966 Annual Calendar and Equation of Time*
On its 1966 Annual Calendar and Equation of Time model, Girard-Perregaux combines the annual calendar with an extremely rare indication of the time between true solar time and mean solar time (see the Equations of Time chapter).

4. Girard-Perregaux,
Cat's Eye Annual and Zodiac Calendars
Resolutely dedicated to women, the Cat's Eye Annual and Zodiac Calendars watch combines a snail-shaped date display with a large comet's tail-shaped aperture revealing the ever-circling dance of the Zodiac signs.

5. A. Lange & Söhne,
Saxonia Calendrier Annuel
The first A. Lange & Söhne watch to be equipped with an annual calendar, the Saxonia Annual Calendar combines the German brand's celebrated and patented large date display with three classic windows for the day, month and moonphases.

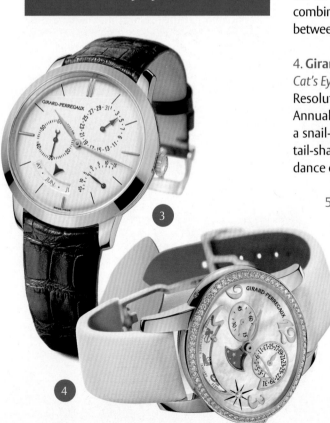

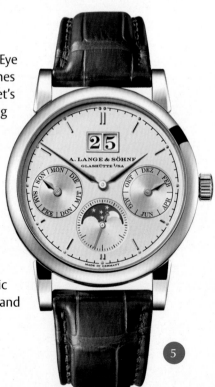

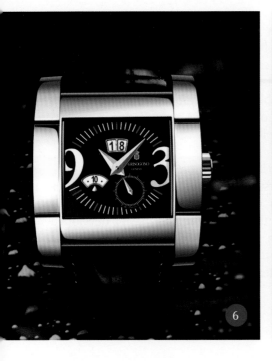

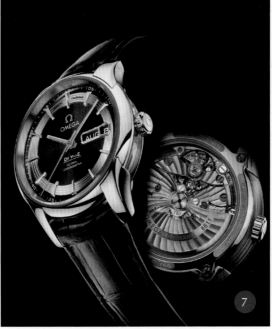

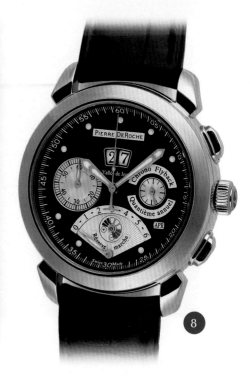

6. de Grisogono, *Instrumento Novantatre*
Featuring a large date at 12 o'clock, an arc of a circle aperture displaying the month number, along with oversized 9 and 3 o'clock numerals, the Instrumento Novantatre by de Grisogono boasts an original design and pleasant operational terms thanks to its annual calendar mechanism.

7. Omega, *De Ville Hour Vision Annual Calender*
Equipped with a self-winding movement, a co-axial escapement and an annual calendar with instant date jump, the Omega De Ville Hour Vision Annual Calendar displays the month and date in a double window at 3 o'clock.

8. Pierre DeRoche, *GrandCliff QA Power Reserve*
The Dubois Dépraz movement manufacturer was one of the first to offer the annual calendar—as a module. The GrandCliff QA Power Reserve model by Pierre DeRoche, a brand founded by the brother of the executive heads of Dubois Dépraz, combines the annual calendar with a chronograph featuring retrograding 60-minute and 6-hour counters, a flyback function and a large date.

9. Patek Philippe,
Ref. 4936 (ladies') and Ref. 5205 (men's)
Patek Philippe's patented Annual Calendar, launched in 1996, has asserted itself as a bestseller from the Geneva-based manufacturer. It has appeared in both men's and ladies' versions, clothed with a number of different external features and with various displays.

10. Corum, *Romulus Retrograde Annual Calendar*
Corum has introduced a variation on one of its star creations in a model named Romulus Retrograde Annual Calendar, with the date appearing on the arc of a circle running from 8 to 4 o'clock, and a bezel engraved with the collection's signature Roman numerals.

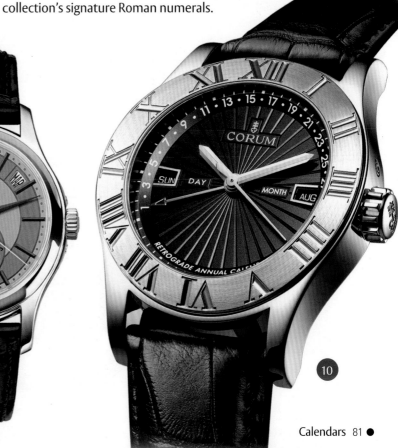

NON-GREGORIAN CALENDARS

One must admit that, in light of the almost universal adoption of the Gregorian calendar for civil activities, watchmakers have not really concerned themselves with developing watches based on other types of calendar, such as the Islamic, Hebraic or Chinese systems. But things might well change and give rise to creations of unprecedented complexity.

1. Parmigiani Fleurier, *Islamic Clock*

In November 2010, Parmigiani Fleurier presented the first mechanical clock to count off time according to the Islamic perpetual calendar. It took more than four years to develop this mechanism capable of precisely following the lunar cycle, while taking account of years of 354 and 355 days. A pocket-watch version may well follow...

2. Alain Silberstein, *Hébraïka Perpétuel*

In 1994, Alain Silberstein unveiled the Hébraïka Perpétuel, the first wristwatch equipped with a perpetual Hebraic calendar (displaying the date, month and year), developed in cooperation with watchmaker Svend Andersen. Alain Silberstein also plans to create models in which the Gregorian calendar rubs shoulders with the Islamic, Hebraic or Chinese calendars.

1

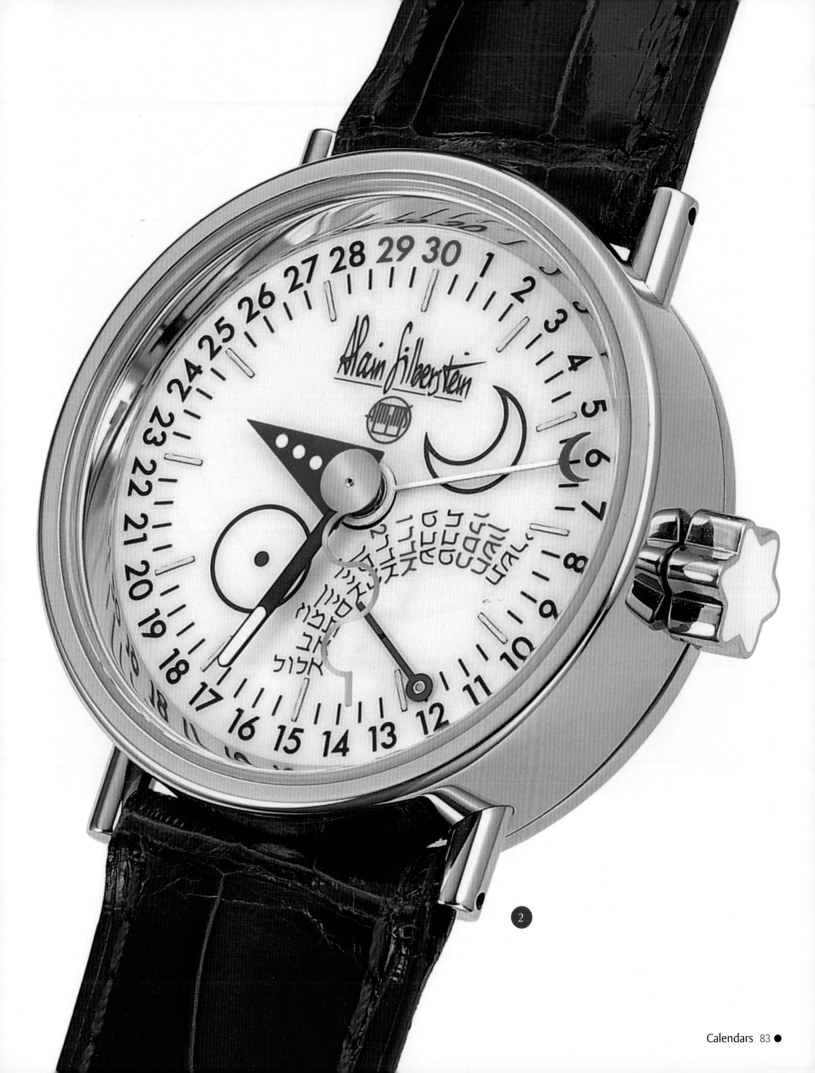

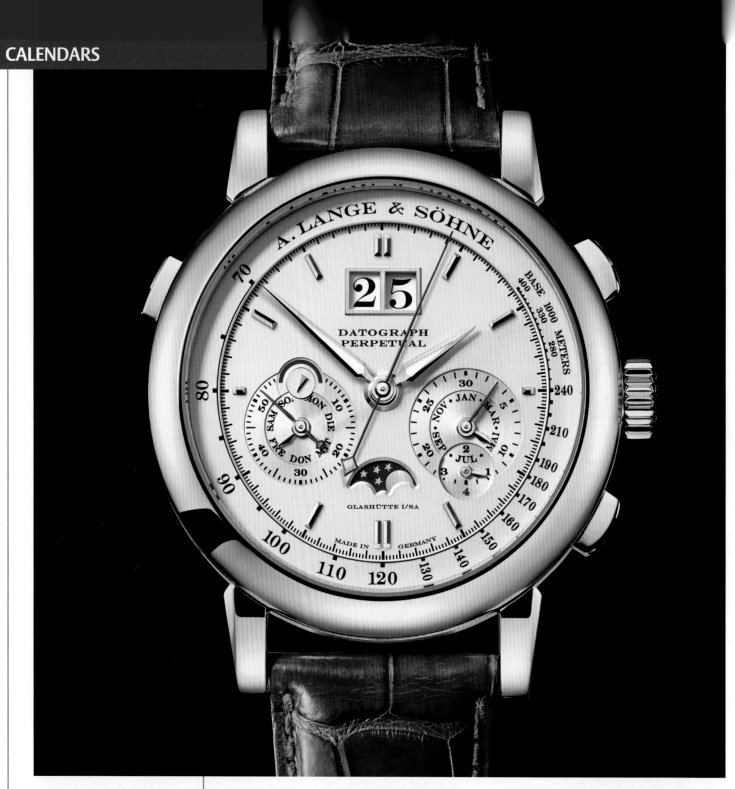

A. LANGE & SÖHNE

DATOGRAPH PERPETUAL – REF. 410.032

This model is driven by the manually wound Lange L951.1 movement. It is a flyback chronograph with a precise jumping minute counter as well as perpetual calendar with a large date, moonphase display, day of the week, month, leap-year display, small seconds hand with stop seconds, and day/night indicator. The plates and bridges are made of silver and the balance cock is engraved by hand. The three-piece rose-gold case features an untreated German antireflective sapphire crystal and caseback, as well as a main pushpiece for simultaneously advancing all calendar displays, recessed pushpieces for separately advancing the calendar displays and two chronograph pushpieces. The hand-stitched crocodile strap is secured with a solid gold buckle.

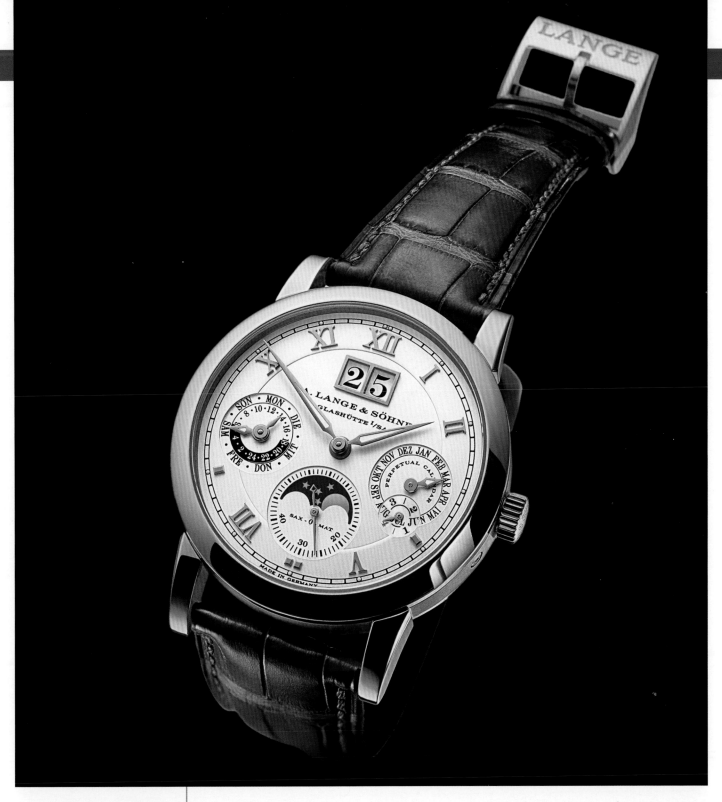

A. LANGE & SÖHNE

LANGEMATIK PERPETUAL – REF. 310.032

Powered by the self-winding Caliber L922.1 SAX-0-MAT, the Langematik Perpetual is the world's first self-winding wristwatch with an outsize date and a perpetual calendar featuring separate pushpieces for individual corrections of the calendar indications (date, day of the week, month, leap year, and moonphase displays), as well as a main pushpiece for advancing all displays. Caliber L922.1 SAX-0-MAT has a 46-hour power reserve, stop seconds with a patented zero-reset mechanism, plates and bridges made of untreated German silver, and a hand-engraved balance cock. The Langematik Perpetual's three-piece pink-gold case is fitted with antireflective sapphire crystals on the front and back, and a crown for winding the watch and setting the time. The solid silver and argenté dial is topped with luminous pink-gold hands. The watch's crocodile strap is secured via a solid gold buckle.

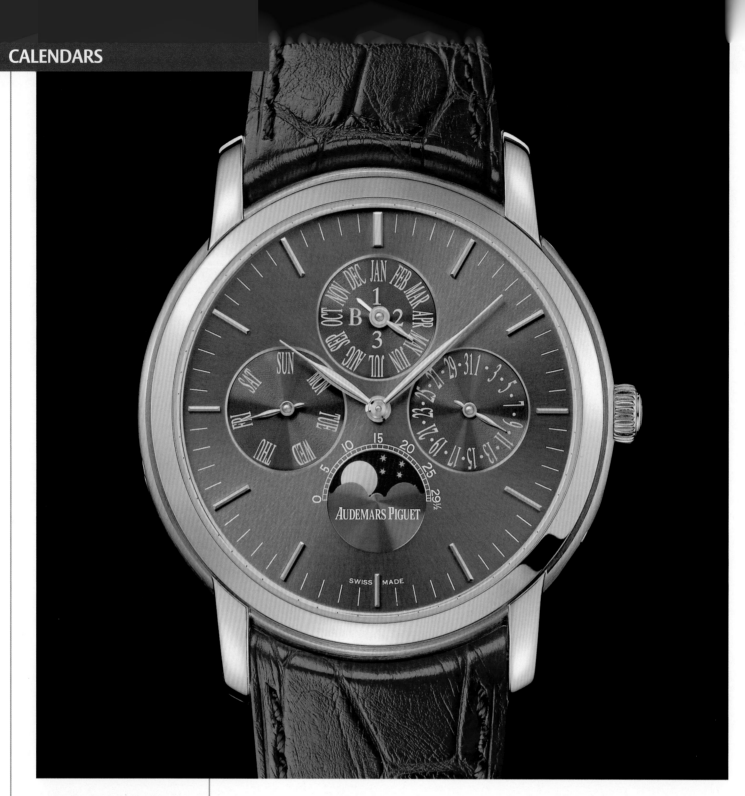

AUDEMARS PIGUET

JULES AUDEMARS PERPETUAL CALENDAR – REF. 26390OR.OO.D088CR.01

The ultra-thin profile of this watch is truly fascinating and it is even more surprising when one considers that such a slim case houses the automatic-winding 2120/2802 movement, which indicates the day, date, month, moonphase and leap-year cycle—all thanks to a mechanism barely 4mm thick! The movement possesses an engraved rotor with a 21K gold segment revealed through the sapphire crystal caseback. The case is in 18K pink gold.

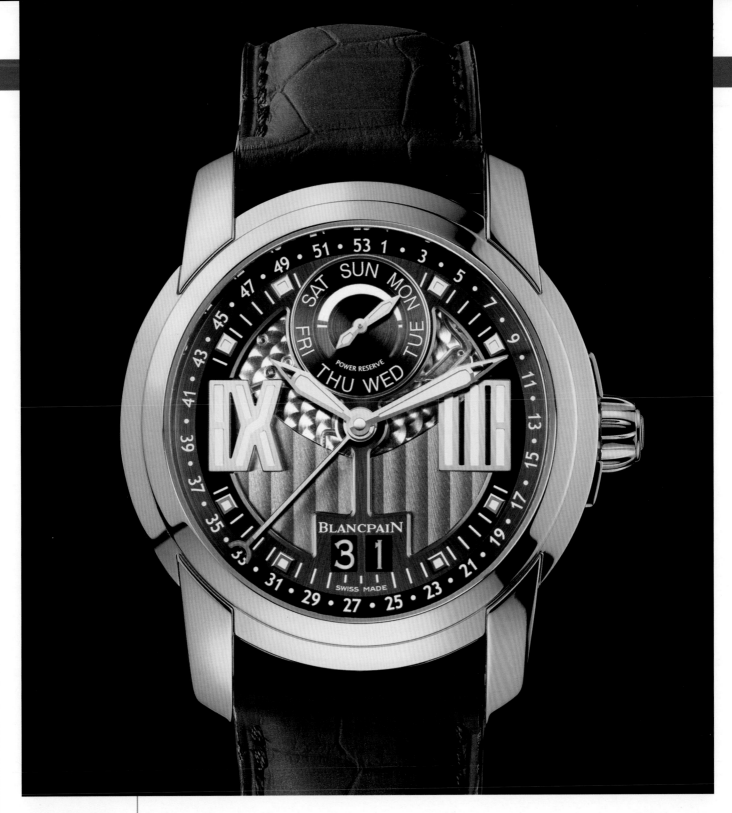

BLANCPAIN

L-EVOLUTION SEMAINIER GRANDE DATE 8 JOURS – REF. 8837-1134-53B

Blancpain's L-Evolution Semainer Grande Date 8 Jours is distinguished by its 8-day power reserve. The calendar displays the day, week, and large date. The 37R8G caliber is housed in the steel 43.5mm case, which is water resistant to 100atm. The L-Evolution Semainer Grande Date 8 Jours is also available in an 18K red- or white-gold case.

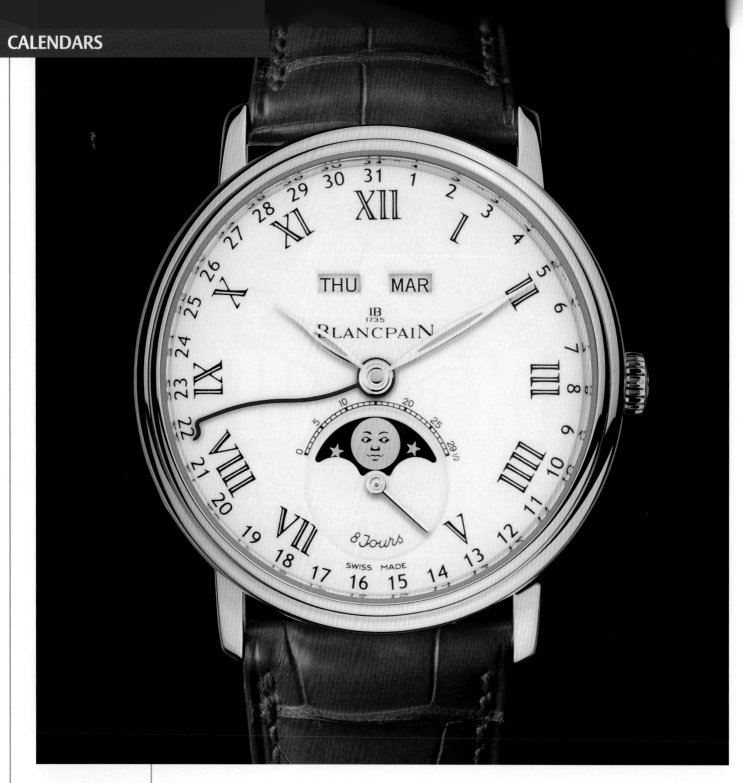

BLANCPAIN

VILLERET COMPLETE CALENDAR 8 JOURS – REF. 6639-3631-55B

Blancpain's Complete Calendar 8 Jours boasts an 8-day power reserve and an automatic-winding 6639 caliber, which is housed in the rose-gold 42mm case. The complete calendar displays hours, minutes, small seconds, and moonphase. Complemented by a light brown Louisiana alligator leather strap, the Complete Calendar 8 Jours is available in a limited edition of 275 pieces.

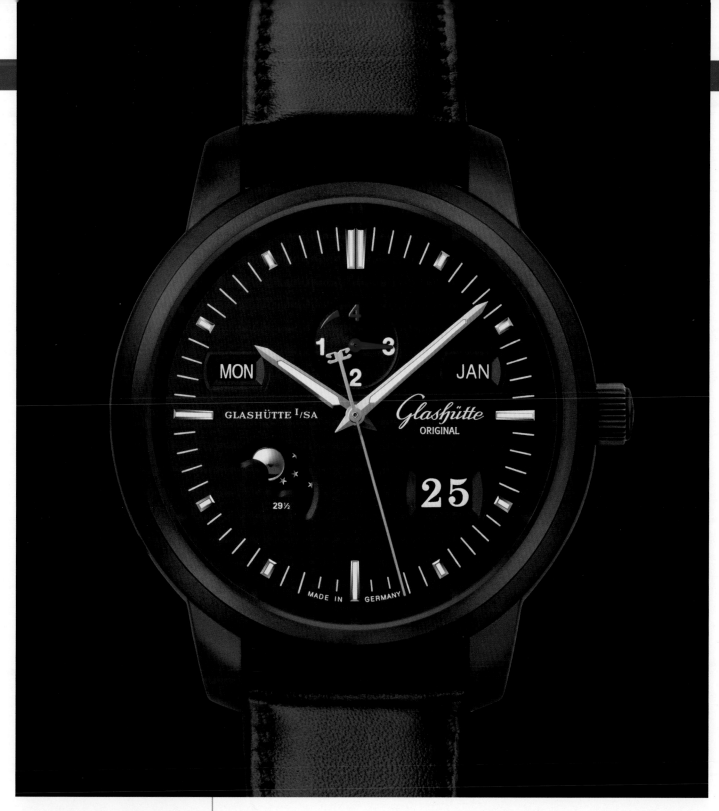

GLASHÜTTE ORIGINAL

SENATOR PERPETUAL CALENDAR – REF. 100.07.06.06.05

The matte black ceramic case of the Senator Perpetual lends the traditionally complicated art of watchmaking a modern appearance. The day, month, and panorama date are presented with white numerals against a black background, and a silver disk decorated with stars displays the moonphase. A leap-year display with jumping indicator located at 12:00 indicates a leap year when its red indicator points to the 4. The 42mm case houses automatic manufacture Caliber 100-07, which commands a power reserve of more than 55 hours and sports a reset mechanism that allows easy synchronization of the second hand with a time standard.

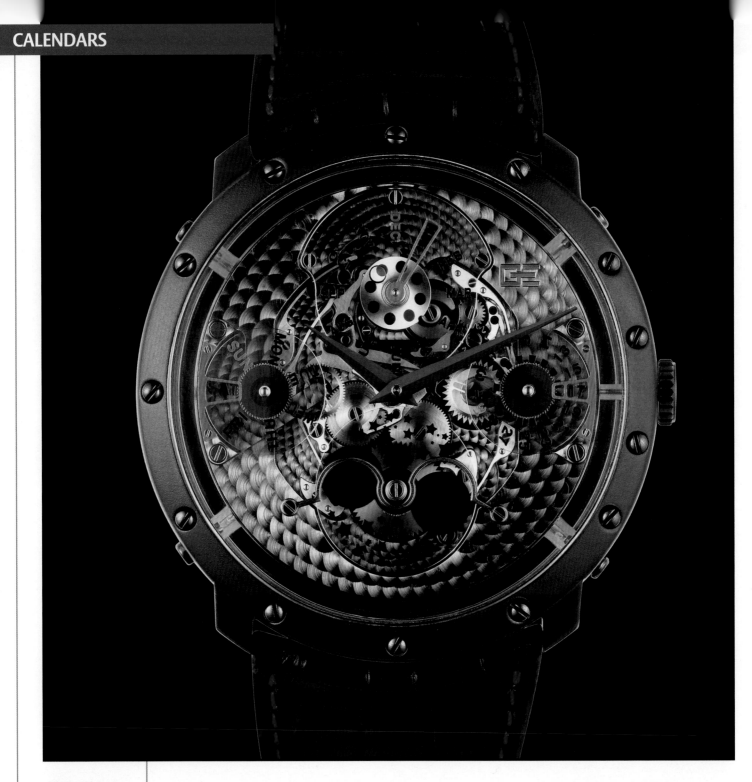

GUY ELLIA

TIME SPACE QUANTIEME PERPETUEL

The Time Space, original ambassador of Guy Ellia, is transformed into a perpetual calendar for this version. A mechanical hand-winding Frédéric Piguet caliber harbored in a 46.8mm black-gold case allows the owner to read the hour, minute, day, month, date and moonphases, while taking leap years into account. With a brushed bottom plate of 7.75mm, this watch symbolizes elegance, complexity and thinness. A specific automatic winder is integrated to the watch box. This model is also available in white gold and pink gold.

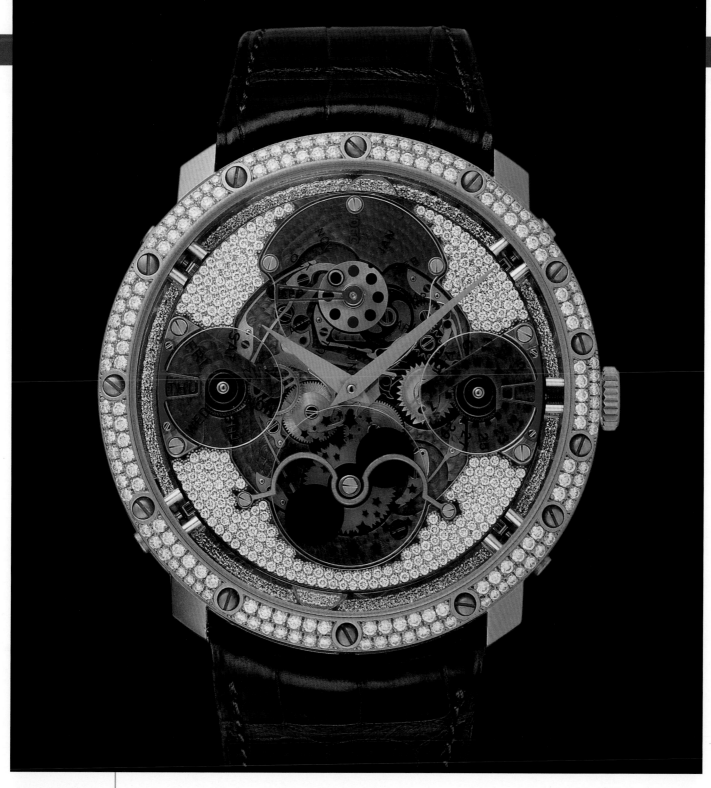

GUY ELLIA

TIME SPACE QUANTIEME PERPETUEL — FULL SET

The Time Space, original ambassador of Guy Ellia, is transformed into a perpetual calendar for this version. A mechanical hand-wound Frédéric Piguet caliber harbored in a 46.8mm white-gold case allows the owner to read the hour, minute, day, month, date and moonphase, while taking leap years into account. With a brushed bottom plate of 7.75mm, this clear allusion to the Couteaux watches symbolizes elegance, complexity and thinness. A specific automatic winder is integrated into the watch box and this model is also available in pink gold.

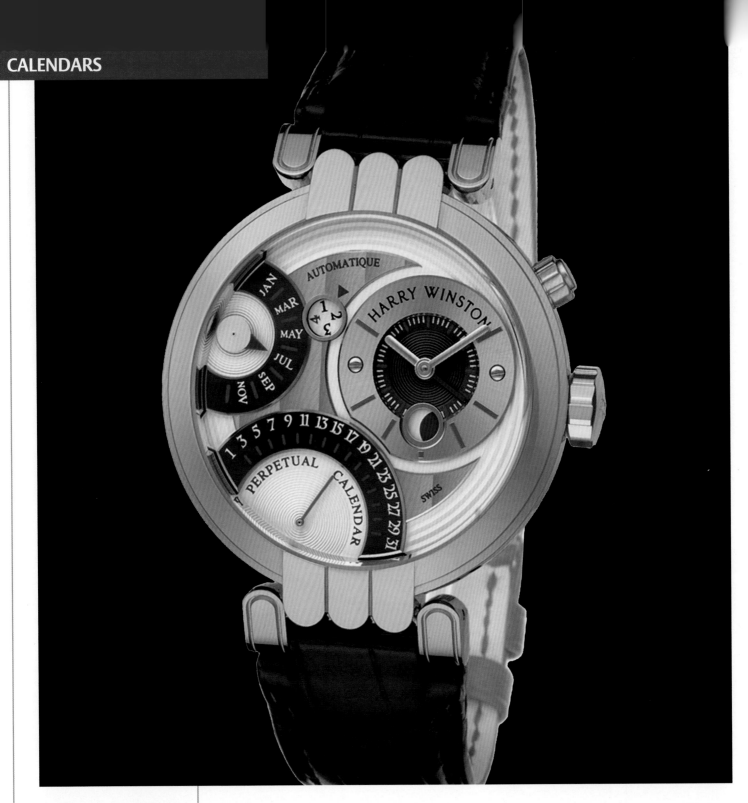

HARRY WINSTON

PREMIER PERPETUAL CALENDAR – REF. 200/MAPC41WL.W1

In 1989 Harry Winston introduced the first Bi-Retrograde Perpetual Calendar, sparking a revolution in contemporary watchmaking. Two decades later, this iconic design returns to center stage. The 41mm white-gold case has been reinvented with even more refinement, adding a subtle groove in the side to highlight its elegant contours, while maintaining the three signature arches. The off-center hours and minutes, retrograde months at 10:00, and retrograde date at 7:00 are arranged in a contemporary manner, while the understated leap-year and moonphase apertures are set opposite each other. Driven by a mechanical self-winding movement with a 45-hour power reserve, the Premier Perpetual Calendar is also available with a silvered dial.

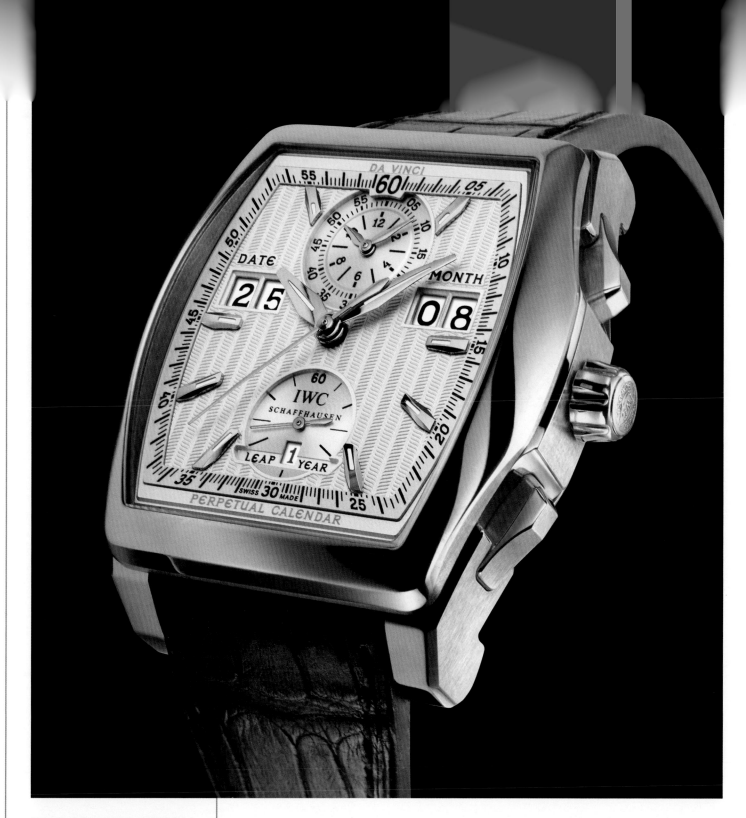

IWC SCHAFFHAUSEN

DA VINCI PERPETUAL CALENDAR DIGITAL DATE MONTH – REF. IW376101

In 1884, IWC secured the rights to the Pallweber system developed by Joseph Pallweber and started producing the first "digital" watches in IWC's history. Rather than an analog display with hands, digits were presented in separate windows; only the seconds were shown via a hand. Now, 125 years later, IWC presents the Da Vinci Perpetual Calendar Digital Date-Month with large-figure digital displays for the date and the month. The power required to switch both month and date discs at the end of the month is accumulated over the course of the entire month in a quick-action switch specially developed for this purpose. At the end of the month, the energy is released and displays are advanced, even the digital leap year if necessary. The chronograph can run continuously without having any noticeable effect on the watch's rate and, thanks to the flyback function, can be reset to zero without being stopped. The new IWC-manufactured 89800 caliber consists of 474 individual parts and builds up a power reserve of 68 hours. The movement is a massive watchmaking achievement.

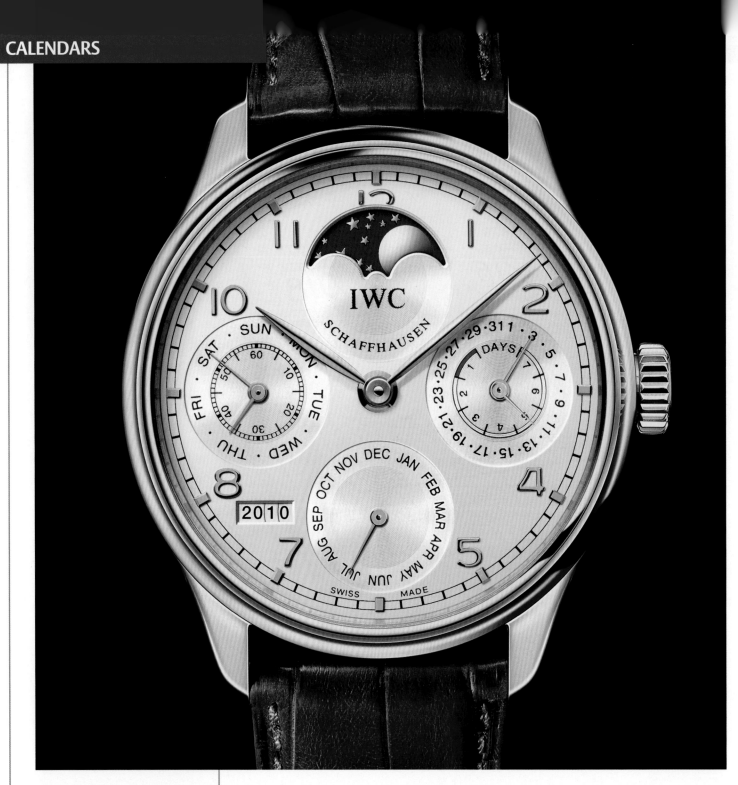

IWC SCHAFFHAUSEN

PORTUGUESE PERPETUAL CALENDAR RED GOLD – REF. IW502302

The moonphase display on the Portuguese Perpetual Calendar, Reference 5023, is grand-scale theatre on a tiny stage. Attended by a cluster of embossed stars, the moon rises behind the hemispherical cut-out on the left and waxes to full moon in the center, before disappearing on the right-hand side. IWC's design engineers have calculated that the moonphase display deviates from the duration of the moon's actual course by just 1 day in 577.5 years. No one, so far, has noticed the difference. In other respects, this elegant, up-to-the-minute timepiece leaves virtually no wish unfulfilled: perpetual calendar, four-digit year display, and a 7-day automatic movement with Pellaton winding and power reserve display. Reference 5023 is available in two versions: in a red-gold case with silver-colored dial and red-gold-plated moon against a midnight blue background; or slightly more restrained, in white gold with rhodium-plated appliqués on a slate-colored dial with a sun-pattern finish. As in the sister models (Reference 5021), the cases now measure 44.2mm in diameter.

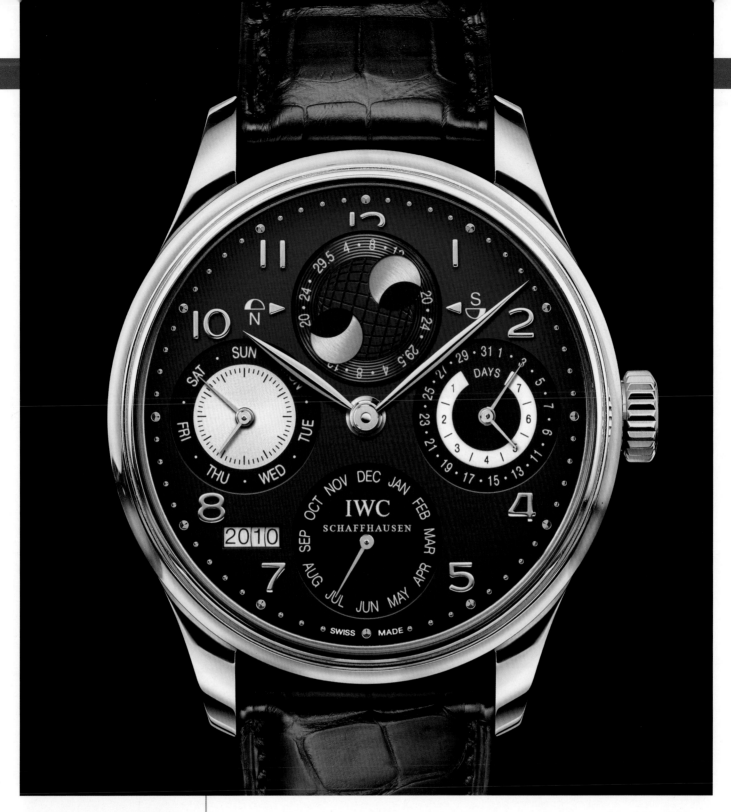

IWC SCHAFFHAUSEN

PORTUGUESE PERPETUAL CALENDAR WHITE GOLD – REF. IW502121

The moon is useful to sailors on the open sea not only for navigational purposes. Its influence on coastal tides has always been of greater importance, because the timing of their ebb and flow is reliably dictated by the moon: at new and full moons, high tides are exceptionally high and low tides exceptionally low. In the English Channel the difference can be up to 11.5m and in the Gulf of Maine as much as 21m, which illustrates the enormous importance of the moon for shipping. Aside from the date, day, month and year in four digits, the Portuguese Perpetual Calendar also indicates the number of days remaining until the next full moon. The display showing its course and featuring mirror images of the moon in the northern and southern hemispheres deviates from the moon's actual progress by just 12 seconds in one lunar period. The striking color combination found in the new version in white gold will increase its attraction to watch lovers and stargazers: the rhodium-plated moonphase indicator discs wax and wane thanks to a midnight-blue cut-out display in a dial also finished in midnight blue.

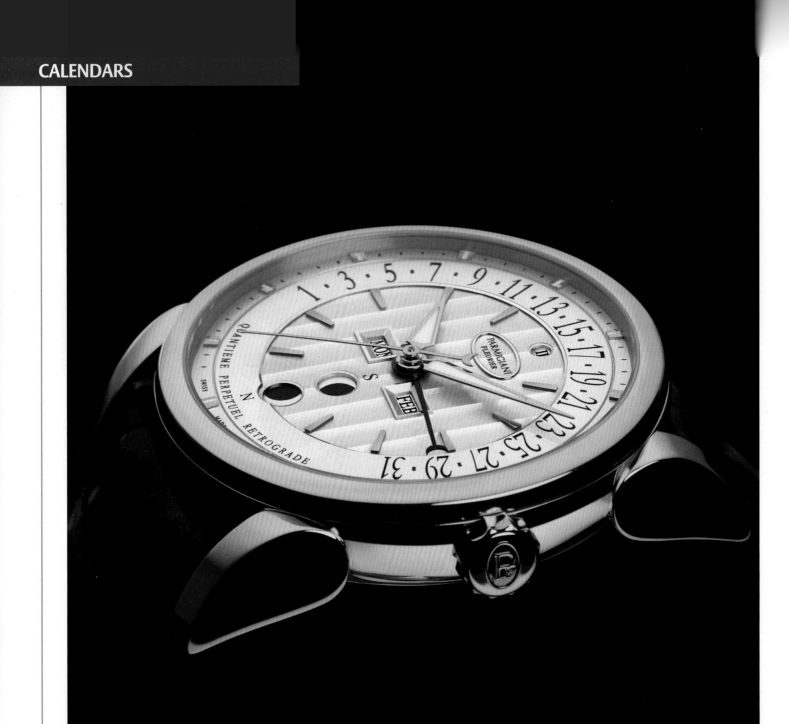

PARMIGIANI

TONDA 42 RETROGRADE PERPETUAL CALENDAR – REF. PFS227-1002600

Parmigiani's Tonda 42 Retrograde Perpetual Calendar is replete with functions, displaying hours, minutes, seconds, precision moonphase, and perpetual calendar with retrograde date, leap year, day and month window display. This watch is water resistant up to 30m. The 42mm case is crafted in 18K rose gold and houses the PF333.01 movement. The dial features Côtes de Genève finishing with "velvet" date ring, applied indexes, and delta-shaped hands with luminescent coating. This timepiece is mounted on an Hermès alligator strap with ardillon buckle.

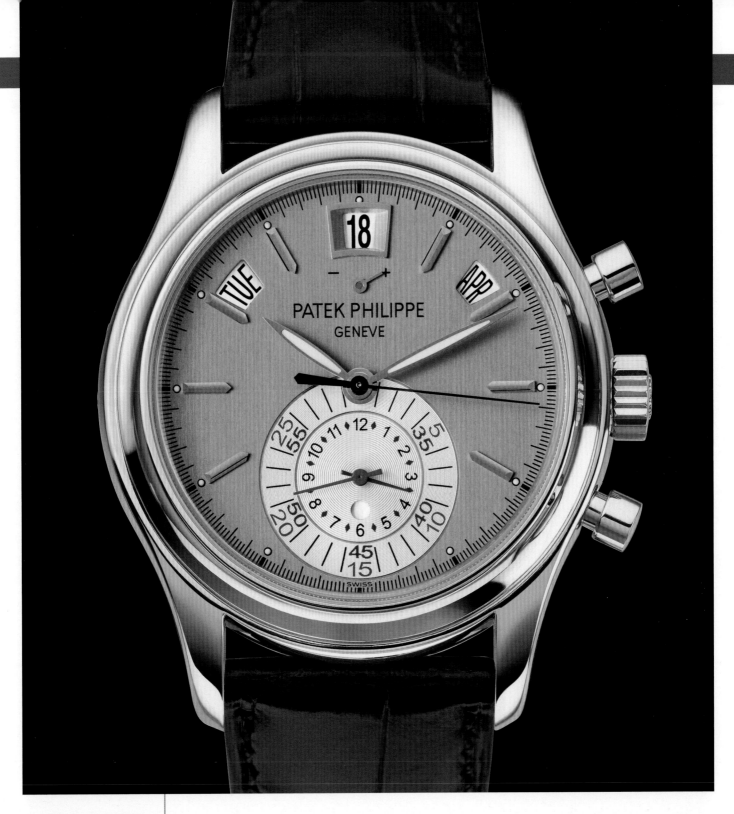

PATEK PHILIPPE

ANNUAL CALENDAR CHRONOGRAPH – REF. 5960R

Developed and manufactured in-house, the self-winding CH 28-520 IRM QA 24H chronograph caliber stands out with numerous features. It has a flyback column-wheel chronograph, a power reserve indicator, an annual calendar with day, date, and month, and a day/night indicator. The patented Patek Philippe Annual Calendar is a full-function calendar that automatically recognizes months with 30 and 31 days. On the dial's three concentric scales, it indicates elapsed minutes and hours while the chronograph is running. The day, date, and month apertures are arranged along an arc at the upper periphery of the dial. The new rose-gold case, with a diameter of 40.5mm, adds an attractive and contemporary touch of nostalgia to this impressive instrument.

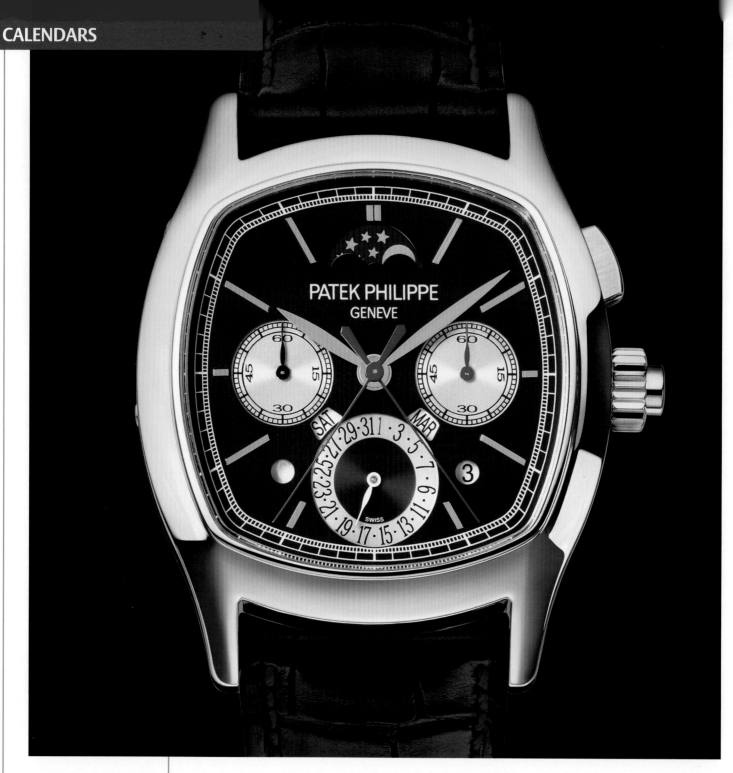

PATEK PHILIPPE

SPLIT-SECONDS CHRONOGRAPH WITH PERPETUAL CALENDAR – REF. 5951P

With this masterpiece, Patek Philippe impressively demonstrates the multiple talents of the CHR 27-525 PS split-seconds chronograph movement. In the Ref. 5951P, it not only drives the rattrapante chronograph but also controls a perpetual calendar. The unequaled slenderness of the base movement inspired the developers of the calendar module to strive for compactness as well. The result is a stunning movement with an overall height of only 7.3mm. To salute this extraordinary accomplishment, it is housed in a cushion-shaped case made of 950 platinum with a sapphire crystal exhibition caseback.

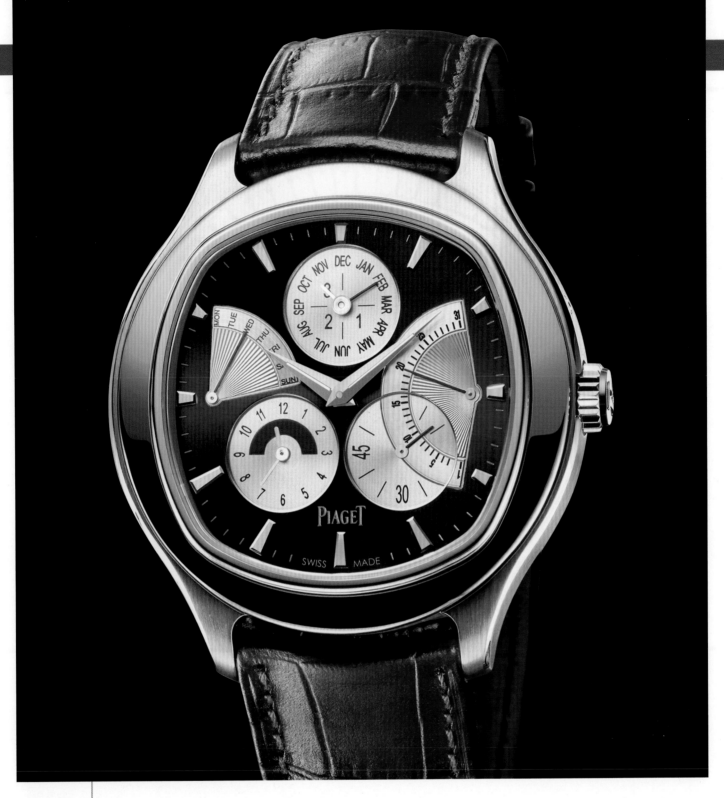

PIAGET

PIAGET EMPERADOR COUSSIN – REF. G0A33019

The Piaget Emperador Coussin represents a subtle architecture of the 46mm case that enables it to adapt to all wrists and imparts a particularly elegant profile. Measuring 5.6mm thick, the Manufacture Piaget Calibre 855P self-winding movement of this watch was designed, developed and produced entirely in-house. It displays the hours, minutes, small seconds at 4:00, month and leap years at 12:00, along with retrograde day of the week and date displays at 9:00 and 3:00 respectively. In addition, this Calibre 855P stands out from most ordinary perpetual calendars by the addition of a double-hand dual time zone display appearing in a subdial at 8:00. The self-winding Piaget Calibre 855P beats at a cadence of 21,600 vph and is endowed with an approximately 72-hour power reserve.

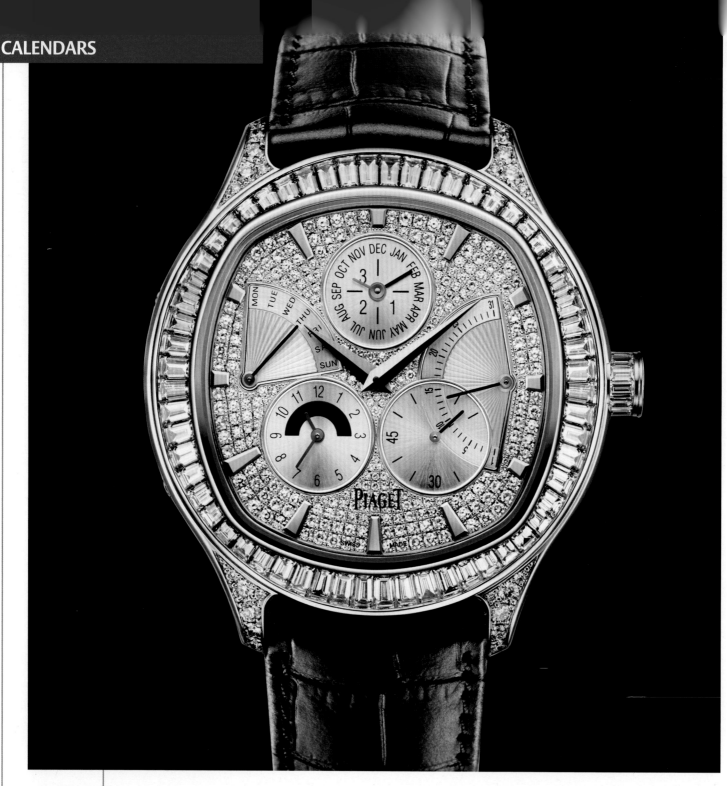

PIAGET

PIAGET EMPERADOR COUSSIN PERPETUAL CALENDAR – REF. G0A35020

The Piaget Emperador Coussin Perpetual Calendar houses Calibre 856P, a mechanical self-winding movement beating at a cadence of 21,600 vph and boasting a 72-hour power reserve. Its mainplate and bridges are circular-grained and beveled, their flanks are hand-drawn, and the decoration is enhanced with blued screws and circular Côtes de Genève. Its distinctive cushion shape and the decision to combine full-cut and baguette-cut diamonds totaling 9.9 carats clearly added to the daunting complexity of the watch. Witness the extraordinary jeweling of the bezel: the succession of 60 baguette-cut diamonds—one for each minute—seems to literally give life and movement to this case offering a display of virtuoso gem-setting dexterity. The dial is also a major accomplishment, featuring a surface housing no less than 263 diamonds, 12 hour markers and five subdials.

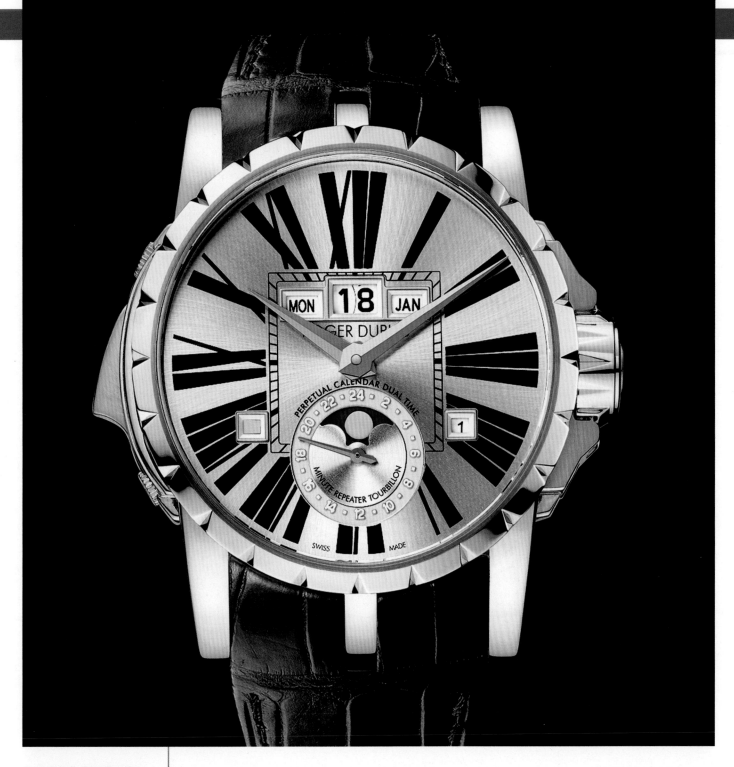

ROGER DUBUIS

EXCALIBUR PERPETUAL CALENDAR, MINUTE REPEATER TOURBILLON IN PLATINUM
REF. EX45-082-98-00-00-RR00/B

Limited to just eight pieces, the Excalibur Perpetual Calendar, Minute Repeater Tourbillon is lavished with features: a minute repeater with centrifugal dissipater, instantaneous perpetual calendar with oversized date, a flying tourbillon at 5:30, dual time zone display, automatic winding by double micro-rotor in platinum, 50-hour power reserve, and fine adjustment to six positions. Hours, quarter-hours, and minutes chime on demand, and display windows indicate the day of the week, date, leap year, day/night, high-precision moonphase and a dual time zone indication. The RD 0829 caliber pulses within the 45mm platinum case. The hand-stitched genuine alligator strap is complemented by its platinum folding buckle.

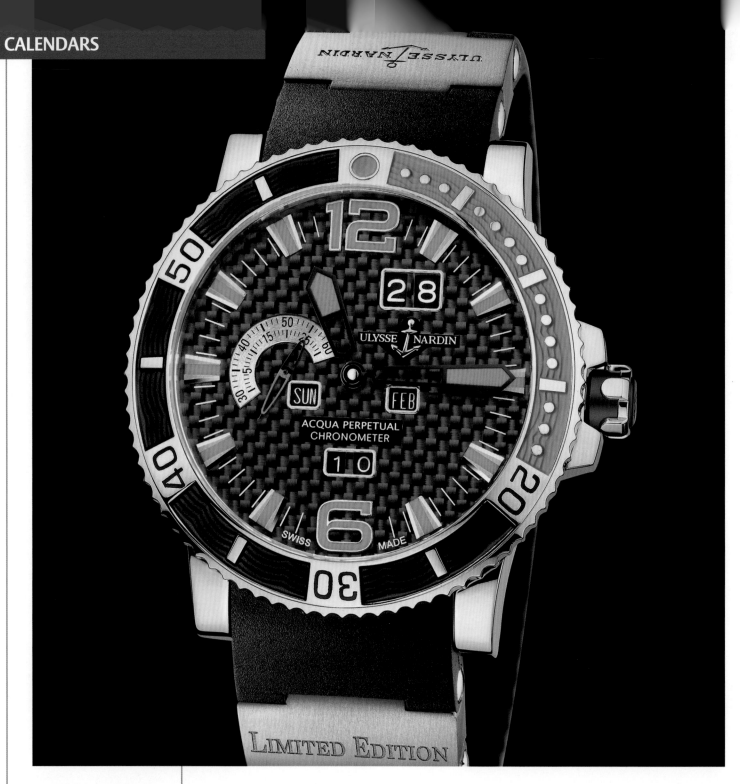

ULYSSE NARDIN

ACQUA PERPETUAL – REF. 333-90-3

The Acqua Perpetual features a rotating bezel and black carbon-fiber structured dial. The UN-33 caliber pulses within a 45mm titanium case. This perpetual calendar is adjustable backwards and forwards from a single crown. Part of a limited edition of 500 pieces, the Acqua Perpetual is also available in stainless steel with a titanium bracelet.

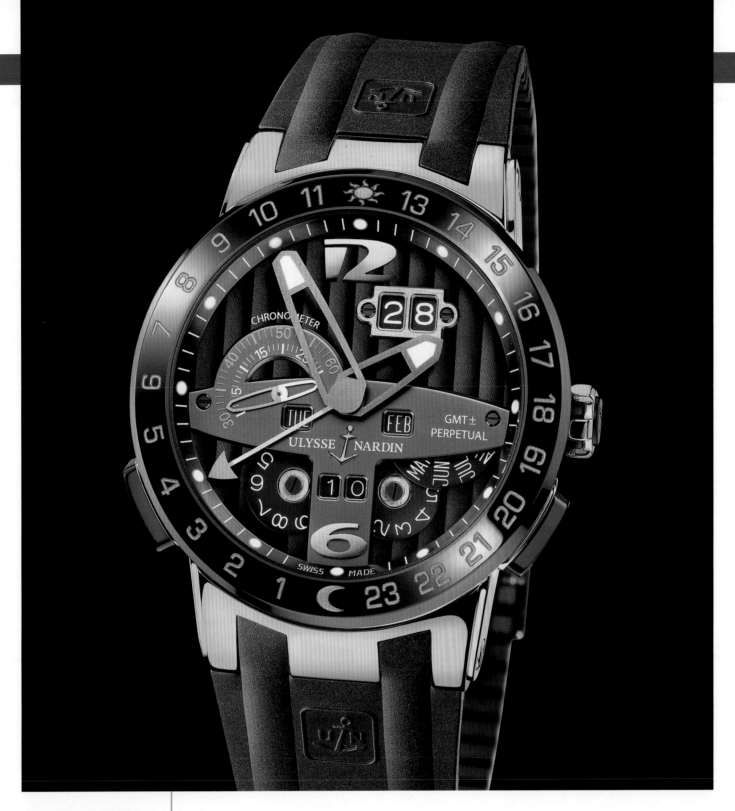

ULYSSE NARDIN

EL TORO – REF. 322-00-3

Adjustable backwards and forwards from a single crown, the El Toro is powered by its UN-32 caliber. This bold perpetual calendar boasts a second time zone with patented quickset on its main dial, all housed in a fine 43mm 18K rose-gold case. A third hand indicates permanent home time. The El Toro, in a limited edition of 500 pieces, is also available in platinum with a crocodile strap.

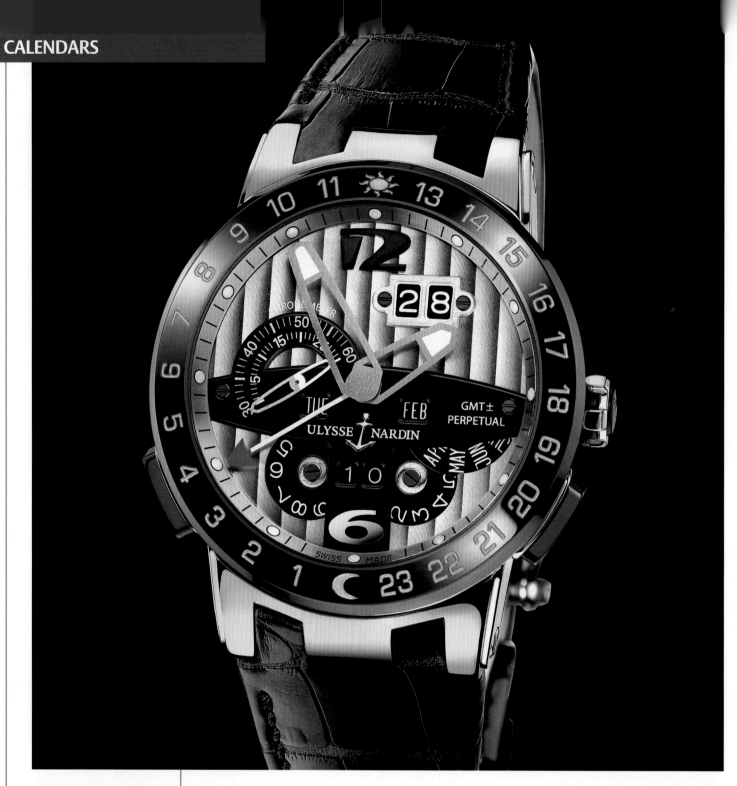

ULYSSE NARDIN

EL TORO – REF. 329-00-3

Housed in a 43mm platinum case, this perpetual calendar moves to the rhythm of its UN-32 caliber. The El Toro is adjustable backwards and forwards from a single crown. Complimented by a crocodile strap, this timepiece also features a second time zone with patented quickset on its main dial and permanent home time indicated by a third hand. The El Toro perpetual calendar is part of a limited edition of 500 pieces.

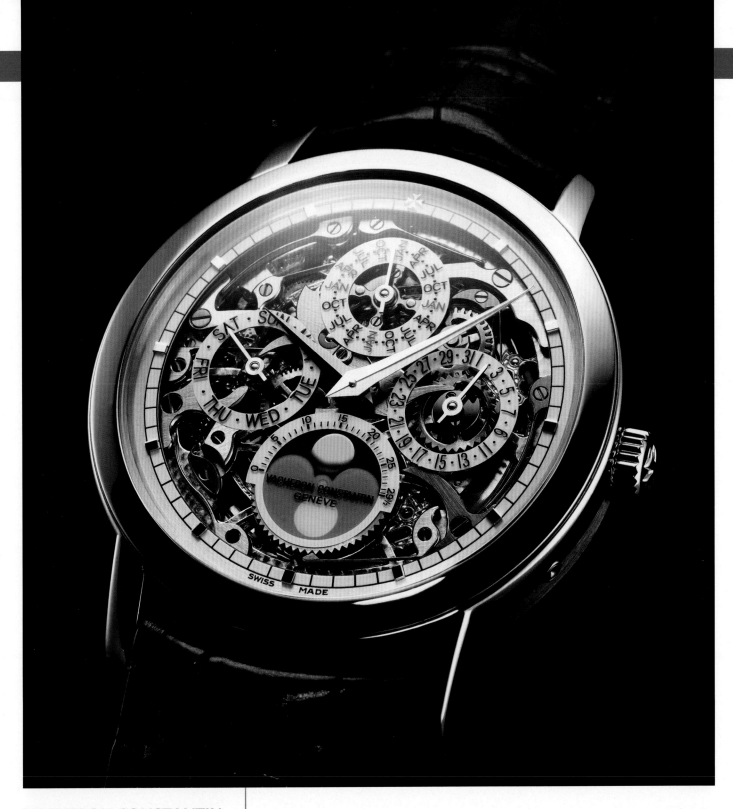

VACHERON CONSTANTIN

PATRIMONY TRADITIONNELLE SKELETON PERPETUAL CALENDAR – REF. 43172

The Patrimony Traditionnelle Skeleton Perpetual Calendar houses the 1120 QP SQ self-winding caliber with 36 jewels, a 40-hour power reserve, and stamped with the prestigious Geneva Seal. The movement is distinguished by the Art Nouveau motif of its beautifully finished engraving; the elegant shapes of the Eiffel Tower inspired Vacheron Constantin's master engravers. The dial was designed to provide an excellent view of the skeleton movement and perfect legibility of the perpetual calendar indications. Vacheron Constantin designed a transparent sapphire dial enhanced by a silvered ring with the hour markers and minute track. The perpetual calendar indications sit on this transparent dial, consequently gaining in both size and legibility. This watch is available in 950 platinum or in 18K rose gold.

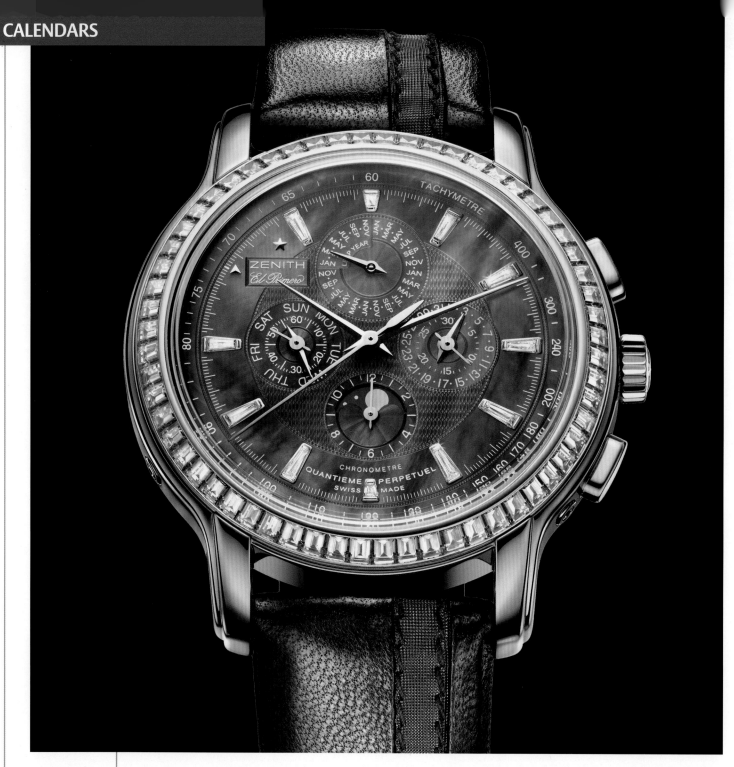

ZENITH

ACADEMY QUANTIEME PERPETUEL EL PRIMERO BLACK TIE

Crafted in platinum, this Academy Quantième Perpétuel El Primero Black Tie is powered by the proprietary El Primero 4003 automatic chronograph movement with perpetual calendar. The COSC-certified chronometer caliber consists of 321 components, including 31 jewels. With 50 hours of power reserve, the watch indicates date, moonphase, day, month and leap year, chronograph functions, and tachometer readout. The case's 60 baguette-cut Top Wesselton diamonds (5.4 carats) encircle a solid gold dial with genuine Polynesian mother-of-pearl and 11 diamond indexes. It is released in an exclusive limited and numbered edition on a handmade lambskin "Black Tie" leather strap with satin trim.

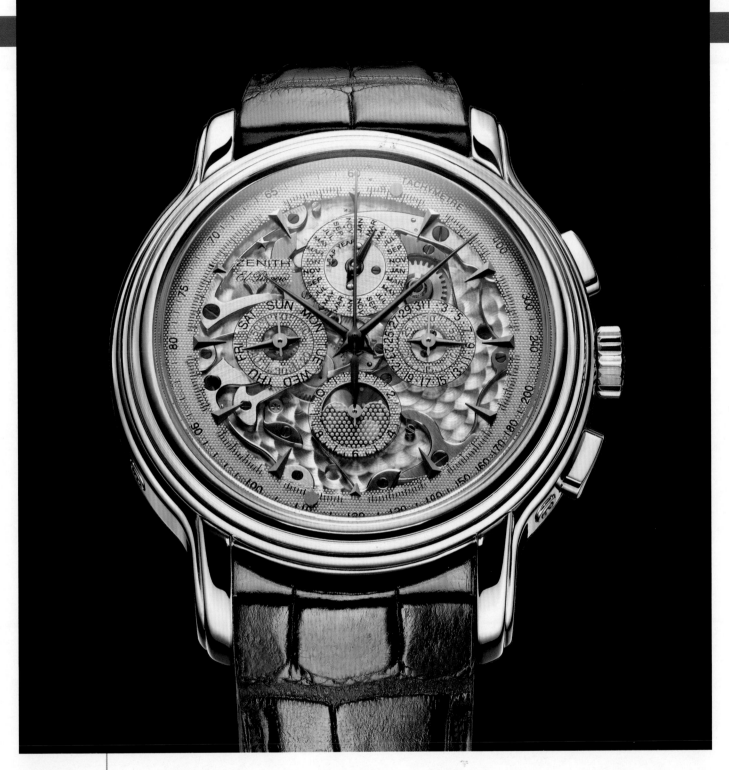

ZENITH

ACADEMY QUANTIEME PERPETUEL EL PRIMERO CONCEPT

This limited edition 18K white-gold Academy Quantième Perpétuel El Primero Concept houses the automatic El Primero 4003 C (a COSC-certified chronometer with perpetual calendar that beats at 36,000 vph and carries 50 hours of power reserve), which is visible through the caseback. The movement with circular-grained mainplate is composed of 321 parts including a 22K gold oscillating weight with Côtes de Genève guilloché pattern. The perpetual calendar indicates date (in a ring around the 30-minute counter at 3:00), moonphase (inside the 12-hour counter at 6:00), day at 9:00 and month and leap year at 12:00. The sapphire dial is circled with a tachometric scale.

Multi-Complications

For watchmaking purists, a "complication" is any function besides the hours and minutes. For some, even the seconds display is considered a complication, especially if it appears in an off-centered subdial. But the definition of the word "complication" has been a topic of heated debate for many years now. By way of example, the tourbillon is not an additional function, but is it a complication? A currently widespread definition considers any device that complicates the basic movement mechanism as a complication. From this standpoint, the "stop seconds" device, digital display or jumping hours are also considered to be complications, while often making the watch simpler to use.

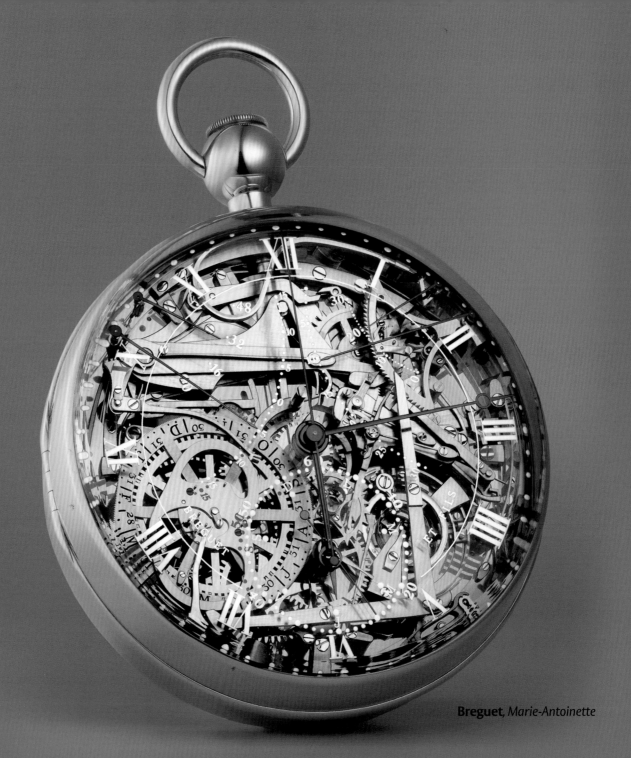

Breguet, *Marie-Antoinette*

THE ART OF GRAND COMPLICATIONS

Horology is a sphere of seemingly infinite knowledge and inventions. The first time-measuring machine would seem to date back to the first century B.C., in the shape of a bronze gear calendar found off the coast of the Greek island of Antikythera. Even though it would be exaggerating to refer to it as an authentic clock, this timepiece marks the symbolic starting point of an uninterrupted succession of enhancements and improvements that runs right through to the present day.

So many developments surrounding a single object were bound to inspire horology specialists to pursue visions of grandeur—or rather of miniaturization—by seeking to unite all manner of innovations and complications within a single case. One of the most famous examples, created in the 18th century, is that of the "Marie-Antoinette" watch by Breguet, ordered for the queen of France in 1783, and not completed until 1827. This masterpiece included a range of features including automatic winding, an independent large seconds hand, a minute repeater, a perpetual calendar, an equation of time, a power reserve indicator and a thermometer. It was stolen from a museum in Jerusalem in 1783, before showing up again in 2007 in somewhat obscure circumstances. In 2008, Breguet presented an identical replica of this legendary timepiece, housed within a box carved out of wood from the queen's favorite oak tree at Versailles.

RECORD-BREAKING POCKET-WATCHES

If there is one watch brand that has particularly distinguished itself in the field of ultra-complicated watches, it would undoubtedly be Patek Philippe. Between 1925 and 1933, the Geneva-based manufacturer created for Henry Graves, Jr. a double-faced pocket-watch featuring 24 complications, including a grand strike mechanism chiming on four gongs, as well as a depiction of the night sky as seen from New York. Alongside the Graves watch, the title of "the world's most complicated watch" was for many years also hotly disputed by another masterpiece, the Leroy 01 (1904), which claimed to feature between 20 and 25 complications. In 1989, Patek Philippe put an end to this particular quarrel by presenting Calibre 89. With its 33 complications and 1,728 parts, this timepiece is to date the most complicated portable watch ever. In addition to the complete repertoire of so-called "classic" complications (date, chronograph, striking mechanism, astronomical complications, etc.), it also features several extremely rare functions such as the so-called "secular" calendar (see the Perpetual Calendars chapter), as well as displaying the date of Easter. Calibre 89 is also endowed with a sky chart portraying the Milky Way and enabling admirers to distinguish 2,800 stars in the Northern Hemisphere, as well as their magnitude.

In 2000, Patek Philippe once again caused a sensation by unveiling the double-faced Star Caliber 2000 pocket-watch, with 21 complications. In this case, the goal was not to assemble the largest number of functions, but those that "provide the most poetic representation of time," meaning, above all, astronomical functions. Without claiming to vie for a place in the Guinness Book of Records, other watchmakers have also recently introduced ultra-complicated pocket-watches distinguished by their extreme sophistication, such as the Grande Complication Savonnette by Audemars Piguet, associating a perpetual calendar, minute repeater and split-seconds chronograph within a yellow-gold case with a cover.

CLOCKWISE FROM TOP LEFT
Patek Philippe, *Graves*
Leroy, *01*
Patek Philippe, *Calibre 89*
Patek Philippe, *Star Caliber 2000*
Audemars Piguet, *Grande Complication Savonnette*

HOROLOGICAL FEATS IN WRISTWATCH SIZE

The appearance of the wristwatch in the early 20th century forced watchmakers to display a wealth of ingenuity in miniaturizing mechanisms and combining them within exceptional models. Since the renewal of mechanical watchmaking in the 1980s, we have witnessed a number of ultra-complicated timepieces, and the great manufactures—aided and abetted by computerized technologies—have resumed the race to create "the world's most complicated watch." In 1991, Blancpain presented the 1735, which united the "six masterpieces of the art of horology": ultra-thin movement, moonphase, perpetual calendar, split-seconds chronograph, tourbillon and minute repeater. In 2001, Patek Philippe reaffirmed its mastery by presenting the Sky Moon Tourbillon, a double-faced wristwatch featuring an unprecedented combination of the 12 rarest and most fascinating complications, including a minute repeater with a "cathedral" gong, a tourbillon, and a mobile sky chart.

In 2006, Jaeger-LeCoultre upped the ante by unveiling the Reverso grande complication à triptyque, a watch that makes unprecedented use of the famous reversible or swivel watch system created in 1931. This exceptional timepiece features three faces displaying three dimensions of time: on the front is "civil" or standard time, with a new detent escapement system and a titanium tourbillon; on the back, sidereal time, with a sky chart, Zodiac calendar, equation of time and sunrise and sunset times; and thirdly, on the watch cradle or carrier, perpetual time, with a complete calendar. This amounted to a grand total of 18 complications.

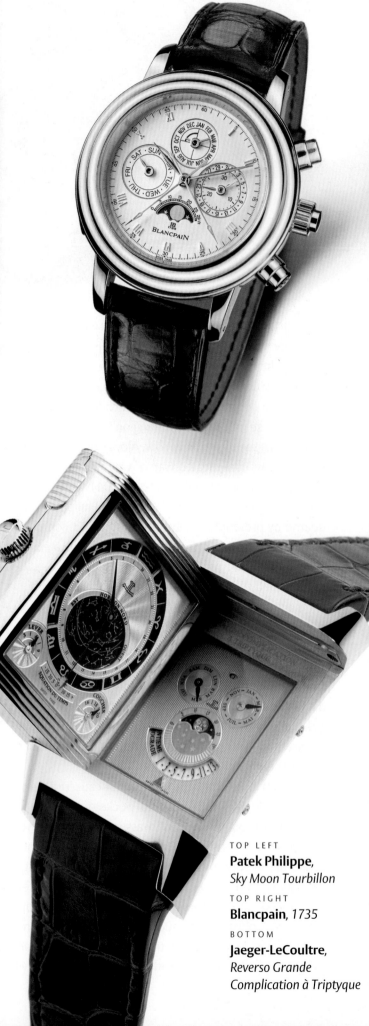

TOP LEFT
Patek Philippe,
Sky Moon Tourbillon

TOP RIGHT
Blancpain, *1735*

BOTTOM
Jaeger-LeCoultre,
*Reverso Grande
Complication à Triptyque*

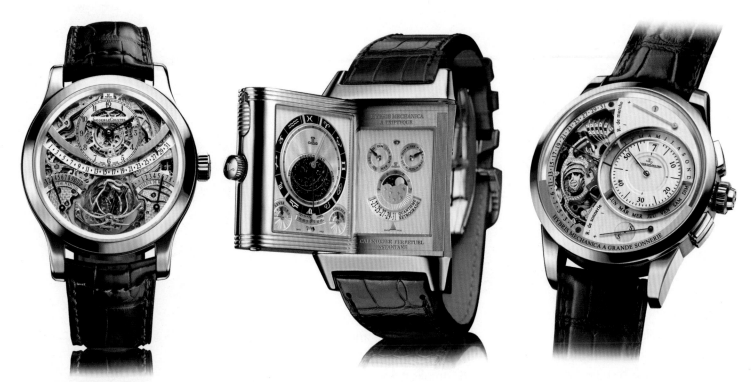

This complications record was bested by the same brand in 2009, when Jaeger-LeCoultre presented a trio of timepieces named Hybris Mechanica 55—from the Greek word "hybris", meaning excess. These three watches features a total of 55 complications—some of which are featured in more than one model. The first, the l'Hybris Mechanica à Gyrotourbillon, pays tribute to the quintessence of mechanical time measurement thanks to its "spherical tourbillon" already introduced by Jaeger-LeCoultre on its Gyrotourbillon I and II models (see Tourbillon chapter). The movement also includes a perpetual calendar with four retrograding hands and an equation of time display adjustable according to the place—all housed within a round case inspired by the Master line. The second, the Hybris Mechanica à Triptyque, reflects the principle of the Reverso grande complication à triptyque described above, while the third model, the Hybris Mechanica à Grande Sonnerie, boasts no fewer than 26 complications.

It highlights the magic of the audible indication of time with a 1,300-part movement combining a flying tourbillon, a perpetual calendar with retrograding hands and a minute repeater mechanism featuring a number of patented innovations (see the Minute Repeaters and Sonneries chapter), all housed in a Duomètre style case. This trilogy is delivered in an authentic 1.5m-tall watch safe featuring luxurious finishing and will be produced in a strictly limited run of 30 pieces between 2009 and 2014.

Although hard to beat, this record has nonetheless continued to inspire certain brands, such as Chopard, which in 2010 presented a model created for its 150th anniversary: the L.U.C 150 All-in-One. Comprising 516 parts and 42 jewels, its L.U.C 4TQE movement drives 14 complications, some of which are presented on the back of the watch, namely the equation of time, power reserve, 24-hour day/night indication, sunrise and sunset times and astronomical orbital moonphases.

TOP LEFT
Jaeger-LeCoultre, *Hybris Mechanica à Gyrotourbillon*

TOP CENTER
Jaeger-LeCoultre, *Hybris Mechanica à Triptyque*

TOP RIGHT
Jaeger-LeCoultre, *Hybris Mechanica à Grande Sonnerie*

RIGHT
Chopard, *L.U.C 150 All-in-one*

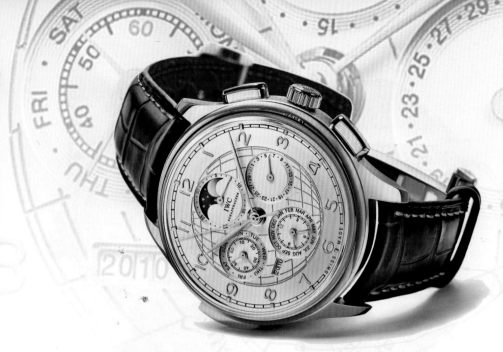

AN ENDURING TRADITION

Nevertheless, this rivalry regarding the number of complications within a given timepiece should not make us lose sight of the historical definition of a grand complication watch. Traditionally, the latter comprises three horological complications: the first provides an astronomical indication, such as a perpetual calendar; the second features an audible indication, such as a minute repeater; and the third generally uses one or several extra hands to display an additional indication, generally a chronograph.

In its new Portuguese Grande Complication, IWC has scrupulously complied with these precepts. This timepiece comprises a minute repeater, a chronograph as well as a perpetual calendar that not only displays the date, day and month, but also the year, the decade, the century and even the millennium by means of a four-digit display. In another interpretation of the original definition, the Jaeger-LeCoultre Master Grande Tradition Grande Complication unites a minute repeater, a sidereal Zodiac calendar and a flying tourbillon—which serves as a hand pointing to the sidereal hours. This distinctive feature is powered by a complex mechanism, with a disk below the dial performing a full rotation in 24 hours and featuring a small sun that indicates civil time around the rim. It is topped by a second blue lacquered disk depicting the sky chart, to which the flying tourbillon is affixed. The latter moves in step with the sky chart, itself mounted on a ball-bearing mechanism.

Presented in 2008 in a barrel-shaped case and re-issued in 2010 in a round version, the Chapter One model by the Maîtres du Temps picks up the idea of a tourbillon combined with a pointer-type astronomical indications. This unique creation combines a single-pusher column-wheel chronograph, a retrograde calendar, a retrograde dual time zone display as well as the day of the week and moonphase on two rollers placed at 6 and 12 o'clock.

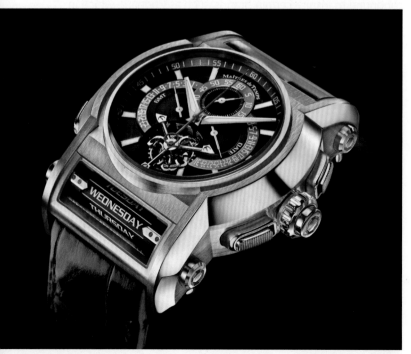

A USEFUL OR PRACTICAL COMPLICATION

Above and beyond the notion of horological functions displayed on the dial or back of a watch, a complication may be of a primarily practical or technical nature. In the former category, we find the numerical or digital display (which is more practical than a hand for indicating the date); a mechanism enabling the user to adjust the hands at any time of day or night and in both directions (still an extremely rare feature); and the stop-seconds device, a kind of mechanical arm that immobilizes the balance and enables time-setting to within the nearest second.

In the category of technical complications, mention must be made of the Chronomètre à Résonance by F.P. Journe, which won the Best Complicated Watch prize at the 2010 Grand Prix d'Horlogerie de Genève. Created in 2000, this timepiece was reintroduced in an updated version for its tenth anniversary. In addition to a 24-hour display and digital minutes appearing through an aperture at 10 o'clock, a dual time zone indication (hours and minutes) in a subdial at 2 o'clock, double small seconds at 6 o'clock and a power reserve display at 11 o'clock, the most distinctive feature of this model lies in its escapement. The latter comprises two mechanical balances beating in a perfectly synchronized manner according to the principle of resonance. A natural physical phenomenon, resonance defines the manner in which a body absorbs the energy delivered by another body in motion. The first is called the "resonator," and the second the "exciter." In the case of the Chronomètre à Résonance, this phenomenon serves to enhance precision.

With the Patrimony Traditionnelle Calibre 2755 in platinum, Vacheron Constantin also reveals its creative genius. The minute repeater of this model is equipped with a centripetal striking mechanism regulator, or strike governor, a device serving to control the duration of a musical frequency. When the sliding bolt of the striking mechanism is activated, the force supplied by the barrel-spring actions a flywheel fitted with two inertia-blocks or weights, which exercise pressure on the central pivoting shaft, thereby acting as a brake to slow down and stabilize the overall rotation speed. In addition to a minute repeater, this timepiece also features a perpetual calendar and is powered by a tourbillon regulator.

TOP
F.P. Journe, *Chronomètre à Résonance*
BOTTOM
Vacheron Constantin, *Patrimony Traditionnelle "Calibre 2755"*

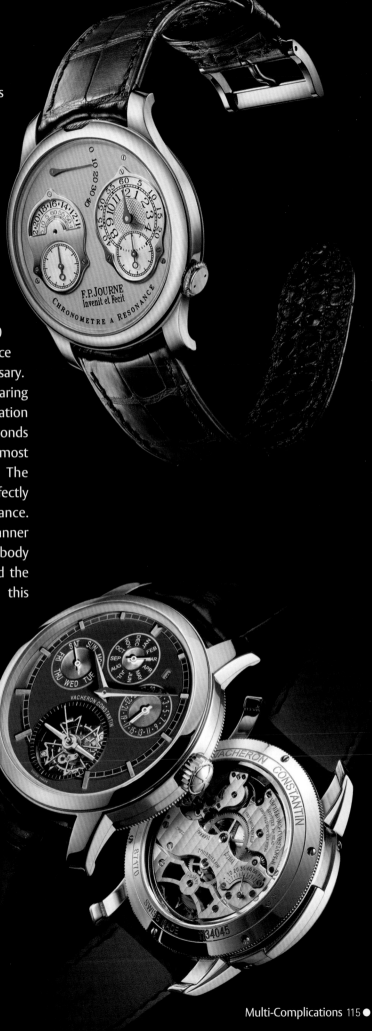

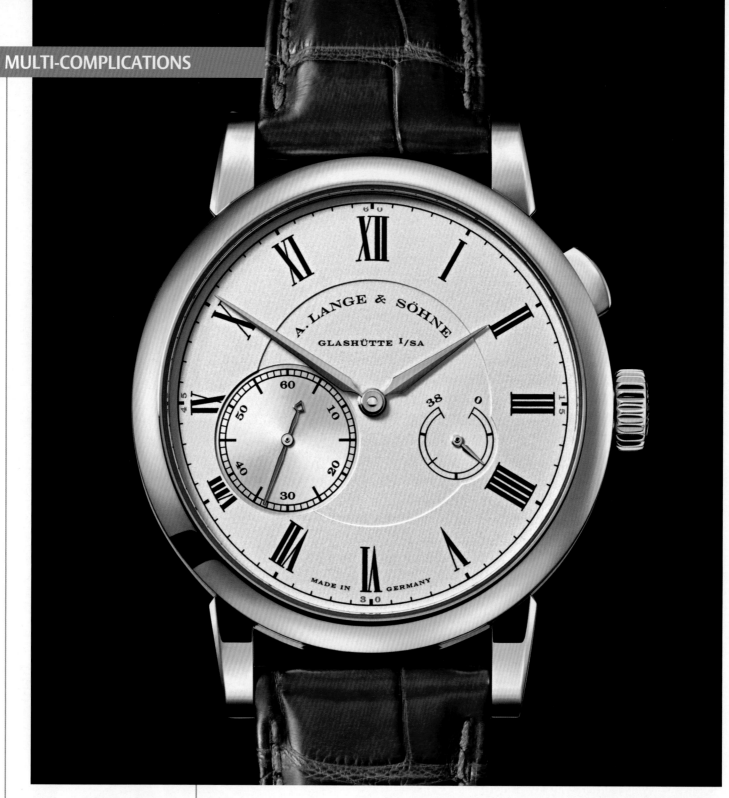

A. LANGE & SÖHNE

RICHARD LANGE "REFERENZUHR" – REF. 250.032

The Richard Lange "Referenzuhr" houses a manual-winding Lange L033.1 movement with a zero-restart function. The activation of a pushpiece above the crown causes its seconds hand to jump to zero and wait there as long as the pushpiece is depressed. During that time, a vertical disc clutch assures that the ongoing measurement of time is not interrupted—the movement keeps running. When the pushpiece is released, the seconds hand restarts instantaneously. The timepiece features a large balance wheel with off-center poising weights and a balance spring manufactured in-house. This timepiece is limited to 50 pieces in platinum and 75 in pink gold.

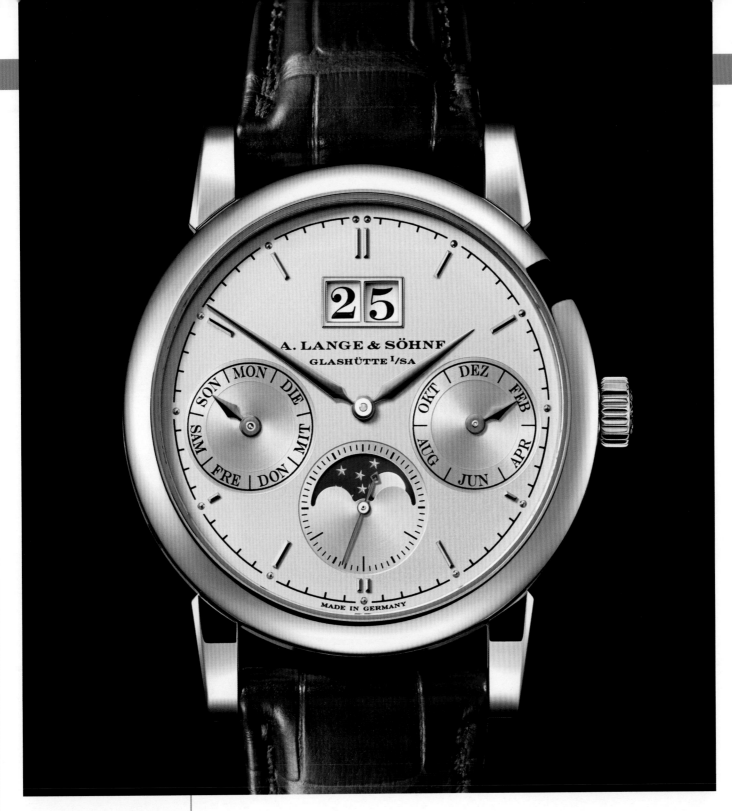

A. LANGE & SÖHNE

SAXONIA ANNUAL CALENDAR – REF. 330.026

An annual calendar complication is one of the most popular and sublimely useful functions in horology. A. Lange & Söhne has now added the first to the Saxonia family: the Saxonia Annual Calendar. This timepiece displays a large date, day of the week, and month. The moonphase display is so accurate that it only needs to be corrected by one day every 122 years, assuming the watch runs without interruption. The Saxonia Annual Calendar includes the self-winding SAX-O-MAT caliber with a 46-hour power reserve and a zero-reset hand-setting mechanism. The plates and bridges are made of untreated German silver and the balance cock is engraved by hand. The timepiece is available in a white- or pink-gold case with a diameter of 38.5mm.

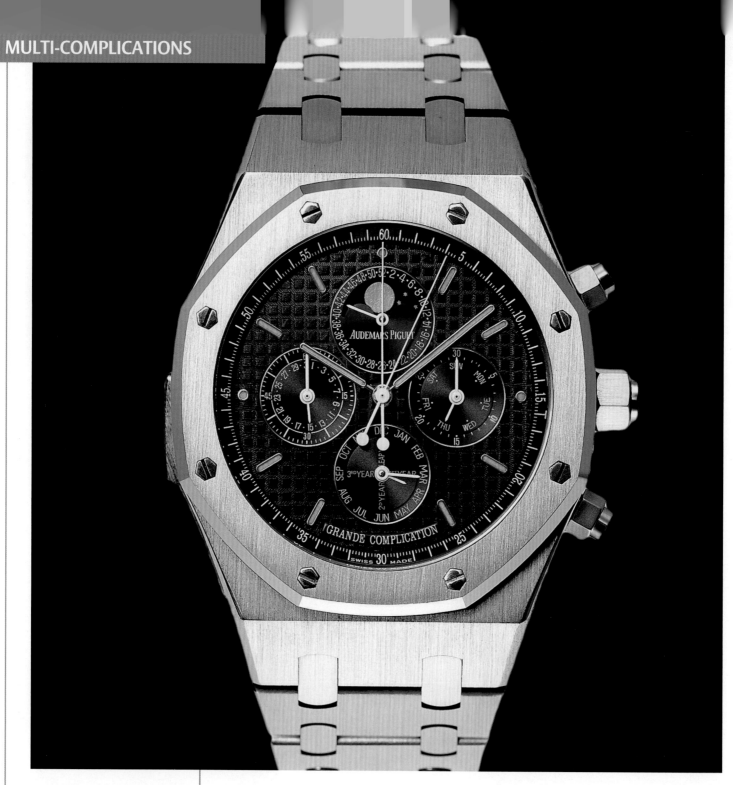

AUDEMARS PIGUET

ROYAL OAK GRANDE COMPLICATION – REF. 25865BC.OO.1105BC.01

The Royal Oak Grande Complication is powered by the 2885 caliber, a self-winding movement of 13.5''', which features a split-seconds chronograph, a minute repeater and a perpetual calendar. Seconds are displayed in a subdial at 9:00. Housed in an 18K white-gold case, the movement beats at 19,800 vibrations per hour. The dial displays 12 indications, including day, date, month, leap years and moonphase. The movement is comprised of 654 pieces.

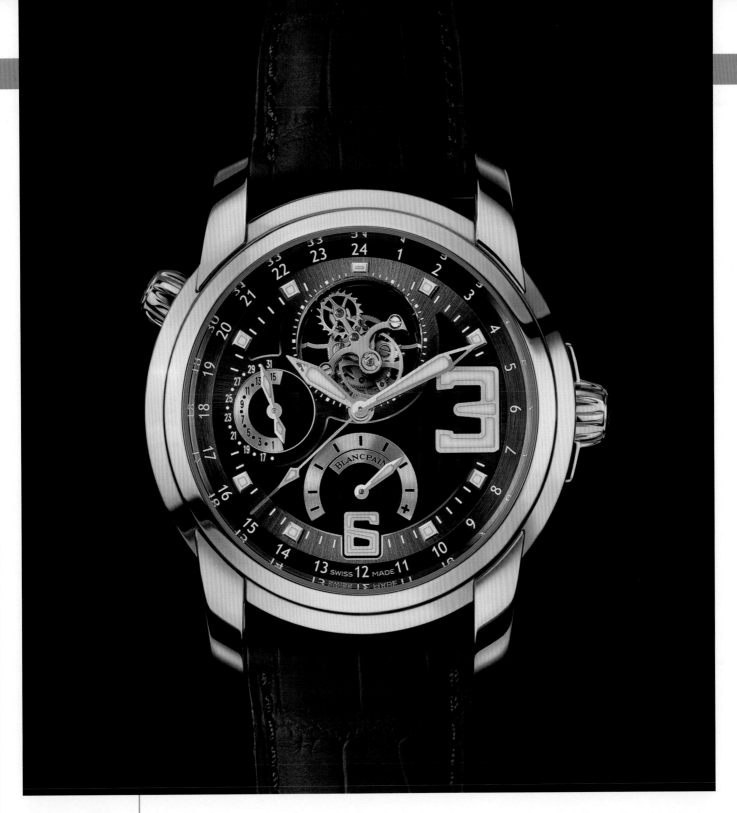

BLANCPAIN

L-EVOLUTION TOURBILLON GMT – REF. 8825-3630-53B

Blancpain's L-Evolution Tourbillon GMT features a flying tourbillon at 12:00 and a GMT dual time zone. Double-hand date is displayed at 9:00. The 5025 caliber pulses within the 43.5mm red-gold case. The dial provides a distinct view of its baseplate, adorned with Côtes de Genève. This fine timepiece is available in a limited edition of 99 pieces.

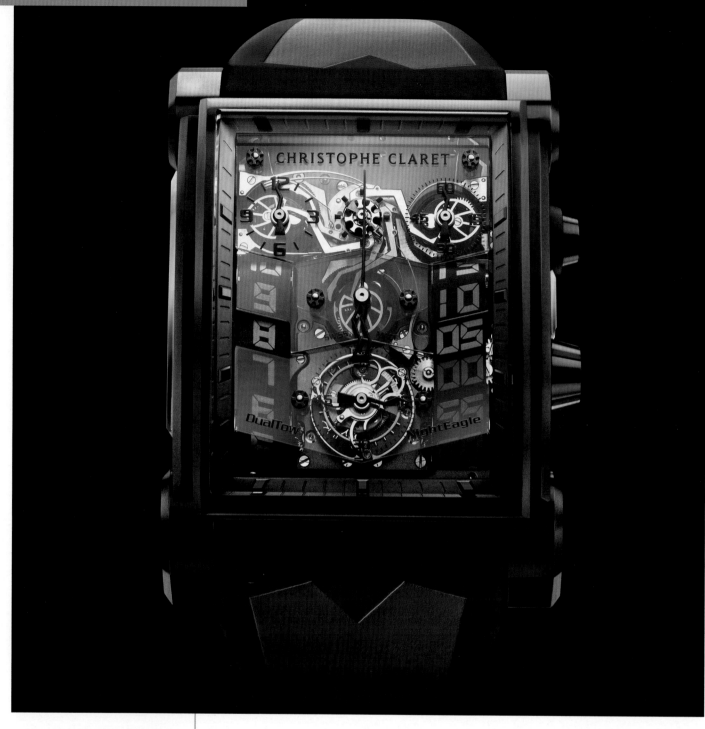

CHRISTOPHE CLARET

DUALTOW NIGHTEAGLE – REF. MTR.CC20A.009

To celebrate the 20th anniversary of his Manufacture, Christophe Claret launched the first piece under his own brand name: DualTow. This timepiece is a single-pusher planetary-gear chronograph with a striking mechanism and tourbillon. The major innovation of this watch, issued in a limited series of 68 pieces, all unique and customizable, lies in its patented single-pusher chronograph function operating by means of nine planetary gears. It is equipped with an ingenious belt-style display of the hours and minutes. The new version, NightEagle, finds its inspiration in the ultra-secret world of stealth aircraft such as the American F-117 Night Hawk, reflected in its taut lines, sharp angles, tone-on-tone colors and transparency effects.

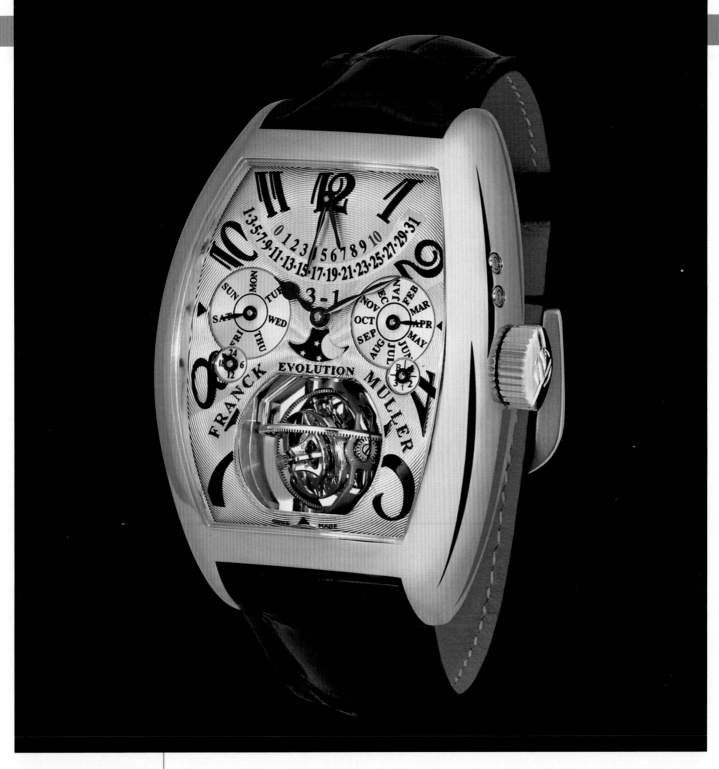

FRANCK MULLER

TOURBILLON 9850 EVOLUTION 3.1 – REF. 9850 T EV 3.1

The Tourbillon 9850 Evolution 3.1 plays a crucial step in the continuing evolution of the popular complication, with a tourbillon rotating on three axes, an extraordinary accomplishment from a renowned watchmaker. The watch also boasts a perpetual calendar that indicates the day, month and year, with an impressive retrograde display of the date. Mounted on a black alligator strap, the timepiece is available in a platinum or white-gold case.

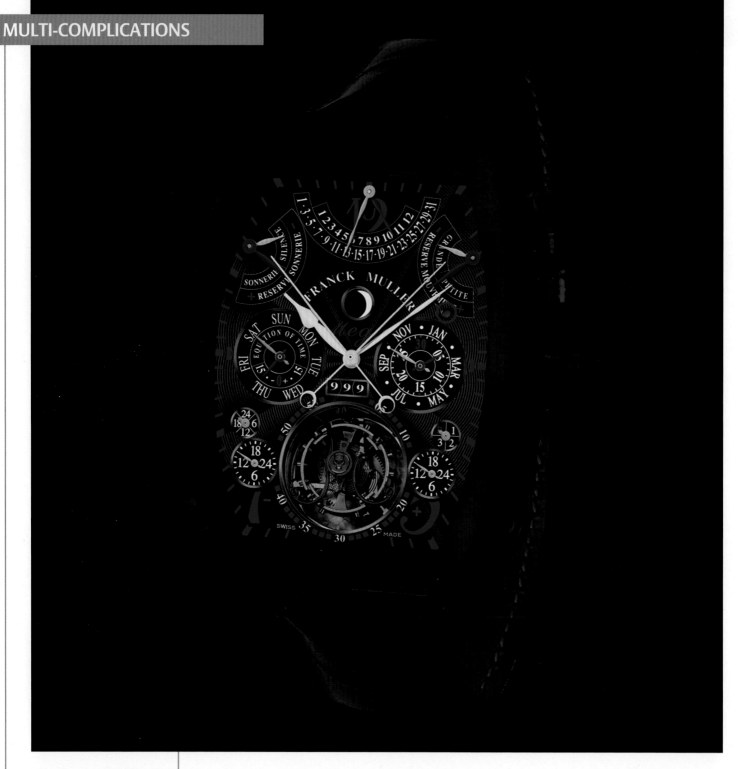

FRANCK MULLER

TOURBILLON AETERNITAS MEGA IV – REF. 8888 T QP S

The Aeternitas Mega is the pinnacle of success in the art of watchmaking in terms of complexity and complications. Each of the piece's 1,483 components was crafted to give the watch an elegant design. This extraordinary number of components was necessary for the remarkable number of complications in the watch, including: equation of time, secular calendar accurate for 999 years, minute repeater with Westminster chime, flyback chronograph and two additional time zones. The minute repeater function boasts a grand strike and small strike, offering the option of sounding the hours and quarter-hours, or only the quarter-hours.

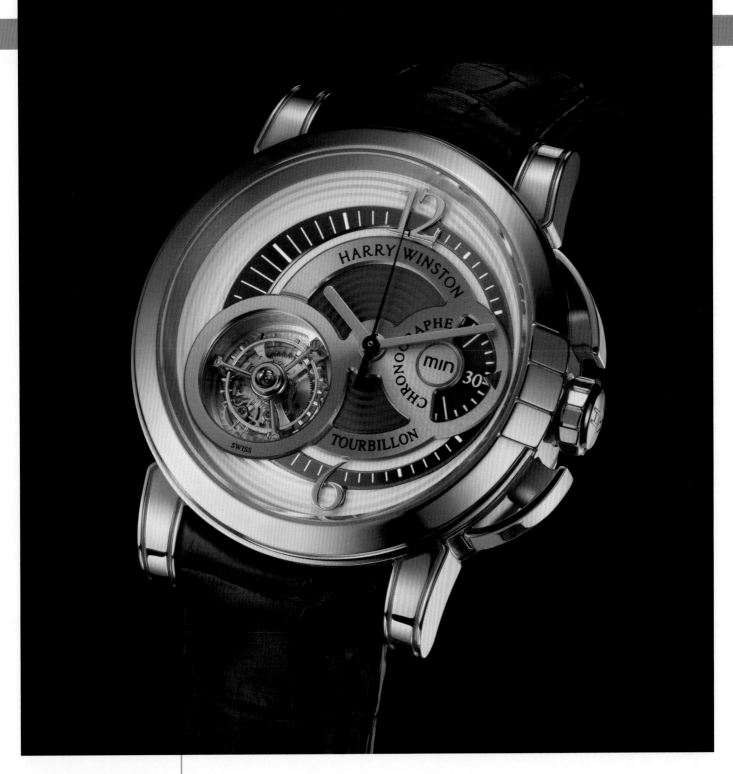

HARRY WINSTON

MIDNIGHT CHRONO TOURBILLON – REF. 450/MMTC42RL.K

Sleek and sophisticated, the Midnight Chrono Tourbillon features an open dial design that showcases the tourbillon. Not merely a functional element, but an essential design component, the mechanism is housed in a hollowed window at the bottom left corner, framed by a gold ring. The sharp transparency of the sapphire crystal tourbillon bridge provides a clear view of the mechanism. The hour and minutes are off-center, and the chronograph minutes counter and seconds hand are in blue. The 42mm red-gold case's transparent caseback displays the mechanical self-winding movement, with a 72-hour power reserve. The edition is limited to 50 pieces in rose gold and 50 pieces in white gold, and fitted with a black alligator strap.

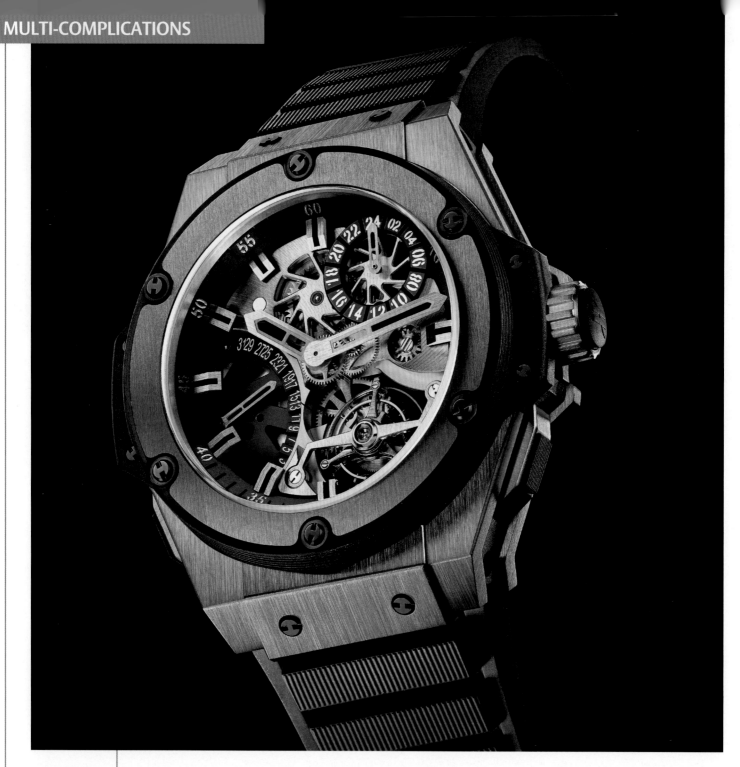

HUBLOT

KING POWER TOURBILLON GMT ZIRCONIUM – REF. 706.ZX.1170.RX

Released in a strictly limited, numbered edition of 28 pieces, Hublot's King Power Tourbillon GMT is the brand's first tourbillon watch to feature a dual time zone indicator. This two-color subdial at 2:00 displays at a glance the time in the location of the traveler's choice. At 9:00 lies yet another complication: a retrograde date display. A 48mm Zirconium King Power case houses this beauty, topped with a micro-blasted black ceramic bezel with molded black rubber, affixed with six black PVD-coated titanium H-shaped screws. The piece is powered by the HUB6121 movement, which beats at 21,600 vph and includes 278 jewels. The piece is mounted on an adjustable articulated black rubber strap.

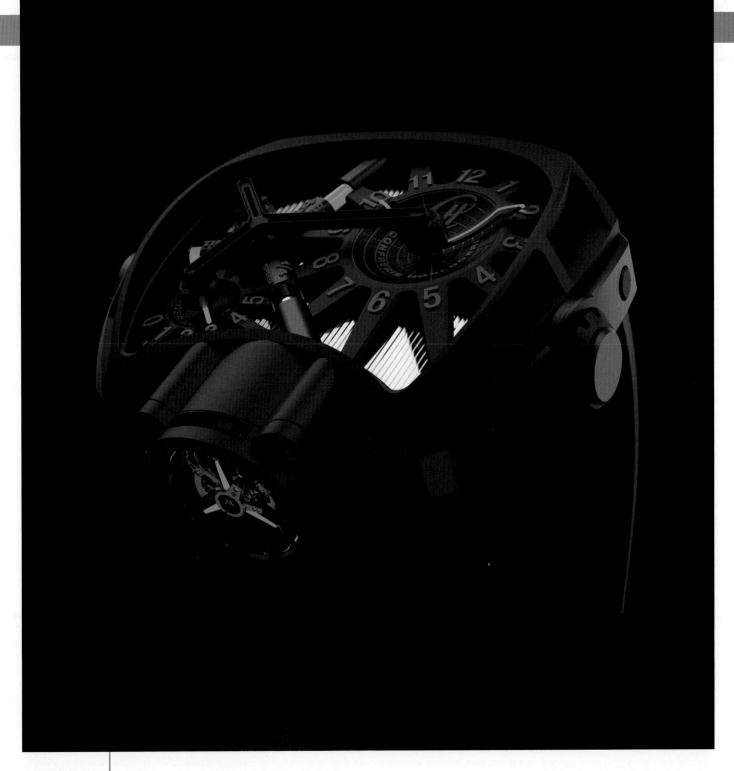

HUBLOT

LA CLE DU TEMPS – REF. MP-02

With its spectacular new "Key of Time" tourbillon, Hublot achieves what everyone the world over has long wished for: the ability to slow down time in our happiest moments, or speed it up through our more trying ones. A three-position lever at 9:00 is the key to this extraordinary complication. When the lever is in position 1, the hands slow down, making a full conventional hour seem like just 15 minutes. In position 2, then hands move at their conventional rate, and in position three, time seems to speed up, racing through a full hour on the dial when just 15 minutes have gone by. When the wearer wishes to return to "real" time, the movement's mechanical memory allows the hands to adjust automatically once the lever is returned to position 2. In addition to this exceptional complication, the Key of Time boasts a vertical flying tourbillon cage, with the added detail of a seconds indicator on its edge.

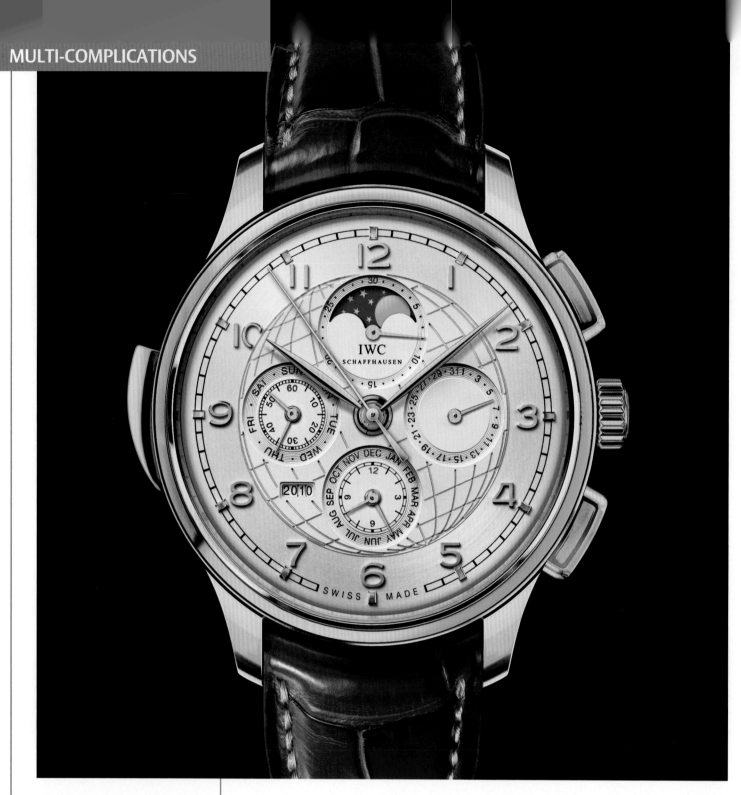

IWC SCHAFFHAUSEN

IWC PORTUGUESE GRANDE COMPLICATION – REF. IW377402

Vasco da Gama's flagship was dubbed the São Gabriel; the new flagship of the most celebrated watch family from IWC is the Portuguese Grande Complication. Only the most qualified helmsmen and navigators of their day were good enough to accompany da Gama's fleet; in much the same way, the Portuguese Grande Complication, which is water resistant to 3 bar, unites a wealth of watchmaking's most outstanding achievements in its 45mm red-gold case. These include a perpetual calendar that is mechanically programmed until 2499 (it requires just three adjustments in the non-leap years 2100, 2200 and 2300) as well as a perpetual moonphase display and chronograph. When activated by the slide, the minute repeater chimes out the time precisely in harmonious tones. A globe of the world discreetly engraved with lines of latitude and longitude provides a background to the silver-colored dial with its solid red-gold appliqués. On the caseback, an intricate engraving of a sextant is an unmistakable sign that the watch is part of IWC's Portuguese family. The strap is stitched with 18K red-gold thread.

JAEGER-LeCOULTRE

AMVOX3 TOURBILLON GMT – REF. Q193.K4.50

Born from the partnership between Aston Martin and Jaeger-LeCoultre, the AMVOX line represents perfectly the aesthetic world of these two legends of luxury. Its round ceramic case is the first ever made in this material by Jaeger-LeCoultre. It houses the hand-crafted, hand-decorated, automatic-winding Jaeger-LeCoultre Calibre 988 tourbillon movement, driving two time zone displays and a date making a larger jump between the 31st day of one month and the 1st day of the next so as not to obstruct the full view of the tourbillon mechanism. The extraordinary openworked dial reveals the ruthenium-coated bridges and baseplate, as well as the blackened central bridge of the AM/PM indicator.

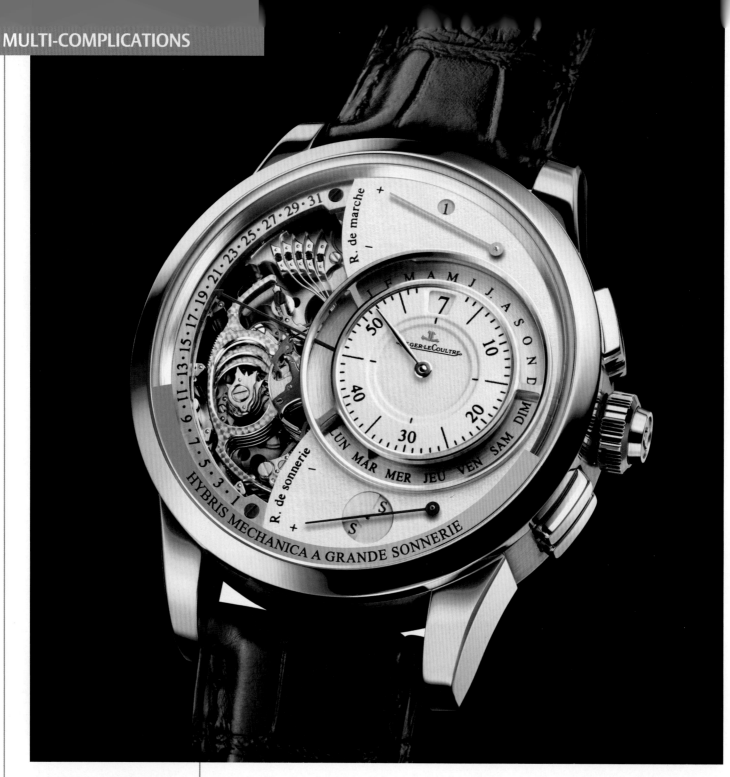

JAEGER-LeCOULTRE

HYBRIS MECHANICA 55 GRANDE SONNERIE – REF. 603.34.20

The exceptional Hybris Mechanica 55 Grande Sonnerie boasts a bevy of challenging complications: flying tourbillon, jumping hours, perpetual calendar and a minute repeater with Westminster chimes that can be activated in three striking modes: grande sonnerie, petite sonnerie and silent. The automatic-winding Jaeger-LeCoultre 182 caliber drives this complicated collection, and its two barrels provide 50 hours of autonomy. The 44mm white-gold case is water resistant to 50m.

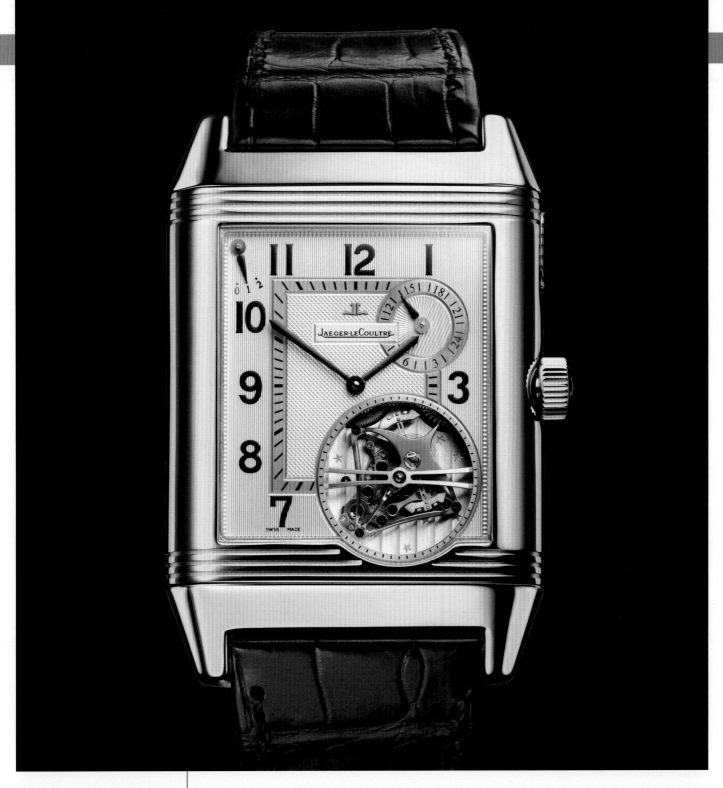

JAEGER-LeCOULTRE

HYBRIS MECHANICA REVERSO GRANDE COMPLICATION A TRIPTYQUE 1 – REF. 232.64.20

The Reverso Grande Complication à Triptyque displays three dimensions of time—civil, sidereal and perpetual time—on three faces, pushing the boundaries of watchmaking possibility. The front side displays a tourbillon, while the back features a Zodiac calendar with an astronomical chart, an equation of time and sunrise and sunset times. The watch's third face is notable for its unusual position: a perpetual calendar in the Reverso carriage. The timepiece boasts a total of 18 functions and has six patents pending. The movement that drives all these functions is the manual-winding Jaeger-LeCoultre 175, housed within a platinum 950 case that measures 37.7x55x17.9mm.

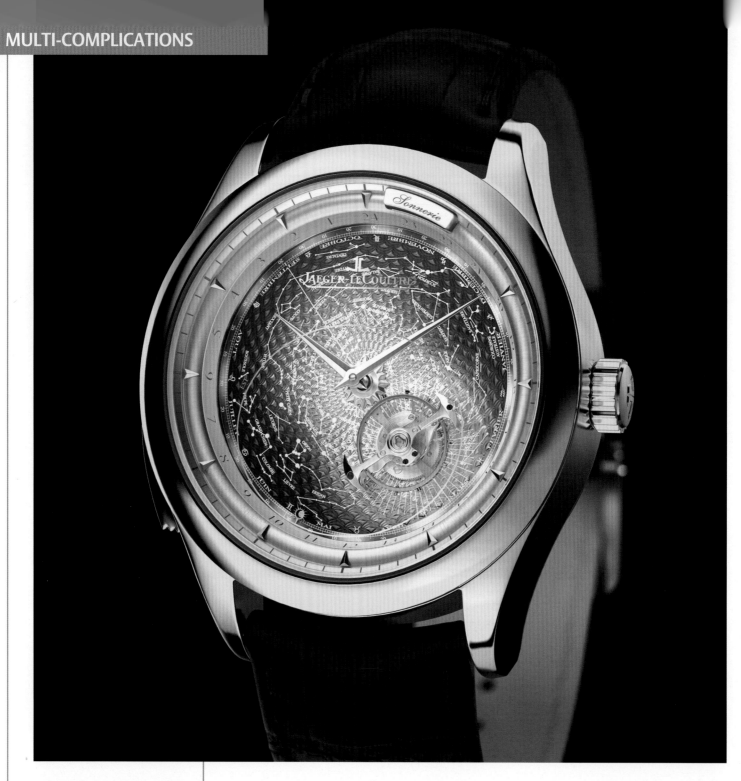

JAEGER-LeCOULTRE

MASTER GRANDE TRADITION GRANDE COMPLICATION – REF. 502.35.80

The Master Grande Tradition Grande Complication features three remarkable complications that combine refinement and elegance with the latest in technology: a minute repeater, flying tourbillon and Zodiac calendar with sidereal time. The tourbillon is exceptional in that it serves as an hour hand, indicating not solar time, but sidereal time, which is determined by the stars. The gong of the minute repeater is crafted from a special alloy and machined from a single piece, endowing it with an unusually rich sound. The Jaeger-LeCoultre 945 powers these complications, and the ensemble is housed in an 18K white-gold case.

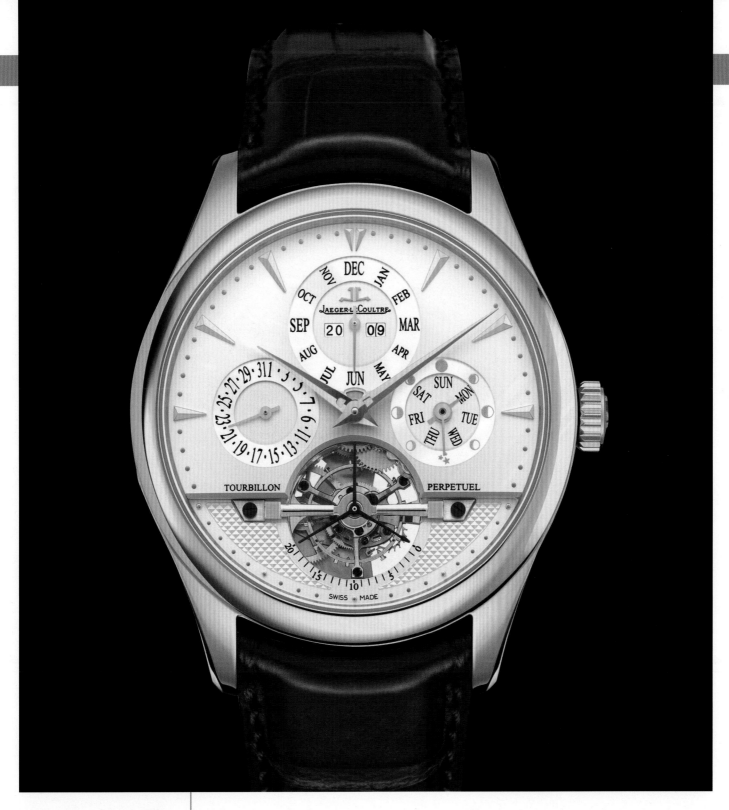

JAEGER-LeCOULTRE

MASTER GRANDE TRADITION TOURBILLON WITH PERPETUAL CALENDAR – REF. 500.24.2A

The first Jaeger-LeCoultre caliber to associate a tourbillon with a perpetual calendar comprises exactly 401 components. Its fascinatingly original conception is based on a split-level structure. The dial is divided between an upper part displaying the hours and minutes as well as the perpetual calendar indications, and a lower part on which a slight difference of level shows off the prominent tourbillon. The grade 5 titanium carriage is so light that the 78-part tourbillon escapement weighs a mere 0.28g! The perpetual calendar displays the date, day of the week and month, while automatically taking account of the length of the months and the leap-year cycle.

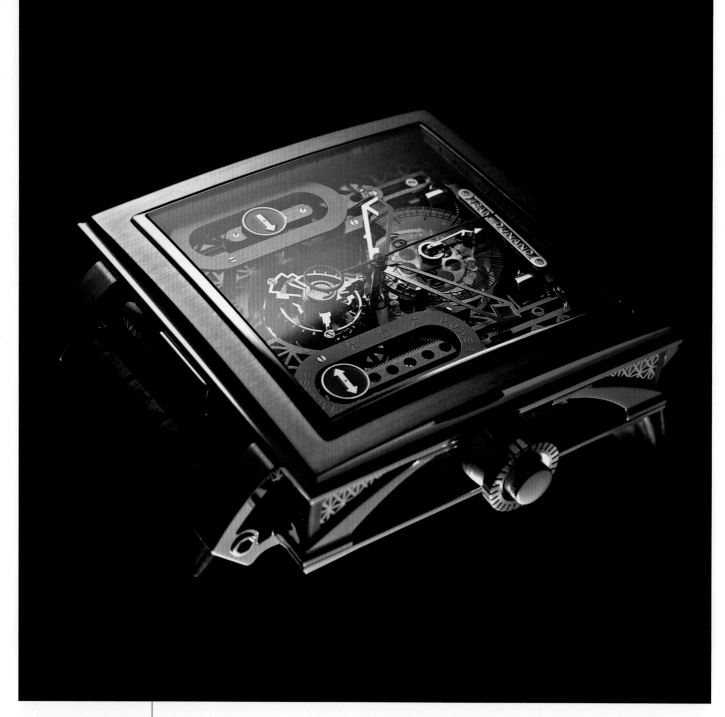

JEAN DUNAND

THE PALACE

The unique technical architecture of the Palace is integral to its aesthetics, with structures and transmissions evoking modern civilization's rich engineering heritage. A monopusher column-wheel chronograph with a rare instantaneous 60-minute counter sits at the top of the dial above a one-minute flying tourbillon. On the left, a complex spiral cam driven through a 90° conical gear controls the disc indicating the second time zone, rotating the arrow 180° at the top to use time scales on both sides of its oval track. A similar track on the right displays the 72-hour power reserve with power transmitted via a tiny chain complete with a miniature tensioner. The movement's 703 components are housed in a 48x49mm case featuring a titanium case middle and bezel, caseback and lugs, in 18K red or white gold.

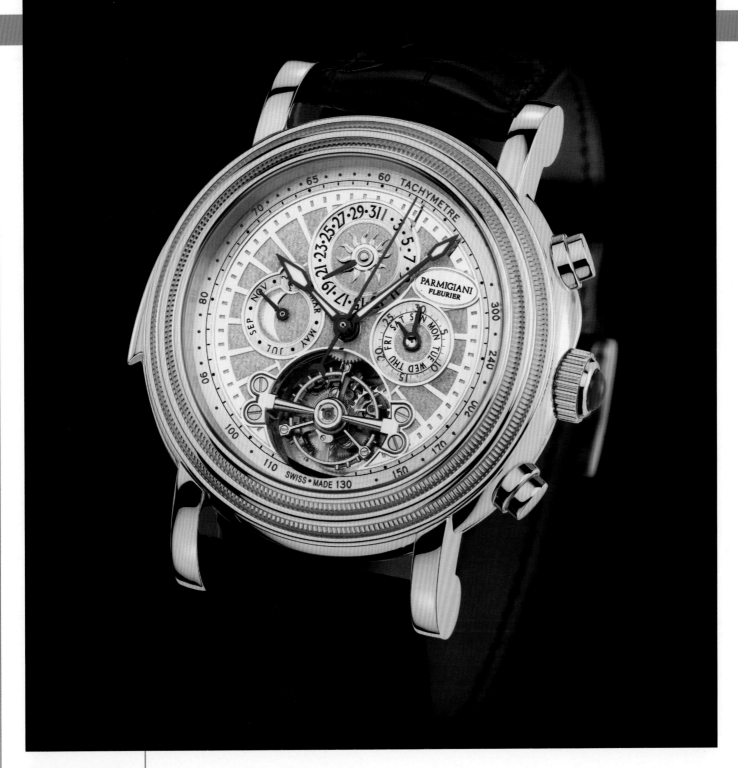

PARMIGIANI

TECNICA CHRONO – REF. PFH435-1005301

The "Mandar" theme of Parmigiani's Technica Chrono is inspired by Mandala art and the sequence of time. This timepiece not only displays hours and minutes, but also boasts a minute repeater, perpetual calendar and chronograph. The PF352.01 movement is housed in the 44mm 750 rose-gold case, which is water resistant to 30m. The 18K gold base is hand-engraved to reflect the Mandala theme. The Technica Chrono is completed by an alligator strap with an ardillon buckle engraved in 750 rose gold with translucent red enamel.

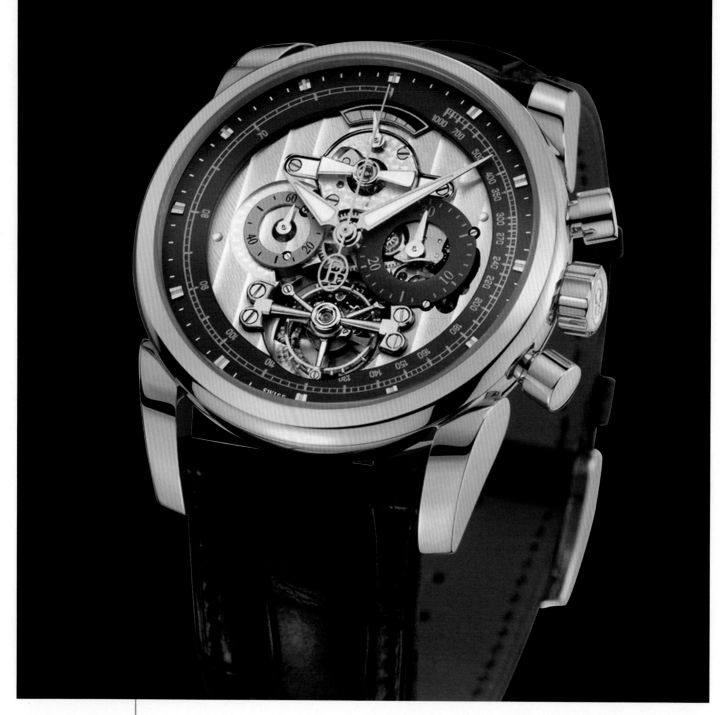

PARMIGIANI

TONDAGRAPH 43 TOURBILLON CHRONOGRAPH – REF. PFH236-1000300

Parmigiani's Tondagraph 43 Tourbillon Chronograph is powered by the PF354 movement, housed in a 43mm case in 18K rose gold. This timepiece displays hours, minutes, small seconds at 9:00, and a quarter-second chronograph with large central second hand and 30-minute counter at 3:00. Rose-gold models such as the one pictured also display a power reserve indicator at 12:00. The dial features a Côtes de Genève guilloché center, 30-minute counter, applied indexes, and delta-shaped hands with luminescent coating. The Tondagraph 43 Tourbillon Chronograph is water resistant to 30m and mounted on an Hermès alligator with folding buckle. The piece is also available in rose gold.

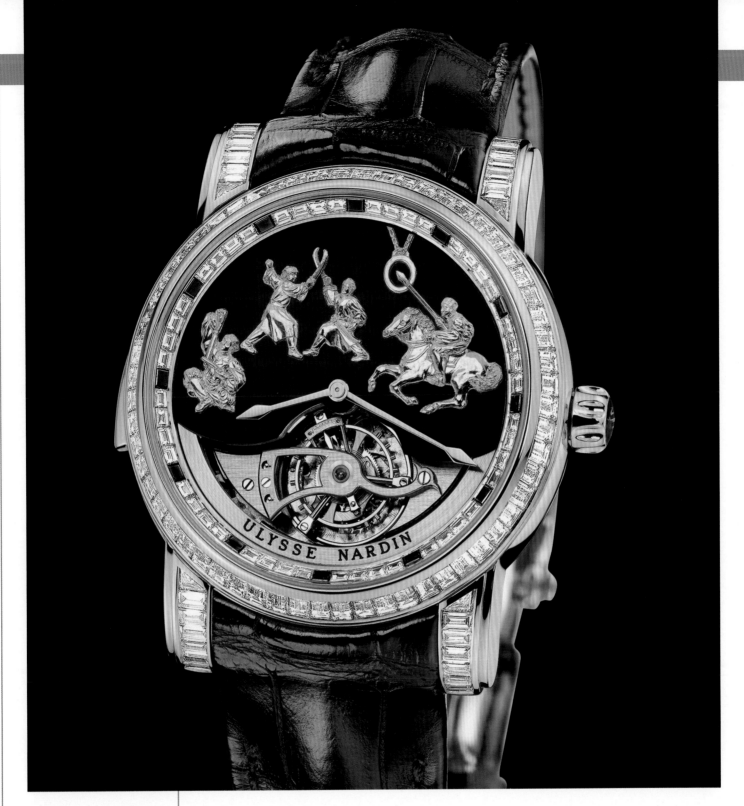

ULYSSE NARDIN

"GENGHIS KHAN HAUTE JOAILLERIE" – REF. 786-81/04

Housed in a 42mm 18K rose-gold case, the Genghis Khan Haute Joaillerie features a Westminster minute repeater carillon tourbillon, and animated Jaquemarts engaged in epic battle adorn the dial. This piece, powered by the UN-78 caliber, is also available in 18K white gold.

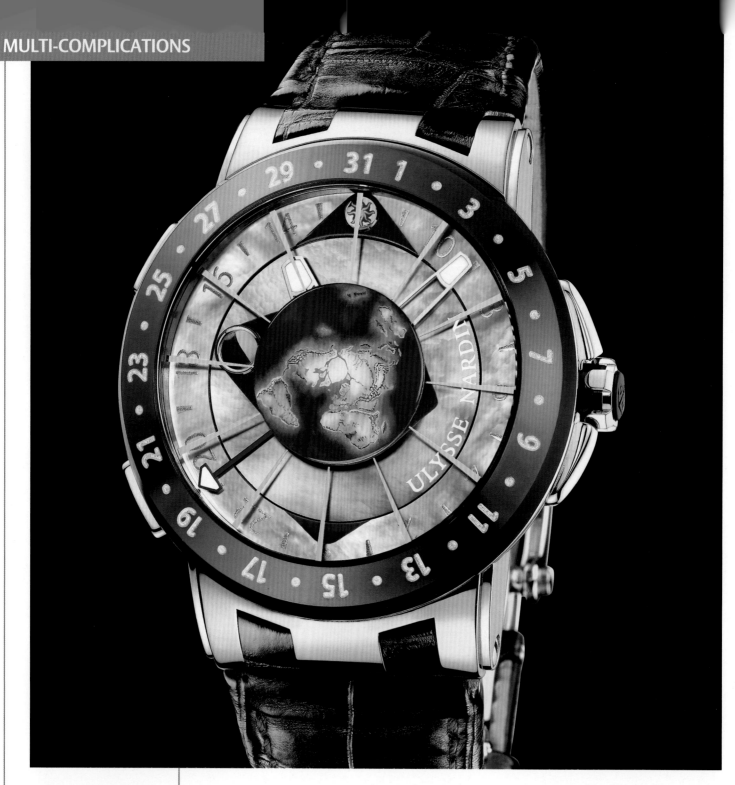

ULYSSE NARDIN

MOONSTRUCK – REF. 1069-113

Created in a limited edition of 500 pieces, the Moonstruck displays scientifically accurate moonphase and solar time and indicates the tides' flood and ebb. The piece's UN-106 caliber beats within a 46mm platinum case, adorned with a hand-painted mother-of-pearl dial and ceramic bezel. The Moonstruck is also available in rose gold.

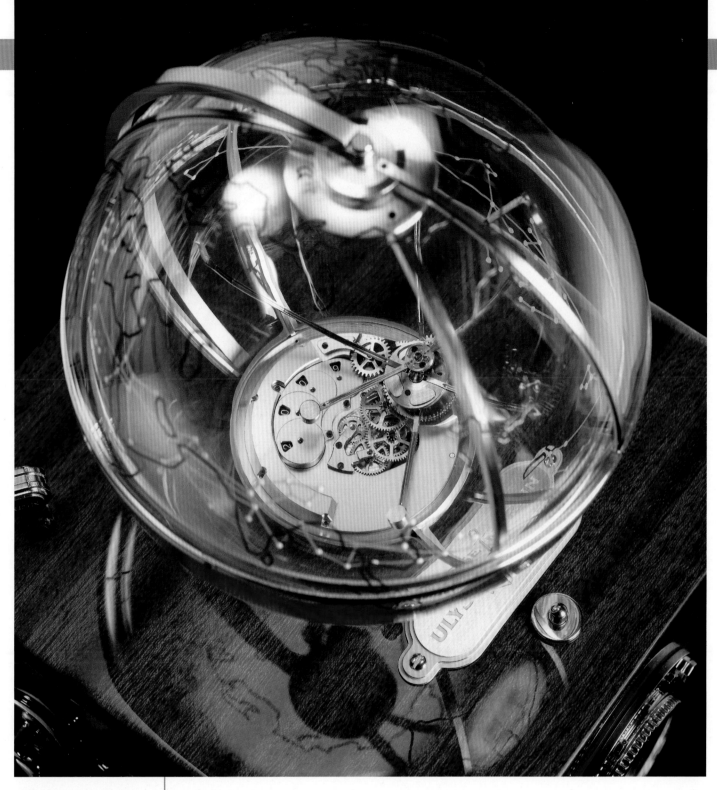

ULYSSE NARDIN

PLANET EARTH – REF. 9010-100

The cosmically complicated Planet Earth desk clock is powered by the UN-901 caliber and available in a limited edition of 99 pieces. With a spherical presentation of the Earth in the universe, this astronomical desk clock exhibits the exact position of the sun and moon at each moment of the day. Stars are situated in relation to any location on planet Earth.

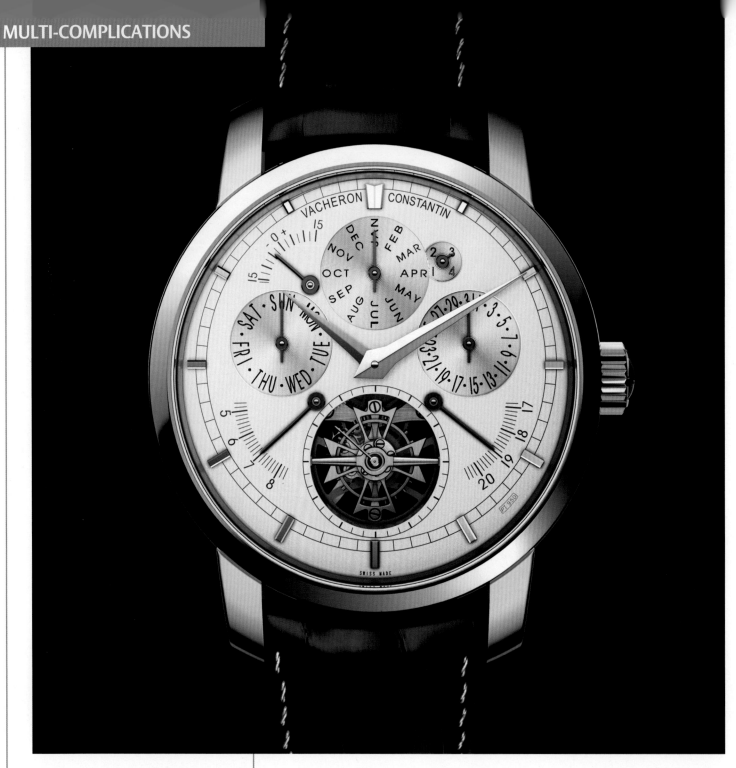

VACHERON CONSTANTIN

PATRIMONY TRADITIONNELLE CALIBRE 2253 – REF. 88172

Vacheron Constantin presents the Patrimony Traditionnelle Caliber 2253 watch in the Collection Excellence Platine. This model features a major astronomical complication in terms of technical application. Entirely constructed by Vacheron Constantin's engineering department and developed over thousands of hours, the new Caliber 2253 provides information derived from Earth's orbit around the sun, notably a perpetual calendar, the equation of time, and the times of sunrise and sunset. It has a tourbillon escapement as well. Such is the complexity and level of finish of this horological masterpiece, that it comprises no fewer than 457 parts in a movement only 9.6mm thick. Production is limited to just ten pieces.

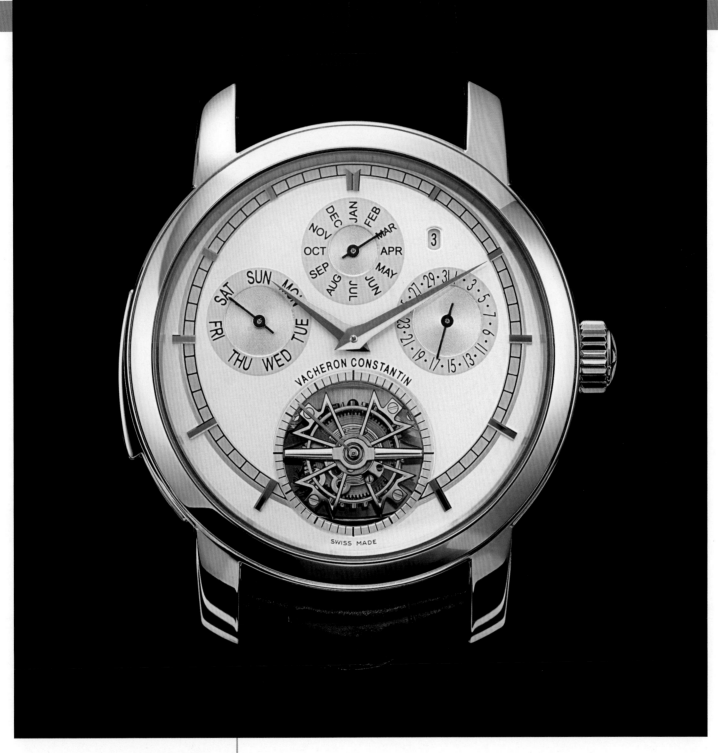

VACHERON CONSTANTIN

PATRIMONY TRADITIONNELLE CALIBRE 2755 – REF. 80172

The Patrimony Traditionnelle Calibre 2755 belongs in the multi-complication category as a worthy heir of Vacheron Constantin's 250th anniversary masterpiece, the Tour de l'Ile, and as the ultimate demonstration of its unequalled skills. This incomparable timepiece harbors three of the most sophisticated complications in the universe of high-class watchmaking: the tourbillon, the perpetual calendar and the minute repeater. The Calibre 2755 beats at a frequency of 18,000 vph and has a power reserve of approximately 55 hours. This watch is housed in a 44mm platinum case, giving the minute repeater chime a remarkable resonance.

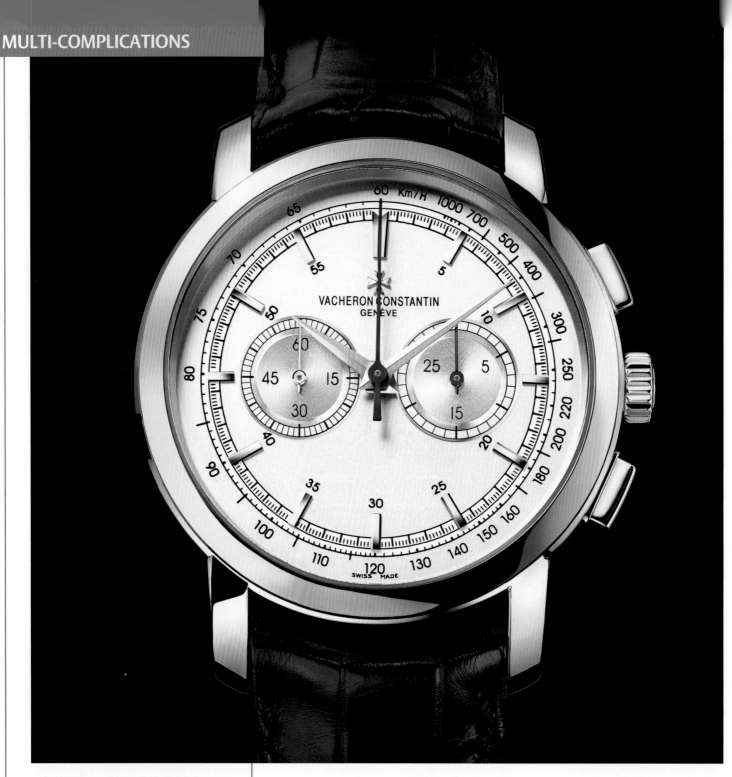

VACHERON CONSTANTIN

PATRIMONY TRADITIONNELLE CHRONOGRAPH – REF. 47192

In the highest tradition of the best chronographs, the Patrimony Traditionnelle Chronograph is fitted with the acclaimed 1141 caliber, which features a column wheel. Another distinguishing feature of this new Vacheron Constantin chronograph is its silvered opaline dial with two counters characteristic of the 1940s, the chronograph's golden age. The 30-minute chronograph counter at 3:00 and the small seconds at 9:00 give the dial perfect balance. The manufacture's designers have taken full advantage of the case's impressive 42mm diameter to guarantee optimum legibility of all the indications, including the tachometer scale on the dial rim. The 18K white-gold case has been tested for water resistance to a pressure of 3 bar, the equivalent of 30m. Like the other models in this line, it has a sapphire crystal caseback, through which one can admire the unique and characteristic geometry of the manual-winding 1141 chronograph movement and its exemplary finishing. The 1141 also has a 48-hour power reserve.

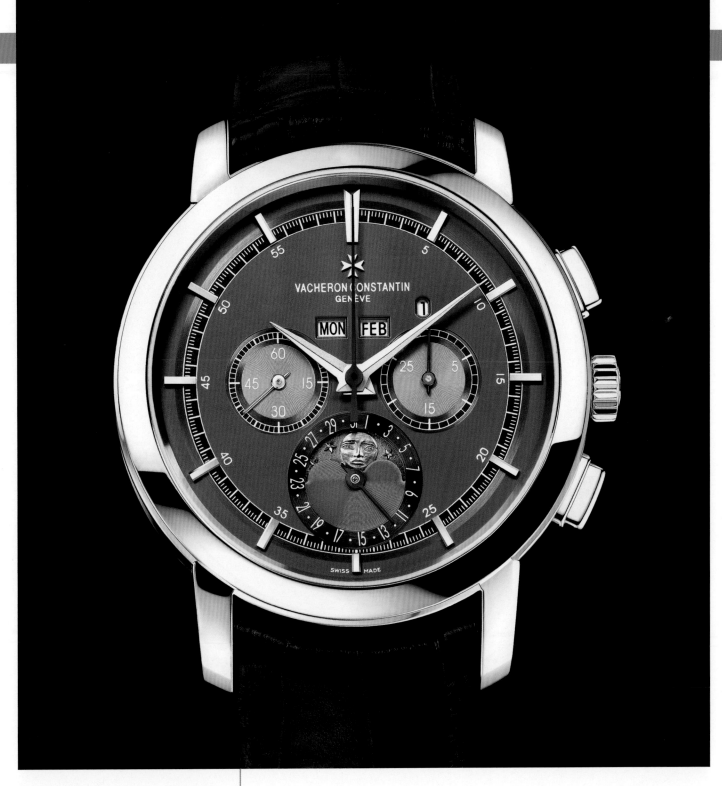

VACHERON CONSTANTIN

PATRIMONY TRADITIONNELLE CHRONOGRAPH PERPETUAL CALENDAR – REF. 47292

The Patrimony Traditionnelle Chronograph Perpetual Calendar Calibre 1141QP embodies the Vacheron Constantin convention in styling. It brings together a chronograph and a perpetual calendar driven by a highly regarded hand-wound movement. The Calibre 1141 is an exceptional design that has been used in some of the best chronographs. Experts consider it a model of highly complex chronograph construction.

VACHERON CONSTANTIN

QUAI DE L'ILE DATE SELF-WINDING – REF. 86050

Named for the brand's historic Geneva address, the new Quai de l'Ile line reveals the manufacture's pioneering character while drawing on more than 250 years of experience. The Quai de l'Ile Date Self-Winding makes an immediate impact with a semi-transparent dial, suspended displays, an appealing modern case, and an intriguing combination of materials. With a dial embodying the very latest security-printing technologies and a cushion-shaped case, the designers opted for a theme of transparency and avant-garde design. Visible through the dial, the movement is stamped with the prestigious Geneva Hallmark designed, developed and manufactured in-house. The rhodium-plated Caliber 2460QH displays the date via a disc and is housed in a 41mm 18K pink-gold case with gray dial. Also available in palladium with gray dial and rhodium-plated movement, and in titanium with dark dial and ruthenium movement, it is delivered with two straps: one in black or dark brown hand-stitched, saddle-finish, large square-scaled alligator leather; one in dark brown or black vulcanized rubber with a refined and elegant design.

VACHERON CONSTANTIN

QUAI DE L'ILE DAY-DATE AND POWER RESERVE SELF-WINDING – REF. 85050

The new Quai de l'Ile Day-Date and Power Reserve Self-Winding's fascinating semi-transparent dial embodies the latest security-printing technologies. Visible through the dial, the movement is stamped with the prestigious Geneva Hallmark designed, developed and manufactured in-house. Caliber 2475SC/1 displays the date, day of the week and power reserve via hands. Shown in a 41mm palladium case with gray dial and rhodium-plated movement, this watch is also available in 18K pink gold with gray dial and rhodium-plated movement, and in titanium with dark dial and ruthenium movement. There are two straps: one in black or dark brown hand-stitched, saddle-finish, large square-scaled alligator leather; one in dark brown or black vulcanized rubber. The brand has developed a personalization concept that is totally new in haute horlogerie: thanks to the Quai de l'Ile case's remarkable seven-piece middle, it is possible to choose from three metals, two dials and two different finishes on the movements to personalize the dream watch.

Tourbillons

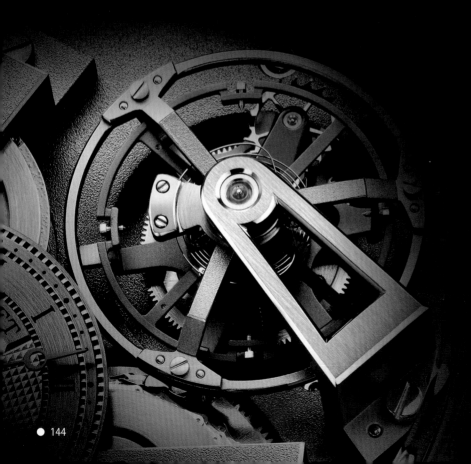

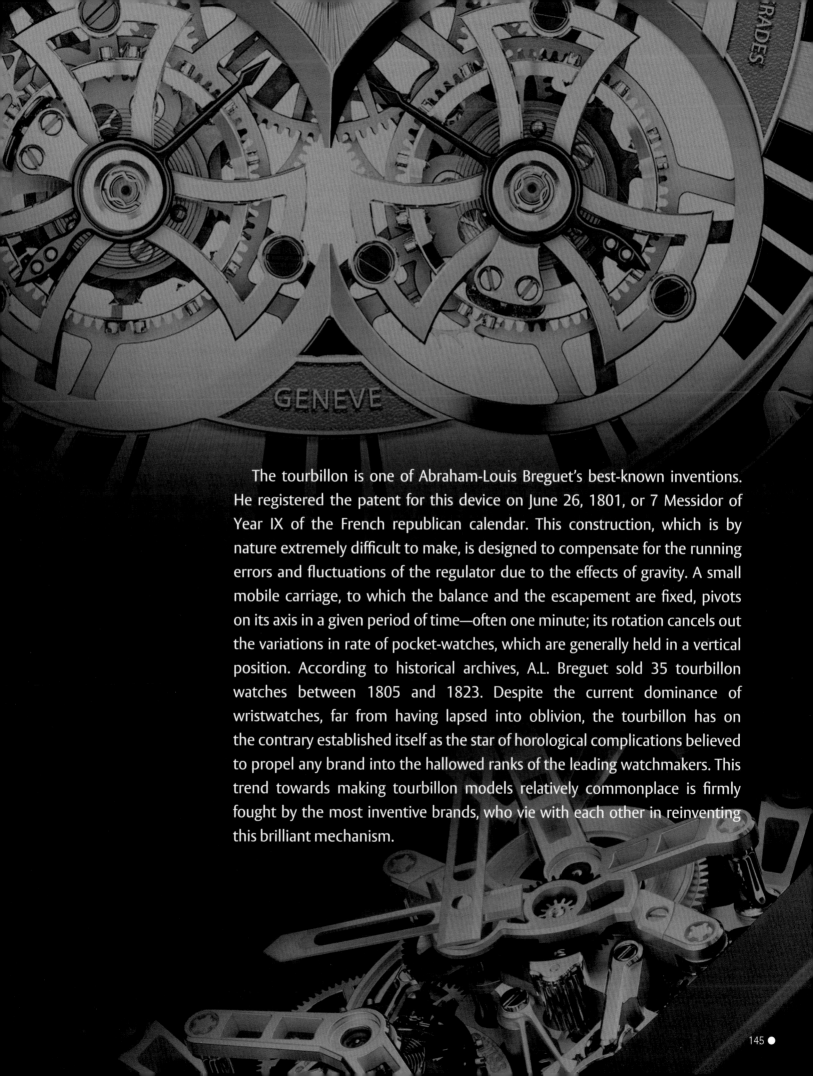

The tourbillon is one of Abraham-Louis Breguet's best-known inventions. He registered the patent for this device on June 26, 1801, or 7 Messidor of Year IX of the French republican calendar. This construction, which is by nature extremely difficult to make, is designed to compensate for the running errors and fluctuations of the regulator due to the effects of gravity. A small mobile carriage, to which the balance and the escapement are fixed, pivots on its axis in a given period of time—often one minute; its rotation cancels out the variations in rate of pocket-watches, which are generally held in a vertical position. According to historical archives, A.L. Breguet sold 35 tourbillon watches between 1805 and 1823. Despite the current dominance of wristwatches, far from having lapsed into oblivion, the tourbillon has on the contrary established itself as the star of horological complications believed to propel any brand into the hallowed ranks of the leading watchmakers. This trend towards making tourbillon models relatively commonplace is firmly fought by the most inventive brands, who vie with each other in reinventing this brilliant mechanism.

Richard Mille

*President and CEO
of Richard Mille*

"Haute horology must open up to the world!"

An exhibitor for the second year running at the Salon International de la Haute Horlogerie held in Geneva at the end of January, Richard Mille has lost nothing of his witty eloquence.

Richard Mille caused a sensation in 2010 by having Rafael Nadal play with a customized watch. He is planning to do the same with Bubba Watson, the larger-than-life golf player who has never taken a golf lesson and yet is definitely the rising star on the circuit. After Felipe Massa and Rafael Nadal, Richard Mille has thus found his new crash tester—a way of living dangerously while nonetheless putting across the message that haute horology is not pompous!

How did the year 2010 end for you?
Better than 2009, which was better than 2008, which was better than 2007...

So you didn't go through a crisis?
No. I had to face certain delivery problems, but that makes sense. I launch many new models each year. When I create a model, I discuss it with my partners, either Audemars Piguet (Renaud & Papi) or Vaucher manufacture. But I don't wait for green lights on all the parameters before getting started. The development phase then follows its course and producing the movements can be a very long process. Ensuring a reliable product also takes time.

And does that cause problems?
It can be difficult in terms of references, such as when the RM 025 came out before the RM 017, or for the RM 018 "Hommage à Boucheron," which should have been delivered two years ago and has only just emerged from our workshops. If the problem occurs on several references, that necessarily influences sales which become more uncertain.

How many watches did you sell last year?
Around 2,500.

The same as in 2009...
Yes, but the average price of my watches has increased, and, notably, turnover has as well. The Richard Mille brand has grown constantly since its launch in 2001.

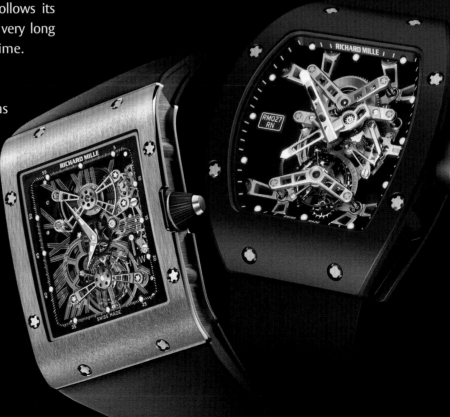

RIGHT
The RM 017 Extra Flat Tourbillon boasts a total thickness of just 8.7mm and an extra-flat manual-winding movement in titanium.

FAR RIGHT
The RM 027 was originally created for Rafael Nadal and weighs under 20 grams.

How many watches do you want to sell in the future?

I'm not obsessed by sales volume. In 2011, I hope to reach around 2,800, and in due course 4,000 to 5,000 per year. These figures correspond to the realities of the market and to industrial reliability. If we did produce more, I would have to enter into the commercial aspects of the business, and I'm not at all interested in doing that. I am currently working within a system that enables me to create what I want to and to work, in a way, according to my "whims"—which is something you can do when you're dealing with small quantities.

How do you intervene in the creative process?

At full throttle! It's a matter of teamwork, with a long and difficult process of development. Before everything else, it begins with the concept, which is a major element for me. It then becomes a set of technical specifications, with the sketch serving as a blueprint. The Nadal is a perfect example of this process.

Why did you create the world's lightest watch for him, weighing less than 20 grams including the strap?

Because to begin with, he didn't want to wear a watch during matches, and for me, that was an essential prerequisite for working with him. So in order to persuade him, I told him I would make a watch especially for him.

And was he easily convinced?

The day I went to see him in Palma with the prototype, I had in my pocket an RM 012 in platinum, which had just been repaired. It must have weighed at least 300 grams. Rafael was very impatient, because he loves watches. I took out the RM 012 and I explained that this watch was the result of a huge effort in terms of its weight. He put it on his wrist and moved around with it for a few minutes, and then said: "But Ricardo, I'll never be able to play with that!" As he was recovering from an injury, I told him he was underestimating himself, that his muscles had melted away and that he simply wasn't in top form.

So did you end up giving him the actual watch?

Of course! He immediately took a racket to hit a few balls with the RM 027. It is so light that in the beginning, when he wiped his forehead with his wristband, he hurt himself because he forgot he was wearing a watch. Today, the RM 027 is like a second skin for him, and the "graft" has taken beyond my wildest expectations.

You've managed to find a gem of an ambassador...

I don't like the term "ambassador." What I want is to have my products worn in real-life conditions. If it's a sports watch, it must be able to play sports! Rafael Nadal is above all a crash tester. He broke five RM 027 watches before we achieved a perfect result. The same goes for Felipe Massa: he is the only Formula 1 racing driver to wear a watch during Grand Prix races, and it's obviously not so that he can read the time on it! On the other hand, we obtain a lot of information from our athletic partners, which helps us to constantly improve our products, and that is where communication is key.

Are you planning to work with other sports personalities in this way?

Yes, one of our new releases for 2011 is the RM 038 Tourbillon Bubba Watson. 32-year-old Bubba Watson is currently establishing himself as one of the best golfers of his generation. He is a self-taught player and has never taken a single lesson. At 191 cm tall and 82 kg on the scales, he has one of the most impressive physiques on the circuit. He also has one of the most powerful drives, and since 2006, he has been the player who hits the furthest on the US PGA tour.

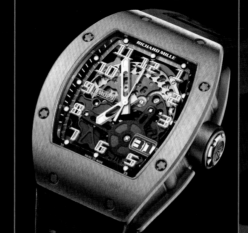
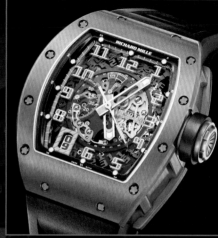

To promote your watches, you have also created billboard advertising campaigns, and there too, you are keeping off the beaten track. For the RM 016, a visual shows an ultra-sexy lady holding a monkey wrench; and for the RM 020 pocket-watch, a woman's hand grabs the object from the jeans of a bare-chested hunk. Aren't you afraid of shocking people?

People love it! Of course I have been censured in certain countries such as the United States or in the Middle East. But that's not a problem, because I'm not looking to create a disturbance. I just don't want haute horology to become a ghetto; I want it to open up to the world.

And what do you see as the solution to avoid this?

Watchmaking must look to art, architecture, sports, lifestyle... With the RM 020, I started off with a more traditional approach, with a majestic view of a watch. Then I realized that even though it was extremely technically advanced, this pocket-watch was very much a lifestyle object. So I decided to do something completely different with a pair of unbuttoned jeans and a woman's hands. I don't make watches to be kept in safes; they are designed to be worn—and that's exactly what the ad conveys!

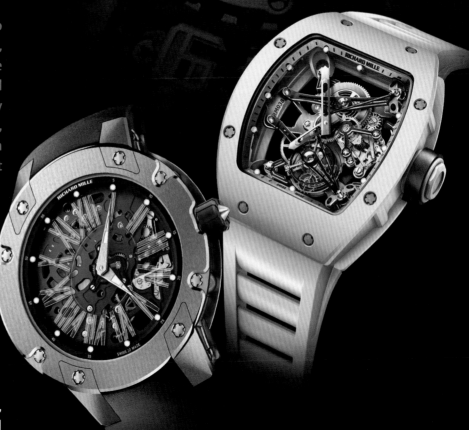

TOP LEFT
The RM 029 oversize date automatic is housed in a 48x39.7mm case that is crafted in 18-karat red gold, 18-karat white gold or titanium.

TOP RIGHT
The RMAR1 movement, which beats inside the RM 030 automatic with declutchable rotor, boasts a novel system that prevents over-winding of the movement.

ABOVE LEFT
The round case design of the RM 033 Ultra Flat automatic measures 45.7mm in diameter and is just 6.3mm thick, with the curving caseback and spline case screws that are characteristic of Richard Mille watches.

ABOVE RIGHT
The skeletonized, manual-winding tourbillon RM 038 'Bubba Watson' is the fruit of another collaborative partnership between Richard Mille and the world of athletics.

Jean-Claude Biver
CEO of Hublot

"The Confrérie Horlogère and Hublot have merged"

Emerging from the high-end movement company BNB Concept that had filed for bankruptcy, the Confrérie Horlogère was supposed to become an independent entity, property of Hublot. Since December 1, 2010, however, it has become an integral part of the manufacture. This merger is even more welcome in that it was requested by the staff of the Confrérie itself. Thus prepared for action, the brand hopes to sell in 2011 even more watches than the 22,000 of last year, itself an historic record.

He is everywhere: Paris, Miami, Beijing. In all fields of combat: haute horology, in-house movements. On all fronts: soccer, Formula 1, sports. All things considered, it is not surprising that Jean-Claude Biver turned 2010 into Hublot's best year ever. And 2011, despite some small clouds such as the indebtedness of Europe, also looks set to be a brilliant year. At the forefront of the projects undertaken by this energetic leader are the development of the Chinese market and an impressive upsurge in the United States.

What new releases will you surprise us with in 2011?
To be honest, I don't even know about all of them! (Laughs.) There will be a few exceptional pieces, such as the Tourbillon Minute Repeater Chronograph model. It is the logical continuation to the Minute Repeater Tourbillon that we presented last year. The base movement is the same, with a chronograph added.

Is this a creation of the Confrérie Horlogère?
Absolutely!

The Confrérie Horlogère started as part of the former BNB Concept, which no longer exists. You said in February 2010 that you wanted to create a subsidiary...
Yes, that was my intention in the beginning. The Confrérie Horlogère originally moved into the space that Chaumet was supposed to take over, in our manufacture in Nyon. I had intended to give Mathias Buttet, the former president of BNB Concept, a separate haute horology project. But today, the 29-person team has been completely integrated into the rest of the manufacture—we've fused together! The Confrérie designers work with the Hublot designers, they use the same machines, etc.

And this integration is going well?
It's going wonderfully, all the more so because the request came from the Confrérie Horlogère itself! Mathias Buttet, who came in as the leader of the Confrérie, is now in charge of the T0 (editor's note: the pre-mounting, i.e. the placement of the arbors, pins, jewels and the mounting for the components) for all of our complicated and Unico movements.

When did this happen?
All of this is very recent—it started on December 1, 2010.

How many haute horology movements did the Confrérie produce in 2010?
Around 170: 150 tourbillons and around 20 minute repeater tourbillons, at an average price of 180,000 Swiss francs ($188,000 in US dollars) per watch.

And how many watches did Hublot produce in 2010?
22,000 watches, for sales of almost 300 million Swiss francs ($314 million): it's a record in our history! November 2010 was the best November that Hublot has ever had, and it was the fifteenth month in a row to set a monthly record. It's phenomenal!

You recently opened a boutique on Place Vendôme in Paris, followed shortly afterward by Beijing, and then Miami in September 2010. Does your success stem from your distribution strategy of having own-name boutiques?

The boutiques you just mentioned opened later in the year, so they didn't have a great impact on sales in 2010. But I hope they will in 2011!

You also revisited the idea of the single-brand temporary boutique this winter in Verbier, the famous ski resort...

Yes, this is the second year we're doing it, in partnership with a retailer. It's very appealing in terms of sales, and it's a concept that we will certainly expand to other ski resorts, and maybe even beach resorts, such as Porto Cervo in Sardinia, Italy. It's an idyllic spot, and one for which we have already released specially designed models!

Will the Hublot boutiques, permanent or temporary, open up to other brands?

There are currently 33 single-brand Hublot boutiques throughout the world, of which only three belong to us: Paris, Beijing and Shanghai. The others were opened either in partnership with local retailers, or as franchises. We are also involved in about 480 multi-brand points of sale, so as you can see, we're not abandoning them.

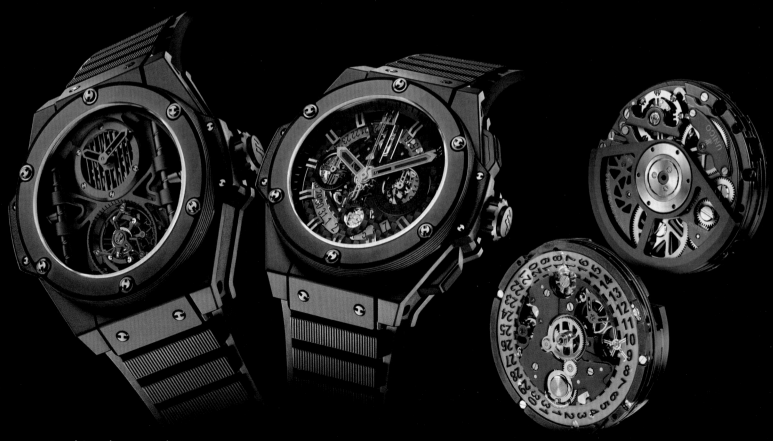

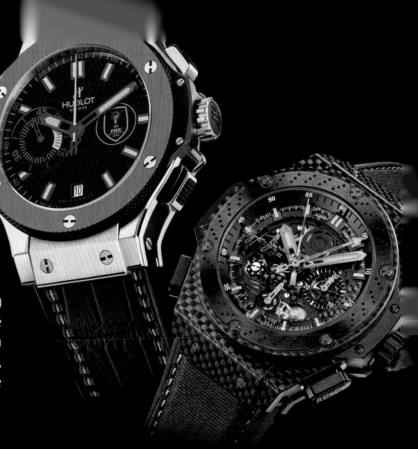

But you've announced the opening of 15 more boutiques in China over the next three years…

It is true that we are focusing on developing our Chinese market. We're nearly the last brand to do so! With just four retailers in China, we have not yet established a major presence over there!

Are you behind?

Well, we can't forget that Hublot launched our first Big Bang in June 2005—not so long ago! That year, we had 30 million Swiss francs ($31.4 million) in sales and 2 million ($2.09 million) in losses. You can't conquer the whole planet in five years, especially when you are self-financed. You have to go step by step: we built a manufacture, acquired a part of BNB Concept, and now we are developing the Chinese market.

Is there a lot of potential for Hublot in China?

Some brands make 30 or 40 percent of their sales in China. In 2010, China was responsible for 0.89 percent of Hublot's sales, so the potential for growth is phenomenal! Certain brands envy us for that.

Are there other markets that will capture your attention in 2011?

Brazil is a very important country, and we're also focusing on the United States.

From the outside, it seems like nothing has changed since Hublot was acquired by LVMH…

As of April 2011, Hublot has belonged to LVMH for three years. And it's not just your imagination—nothing has changed! That was in the purchase plan: we kept the same strategy and the same direction. And my bosses in Paris are very happy with it.

Do you have any dreams for Hublot?

I want to put into place a team that will conquer the future, and that is not easy to do. As I will not be around indefinitely, I want to make sure that my business is not orphaned. We're on the

Carlos Rosillo
CEO of Bell & Ross

When Bell & Ross began making precision time-keeping instruments for professional users in the early 1990s, it started with a round watch inspired by 1940s aviators.

As the company's collection grew through the years, so did its following of enthusiasts who identified with the watch's core values of impeccable legibility and reliability.

In 2005, the brand introduced its first square case with the Aviation collection. The angled design struck a nerve with collectors that further fueled Bell & Ross's popularity. For several years, the square case took center stage as it evolved to include different materials and functions.

Last year, the company circled back to its round roots with the newly redesigned Vintage collection.

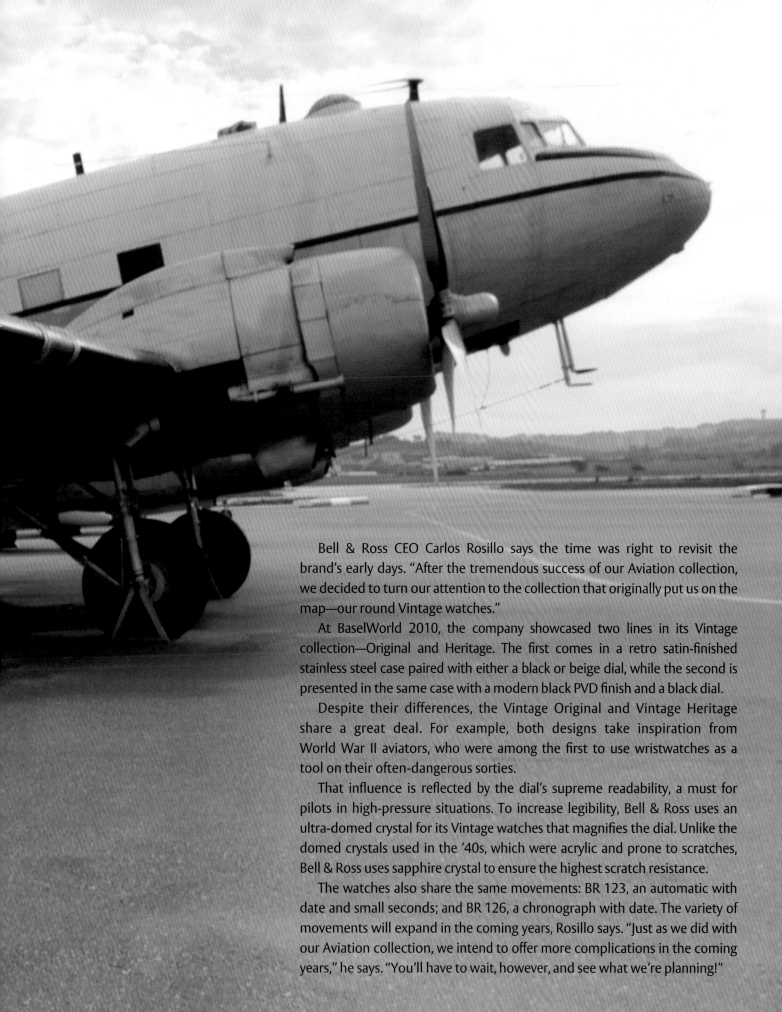

Bell & Ross CEO Carlos Rosillo says the time was right to revisit the brand's early days. "After the tremendous success of our Aviation collection, we decided to turn our attention to the collection that originally put us on the map—our round Vintage watches."

At BaselWorld 2010, the company showcased two lines in its Vintage collection—Original and Heritage. The first comes in a retro satin-finished stainless steel case paired with either a black or beige dial, while the second is presented in the same case with a modern black PVD finish and a black dial.

Despite their differences, the Vintage Original and Vintage Heritage share a great deal. For example, both designs take inspiration from World War II aviators, who were among the first to use wristwatches as a tool on their often-dangerous sorties.

That influence is reflected by the dial's supreme readability, a must for pilots in high-pressure situations. To increase legibility, Bell & Ross uses an ultra-domed crystal for its Vintage watches that magnifies the dial. Unlike the domed crystals used in the '40s, which were acrylic and prone to scratches, Bell & Ross uses sapphire crystal to ensure the highest scratch resistance.

The watches also share the same movements: BR 123, an automatic with date and small seconds; and BR 126, a chronograph with date. The variety of movements will expand in the coming years, Rosillo says. "Just as we did with our Aviation collection, we intend to offer more complications in the coming years," he says. "You'll have to wait, however, and see what we're planning!"

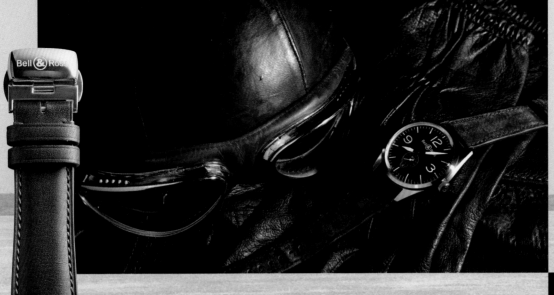

Despite the new design, the latest generation of Vintage watches maintains a strong connection to earlier models. "Both featured automatic mechanical movements and models that include a two-counter chronograph and date," Rosillo explains. "We also used similar dial colors such as beige and black and satin-finish stainless steel cases."

The major difference, Rosillo says, is case size. "When designing the collection, we did considerable research and discovered that the ideal size for a round case was a 41mm diameter. This represents a break from earlier round models, which ranged from 37.5mm to 42.5mm."

The updated look, Rosillo continues, does not come at the expense of the brand's core values. "Square or round, we design our watches with the professional user in mind and always incorporate our four design principles—legibility, functionality, precision and water resistance—into every watch."

This rebirth of the Vintage collection provided Bell & Ross with an opportunity to create a unified aesthetic code that connected the Vintage and the Aviation collections.

"When we designed the Vintage Collection, one of our top priorities was to link it to our Aviation Collection," Rosillo explains. "As a result, the numerals and indexes of the Vintage watches are identical to those of the square watches in the Aviation Collection. Our goal was to tie in all of our collections and make a Bell & Ross watch instantly recognizable to collectors no matter what the shape of the case."

His response brings up an interesting point. Because Bell & Ross has enjoyed such tremendous success with its square models, was Rosillo concerned the iconic Aviation collection would overshadow the other watches in its collection?

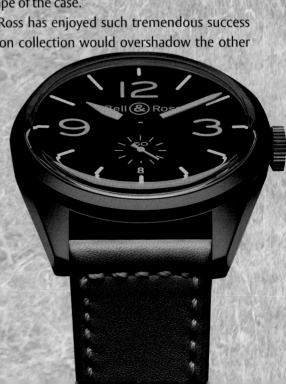

LEFT
In a nod to the aviators who inspired its design, the Vintage Original's 41mm stainless steel case has a satin finish to prevent light from reflecting off the case and distracting the pilot.

TOP
The Vintage Original's black dial provides a high degree of readability thanks to the photoluminescent coating on the numerals, indexes and hands.

ABOVE RIGHT
This Vintage Original is equipped with BR 126, an automatic movement that includes a chronograph and date function.

RIGHT
Similar to pilot's watches from the 1940s, all the Vintage models use an ultra-domed sapphire crystal to magnify the dial and increase legibility.

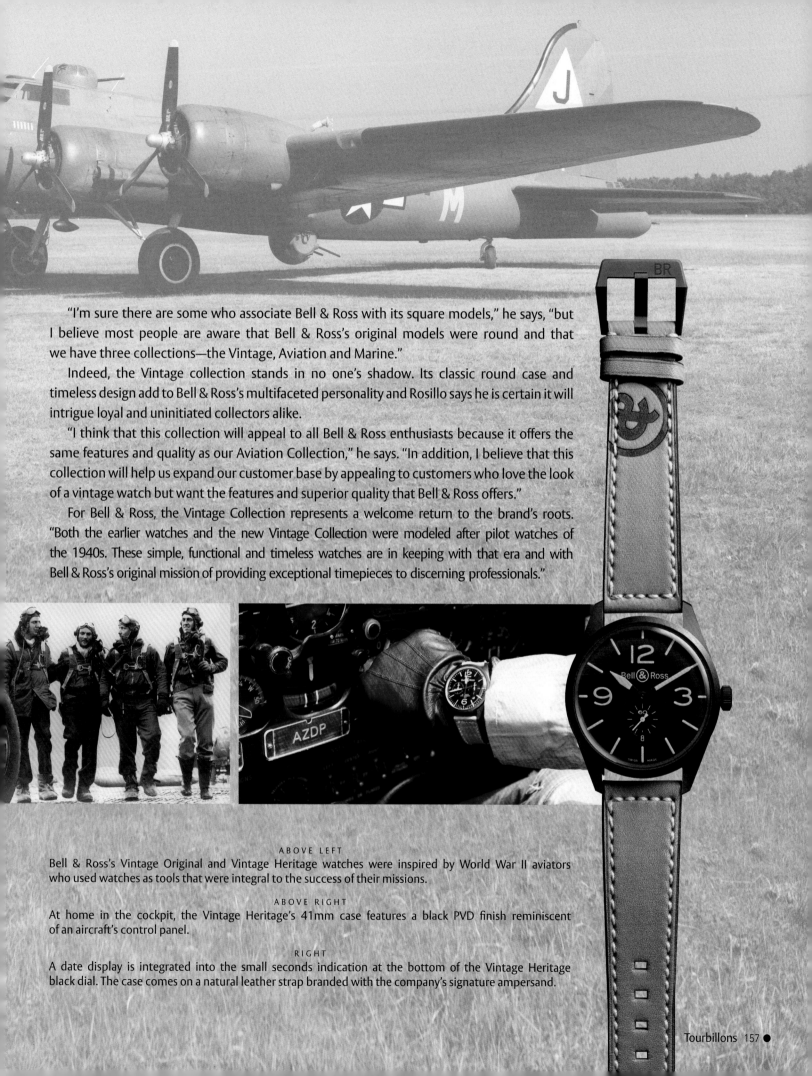

"I'm sure there are some who associate Bell & Ross with its square models," he says, "but I believe most people are aware that Bell & Ross's original models were round and that we have three collections—the Vintage, Aviation and Marine."

Indeed, the Vintage collection stands in no one's shadow. Its classic round case and timeless design add to Bell & Ross's multifaceted personality and Rosillo says he is certain it will intrigue loyal and uninitiated collectors alike.

"I think that this collection will appeal to all Bell & Ross enthusiasts because it offers the same features and quality as our Aviation Collection," he says. "In addition, I believe that this collection will help us expand our customer base by appealing to customers who love the look of a vintage watch but want the features and superior quality that Bell & Ross offers."

For Bell & Ross, the Vintage Collection represents a welcome return to the brand's roots. "Both the earlier watches and the new Vintage Collection were modeled after pilot watches of the 1940s. These simple, functional and timeless watches are in keeping with that era and with Bell & Ross's original mission of providing exceptional timepieces to discerning professionals."

ABOVE LEFT
Bell & Ross's Vintage Original and Vintage Heritage watches were inspired by World War II aviators who used watches as tools that were integral to the success of their missions.

ABOVE RIGHT
At home in the cockpit, the Vintage Heritage's 41mm case features a black PVD finish reminiscent of an aircraft's control panel.

RIGHT
A date display is integrated into the small seconds indication at the bottom of the Vintage Heritage black dial. The case comes on a natural leather strap branded with the company's signature ampersand.

Steve Clerici

CEO of Rebellion

"Rebellion is different and non-conformist"

The Rebellion brand made a dramatic entrance into the watchmaking world when it launched in 2008. Based in Lonay at the heart of the Swiss watchmaking region, it immediately captured attention due to its highly distinctive and resolutely non-conformist products. Closely linked to the world of motor sports—Rebellion has its own racing team—the brand made a name for itself at BaselWorld 2010 by presenting the Rebellion T-1000 model, an imposing timepiece aiming for a massive 1,000-hour power reserve. Working with some of the most talented watchmakers and designers of our times, Rebellion has displayed special expertise in creating highly sophisticated models including an astonishing regulator and a powerful tourbillon model, as well as the Predator chronograph. An impressive record for such a youthful brand, which has found its place in the circle of contemporary horologers. We present an encounter with its CEO, Steve Clerici.

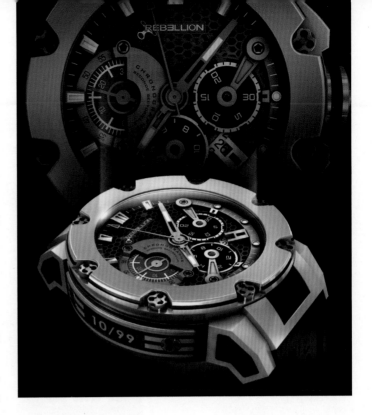

What was your professional background prior to the launch of Rebellion?

I was in the watch industry for ten years and I worked mainly for high-end private label businesses. I then spent six years working in cosmetics before returning to watchmaking. In doing so, I associated with a longtime friend who shares my passionate interest in both watchmaking and automobiles, and with whom I nurtured a long-cherished dream of creating a watch brand. The first concrete elements date back to 2007, with a few original sketches scribbled in the back of an envelope, expressing certain strong traits of character and a keen desire to power ahead.

If you had to explain Rebellion to the uninitiated, what would you say?

We were both keen to establish a different and non-conformist watch brand. To put things simply, we wanted to be independent from a group and to be able to give life to the kind of products we had always dreamed of. We also wanted to build something that would last, since our long-term aim is to be able to make movements and offer them to other brands.

What about market positioning?

We offer extremely exclusive products. What have we learned from the crisis? That real values endure. Although we are young, we aim to create a lasting brand. To do so will mean avoiding the mistakes that proved fatal to some, which means we must offer watches at justifiable and attractive prices for collectors. Moreover, we still intend to remain a niche brand, which naturally implies exclusive production. That's what we offer with Rebellion.

In which markets are you currently represented?

We are steadily expanding our distribution. Before entering new markets, we want to be sure, on the one hand of being able to start off with the best possible partners, and on the other of being able to deliver the desired quantities. But at the end of 2010, we were strongly active in Russia—while hardly at all in the rest of Europe—and well represented in both Asia and the United States. As far as the rest of the world is concerned, we intend to gradually build our network with the finest partners.

How did things go in the beginning?

Initially, not too well. We made certain mistakes and didn't always make the right choices until we began working with Laurent Besse, a design engineer specializing in exceptional movements, whose experience and competence gave the project genuine horological credibility. We also enlisted the services of a brilliant designer who is well recognized in the watch industry, Eric Giroud. With these two professionals, we have been able to develop highly demanding products that are radically different from current standard production. That's what has kept us going: the desire to be different and non-conformist, and a wish to keep pushing the boundaries. That is indeed Rebellion's very reason for being. Shortly afterwards, we developed the T-1000 and its 1,000-hour power reserve—a crazy but thrilling challenge!

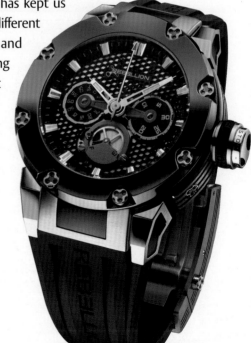

TOP

The latest addition to Rebellion's models, the Predator chronograph features sectorial seconds.

RIGHT

The Predator chronograph comes in a single-pusher version.

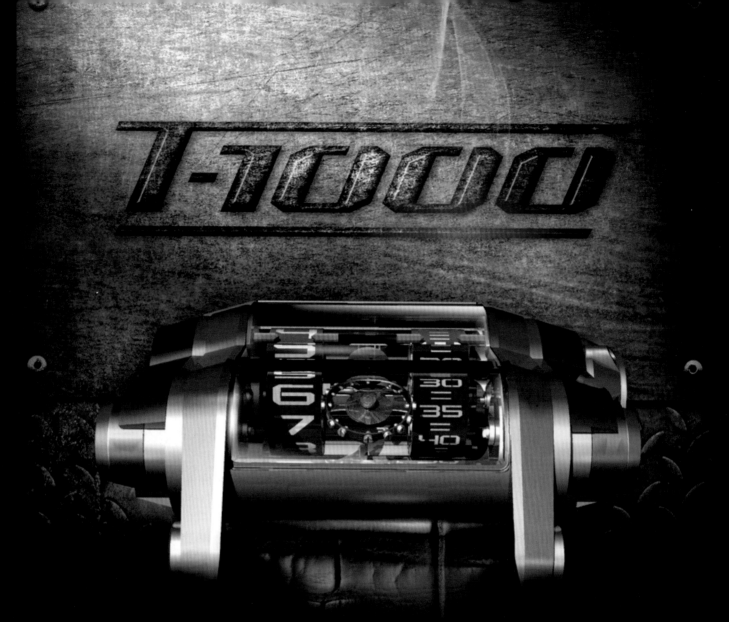

T-1000

What was the initial idea for the T-1000?

As you know, here at Rebellion we are strongly committed to motor racing and we wanted to build a watch to match a racing car: to beat records. Such was the objective behind the T-1000, an extreme watch if ever there was one. The T-1000 was developed for the exclusive purpose of being a record-breaking champion model. Today we have reached 1,000 hours, but if we have to do more in the future, we will do far more. Patents have already been filed with this in mind.

We have also done a lot of research on materials. There was a lot of trial and error, but we nonetheless stuck to a choice that may seem non-conformist to the rest of the profession, in that we opted for a chassis—meaning everything that holds a movement—in aluminum. The advantage is that it weighs just 3.5 grams! And this particular kind of aluminum dilates very little and is twice as hard as other aluminums.

We were lucky enough to be able to rely on suppliers who were prepared to get fully involved and who delivered specific products that met our expectations.

Is it easy to find suppliers prepared to take on such exceptional challenges?

It's actually far easier when you approach them with a genuine challenge for a totally unprecedented product than for an ordinary product, since many suppliers are prepared to take on new projects that involve risk-taking. But they are of course passionate enthusiasts ready to shift into high gear in order to push the boundaries of feasibility. The aim is to create a watch with a long-term future. It will be back with other exteriors and other "bodywork."

How far have you progressed in the development of this incredible 1,000-hour movement?

The movement is working smoothly and we have achieved the 1,000 hours! The other good news is that it is far more accurate that we expected. All of which means we are extremely pleased to have launched into this fantastic adventure!

In addition to the T-1000, you have recently launched a new round chronograph...

Then Predator is in fact the first round watch by Rebellion. It maintains the brand's signature features and its design is the work of Eric Giroud. Inspired by the automobile world, this Predator chronograph with sectorial seconds was conceived and developed in harmony with the spirit of the collection as a whole: edgy design, authenticity, high performance and uncompromising quality. The result is a watch that expresses these qualities and thus determination. Moreover, in accordance with our philosophy, this chronograph incorporates several elements inspired by motor racing, such as brake discs and pedals. The same goes for the honeycomb-structured dial, which guarantees maximum transparency and lightness while ensuring maximum rigidity. The sectorial seconds counter at 9 o'clock enables easy read-off of the passing of time thanks to a double hand with a short side indicating 0 to 30 seconds and a longer one displaying the time between 30 and 60 seconds. For its "motorization," the Predator chronograph is driven by a mechanical self-winding movement with indications of the hours, minutes, sectorial seconds and date at 4:30 as well as 12-hour, 30-minute and 60-second chronograph counters.

In keeping with your determination to remain exclusive, this chronograph can also be customized...

Yes indeed, although it is already offered in a choice of red gold, red gold and ceramic, steel, steel and ceramic, and red gold and steel versions, the complexity of the sandwich-style construction of this timepiece makes it possible to imagine all manner of personalized options. That is also what we intend to offer at Rebellion.

LEFT
The Rebellion REB-7 Regulator features a large date at 6 o'clock and a small hours subdial at 12 o'clock.

ABOVE
The REB-5 is Rebellion's tourbillon from its own manufacture.

Tourbillons

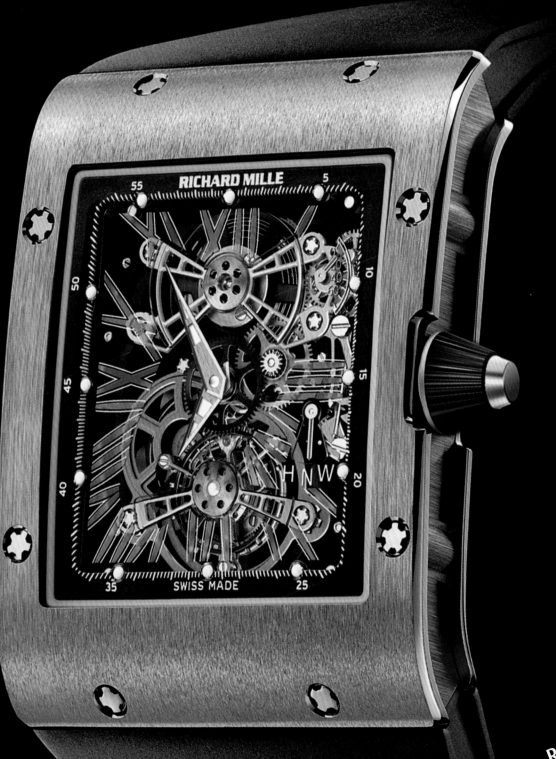

Richard Mille,
RM 017 Extra Flat Tourbill

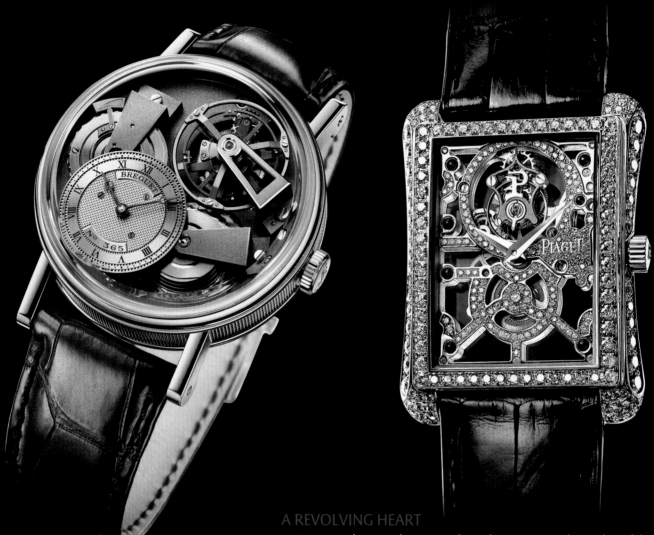

A REVOLVING HEART

Most pocket-watches were slipped into a special pouch or fob on a trouser belt, waistcoat or jacket. Thus maintained in a vertical position for many hours, their mechanism—starting with the balance and balance-spring—underwent the detrimental effects of gravity. To avoid such irregularities, the famous watchmaker Abraham-Louis Breguet (1747-1823) had the idea of enclosing the "heart" of the watch (the balance, balance-spring and escapement) within a small mobile carriage spinning on its axis once a minute. By successively adopting all the possible vertical positions, the balance enabled the different variations in rate to compensate for each other. The triumph of the wristwatch in the 20th century might have led to the disappearance of the tourbillon, since this device loses much of its interest when a watch moves in all directions with the movement of the wrist. However, the revival of mechanical watchmaking in the 1980s propelled the tourbillon to the pinnacle of horological complications by establishing it as the supreme embodiment of Swiss know-how.

TOP LEFT
Breguet, *Tradition 7047 Tourbillon*
TOP RIGHT
Piaget, *Emperador Skeleton Gem-set Tourbillon*
LEFT
Graham London, *Tourbillongraph Trackmaster Chromium*

Since the turn of the millennium, we have been witnessing a genuine tourbillon craze. Over 50 Swiss brands offer them within their collections, which is pretty surprising when one considers that only a handful of artisans are really able to make this mechanism. Faced with this relatively widespread occurrences, the major watch firms are determined to offer "in-house" tourbillon movements featuring innovative solutions. As befits its historical rank, Breguet gives pride of place to this gem in its rich heritage. The Tradition collection in particular has welcomed the 7047 watch, which reveals a spectacular tourbillon mechanism with a fusée and chain transmission device optimizing the regularity of the movement rating. For its Emperador collection, Piaget has created the world's thinnest tourbillon movement (at just 3.5mm thick). On the Emperador Skeleton Gem-set Tourbillon, the brand presents an ethereal version of this mechanism, featuring diamonds and sapphires set directly in the movement blank. To mark its 150th anniversary, Chopard launched the L.U.C Engine One Tourbillon with an L.U.C 1TRM tourbillon movement mounted on silent-blocks that absorb shocks, much like on car engines. Beating at a rate of 28,800 vibrations per hour, this caliber is chronometer-certified by the COSC, a rare feature on tourbillon watches. In terms

of innovations, Blancpain has distinguished itself recently by launching the first wristwatch equipped with a karussel. The latter is an alternative to the tourbillon and is distinguished (although not all experts agree) by its double gear train linking it to the barrel—the first supplies the energy required to run the escapement, and the second controls the speed of rotation of the carriage. In deciding to tackle this more or less forgotten complication invented in 1892, Blancpain has also accelerated its speed of rotation which now amounts to 60 seconds, as opposed to several minutes on a traditional karussel. Also seeking enhanced precision, Montblanc has developed an unusual system: on its ExoTourbillon Chronograph in the Villeret 1858 collection, the brand has placed the balance on the outside of the tourbillon carriage. Since the latter is larger and freed from the inertia of the carriage, its amplitudes are more precise and it requires less energy. In terms of financially affordable tourbillons, the feat achieved by Graham London with its Tourbillograph Trackmaster Chromium thanks to an optimized industrial process certainly deserves a mention.

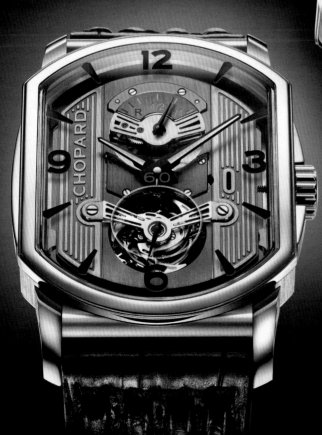

LEFT
Chopard , *L.U.C Engine One Tourbillon*
ABOVE
Montblanc, *ExoTourbillon Chronograph*
RIGHT
Blancpain, *Carrousel Volant Une Minute*

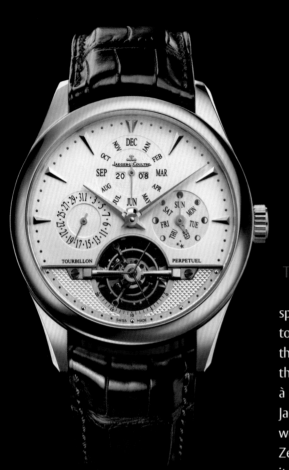

TRANSPARENCY REIGNS

With its mobile carriage spinning on its axis like a planet, the tourbillon provides a fascinating sight that most brands are keen to exhibit through the dial. In its Master Grande Tradition Tourbillon à Quantième Perpétuel (see the chapter on Perpetual Calendars), Jaeger-LeCoultre reveals a titanium tourbillon carriage at 6 o'clock weighing just 0.28g and composed of 78 parts. The Tourbillon by Zenith features a 12 o'clock opening showing the tourbillon, with its balance beating at 36,000 vibrations per hour, as it does on all El Primero movements. On the Grand Tourbillon Heures Mystérieuses by Montblanc, this mechanism plays a starring role in the upper part of the dial, with a bridge forming two figure 8s—the symbol of infinity. The superbly stylish timepiece, made by the Manufacture Minerva (integrated within Montblanc) is also distinguished by its hours/minutes display that appears to be suspended in mid-air thanks to crystal discs. High-end finishes are also the hallmark of Bovet Fleurier, which adorns the tourbillon of the Amadeo Fleurier 44 Tourbillon 7 Days Reverse Hand-Fitting, visible through a dial opening at 3 o'clock and featuring finely chased bridges. Its case is easily convertible into a wristwatch, a table watch, a pocket-watch or a pendant watch.

TOP LEFT
Jaeger-LeCoultre, *Master Grande Tradition Tourbillon à Quantième Perpétuel*
TOP RIGHT
Montblanc, *Grand Tourbillon Heures Mystérieuses*
LEFT
Zenith , *Tourbillon*

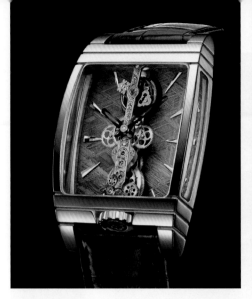

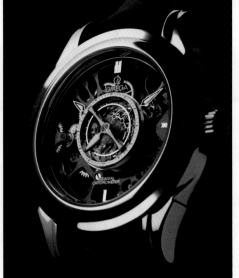

FLOATING ISLAND

Other brands go even further in playing with composition and transparency effects. The impressive baguette-type movement of the new Golden Bridge Tourbillon by Corum provides fascinating views of its organs, including the world's smallest tourbillon carriage, measuring only 8.5mm in diameter. On the Royal Blue Tourbillon by Ulysse Nardin, the sapphire bridges and mainplate create the illusion that the mobile carriage is floating in a void. The same impression prevails with the Horology H88 Flying Sculptura concept watch by Beat Haldimann, which is also entirely hand-free and thus entirely devoted to the perfectly regular vision of the passing of time—a genuine work of art. On its Tourbillon Central Co-Axial Platinum Skeleton watch, Omega has also chosen to create a spectacular show. Placed in the center of the dial, the tourbillon—with its platinum carriage—dominates the entire COSC-certified movement. The hands are represented in gold on sapphire discs that appear to be literally flying through the air.

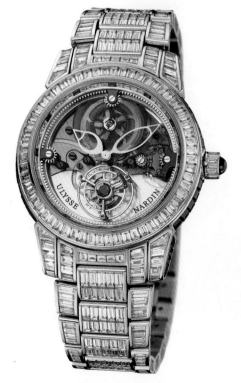

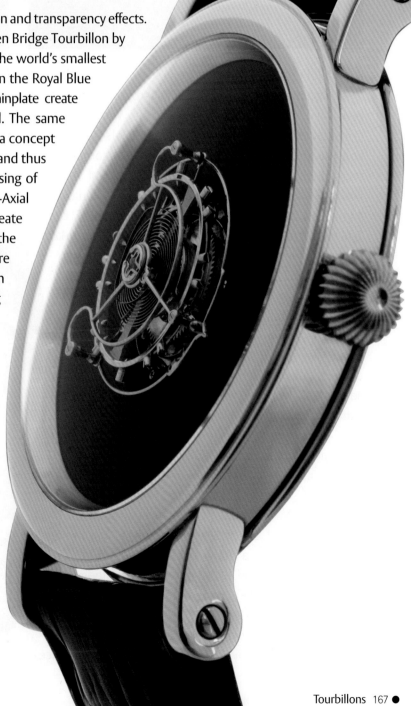

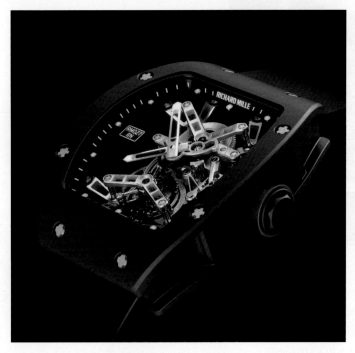

AN ENDLESS RACE

In recent seasons, the venerable tourbillon has been revitalized by models associating it with innovative constructions and high-tech materials—a process considerably boosted by the use of new computerized technologies. Richard Mille is definitely one of the most prominent specialists in this field. With its case and movement composed of avant-garde materials, the RM 027 is even lighter than the already feather-weight RM 009 Felipe Massa (less than 30g without the wristband). The newcomer, worn in matches by tennis champion Rafael Nadal, and weighing in at just 20g including the wristband, is thus one of the lightest watches ever made! Its movement is made from titanium and LITALTM, a lithium alloy containing aluminum, copper, magnesium and zirconium. This addition of lithium endows the movement with extreme flexibility as well as shock resistance. This alloy is used in the components of many aircraft such as the A380, helicopters, rockets and satellites, as well as Formula 1 racing cars. The Breguet Marine Tourbillon Chronograph combines a balance-spring, an escape-wheel and a lever in silicon with a tourbillon featuring a titanium bridge and pillars. Jaeger-LeCoultre has also sparked a full-fledged revolution with the Master Compressor Extreme Lab, the first mechanical watch to run in an entirely accurate and reliable way without any lubricant. This feat was made possible by a new geometry of the balance,

new ultra-light materials and a state-of-the-art tourbillon regulator fitted with a magnesium carriage. A worthy new version of the Freak Caliber (first introduced in 2001), in which the entire movement spins on its axis like a tourbillon carriage, the InnoVision by Ulysse Nardin also runs without lubrication thanks to various technological innovations in the field of silicon.

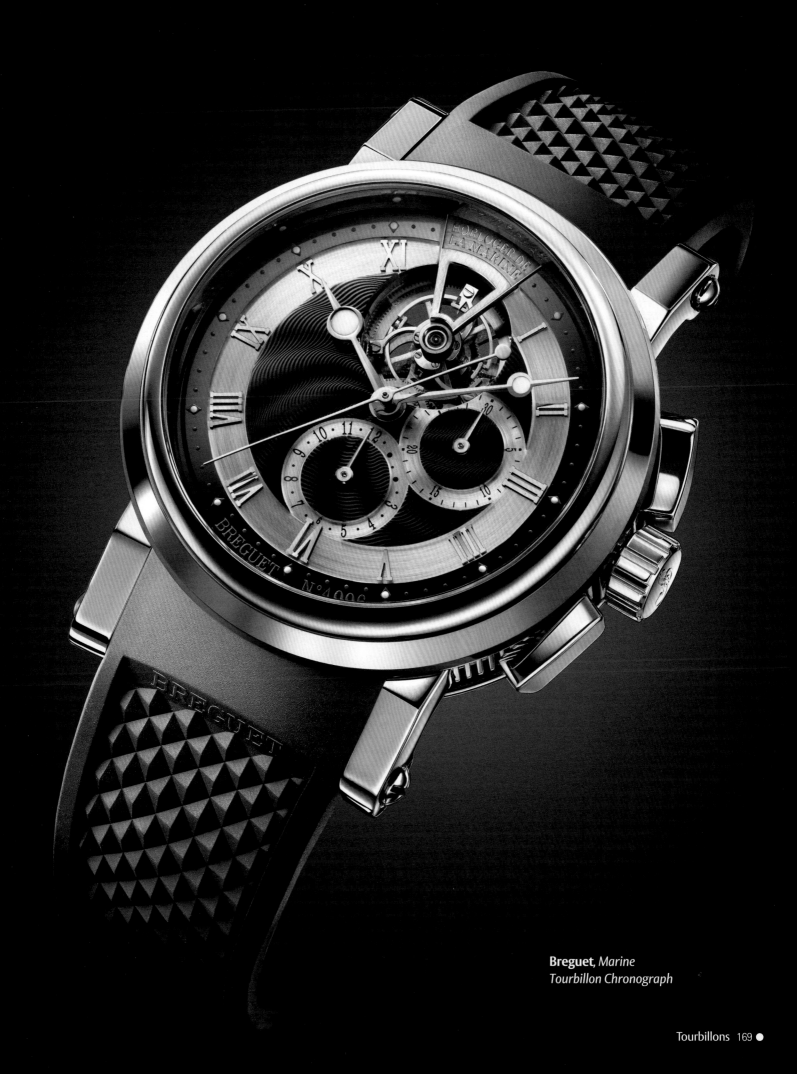

Breguet, *Marine*
Tourbillon Chronograph

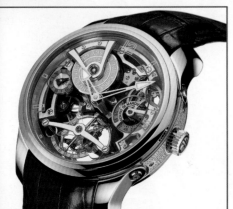

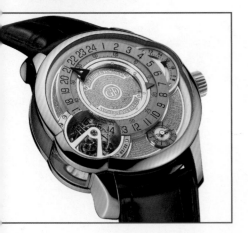

THE THIRD DIMENSION

Recent years have also witnessed the appearance of a new generation of tourbillons equipped with several simultaneous rotations axes and/ or turning at speeds different from the classic one revolution per minute. The aim is to offer constructions more suitable to wristwatches and to enhance their precision, particularly by multiplying the spatial positions adopted by the balance-and-spring assembly. The Gyrotourbillon 1 by Jaeger-LeCoultre features two nested carriages: an outer carriage spins on its axis in 60 seconds, while the inner carriage, set at a 90° angle in relation to the first, rotates in 17.75 seconds. This spherical tourbillon concept was back in the spotlight in 2008 on the Gyrotourbillon 2, this time in the Reverso case. The Bi-axial Tourbillon by Girard-Perregaux also combines two concentric carriages, spinning on their respective axes in 45 seconds and one minute and fifteen seconds respectively. A similar double carriage principle (but with a 30° angle) inspired the Opus 6 by Harry Winston, developed by Stephen Greubel and Robert Forsey. Under their own Greubel Forsey brand name, these two watchmakers have also developed several innovative constructions playing on angles and speeds of rotation. The Double Tourbillon 30°, reinterpreted in 2009 in the amazingly transparent Double Tourbillon Technique model, has an inner carriage rotating in one minute and an outer carriage spinning in four minutes.

ABOVE FROM TOP TO BOTTOM
Harry Winston, *Opus 6*
Greubel Forsey, *Double Tourbillon Technique*
Greubel Forsey, *Invention Piece 3*

TOP RIGHT
Jaeger-LeCoultre, *Gyrotourbillon 2*

RIGHT CENTER
Girard-Perregaux, *InnoVision*

RIGHT
Thomas Prescher, *InnoVision*

FAR RIGHT
Panerai, *Radiomir Tourbillon GMT
Ceramica Lo Scienzato*

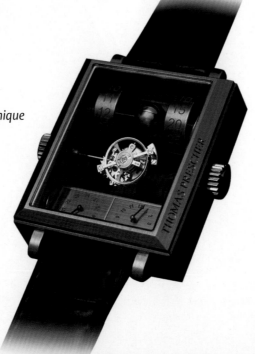

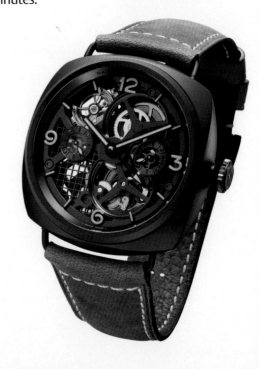

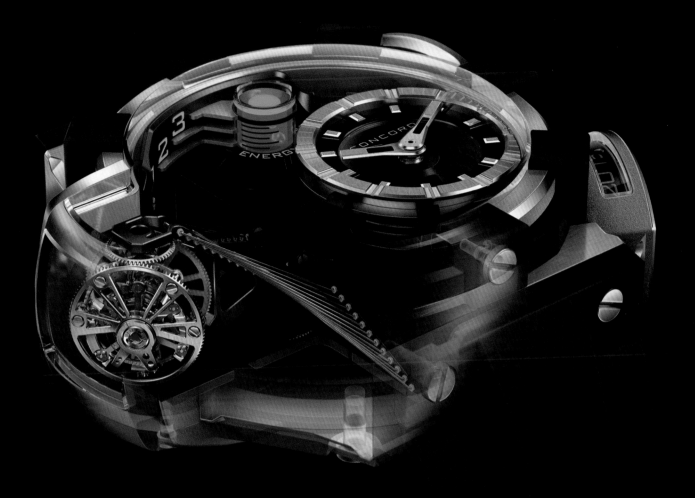

On the Tourbillon 24 Seconds Incliné, the heart of the Invention Piece 3, the carriage set at 25° and turning 2.5 times faster than an ordinary carriage, called for a new inclined gearing profile as well as specific alloys. After his round watch with triple-axis tourbillon, Thomas Prescher is pursuing his exploration of tourbillons by launching the Mystérieux Tourbillon Double Tourbillon Automatique. Only the drums serving as time displays, the tourbillon, the calendar and the oscillating weight are visible, while the movement is completely concealed by the bezel in the left and right-hand sides of the case. Placed on a rotation axis by means of a dedicated arm, the centered tourbillon turns on two axes. In order to escape the controversy surrounding the actual utility of a tourbillon (designed for vertical positions) in a wristwatch (that adopts multiple positions), other brands have chosen to innovate by placing their tourbillon vertically! On the Radiomir Tourbillon GMT Ceramica Lo Scienzato by Panerai, the carriage turns at a right angle to the oscillation axis of the balance, performing two turns per minute. Its Caliber P.2005/S is also distinguished by a substantial six-day power reserve, achieved thanks to the

energy from three barrels. Concord created shock waves in 2009 by launching the Quantum C1 Gravity, equipped with an unprecedented bi-axial tourbillon positioned vertically, meaning almost outside the movement, and linked to the mainplate by a system of cables reminiscent of suspension bridges. As for Zenith, its Christophe Colomb, presented in autumn 2010, picks up on the concept of the "gyrogravitational tourbillon" with a gyroscopic carriage introduced in its Defy Xtreme Tourbillon and replacing the more traditional mechanism at 6 o'clock. This mechanism mounted on gimbals, like marine chronometers, appears in a sapphire bubble crossing right through
the movement.

TOP
Concord, *C1 Quantum Gravity*

RIGHT
Zenith, *Christophe Colomb*

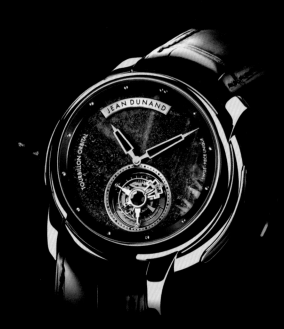

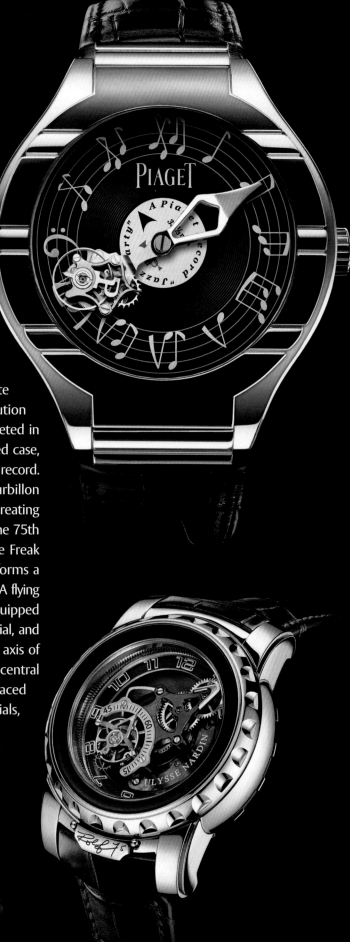

MAGIC ROUNDABOUTS

With its Tourbillon Orbital, Jean Dunand does not operate in the third dimension, but instead offers a sophisticated system in which the tourbillon spins on its axis in one minute, while performing a complete turn of the dial in one hour. The same principle of a double revolution applies to the Polo Tourbillon Relatif Limelight Jazz by Piaget, interpreted in 2010 in an extremely musical version with a black grand feu enameled case, engraved with musical notes and featuring a dial that looks like a vinyl record. Suspended from the tip of the minute hand, the mobile flying tourbillon carriage appears to be disconnected from the movement driving it, creating a fine encounter between mechanical prowess and visual magic. For the 75th birthday of its owner Rolf Schnyder, Ulysse Nardin has launched the Freak Diavolo, a sportier new version of the InnoVision. Its tourbillon performs a complete turn around its center in one hour and indicates the minute. A flying tourbillon revolves majestically above the carrousel. Its carriage is equipped with an arrow indicating the seconds on a semi-circular transparent dial, and performing one full tour per minute. The zero always begins on the axis of the minutes indicator. There is no carrousel at Cartier, but instead a central elongated tourbillon carriage turning around the dial in one minute. Placed above the movement of the Rotonde Astrotourbillon, between two dials, it is balanced by a platinum counterweight.

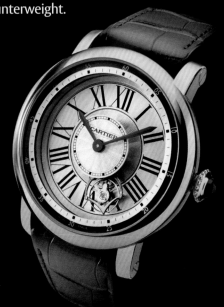

TOP LEFT
Jean Dunand, *Tourbillon Orbital*
TOP RIGHT
Piaget, *Polo Tourbillon Relatif Limelight Jazz*
RIGHT
Cartier, *Rotonde Astrotourbillon*
FAR RIGHT
Ulysse Nardin, *Freak Diavolo*

A FLURRY OF TOURBILLONS

Another technical and aesthetic path explored by some watchmakers is the multiplication of tourbillons within a single watch. The Twin Rotating Tourbillons model by Breguet boasts two independent tourbillons coupled by a differential gear and fixed to a mainplate performing a complete rotation in 12 hours. These two mechanisms mutually compensate for their infinitely small variations in rate in order to offer superior precision. The Histoire de Tourbillon 1 watch by Harry Winston is the first gem in a new series of five extremely limited editions with just twenty models each. This inaugural piece features a case made from white gold and zalium, housing two ultra-light tourbillons set at a 25° angle and performing one rotation in 36 seconds. In 2008, after five years of development, Greubel Forsey presented a Quadruple Tourbillon à différentiel, with two asymmetrical double tourbillons linked by a spherical differential acting like that of a car. The latest new release of this kind is Excalibur Double Tourbillon by Roger Dubuis.

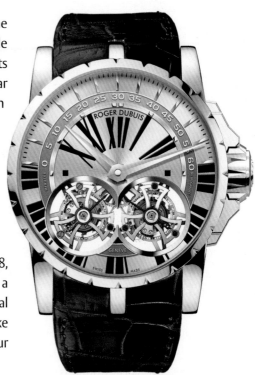

TOP LEFT
Breguet, *Twin Rotating Tourbillons*

BOTTOM LEFT
Greubel Forsey, *Quadruple Tourbillon à différentiel*

ABOVE
Roger Dubuis, *Excalibur Double Tourbillon*

BELOW
Harry Winston, *Histoire de Tourbillon 1*

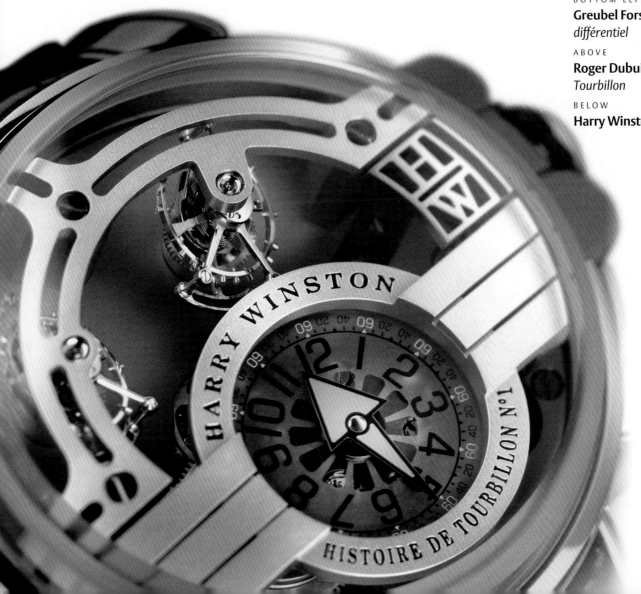

WHIRLING DIAMONDS

Celebrating the union of haute horology and haute jewelry, certain great names in the luxury business have also designed a few tourbillon watches specially dedicated to women. The Kalpa XL Tourbillon Diamants by Parmigiani Fleurier offers a one-week power reserve and a carriage performing two rotations per minute. The Jules Audemars Ladies' Tourbillon Chronograph sparkles with 251 brilliant-cut diamonds and 68 baguette-cut diamonds. Chopard has innovated by dedicating to women a watch with a magnificent beating heart in the shape of a L.U.C in-house made movement, complete with tourbillon, nine-day power reserve, chronometer certification and Geneva Seal quality hallmark. The case of this L.U.C Tourbillon Lady is entirely set with baguette-cut diamonds and the tourbillon bridge is adorned with a "C" for Chopard. And finally, the superbly understated Midnight Tourbillon nacre from Van Cleef & Arpels, issued in a 100-piece limited edition, features a handcrafted white mother-of-pearl dial.

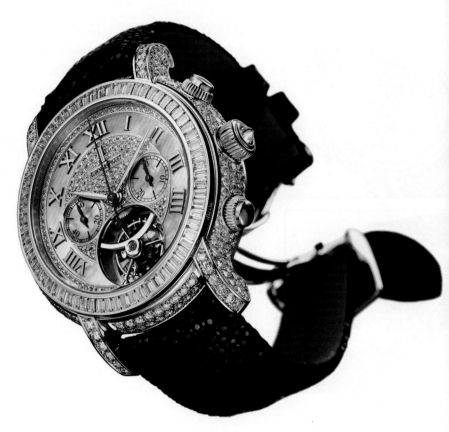

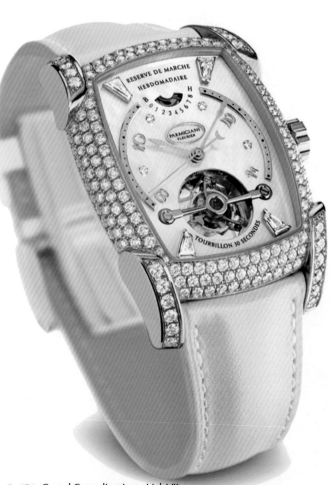

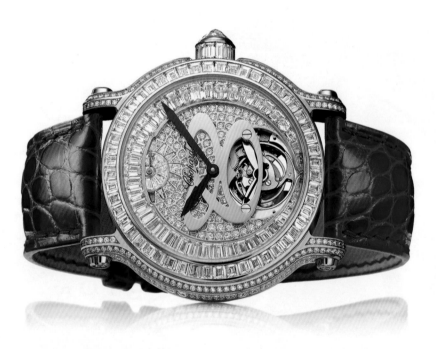

TOP
Audemars Piguet, *Ladies' Tourbillon Chronograph*

LEFT
Parmigiani, *Kalpa XL Tourbillon Diamants*

ABOVE
Chopard, *L.U.C Tourbillon Lady*

FACING PAGE
Van Cleef & Arpels, *Midnight Tourbillon nacre*

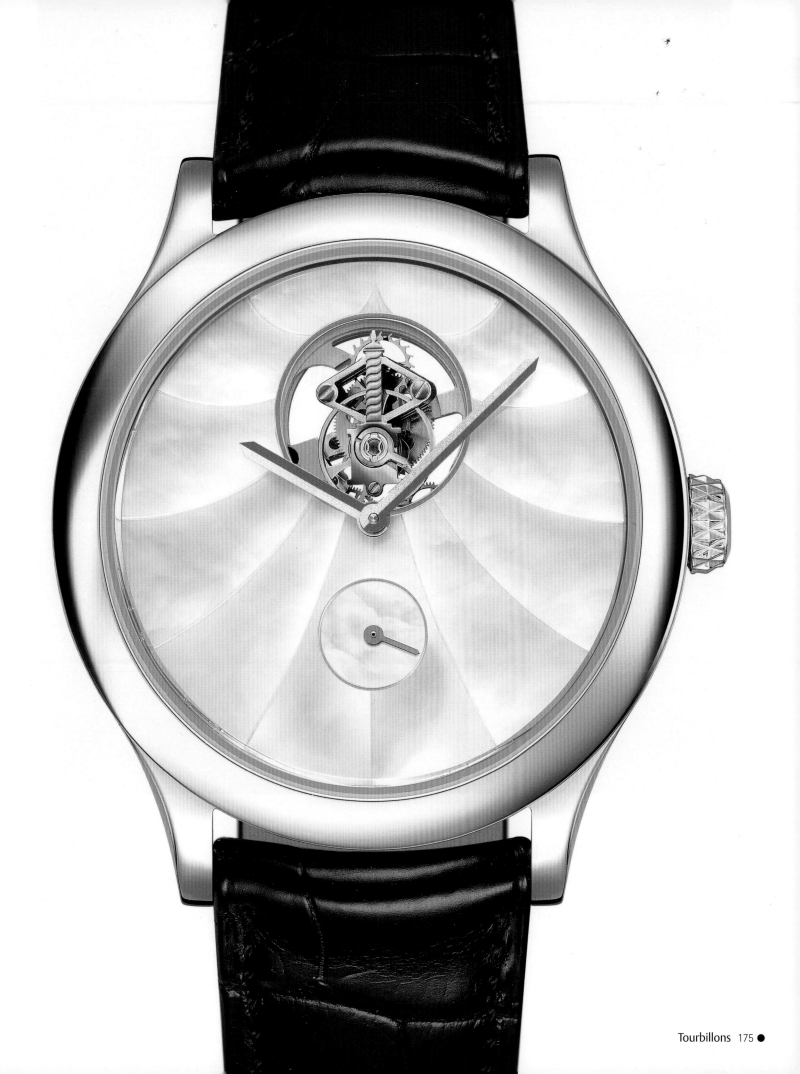

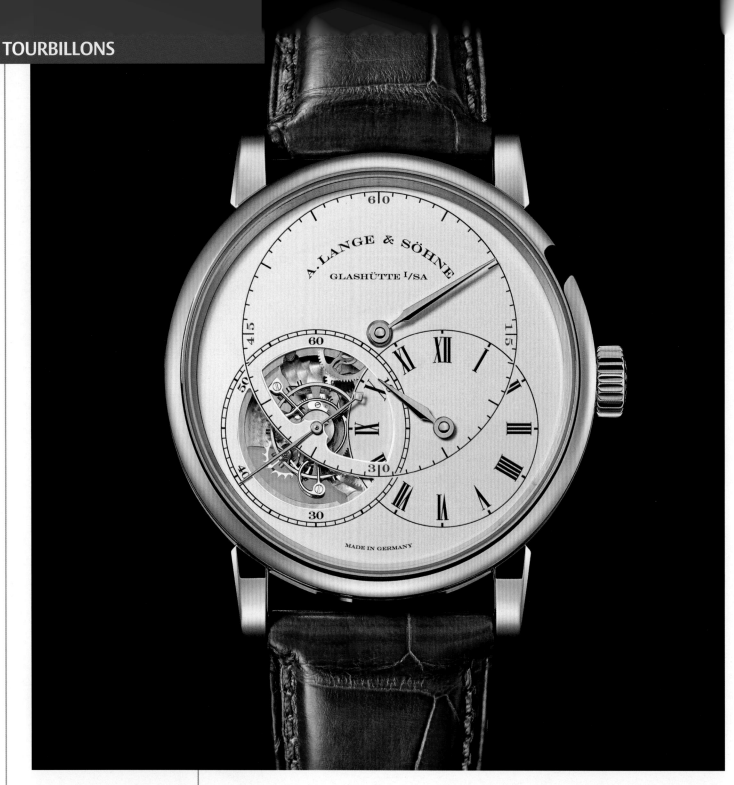

A. LANGE & SÖHNE

RICHARD LANGE TOURBILLON POUR LE MERITE – REF. 760.032

The Richard Lange Tourbillon "Pour le Mérite" is powered by the manual-winding new hand-finished Lange manufacture L072.1 caliber. It incorporates a fusée-and-chain transmission as well as a tourbillon with a patented stop-seconds mechanism and a balance spring manufactured in-house. The 41.9mm case comes in platinum or rose gold with a 36-hour power reserve. Its dial features three intersecting circles for the time indicators. The largest dial indicates the minutes while the smaller subdials represent the seconds and hours. The watch includes a crocodile strap secured with a solid gold buckle. The Richard Lange Tourbillon "Pour le Mérite" in platinum is limited to 100 pieces.

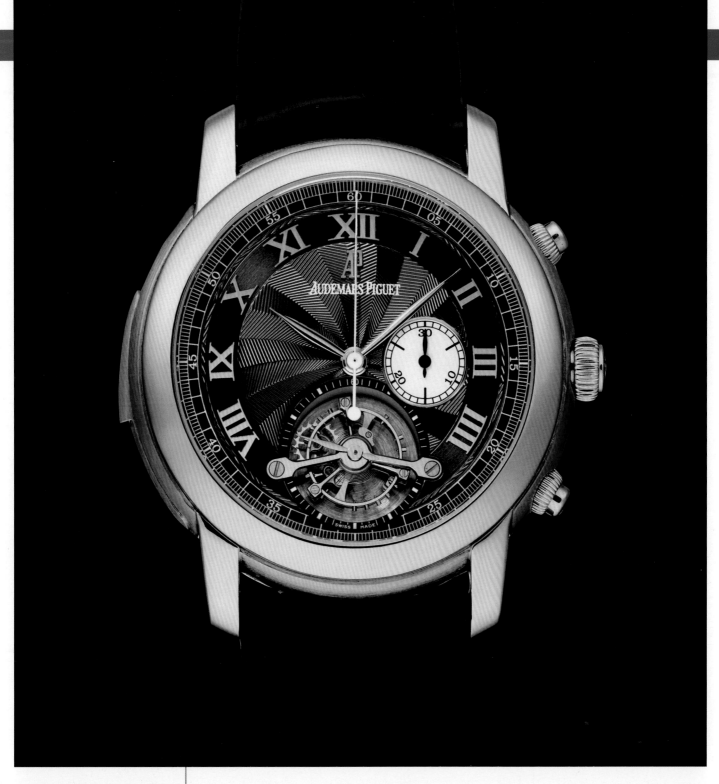

AUDEMARS PIGUET

JULES AUDEMARS MINUTE REPEATER TOURBILLON WITH CHRONOGRAPH
REF. 26050OR.OO.D002CR.01

The 18K pink-gold Jules Audemars Tourbillon Minute Repeater Tourbillon with Chronograph houses the manual-winding 2874 movement. It boasts a minute repeater mechanism that sounds the hours, quarter-hours and minutes upon request with a two-note chime, as well as a chronograph with 30-minute counter and small seconds on the tourbillon axis. This watch is also available in 18K white gold.

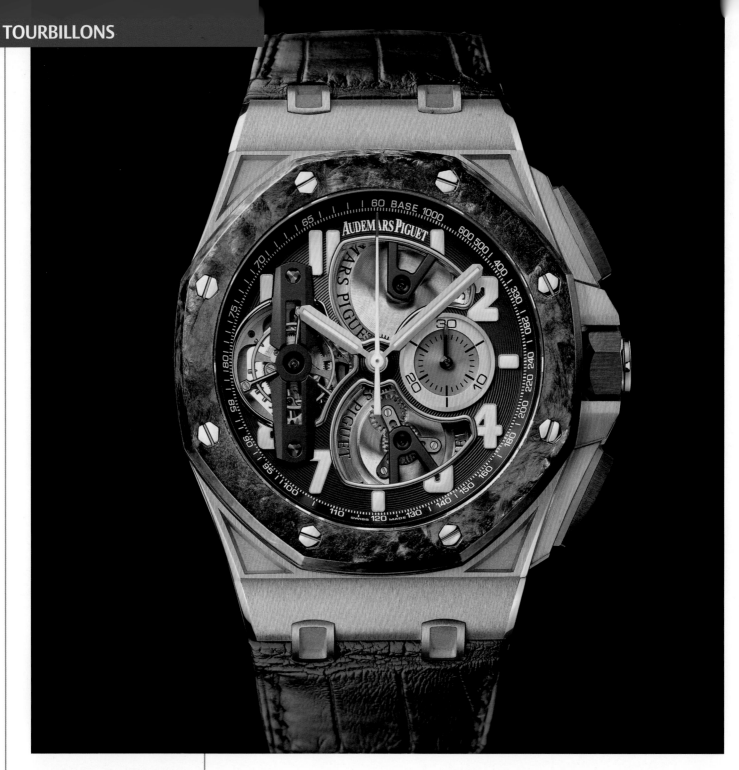

AUDEMARS PIGUET

ROYAL OAK OFFSHORE HAND-WOUND TOURBILLON WITH CHRONOGRAPH

REF. 26288OF.OO.D002CR.01

The Royal Oak Offshore tourbillon chronograph, developed and crafted entirely by Audemars Piguet, houses the manual-winding 2912 caliber with two barrels, a tourbillon and a 10-day power reserve. The case is in 18K pink gold with a forged carbon bezel, black ceramic crown and pushers, assembly screws in polished steel and a glareproof sapphire crystal and caseback. The black dial is snailed and openworked at 6:00, 9:00 and 12:00, with applied luminescent gold numerals and hands.

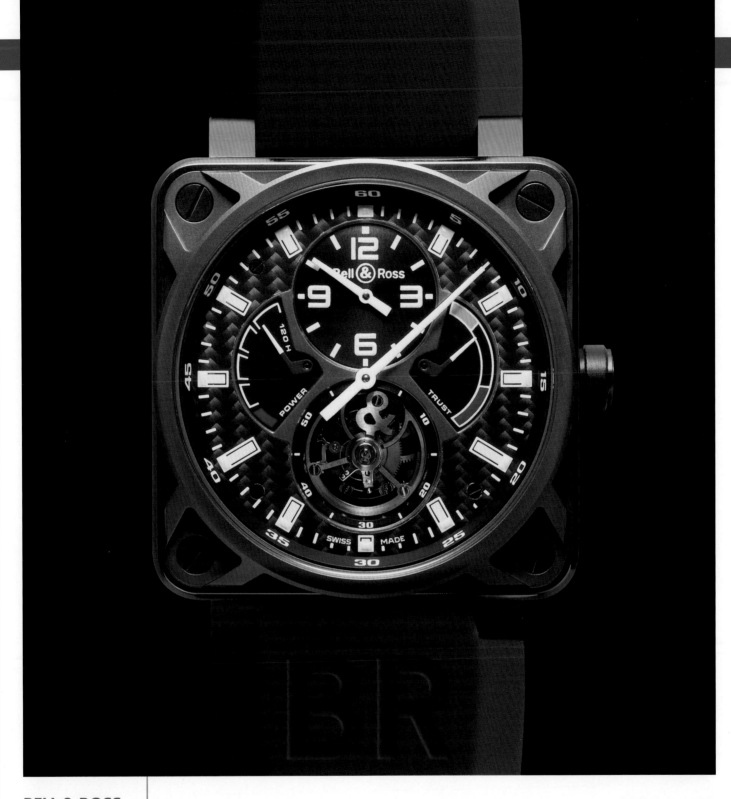

BELL & ROSS

BR 01 INSTRUMENT TOURBILLON

The mechanical manual-winding BR 01 INSTRUMENT TOURBILLON movement contains carbon-fiber mainplates and a black-gold tourbillon carriage. It is housed inside a XXL 46mm case, crafted in glass-bead-blasted titanium with DLC (Diamond-Like Carbon) virtually scratch-proof coating. The dial is in black carbon fiber; the numbers, hands and indexes have photoluminescent coating for nighttime reading. Hours can be read in a counter at 12:00, a trust index is positioned at 3:00, and the 120-hour power reserve indicator is at 9:00. A central hand displays the minutes. The timepiece is fitted on a rubber or alligator leather strap and is water resistant to 100m. Limited edition of 60 pieces.

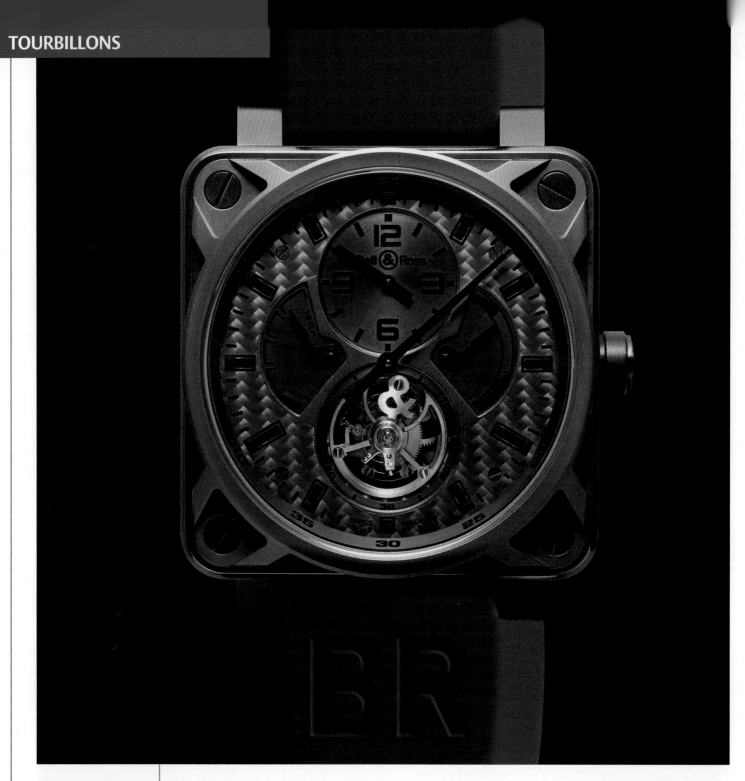

BELL & ROSS

BR 01 INSTRUMENT TOURBILLON PHANTOM

Created in a limited edition of just 18 pieces, the BR 01 INSTRUMENT TOURBILLON PHANTOM has a black carbon-fiber dial and is encased in glass-bead-blasted titanium with DLC. It is powered by a mechanical manual-winding BR 01 TOURBILLON with carbon-fiber mainplates and a black-gold tourbillon carriage. The hours are shown in a counter at 12:00, the trust index is positioned at 3:00, and the 120-hour power reserve indicator is at 9:00. A central hand displays the minutes. The watch is water resistant to 100m.

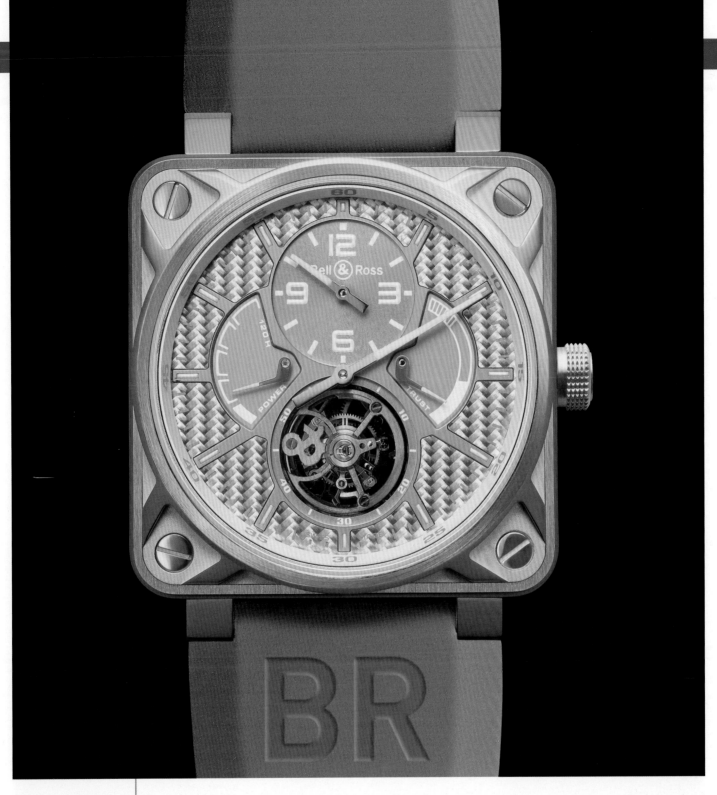

BELL & ROSS

BR 01 INSTRUMENT TOURBILLON GOLD (ALUMINUM + PINK GOLD)

The polished pink-gold case houses a manual-winding mechanical movement. The watch displays a trust index at 3:00, a 120-hour power reserve indicator at 9:00, an hour counter at 12:00 and a central minute hand. The BR 01 INSTRUMENT TOURBILLON GOLD features carbon-fiber mainplates and a tourbillon cage in 5N gold. The dial is in aluminum fiber, with indexes and hands treated with photoluminescence for easy nighttime reading. The case boasts a large 46x46mm measurement and sapphire crystals on the front and back. Water resistant to 100m, the watch is available on a rubber or alligator strap.

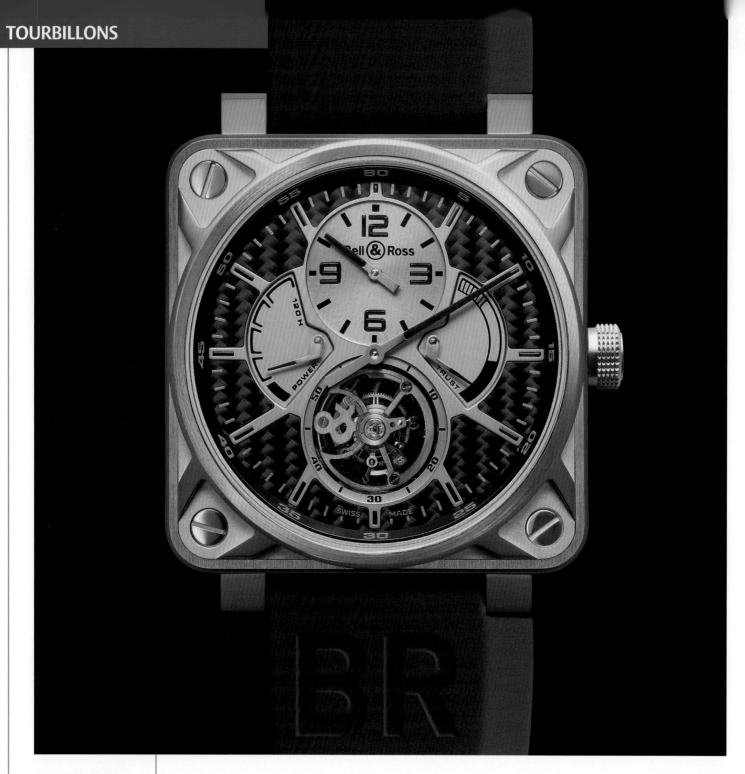

BELL & ROSS

BR 01 INSTRUMENT TOURBILLON GOLD (PINK GOLD + TITANIUM)

The BR 01 INSTRUMENT TOURBILLON GOLD features a mechanical manual-winding movement that powers its various displays: minutes on a central hand, hours in a subdial at 12:00, a trust index at 3:00, and a 120-hour power reserve indicator at 9:00. The hands and indexes feature photoluminescent coating for easy nighttime reading. The case, water resistant to 100m, is crafted in 18K pink gold and measures an extra-large 46x46mm.

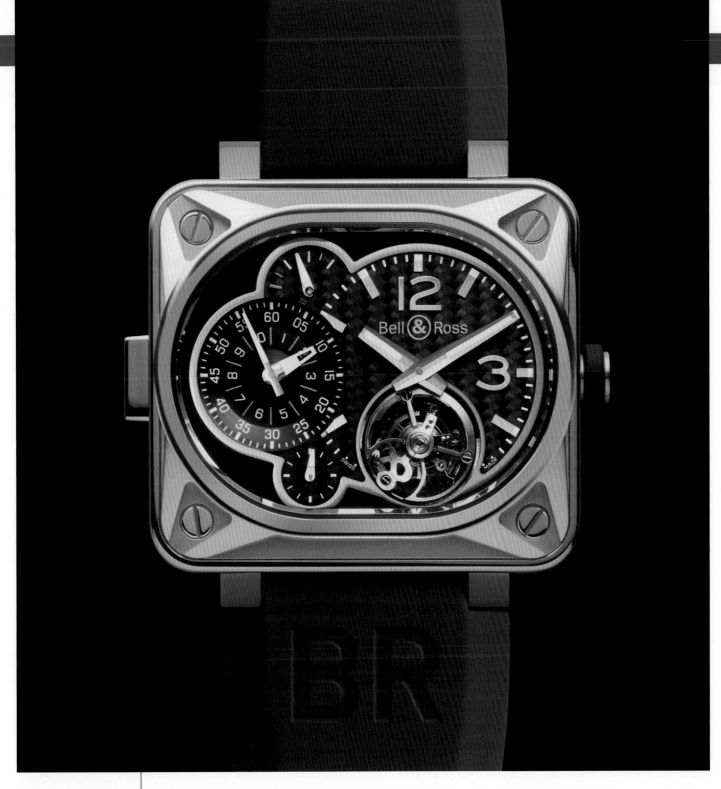

BELL & ROSS

INSTRUMENT BR MINUTEUR TOURBILLON

This tourbillon is powered by a manual-winding mechanical movement and its bridges are in pink gold and anodized aluminum. The watch displays the hours, minutes, small seconds, a three-day power reserve indicator and a flyback function (2 counters: 60 minutes and 10 tenths of an hour), which features a zero-setting and quick restart. The case is in polished pink gold and measures 44x50mm. The black dial possesses hands and an index treated with photoluminescence for easy nighttime reading. Water resistant to 100m, the watch is available on a rubber or alligator strap.

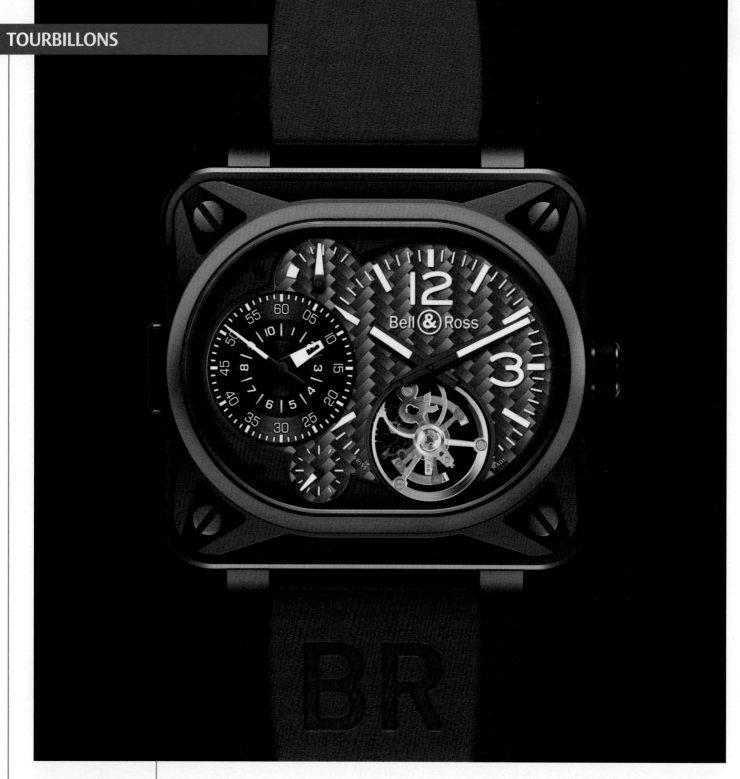

BELL & ROSS

INSTRUMENT BR MINUTEUR TOURBILLON

This tourbillon is powered by a manual-winding mechanical movement and its bridges contain carbon-fiber mainplates and a black-gold tourbillon carriage. The watch displays the hours, minutes, small seconds, a three-day power reserve indicator and a flyback function (2 counters: 60 minutes and 10 tenths of an hour), which features a zero-setting and quick restart. The case is glass-bead blasted titanium with DLC (Diamond-Like Carbon) virtually scratch-proof coating and measures 44x50mm. The black dial possesses hands and an index treated with photoluminescence for easy nighttime reading. Water resistant to 100m, the watch is available on a rubber or alligator strap.

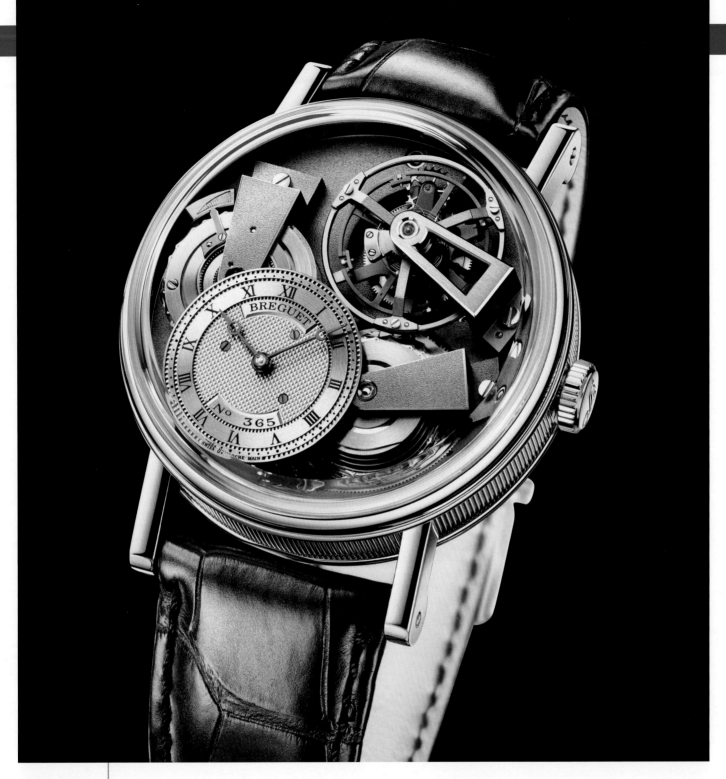

BREGUET

FUSEE TOURBILLON – REF. 7047PT

Breguet's Fusee Tourbillon boasts a manual-winding 596 caliber that possesses a 2.5Hz Breguet balance wheel in titanium with four adjusting screws in gold and a silicon balance-spring. The ensemble provides a 50-hour power reserve, and torque regularity throughout the operation of the timepiece is provided by the fusee-and-chain transmission. The 950 platinum 41mm case is water resistant to 30m. The Fusee Tourbillon shows off a one-minute tourbillon at 1:00 and a guilloché 18K gold subdial at 7:00 for the hours and minutes.

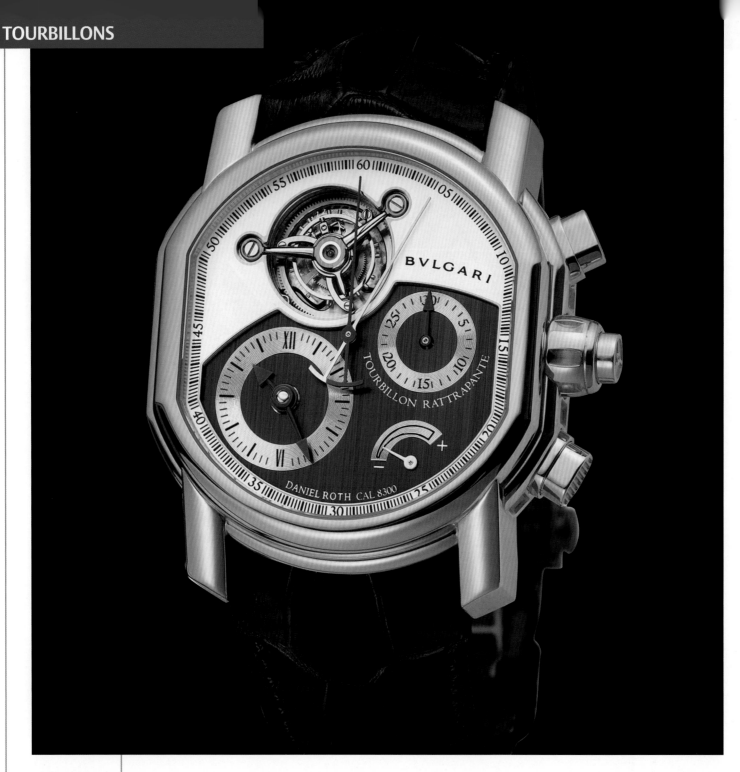

BVLGARI

TOURBILLON CHRONO RATTRAPANTE – REF. BRRP46C14GLTBRA

The Tourbillon Chrono Rattrapante, housed in a double-ellipse rose-gold case, proudly displays its regulating tourbillon between 11:00 and 12:00. The piece, powered by Calibre DR 8300, is equipped with a split-seconds chronograph function displayed by the two central seconds hands: the classic chronograph hand and the superimposed split-seconds hand. When the chronograph pushbutton is activated, the two hands begin running at the same time and are perfectly synchronized. Stopping and resetting brings them both to a halt and repositions them. The split-seconds function is separately activated when, once the central seconds hand has been started, the additional co-axial pushbutton on the crown is activated, thus stopping the split-seconds hand while the chronograph continues running.

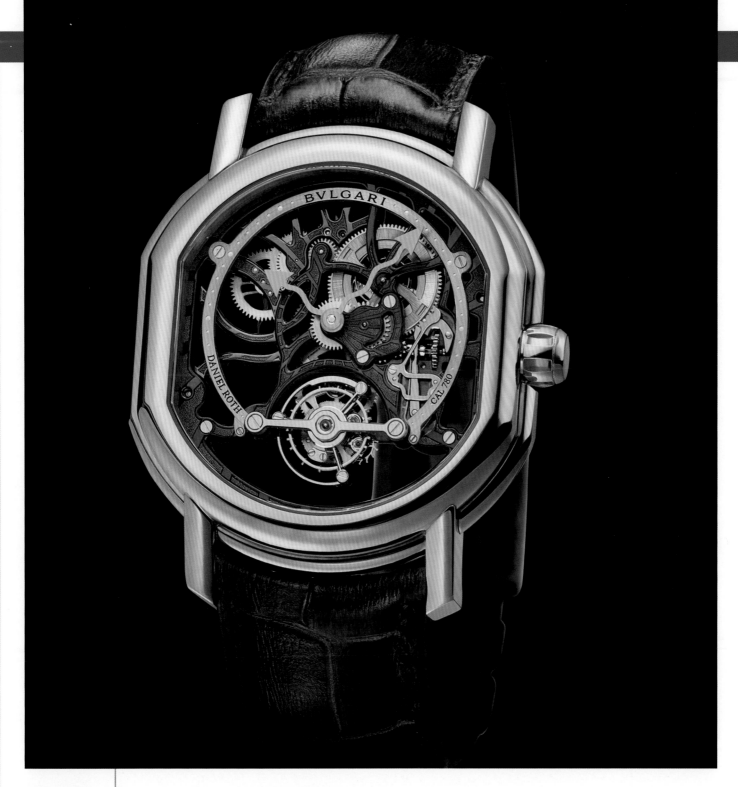

BVLGARI

TOURBILLON LUMIERE – REF. BRRP44C11GLTBSK

To perfect the Tourbillon Lumière, its designers had to pare down the structure of the Calibre DR 780 as much as possible, while maintaining its rigidity and load-bearing capacity. The goal has been fully met in a feather-light creation whose components are clothed in a double-ellipse rose-gold case. The plates, bridges and ratchet-wheel are meticulously openworked. Each of the parts is chamfered, hand-drawn and exquisitely chased. The dial merges into the movement and features a minimum of finely engraved metal serving to mark the hour circle on the front and the power reserve display on the back. The mainplate is barely 3.48mm thick, making this model one of the world's thinnest tourbillon watches.

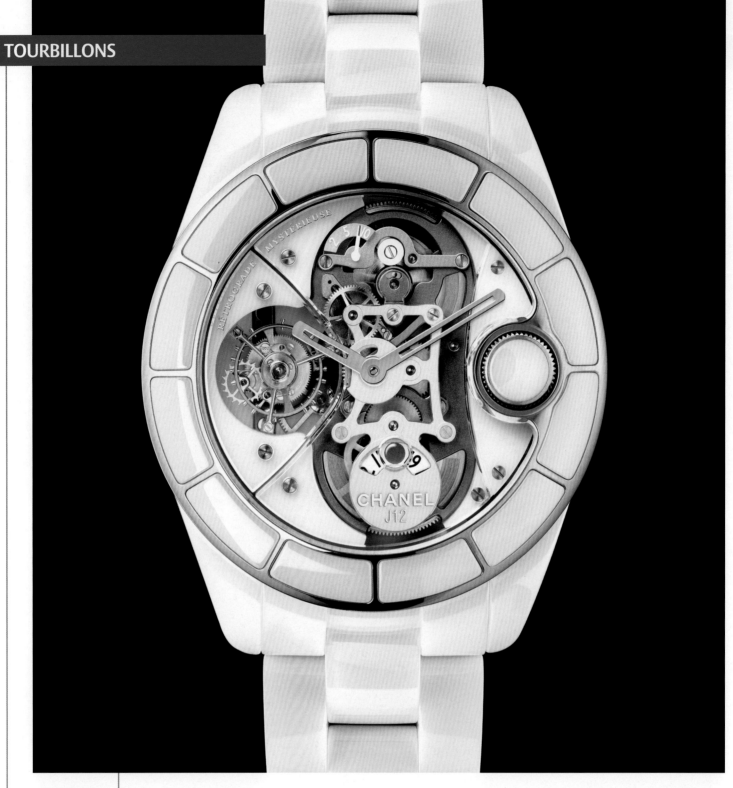

CHANEL

J12 RETROGRADE MYSTERIEUSE – WHITE CERAMIC

When technical prowess compliments the aesthetics
CHANEL RMT-10 Calibre
- R for Retrograde
- M for Mysterious
- T for Tourbillon

After introducing the first tourbillon featuring a highly innovative high-tech ceramic bottom-plate, CHANEL confirmed its status as a pioneer of contemporary watchmaking by creating the J12 Rétrograde Mystérieuse. The Rétrograde Mystérieuse is the embodiment of innovation and includes 5 complications:

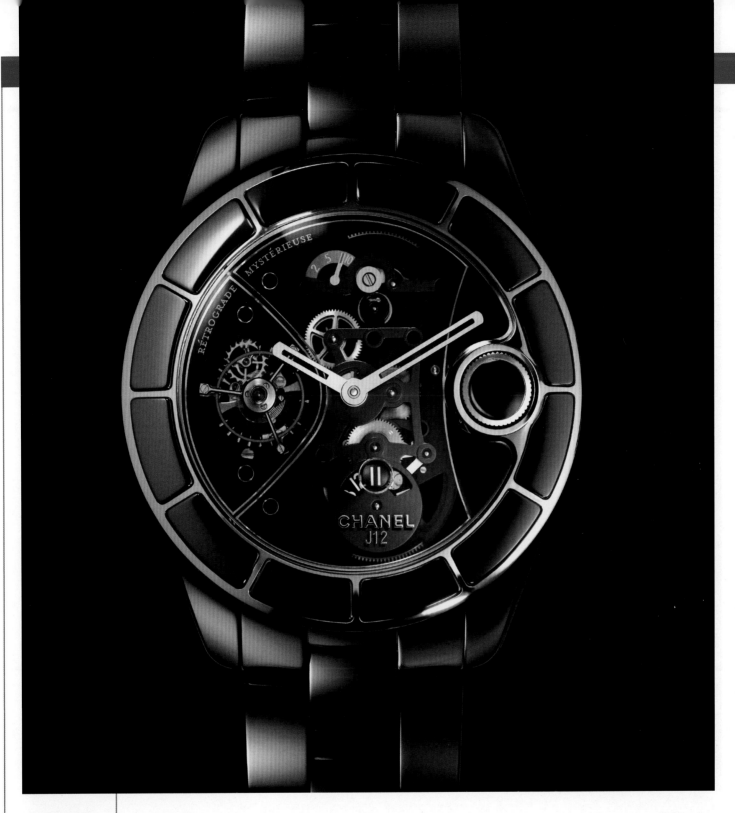

CHANEL

J12 RETROGRADE MYSTERIEUSE – BLACK CERAMIC

1. A tourbillon
2. A retractable vertical crown
3. A retrograde minutes hand
4. A 10-day power reserve
5. A digital minutes display

This perfectly round watch with a 47mm diameter has been designed without a side crown to ensure optimum comfort on the wrist. The work on this complication was entrusted to one of the most "state-of-the-art" watchmaking design/construction workshops: the Giulio Papi team (APRP SA).

Limited and numbered edition of ten pieces in black high-tech ceramic and 18K white gold or ten pieces in black high-tech ceramic and 18K pink gold.

The white ceramic edition is a unique piece.

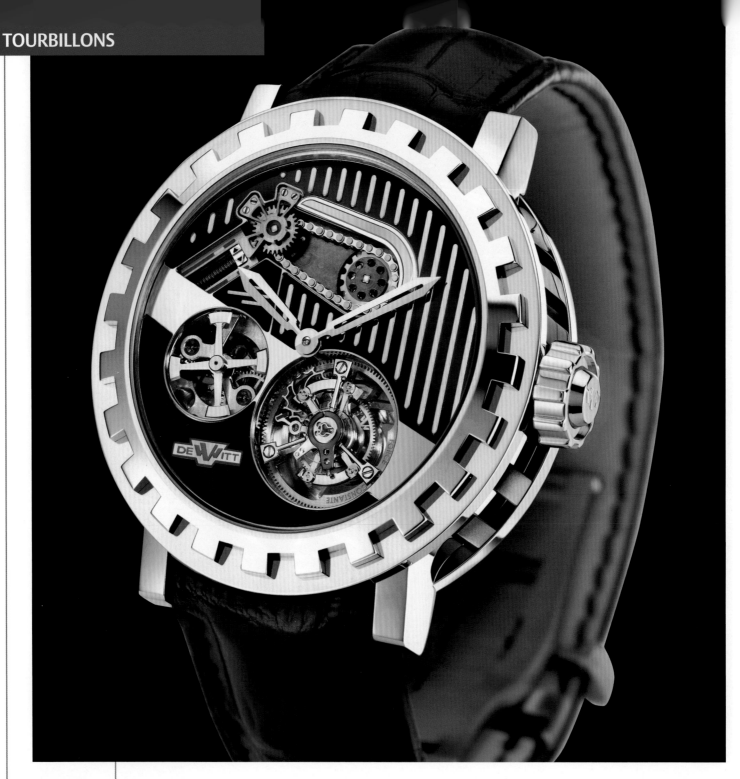

DEWITT

TOURBILLON FORCE CONSTANTE A CHAINE – REF. AC.8050.53.M1030

With a manual-winding movement that incorporates a Flying Tourbillon mechanism with a constant force device, the Tourbillon Force Constante à Chaîne is a milestone of innovation. DeWitt solves an age-old conundrum—how can one ensure the perfectly regular transmission of energy to the watch's mechanism?—with a device designed to transmit impulses whose energy remains identical and regular, however taut the barrel-spring, thanks to three additional wheels: one to ensure correct gear operation and two intermediate wheels between the barrel and the tourbillon. The DW8050 caliber also incorporates a system that relays energy to the power reserve indicator, a landmark innovation. The Tourbillon Force Constante à Chaîne is housed within a 43mm 18K rose-gold case, and available in a limited edition of 99 pieces.

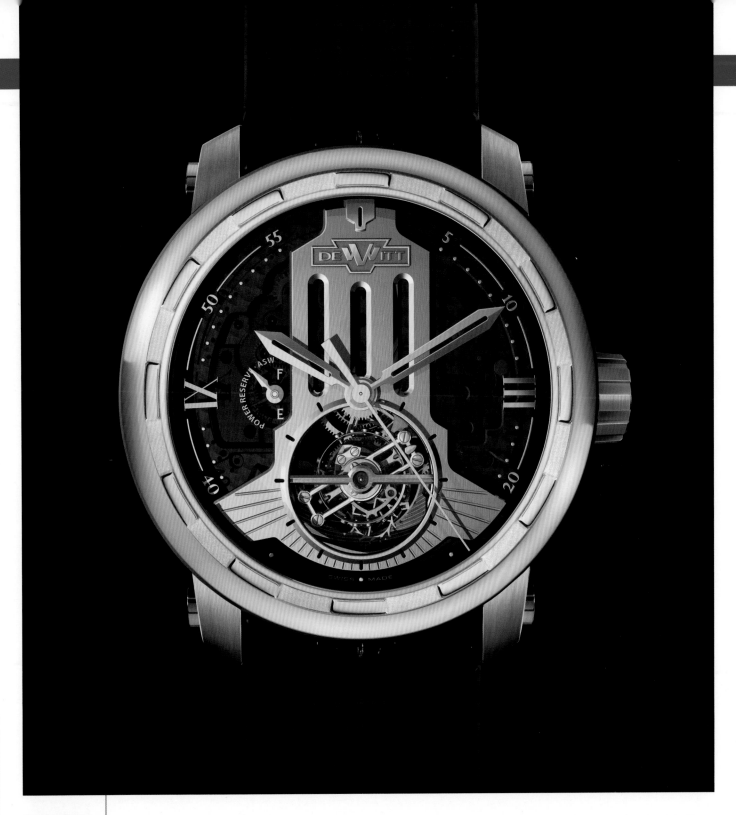

DEWITT

TWENTY-8-EIGHT REGULATOR A.S.W. HORIZONS – REF. T8.TA.53.011

The Twenty-8-Eight Regulator introduces a patented and extremely ingenious Patented Automatic Sequential Winding (A.S.W.) system, which enables the movement to remain within an ideal functioning range, between 92 and 96% of the mainspring torque. Consisting of 320 components, the Twenty-8-Eight Regulator A.S.W. Horizons is powered by the renowned DW 8014 caliber, which combines horological classicism with the extraordinary technological innovation of the A.S.W. device. Within the piece's 37mm 18K rose-gold case, the tourbillon cage is directly connected to the deadbeat second. Offering a power reserve display, the Twenty-8-Eight Regulator A.S.W. Horizons is waterproof to 30m.

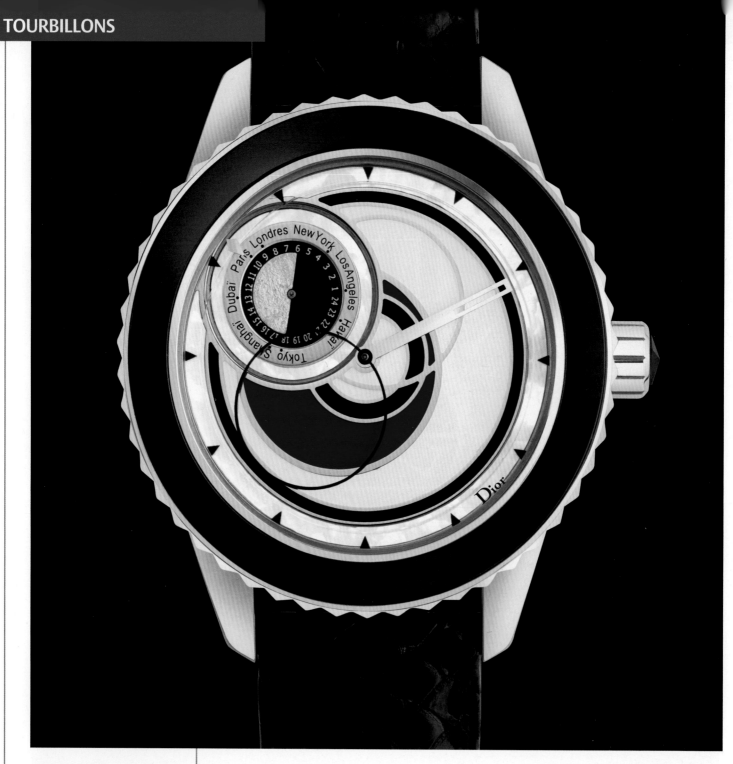

DIOR HORLOGERIE

DIOR CRISTAL "8 FUSEAUX HORAIRES" YELLOW GOLD & LACQUER

A limited edition of eight timepieces, Dior Christal "8 Fuseaux Horaires" is a tribute to Monsieur Dior and his passion for art as well as a reminder of the couturier's lucky number. This new timepiece is equipped with an exclusive automatic-winding "8 Fuseaux Horaires" caliber, which simultaneously displays the local time and time in eight cities worldwide, as well as the day/night indication, on a mobile satellite. This exclusive complication was developed by Les Ateliers Horlogers Dior in collaboration with watch movement designers Orny & Girardin. The playful dial was designed as a work of art in typical Art Deco materials (gold leaf, lacquer and mother-of-pearl) and colors (ivory, coral and gold). Mounted on a black python strap, the Dior Christal "8 Fuseaux Horaires" is embroidered with gold leaf down to the lining, revealing an haute couture oscillating weight.

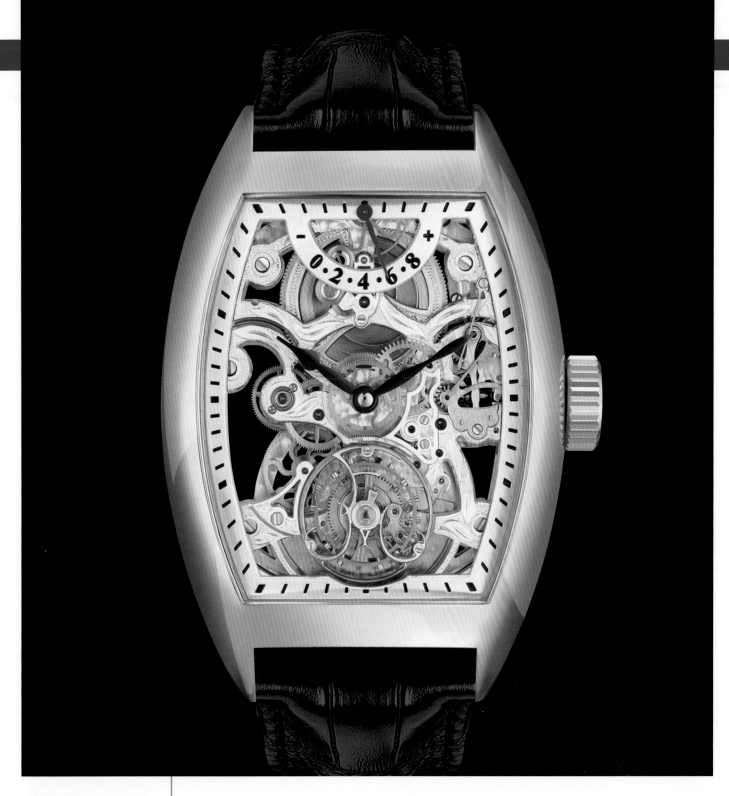

FRANCK MULLER

TOURBILLON CURVEX POWER RESERVE SQUELETTE – REF. 8888 T PR SQT

A work of art in its own right, the Tourbillon Curvex Power Reserve Squelette is powered by a precious movement signed by the Franck Muller Manufacture, delicately worked and cut out in a totally harmonious composition. This allows all the components and the gears to be seen, built into a Cintrée Curvex case that gives the watch a completely unique, innovative appearance in 18K white gold or titanium. The movement has two barrels, guaranteeing an eight-day power reserve. The 14mm tourbillon is stacked on the oscillating weight, visible under the hands. A gauge at the top of the openworked dial indicates the power reserve remaining.

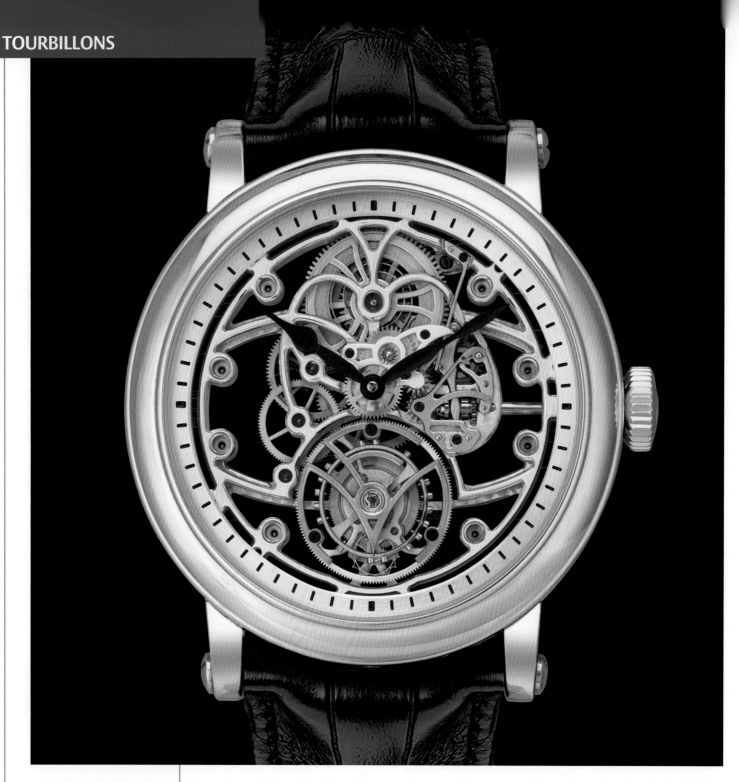

FRANCK MULLER

TOURBILLON SQUELETTE – REF. 7008 T SQT

After the launch of the Aeternitas and Aeternitas Mega collections—both technical achievements at the very summit of the watchmaker's art—Franck Muller has moved on to a first for the company: a range of timepieces without dials. The completely openworked dial of the Tourbillon Squelette reveals the visually harmonious composition of the movement, within a round 18K white-gold case. On the upper bridge of the tourbillon, the design engineers at Manufacture Franck Muller have worked out the initials FM in a very elegant style. A creation as rare as it is original, this collection is once again the evidence of Franck Muller's technical expertise and constant search for beauty.

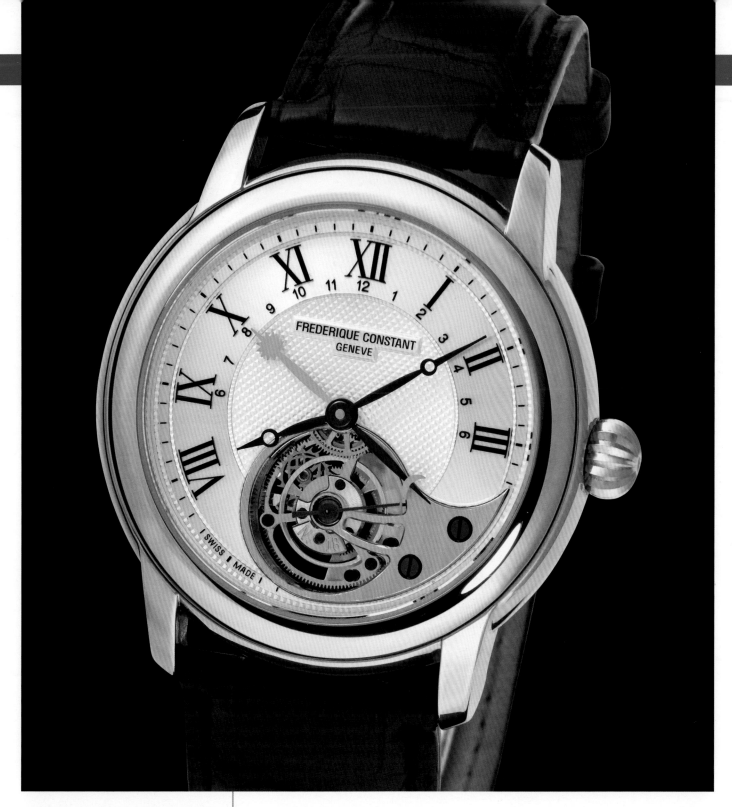

FRÉDÉRIQUE CONSTANT

TOURBILLON MANUFACTURE – REF. FC-980MC4H9

With its Tourbillon Manufacture, Frédérique Constant made a major breakthrough: a tourbillon with a silicon escapement wheel. Using the watchmaker's award-winning Heart Beat Manufacture Calibre as a base, Frédérique Constant developed its tourbillon completely in-house with a number of unique features, including the aforementioned silicon escapement wheel and lever, exceptionally fast oscillation at 28,800 vph and an individually numbered tourbillon cage. The lower weight of the silicon escapement wheel and the reduced friction offered by silicon result in substantially higher energy efficiency. As a result, the tourbillon in the Frédérique Constant Tourbillon Manufacture has an amplitude of over 300° in dial-up and dial-down positions.

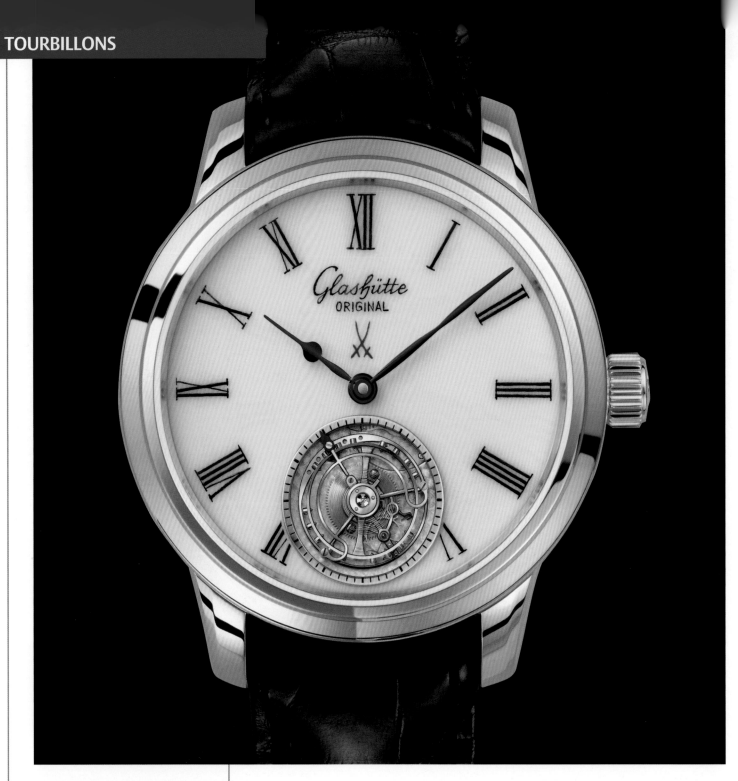

GLASHÜTTE ORIGINAL

SENATOR MEISSEN TOURBILLON – REF. 94.11.01.01.04

Two world-famous Saxon inventions unite in the Senator Meissen Tourbillon: Meissen porcelain and the flying tourbillon. The timekeeper is a picture of stylish classicism in its 40mm rose-gold case, outfitted with exquisite technology. The passing of time is measured by traditionally blued hour and minute hands that glide across the surface of the wafer-thin, white Meissen porcelain dial. The painting of the dial alone requires eight hours to complete. Another significant challenge is posed by milling the cutaway needed to observe the flying tourbillon at the 6:00 on the 0.8mm-thick porcelain dial. The Senator Meissen Tourbillon is powered by the exquisitely finished automatic manufacture Caliber 94-11, which can be admired through the sapphire crystal caseback.

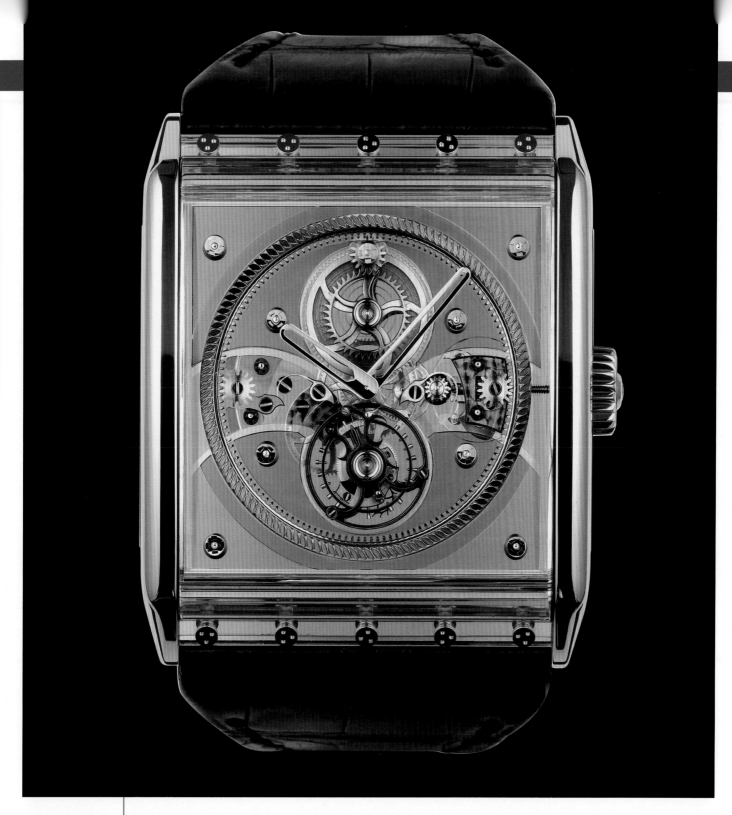

GUY ELLIA

TOURBILLON ZEPHYR

With a movement created by Swiss manufacturer Christophe Claret, the Tourbillon Zephyr symbolizes transparency with excellence. Caliber GES 97 features a 110-hour power reserve and winding ring set with 36 baguette-cut diamonds (1.04 carats), or engine turning and one-minute tourbillon movement. The latter beats at 21,600 vph within an entirely hand-chamfered cage. The convex case with 950 platinum sides has a transparent back cover and hearth engraving. Mounted on an alligator strap with a folding buckle, this model is also available in platinum and titanium.

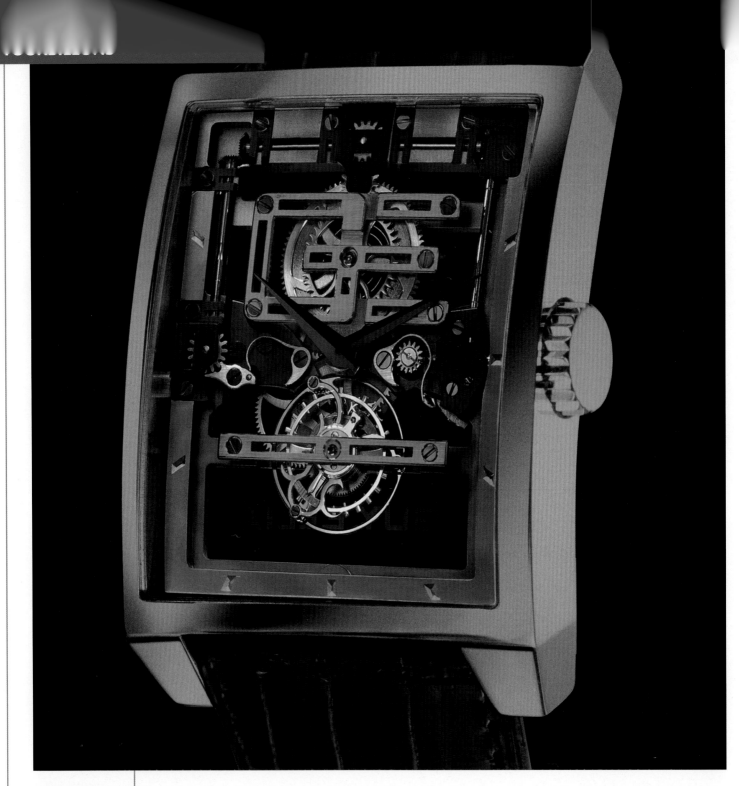

GUY ELLIA

TOURBILLON MAGISTERE TITANIUM

Designer Guy Ellia presents the titanium version of his famous skeletonized mysterious-winding tourbillon. The Time Square Tourbillon Magistere's Caliber TGE 97 was created by Swiss manufacturer Christophe Claret and features a 110-hour power reserve, one-minute tourbillon, and a titanium bottom plate and bridges. The movement beats at 21,600 vph within an entirely hand-chamfered cage.

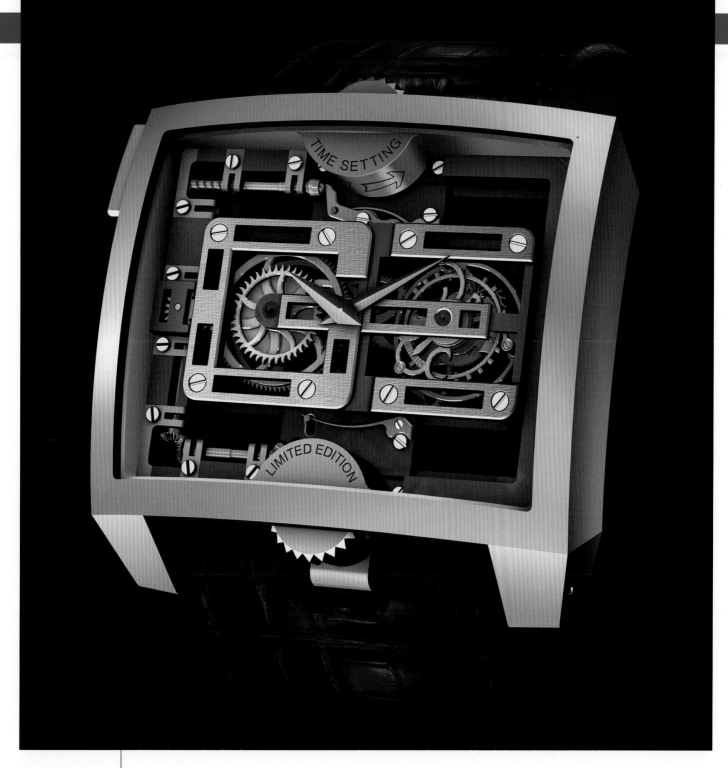

GUY ELLIA

TOURBILLON MAGISTERE II

Guy Ellia has renewed its collaboration with Christophe Claret to present their latest timepiece enhanced with a tourbillon escapement: the Tourbillon Magistère II. Inside its distinctive case, an elongated rectangle (44.2x36.7mm), the skeleton movement has a mysterious winding and features an "invisible" dial, whose main hands display the hours and minutes while seeming to float in space. In fact, the technical genius of this watch, produced in a limited edition of 12 pieces for each version, lies in the inversion of its bridges compared with a classic tourbillon timepiece. Hence the location of the winding crown at 6:00 and the use of the crown positioned at 12:00, while maintaining pressure on the security pushpiece at 10:00 to set the time. This piece is for lovers of fine watchmaking in search of the unusual.

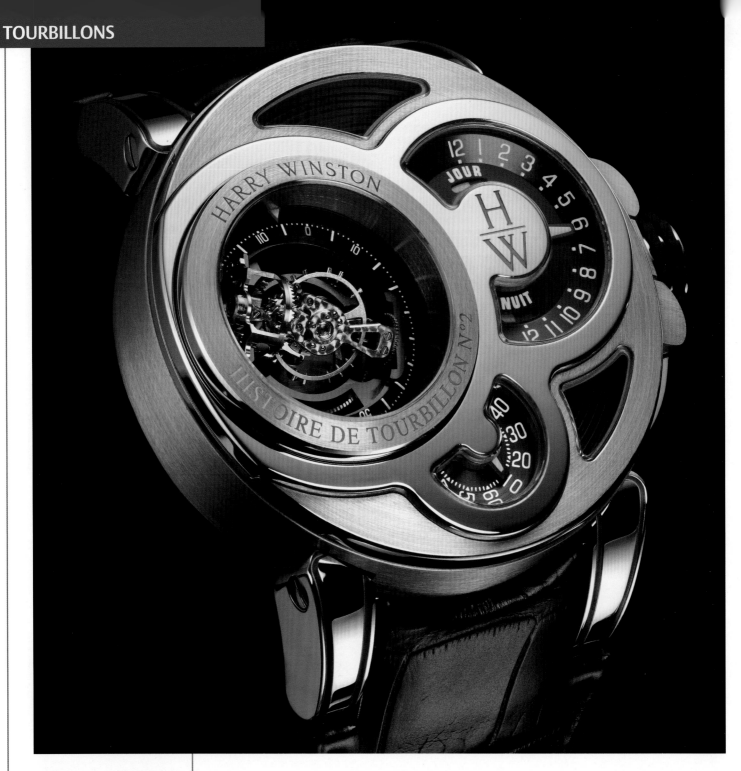

HARRY WINSTON

HISTOIRE DE TOURBILLON 2 – REF. 500/MMT48WL.K

Featuring an ingenious construction that includes a bi-axial flying tourbillon, Histoire de Tourbillon 2 offers its very own interpretation of time measurement. Eight sapphire crystals punctuate the case's front and back. Powered by a mechanical hand-wound movement exclusively developed for Harry Winston, Histoire de Tourbillon 2 showcases the supreme complication in a setting worthy of its stature. While the tourbillon plays the starring role, the hours and minutes appear in their respective subdials at 2:00 and 6:00. Underscored by a beveled inner bezel ring, they are swept over by orange-accented hands standing out clearly against the opaline black dial background. This exclusive timepiece is available in a limited edition of just 20 pieces.

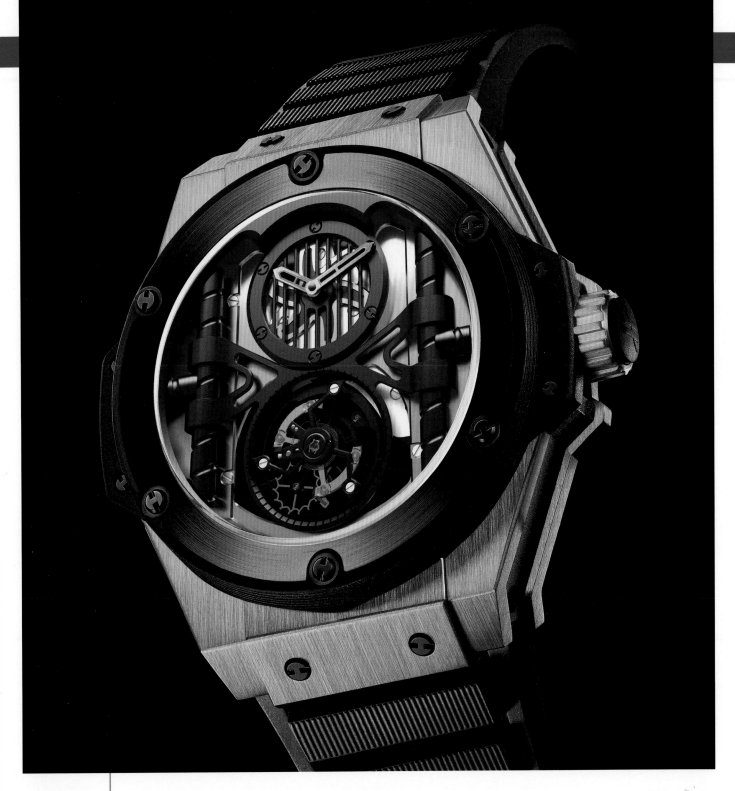

HUBLOT

KING GOLD CERAMIC TOURBILLON MANUFACTURE – REF. 705.OM.0007.RX

This piece houses the HUB6002 caliber in a handsome 48mm King Power case in satin-finished 18K King Gold. The movement powers a tourbillon at 6:00 with a small seconds display, while hours and minutes tick away in an off-center subdial at 12:00. The sapphire crystal is treated with an antireflective coating, and the caseback is crafted in satin-finished 18K King Gold. The piece is mounted on a black rubber strap with a deployant buckle clasp in 18K red gold.

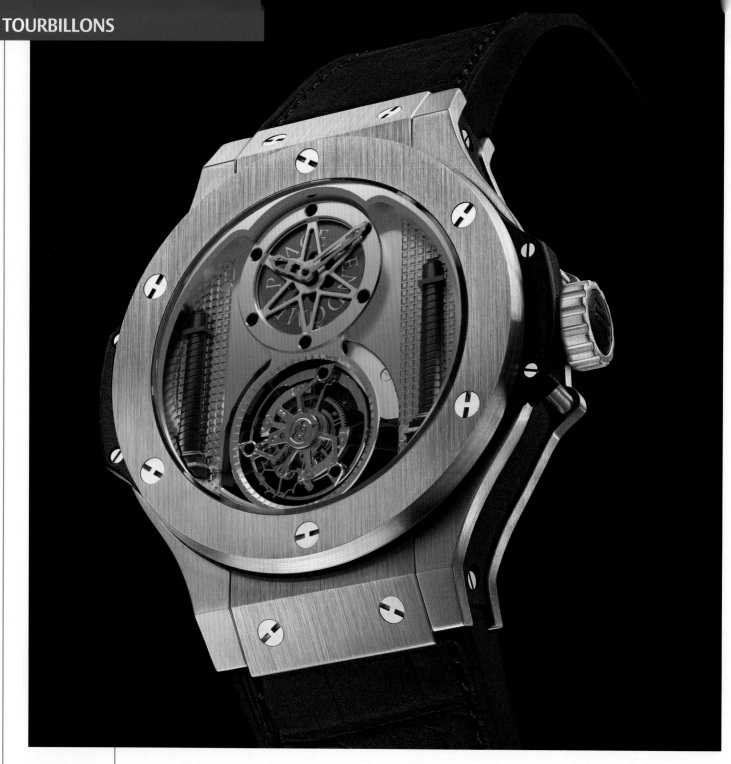

HUBLOT

VENDOME GOLD TOURBILLON – REF. 305.PX.0009.GR

The Vendôme Collection showcases some of Hublot's most exceptional pieces, and the Gold Tourbillon is a stunning example. Housed in a 44mm satin-finished 18K red-gold Big Bang case, the timepiece also features an 18K red-gold dial that showcases the tourbillon and associated seconds subdial at 6:00 and displays hours and minutes in an off-center subdial at 12:00, whose hands are treated with a black luminescent coating. The HUB6003 movement provides a 120-hour power reserve.

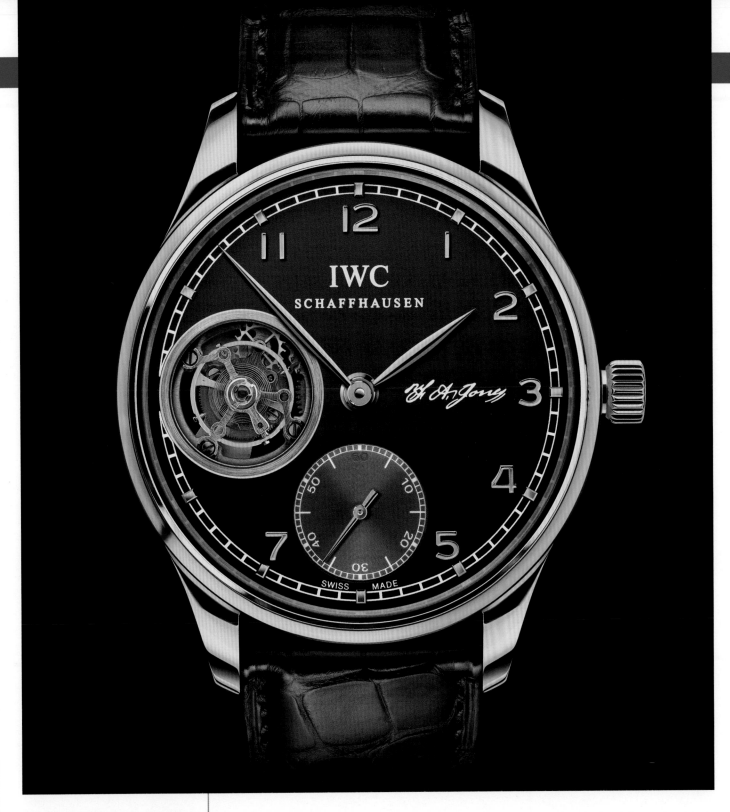

IWC SCHAFFHAUSEN

PORTUGUESE TOURBILLON HAND-WOUND – REF. IW544705

In the new Portuguese Tourbillon Hand-Wound, the "whirlwind"—as the word translates—revolves on its axis at 9:00 on the dial, or, in nautical terms, at 270° west. The sight of the mechanical, cantilever-mounted minute tourbillon revolving around its own axis invariably attracts rapt attention from watch lovers. Gracing the dial on the opposite side, at 3:00, is the flowing signature of company founder F. A. Jones. Watch cognoscenti will be unable to resist the temptation to cast a glance through the transparent sapphire crystal back, where they will see the IWC-manufactured 98900-calibre movement with its intricately decorated, nickel-plated three-quarter bridge made of nickel silver. It belongs in the long tradition of the 98 caliber, which was first designed for hunter pocket-watches in the 1930s and has since been continuously improved. For this model, IWC's engineers increased the balance frequency to 28,800 vph, which guarantees excellent precision. As you would expect of such a desirable timepiece, this gem in 18K red gold is strictly limited to 500 watches.

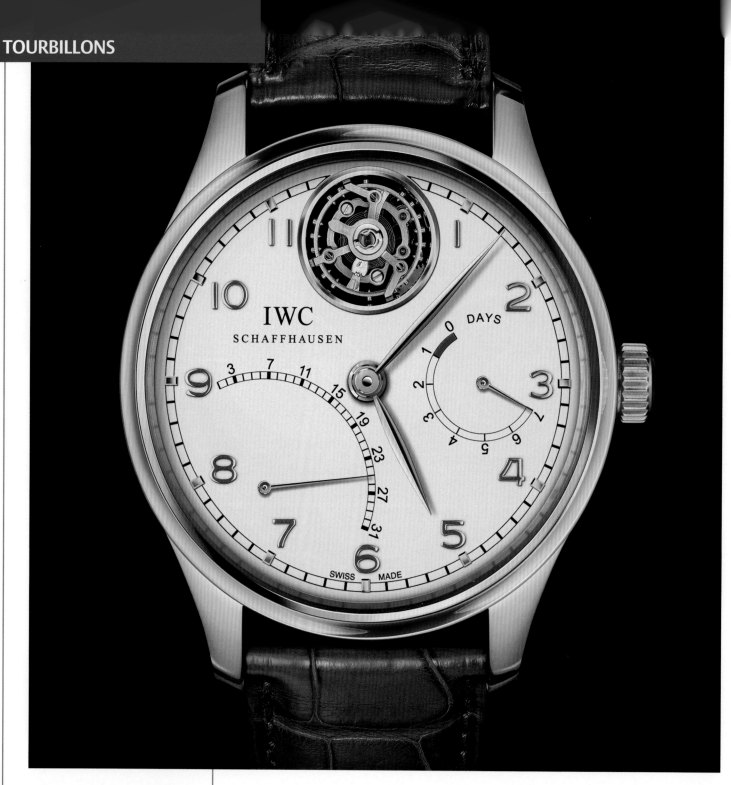

IWC SCHAFFHAUSEN

PORTUGUESE TOURBILLON MYSTERE RETROGRADE – REF. IW504402

With an appearance as magical as it is distinctive, the Portuguese Tourbillon Mystère Rétrograde is guaranteed to attract inquisitive glances. Watch lovers will be particularly fascinated by the unusual arrangement of the flying tourbillon, consisting of 81 parts, against a deep black background, creating the illusion that the filigree cage containing the balance is rotating in mid-air. Set in a mirror-finished ring, it resembles an animated "12" and forms the optical centerpiece of the entire dial. The retrograde date display is not only an original complication but also makes a good deal of sense, because a conventional date disc would conceal the tourbillon. After the 31st of the month, it automatically jumps back to the 1st; in shorter months, the hand can be rapidly advanced until it reverts to the 1st. On the right-hand side of the dial, the 7-day power reserve display indicates how much energy remains in the IWC-manufactured 51900 caliber. As befitting a timepiece of this quality, the Portuguese Tourbillon Mystère Rétrograde premieres in a glamorous red-gold case with a silver-colored dial and in platinum with a dial in ruthenium black.

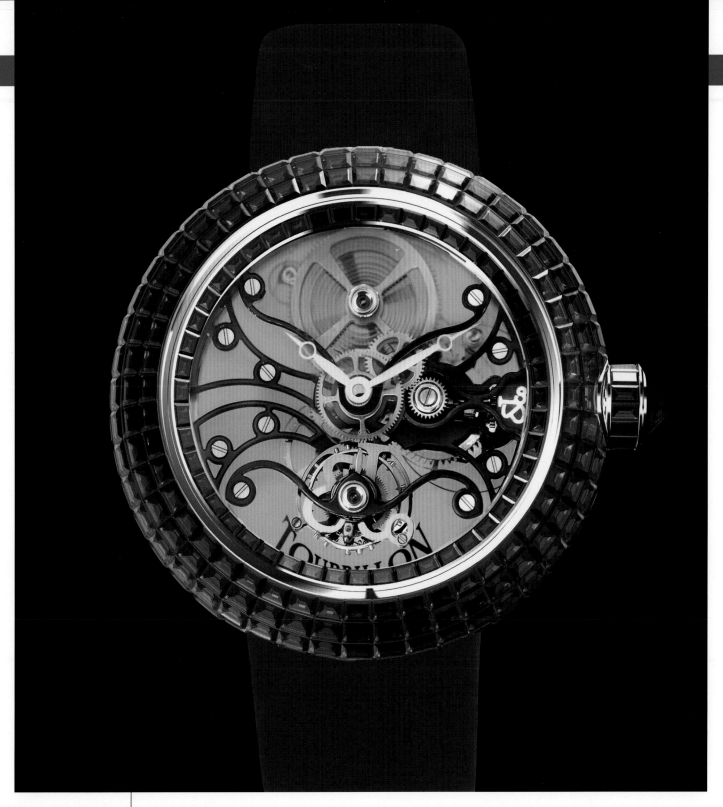

JACOB & CO

CRYSTAL TOURBILLON – REF. CR2

The Crystal Tourbillon is powered by the manual-winding Jacob & Co 7 Caliber, skeletonized and set with 1.6 carats of baguette-cut diamonds. The tourbillon movement can be seen through both the transparent dial and the exhibition caseback. The 47mm case, crafted in 18K white gold, is set with 17.48 carats of baguette-cut diamonds. Mounted on a satin strap, the watch also bears 2.22 carats of baguette-cut diamonds on its buckle.

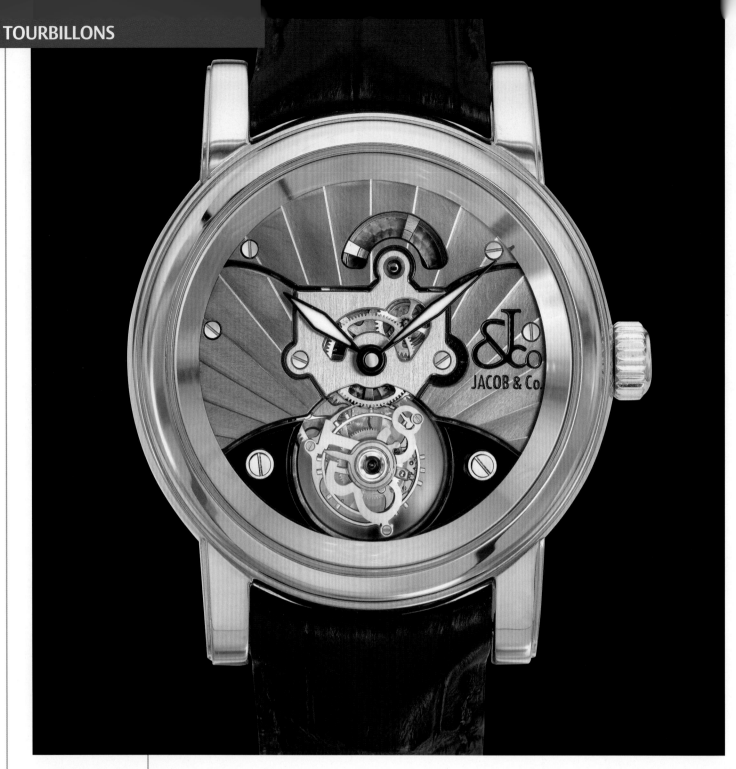

JACOB & CO

PANGEA TOURBILLON – REF. PANGWG

A masterpiece of mechanical complexity, the Pangea Tourbillon is powered by the Jacob & Co Caliber 2901. This state-of-the-art tourbillon beats at 28,800 vph and offers a 50-hour power reserve. With a 46mm case crafted in 18K white gold, the Pangea Tourbillon collection will be produced in a limited edition of 18 pieces, ensuring its exclusivity.

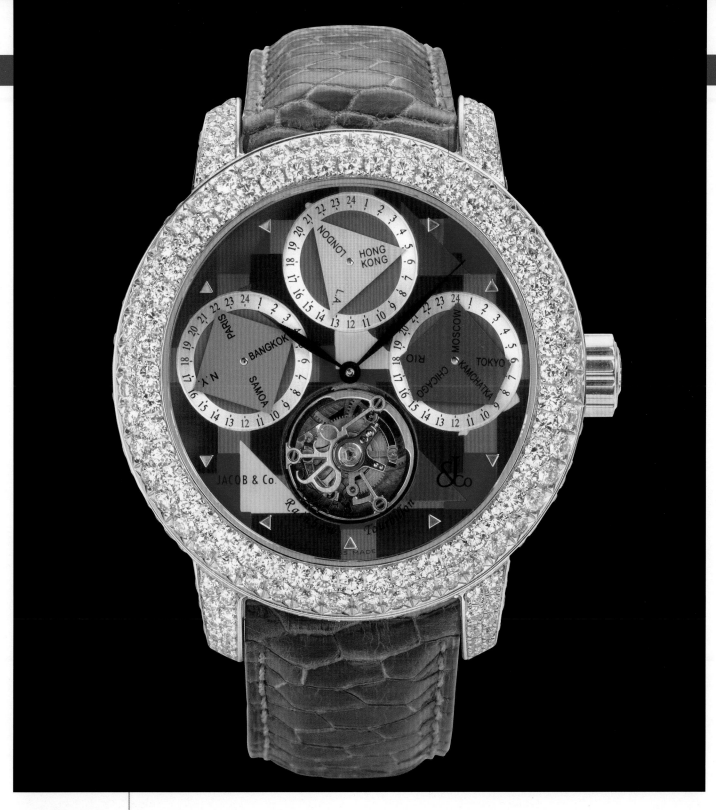

JACOB & CO

RAINBOW TOURBILLON – REF. R1WGDC

In the pursuit of sophistication, innovation, and perfection in the field of fine watchmaking, Jacob & Co visualized the combination of a tourbillon device with the multiple time zone concept. The resulting world-class product was the Rainbow Tourbillon, the first timepiece to marry these two features in a limited edition collection. The specific time zone varies by style, with the timepiece covering between 12 and 24 time zones in addition to the primary time zone of the wearer. The 24-jewel movement operates at a frequency of 21,600 vph, with a 120-hour power reserve. The movement is a mechanical manual-winding tourbillon device visible through the dial and the exhibition caseback. The limited edition series of 47.5mm timepieces with 11.72 carats of diamonds on the case will feature 18 pieces produced in each metal: white, yellow and rose gold.

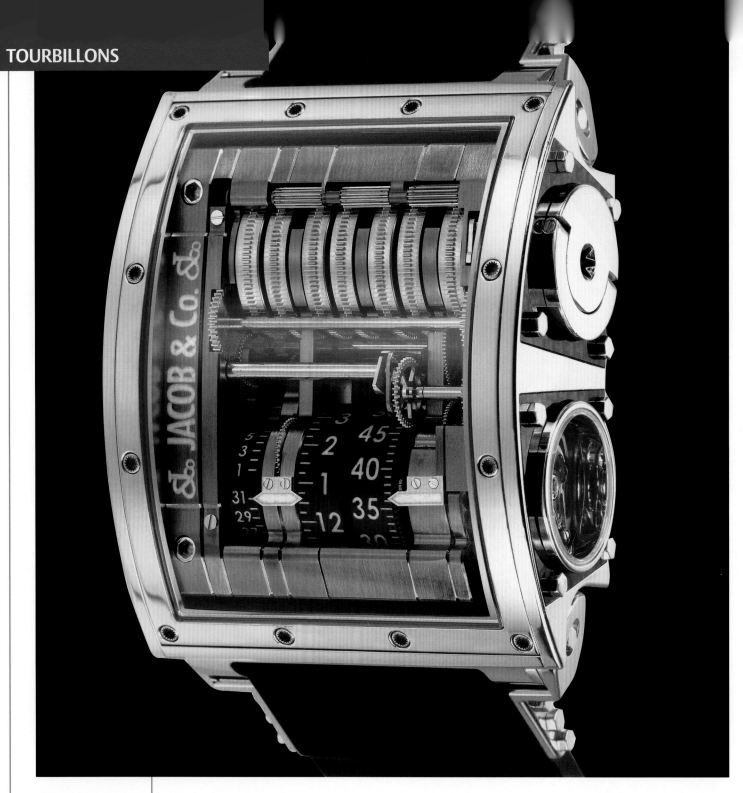

JACOB & CO

THE QUENTTIN – REF. QUENRG

The Quenttin is the most technically advanced in the Jacob & Co family and arguably throughout the timepiece world. This limited edition, Swiss made, technically sophisticated instrument melds movement and state-of-the-art craftsmanship. The Quenttin, housing a vertical mechanical movement with manual-winding escapement, has the first ever 31-day power reserve supplied by the energy of seven spring barrels. Due to the unique configuration of this revolutionary tourbillon, the hours, minutes and power reserve are indicated by vertical discs assembled coaxially. Only 135 pieces of this innovative timepiece will be created; 99 pieces in white gold, 18 pieces in 18K rose gold and 18 pieces in magnesium.

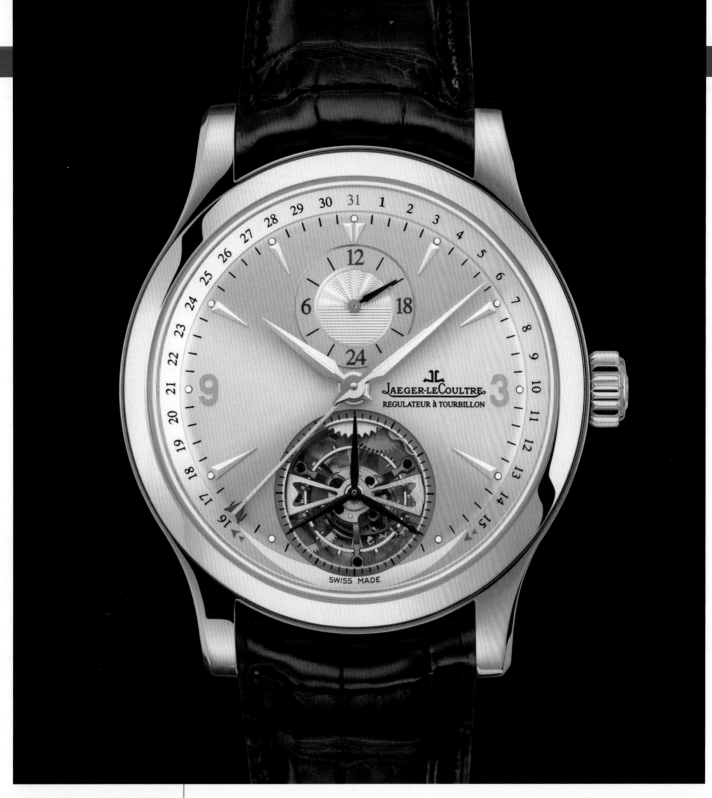

JAEGER-LeCOULTRE

MASTER TOURBILLON – REF. 165.24.20

The Master Tourbillon shows off its namesake complication in a classic display at 6:00, which finds an echo at 12:00 in a small second time zone indication. A red-tipped hand slowly sweeps around the dial to indicate the date—slowly, that is, until it swiftly makes the transition from 15 to 16, so as not to obstruct the tourbillon. All of this is driven by the automatic-winding Jaeger-LeCoultre 978 caliber, which possesses 302 components and 33 jewels. The silvered, sunray-brushed dial is adorned with gilt Arabic numerals and hour markers that match the piece's 18K pink-gold case, which is water resistant to 50m.

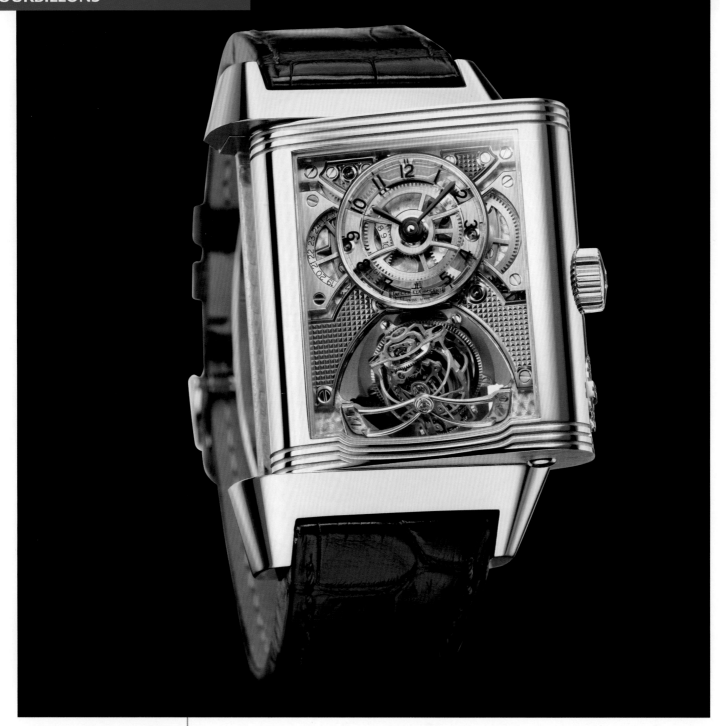

JAEGER-LeCOULTRE

REVERSO GYROTOURBILLON 2 – REF. 233.64.20

An extremely sophisticated tourbillon rotates in three dimensions on the Reverso Gyrotourbillon 2, whose front dial also displays hours, minutes, seconds and a 24-hour display. The spherical tourbillon innovates with a cylindrical balance-spring, used here for the first time in a wristwatch, that ensures greater accuracy. Powered by the Jaeger-LeCoultre 174, which boasts 373 components and 58 jewels, the piece takes advantage of its iconic Reverso case to place a movement operating indicator on the back dial. The platinum 950 case frames a rhodium-plated white-gold dial with Clous de Paris on the front, as well as a rhodium-plated white-gold dial on the back.

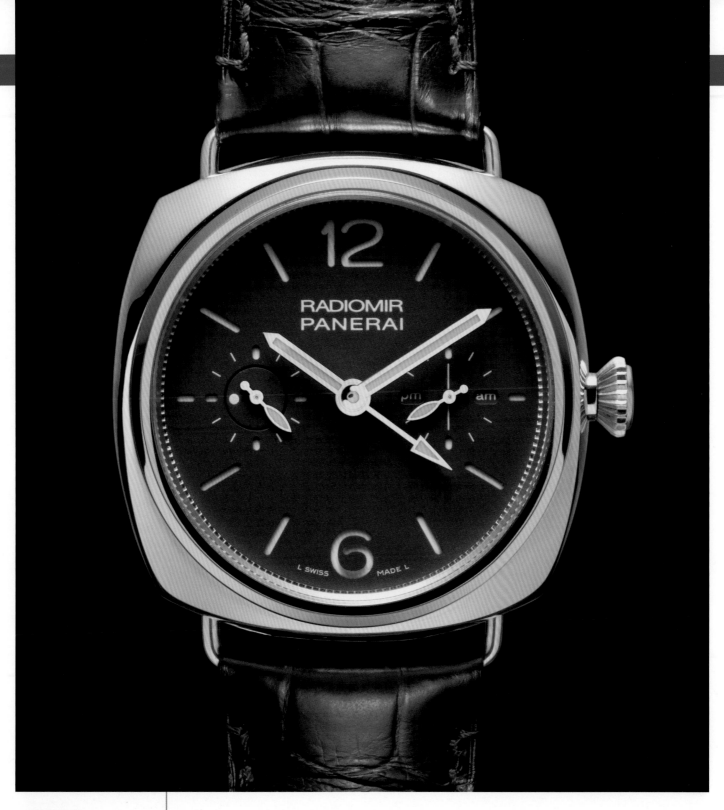

PANERAI

RADIOMIR TOURBILLON GMT – REF. PAM00330

A faithful reproduction of the very first watches of its kind, the Radiomir Tourbillon GMT 48mm in pink gold is powered by the caliber P.2005 with tourbillon, representing the sophistication of Officine Panerai's manufacturing skill. Not only does the cage make a full rotation in 30 seconds instead of every minute, it is also the only existing tourbillon to place the rotating balance wheel inside a cage that is perpendicular to the base of the movement. This unusual feature better compensates for any positional inaccuracies the watch may assume while being worn on the wrist. Made up of 239 components and featuring a six-day power reserve, this structurally complex and highly innovative manual-winding movement is revealed through the sapphire crystal caseback and stealthily indicated by the luminescent dot at 9:00. This piece is water resistant to 10 bar (100m).

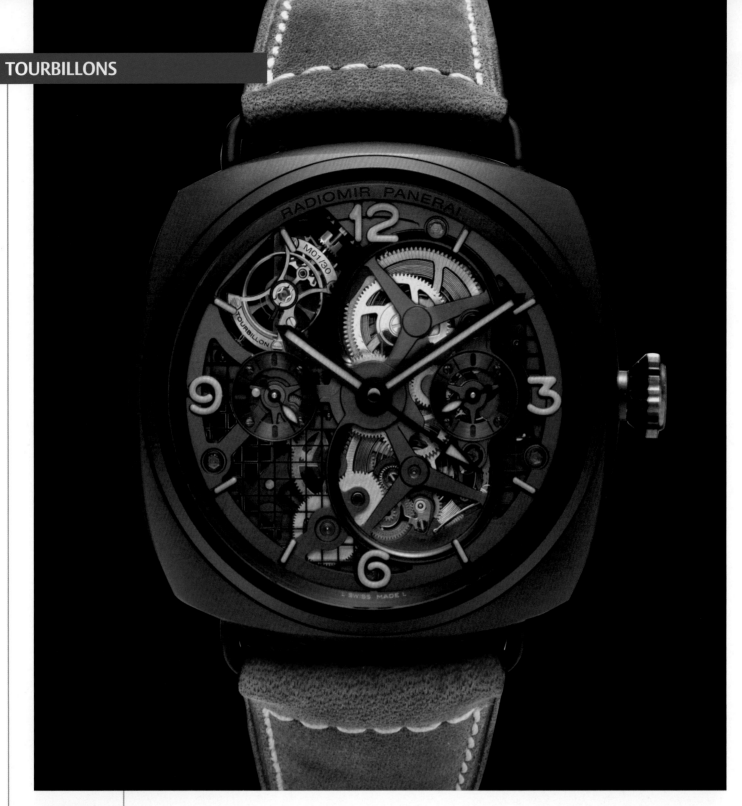

PANERAI

RADIOMIR TOURBILLON GMT CERAMICA, 48MM – REF. PAM00348

As part of Officine Panerai's dual-timepiece tribute to the 400th anniversary of Galileo Galilei's discovery of the four moons of Jupiter, the ambitious manufacturer set about creating the aesthetically groundbreaking Radiomir Tourbillon GMT Ceramica 48mm, also known affectionately to Panerai fans as "Lo Scienziato." The main novelty of Lo Scienziato is its refined skeletal structure, made of a fine mesh that supports the external band (which has small ecru luminescent Arabic numerals and hour markers) as well as subdials showing small seconds, tourbillon movement and AM/PM. The second time zone is indicated by a third central hand. It is powered by the 277-component P.2005/S movement, which is characterized by its tourbillon that rotates perpendicularly to the balance axis and completes two rotations per minute to guarantee greater precision. The case itself is made of a zirconium oxide ceramic, an exceptionally hard, corrosion-resistant material, and is water resistant to 10 bar (100m), qualifying it as a true traditional Radiomir. This tribute to the Florentine astronomer will be available in a limited edition of 30 pieces.

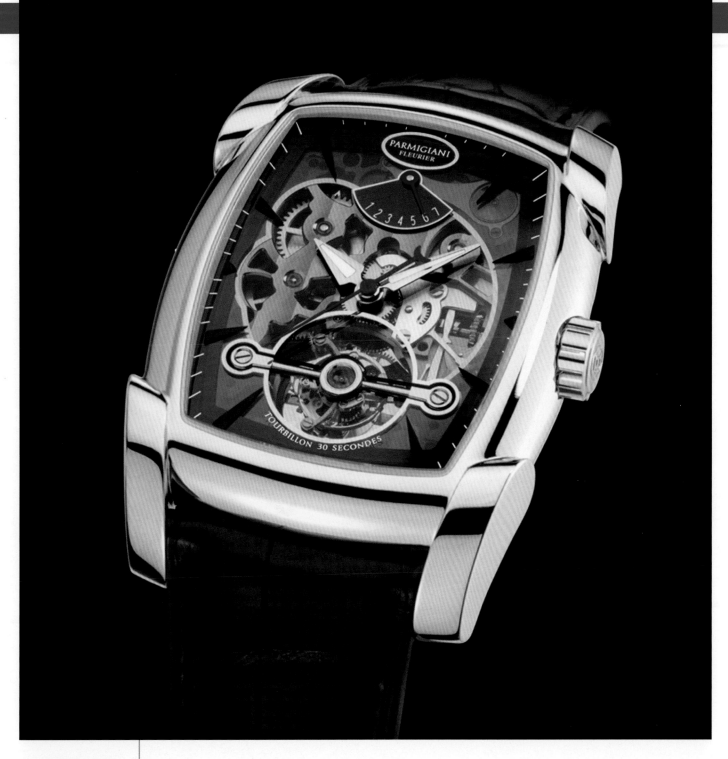

PARMIGIANI

KALPA XL TOURBILLON – REF. PFH159-2002800

Parmigiani's Kalpa XL Tourbillon displays hours, minutes, seconds and the power reserve, as well as a tourbillon at 6:00. The watch's PF500.01 movement is encased in a 44.7x37.2mm case, which is water resistant to 30m. The dial features an openworked center and delta-shaped hands. The Kalpa XL Tourbillon is set on a Hermès alligator with ardillon buckle. In a diamond-set version, 215 baguette-cut diamonds adorn the exterior. This piece is also available in rose gold.

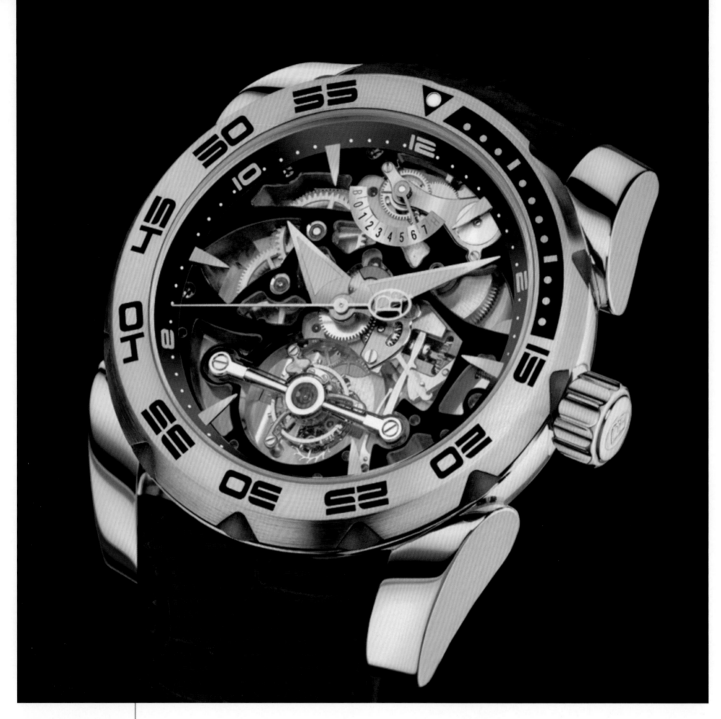

PARMIGIANI

PERSHING OPENWORKED TOURBILLON – REF. PFH552-1010300

Parmigiani's Pershing Openworked Tourbillon is powered by the PF511 movement within its 45mm case, crafted in 18K rose gold. This watch, which boasts a 30-second tourbillon, displays hours, minutes, seconds and power reserve on the sapphire crystal dial and its case is water resistant to 200m. The openworked sapphire dial features rhodium-plated applied indexes and delta-shaped hands with luminescent coating. An Hermès alligator strap with safety folding buckle completes the piece's allure. A palladium version is also available, featuring a bezel adorned with 60 baguette-cut diamonds.

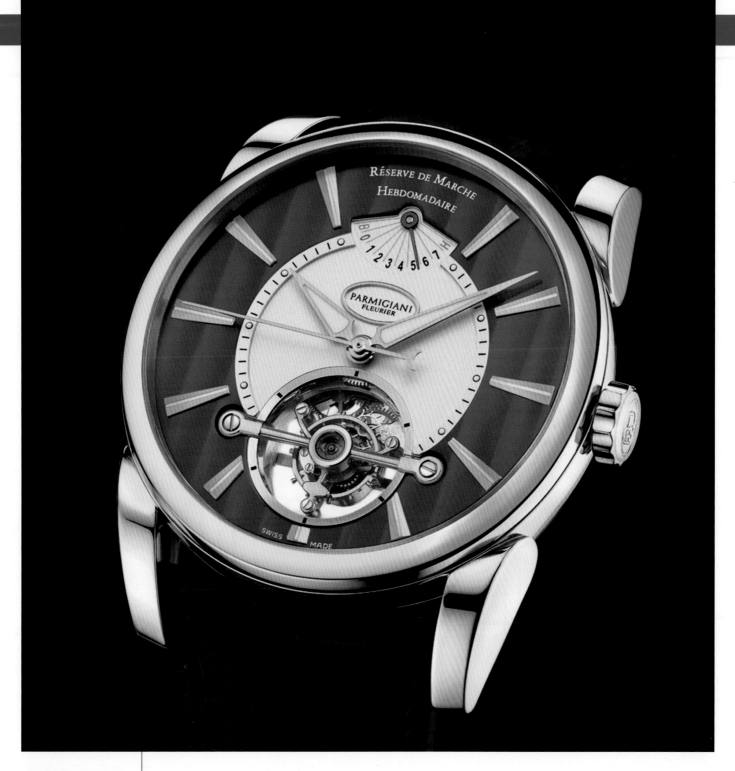

PARMIGIANI

TONDA 42 TOURBILLON – REF. PFH251-2000200

Parmigiani's Tonda 42 Tourbillon is powered by the PF510.01 movement within its 42mm case, crafted in platinum. This timepiece is water resistant to 30m and displays hours, minutes, seconds and power reserve. The dial is decorated with Côtes de Genève, a velvet-finished center, trapezoidal applied indexes with luminescent coating, and delta-shaped hands. The watch is mounted on an Hermès alligator strap with safety folding buckle. The piece is also available in rose gold.

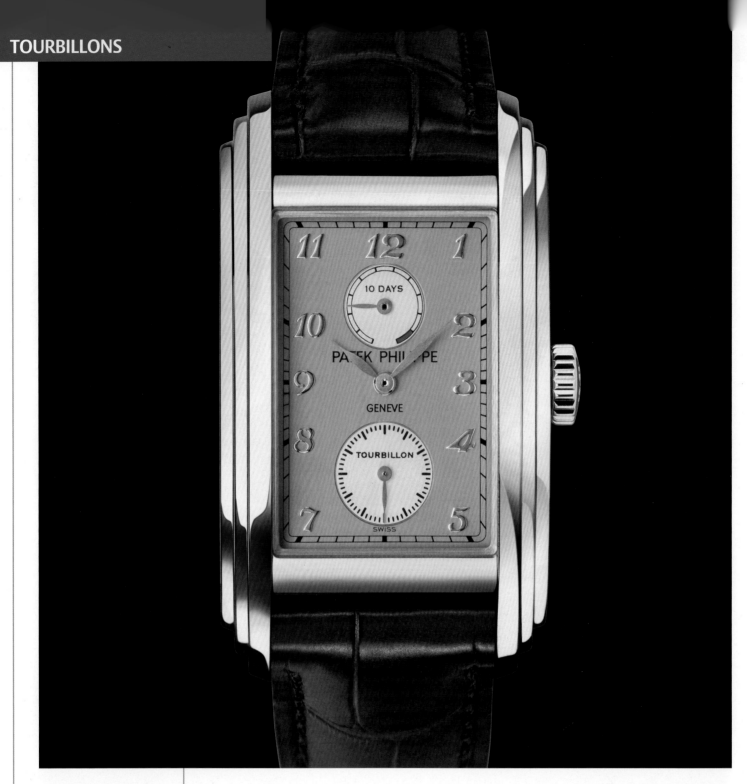

PATEK PHILIPPE

10 DAY TOURBILLON – REF. 5101R

The new Ref. 5150R runs accurately for 240 hours when fully wound, as indicated by the power reserve indicator at 12:00. In this extraordinary 28-20/222 manufacture movement, Patek Philippe has implemented yet another rare mechanism: a tourbillon escapement. The device consists of 72 individual parts that together weigh a scant 0.3g. All steel parts of the filigreed cage are meticulously finished by hand. Despite its considerable length of more than 5cm, the anatomically curved 18K rose-gold case gently hugs the wrist. The sapphire crystal caseback reveals the meticulously decorated plate and bridges, the intricate tourbillon, and the jewels held in gold chatons.

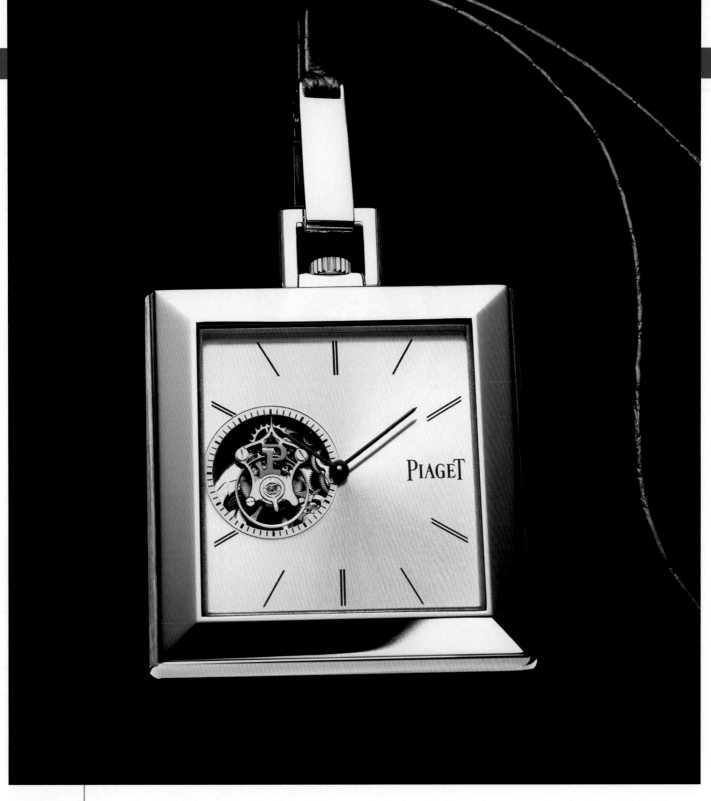

PIAGET

ALTIPLANO TOURBILLON GOUSSET IN WHITE GOLD — REF. G0A32063

Piaget now revives the tourbillon pocket watch, interpreted in a highly contemporary square form characteristic of the brand, that of the Altiplano collection. The 40mm white-gold case houses the Piaget mechanical hand-wound Calibre 600P, the world's thinnest tourbillon movement at just 3.5mm thick. Admirably reflecting the mastery inherent to the manufacture, the carriage of this tourbillon—visible through a dial opening at 9:00—is made of 42 parts and weighs a mere 0.2g. Like all vintage Piaget models, the caseback is engraved with the brand's coat of arms. To provide a variety of manners of wearing it, this refined and elegant watch comes with a white-gold chain as well as a leather cordlet.

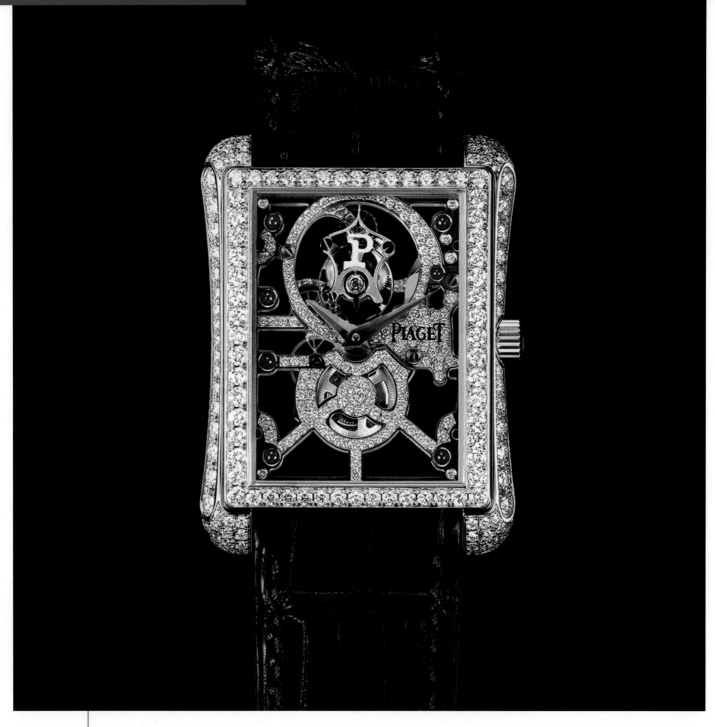

PIAGET

PIAGET EMPERADOR GEMSET TOURBILLON SKELETON – REF. G0A31047

This Emperador Tourbillon symbolizes the alchemist's blend that Piaget achieves once again between haute horology and haute joaillerie. Piaget has developed the world's thinnest tourbillon, at a mere 3.5mm thick, and has chosen a flying version placed at 12:00 for aesthetic reasons. 159 round diamonds totaling approximately 0.2 carat and 7 sapphire cabochons (0.2 carat) adorn this exceptional caliber, whose lower side is graced with the extreme refinement of a sunray guilloché decorative motif comprising 60 divisions, which correspond to 60 seconds. This hand-wound movement has a power reserve of approximately 40 hours and beats at a cadence of 21,600 vph.

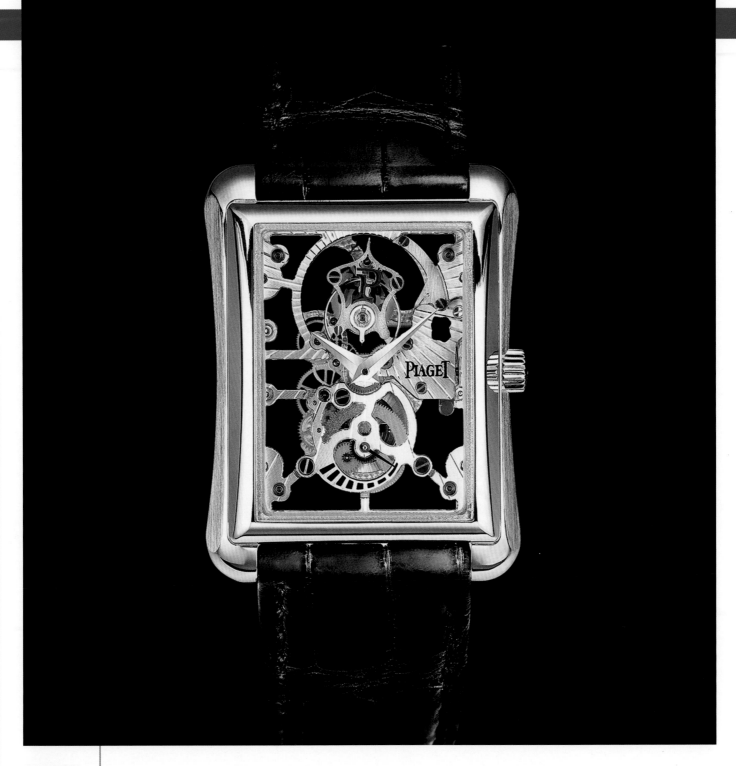

PIAGET

PIAGET EMPERADOR SKELETON TOURBILLON – REF. G0A29108

Equipped with the mechanical manual-winding Piaget 600P shaped caliber, this Piaget Emperador tourbillon symbolizes the alchemist's blend that Piaget achieves once again between haute horology and haute jewelry. Piaget has developed the world's thinnest tourbillon, a mere 3.5mm thick, and has chosen a flying version placed at 12:00 for aesthetic reasons. The shaped caliber's lower side is graced with the extreme refinement of a sunray guilloché decorative motif comprising 60 divisions representing 60 seconds. This movement has a power reserve of approximately 40 hours and beats at a cadence of 21,600 vph.

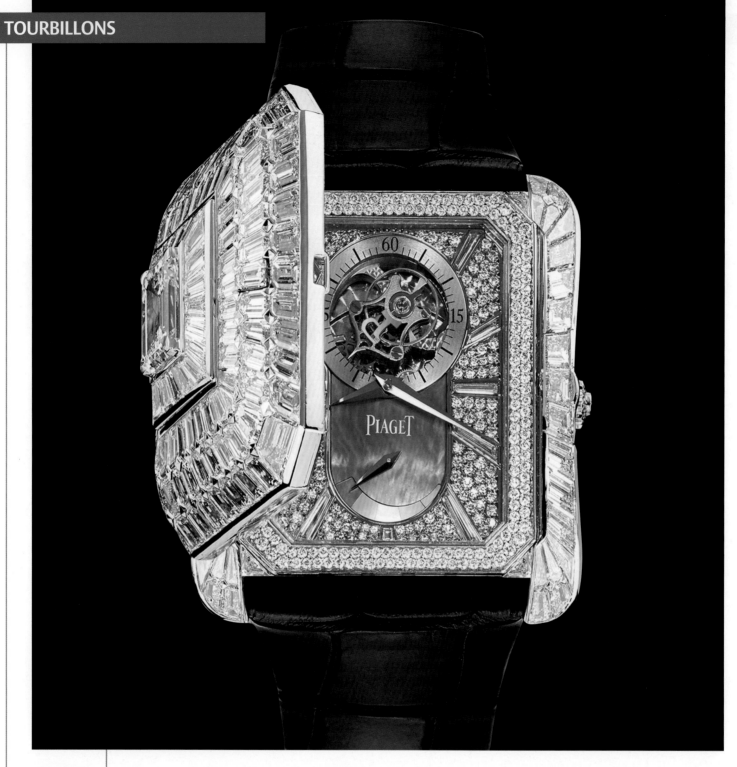

PIAGET

PIAGET EMPERADOR TOURBILLON – REF. G0A32246

This watch hides two timepieces: the first one contains a small quartz movement under a dial of inlaid white mother-of-pearl, set in a module that drops down when closed. But a new surprise lies in the discovery of a second watch—the world's thinnest version of a tourbillon (Calibre Piaget 600P) highlighted in a diamond-rimmed dial, baguette hour-markers and a center of Polynesian mother-of-pearl as well as a power reserve indicator in inlaid colored mother-of-pearl. The case, encrusted with 589 brilliant-cut diamonds (approximately 2.9 carats) and 207 baguette-cut diamonds (approximately 32.9 carats) each cut and set by hand, extends to a black alligator leather bracelet.

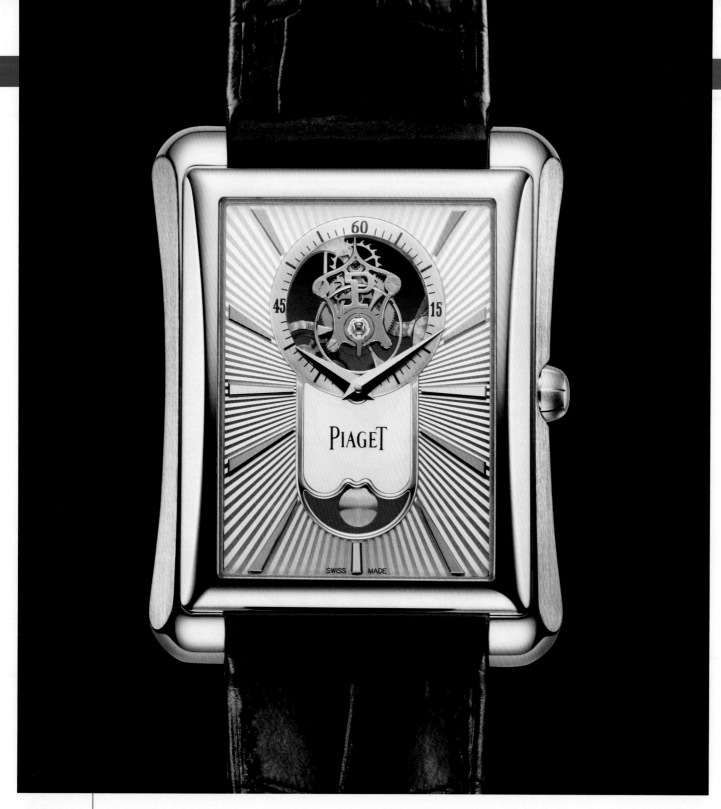

PIAGET EMPERADOR TOURBILLON MOON PHASE – REF. G0A35121

The Piaget Emperador Tourbillon Moon Phase houses the Calibre 640P, an ultra-thin manual-winding mechanical tourbillon measuring 3.5mm. This tourbillon maintains the sophisticated lines and finishings of the Piaget Emperador watches, but offers a more powerful and masculine size. The carriage of this tourbillon—visible through a dial opening at 12:00—consists of 42 parts and weighs a mere 0.2g. A moonphase display appears at 6:00 on a sunburst guilloché dial with 18K white-gold appliqués. A golden moon and a star-studded pyrite dial enhance the lapis lazuli moonphase disc.

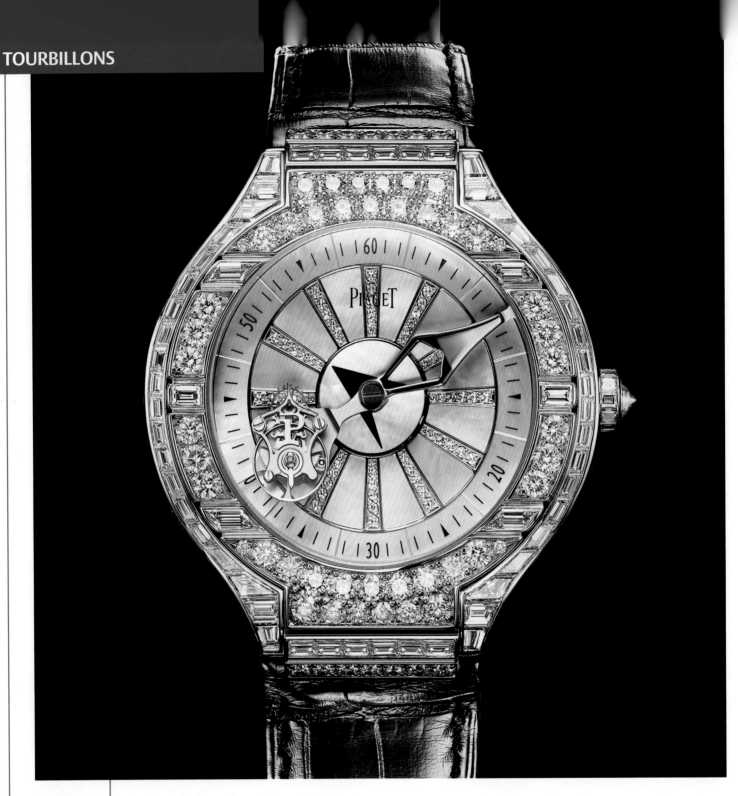

PIAGET

PIAGET POLO GEMSET TOURBILLON RELATIF – REF. G0A32148

The Piaget Polo Gemset Tourbillon Relatif, a huge success and exclusive to Piaget, features a rotating mobile carriage apparently disembodied from the movement at the end of the minute hand. This watch houses the Calibre 608P, a mechanical manual-winding flying tourbillon movement beating at a frequency of 21,600 vph and endowed with a 72-hour power reserve. Development took three years and watchmakers needed almost a week to assemble each piece. The case is covered with brilliant-cut and baguette diamonds, each cut and set by hand. Each numbered piece sparkles with 731 diamonds weighing a total 19.3 carats. Setting them in sequence took around 200 hours.

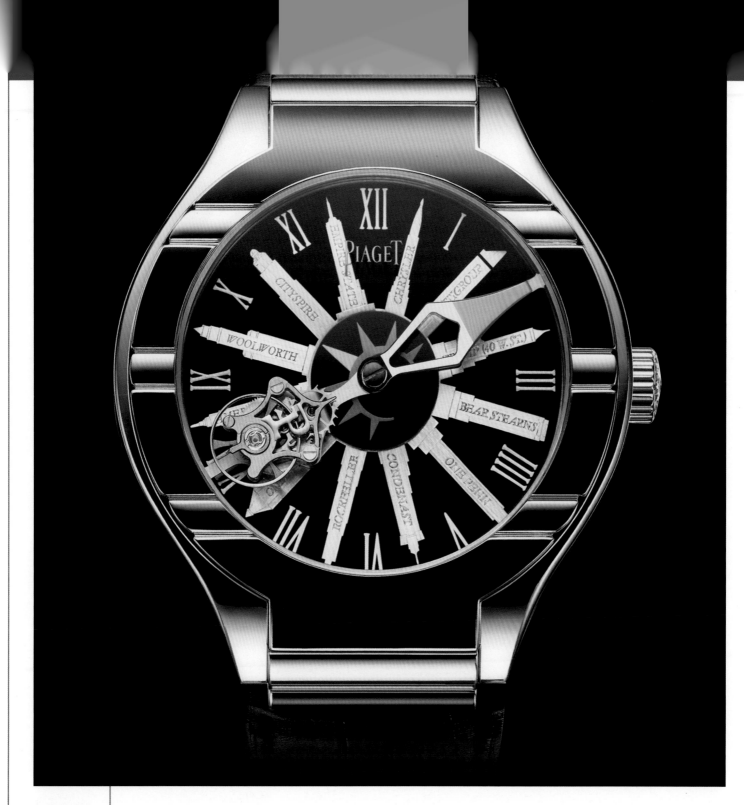

PIAGET

PIAGET POLO TOURBILLON RELATIF ENAMEL PERSONALISED – REF. G0A33045

This creation evokes the black and white colors of a classic New York evening. The Polo Tourbillon Relatif combines the complexity of a Piaget 608P flying tourbillon movement with the extreme sophistication of a stunningly beautiful enameled and chased décor. The Calibre 608P is housed within an 18K white-gold champlevé enameled case. The outlines of the city's twelve highest skyscrapers are engraved on an 18K white-gold dial, illuminated by the contrasts with black enamel surrounding them. Moreover, the black enameled side of the case is engraved with the most famous landmarks, and the crown of the model bears a symbol representing New York.

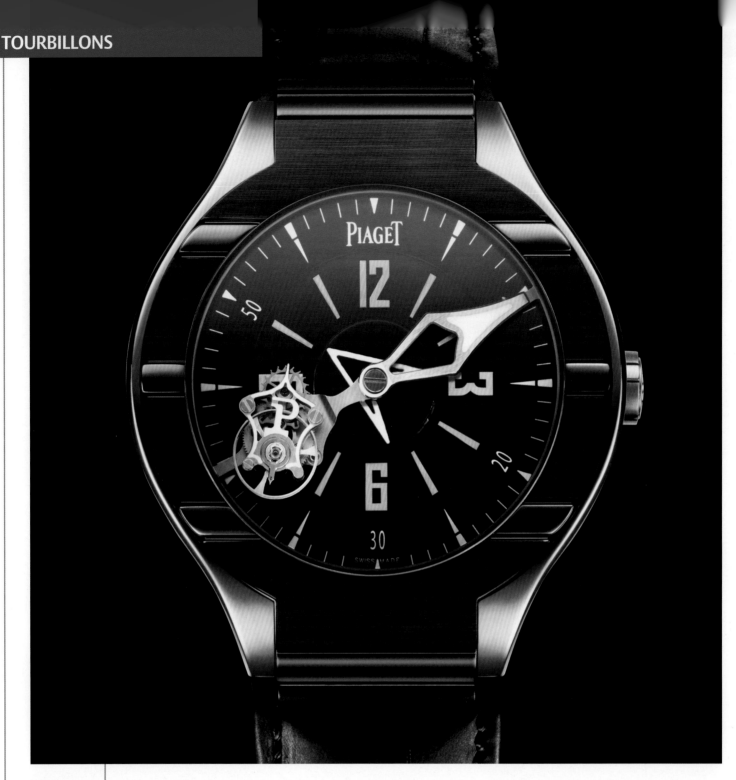

PIAGET

PIAGET POLO TOURBILLON RELATIF IN PINK GOLD — REF. G0A35124

Suspended from one end of the minute hand, the flying tourbillon carriage appears to be disconnected from the base movement driving it. The hours are read off a central disc, while the tourbillon carriage is swept along in the rotation of the minute hand. Expressing the magic of perfect equilibrium, the Piaget Polo Tourbillon Relatif marks off time to the rhythm of the new proprietary Calibre 608P, a mechanical manual-winding flying tourbillon movement. Composed of 42 parts, the carriage—which spins on its axis once per minute, in addition to the hourly rotation around the dial—weighs a mere 0.2g! Within a 45mm black and 18K rose-gold case, the tourbillon movement, Piaget Calibre 608P, beats at a frequency of 21,600 vph and is endowed with a 72-hour power reserve.

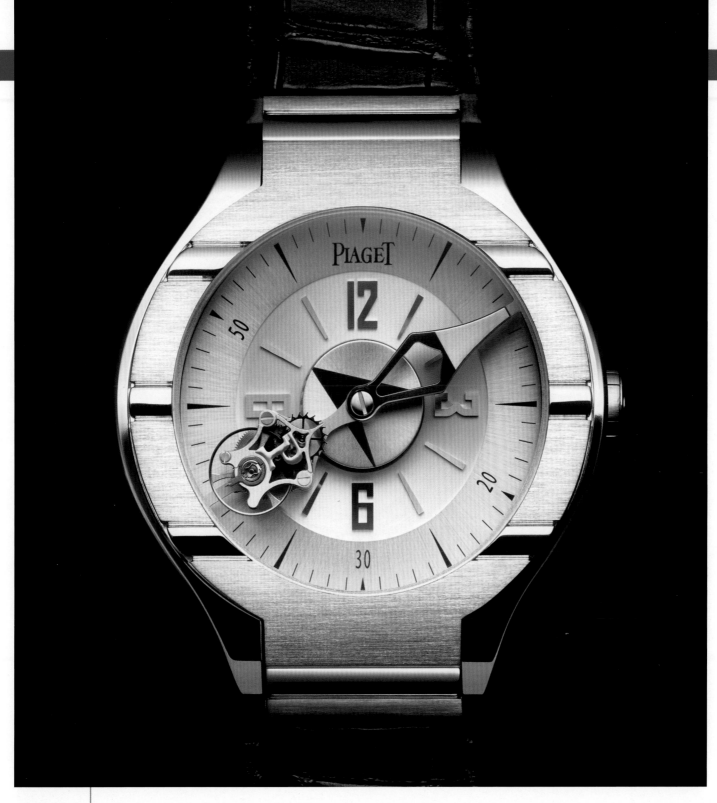

PIAGET

PIAGET POLO TOURBILLON RELATIF IN WHITE GOLD – REF. G0A31123

Suspended from one end of the minute hand, the flying tourbillon carriage appears to be disconnected from the base movement driving it. The hours are read off a central disc, while the tourbillon carriage is swept along in the rotation of the minute hand. Expressing the magic of perfect equilibrium, the Piaget Polo Tourbillon Relatif marks off time to the rhythm of the new proprietary Calibre 608P, a mechanical hand-wound flying tourbillon movement. Composed of 42 parts, the carriage—which spins on its axis once per minute, in addition to the hourly rotation around the dial—weighs a mere 0.2g! The tourbillon movement, Piaget Calibre 608P, beats at a frequency of 21,600 vph (3 Hz) and is endowed with a 72-hour power reserve.

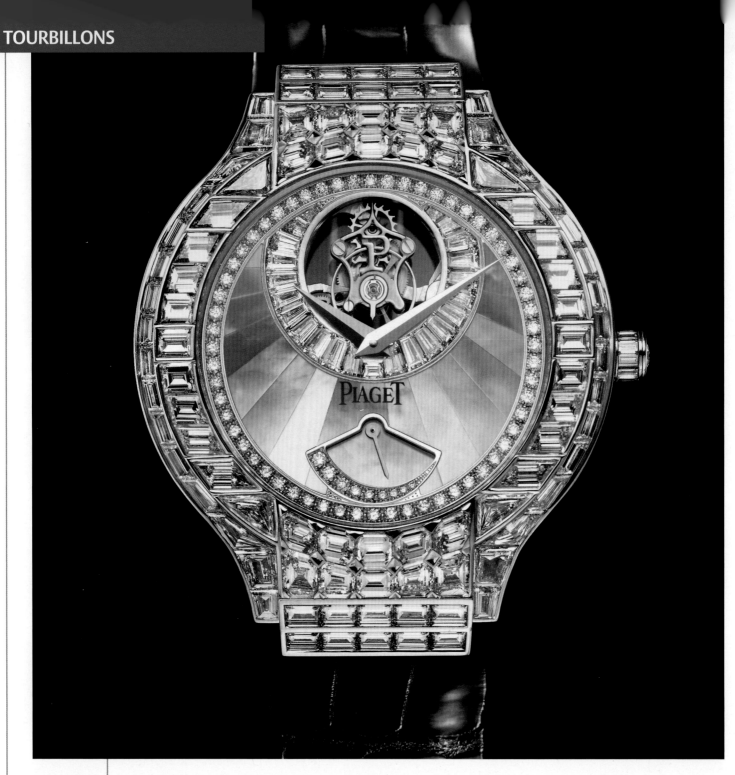

PIAGET

PIAGET POLO TOURBILLON IN WHITE GOLD – REF. G0A30111

A wonderful rendition of an iconic timepiece, this Piaget Polo Tourbillon is equipped with the shaped 600P caliber. The mechanical manual-winding movement consists of 24 jewels and offers 40 hours of power reserve; the bridges of the tourbillon are created in titanium. The case is crafted in 18K white gold and set with fancy-cut diamonds.

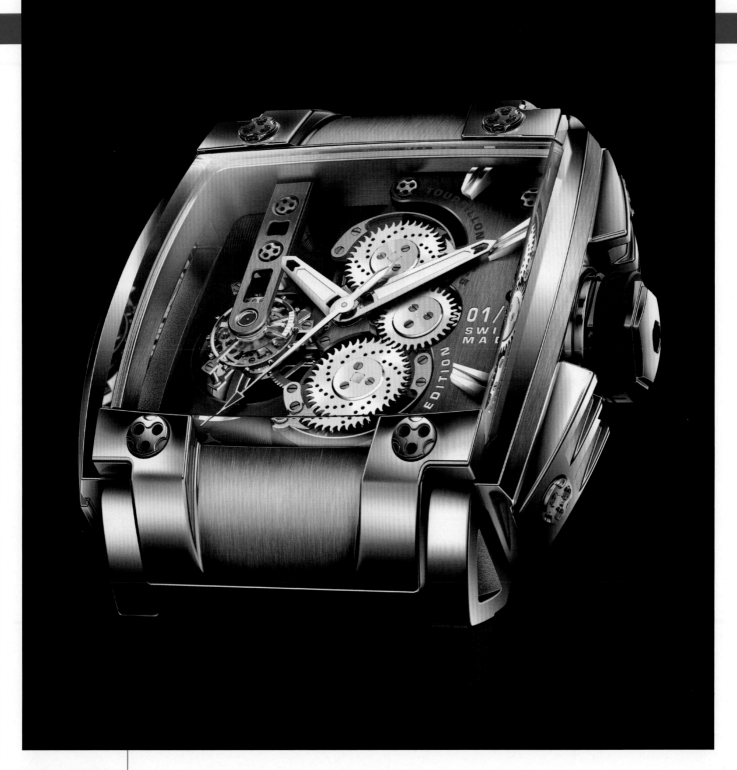

REBELLION

REB-5 TOURBILLON ROSE GOLD – REF. REB5TFG

In making a complete revolution every 60 seconds, Rebellion's REB-5 stands out from the crowd, both technically and aesthetically, by using twin mainspring barrels to provide a massive seven days of power! It is an achievement perhaps less surprising on discovering that the movement was developed specifically for Rebellion by renowned Swiss master watchmaker Laurent Besse. The REB-5 is available in an extremely exclusive limited edition of just 12 pieces per year.

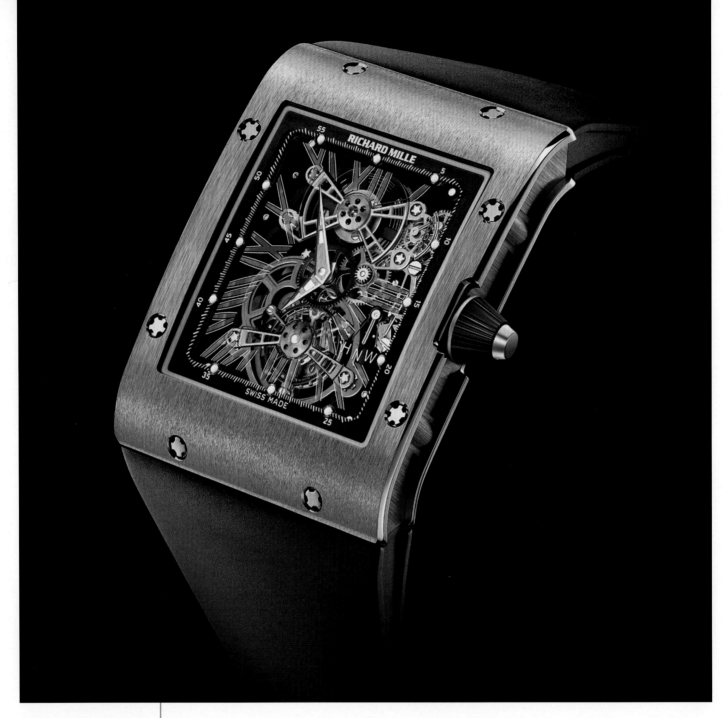

RICHARD MILLE

RM 017 EXTRA FLAT TOURBILLON

A world premiere for 2011, with a total thickness comprising a mere 8.7mm, the new RM017 with its manual-winding movement with circa 70 hours power reserve is amongst the thinnest tourbillon constructions ever created. The RM017 uses a movement baseplate in grade 2 titanium, treated with a black PVD coating. The wearer activates the separate functions of winding, neutral and hand-setting via a special pusher in the crown for. The RM017 combines cutting-edge technology with elegance and exceptional lines, useful functionality and unmistakable recognition: the RM 017 Extra Flat Tourbillon typifies everything that Richard Mille Watches stands for.

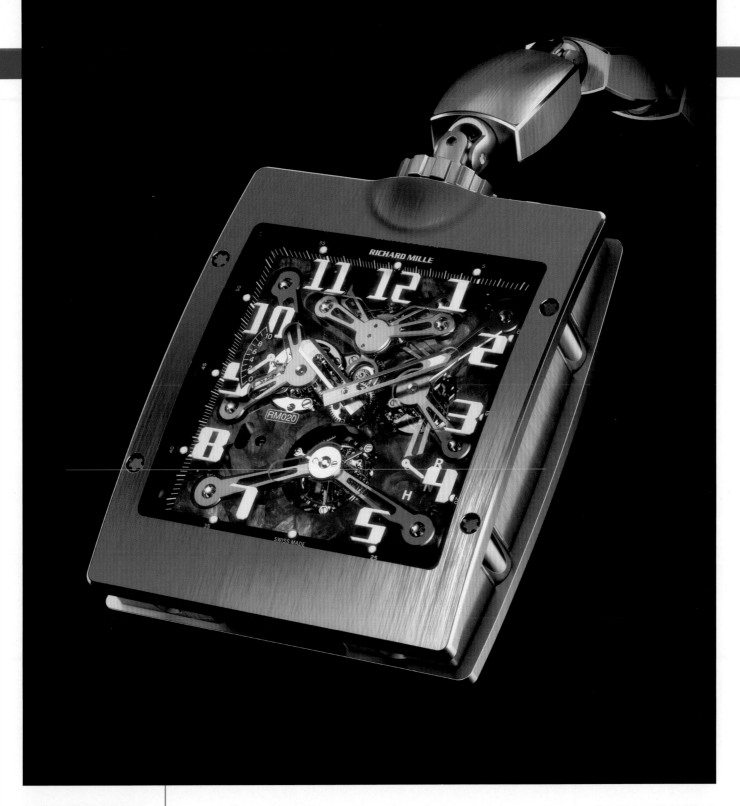

RICHARD MILLE

RM 020 TOURBILLON POCKET WATCH

This manual-winding tourbillon pocket-watch is the first built using a baseplate structure created from carbon nanofiber, completely befitting the first radically new tourbillon pocket-watch design of the 21st century. It provides hours, minutes, power reserve indicator (circa 10 days of power via a double barrel system), and function indicator for winding, neutral, and hand-setting operations. The PVD-treated variable inertia, free-sprung balance wheel with overcoil spring with Zircon endstones for the tourbillon cage provides optimal chronometric results and excellent long-term wear. It is supplied with a titanium watch chain comprising a new design of fast release/attach mechanism, and in the tradition of fine pocket-watches of the past, it can also function as a *pendulette de bureau* with its specially designed stand. The chain, clasp, crown cover and stand require 189 component parts and 580 separate finishing and control operations.

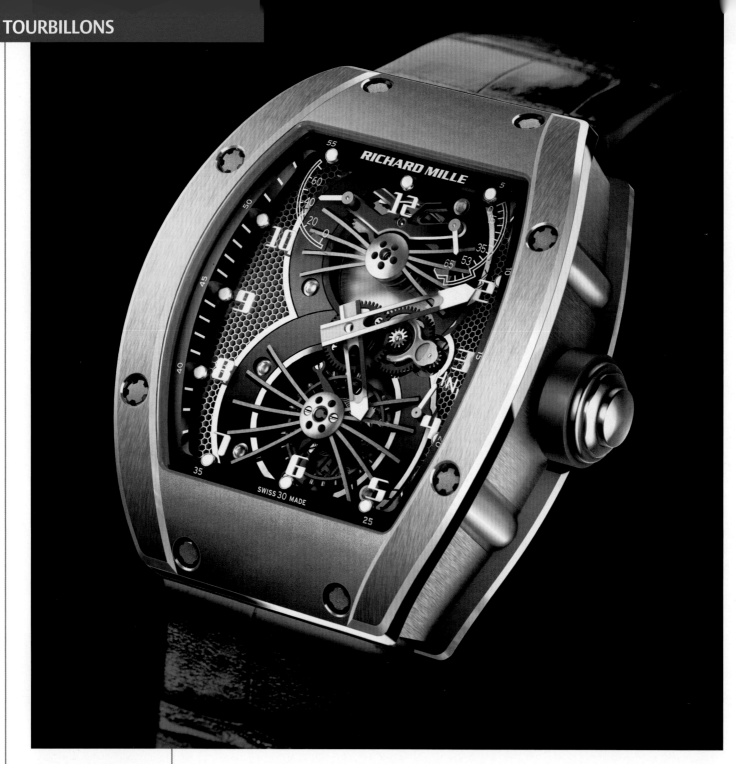

RICHARD MILLE

RM 021 TOURBILLON 'AERODYNE'

Continuing the expansion and application of truly unique materials to watchmaking, the RM 021 Tourbillon 'Aerodyne' is the first watch created with a composite baseplate utilizing a titanium exterior framework in combination with honeycombed orthorhombic titanium alumide and carbon nanofiber. This material was originally the subject of research by NASA for application as a core material of supersonic aircraft wings. This new tourbillion provides hours, minutes, indicators for power reserve (circa 70 hours), torque indicator and function indicator for winding, neutral, and hand-setting operations. The PVD-treated variable inertia balance wheel with overcoil spring and ceramic endstone for the tourbillon cage offers optimal chronometric results and excellent long-term wear capability.

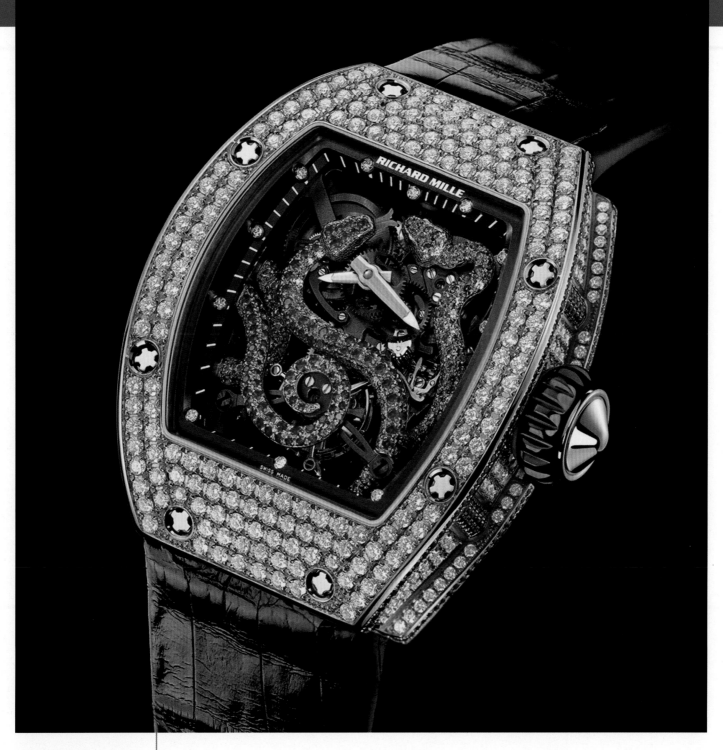

RICHARD MILLE

RM 026 TOURBILLON

The RM 026 Tourbillon transforms invisible energy, inspiration and emotion, with a combination of esoteric sensibility and technical horology perfectly matched for the 21st century. The multiple muses behind the design and inspiration of this new tourbillon are fully grounded in the eternal themes of nature, Gaia and the passage of time. Two creatures adorn its precious movement: a ruby and an emerald encrusted snake writhe and search within the tourbillon movement, simultaneously holding the tourbillon movement in place. The baseplate of the watch has been created of pure black onyx, a gemstone able to deflect and channel harmful energy towards the Earth, thus providing stability. Due to this ability, black onyx is considered a stone of protection against negative thoughts, as well being the stone of equilibrium and inspiration.

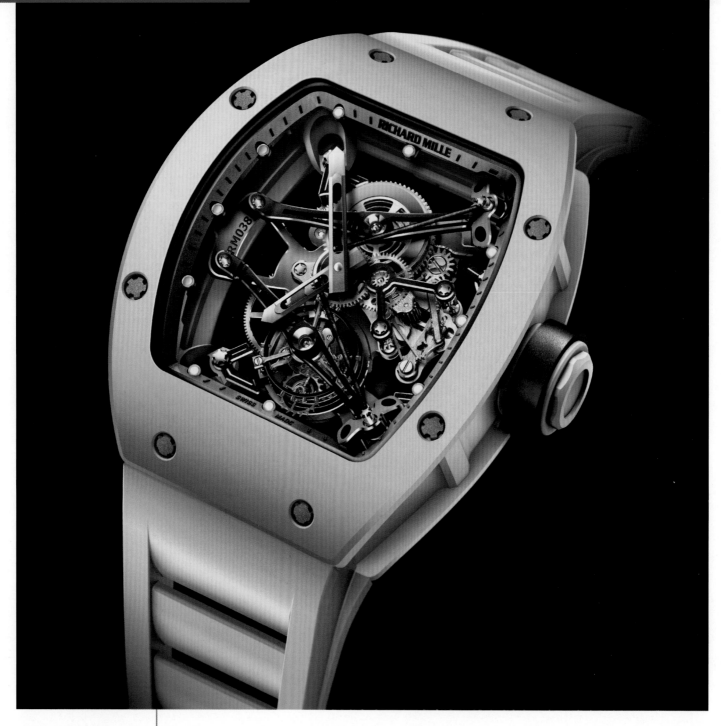

RICHARD MILLE

RM 038 TOURBILLON 'BUBBA WATSON'

Richard Mille's new creation RM 038 Tourbillon 'Bubba Watson' represents another partnership between Richard Mille and the world of sports, specifically professional golf. The 48x39.7x12.8mm case houses the manual-winding, skeletonized 3Hz tourbillon caliber RM038, with its 19 jewels and grade 5 titanium baseplate and bridges. This allows the whole assembly to be given great rigidity, as well as the precise surface flatness essential for the perfect functioning of the gear train. The case of the RM 038 is made of an extremely rugged and light magnesium alloy classified as AZAZ91, composed of aluminum combined with zinc, magnesium and other trace metals. The resulting magnesium alloy provides a light yet extremely strong material.

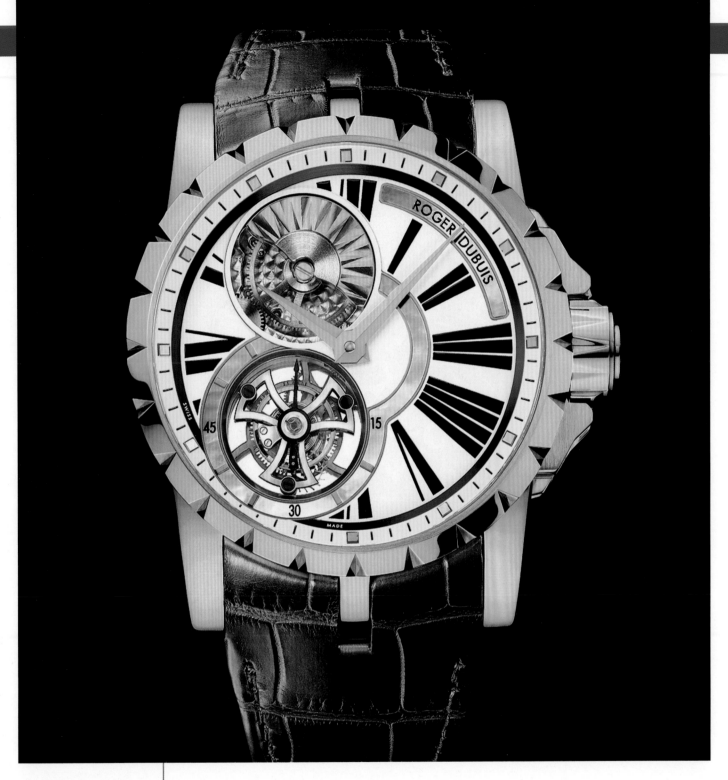

ROGER DUBUIS

EXCALIBUR AUTOMATIC TOURBILLON – REF. EX45-520-50-00/01R00/B

Distinguished by a flying tourbillon at 7:00 and automatic winding by a micro-rotor visible on the dial, the Excalibur Automatic Tourbillon features a 60-hour power reserve and is finely adjusted to six positions. This exceptional timepiece is powered by its RD 520 caliber and housed within a 45mm rose-gold case. The hand-stitched, genuine alligator strap is fully adjustable with a rose-gold buckle. The Excalibur Automatic Tourbillon is part of a limited edition of 88 pieces.

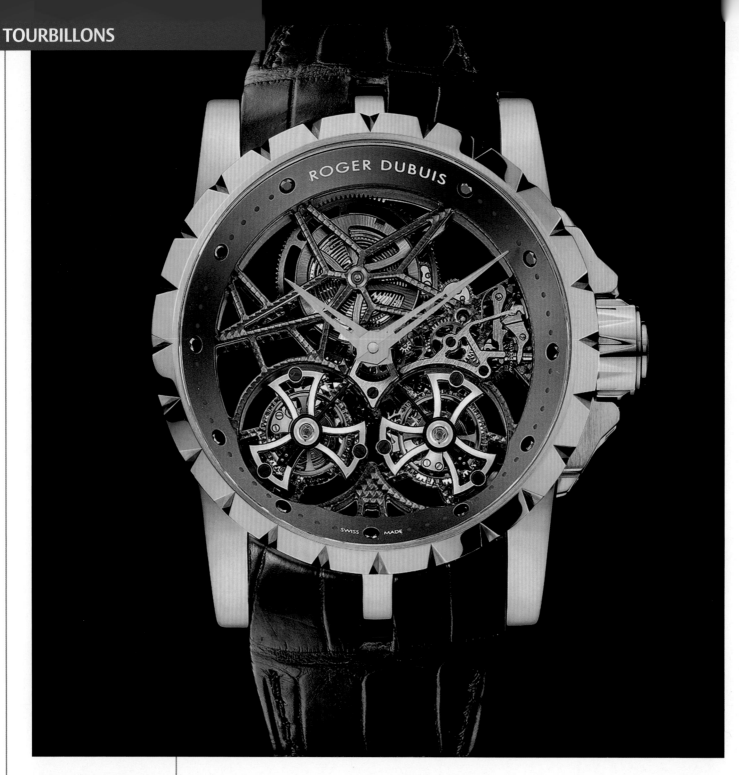

ROGER DUBUIS

EXCALIBUR DOUBLE TOURBILLON SKELETON IN PINK GOLD

REF. EX45-01SQ-50-00/SE000/B1

Framed by a magnificent 45mm rose-gold case, the Excalibur Double Tourbillon Skeleton is powered by its RD 01SQ caliber. This double flying tourbillon features 28 jewels and tourbillon carriages visible at 4:30 and 5:30. The watch possesses 48 hours of power reserve and is finely adjusted to five positions. The alligator strap is hand-stitched, complemented with a rose-gold deployment buckle to match the case. The Excalibur Double Tourbillon Skeleton is available as a limited edition of 28 pieces.

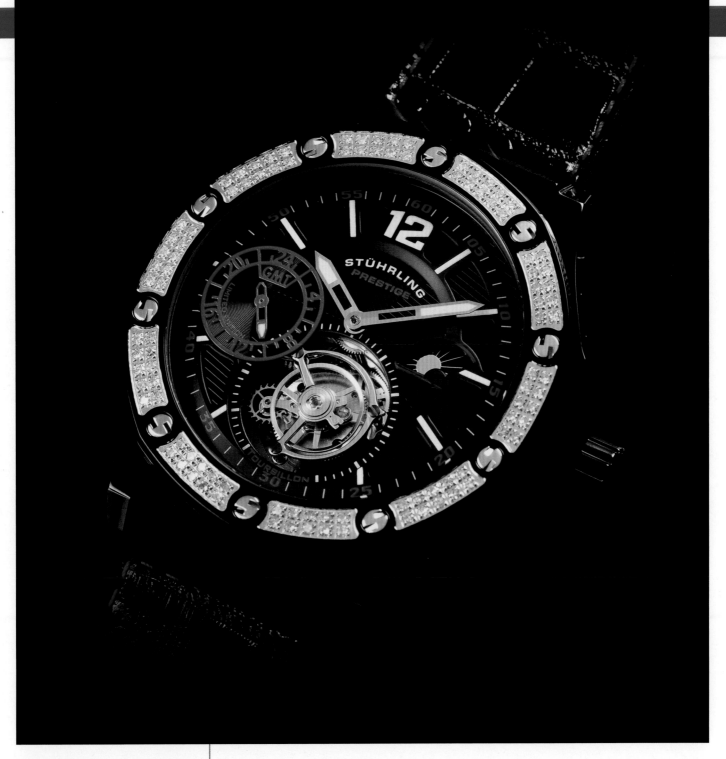

STÜHRLING ORIGINAL

APOCALYPSE REVELATION DIAMOND TOURBILLON

Stührling Original's Apocalypse Revelation Diamond Tourbillon houses a Caliber St-93310, 19-jeweled tourbillon movement that powers its many complications: skeletonized hour and minute hands, a striking GMT subdial complemented by an animated AM/PM indicator and a rotating tourbillon cage that functions as small seconds. The piece boasts a bold decagonal bezel accented with Stührling Original's signature "S" screws and double rows of genuine diamonds with a combined weight of 1.25 carats. A separate faceplate atop the hydraulically stamped main dial displays the luminous Arabic numeral 12, markers and minutes track, and an exhibition caseback presents the bottom plate of the decorated movement. The Apocalypse Diamond Revelation Tourbillon is then furnished with a high-grade silicon rubber strap elegantly stitched with alligator-embossed genuine leather. Available in midnight blue and polished black, the entire edition consists of 50 units (25 in each execution).

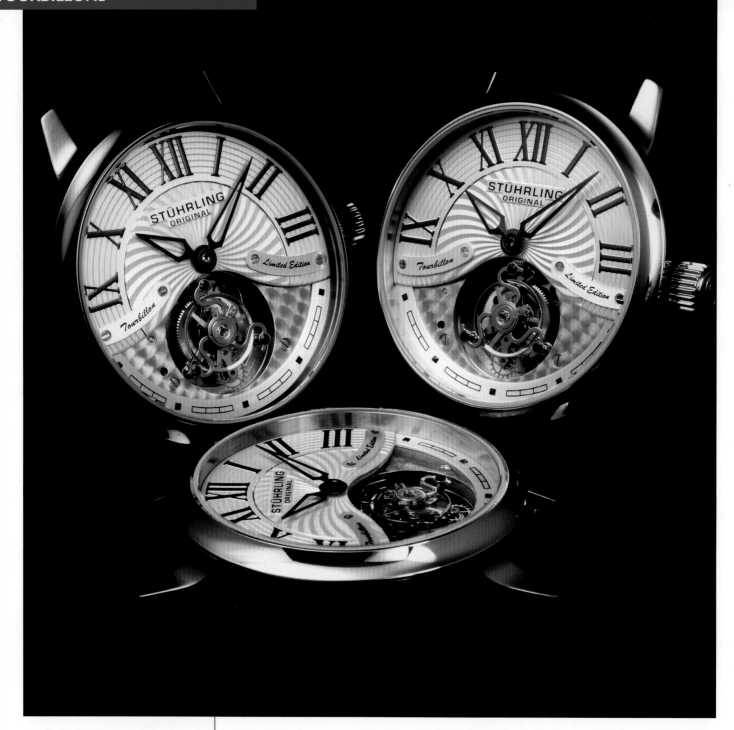

STÜHRLING ORIGINAL

IMPERIAL DYNASTY TOURBILLON

Stührling Original's Imperial Dynasty Tourbillon is powered by its Caliber St-93301, an 18-jeweled tourbillon movement that beats at 28,800 vph. The hand-assembled dial showcases classic Stührling Original dial-work with a swirled sunray pattern in the center; concentric circle design on the outer chapter ring; individually hand-applied Roman numerals; and two arched nameplates denoting "Tourbillon, Limited Edition." The bottom plate of the movement is decorated with Côtes de Genève. Mounted on a 22mm-wide genuine farm-raised Louisiana alligator strap and completed with a case-matching pushbutton dual deployant clasp, the Imperial Dynasty Tourbillon is available with 16K rose-gold plating, 23K yellow-gold plating or a striking gunmetal finish. The entire edition consists of 1,250 units (300 yellow, 500 rose, and 450 gunmetal).

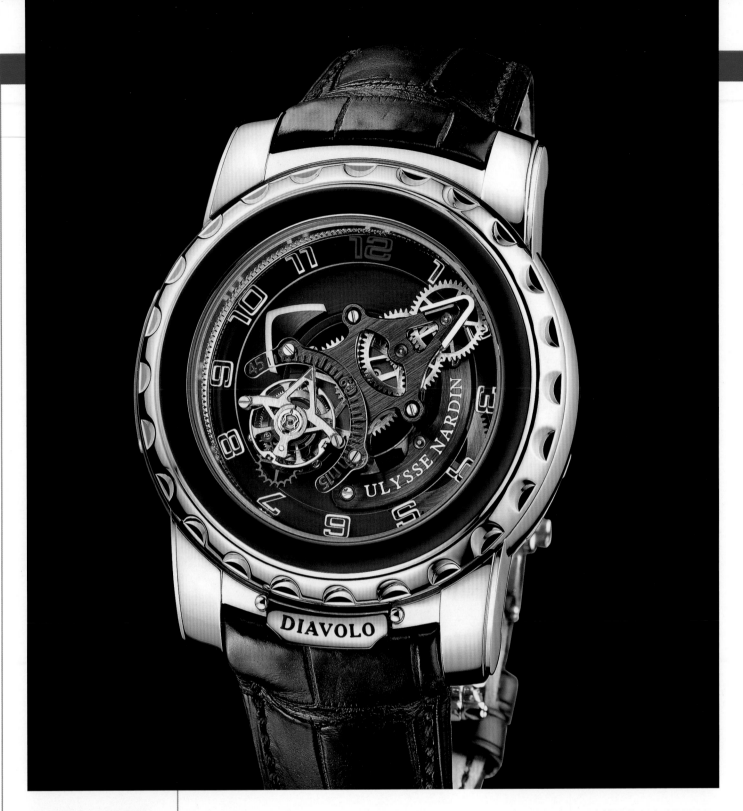

ULYSSE NARDIN

FREAK DIAVOLO – REF. 2080-115

The Freak Diavolo is an eight-day carrousel tourbillon whose UN-208 caliber includes a Dual Ulysse silicium escapement and flying tourbillon. The Freak Diavolo is housed in a 44.5mm 18K white-gold case, and is also available mounted on a bracelet.

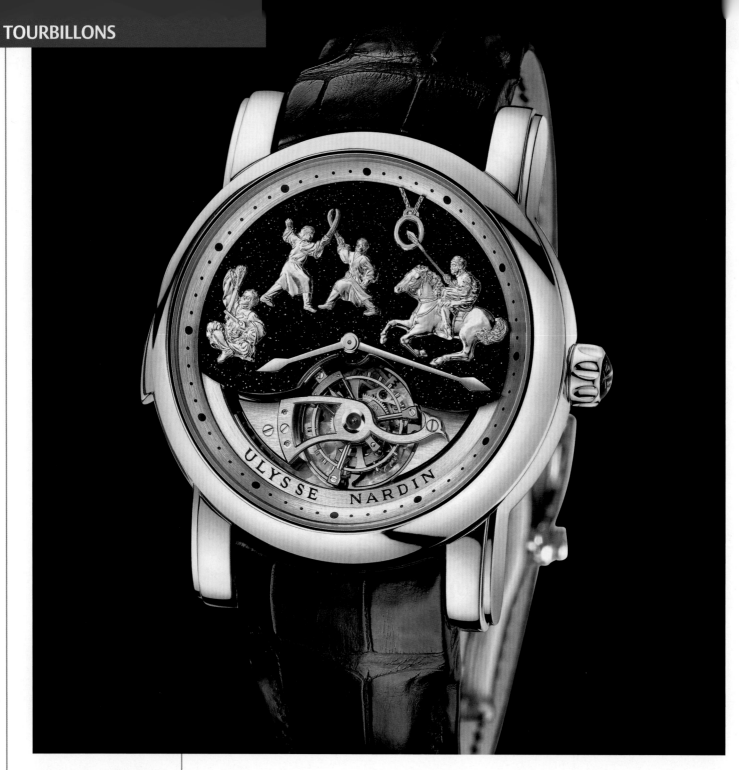

ULYSSE NARDIN

GENGHIS KHAN – REF. 789-80

Released in a limited edition of 30 pieces, the Genghis Khan Westminster Minute Repeater Carillon Tourbillon is housed in a 42mm platinum case. Its UN-78 movement powers its animated Jaquemarts upon its aventurine dial.

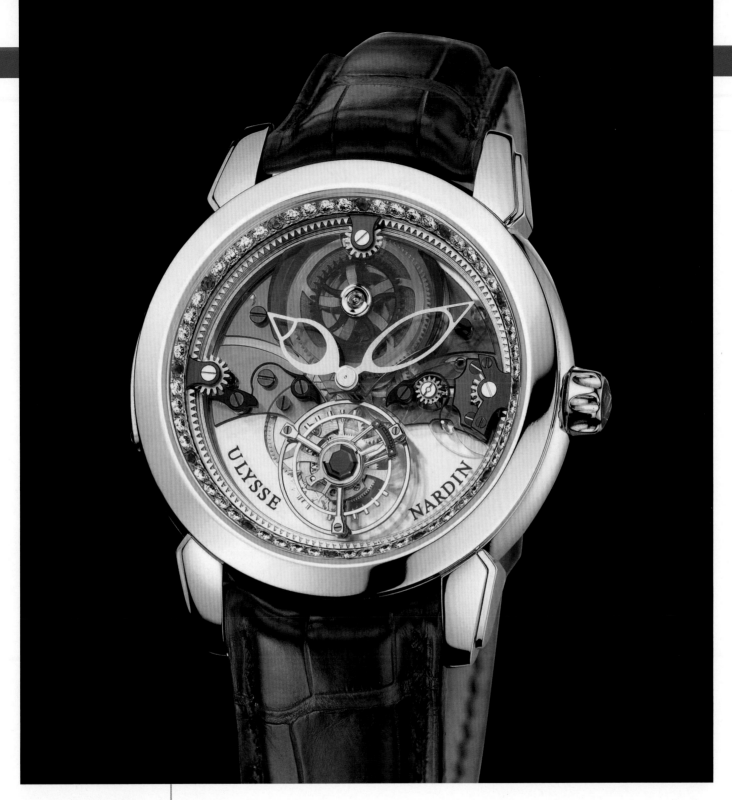

ULYSSE NARDIN

ROYAL BLUE – REF. 799-90

With its 43mm platinum case, and sapphire main plate and bridges, the Royal Blue makes a bold statement. The UN-79 caliber boasts a flying tourbillon and circular rack-winding mechanism. The Royal Blue is part of a limited edition of 99 pieces.

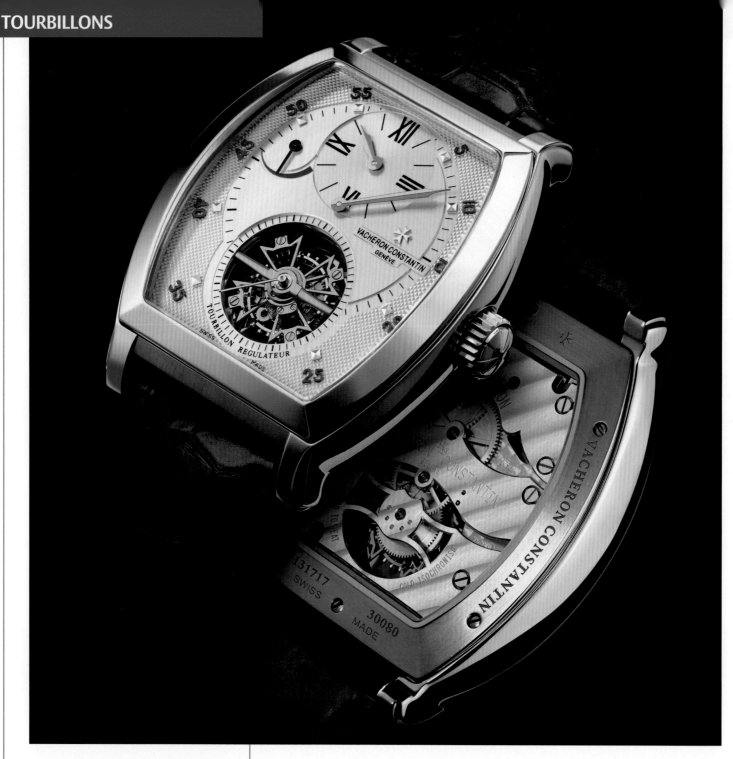

VACHERON CONSTANTIN

MALTE TOURBILLON REGULATOR – REF. 30080

For this Malte Tourbillon Regulator's large, perfectly balanced tonneau case, Vacheron Constantin's master watchmakers designed a mechanical movement that fits perfectly into this geometric shape: Caliber 1790R. This movement is equipped with the tourbillon, which remains one of the most emblematic complications of the art of watchmaking and is the distillation of all the savoir-faire possessed by the brand's master watchmakers; and the regulator display offering a vertical reading of the time on the tourbillon cage. Five different finishings (snailing, guilloché, opaline, vertical satining, and circular satining) ensure that each indication is extremely easy to read. Water resistant to 100 feet, the case is enhanced with a domed sapphire crystal that prolongs the lines of the bezel. The Malte Tourbillon Regulator is available in 950 platinum or 18K pink gold on a dark blue (for the platinum version) or brown (for the pink-gold version) hand-stitched, saddle-finish alligator strap with a folding clasp and polished half Maltese cross.

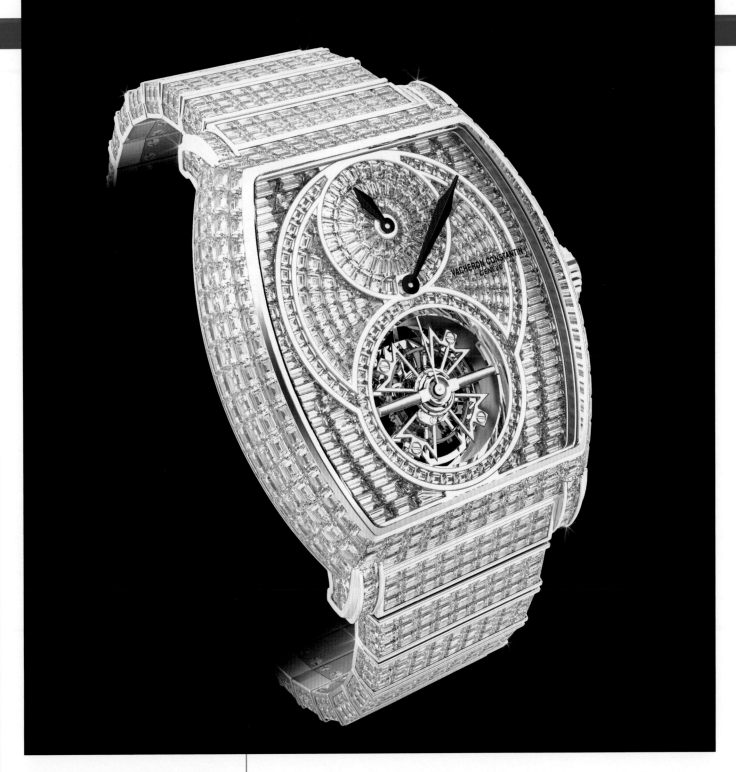

VACHERON CONSTANTIN

MALTE TOURBILLON REGULATOR HIGH JEWELLERY – REF. 30682

Vacheron Constantin introduced a bouquet of watches highlighting its technical mastery and refined aesthetics that confirms the brand's leading position in the watchmaking field. Symbolizing the cultural bridge between the arts, engineering and creative genius, Vacheron Constantin's Malte Tourbillon Regulator brings together aesthetic philosophy and the magic of watchmaking. This exceptional piece is a vibrant dedication to the Métiers d'Art. The invisible settings are all entirely hand-crafted, creating a supreme glamour of time.

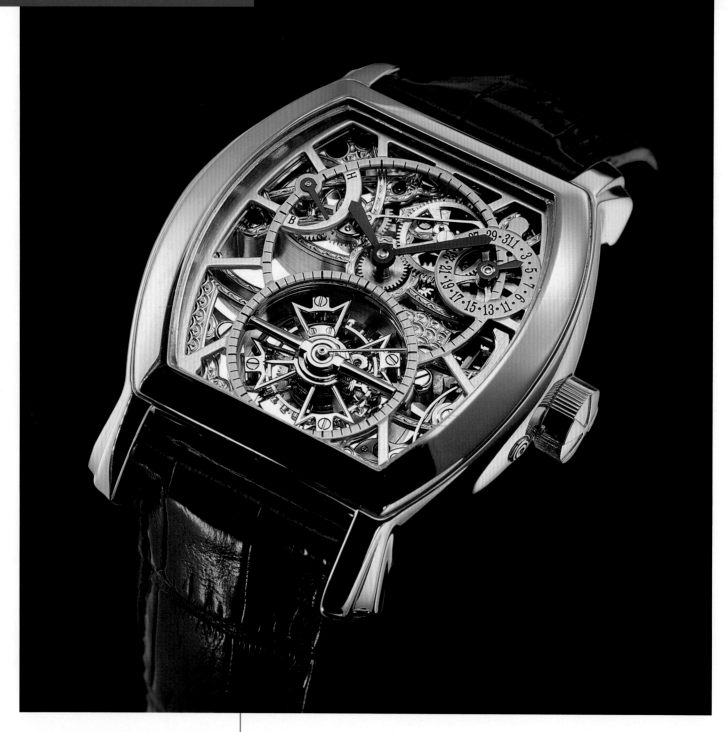

VACHERON CONSTANTIN

OPENWORKED MALTE TOURBILLON – REF. 30067

Housed in a stunning 18K pink-gold tonneau case, this Malte Tourbillon is powered by the hand-wound 1790 mechanical caliber with tourbillon regulator. It offers a 31-day analog date calendar, 55 hours of power reserve, and is completely openworked and beveled. The dial features baton hands and a crown signed with the embossed symbol of Vacheron Constantin.

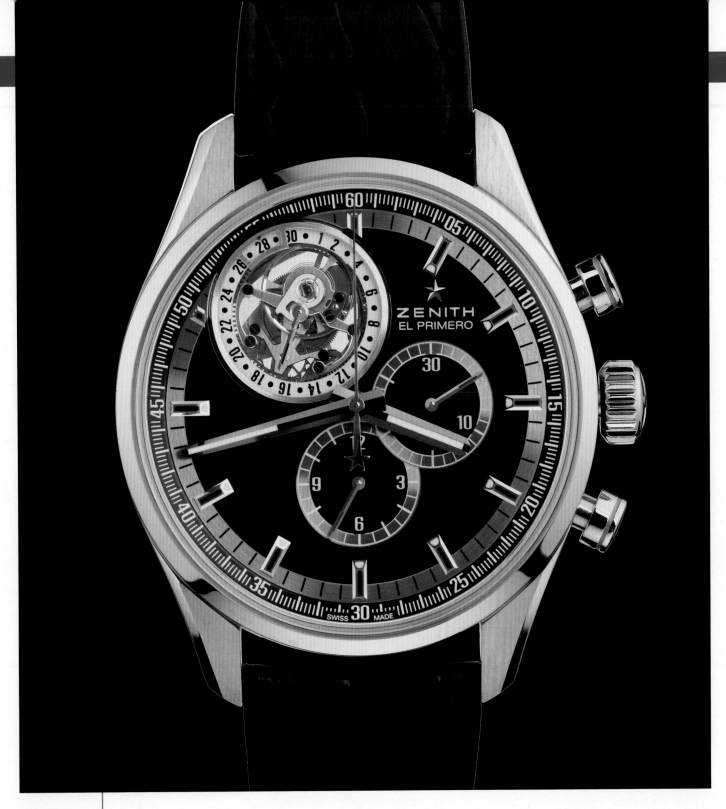

ZENITH

EL PRIMERO TOURBILLON – REF. 03.2050.4035/21.C630

Zenith's El Primero Tourbillon is distinguished by its chronograph with central seconds hand, 30-minute counter at 3:00 and 12-hour counter at 6:00. The El Primero 4035 D automatic-winding movement, whose oscillating weight bears a Côtes de Genève decoration, beats within the stainless steel 44mm case, which is water resistant to 100m. The dial features rhodium-faceted hands and indexes treated with SuperLumiNova SLN C1. The tourbillon at 11:00, which makes one turn per minute, displays small seconds on and date around the carriage. Completed with an alligator leather strap with stainless steel triple-folding buckle, the El Primero Tourbillon is available in a limited edition of 250 pieces.

Chronographs, Split-Seconds and Flyback Chronographs

While the striking mechanism is the oldest of the classic watchmaking complications (see the Minute Repeater Chapter), the chronograph is one of the most recent, as watches first had to reach a sufficient degree of precision before short-time measurements could be envisaged. Nonetheless, a number of fields, ranging from the army and navy to sports competitions, as well as industry and transport, became increasingly eager to have timekeeping instruments. This demand accelerated the development of this complication, which first appeared in 1822. Since this historic date, a number of improvements have developed, starting with the split-seconds hand, and followed by the stop/start/reset functions. Today, the chronograph is enjoying a wave of popular enthusiasm, and a number of brands are equipping these models with their own in-house movements.

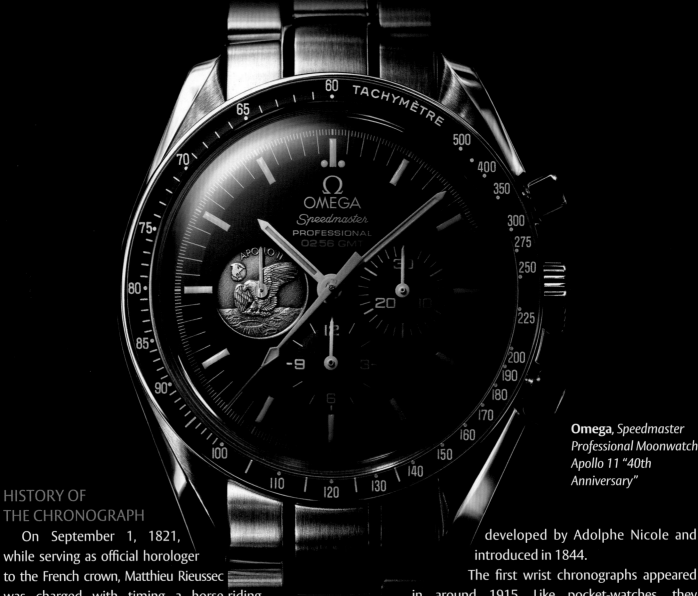

Omega, *Speedmaster Professional Moonwatch Apollo 11 "40th Anniversary"*

HISTORY OF THE CHRONOGRAPH

On September 1, 1821, while serving as official horologer to the French crown, Matthieu Rieussec was charged with timing a horse-riding competition held on the Champs de Mars in Paris. For this event, he accordingly developed a "time-keeper or a timer of the distance covered" that he patented the following year under the name "seconds chronograph." Accurate to within one-fifth of a second, it was equipped with a pointed hand that passed through a reserve of ink and then deposited a drop of the ink on the dial at the beginning and end of each measurement. This measurement was to be perfected by Frédérick Louis Fatton, who, on behalf of Abraham-Louis Breguet, transformed it into a pocket chronograph with a fixed dial. Then came the split-seconds hand, an additional hand superimposed over the central sweep-seconds hand and serving to measure a second event that began at the same time. It was to take on its definitive form in 1831 under the impetus of Austrian chronometer maker Joseph Thaddeus Winnerl. Finally, the reset function— which goes hand in hand with starting and stopping—was developed by Adolphe Nicole and introduced in 1844.

The first wrist chronographs appeared in around 1915. Like pocket-watches, they featured a single pusher (housed in the crown) for all three functions. Breitling gave the chronograph its modern configuration by creating the first independent pusher in 1915, and in 1934 the second pusher for resetting. In 1937, Dépraz & Cie (later to become Dubois Dépraz) presented a chronograph movement controlled via a cam system that was less expensive and less difficult to produce than the traditional column wheel. The chronograph pursued its glorious career with the birth of several great classics, including the Speedmaster by Omega, which was to accompany American astronauts to the Moon in July 1969, hence its "moonwatch" nickname. To celebrate the 40th anniversary of the event in 2009, Omega introduced two special editions named Speedmaster Professional Moonwatch Apollo 11 "40th Anniversary." The small seconds display features a medallion depicting the logo of the Apollo 11 mission with an eagle holding an olive branch in its talons, alongside the inscription "02:56 GMT."

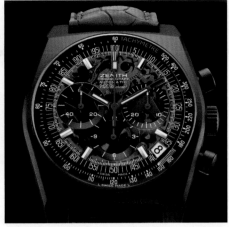
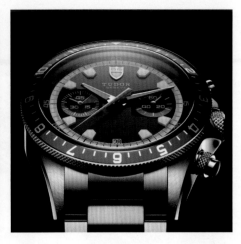

COMMEMORATIVE WATCHES

1969 also saw the creation of the first self-winding or automatic chronograph movements. The one developed by the Breitling/Büren/Heuer-Leonidas trio in cooperation with Dubois Dépraz, and named the Chronomatic, is a cam movement featuring a module construction with an off-centered microrotor (oscillating weight); while the one presented by Zenith, the famous El Primero, is an integrated movement with a column wheel and a central rotor. Thanks to its frequency of 36,000 vibrations per hour, it was also the first mechanical chronograph movement able to measure times to within one-tenth of a second. In addition to the Zenith models, the El Primero caliber also subsequently equipped certain timepieces from the greatest names in the business. For example, it is found at the heart of the legendary Cosmograph Daytona, before Rolex developed its own chronograph movement at the turn of the third millennium. For its 150th anniversary, TAG Heuer also re-issued its famous Silverstone Chronograph, initially equipped with the Chronomatic Caliber 11. The watch not only echoes the lines of its illustrious predecessor, but also the "Heuer" logo and the "Silverstone" inscription at 12 o'clock. Finally, Tudor has also drawn inspiration from its historical Tudor Oysterdate, presented in 1970, when launching its new Heritage Chrono.

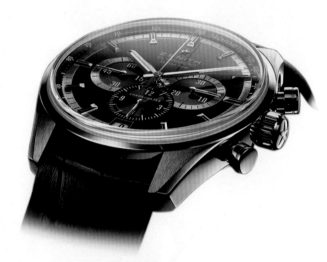

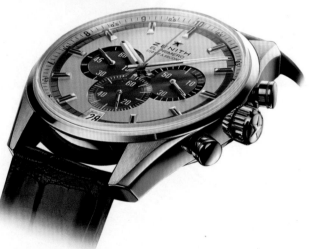

TOP FROM LEFT TO RIGHT
Rolex, *Cosmograph Daytona*
Zenith, *New Vintage 1969 – The Originals*
Tudor, *Heritage Chrono*

RIGHT CENTER
Zenith, *El Primero 36 000 VpH*

ABOVE
Zenith, *El Primero Striking 10th*

LEFT
TAG Heuer, *Silverstone Chronograph*

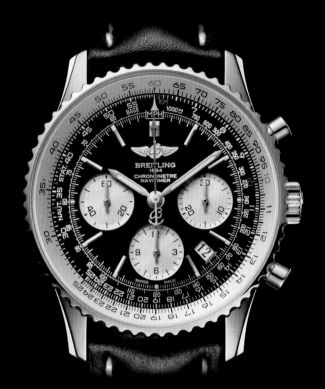

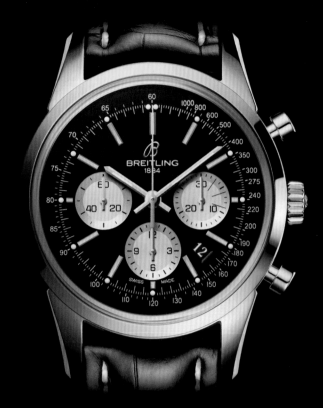

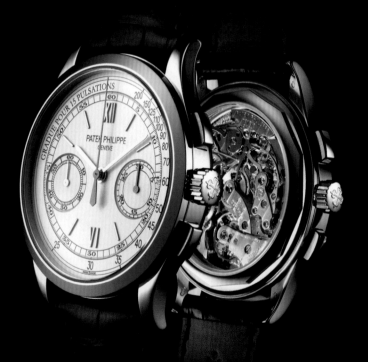

THE FASHION FOR CHRONOGRAPHS MADE "IN-HOUSE"

Meanwhile, Breitling, which had also participated in the development of the Chronomatic in 1969, has opted to invest in making its own chronograph movement, Caliber 01. The latter equips in particular the new Navitimer Caliber 01 and Transocean Chronograph Caliber 01 models. Several other brands have now made the same choice. For a long period prior to this trend, only a few rare brands, or even full-fledged manufactures, had proved able to develop and produce their own chronograph movements. A large number of the mechanical chronographs offered under a variety of signatures actually house an ETA 7750 Valjoux movement, reworked to various degrees, and sold at widely differing prices that are sometimes hard to justify. But things are changing. The public is better informed and prepared to pay the price for a chronograph from a well-known brand, provided it has an exclusive or relatively original movement. The Swatch Group's announcement that it would cease delivering ETA movement blanks as of January 1, 2011 has also spurred competitors to find alternative solutions. In recent years, we have therefore witnessed a growing number of chronograph movement developments made in-house, often combined with innovative concepts.

The year 2010 was also a key year for the chronograph at Patek Philippe, which presented no less than three in-house movements and a number of new models, starting with the Ref. 5170 Chronograph, equipped with manually-wound Caliber CH29-535 PS. The movement features a column wheel and horizontal coupling of the toothed wheels. Though the movement is classically structured, it is nonetheless protected by six patents.

TOP LEFT
Breitling, *Navitimer Caliber 01*
TOP RIGHT
Breitling, *Transocean Chronograph Caliber 01*
ABOVE
Patek Philippe, *Ref. 5170 Chronograph*

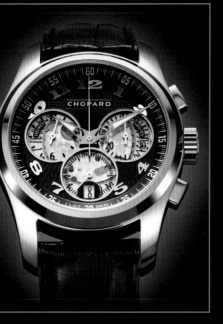

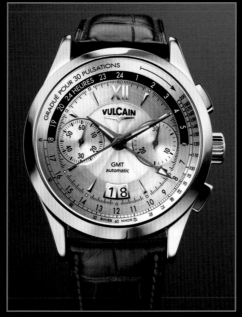

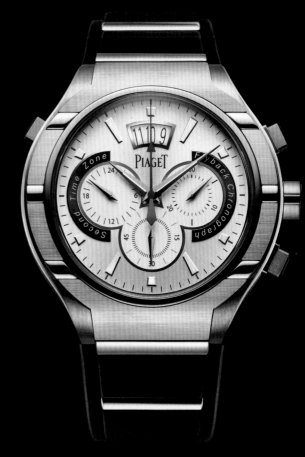

Chopard has recently unveiled a column-wheel movement with vertical coupling, flyback function and a 60-hour power reserve, which drives its L.U.C Chrono One model. Piaget has created Caliber 880P with 24-hour dual time zone display and flyback function, which is featured in the new Polo FortyFive collection. The collection was launched in 2009 to mark the 30th anniversary of the Polo model, and is characterized by a sporty chic look combining titanium, steel and rubber. Parmigiani Fleurier has made its grand entry into the sports watch world by presenting the Kalpagraph with its in-house developed movement, while the master of alarm watches, Vulcain, has revived the chronograph tradition by presenting the Vulcanograph, equipped with a self-winding column-wheel movement.

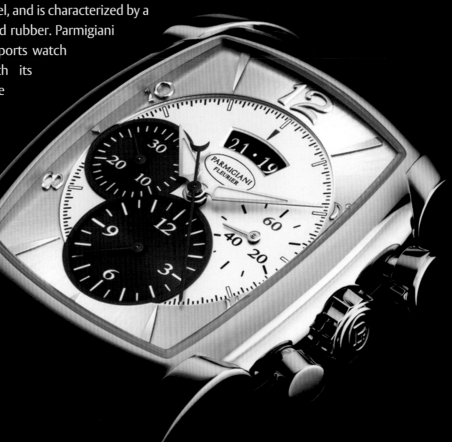

TOP LEFT
Chopard, *L.U.C Chrono One*

TOP CENTER
Vulcain, *Vulcanograph*

TOP RIGHT
Piaget, *Polo FortyFive Chronograph*

RIGHT
Parmigiani, *Kalpagraph*

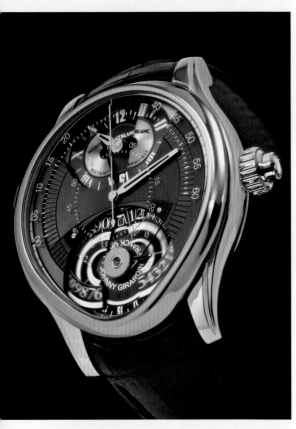

CLASSICISM REINVENTED

Chronographs were long distinguished by their rather classic aesthetic appearance, featuring three small totalizers arranged symmetrically. This traditional look is now being swept away by a wave of new models aiming to reinvent the time display. Eberhard & Co set the tone by launching the Chrono4, followed in 2010 by the Chrono4 Badboy, which is larger than its predecessor. Its most distinctive feature lies in its four totalizers lined up horizontally. Nonetheless, the most spectacular example of this more unconventional approach is the work of two watchmakers at Montblanc who—thanks to the "Timewriter" concept launched by the brand in 2008 to support creative talents with innovative ideas—developed the Metamorphosis. Moving a dedicated slide-piece at 9 o'clock makes the dial indications of the hours, minutes, seconds and date literally disappear, "magically" replaced by the chronograph counters. To achieve this fascinating result, its creators drew inspiration from the methods used to make automatons.

The world of chronographs has also seen the emergence of new materials serving to enhance their sturdiness, lightness or performance, as well as overturning existing design codes. Witness the MC12 Tourbillon Chronograph by Audemars Piguet, a creation combining high-tech materials with a daring automobile-inspired design. The AMVOX2 Chronograph Concept by Jaeger-LeCoultre has even introduced a mini-revolution in terms of its controls: the traditional pushers have been replaced by a system based on a caseband that swivels slightly along the 9-3 o'clock axis. To start or stop the chronograph, the wearer need only lightly press the upper part of the watch glass, while resetting is done by pressing the lower part. With its Nicolas Rieussec Open Date Silicium Escapement Chronograph model, Montblanc enters the silicon era while paying tribute to the inventor of the first chronograph.

ABOVE
Montblanc, *Metamorphosis*

TOP RIGHT
Eberhard & Co, *Chrono4 Badboy*

BELOW
Jaeger-LeCoultre, *AMVOX2 Chronograph Concept*

BOTTOM RIGHT
Audemars Piguet, *MC12 Tourbillon Chronograph*

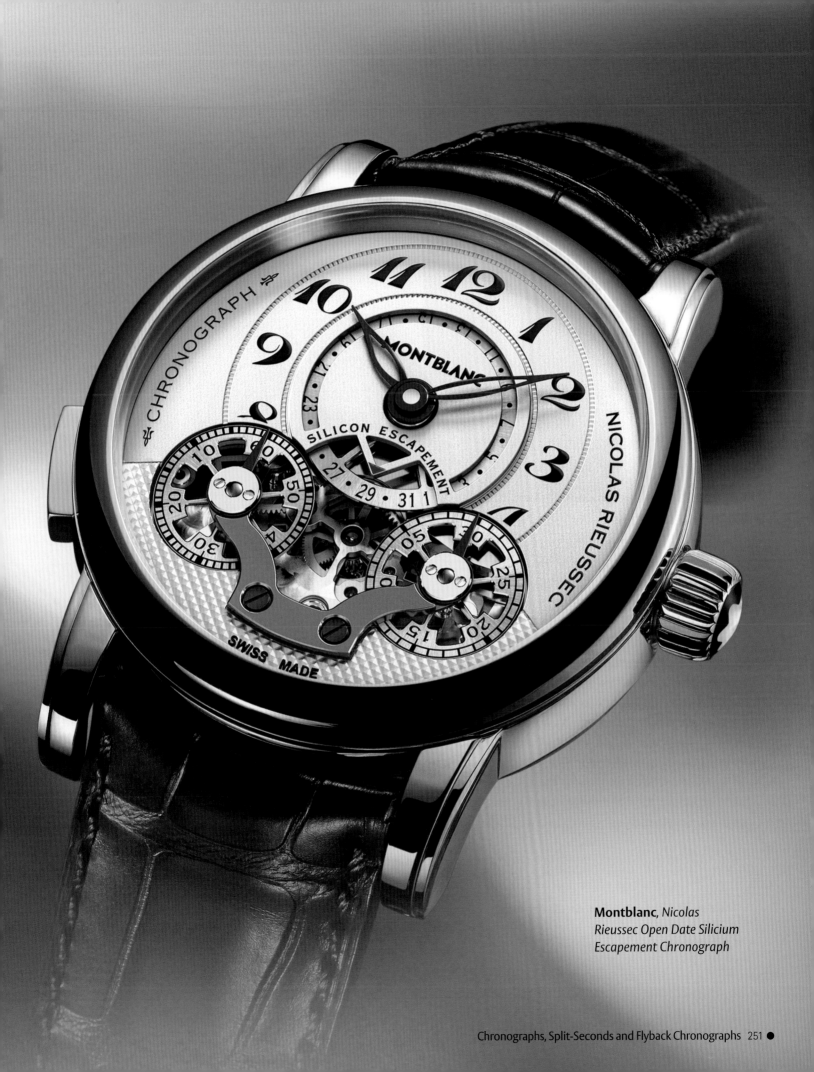

Montblanc, *Nicolas Rieussec Open Date Silicium Escapement Chronograph*

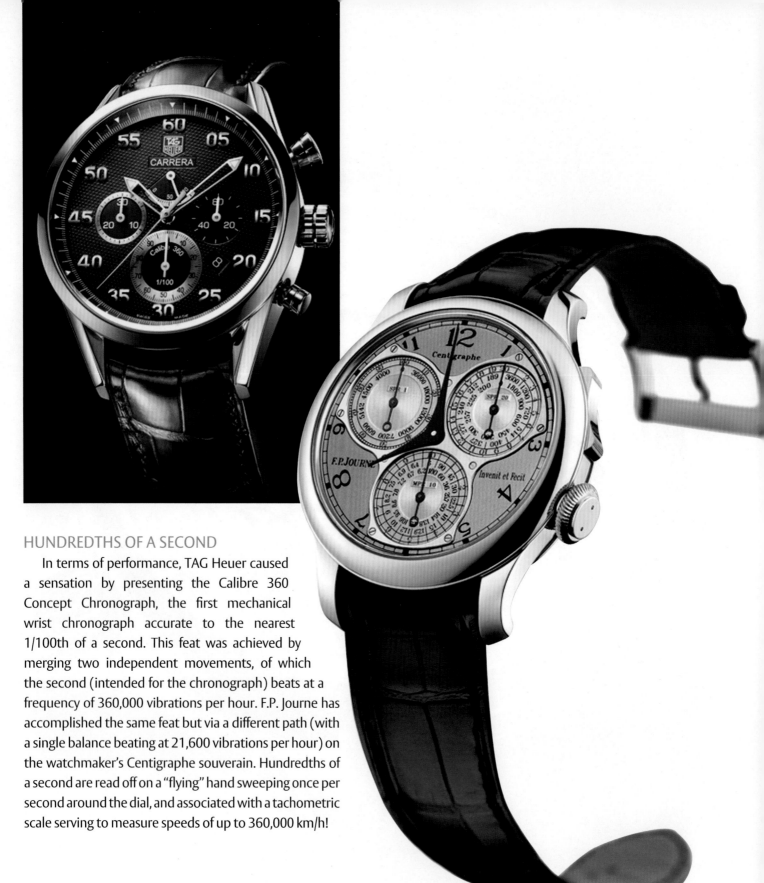

HUNDREDTHS OF A SECOND

In terms of performance, TAG Heuer caused a sensation by presenting the Calibre 360 Concept Chronograph, the first mechanical wrist chronograph accurate to the nearest 1/100th of a second. This feat was achieved by merging two independent movements, of which the second (intended for the chronograph) beats at a frequency of 360,000 vibrations per hour. F.P. Journe has accomplished the same feat but via a different path (with a single balance beating at 21,600 vibrations per hour) on the watchmaker's Centigraphe souverain. Hundredths of a second are read off on a "flying" hand sweeping once per second around the dial, and associated with a tachometric scale serving to measure speeds of up to 360,000 km/h!

ABOVE
TAG Heuer, *Calibre 360 Concept Chronograph*
RIGHT
F.P. Journe, *Centigraphe souverain*

SINGLE COUNTERS IN THE LIMELIGHT

In a deliberate departure from the system of separate subdials for the minutes and hours, several watchmakers have opted for a single counter regrouping these two indications—the goal being to enable simple and fast reading of long times, just as one would read off the time on a watch. Such is the case for IWC with its Da Vinci Chronograph, featuring a barrel-shaped case and an in-house chronograph movement. In its Duomètre à chronographe, Jaeger-LeCoultre offers a new movement construction concept with two independent mechanisms: one for the time (golden hands), and the other for the chronograph (blue hands), synchronized by the same regulating organ. The hours and minutes counters are regrouped in a dial at 2:30 and a flying or jumping seconds display at 6 o'clock enables sixth-of-a-second measurements. On the new Rotonde à Chronographe central watch by Cartier, the chronograph indications are regrouped in the dial center, with a seconds hand and a 30-minute circular-arc totalizer; while the hours and minutes are displayed around the rim by means of two hands (of which only the tips are visible, and which therefore never hide the chronograph from view).

TOP RIGHT
Cartier, *Rotonde à Chronographe central*
BELOW
Jaeger-LeCoultre, *Duomètre à chronographe*
RIGHT
IWC, *Da Vinci Chronograph*

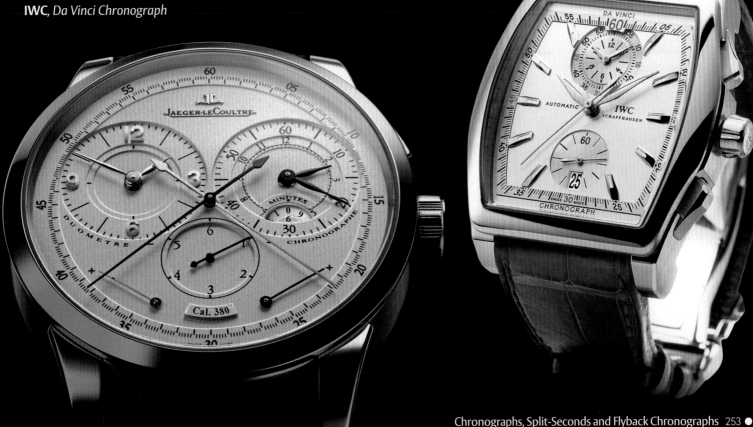

WHEN HANDS DISAPPEAR

In order to vary the looks and time indications, watchmakers also make use of disc-type displays. On the Porsche Design Indicator Chronograph by Eterna, the hours and minutes of the times being measured are displayed in a mechanical "digital" manner by means of rotating discs appearing through a double window at 3 o'clock. The Grand Carrera Calibre 17 RS2 in titanium by TAG Heuer—the star model in a collection distinguished by its Rotating System—features two disc-type indications: one for the small seconds, and the other for the chronograph minute counter. Original displays are also the keynote of the GrandCliff TNT Penta self-winding chronograph by Pierre DeRoche. The two date discs meet at 12 o'clock, while three others respectively provide 60-minute and 12-hour displays of the flyback chronograph functions, as well as running seconds. This model is equipped with the exclusive Dubois Dépraz movement.

TOP RIGHT
Eterna, *Porsche Design Indicator Chronograph*
BELOW
TAG Heuer, *Grand Carrera Calibre 17 RS2*
RIGHT
Pierre DeRoche, *GrandCliff TNT Penta*

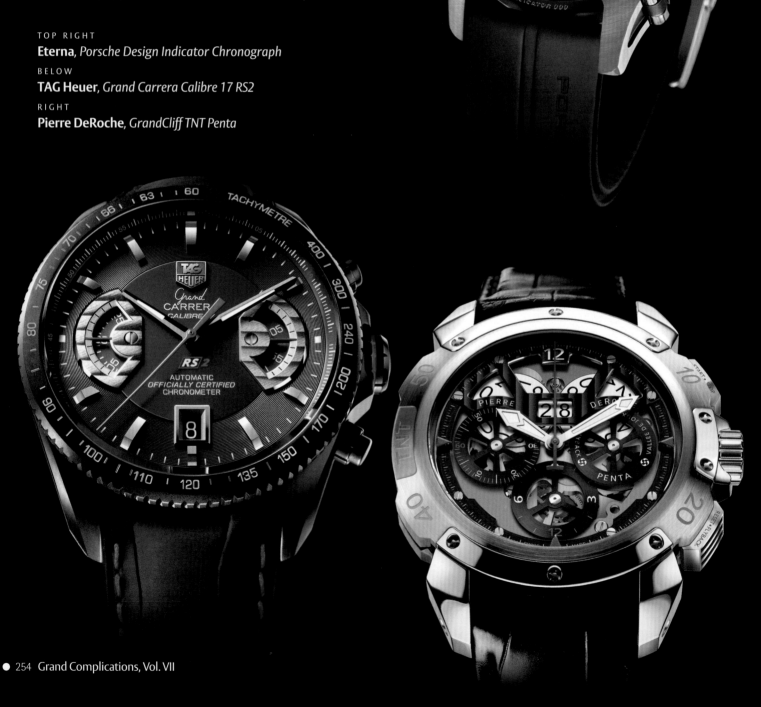

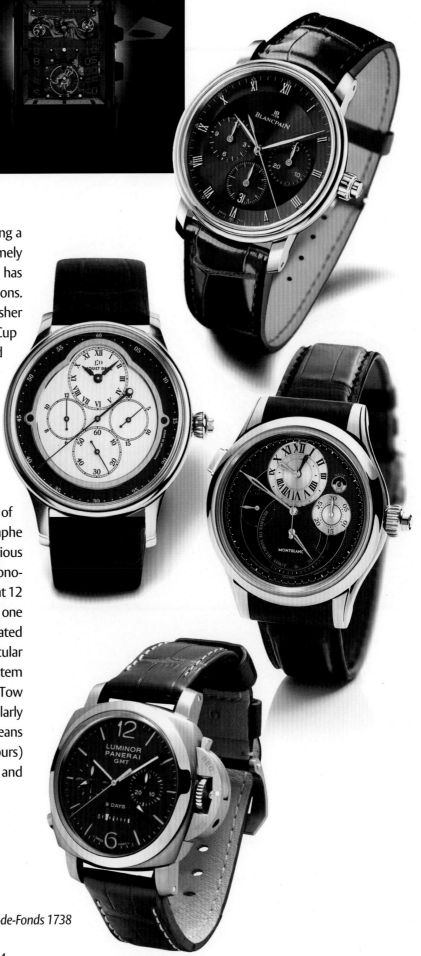

A SINGLE MULTIFUNCTION PUSHER

While on the topic of specialties, we are currently seeing a spate of "monopusher" chronographs boasting an extremely sophisticated construction, since the single pusher has to successively handle the start, stop and reset functions. Among these stellar models are the Villeret Single-Pusher Chronograph by Blancpain, as well as the Admiral's Cup Chronograph 44 Centro Mono-Pusher by Corum, launched to mark the 50th anniversary of the collection. The Chronographe Monopoussoir Hommage La Chaux-de-Fonds 1738 by Jaquet Droz is the first timepiece of its kind to feature an hour counter as well as an off-centered hour-minute indication. Among other exclusive movements, Officine Panerai has created the GMT 8 Days monopusher hand-wound Caliber P.2004. Montblanc has confirmed its move to the ranks of luxury watchmakers by unveiling the Grand Chronographe Régulateur, developed and produced by the prestigious Minerva movement manufacture. This single-pusher chronograph features a distinctive regulator-type dial, with hours at 12 o'clock and a large central minutes hand. Christophe Claret, one of the main suppliers of complicated mechanisms, celebrated his company's 20th anniversary by presenting a spectacular single-pusher planetary-gear chronograph with striking system and tourbillon, introduced under his own name. This DualTow model, shown here in its NightEagle version, is particularly distinguished by its chronograph, which operates by means of three planetary gears (for the seconds, minutes and hours) that limit the variations in amplitude of the balance and thereby considerably enhance precision.

TOP LEFT
Corum, *Admiral's Cup Chronograph 44 Centro Mono-Pusher*
TOP RIGHT
Christophe Claret, *DualTow*
RIGHT FROM TOP TO BOTTOM
Blancpain, *Villeret Single-Pusher Chronograph*
Jaquet Droz, *Chronographe Monopoussoir Hommage La Chaux-de-Fonds 1738*
Montblanc, *Grand Chronographe Régulateur*
Panerai, *GMT 8 Days monopusher hand-wound Caliber P.2004*

TIME FOR LADIES

Another marked trend in the early 21st century is the multiplication of models designed exclusively for women. These new ladies' chronographs are adorned in tender colors, while their dials are finely crafted and sometimes gem-set. On its Ladies First Chronograph, Patek Philippe combines a fine mechanism with aesthetic beauty by paving the dial with diamonds. As its name implies, the Ladies First Chronograph is the first model to be equipped with the in-house made CH 29-535 PS movement. Girard-Perregaux also offers a fine combination of technology and aesthetic beauty on its self-winding ladies' Small column-wheel chronograph.

ABOVE
Girard-Perregaux, *Small column-wheel chronograph*
RIGHT
Harry Winston, *Premier Large Chronograph*
FACING PAGE
Patek Philippe, *Ladies First Chronograph*

SPLIT-SECONDS CHRONOGRAPHS

Astonishingly, the "split-seconds hand" was the first advanced feature introduced to the original chronograph, well before the start, stop and reset function. Split-seconds chronographs are fitted with an additional seconds hand, superimposed over the central sweep-seconds hand, and which may be stopped while running in order to measure a "split" or intermediate time or to maintain a reference time; after which simply pressing a pusher is enough to make it "catch up with" the first hand. This ultra-sophisticated disconnecting system is regarded as one of the most difficult to make, on a par with a tourbillon or a minute repeater.

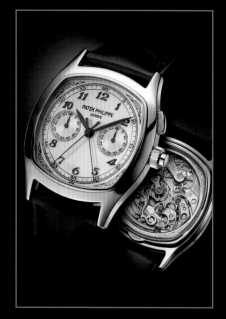
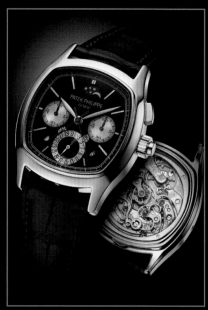

The split-seconds chronograph, invented in 1931, is one of the most striking demonstrations of horological expertise. Prestigious brands are thus naturally all keen to offer models of this type within their collections. In 2010, Patek Philipe has equipped its Ref. 5950A with the "in-house made" single-pusher split-seconds chronograph movement, CHR 27-525 PS. Presented in 2005, and just 5.25mm thick, this caliber is the thinnest in its category. The case of this model is in steel, a rare feature on Patek Philippe watches. Another single-pusher split-seconds chronograph from the same brand, Ref. 5951P, is newly combined with a perpetual calendar display. In its Tourbograph Pour le Mérite, A. Lange & Söhne combines a split-seconds chronograph with two of the most complex mechanisms ever devised to enhance the precision of watch movements: a tourbillon and a fusée and chain transmission device.

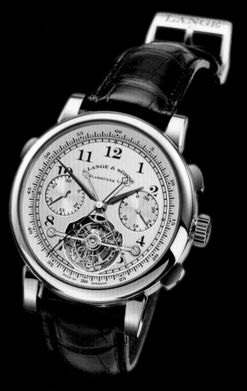
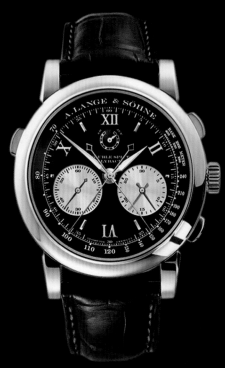
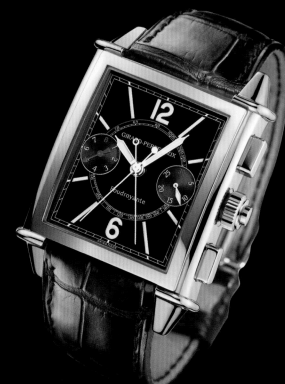

The brand from Saxony, Germany has also innovated by introducing the Lange Double Split model, the first wrist chronograph with double split function: one for the seconds, and the other for the minutes. Girard-Perregaux has equipped its Chronographe à rattrapante Vintage 1945 XXL Foudroyante with a jumping or flying seconds hand that sweeps around a subdial in one second, enabling one-eighth of a second time readoff. On its Double Chronograph Pilot's Watch, IWC has housed the split-seconds chronograph within a high-tech scratch-resistant ceramic case featuring an antimagnetic soft iron inner cage. Blancpain offers a combination of sophisticated technical features in its Single-pusher split-seconds chronograph (with two pushers, one for the three chronograph functions, and another for the split-seconds hand). Officine Panerai has enriched its range of "in-house made" movements by presenting the Caliber P.2006 split-seconds movement, also based on a single-pusher system.

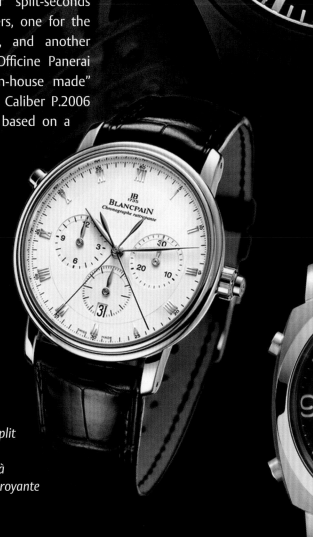

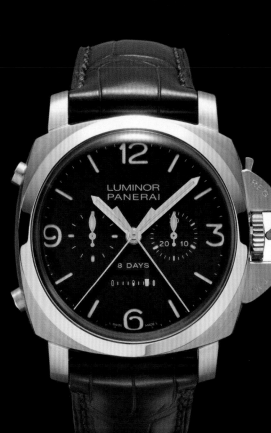

REGATTA CHRONOGRAPHS

So-called "regatta" chronographs are distinguished by their countdown system serving to follow the last few minutes counting down to the start of a race.

These models have once again got the wind in their sails since the 32nd America's Cup in 2007. On this occasion, Omega introduced the Seamaster NZL-32, featuring a 2x5-minute countdown appearing on five hollow spheres as well as through a counter at 3 o'clock. On the Tambour LV Cup Régate by Louis Vuitton, round windows are replaced by trapezoidal cut-outs forming the outline of a spinnaker. Audemars Piguet presented the Royal Oak Offshore Alinghi Team, with a window for the minutes countdown, a central sweep seconds hand, and a flyback function serving to instantly restart the various timing operations, all housed within a high-tech forged carbon case. Girard-Perregaux created the Laureato Regatta, a single-pusher tourbillon chronograph with an additional central minutes hand for the countdown. Rolex has reasserted its place in the sailing universe by launching the Oyster Perpetual Yacht-Master II boasting an extremely clever bezel/crown/pusher system serving to follow the countdown by means of a large hand with a highly visible triangular tip. The HD3 also surfed this trend by launching the Raptor Chrono, featuring a futuristic design and a 15-minute disc-type countdown display.

And speaking of countdowns, the German brand Glashütte Original with its PanoRetroGraph was the first to present a chronograph counting in both directions. This timepiece is also equipped with a flyback function serving to start a new timing operation by pressing the pusher at 4 o'clock without needing to stop and reset the hands.

FACING PAGE
TOP
Omega, *Seamaster NZL-32*
CENTER LEFT
Girard-Perregaux, *Laureato Regatta*
CENTER RIGHT
Rolex, *Oyster Perpetual Yacht-Master II*
BOTTOM LEFT
Louis Vuitton, *Tambour LV Cup Régate*
BOTTOM CENTER
Audemars Piguet, *Royal Oak Offshore Alinghi Team*
BOTTOM RIGHT
HD3, *Raptor Chrono*

THIS PAGE
Glashütte Original, *PanoRetroGraph*

A. LANGE & SÖHNE

1815 CHRONOGRAPH – REF. 402.032

The 1815 Chronograph houses an A. Lange & Söhne manufactured manual-winding L951.5 movement complete with a hand-engraved balance cock. One of the highlights among the numerous technical features is the flyback function with precisely jumping minute counter, a device found only in very few chronographs. The two symmetrically positioned subsidiary dials for the seconds and 30-minute counter emphasis the balanced geometry and the classic style of the watch. The pink- or white-gold case measures 39.5mm and is fitted with antireflective sapphire crystal on the front and back. The dial is solid silver with blued steel hands. The hand-stitched crocodile strap is secured with a solid gold buckle.

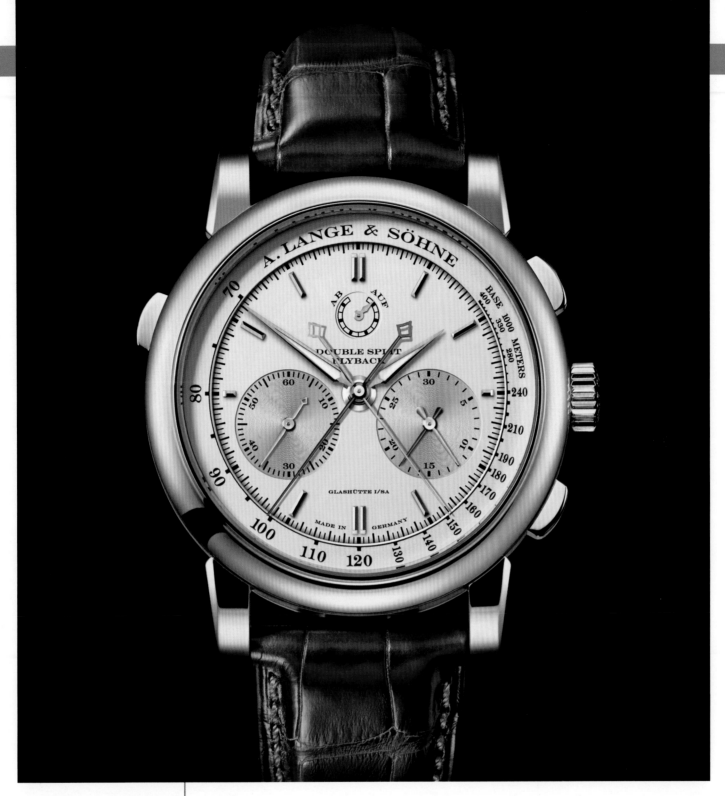

A. LANGE & SÖHNE

DOUBLE SPLIT – REF. 404.032

This model is powered by the manual-winding Lange L001.1 movement. The Double Split is a flyback chronograph with double rattrapante, controlled by classic column wheels. Included is a jumping chrono minute counter and rattrapante minute counter, flyback function with indication for hours, minutes, small seconds with stop seconds and power reserve indicator. The movement is encased in a 43mm rose-gold case with sapphire crystal on the front and caseback. The dial is two-tiered solid silver. The Double Split is also available in platinum.

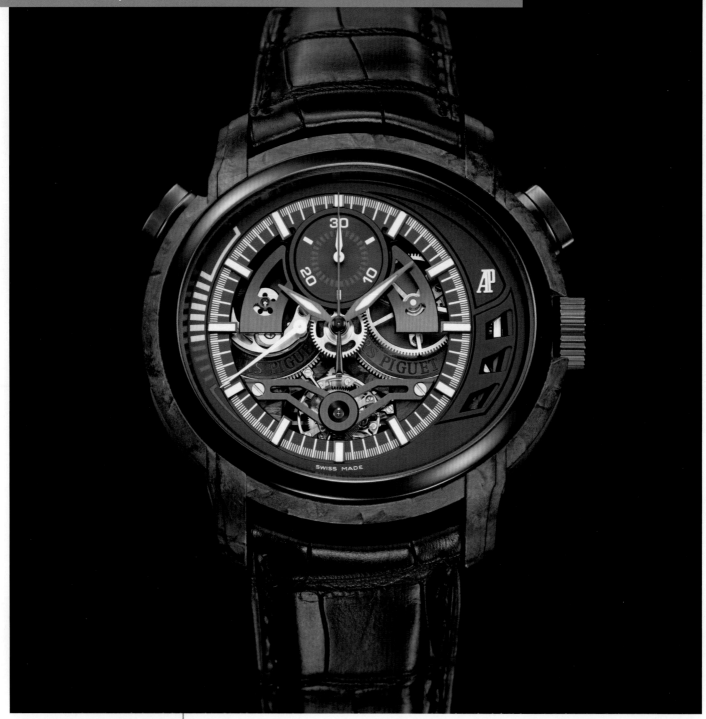

AUDEMARS PIGUET

MILLENARY CARBON ONE TOURBILLON CHRONOGRAPH – REF. 26152AU.OO.D002CR.01

Audemars Piguet Caliber 2884 is an oval hand-wound movement developed and crafted entirely by Audemars Piguet. It is a complex movement equipped with a tourbillon, an ultra-efficient column-wheel chronograph mechanism and twin barrels. This watch's case is in forged carbon with a black ceramic bezel, crown and pushbuttons, a cambered glareproof sapphire crystal, and blackened titanium caseback fitted with sapphire crystal. Limited edition of 120 pieces.

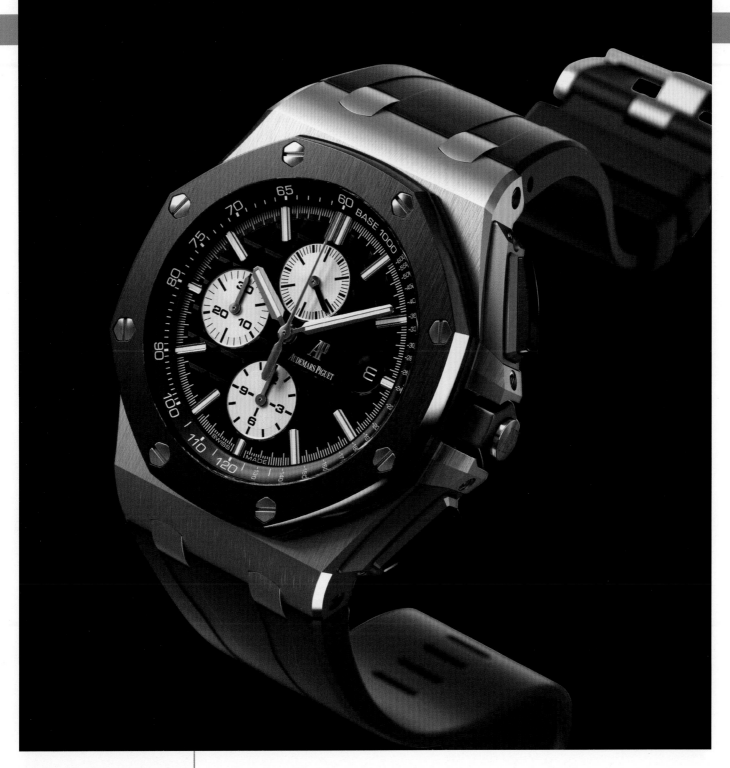

AUDEMARS PIGUET

ROYAL OAK OFFSHORE CHRONOGRAPH – REF. 26400RO.OO.A002CA.01

The Royal Oak Offshore model involves far more than just a change of size; the entire aesthetic of the case has been reworked. The 44mm case middle is composed of two materials: ceramic and pink gold. The extreme reliability of the 3126/3840 movement provides excellent user-friendliness, particularly due to the instant jump and fast-adjusted date mechanism, along with a 60-hour power reserve and a stop seconds device when setting the time. The movement can be admired through the sapphire crystal caseback. Finally, the newly developed oscillating weight is crafted all of a piece from a block of 22K gold coated with an anthracite galvanic treatment.

BVLGARI

ENDURER CHRONOSPRINT – REF. BRE56BSLDCHS

This watch immediately exudes a strong personality dominated by the contours of its 56mm case in Staybrite© steel. This rugged exterior protects an exclusive automatic-winding movement with a simplified chronograph function that measures longer times than traditional chronographs. The Chronosprint function indicates the hours and minutes by two hands mounted on a single arbor. One press on a notched pushpiece at 7:30 positions the hands at 12:00 and startes the chronograph. The watch's Calibre DR 1306 beats at 28,800 vph and drives the hour and minute hands on a slightly off-center axis, while the larger date window appears at 12:00.

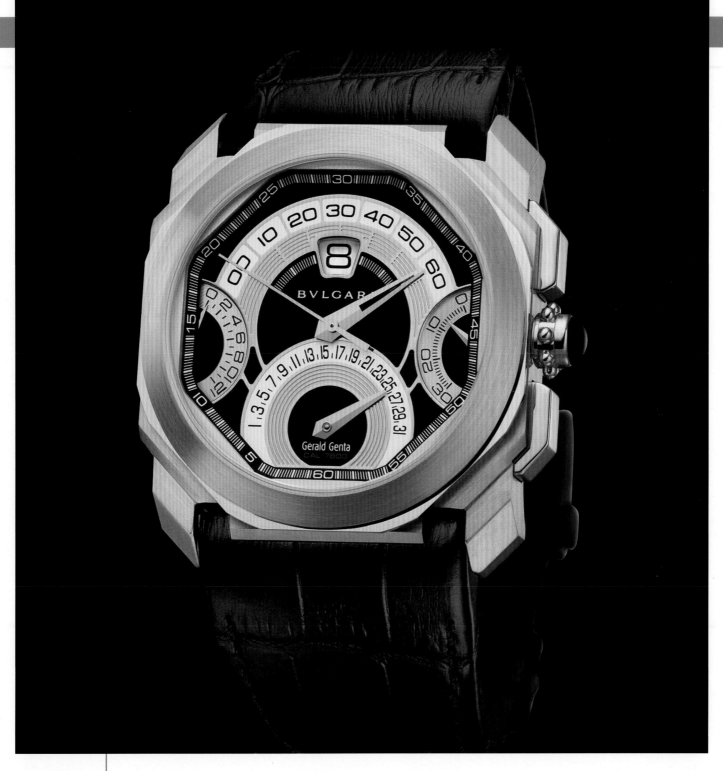

BVLGARI

OCTO CHRONOGRAPHE QUADRI-RETRO – REF. BGOP45BGLDCHQR

The Calibre GG 7800 driving the Octo Chronographe Quadri-Retro features four retrograde functions—minutes, date, chronograph hour and seconds counters—along with jumping hours through a window at 12:00 and a large chronograph seconds hand appearing at 6:00. This choice ensures that the hour indication is never hidden from sight. The traditionally built column-wheel movement is treated to impeccable finishing and is housed within an imposing 45mm case. The two chronograph pushers at 2:00 and 4:00, respectively controlling the stop/start functions and reset function, are perfectly integrated within the case middle. The well-structured visual composition of the dial combines a jet black lacquered surface, silvered segments and white arcs with a minute track at 12:00 and date at 6:00, as well as chronograph and minute counters at 9:00 and 12:00.

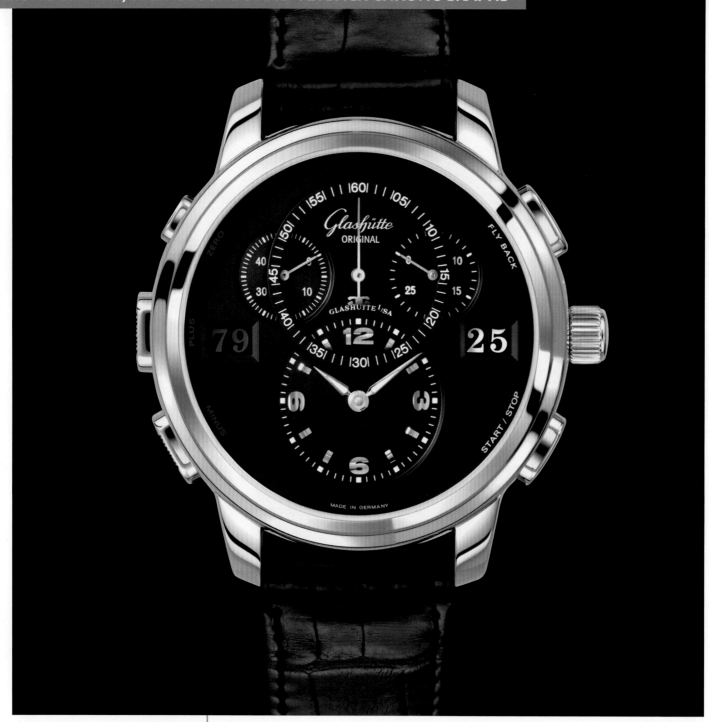

GLASHÜTTE ORIGINAL

PANOMATICCOUNTER XL – REF. 96.01.02.02.04

The PanoMaticCounter XL presents its curiously fascinating counter complication in an elegant and effective manner. Red numerals appear on a black background in a double-digit window positioned at 9:00. The wearer activates the counter using three pushers positioned on the left side of the stainless steel case moving the count forward, backward, or resetting it to zero. Aligned along the vertical axis are the off-center hour and minute display in the lower half of the dial and, in the upper half, the large chronograph stop-seconds scale, raised above the black dial and flanked by the small seconds and 30-minute counters, whose zero points have been rotated 60° to guarantee optimum legibility. The PanoMaticCounter XL features the new Caliber 96-01, a classic column-wheel chronograph with flyback function, which is based on the award-winning Glashütte Original Caliber 95.

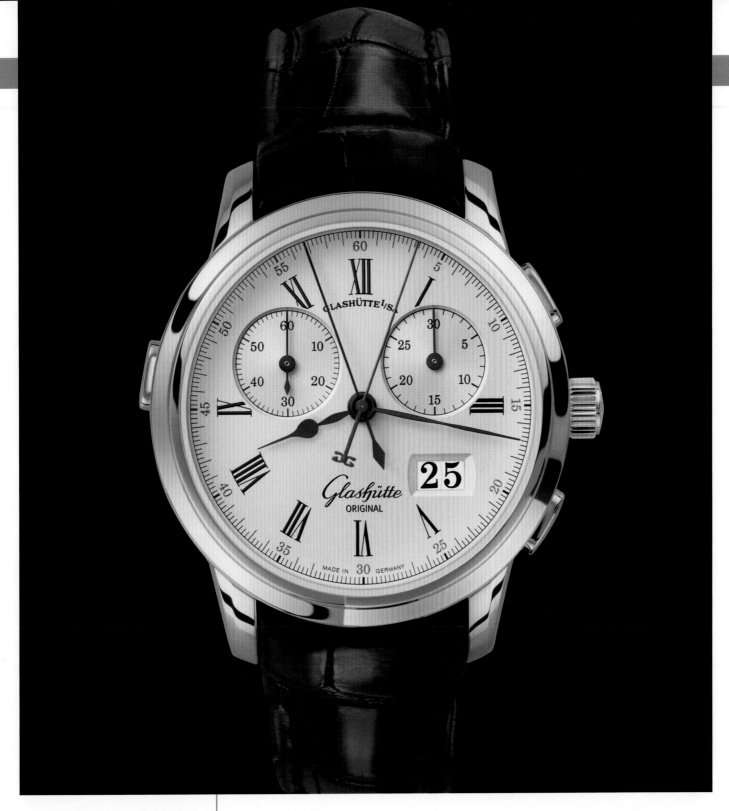

GLASHÜTTE ORIGINAL

SENATOR RATTRAPANTE – REF. 99.01.01.01.04

The Senator Rattrapante's domed, anti-reflective sapphire crystal reveals a look at its cleanly designed and structured dial, with all relevant details legible at a glance. The sweep hour and minute hands as well as the off-center stop seconds hand glide in shiny blue across the dial. Should the wearer activate the rattrapante function, the red split-seconds hand begins to chase after its blue counterpart. The dial also shows off the panorama date so characteristic of Glashütte Original at 4:00. Another remarkable characteristic of the Senator Rattrapante is its flyback function. The great advantage of this is that the wearer can take a differential time measurement, reading the result directly without needing to reset. This exclusive timepiece's manual-winding Caliber 99 ticks within a solid, completely polished 42mm rose-gold case.

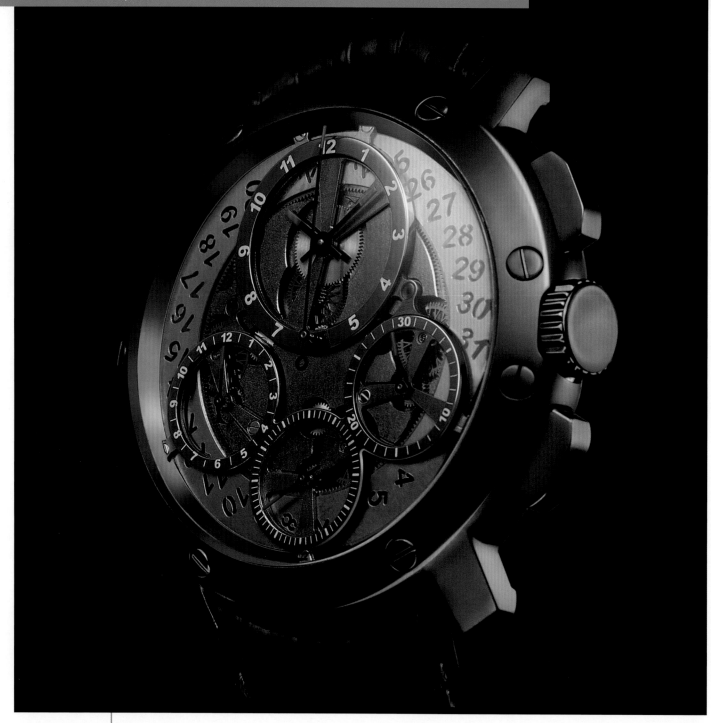

GUY ELLIA

JUMBO CHRONO

The Jumbo Chrono, the first round men's watch created by GUY ELLIA, is based on an interesting technological approach demonstrating that it is possible to combine aesthetic balance with masculine detail and a fine mechanical movement. The Jumbo Chrono boasts an exceptional 50mm size that is rarely seen in the world of luxury watches. The Jumbo Chrono's rhodium-plated rotor is unique and the impressive discovery dial reflects a strong graphic design: sweep-seconds chronograph in the center, hour and minute at 12:00, date at 2:00, 30-minute counter at 3:00, seconds at 6:00, and 12-hour counter at 9:00. This model is shown in black gold, but is also available in white gold and pink gold.

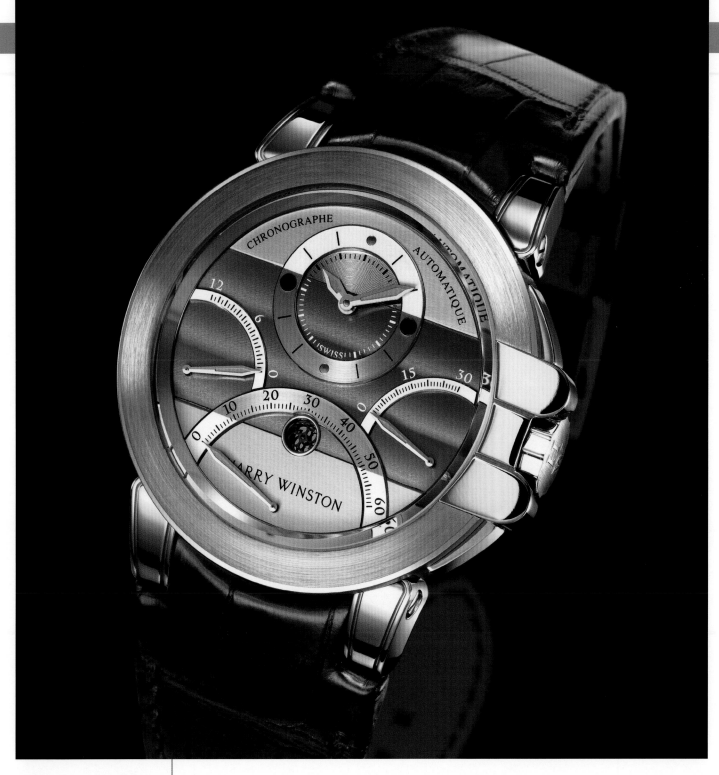

HARRY WINSTON

OCEAN TRIPLE RETROGRADE CHRONOGRAPH – REF. 400.MCRA44WL.W1

The 44mm white-gold case of the Ocean Triple Retrograde Chronograph houses three retrograde indications, skillfully arranged to ensure a harmoniously contemporary appearance: the chronograph seconds at 6:00 overlap with the 30-minute and 12-hour totalizers facing each other at 4:00 and 8:00 respectively. This retrograde trilogy is dominated by an hour and minute circle secured to the dial by two blued screws. The diamond-polished, snailed and circular satin-brushed finishes add even more visual interest to the dial. Several blue accents, a favorite Harry Winston color, including on the hands, accentuate the readability of the indications. Equipped with a mechanical self-winding movement endowed with a 40-hour power reserve, the Ocean Chronograph is water resistant to 100m and also available in a rose-gold version.

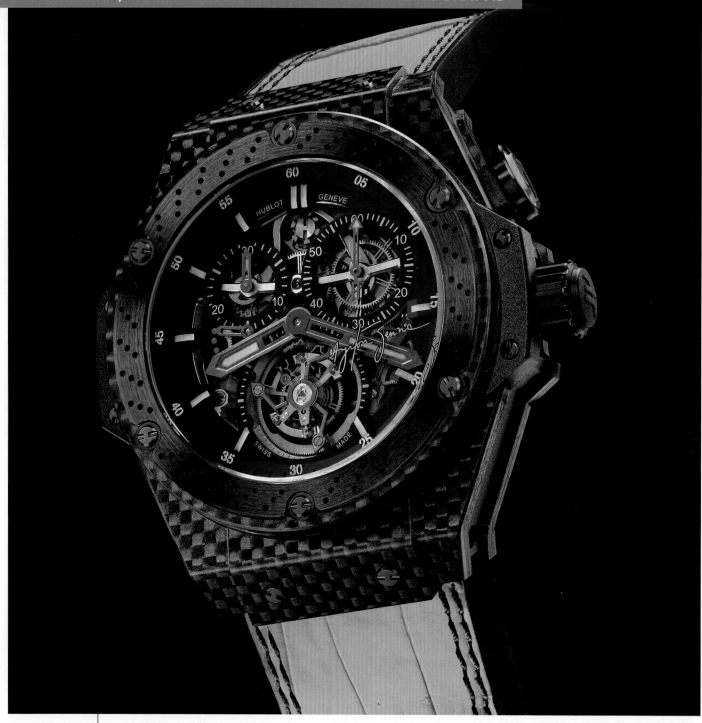

HUBLOT

KING POWER AYRTON SENNA – REF. 719.QM.1729.NR.AES10

Available in a limited, numbered edition of 500 pieces, Hublot's King Power Ayrton Senna pays tribute to the Brazilian racecar driver in a 48mm carbon fiber King Power case. The mechanical chronograph, powered by the HUB4247 caliber, is self-winding, with a split-seconds function and power reserve indicator. The pushpieces govern the chronograph's functions: at 2:00 lies the one that starts the chronograph, at 4:00 is reset and the split-seconds function is activated by the pushpiece at 7:00. The matte black carbon dial features black nickel indexes coated with yellow SuperLumiNova, with the same treatment on the satin-finished black nickel hands. For a finishing touch, SuperLumiNova dots in green, blue and red mark the power reserve indicator.

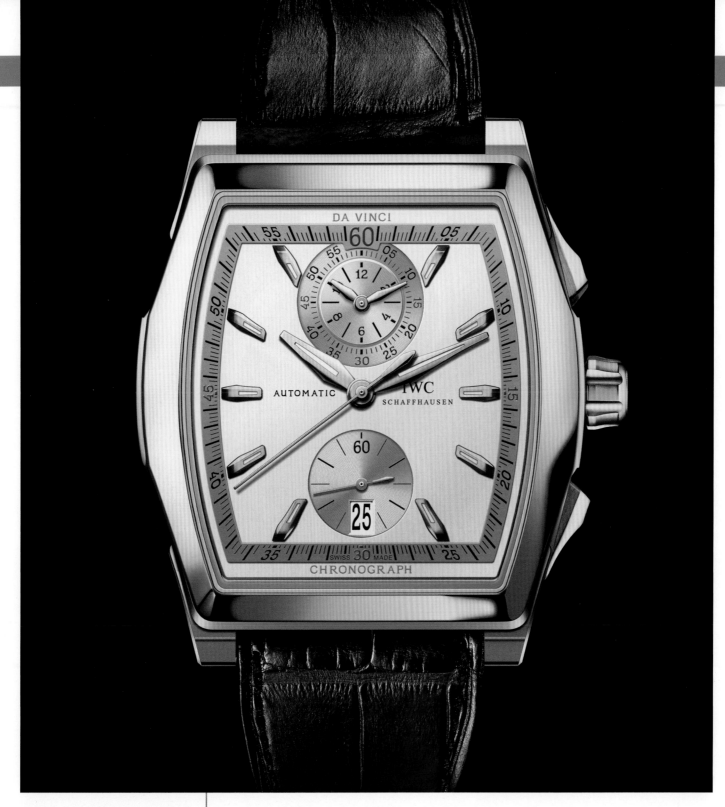

IWC SCHAFFHAUSEN

DA VINCI CHRONOGRAPH – REF. IW376402

For the Da Vinci Chronograph, IWC developed its first proprietary chronograph movement and gave it a modern interpretation with an incomparable analog time display. The manufacture's 89360 caliber boasts a 68-hour power reserve, an IWC double-pawl automatic-winding system, and is actuated via a classic column wheel. The Da Vinci Chronograph is available in platinum, rose gold or steel.

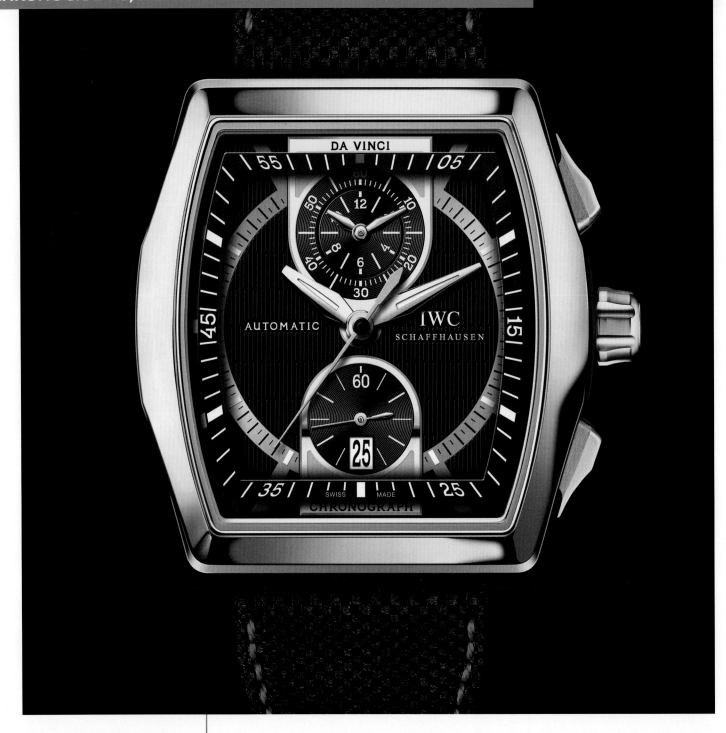

IWC SCHAFFHAUSEN

DA VINCI CHRONOGRAPH CERAMIC – REF. IW376601

In 1986, IWC unveiled a Da Vinci in a ceramic case. The new Da Vinci Chronograph Ceramic combines zirconium oxide, which is extremely scratch-resistant, non-magnetic and acid-proof, with grade 5 titanium, a material that has proven its worth in aircraft manufacture, among other things. Apart from the striking bezel, other parts machined from titanium are the caseback, the crown and the buttons. For the first time ever, the titanium is satin-finished and polished, giving the watch its luxurious appearance and smooth, silky feel. The inside of the case likewise features various innovations. In another first for IWC, the movement mounting and the seats for the operating parts are machined directly into the ceramic casing ring. The chronograph pushbuttons are fitted with newly developed, wear-resistant pushpins, likewise made of ceramic. Also new for IWC is the extravagant design of the dial, which has assumed an attractive, three-dimensional quality. The réhaut volant, a tonneau-shaped minute display, appears to hover above the dial, while the stopwatch hand partially glides below it. This floating chapter ring assumes the same convex shape as the sapphire glass, making the inner surface of the bezel appear flatter. The watch's overall appearance is rounded off by a specially treated calfskin strap whose surface structure is reminiscent of a high-tech fabric. The flyback chronograph combines the hour and minute counters in a single totalizer.

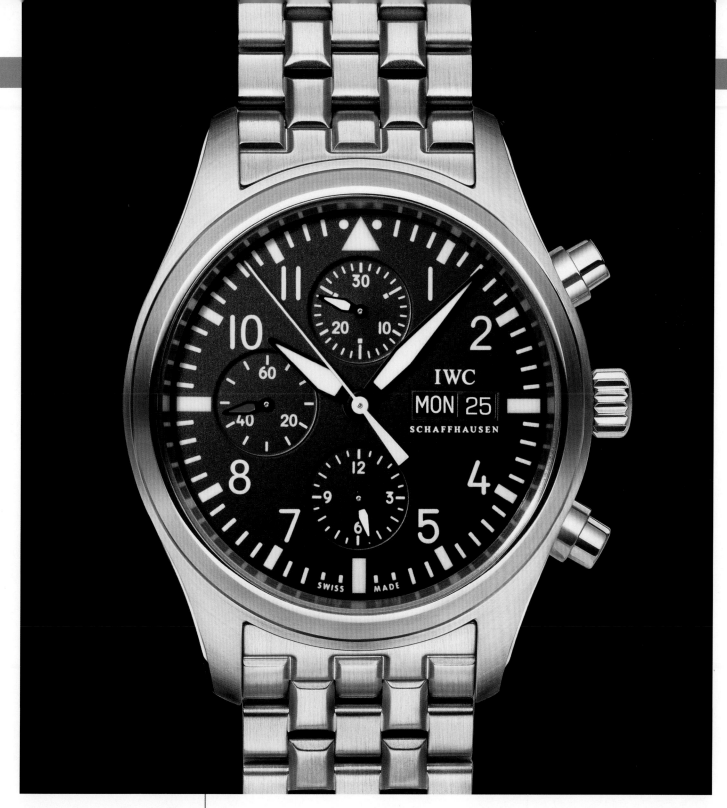

IWC SCHAFFHAUSEN

PILOT'S WATCH CHRONO-AUTOMATIC – REF. IW371704

The Pilot's Watch Chrono-Automatic features a robust mechanical chronograph with day and date indicator. It houses the IWC 79320 caliber with 25 jewels, 44 hours of power reserve and features a soft inner iron case to protect against magnetic fields. With its cockpit look, this watch has outstanding readability.

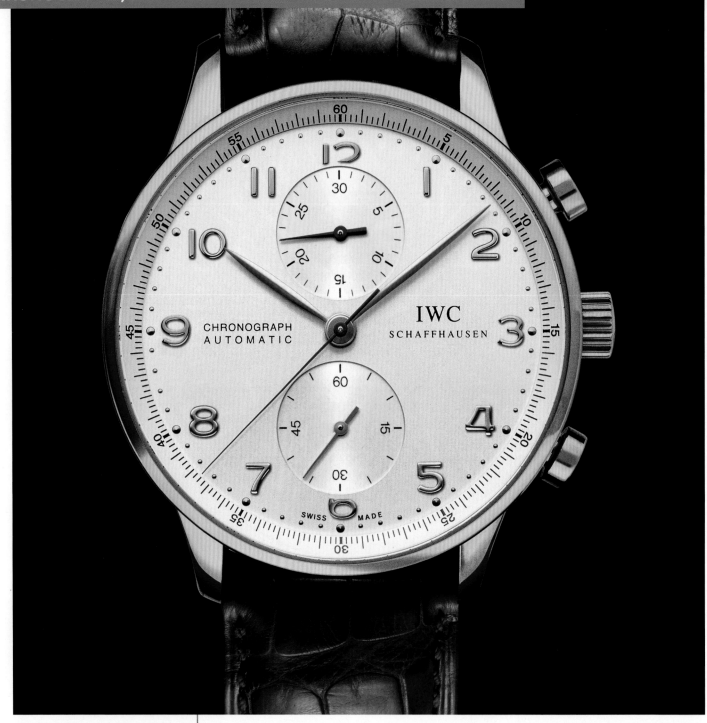

IWC SCHAFFHAUSEN

PORTUGUESE CHRONOGRAPH – REF. IW371480

The tradition behind the Portuguese family of watches stretches all the way back to the precision nautical instruments used by seafarers to discover the world. A traditional line like this needs a chronograph with a scale calibrated to an accuracy of a quarter of a second. The elegant design and moderate height of the case have made the Portuguese Chronograph one of the most sought-after Portuguese models of them all. Everything is integrated harmoniously on the clearly organized dial: the recessed totalizers, the embossed Arabic numerals and the perfectly proportioned feuille hour and minute hands. This year, two new versions join the chronograph fleet, both in cases with the warm appeal of red gold. The slate-colored dial with its shimmering sun-pattern finish and jet-black counters is simply superb. In the second new version, the blued hands for times recorded by the stopwatch provide a colorful contrast to the silver-plated dial.

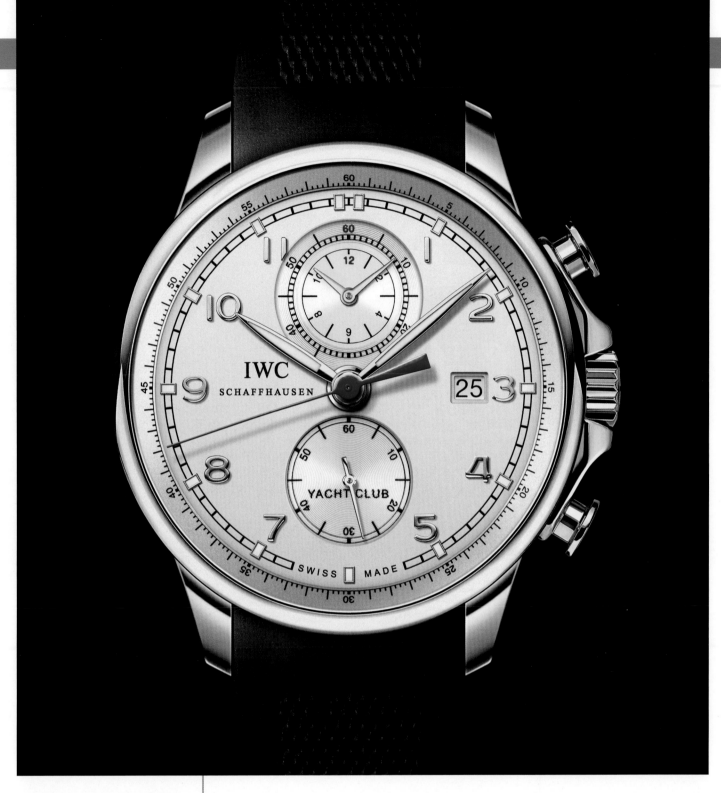

IWC SCHAFFHAUSEN

PORTUGUESE YACHT CLUB CHRONOGRAPH – REF. IW390206

The name of the new Portuguese Yacht Club Chronograph harks back to the legendary Yacht Club Automatic of the 1960s and 70s, an ocean-going watch so exclusive that it became one of IWC's most successful watches ever. The Portuguese Yacht Club Chronograph has all the precision of a nautical instrument in its genes and boasts a wealth of advanced technical features. Powered by the rugged IWC-manufactured 89360 caliber, and water resistant to 6 bar, the chronograph is geared for competition use with a flyback function, an additional flange with quarter-second calibration for recording short periods of time and an analog display for longer stop times on a subdial. The Portuguese Yacht Club Chronograph is the only Portuguese model to feature crown protection along with luminescent hands and indexes. It is available in stainless steel with a black or silver-colored dial and in red gold with a slate-colored dial and black totalizers. It is supplied with a rubber strap, making it the perfect companion for water sports of all kinds.

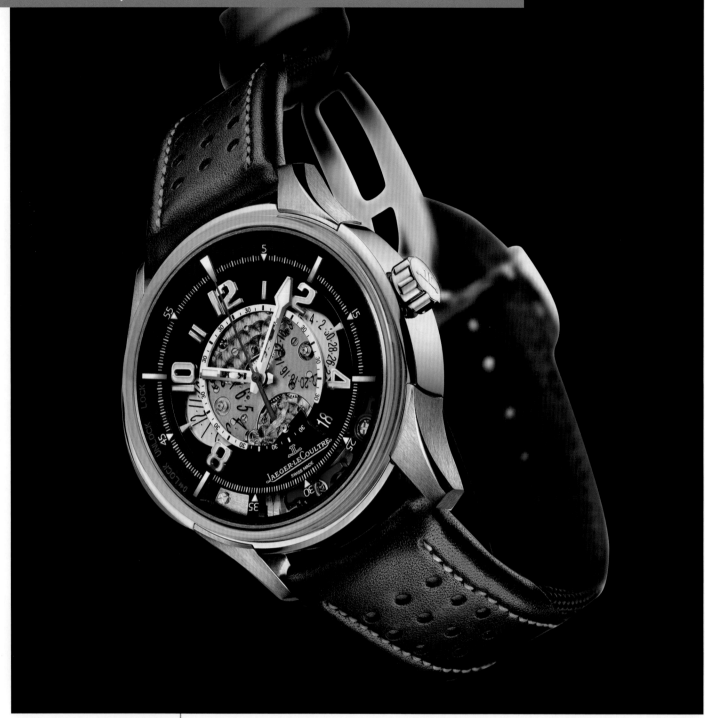

JAEGER-LeCOULTRE

AMVOX2 CHRONOGRAPH DBS – REF. Q192.84.70

Born from a partnership between Jaeger-LeCoultre and Aston Martin, the AMVOX2 Chronograph DBS is distinguished by its revolutionary Jaeger-LeCoultre patented vertical-trigger chronograph. In a huge leap forward from the traditional pushpieces on the case, the chronograph function can be triggered and disengaged by pressing the sapphire crystal at the 12:00 position, while resetting is done in a similar way by pressing at the 6:00 mark. The model's design reveals its ties to Aston Martin: the distinctive 270° sweep of the black dial resembling that on dashboard counters, the luminescent numerals, and the 30-minute and 12-hour chronograph counters on luminescent white discs. The piece is powered by the automatic-winding Jaeger-LeCoultre 751E, which is crafted, assembled and decorated by hand.

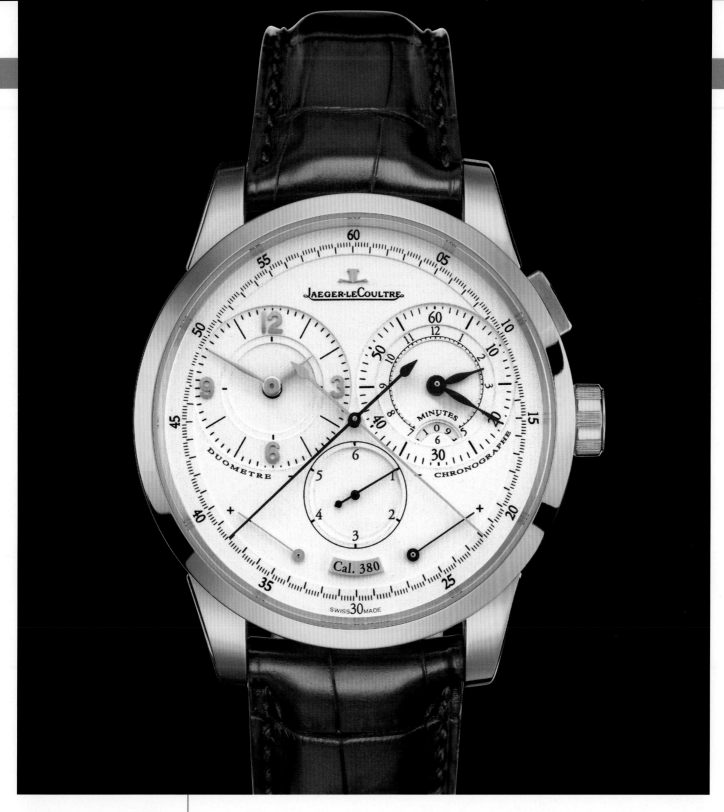

JAEGER-LeCOULTRE

DUOMETRE A CHRONOGRAPHE – REF. 601.24.20

The Duomètre à Chronographe is a true masterpiece of micromechanics, supplied with two independent power reserves by its "Dual-Wing" caliber. One power reserve is devoted entirely to the chronograph functions: hours, minutes, seconds, a display of units per minute and a foudroyante seconds display with zero reset. A counter at 6:00 displays the jumping seconds, divided into six units and linked to the chronograph seconds hand. The attention to aesthetic detail extends to the decoration on the Jaeger-LeCoultre 380 caliber, as bridges that relate to conventional time measurement are finished differently from those involved with the chronograph functions.

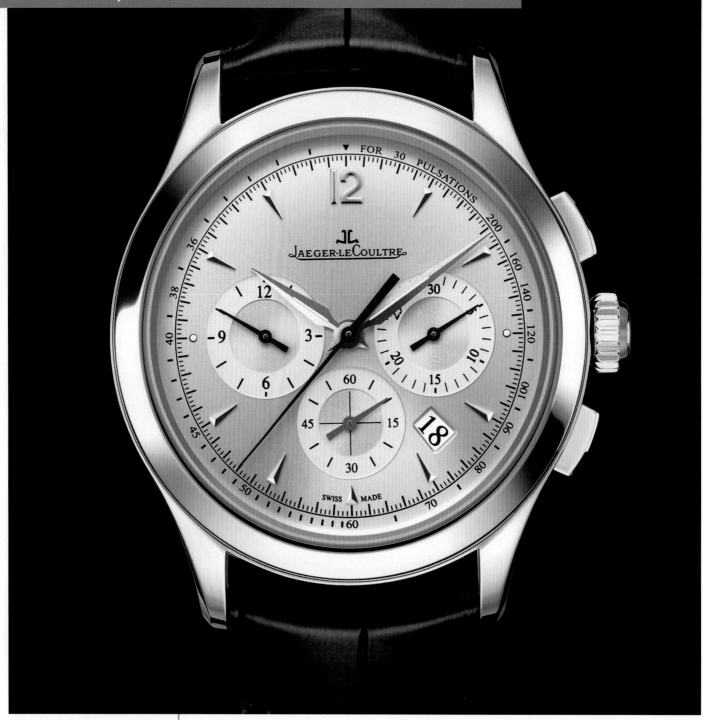

JAEGER-LeCOULTRE

MASTER CHRONOGRAPH – REF. 153.84.20

The Master Chronograph is powered by the automatic-winding Jaeger-LeCoultre 751 A/I caliber, which comprises 277 components and beats at 28,800 vph. Two barrels provide 65 hours of power reserve. The stainless steel case, with a diameter of 40mm, provides a perfect complement to the silver sunray-brushed dial, and provides water resistance to 50m. Small seconds tick away in a subdial at 6:00, leaving the center hand to measure chronograph seconds. The chronograph function is completed by a 30-minute counter at 3:00 and a 12-hour counter at 9:00. The piece is also available with an 18K pink-gold case.

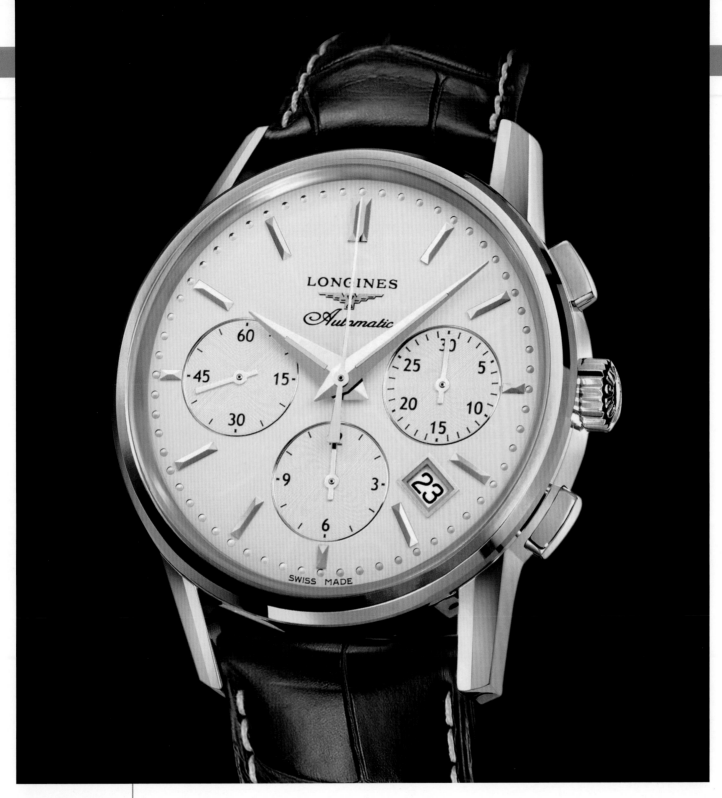

LONGINES

THE LONGINES COLUMN-WHEEL CHRONOGRAPH – REF. L2.733.4.72X

The Longines Column-Wheel Chronograph features a 30-minute counter at 3:00 and 12-hour counter at 6:00. Encased in stainless steel and 39mm in diameter, this timepiece is powered by its L688.2 caliber and features a 54-hour power reserve. Completed by a genuine alligator strap, the Longines Column-Wheel Chronograph is also available in 18K rose gold.

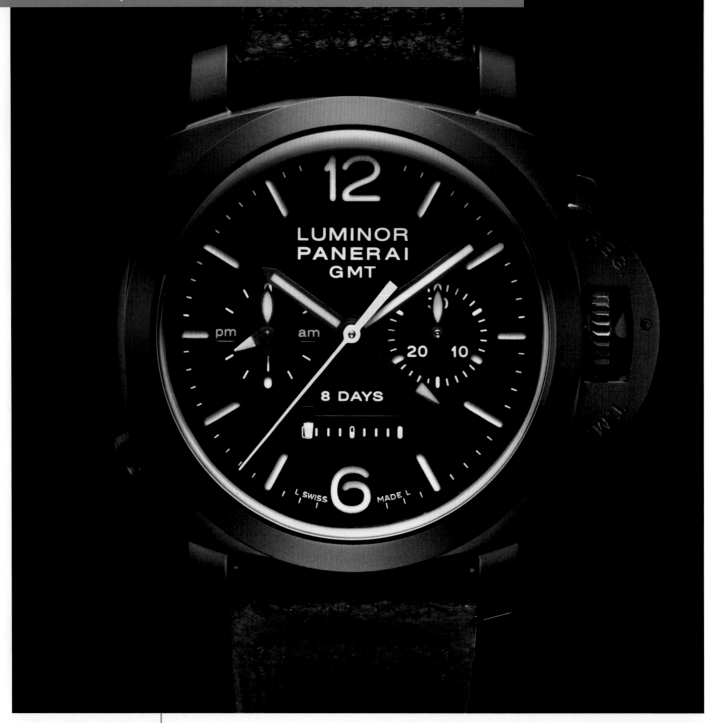

PANERAI

LUMINOR 1950 8 DAYS CHRONO MONOPULSANTE GMT – REF. PAM00317

Innovative yet traditional, the Luminor 1950 8 Days Chrono Monopulsante GMT has an avant-garde movement fitted inside a 44mm black ceramic case that is unmistakable for its original and functional qualities. The P.2004 caliber, executed exclusively by Officine Panerai, consists of 329 components and features a second time zone with a 24-hour indicator, seconds reset and an 8-day power reserve, which is displayed via a linear indicator on the dial. Visible through the sapphire crystal caseback, the bridges are treated with a special hard black coating. This watch stands out among other sports chronographs due to reliability, water resistance to 10 bar (100m), and its single pushpiece controlling all functions.

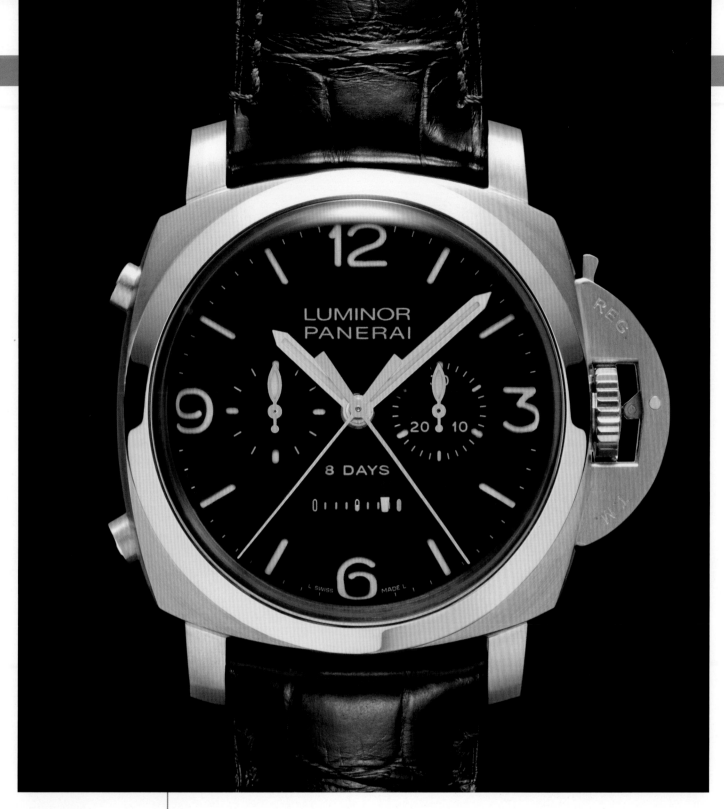

PANERAI

LUMINOR 1950 8 DAYS RATTRAPANTE – REF. PAM00319

Representing the latest and most sophisticated development of the P.2004 caliber, the P.2006/3 split-seconds chronograph caliber made of 350 components is executed entirely by Officine Panerai. This exceptional manual-winding movement is contained in a classically elegant 47mm case, which is water resistant to 10 bar (100m) and crafted of brushed 18K pink gold. With an 8-day power reserve and just two pushpieces to control all of its functions (rather than the usual three), this rattrapante model is extremely rare in a limited edition of 300 pieces.

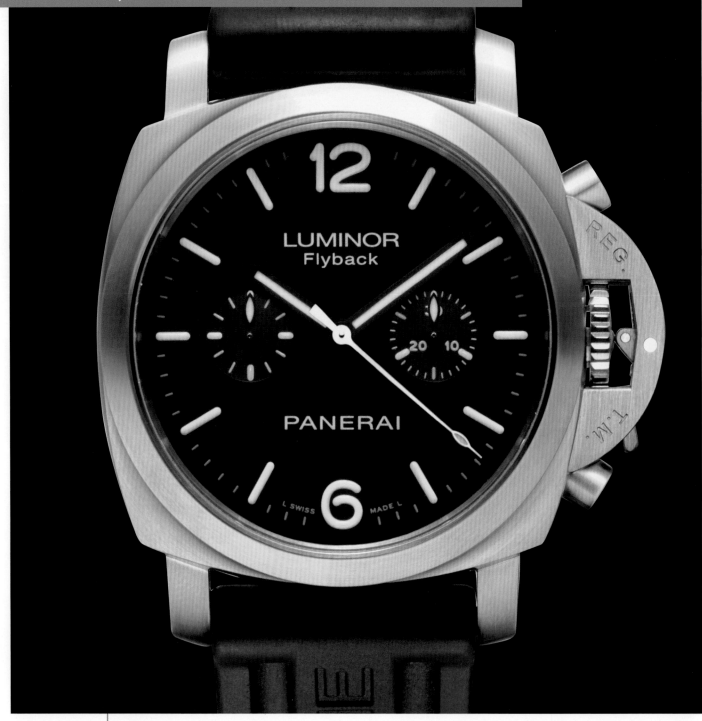

PANERAI

LUMINOR 1950 FLYBACK, 44MM – REF. PAM00361

This high-performance sportsman's watch is fitted with a COSC-certified Panerai OP XIX movement. The flyback function on the subdial at 3:00 enables timing to be interrupted, returned to zero and restarted—all with a single touch. The Luminor 1950 case is crafted in brushed steel and comes with a black rubber strap. This timepiece has a power reserve of 42 hours and is water resistant to a depth of 10 bar (100m).

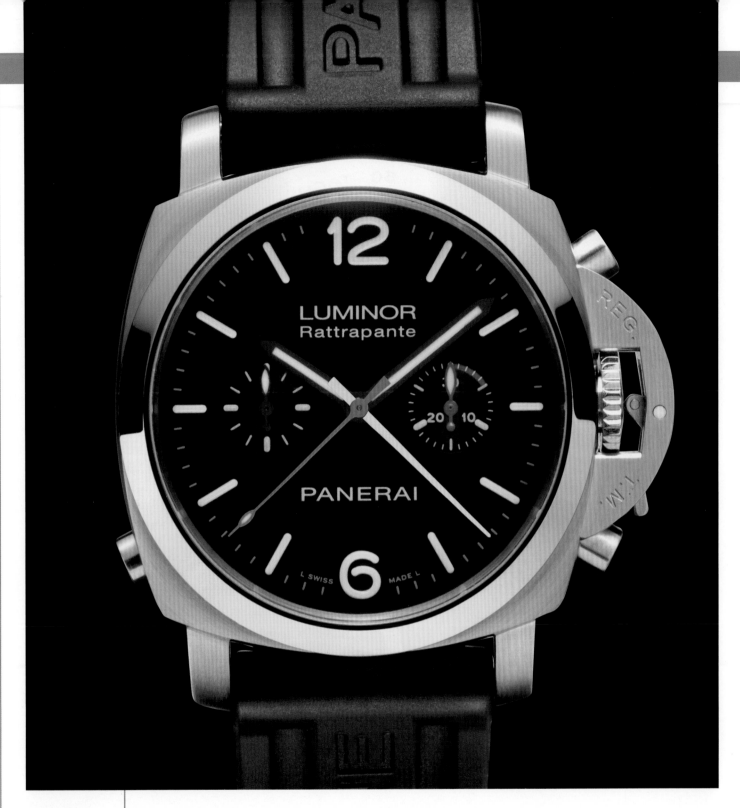

PANERAI

LUMINOR 1950 RATTRAPANTE, 44MM – REF. PAM00362

This highly competitive sportsman's chronograph rattrapante is fitted with a COSC-certified Panerai OP XVIII caliber. The split-seconds function enables the total time and an unlimited number of intermediate times (relating to the action of a moving object) to be taken and can also measure the successive arrival times of two competitors. The Luminor 1950 case is fashioned in polished steel and comes with a black rubber strap. This timepiece has a power reserve of 42 hours and is water resistant to a depth of 10 bar (100m).

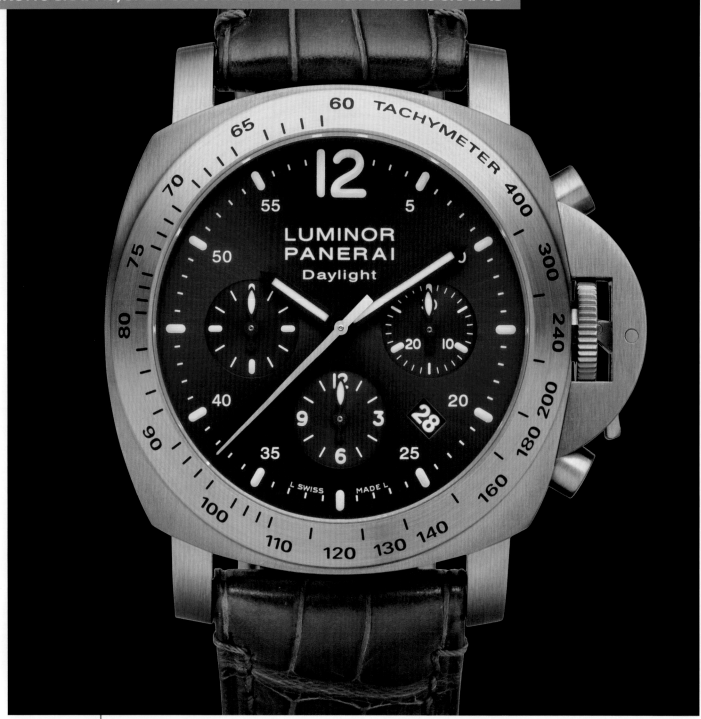

PANERAI

LUMINOR CHRONO DAYLIGHT TITANIO – REF. PAM00326

The Panerai Luminor Chrono Daylight is a high-performance sports watch fitted with the Panerai OP XII caliber, a COSC-certified movement with chronograph functions on three counters. Two chronograph pushpieces on the three-part, 44mm brushed steel case are integrated into the patented device protecting the crown, which ensures the piece is water resistant to 10 bar (100m). The "Daylight" inscription at 12:00 brings back to the limelight a name reserved by Officine Panerai for Sylvester Stallone, who starred in the successful film of the same title.

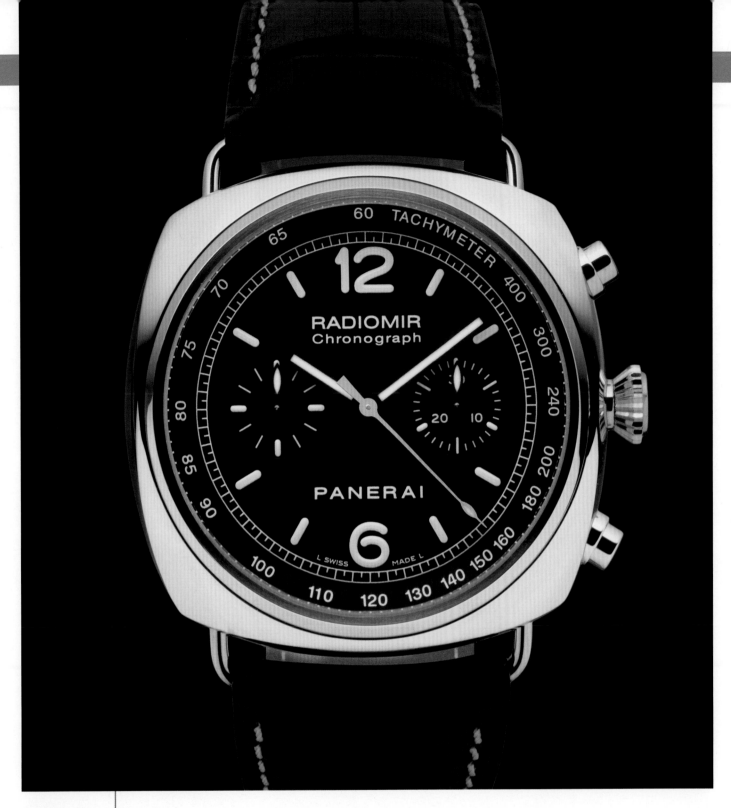

PANERAI

RADIOMIR CHRONOGRAPH – REF. PAM00288

The Radiomir Chronograph, fitted with the COSC-certified Panerai OP XII caliber, is a classic model with its own sports character. It has two chronometer pushpieces perfectly incorporated into the design of the 45mm polished steel case (at 2:00 and 4:00). These "pump" type pushpieces, coupled with the screw-down winding crown, ensure the watch's perfect water resistance to a depth of 10 bar.

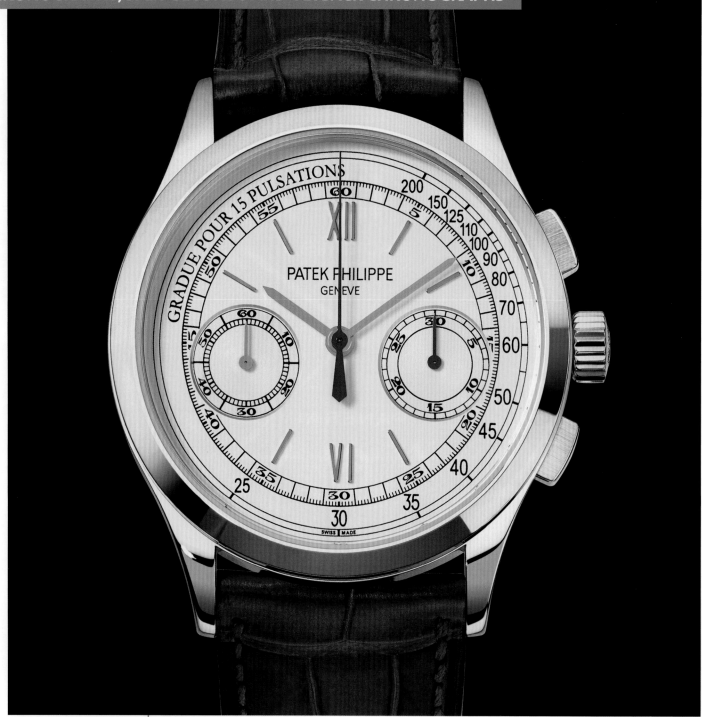

PATEK PHILIPPE

CHRONOGRAPH – REF. 5170J

The Ref. 5170J is a truly classic chronograph. It comes in a yellow-gold case with a diameter of 39mm and possesses the CH 29-53 PS manufacture chronograph movement. Its case design uses the round Calatrava style with rectangular pushers that evoke Patek Philippe's coveted vintage chronographs from the 1940s. The new caliber within, a manual-winding two-pusher chronograph movement with column-wheel control and a horizontal clutch, was entirely developed in the brand's workshops. It incorporates six patented inventions and beats at a frequency of 28,800 vph. The silvered white dial bears slim applied hour markers, yellow-gold applied Roman numerals at 12:00 and 6:00, and black transfer-printed scales.

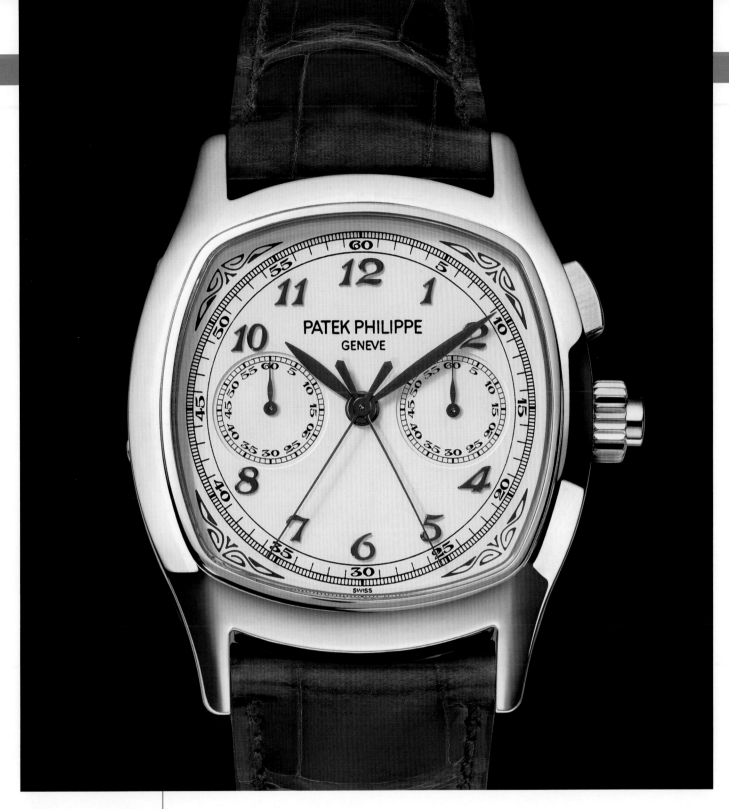

PATEK PHILIPPE

SPLIT-SECONDS CHRONOGRAPH – REF. 5950A

Launched in 2005, the caliber CHR 27-525 PS split-seconds chronograph movement has just embarked on a new career. Measuring just 5.25mm in thickness, it is the thinnest ever made, and it is still crafted one at a time. The innovative element is its armor of steel, which Patek Philippe has elevated to the status of a precious metal. The cushion-shaped case is water resistant to 30m and the sapphire crystal exhibition caseback features the same camber as the sapphire crystal covering the dial—an appropriately finished frame for the elaborate caliber with its hand-chamfered components. The orchestration of micromechanical art is gracefully complemented on the face of the watch with delicate foliage engraving that adorns the four corners of the dial.

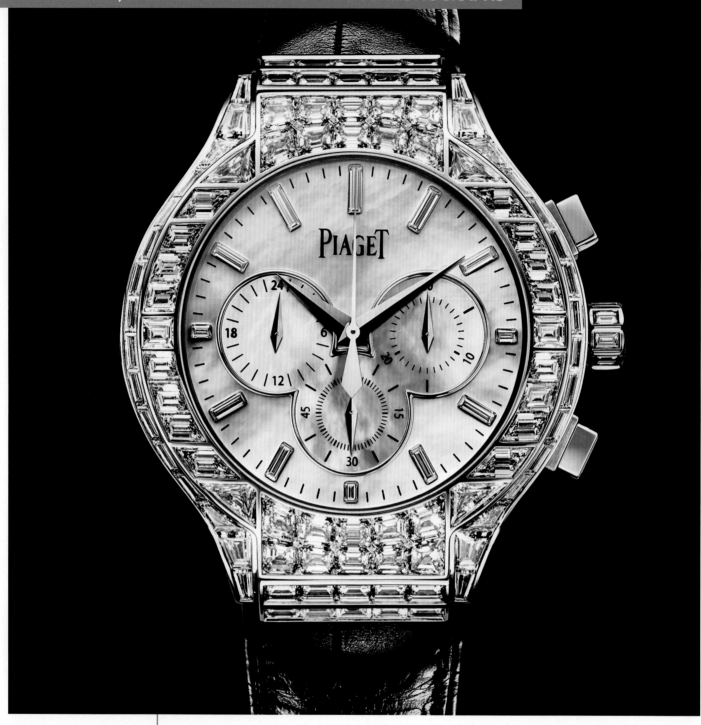

PIAGET

GEMSET PIAGET POLO – REF. G0A35112

This watch brilliantly embodies the best of two worlds according to Piaget: haute horology and haute jewelry. Equipped with the self-winding Calibre 881P, developed and crafted by Piaget, it displays the hours, minutes, small seconds and dual time zone, as well as the flyback chronograph function. Refinement is taken to extremes with the gem-set oscillating weight. As beautiful on the outside as it is inside, its 18K white-gold case is enhanced by 700 diamonds, including 94 baguette-cut stones of 36 different sizes, all selected and calibrated by the Piaget Master Jewelers in order to ensure they adapt perfectly to the case's shape. Fitted with a mother-of-pearl dial, this model is also adorned with a gem-set caseback.

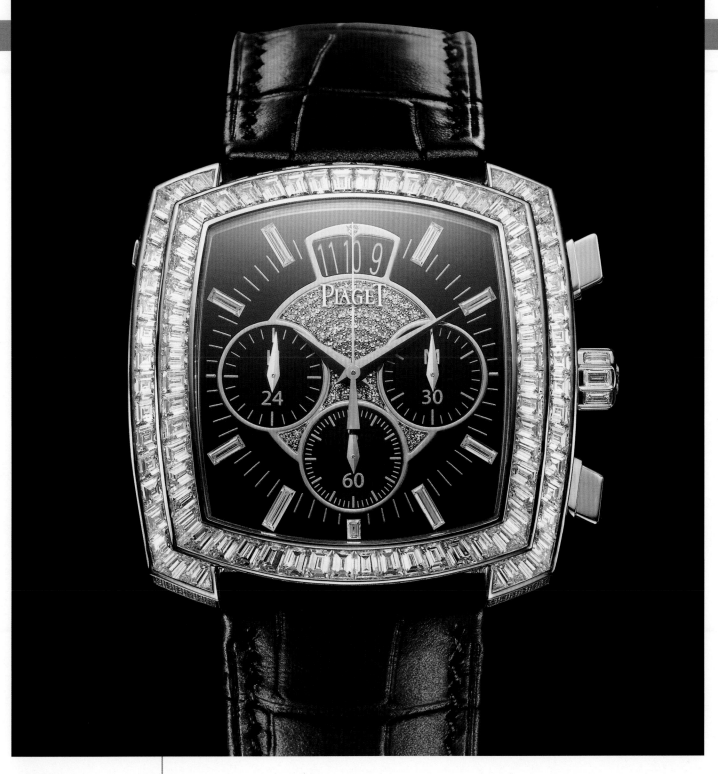

PIAGET

LIMELIGHT EXCEPTIONAL PIECE – REF. G0A33144

This timepiece is an exceptional creation equipped with the 880P; a mechanical chronograph movement designed, developed and produced by the manufacture de Haute Horlogerie Piaget. In addition to indicating the hours, minutes, small seconds at 6:00, date at 12:00 and a second time zone, this proprietary movement features chronograph and flyback functions with 52-hour power reserve in activated chronograph mode. This haute jewelry model is adorned with 634 brilliant- and baguette-cut diamonds (approx. 10.9 carats). It is distinguished by Piaget's characteristic haute horology signature finishes, such as the circular-grained mainplate, beveled and hand-drawn bridges, blued screws, and circular Côtes de Genève.

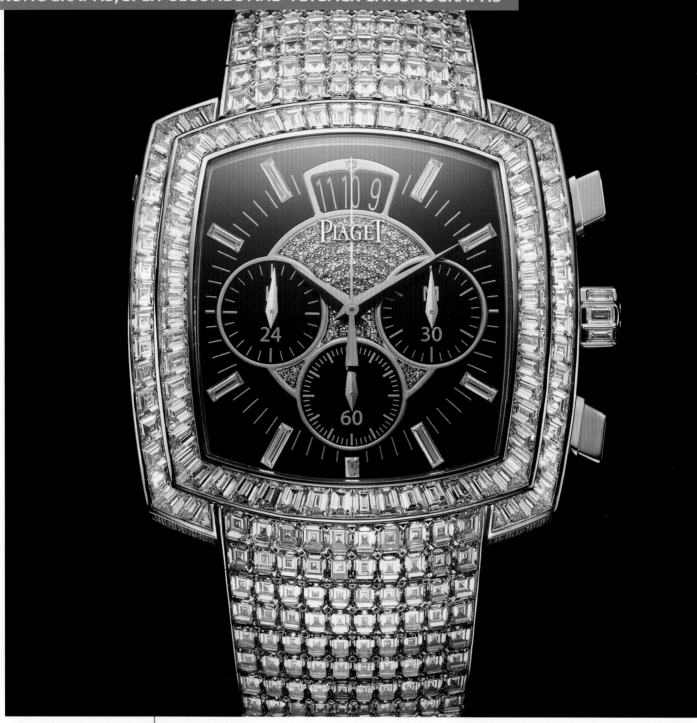

PIAGET

LIMELIGHT EXCEPTIONAL PIECE – REF. G0A33145

The Limelight model is an exceptional creation equipped with the 880P, the first mechanical chronograph movement designed, developed and produced by the Manufacture de Haute Horlogerie Piaget. In addition to indicating the hours, minutes, small seconds at 6:00, date at 12:00 and a second time zone, this proprietary movement features chronograph and flyback functions with a 52-hour power reserve in activated chronograph mode. This haute jewelry model adorned with more than 1,148 brilliant- and baguette-cut diamonds (approximately 47.4 carats) called for almost 600 hours of development (including nearly 385 hours for the bracelet setting alone). It is distinguished by Piaget's characteristic haute horology signature finishes such as the circular-grained mainplate, beveled and hand-drawn bridges, blued screws, and circular Côtes de Genève.

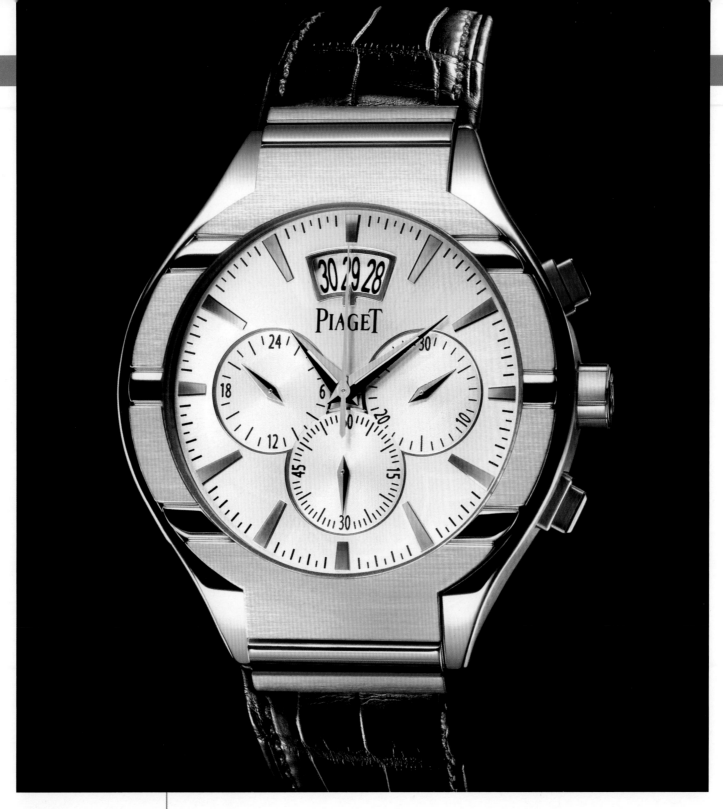

PIAGET

PIAGET POLO CHRONOGRAPH IN PINK GOLD – REF. G0A32039

The Piaget Polo Chronograph model houses the new Calibre 880P, the first mechanical chronograph movement entirely designed, developed and produced by the Manufacture de Haute Horlogerie Piaget. In addition to the chronograph and flyback functions, this proprietary movement drives the hours, minutes and small seconds at 6:00, as well as the date display at 12:00 and a second time zone indication. Within the select circle of manufacture-made chronograph movements, Calibre 880P stands out for its 24-hour dual time zone display positioned at 9:00, the place usually reserved for the standard chronograph hour counter. Featuring two barrels and a large balance with screws, this mechanical self-winding movement provides a 52-hour power reserve in activated chronograph mode. Equipped with a column-wheel mechanism and vertical coupling-clutch, the 5.6mm-thick Calibre 880P is endowed with all the attributes of an haute horology chronograph movement.

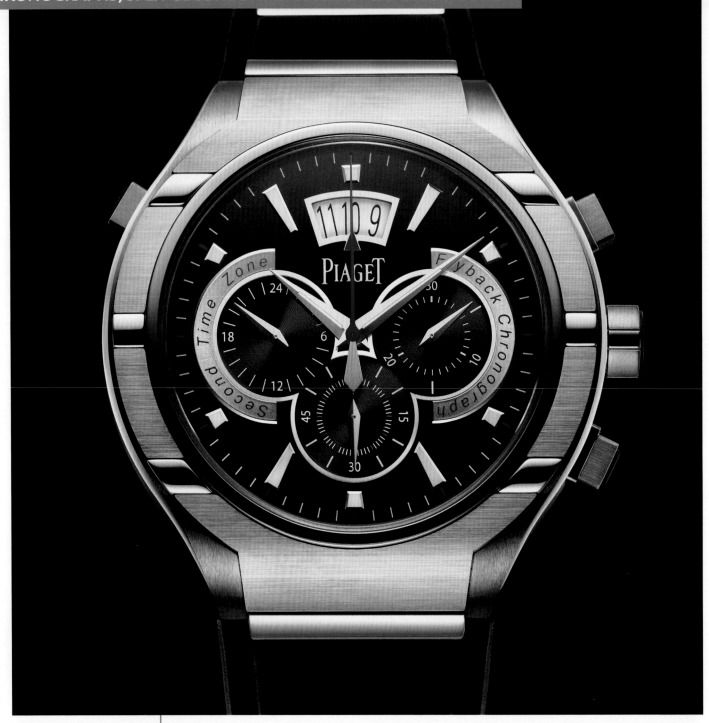

PIAGET

PIAGET POLO FORTYFIVE – REF. G0A34002

The Piaget Polo FortyFive model is made of titanium. It reinterprets the original aesthetic in a case that is watertight to 100m, mounted on a strap made of injection-molded rubber, and expanded to a diameter of 45mm. In addition to its chronograph and flyback functions, the in-house 880P caliber displays the hours and minutes, along with small seconds at 6:00, a second 24-hour time zone at 9:00 and the date at 12:00. This 5.6mm-thick self-winding mechanical movement has two barrels and a large screw balance, and offers a 50-hour power reserve when the chronograph mode is engaged. The subtle marriage of polished and satin-finished surfaces brings out this powerful timepiece's character even more strongly. The sapphire crystal caseback shows off the decoration on the movements: the plate is circular-grained, bridges are beveled and the circular Côtes de Genève pattern and blued screws are the brand's signature aesthetic; the PVD-treated dark gray winding rotor is engraved with the Piaget emblem.

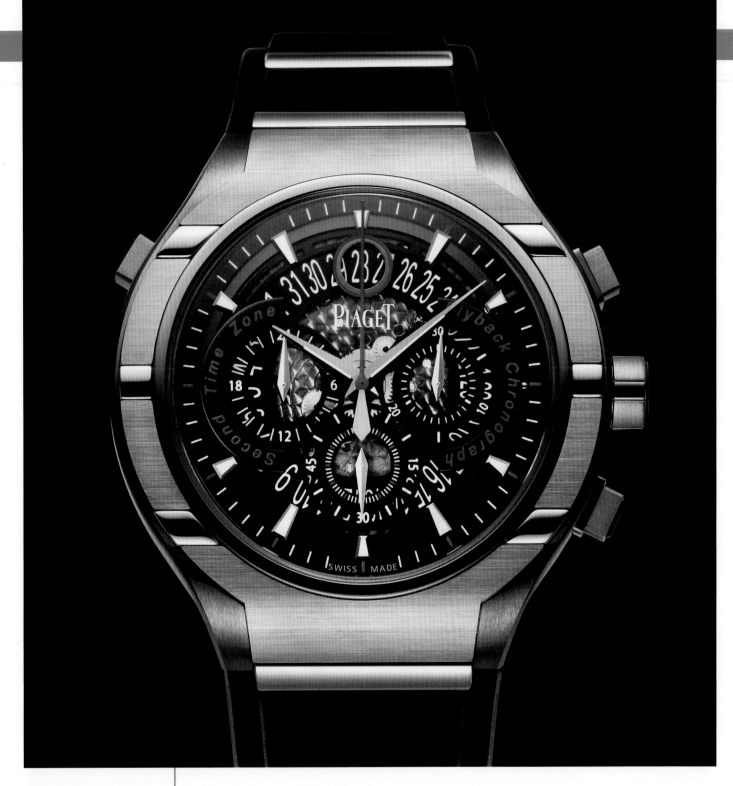

PIAGET

PIAGET POLO FORTYFIVE – REF. G0A35001

In addition to the contrasts between light-colored metal and black rubber, polished steel and satin-brushed titanium, the Piaget Polo FortyFive is endowed with a technical touch thanks to multiple openings in the openworked dial, providing a view of the mechanism, which boasts a black PVD-treated circular-grained mainplate and the date disc. The numerals, hour markers and parts are entwined in a multidimensional ensemble in which every effort has been made to maintain excellent readability. The presence of bright red accents—on the hands, transfers and hour markers—stands out particularly well against the openworked dial with its black and metallic shades. Besides the chronograph and its flyback function, the Piaget 880P movement drives the hours, minutes, small seconds, date display and a 24-hour time zone indication. Thanks to its twin barrels, its power reserve lasts a full 50 hours with the chronograph in operation.

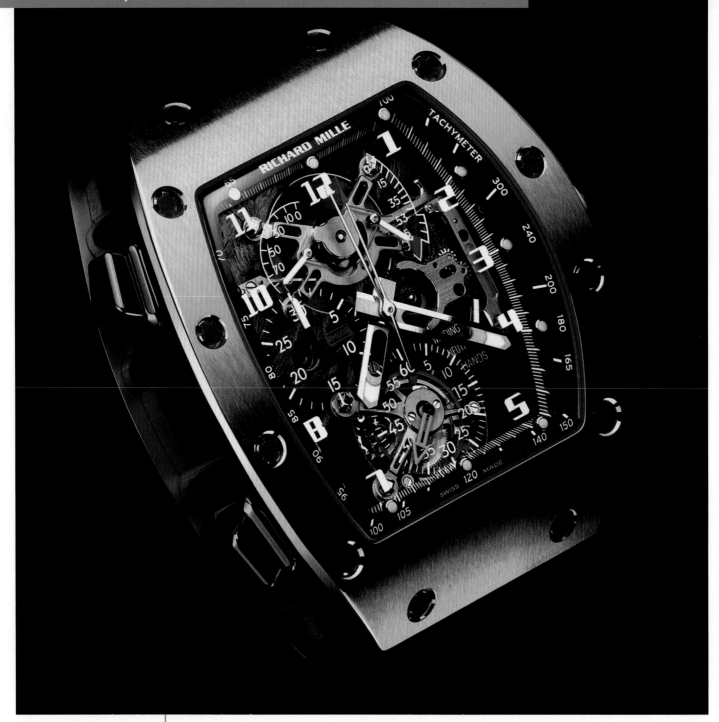

RICHARD MILLE

RM 008 TOURBILLON SPLIT SECONDS CHRONOGRAPH

Representing a totally new design of split-seconds chronograph movement with tourbillon escapement, the RM008-V2 was the result of many years of development. Built on a gray carbon nanofiber baseplate, it offers hours, minutes, seconds at 6:00, 30-minute counter, split seconds, power reserve indicator and a torque indicator in dNmm. The column wheel and other parts of the movement are crafted from titanium; the exceptional movement can be seen through the sapphire crystal caseback. Its unusual pushbutton layout was designed to optimize practical use of the chronograph and split-seconds function.

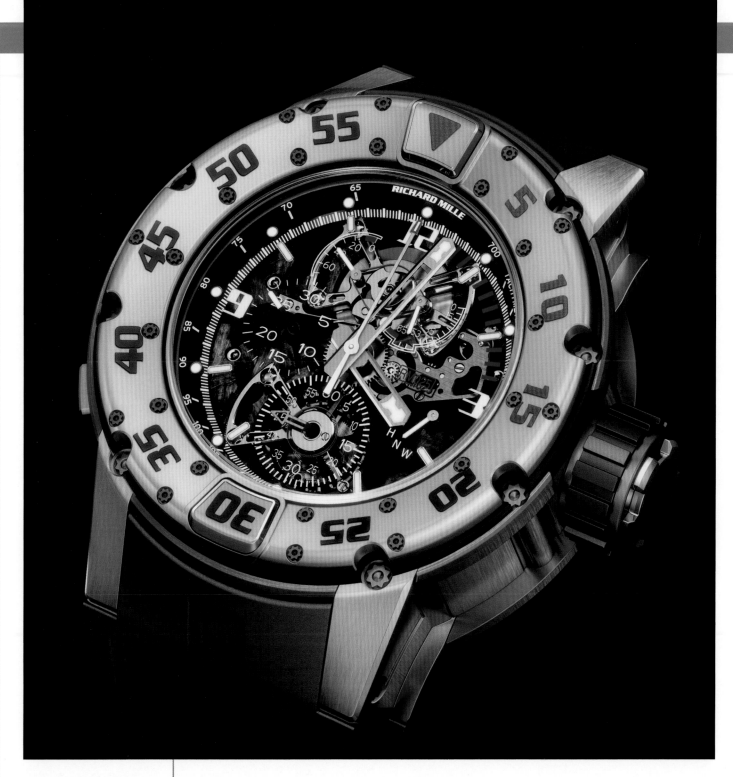

RICHARD MILLE

RM 025 TOURBILLON CHRONOGRAPH DIVER'S WATCH

This unique case, water resistant to 300m, uses torque screws that can be individually and precisely tensioned with high accuracy around the exterior circumference of the case, with the additional integration of the lugs into the case's torque screw system, as well as a screwed crown construction and newly designed watertight pushers. The bezel is constructed of three layers, connected with 24 screws, turning unidirectionally following ISO 6425 norms in order to avoid timing miscalculations. In addition, the entire bezel system is screwed to the case, making it absolutely stable as well as impossible to inadvertently dislocate or loosen. Within ticks the caliber RM025, a carbon nanofiber tourbillon chronograph based upon the famed caliber RM008, which is one of the major and uniquely novel chronograph designs of the 21st century.

TAG HEUER

1911: THE TIME OF TRIP

This is the first dashboard chronograph, patented by Heuer in 1911, designed for aircraft and automobiles. With an 11cm diameter, it fits into all types of dashboards. The large hand at the center of the dial indicates the hour. The pair of small hands located at 12:00 gives the duration of the trip not exceeding 12 hours. The same pushpiece starts, stops and resets the watch to zero. A small window at 3:00 indicates whether the instrument is working correctly. Private collection of TAG Heuer museum.

TAG HEUER

1916: THE MIKROGRAPH

The Mikrograph, the world's first stopwatch accurate to 1/100th of a second, was patented in 1916. This model revolutionized timing, notably in Olympic sprint competitions and technical research. Private collection of TAG Heuer museum.

TAG HEUER

1933: HERVUE PAIR

In 1933 Heuer began offering the Time of Day Clock called the Hervue and the Twelve-Hour Timer called the Autavia mounted together on a double back-plate. In the late 1950s, Heuer began to refer to the Master Time clock and Monte Carlo stopwatch as the "Rally-Master" pair. Private collection of TAG Heuer museum.

TAG HEUER

1965: CARRERA DATE 45

After the launch of the Carrera series in 1964, Jack Heuer created the Carrera Dato 45 in 1965. It was one of the first chronograph models to feature a date disc (at 9:00). Previously, the date had been indicated by a hand. Private collection of TAG Heuer museum.

TAG HEUER

1975: THE CHRONOSPLIT

The Chronosplit is the world's first quartz wrist-worn chronograph with double digital display—LED and LCD; it is accurate to 1/100th of a second. Private collection of TAG Heuer museum.

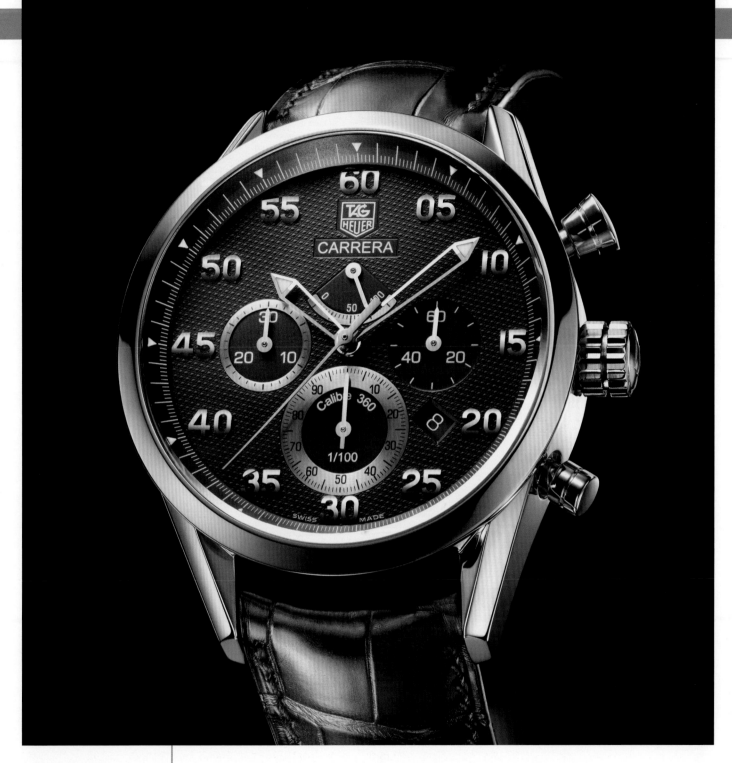

TAG HEUER

2006: THE CARRERA CALIBRE 360 ROSE GOLD LIMITED EDITION

At BaselWorld 2005, TAG Heuer presented the Calibre 360 Concept Chronograph, the first mechanical wrist-worn chronograph to measure and display time to 1/100th of a second. At BaselWorld 2006, privileged collectors looking for the most accurate mechanical timepiece ever made had their first glimpse of the Carrera Calibre 360 Rose Gold, in a special limited edition of only 500 pieces. Private collection of TAG Heuer museum.

TAG HEUER

2006: MONACO CALIBRE 360 LS CONCEPT CHRONOGRAPH

At BaselWorld 2006, TAG Heuer introduced the next evolutionary phase of its 1/100th of a second chronograph technology: the Monaco Calibre 360 LS (Linear Second) Concept Chronograph, a daring new timepiece with an all-new architecture proudly exposing the unparalleled Calibre 360 LS precision technology within. Private collection of TAG Heuer museum.

TAG HEUER

2007: GRAND CARRERA CALIBRE 17 RS CHRONOGRAPHE

In 2007, TAG Heuer introduced a new premium collection of sophisticated timepieces inspired by the spirit of modern GT cars. Among its many premium features is the ingenious Rotating System. This makes it possible to replace conventional hands by a disc displaying functional information even more clearly on the dial and which enables the user to read small seconds and chronograph time effortlessly, intuitively and instantaneously. Launched worldwide in 2008.

TAG HEUER

2008: TAG HEUER GRAND CARRERA CALIBRE 36 RS CALIPER CHRONOGRAPH

TAG Heuer pulled off yet another world first: powered by a column-wheel movement, the Grand Carrera Calibre 36 RS Caliper Chronograph is the only automatic chronograph capable of measuring and displaying 1/10th of a second! Visible through a tinted double sapphire crystal, the COSC-certified movement oscillates at an astonishing 36,000 vibrations per hour. This enables the central seconds hand to tick off 1/10th second intervals, giving at-a-glance readings of an unparalleled exactitude—an engineering feat of the highest level. The breathtaking creation has a stylish 43mm carbide-coated black titanium case, a Calibre 36 RS movement with a power reserve of about 50 hours, and two "Black Gold" Rotating Systems indicating the chronograph minutes at 3:00 and the chronograph hours at 6:00. It also features a linear second at 9:00. Another principle design innovation is the way in which it displays this information. TAG Heuer has developed an exclusive Rotating Scale that permits a precise reading of 1/10th of a second— magnified 10X! The new titanium carbide-coated and rubber bracelet with folding buckle is another stunning innovation.

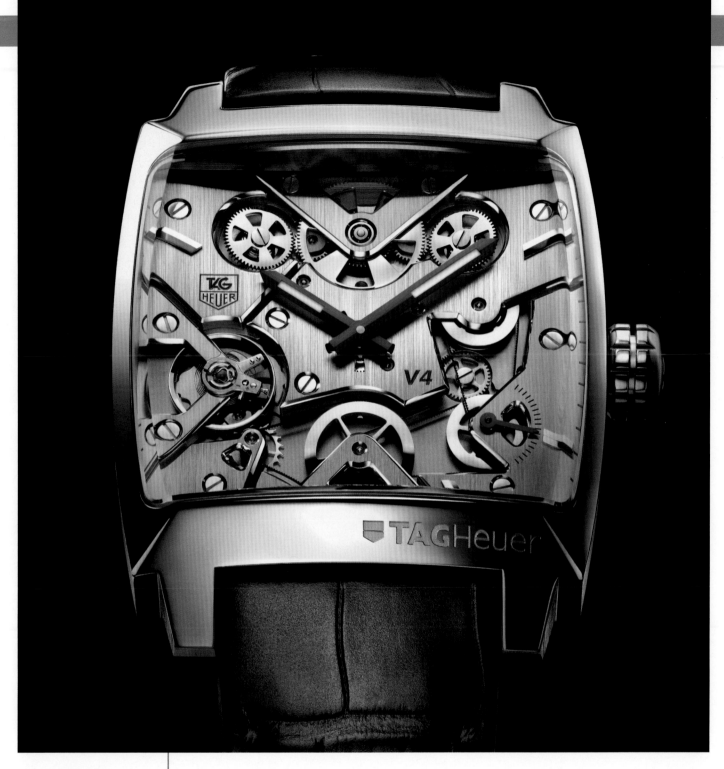

TAG HEUER

2010: TAG HEUER MONACO V4

For its 150th anniversary, TAG Heuer brought to the commercial market its boldest breakthrough innovation since the 1/100th-of-a-second mechanical chronograph. The first advanced integrated mechanical movement of the third millennium, TAG Heuer Monaco V4 represents a complete break with tradition and the audacious next step in mechanical movement engineering. This belt-driven wonderment, first unveiled as a Concept Watch at BaselWorld in 2004, is now industrialized and entirely hand manufactured in TAG Heuer's workshop in an exclusive luxury edition of only 150 platinum pieces. Until the V4, all modern mechanical movements, regardless of their complications, were generally based on "classic" watchmaking components, most of which date back to the 18th and 19th centuries: an energy reserve via one or several springs; a transmission using gears; and a regulatory function usually organized around a recoil escapement. For gear transmission and automatic rewinding, the V4 team set these aside and started from scratch. The result is a complete paradigm shift, two worldwide patents, and a new generation of mechanical movements.

TAG HEUER

2010: TAG HEUER PENDULUM CONCEPT

Since the creation of the Galileo-inspired hairspring by Christiaan Huygens in 1675, the regulating organ of all mechanical watches has been based on a balance wheel and spiral-shaped torsion hairspring system. A coiled strip of fine metal alloy, the hairspring provides the torque necessary for the balance wheel to oscillate and regulate its frequency. In the TAG Heuer Pendulum Concept, the traditional hairspring is replaced by an "invisible" or virtual spring derived from magnets. The complete device forms a harmonic oscillator. The magnetic field, generated by means of four high-performance magnets and controlled in 3D through complex geometric calculations, provides the linear restoring torque necessary for the alternative oscillations of the balance wheel. TAG Heuer Pendulum Concept, the world's first oscillator in a mechanical movement without hairspring, beats at 43,200 vph (6 Hz)—making it a superlative representative of TAG Heuer's unique mastery of high frequencies and ultimate precision. It requires no additional components and is based on physical magnetic properties. It gets its name from an earlier Huygens creation: the pendulum clock of 1657.

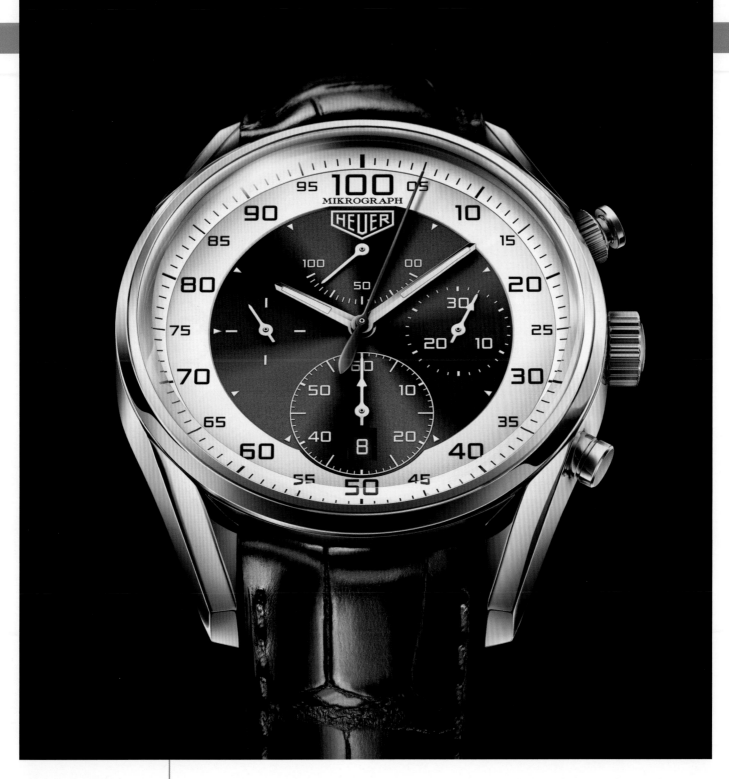

TAG HEUER

2011: TAG HEUER CARRERA MIKROGRAPH 1/100TH SECOND CHRONOGRAPH

TAG Heuer introduces the first ever column-wheel-integrated mechanical chronograph displaying 1/100th of a second with a striking central hand allowing an easy reading: the HEUER CARRERA MIKROGRAPH 1/100th Second Chronograph, entirely designed, patented, developed and manufactured in La Chaux-De-Fonds. Just five years after the revolutionary Calibre 360 Chronograph, TAG Heuer literally re-invents the high-frequency dual assortment mechanical movements and pays a tribute to the legendary Heuer Mikrograph stopwatch of 1916 which made history for more than 50 years in timing high speed sports with its 25 and 50 Hz frequencies. The new Mikrograph 1/100th is a fully integrated COSC-certified chronograph with a column-wheel system. It includes a balance wheel for the watch moving at 28,800 vph (4 Hz), with a 42-hour power reserve; for the stopwatch, the high-frequency Swiss balance wheel oscillates at 360,000 vph (50 Hz), with a 90-minute power reserve, displaying this 1/100th of a second with the central chronograph hand.

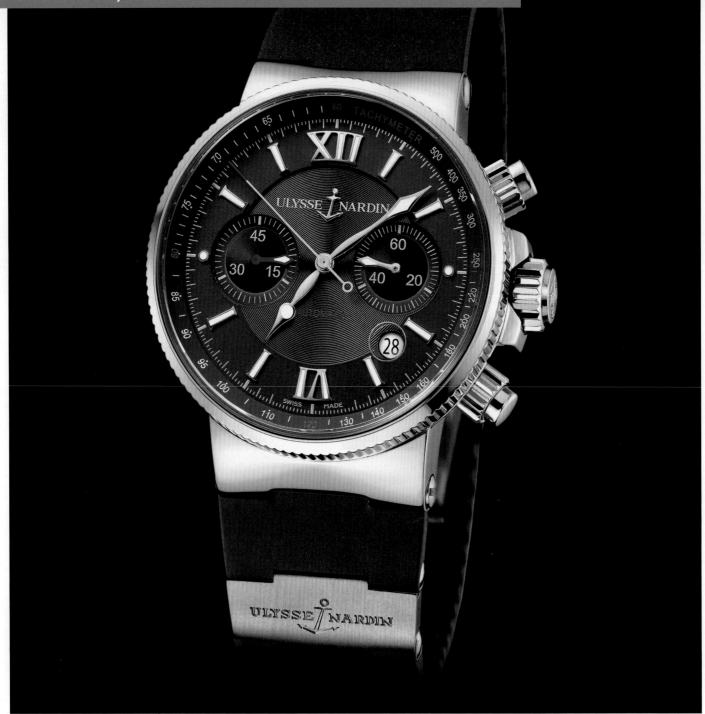

ULYSSE NARDIN

MAXI MARINE CHRONOGRAPH – REF. 353-66-3/355

Presented in stainless steel, the Maxi Marine Chronograph's 41mm case houses Caliber UN-35, which is visible through the exhibition caseback and equipped with an exclusive 45-minute register. The small seconds register is positioned at 3:00 and the date is viewed at 4:00. This Maxi Marine Chronograph is also available in 18K rose gold, on a bracelet or leather strap, and with various dial combinations.

ULYSSE NARDIN

MAXI MARINE CHRONOGRAPH – REF. 356-66-3/354

Shown in 18K rose gold, the Maxi Marine Chronograph's 41mm case houses the Caliber UN-35, which is visible through the exhibition caseback and equipped with an exclusive 45-minute register. The small seconds register is positioned at 3:00 and the date is viewed at 4:00. This Maxi Marine Chronograph is also available in stainless steel, on a bracelet or leather strap, and with various dial combinations.

ULYSSE NARDIN

MAXI MARINE DIVER CHRONOGRAPH – REF. 8003-102-7/91

This Maxi Marine Diver Chronograph is presented in a 42.7mm, stainless steel case and topped with a unidirectional rotating bezel. Caliber UN-800 is visible through the exhibition caseback and the chronograph features central seconds and a small seconds register at 9:00. The watch is also available in 18K rose gold, on a rubber and titanium strap, and with various dial combinations.

ULYSSE NARDIN

MAXI MARINE DIVER CHRONOGRAPH – REF. 8006-102-3A/92

This diver chronograph is presented in a 42.7mm, 18K rose-gold case and topped with a unidirectional rotating bezel. The chronograph features central seconds and a small seconds register at 9:00. Caliber UN-800 is visible through the exhibition caseback. The Maxi Marine Diver Chronograph is available in stainless steel, on a bracelet, and with various dial combinations.

VACHERON CONSTANTIN

MALTE TONNEAU CHRONOGRAPH – REF. 49180

The new Malte Tonneau Chronograph offers date indication via twin oversized apertures in addition to the chronograph and time readouts. It is powered by the mechanical self-winding Vacheron Constantin Caliber 1137 with 37 jewels and 40-hour power reserve. Housed in a 40x50mm white- or rose-gold case, the movement beats at 21,600 vph. The chronograph offers a center seconds hand, 30-minute and 12-hour totalizers, and tracks to 1/6th of a second. This watch is water resistant to a depth of 30 meters (100 feet) and comes on a hand-stitched alligator leather strap with a gold buckle.

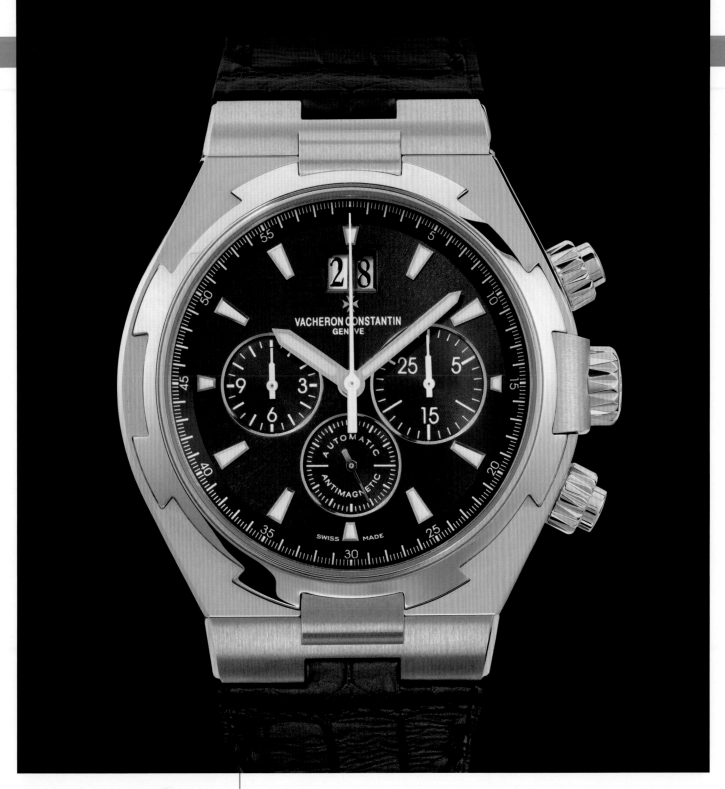

VACHERON CONSTANTIN

OVERSEAS CHRONOGRAPH – REF. 49150

Vacheron Constantin presents the self-winding Overseas Chronograph in a pink-gold version. The sporty, stylish 42mm case displays a Maltese cross-inspired bezel, luminescent hour markers, screw-down pushpieces, water resistance to a depth of 15atm (approximately 150m), and the Overseas' emblematic two-masted sailing ship motif engraved on the solid caseback. The case has a strong and instantly recognizable design and its large anthracite dial clearly sets off all the useful functions offered by the Vacheron Constantin 1137 movement, which beats at a rate of 21,600 vph. This model features two counters (30 minutes at 3:00, 12 hours at 9:00) and the date at 12:00. As with all the models in the line, the pink-gold Overseas Chronograph is equipped with an antimagnetic shield that protects the movement and complex gear trains from disturbances caused by local magnetic fields. The new Overseas Chronograph comes on either a pink-gold bracelet or a choice of two straps: hand-sewn alligator leather or dark brown vulcarbonized rubber.

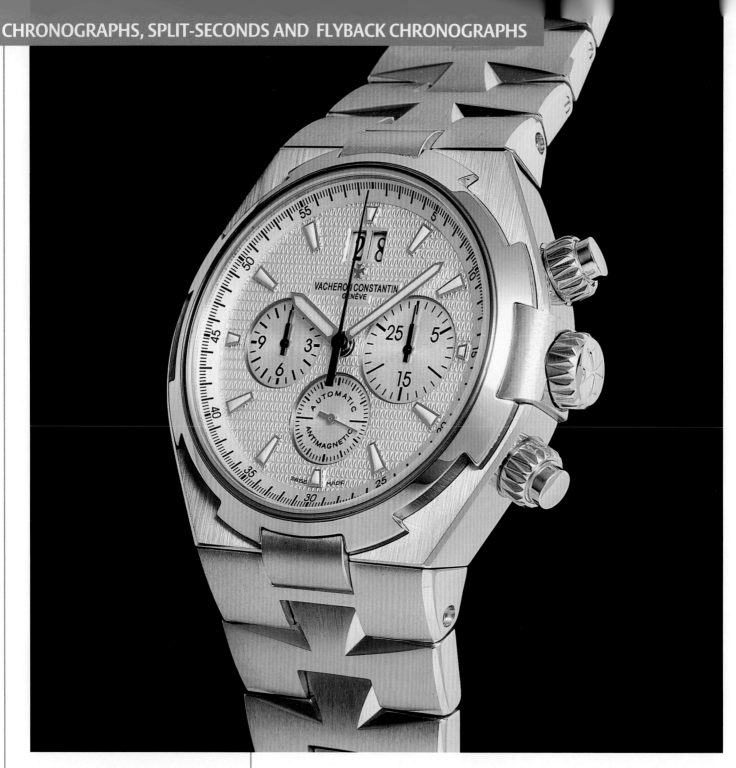

VACHERON CONSTANTIN

OVERSEAS CHRONOGRAPH – REF. 49150/B01J

This 18K gold Overseas Chronograph houses the mechanical automatic-winding Vacheron Constantin Caliber 1137 with column-wheel chronograph. The movement beats at 21,600 vph, is equipped with 37 jewels and offers 40 hours of power reserve. It is protected against magnetic fields by an inner iron case. Water resistant to 15atm, the watch offers hours, minutes, small seconds, large date and chronograph with three counters. In addition to a screw-down crown with case protector, the watch features a three-fold gasket and screw-down pushers. Its caseback is embossed with the Overseas sailboat and the hands and markers are luminescent.

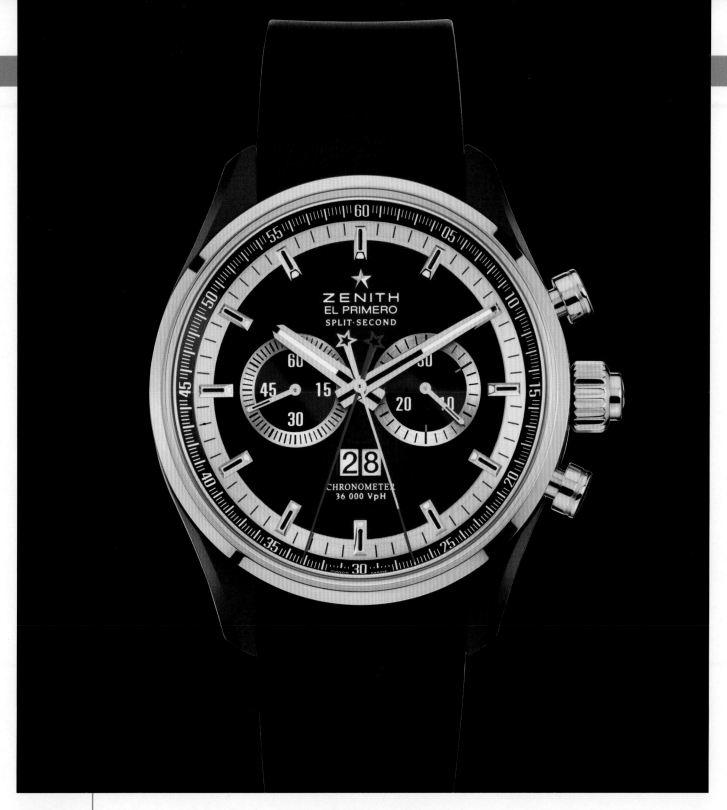

ZENITH

EL PRIMERO RATTRAPANTE – REF. 78.2050.4026/91.R530

Zenith's El Primero Rattrapante is powered by the El Primero 4026 automatic-winding movement within its PVD and rose-gold 44mm case, which is water resistant to 10atm. The black sunray dial displays hours, minutes, small seconds at 9:00, large date at 6:00, and split-seconds chronograph with 30-minute counter at 3:00. An integrated black rubber strap with a PVD triple-folding buckle completes the El Primero Rattrapante.

Multiple Time Zones and GMTs

Before time was divided into 24 time zones, each region had its own local time, based on approximate longitude. There were thus 74 in North America alone, and around 30 in Europe. The spread of long-haul transport—mainly by boat or rail—as well as the concomitant democratization of long-distance travel, led countries to get their timing system into order. In 1994, the International Meridian Conference adopted Greenwich as the 0 reference point and traced 24 lines around the globe corresponding to 15 degrees' longitude each, with the space between them corresponding to one hour. With time thus organized, watchmakers could set about elaborating timepieces sometimes referred to as "captain's watches" and displaying both home time and local or "destination" time. Recent years have seen a flurry of new models offering a variety of designs, display modes and featuring user-friendly or other technical or aesthetic characteristics.

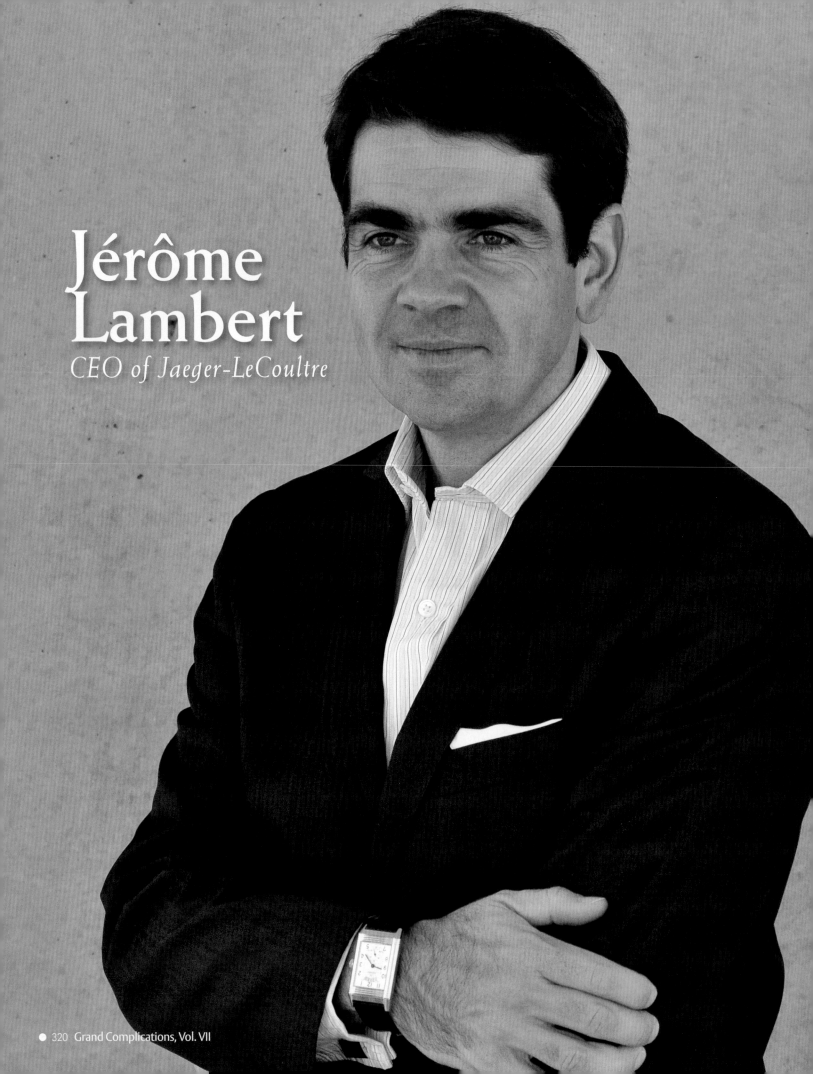

Jérôme Lambert

CEO of Jaeger-LeCoultre

"We are convinced that there is also room for subtlety"

2011 will be a Reverso year for Jaeger-LeCoultre. The swiveling watch is celebrating its 80th birthday and continues to enjoy unabated success. For its Manufacture in Le Sentier (Vallée de Joux), the new models presented in 2011 demonstrate the brand's ability to offer products that are both innovative and classically inspired. We present an interview with Jérôme Lambert, the man who is leading Jaeger-LeCoultre to ever-higher horological peaks.

Glass half-empty types have often said that the Reverso was a handicap for Jaeger-LeCoultre, due to the substantial space within the brand's collections occupied by this iconic model since its birth in 1931. Some even said that the name of the collection tended to supersede that of the brand itself. This was not true 20 years ago, and is even less so today. Many a watch industry boss can only dream of having within their collection—and for the past 80 years—such a strong, highly distinctive and high-profile model. It was the good fortune of Jaeger-LeCoultre to have had the flair to create this reversible model—based on the idea of protecting the watch by turning it over—for polo players in 1931. The company has proven its strength through the evolution of this model, which now plays a prime role in conveying the brand's image and its exceptional know-how. Above and beyond the idea of sturdiness and resistance, the Reverso's second face on the caseback has provided remarkable scope for expressing the talents of engravers, enamelers and gem-setters. These few square centimeters have enabled countless enthusiasts to customize their watch. Over the decades, this has been one of the key characteristics of this model that simply has no equivalent. But that's not all, for as well as becoming an iconic watch, the Reverso has become a particularly demanding receptacle for a number of exceptional mechanisms. In doing so, it conveys the maturity of the manufacture and its rare ability to marry tradition and innovation.

It is worth recalling the Reverso's first real steps in the field of complications. While the Reverso watch has been driven throughout its history by several generations of mechanical movements, it was not until the last decade of the 20th century that it first hosted complications. This new approach sparked the creative imagination of the company watchmakers, who devoted their efforts to creating complicated movements specially designed for the rectangular case of the Reverso. At that time, oversized watches such as the ones currently on the market were not really in vogue; making horological complications that could operate within small areas called for genuine feats of miniaturization. In 1991, the Reverso was equipped with its first complicated movement, Jaeger-LeCoultre Caliber 924. The Reverso Soixantième, which featured a power reserve display and a pointer-type date indication, was to be the first in a prodigious lineage of Reverso watches issued in limited editions. In 1993, the Reverso was fitted with a tourbillon. In 1994, the Manufacture rose to a new challenge with the creation of Jaeger-LeCoultre Caliber 943, which equipped the Reverso Répétition Minutes. In 1996, the Reverso watch was endowed for the very first time with a chronograph mechanism. In 1998, a new 500-piece limited series displayed a dual time zone; and in 2000 a Reverso Quantième Perpétuel added the final chapter to the saga of the six limited edition pink-gold Reverso watches.

In parallel with these strides, Jaeger-LeCoultre had developed the concept of two back-to-back dials on the Reverso Duo and Reverso Duetto models, which could either show the time in two different time zones or feature two different dial styles.

Grande Reverso Duo incorporates the very essence of the Reverso.

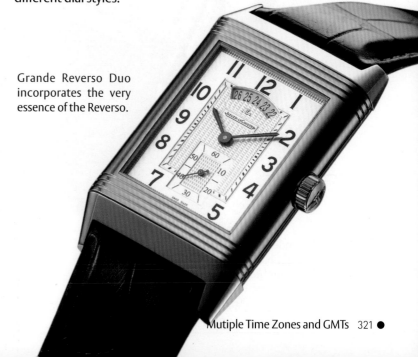

What does this Reverso year mean for Jaeger-LeCoultre in 2011?

It is naturally an important year for us in focusing on the brand fundamentals. The Reverso holds a natural place within our collections and we hope to celebrate it in the best possible way.

It was said at one time that Jaeger-LeCoultre was strongly—and perhaps overly—dependent on the Reverso. Is that true?

Anyone who studies the market will grasp the fact that the Reverso naturally represents a strong point for Jaeger-LeCoultre and is in no way the cause of undue dependence. Depending on the year, the Reverso accounts for between 40 and 50 percent of our sales, which is enough to prove that this line does not single-handedly make Jaeger-LeCoultre what it is. The strength of this collection also varies according to geographical regions, a fact that is also valuable to us. Nonetheless, one thing is for sure: the Reverso is an incredibly rich, iconic watch and we need to capitalize on its intrinsic values.

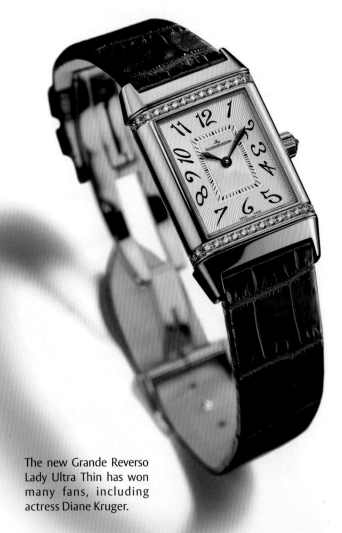

The new Grande Reverso Lady Ultra Thin has won many fans, including actress Diane Kruger.

What are these values?

The Reverso is first and foremost distinguished by its innate finesse, and we at the Manufacture are convinced that there is also room today for subtlety. That is exactly what we plan to offer with the new models released in 2011.

Is this a response to a new trend?

It stems from a twofold reality: there are—and always have been—certain clients looking for classic and understated watches that are complex in construction and yet perfectly functional. The Reverso meets these demands. Moreover, in recent years Jaeger-LeCoultre has demonstrated its unique horological expertise in the field of complicated mechanisms. This reality is an acknowledged and accepted fact, so we no longer need to constantly display our ability to innovate. The new models released in 2011 also correspond to another strong element, namely their genuine value based on outstanding quality, which remains one of the brand's strong points.

So what are these new launches in 2011?

First of all, for 2011, the Reverso was duty-bound to once again surprise and appeal, both by remaining faithful to its legend and by exploring whole new creative vistas. The three first new models presented in 2011—the Grande Reverso Ultra Thin, the Grande Reverso Duo and the Reverso Répétition Minutes à Rideau—are three unusual watches that nurture the roots of the Reverso while profoundly revisiting its technology and its design.

How would you describe the Grande Reverso Duo?

It embodies the very essence of the creative space provided by the Reverso and its two iconic faces. The Grande Reverso Duo shows the time in two time zones and on two different dial designs fitted back to back thanks to the technical ingenuity of a unique construction created by the Manufacture.

You are also presenting a Grande Reverso Ultra Thin…

After 80 years of celebrating classicism, the new Grande Reverso Ultra Thin brings a revolution by focusing on extreme simplicity. The extreme thinness of Jaeger-LeCoultre Caliber 822 (at just 2.94mm!) enabled us to make this Reverso watch slimmer than ever before. While the case with its generous new proportions asserts a genuine presence on the wrist, its sheer slenderness makes it both light and comfortable to wear thanks to its subtly cambered shape.

The pure dial adorned with a vertical guilloché motif, the understated Arabic numerals, the slender blued hands: all the aesthetic codes of the Reverso are repesented in this ultrathin variation. This new watch expresses the quintessence of the personality of the Reverso, a blend of tradition and nobility, an alliance between style and elegance.

Jaeger-LeCoultre is also introducing a special model, the Grande Reverso Ultra Thin Tribute to 1931: what is the idea behind this tribute watch? Because this new Reverso is designed to serve as a link between the past and the present, Jaeger-LeCoultre decided to create two Grande Reverso Ultra Thin Tribute to 1931 models, in steel and in 18-karat pink gold, featuring a black or white dial with baton hour markers and dagger-shaped hands directly inspired by the original Reverso. It is the spirit of 1931 in contemporary dimensions—the Art Deco charm of the first Reverso models in tune with modern times.

Finally, an understated anthem to complication...
The Reverso Répétition Minutes à Rideau belongs to the category of exclusive beautiful complications and innovates through its striking-mechanism activation device combining technical prowess and aesthetic magic.

With this timepiece, we are renewing the feat of treating a single timepiece to several different sides, or faces. With the Reverso Répétition Minutes à Rideau, we achieve this thanks to a sliding curtain that alternately conceals one or the other of the dials.
Four sides and four faces for an aesthetic and technical success to which the Manufacture is adding yet another tour de force: the operation of one of the noblest horological complications, the minute repeater, marks the passing of time by chiming the hours, quarter-hours and minutes on demand, featuring an unprecedentedly pure and sonorous tone.

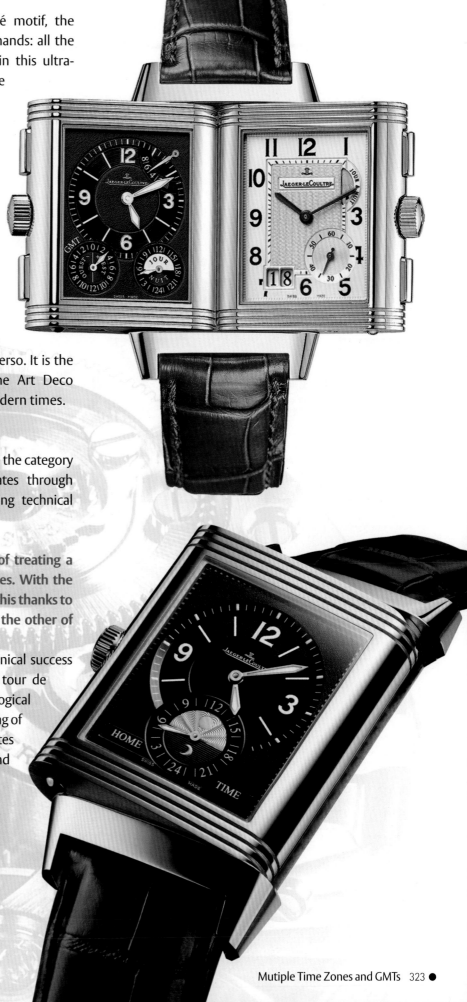

ABOVE
The Reverso Grande GMT features small seconds, large date and a day/night display on the front. The hours and minutes of a second time zone are shown on the back, along with a 24-hour indication, the power reserve and the GMT time difference.

RIGHT
The Grande Reverso 986 Duodate is offered in a limited edition of 1,500 in steel and 500 in pink gold.

Multiple Time Zones and GMTs

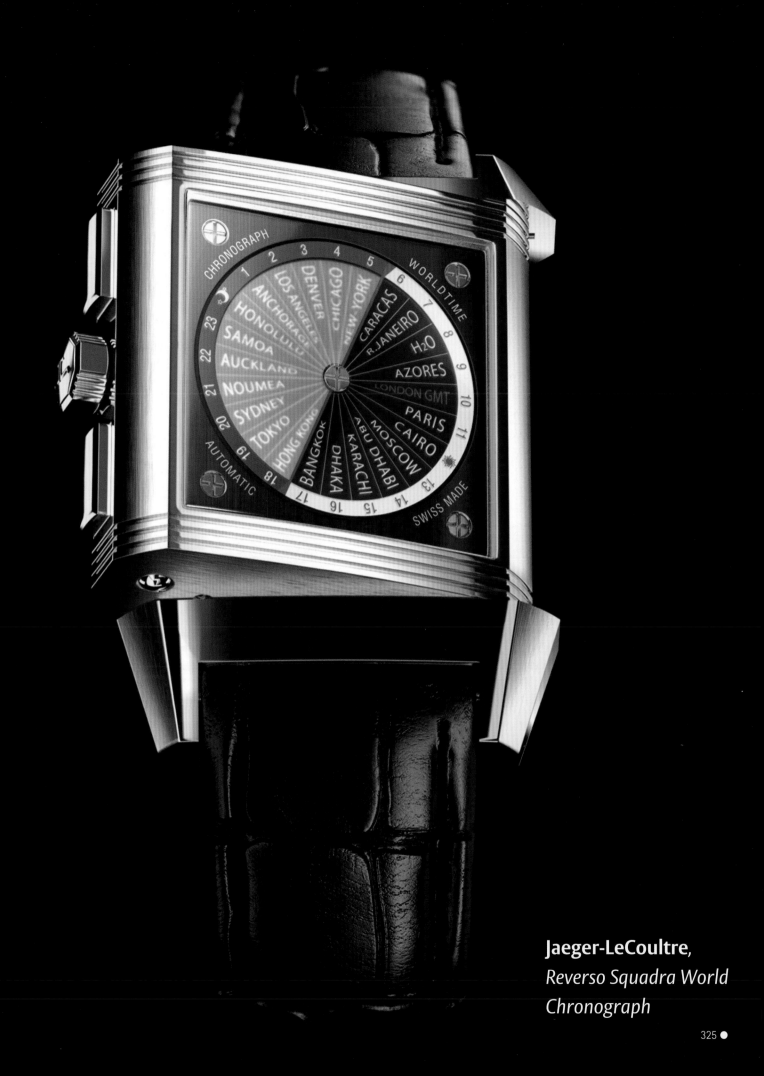

Jaeger-LeCoultre,
Reverso Squadra World
Chronograph

AROUND THE WORLD IN 24 HOURS

To keep step with the development of various means of transport, and particularly the railway system, the International Meridian Conference in 1884 decided to divide the planet into 24 time zones, taking the Greenwich Meridian as the reference point or zero longitude. The first dual time zone watches were equipped with two more or less coordinated movements displaying the time on separate dials. This device was subsequently refined by using a single movement equipped with a mechanism uncoupling the additional hour hand. Today, watchmakers vie with each other in developing ingenious and ever more original systems on watches showing two, three, four or more time zones. Over the years, they have also come to associate this function with others that are greatly appreciated by travelers, such as the alarm, day/night and 24-hour indications.

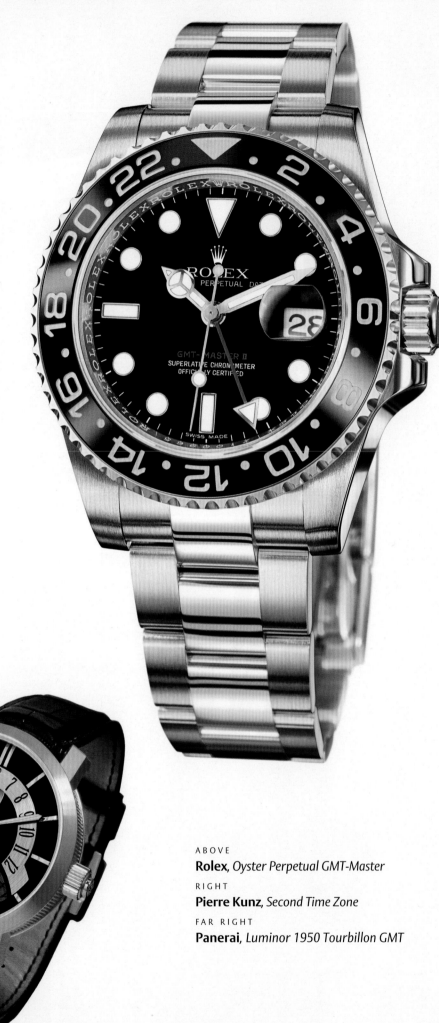

ABOVE
Rolex, *Oyster Perpetual GMT-Master*
RIGHT
Pierre Kunz, *Second Time Zone*
FAR RIGHT
Panerai, *Luminor 1950 Tourbillon GMT*

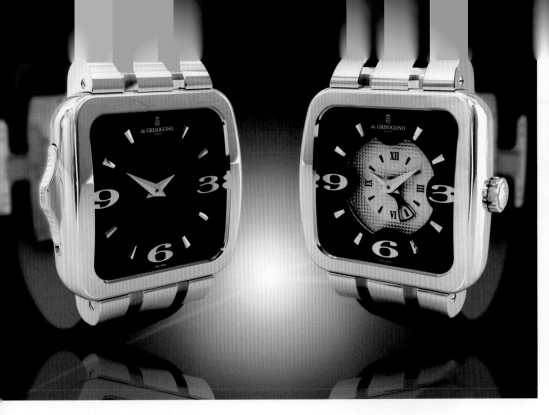
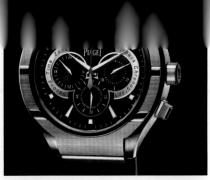
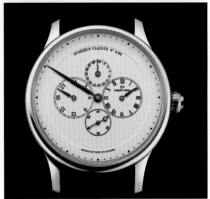

POINTER-TYPE SYSTEM

The simplest way of simultaneously displaying two time zones is to add an additional hour hand in the dial center, making sure it stands out from the first in terms of its shape or color. That is the solution chosen by Panerai on its Luminor 1950 Tourbillon GMT, also endowed with a day/night (AM/PM) indicator indexed to the additional hours hand, distinguishing 2PM from 2AM and thus to avoid waking someone up with a long-distance phone call. To solve the problem of diurnal or nocturnal hours, other brands have opted for a 24-hour dual time zone display. A classic example of this approach is the Rolex Oyster Perpetual GMT-Master, launched in 1955.

The double central hour hand system can give rise to a number of technical or aesthetic variations, such as the one adopted by Pierre Kunz in equipping the Second Time Zone with a retrograding central hand for the second time zone. On the new Fuso Quadrato by de Grisogono, the additional hand is hidden by an aperture-type dial composed of twelve titanium shutters that opens on demand using a slide at 9 o'clock.

The supplementary hour hand sometimes leaves the dial center to take up an offset position in a small subdial. Such is the case on the Polo FortyFive Chronograph by Piaget, with its 24-hour display at 9 o'clock; whereas Les Longitudes by Jaquet Droz is inspired by regulator-type dials and features a subdial with Roman numerals at 3 o'clock for the first time zone shown in 12-hour mode, and a subdial with Arabic numerals at 9 o'clock with a 24-hour display and a central minute hand.

In most analog systems, the dual time zone hand is constantly visible, even when the user does not need it. Patek Philippe has solved this problem in an ingenious and elegant way on its Calatrava Travel Time. When the dual time zone function is not in use, the two superimposed hour hands keep time in a perfectly synchronized manner. The new Grand Chronographe Régulateur by Montblanc also has two superimposable hour hands, but they appear in a subdial at 9 o'clock.

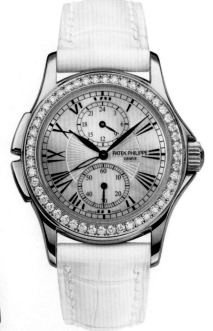

TOP LEFT
de Grisogono, *Fuso Quadrato*
TOP RIGHT
Piaget , *Polo FortyFive Chronograph*
RIGHT CENTER
Jaquet Droz, *Les Longitudes*
ABOVE
Patek Philippe, *Calatrava Travel Time GMT*
LEFT
Montblanc, *Grand Chronographe Régulateur*

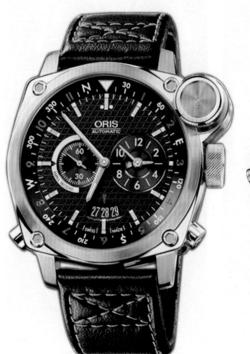

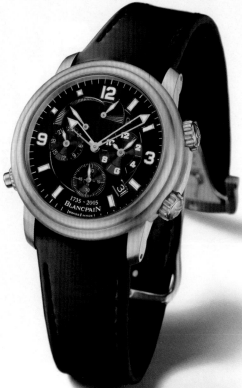

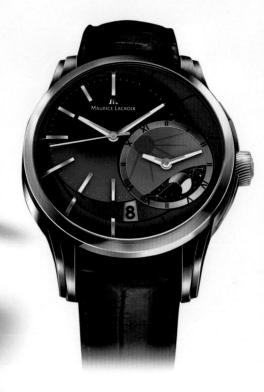

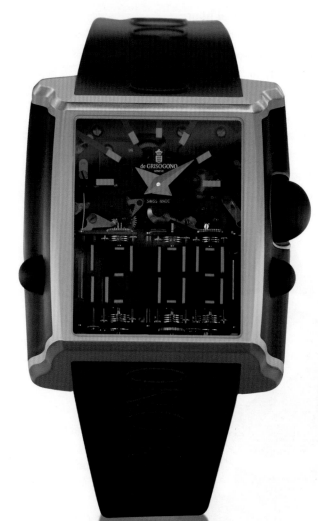

DOUBLE HOUR/MINUTE DISPLAYS

Even though minutes generally remain identical from one time zone to another, some brands choose to display the two time zones thoroughly, using two hands. This is the option taken by Oris on its Worldtimer caliber, featuring a date that changes automatically in both directions when the time is corrected after midnight; on the Oris BC4 Flight Timer, an additional crown positioned vertically at 2 o'clock also serves to adjust the inner bezel to a third time zone. The Léman Alarm GMT from Blancpain combines within a single watch the two complications most useful to travellers. The subdial at 3 o'clock maintains home time. The alarm and the date are indexed to the central display which is intended to be used to indicate local time (or travel time zone)—a detail that might have prevented Phileas Fogg from believing he had failed by a few minutes in his bid to travel around the world in 80 days, whereas he had in fact gained a day by heading eastward. On a more daring note in geometrical terms, the Pontos Décentrique GMT by Maurice Lacroix displays its two complete time zones on two completely off-centered subdials. And in terms of originality, de Grisogono struck a major blow with its Meccanico dG, a completely mechanical watch combining an analog display for the first time zone with a digital display for the second time zone (see Retrograde displays and jumping hours chapter).

TOP LEFT
Oris, *BC4 Flight Timer*

TOP CENTER
Blancpain, *Léman Alarm GMT*

TOP RIGHT
Maurice Lacroix, *Pontos Décentrique GMT*

LEFT
de Grisogono, *Meccanico dG*

Another potential choice is to display two time zones on two separate dials, an approach rendered possible by unusually structured watches. Jaeger-LeCoultre thus makes the most of its famous swivel case on the Reverso Grande GMT, with its two back-to-back dials. The front one features displays including a "GMT differential," indicating the number of hours by which this time zone differs from Greenwich Mean Time or another reference time. With its new Altiplano Double Jeu, Piaget renews the tradition of "secret" watches by offering two dials on two superimposed cases connected by a hinge and equipped with ultra-thin mechanical movements. The 2010 version features a 24-hour display of the second time zone.

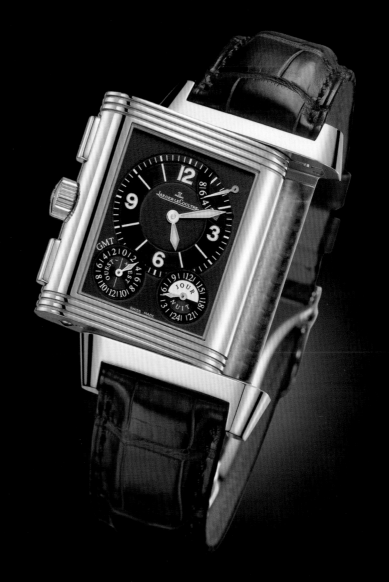

RIGHT
Jaeger-LeCoultre, *Reverso Grande GMT*
BELOW
Piaget, *Altiplano Double Jeu*

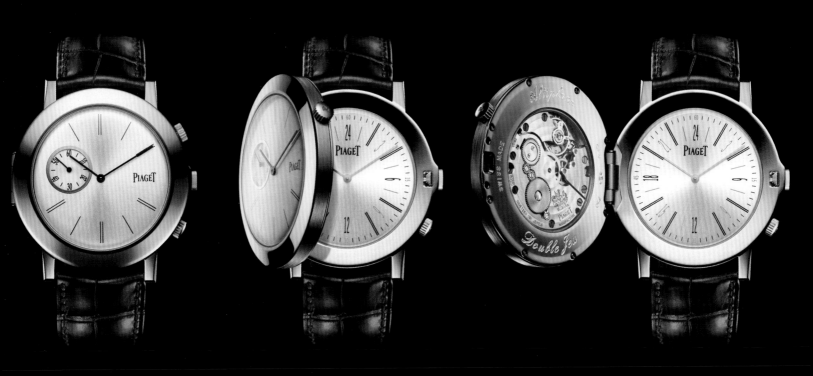

FINE ADJUSTMENTS

On the models mentioned thus far, the second time zone is generally adjustable in one-hour increments—without touching the minute hand. But there are countries in which the difference with Coordinated Universal Time (UTC), that of Greenwich, adopts finer divisions of up to half an hour or even a quarter of an hour. Such is notably the case for Iran (UTC+3h30), India (UTC+5h30) and Nepal UTC+5h45). The new Tonda Hémisphères by Parmigiani Fleurier takes account of this special feature, and its self-winding PF 337 movement serves to adjust the second time zone to within the nearest minute.

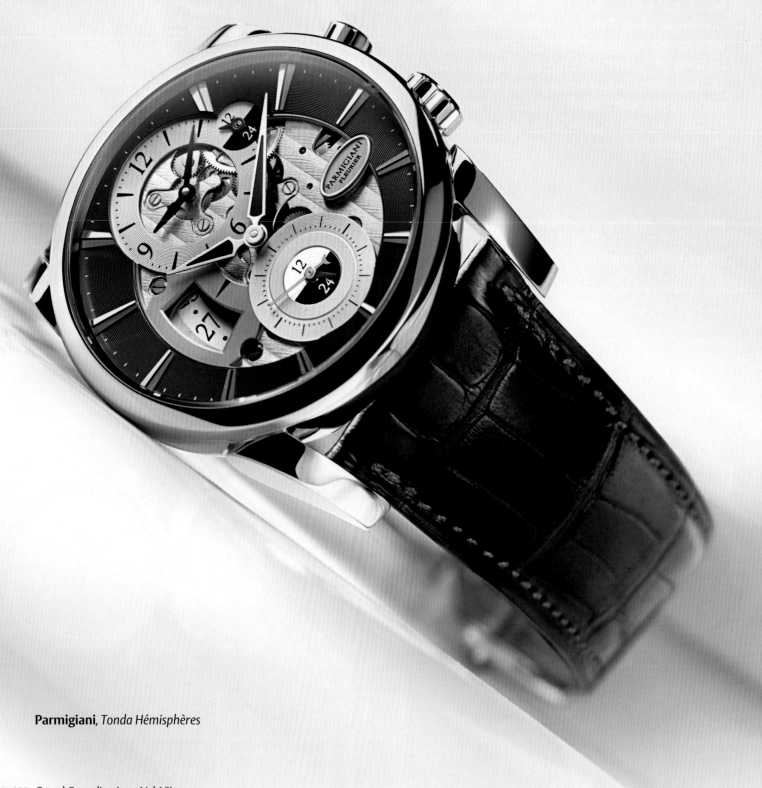

Parmigiani, *Tonda Hémisphères*

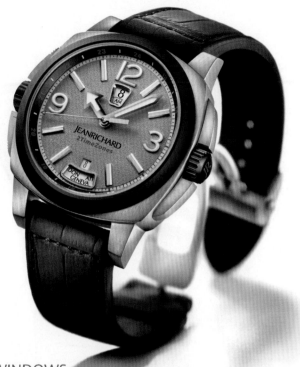

DISCS AND WINDOWS

Multiple time zones may also be displayed using discs and windows instead of hands—or in correlation with the latter. Watchmakers generally take this opportunity to introduce complementary indications such as the names or abbreviations of certain cities representing specific time zones. On the new 2Timezones Zirconium by JeanRichard, the time in the first time zone is displayed in a classic manner in the center, while the second is shown through a window at 12 o'clock, combined with an AM/PM indication. Another aperture at 6 o'clock serves to display the 24 reference cities representing the different time zones. The Concord C1 Worldtimer is distinguished by its original Dubois Dépraz mechanism featuring a broad arc-of-a-circle aperture revealing two discs—one for the cities and the other for the hours. Simply pressing the pusher serves to select the required city, and the corresponding time is instantly displayed opposite. On the Colosso by Hysek, the second time zone is displayed in an unusual way by means of a system of Archimedes screws and conical pinions serving to raise or lower two arrows pointing to the 24 hours. The upper part of the dial is adorned with a three-dimensional globe spinning on its axis in 24 hours, and which may be set to local time or GMT.

By combining windows and hands, some watchmakers offer systems that indicate only one time zone at a time, but enable the user to select another at any time. Les Douze Villes by Jaquet Droz thus combines a disc bearing the name of 12 cities with a jumping-hour system. Simply pressing the pusher displays the required city as well as the corresponding hour—with the minutes shown by the large central hand.

TOP LEFT
JeanRichard, *2Timezones Zirconium*

TOP RIGHT
Concord, *C1 Worldtimer*

CENTER RIGHT
Hysek, *Colosso*

BOTTOM RIGHT
Jaquet Droz, *Les Douze Villes*

ROTATING BEZELS AND MOBILE INNER BEZEL RINGS

Instead of a window or aperture, some watches use a rotating bezel or mobile inner bezel ring serving to select the name of one of the 24 reference cities. The Lange 1 Time Zones by A. Lange & Söhne has two subdials fitted with hour/minute hands and day/night indicators. Home time generally appears on the larger of the two. The second time zone (local time) is adjusted by means of a pusher serving to rotate the inner bezel ring bearing the name of the 24 cities. The user can choose to reverse priorities by giving pride of place to local time (travel time) and by synchronizing it with the patented large date display. The Swiss brand Vogard has presented a patented "timezoner®" system serving to adjust the second time zone via the bezel. The user pulls out the security lever on the side of the case in order to select the required city by rotating the bezel, thus causing the additional hour hand to display the corresponding local time on a 24-hour scale.

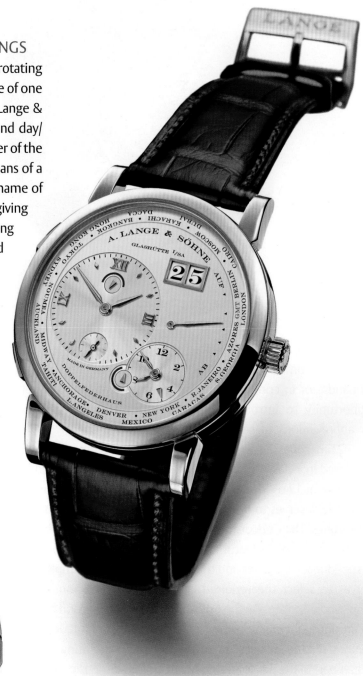

ABOVE
A. Lange & Söhne, *Lange 1 Time Zones*

LEFT
Vogard, *Chronozoner*

AND TIME BECAME UNIVERSAL

In 1936, a watchmaker in Geneva named Louis Cottier invented an ingenious system that allowed one to read off the time all over the world at a glance and at any time. This principle has been developed and perfected in the famous "world time" models by Patek Philippe, such as the recent Ref. 5131. The central part of the dial bears hands indicating local time. It is surrounded by two mobile discs, one with a 24-hour graduation, and the other displaying the names of the 24 reference cities. Local time refers to the city (time zone) lined up with 12 o'clock. To change the main time zone, the user simply activates the single pusher at 10 o'clock, thereby causing the mechanism to simultaneously adjust the city disc, the 24-hour disc and the hour hand.

Girard-Perregaux also offers a world-time display in its "ww.tc" collection, the name standing for "World Wide Time Control." The model that launched the line, the ww.tc Chronograph, has been introduced in a new steel version. Its exclusive system lies in a coupling mechanism that drives a ring displaying the hour in the 24 time zones represented by the corresponding cities. The hour ring also features a day/night contrast that facilitates read-off. On the Reverso Squadra World Chronograph, Jaeger-LeCoultre once again exploits the concept of the double-sided Reverso case. The front dial displays local time, along with a day/night indicator and a large date, as well as chronograph counters. The user can swivel the case to read off world time on a round dial. All the displays are driven by a single automatic movement.

The world time mechanism does not always confine itself to the rim of the dial. On its Chiffre Rouge T01 model, Dior has placed a tiny satellite at 10 o'clock indicating the time in eight cities. Audemars Piguet, in its Jules Audemars Metropolis, associates it with a perpetual calendar. The two rotating world time discs occupy a subdial at 6 o'clock, and the three other subdials are devoted to calendar displays. As for Antoine Preziuso, he offers an extremely appealing reinterpretation of the world time display in his Transworld watch. The central part of the dial is adorned with a mobile map of the globe as viewed from the South Pole and rotating over 24 hours; the outer (fixed) part features a 24-hour graduation with day/night zones. This original and poetic read-off nonetheless requires a certain degree of familiarity with geography and the time zone system!

TOP ROW
FROM LEFT TO RIGHT
Patek Philippe, *Universal Time Ref. 5131*
Girard-Perregaux, *ww.tc Chronograph*
Audemars Piguet, *Jules Audemars Metropolis*

TOP RIGHT
Dior, *Chiffre Rouge T01*

ABOVE
Jaeger-LeCoultre, *Reverso Squadra World Chronograph*

BOTTOM LEFT
Antoine Preziuso, *Transworld*

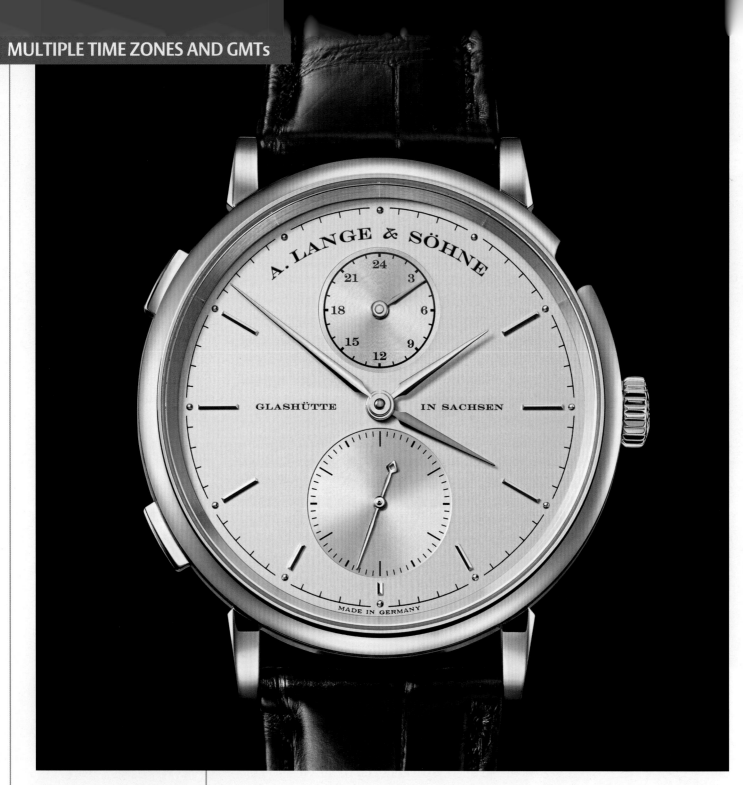

A. LANGE & SÖHNE

SAXONIA DUAL TIME – REF. 385.026

Powered by a completely redesigned self-winding caliber L086.2 with a 72-hour power reserve, the Saxonia Dual Time clearly indicates two time zones on the dial. The solid gold hour hand that indicates local time can be moved forward or backward in one-hour increments by two pushpieces located at 8:00 and 10:00. A supplementary hour hand in blued steel permanently keeps time at the place of origin. The pink- or white-gold 40mm case is fitted with an antireflective sapphire crystal on the front and back. The timepiece is presented on a hand-stitched crocodile strap with a solid gold buckle.

AUDEMARS PIGUET

JULES AUDEMARS DUAL TIME – REF. 26380BC.OO.D002CR.01

The Jules Audemars Dual Time watch in 18K white gold opts for an extremely slim bezel, which ensures maximum opening on the meticulously executed silver-toned dial with a delicately satin-brushed finish. The date and dual time zone displays are surrounded by a decorative fillet highlighting their snailed inner decoration. The dial ensures pleasing readability, with the date display in a subdial at 2:00, the power reserve on the arc of a circle in the left-hand section, and the second time zone at 6:00. The day/night indication at 7:00 provides a simultaneous display of the time in two different time zones.

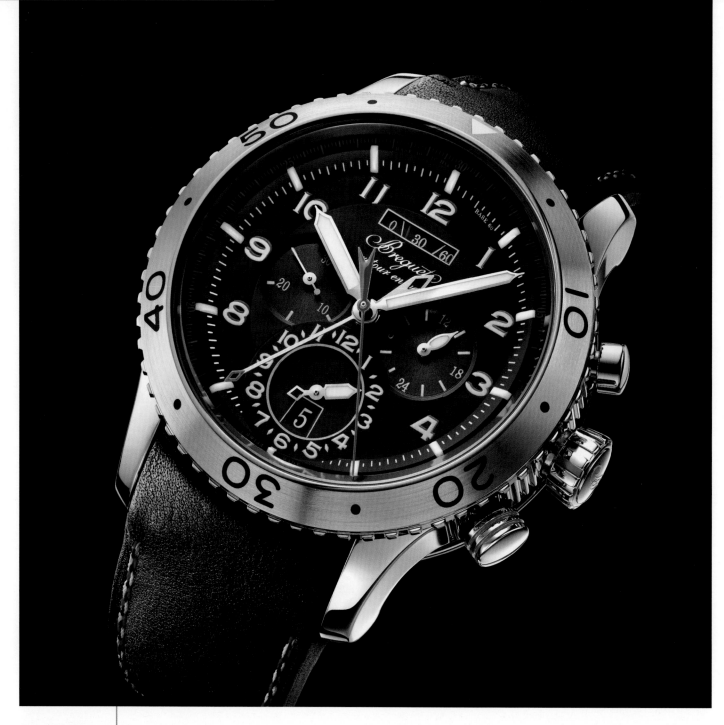

BREGUET

TYPE XXII – REF. 3880ST

This piece features hours, minutes and small seconds on its black oxidized dial, as well as date and second time zone display at 6:00, and a 24-hour indicator at 3:00. As the small seconds display is on a 30-second basis, a window at 12:00 lets the wearer know whether the piece is on the first or second half of the minute. The watch also features a highly precise chronograph function with a central red chronograph seconds hand that sweeps across the dial in just 30 seconds. The 44mm stainless steel case is water resistant to 100m.

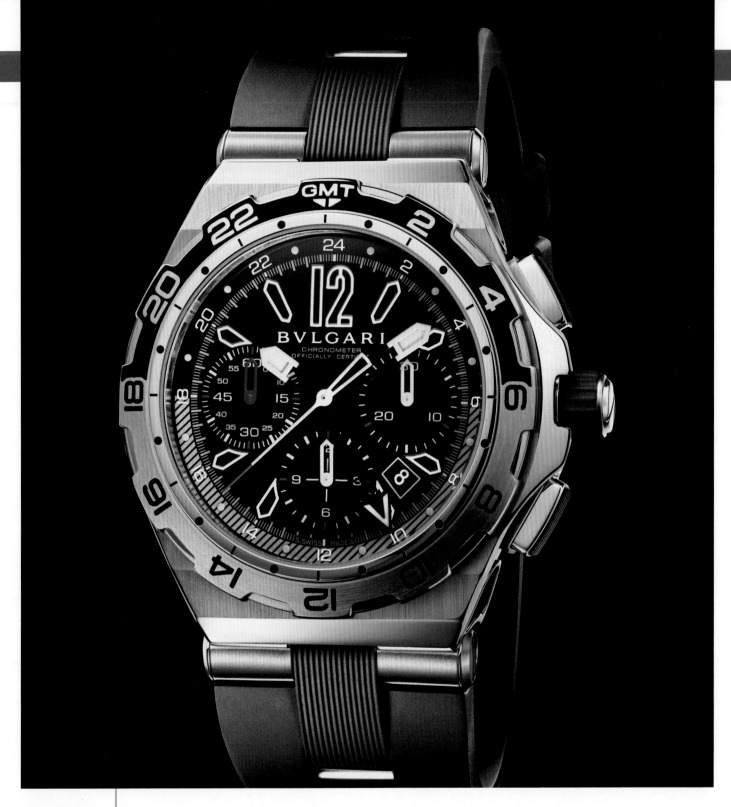

BVLGARI

DIAGONO X-PRO – REF. DP45BSTVDCH/GMT

The heart of this sophisticated machine is the COSC-certified BVL 312 caliber, built on a Valjoux 7750 base and customized with an additional GMT module. Its meticulous overall finishing is enhanced by the finest decorative techniques and surface treatments; it beats at a cadence of 28,800 vph and has a 48-hour power reserve. In addition to the standard display of local time, the two additional hour hands for the other time zones are identified in very different ways to ensure optimal read-off. The outer rim of the dial has a 24-hour indication and shows the day/night zones on a track swept over by the GMT pointer.

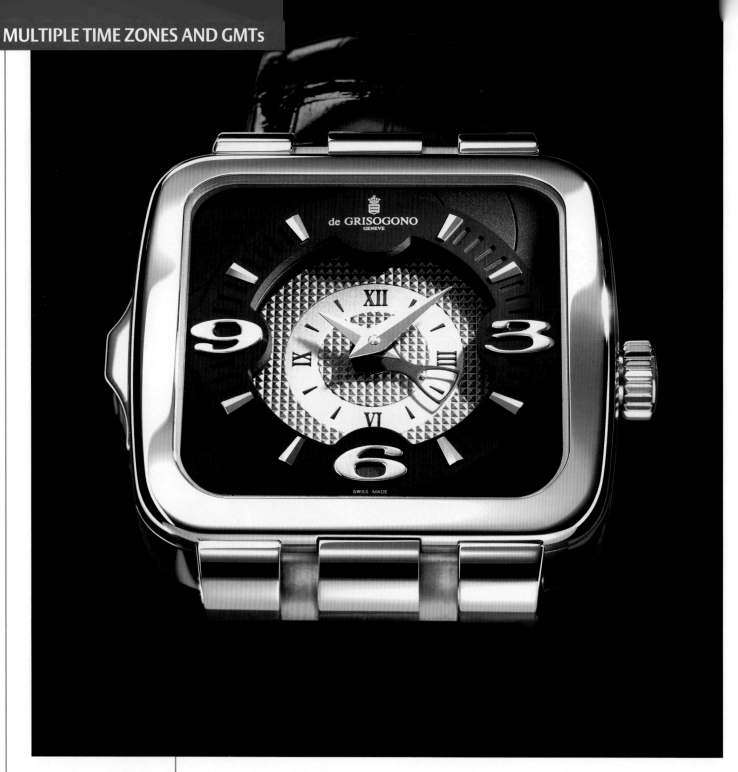

de GRISOGONO

FUSO QUADRATO N°2 OPEN

de GRISOGONO invents with the Fuso Quadrato a new way to display the dual time zone indication. Refreshing the diaphragm system that the House first used on its famous Occhio Ripetizione Minuti, the Fuso Quadrato provides a fun but useful way to use this mechanism: triggered by a lock on the case side, the titanium diaphragm, made of 12 components, opens or closes to reveal or hide the dual time zone indication. The watch proudly expresses its character through a 47x47mm case, with an open sapphire caseback, and is powered by a flawless automatic movement offering 42 hours of power reserve.

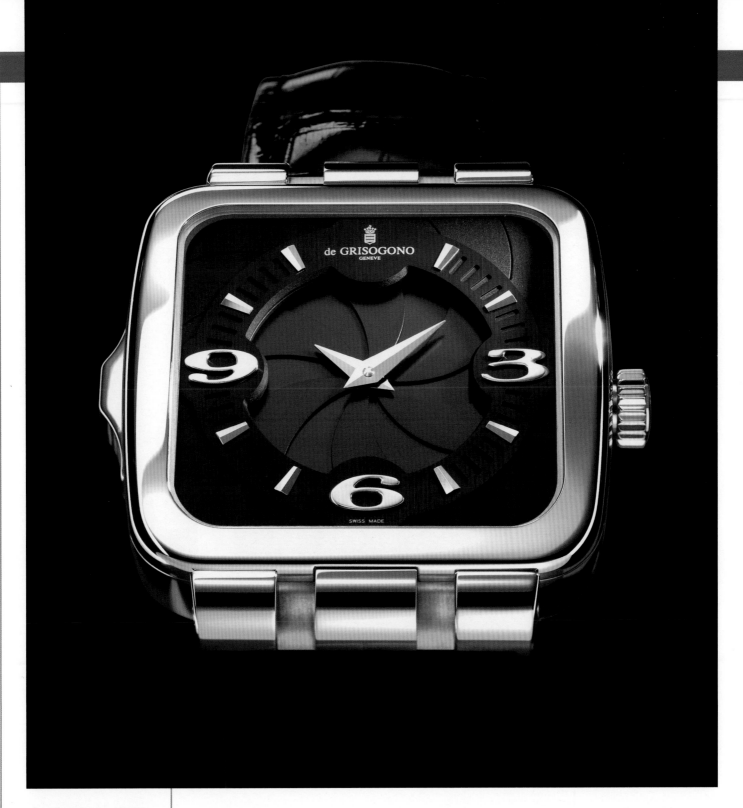

de GRISOGONO

FUSO QUADRATO N°2 CLOSED

The Fuso Quadrato gives de GRISOGONO another showcase for its innovative diaphragm design, this time in the service of a dual time zone complication. Activated by a lock on the side of the case, the diaphragm, which consists of 12 "shutters" in titanium, opens or closes to show or hide the dual time zone indication. The movement provides 42 hours of power reserve and is housed within a 47x47mm case that boasts a sapphire crystal caseback.

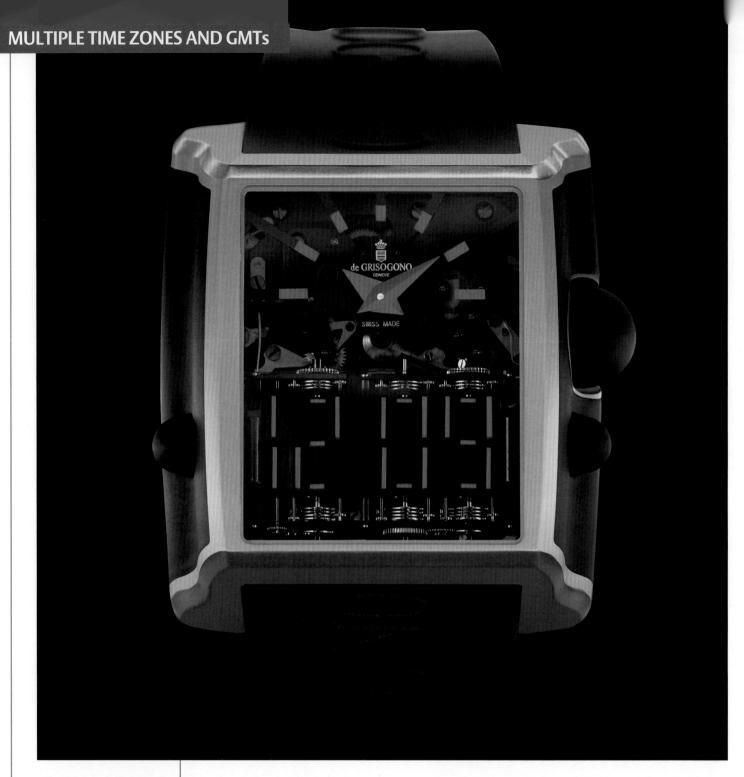

de GRISOGONO

MECCANICO TITANIUM

de GRISOGONO ushers in a new era with its creation of the very first mechanical digital display. A masterpiece with a movement comprising 651 elements, the Meccanico dG features two time zones: an analog display of hours and minutes in the upper part and a mechanical digital display of the second time zone in the lower part—a de GRISOGONO patent. Fawaz Gruosi has achieved what others do not dare dream: propelling haute horology into a new dimension. The exclusive manual-winding dG 042, de GRISOGONO caliber with a 35-hour power reserve, is housed in a curved rectangular case of titanium and rubber. Water resistant to 30m, the case is fitted with a crown cover and correctors made of vulcanized rubber, a transparent black dial with green dauphine hands, and mounted on a black natural rubber strap with titanium. Limited edition of 177 pieces.

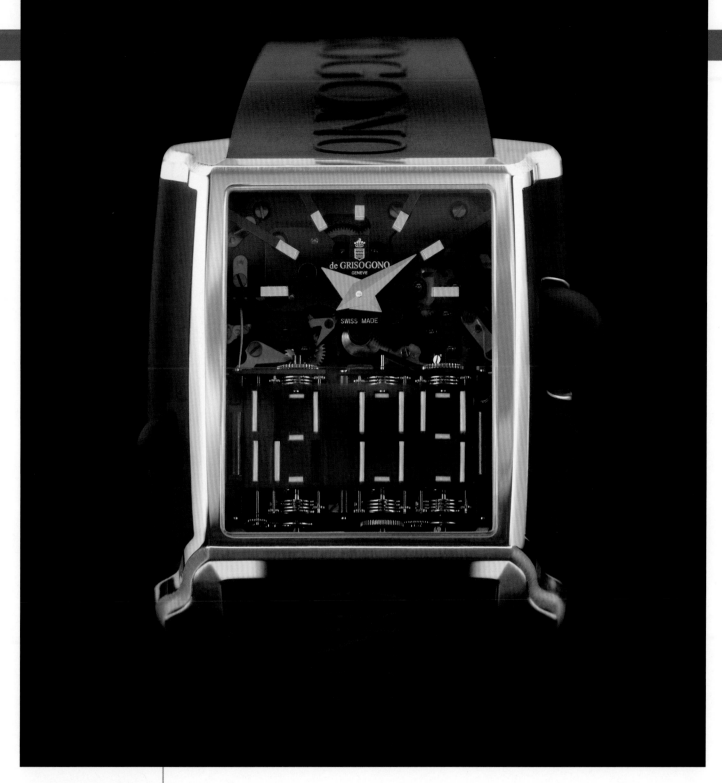

de GRISOGONO

MECCANICO ROSE GOLD

de GRISOGONO has created a world's first with the Meccanico dG's mechanical digital display. Powered by a movement comprising 651 elements, the Meccanico dG features two time zones: an analog display of hours and minutes in the upper part and a mechanical digital display of the second time zone in the lower part. The workings of this breakthrough have been patented by de GRISOGONO. A curved rectangular case of red gold and rubber houses the exclusive manual-winding dG 042, a de GRISOGONO caliber with a 35-hour power reserve. Water resistant to 30m, the case is fitted with a crown cover and correctors made of vulcanized rubber, a transparent black dial with dauphine hands, and mounted on a black natural rubber strap with a red-gold buckle. Limited edition of 177 pieces.

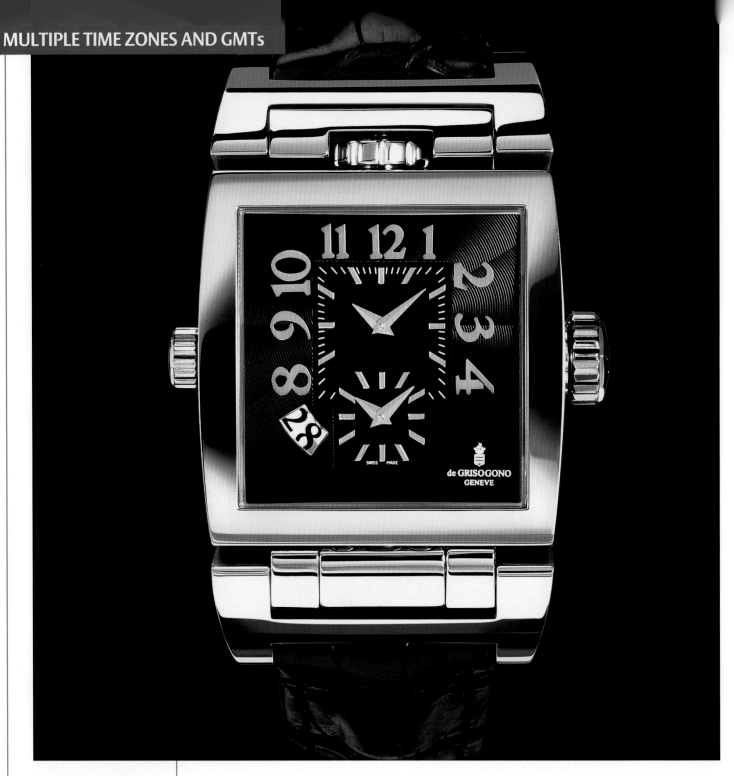

de GRISOGONO

DOPPIO TRE N01

The DOPPIO TRE N01 is a unique and exceptional timepiece as it features an automatic movement providing a three time zone indication on a sharp reversible case: two dials on one side, and the third time zone displayed on the other side of the case. Moreover, the back's indication is as original as it is elegant since time is indicated via two hands crossing the oscillating weight. In this version the DOPPIO TRE is proposed with a steel case and a black alligator bracelet.

DEWITT

THE TRIPLE COMPLICATION-GMT 3 LADIES – REF. AC.2041.40B-102.M121-102

Beauty newly defined, the Triple Complication-GMT 3 Ladies timepiece is bold yet finely detailed. Available in black or white versions, this timepiece is adorned with scintillating black and white diamonds that revolve in conjunction with the timepiece's movement. The watch includes a second time zone, day/night disc and disassociated date.

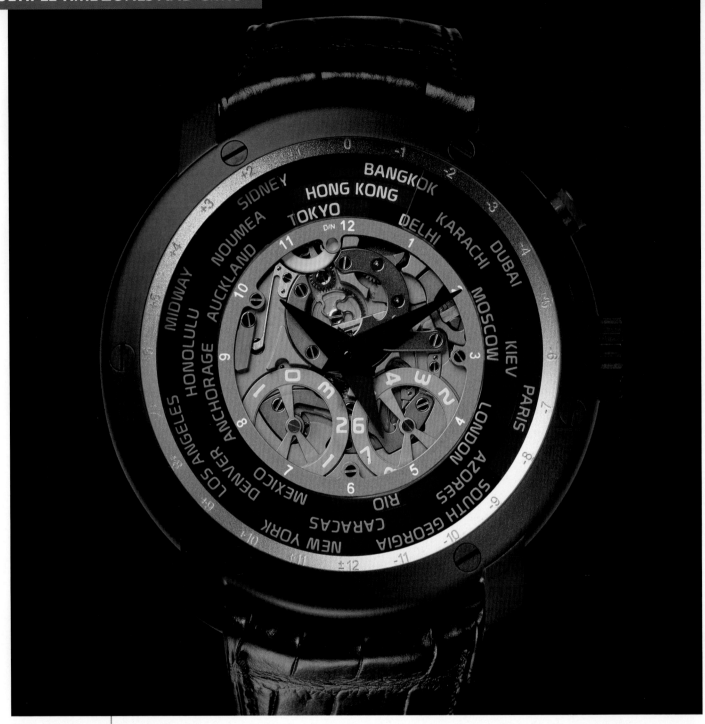

GUY ELLIA

JUMBO HEURE UNIVERSELLE

One of the latest creations by designer Guy Ellia is the Jumbo Heure Universelle with a movement created by Frédéric Piguet. Caliber PGE 1150 features a 72-hour power reserve, a blue sapphire disc, and Côtes de Genève-finished bridges with rhodium plating. The day/night indicator, the grand date and 24 time-zone indications define its singular functions. The Jumbo Heure Universelle bears an exceptional 50mm size that is rarely seen in the world of luxury watches. Mounted on an alligator strap with a folding buckle, this model is presented in black gold and is also available in pink gold and white gold.

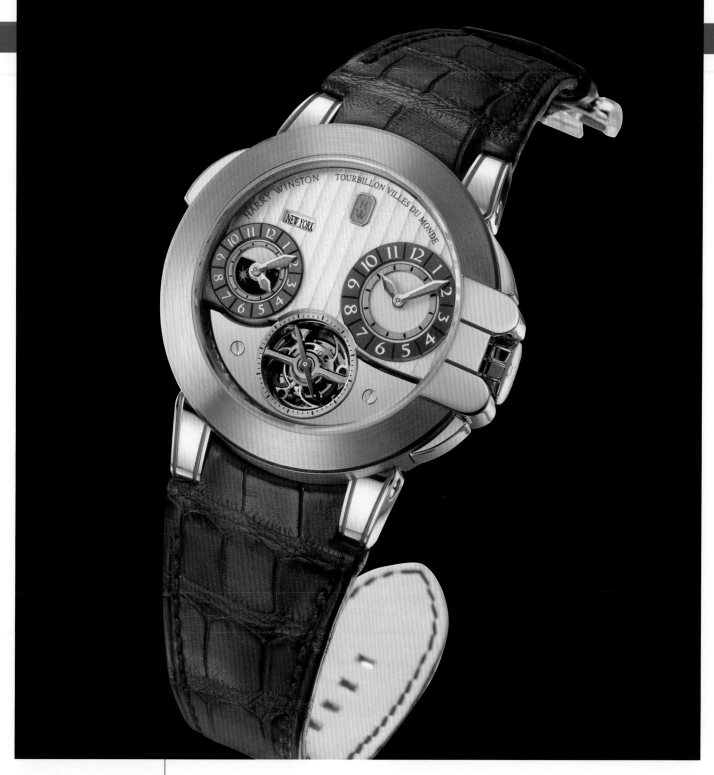

HARRY WINSTON

OCEAN TOURBILLON GMT – REF. 400/MATTZ45RL.WA

Catering to the active connoisseur, the Ocean Tourbillon GMT combines the precision of an automatic tourbillon with the sophistication of the GMT function. A robust 45mm case allows full view of the display, including two subdials. The larger subdial at 2:00 displays the primary time zone; the smaller subdial at 9:00 displays the second time zone. The name of the visited city appears on a jumping display, listing 24 worldwide cities representing each time zone. The single-axis tourbillon is located at 6:00. The case is crafted in red gold on a rich alligator strap. Also available with baguette or brilliant diamonds, the remarkable timepiece is available in a limited edition of 200 pieces.

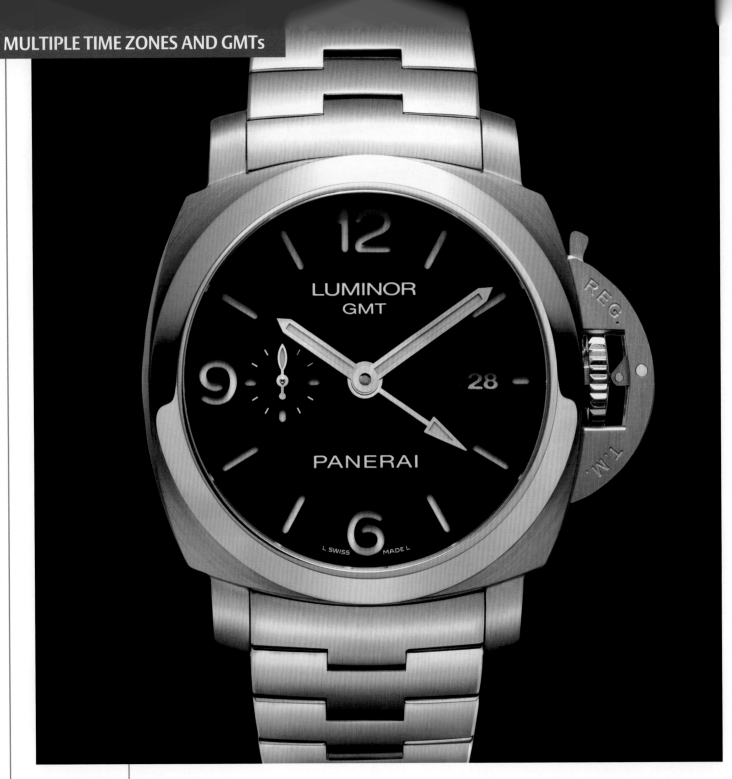

PANERAI

LUMINOR 1950 3 DAYS GMT AUTOMATIC – REF. PAM00329

The P.9001 Calibre, from the latest family of Officine Panerai's in-house movements, comes equipped with a GMT function with a 12-hour indicator, a seconds reset device (historically designed for watch synchronization) and a power reserve indicator. This 227-component movement animates the Luminor 1950 3 Days GMT Automatic. To house these new movements, a specially made version of the Luminor 1950 case has been designed; it respects the proportions of the original, but holds a slightly less convex sapphire crystal, which protrudes only slightly from the bezel. The 44mm stainless steel case is water resistant to 30 bar (300m) and its sapphire crystal caseback reveals the power reserve, which can be read from a rotating disc on the movement.

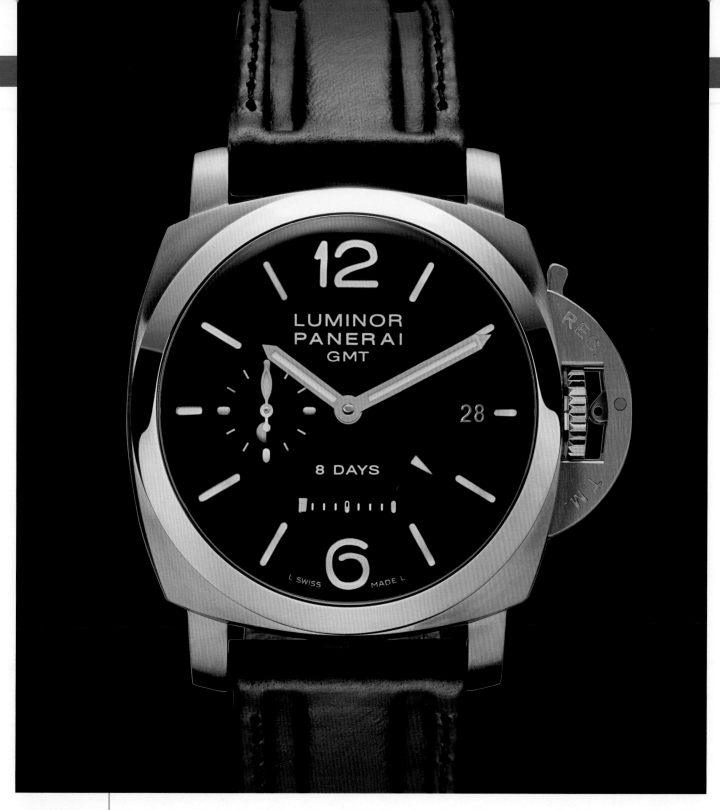

PANERAI

LUMINOR 1950 8 DAYS GMT – REF. PAM00233

In the history of Officine Panerai, 2002 was a fundamental year. Not only did it inaugurate the Manifattura Officine Panerai in Neuchatel, but it marks the year the company began development of its first in-house caliber, which celebrates the milestone with its name, the Panerai P.2002. Consisting of 247 components, it introduces some important new technical innovations. Already in use by Panerai in the 1940s, a hand-wound eight-day power reserve has been achieved by a system of three spring barrels and linear power reserve indication, while the seconds hand is automatically returned to zero by the seconds reset device. The Luminor 1950 8 Days GMT, with its 44mm in diameter, water resistant to 10 bar (100m) case, has become an all-time favorite for those fans of Panerai's Historical Collection who live and work between multiple time zones.

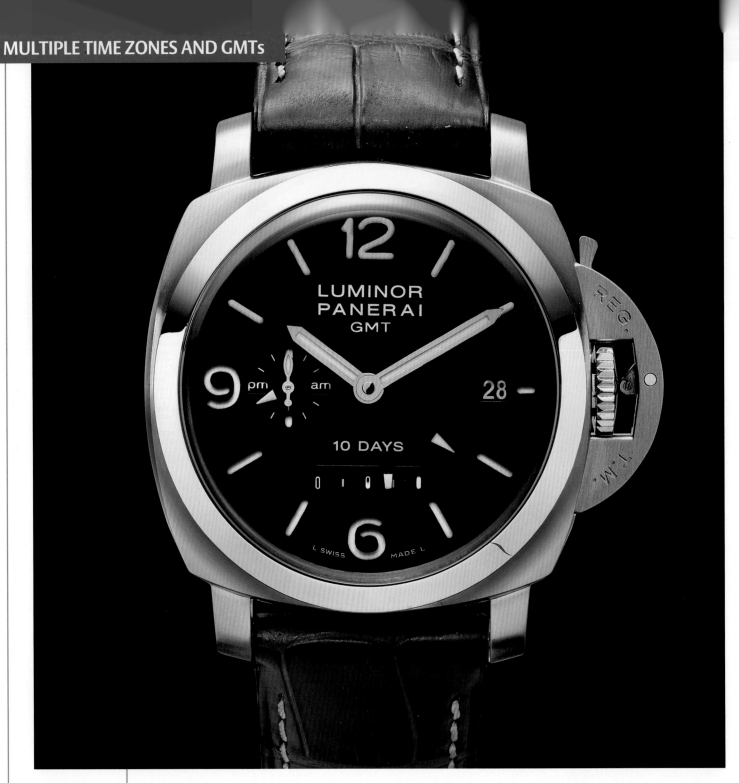

PANERAI

LUMINOR 1950 10 DAYS GMT – REF. PAM00270

Unmistakably Panerai, this handsome timepiece cleanly presents a discreet linear 10-day power reserve indicator and a 24-hour GMT subdial within a 44mm steel case, which is water resistant to 10 bar (100m). The Panerai P.2003 Calibre, comprised of 296 parts, is the first automatic mechanical movement created entirely by Panerai. It has an autonomy of 10 days (240 hours); such a prolonged power reserve is possible because of the innovative system with its unusual energy accumulator, consisting of three spring barrels. Two of these are located one above the other, while the third is linked through a gear train that enables the remaining power to be indicated on an appropriate graduated scale.

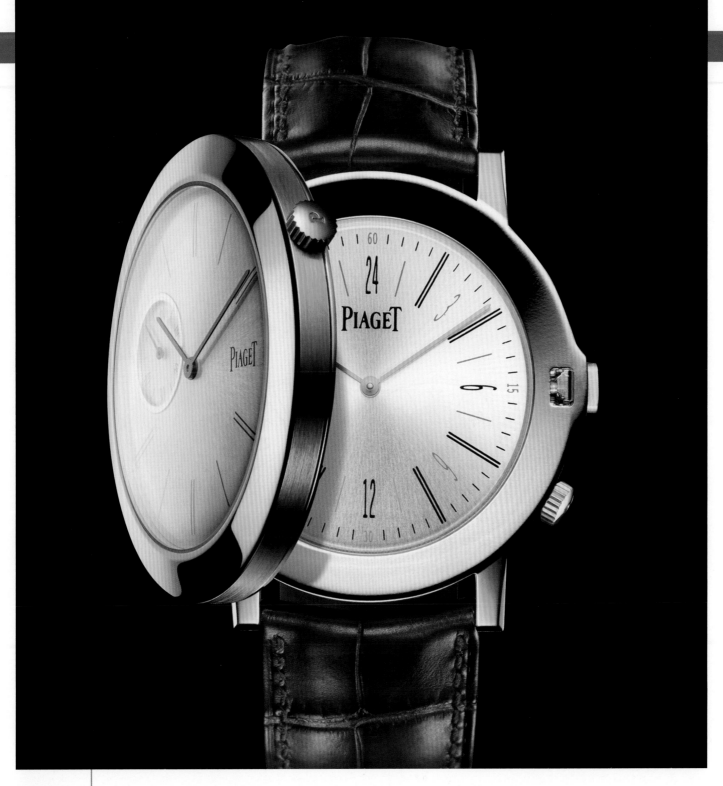

PIAGET

PIAGET ALTIPLANO DOUBLE JEU – REF. G0A35153

The Piaget Altiplano Double Jeu consists of two watches, featuring extremely slender cases and ultra-thin movements that enable them to be superimposed so as to form just one. The result is a decidedly avant-garde, generously sized 43mm watch equipped with two calibers driving different time displays on each dial, a particularly useful function for travelers. In developing the new Calibre 832P based on the ultra-thin Calibre 830P, the Manufacture de Haute Horlogerie wished to further enhance the sophistication of the Double Jeu concept by providing travelers with a dual time zone displayed on a 24-hour scale rather than just 12 hours. The caliber is finished with meticulous care, including beveled bridges adorned with circular Côtes de Genève, a circular-grained mainplate and traditional blued screws.

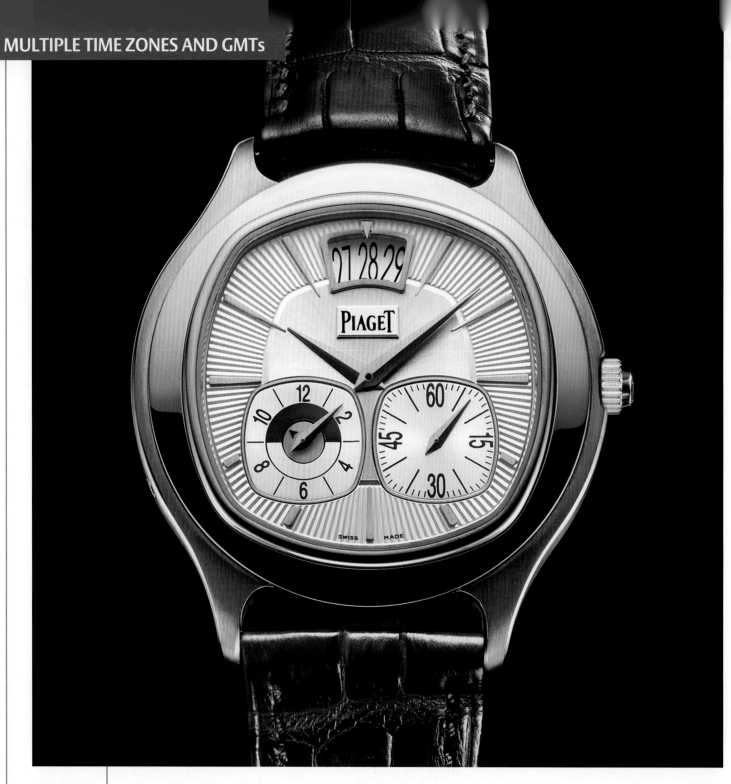

PIAGET

PIAGET EMPERADOR COUSSIN – REF. G0A32017

The Emperador Coussin watch is intended for modern-day nomads, whether businessmen or jetsetters, driven by a love of fine watchmaking craftsmanship. With its sunburst guilloché dial and two large counters indicating the dual time zone and the seconds, this model is a must-have for regular travelers. Proudly bearing the unmistakable Piaget signature, its pink-gold case features a subtle interpretation of the handsomely rounded cushion shape. As a creation truly worthy of Piaget, the Emperador Coussin watch reveals a specially tailored 850P movement adorned with superlative finishing including a circular-grained mainplate, beveled and hand-drawn bridges, blued screws and circular Côtes de Genève.

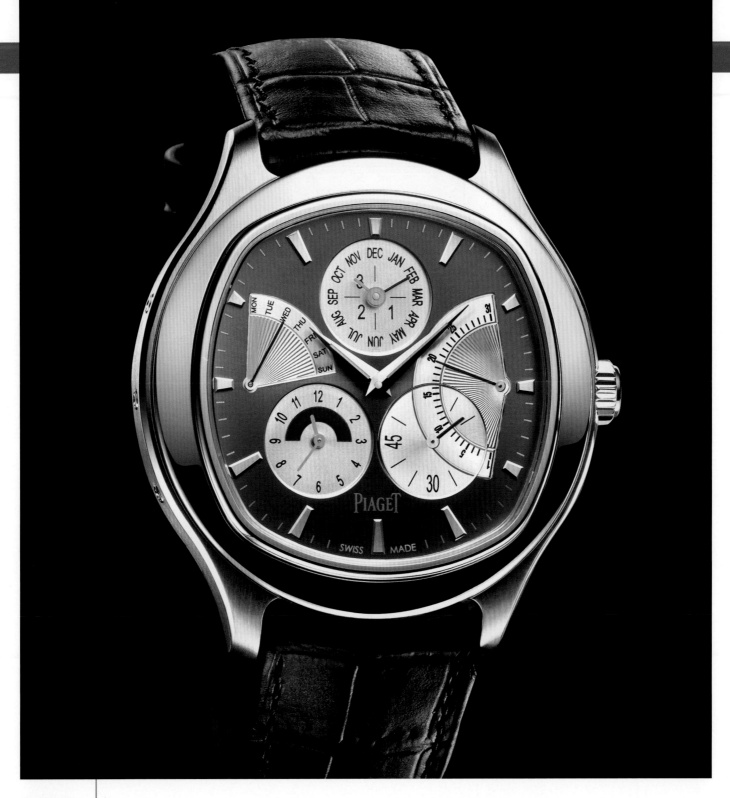

PIAGET

PIAGET EMPERADOR COUSSIN PERPETUAL CALENDAR IN WHITE GOLD – REF. G0A33018

Measuring 5.6mm thick, the Manufacture Piaget Calibre 855P self-winding movement displays the hours, minutes, small seconds at 4:00 and month and leap years at 12:00, along with retrograde day of the week and date displays at 9:00 and 3:00 respectively. In addition to the latter retrograde indications, this Calibre 855P stands out from most ordinary perpetual calendars by the addition of a double-hand dual time zone display appearing in a subdial at 8:00. The subtle architecture of the 46mm case enables to adapt to all wrists and imparts a particularly elegant profile. Subtly alternating polished and satin-brushed surfaces on the case middle, bezel and inner bezel ring, the latter is fitted with a sapphire crystal back providing admirable views of the movement finishings.

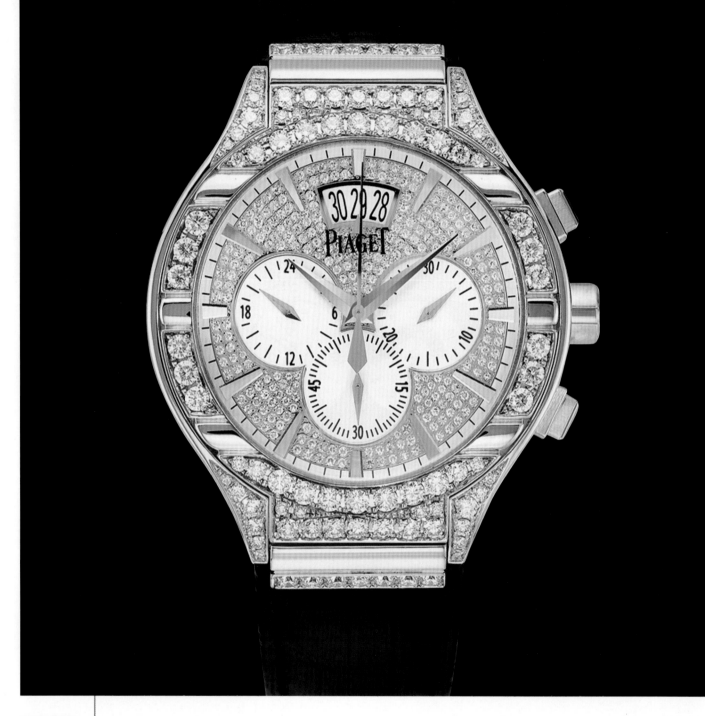

PIAGET

PIAGET POLO CHRONOGRAPH – REF. G0A33038

The Piaget Polo Chronograph model houses the Calibre 800P, a mechanical chronograph movement entirely designed, developed and produced by the Manufacture de Haute Horlogerie Piaget. In addition to the chronograph and flyback functions, this proprietary movement drives the hour, minute and small seconds at 6:00, as well as the date display at 12:00 and a second time zone indication. The 5.6mm-thick Calibre 800P is endowed with all the attributes of an haute horology chronograph movement. The generously sized 43mm-diameter case is set with 622 brilliant-cut diamonds (approximately 4.6 carats) and the dial set with 262 brilliant-cut diamonds (0.8 carats).

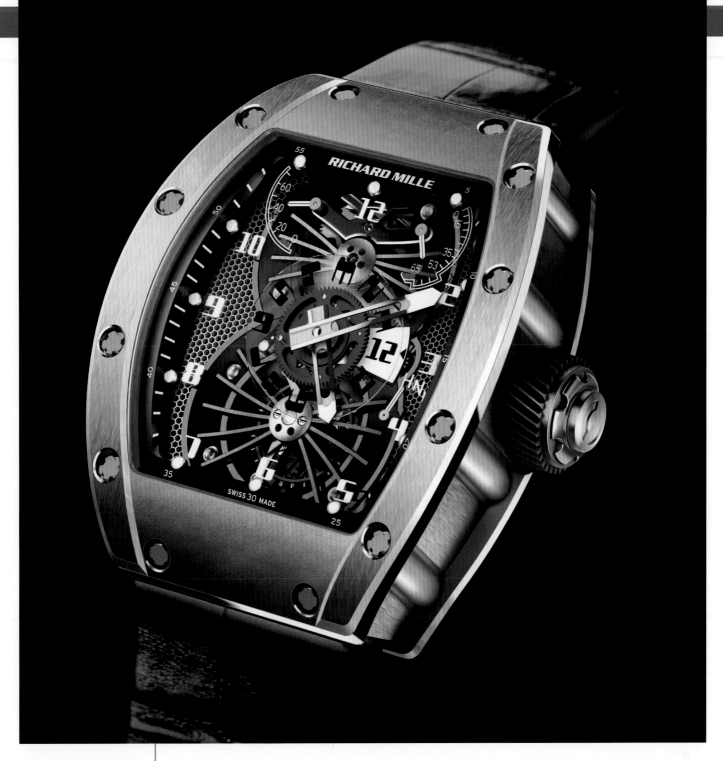

RICHARD MILLE

RM 022 TOURBILLON AERODYNE SECOND TIME ZONE

The RM 022 Tourbillon Aerodyne Second Time Zone is a visual and mechanical evolution of the first Richard Mille timepiece. Within its newly sculpted case design is the manual-winding caliber RM021, built on a baseplate of honeycombed orthorhombic titanium and carbon nanofiber. It provides hours, minutes, indicators for power reserve (circa 70 hours), torque indicator and function indicator for winding, neutral, and hand-setting operations. The finely finished pushbutton, located at 9:00, advances the second time zone in one-hour increments, utilizing a numbered, rotating disc of sapphire visible at 3:00.

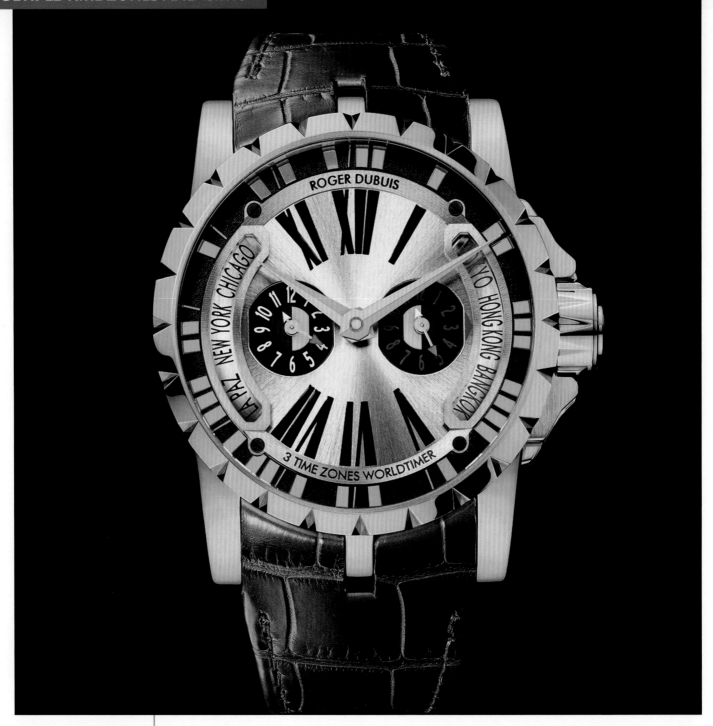

ROGER DUBUIS

EXCALIBUR WORLD TIME – TRIPLE TIME ZONE – REF. EX45-1448-50-00/0RR00/B

The automatic-winding RD 1448 movement of Roger Dubuis's Excalibur World Time – Triple Time Zone incorporates two separate rings, each inscribed with the names of 12 different cities. This system allows it to display the local time centrally while simultaneously calculating and showing the current time for two additional time zones. The wearer selects two locations to be displayed on opposite sides of the rhodium-plated dial; these locations can be adjusted via correctors on the case middle. The time for each location is indicated by an adjacent 12-hour display that also includes an AM/PM indication.

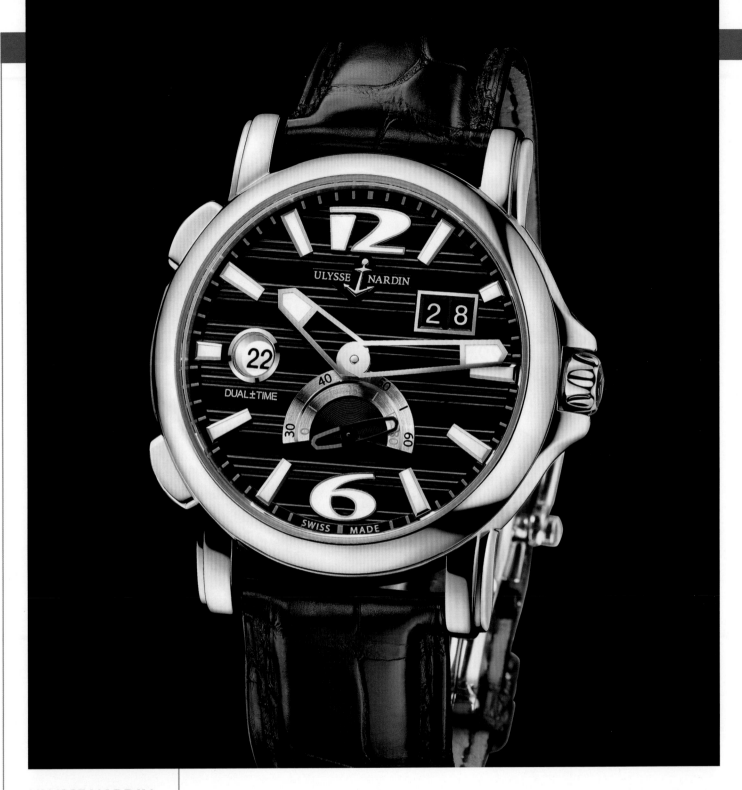

ULYSSE NARDIN

DUAL TIME – REF. 243-55/62

Crafted in stainless steel, this Dual Time houses a UN-24 caliber and features an exhibition caseback. The dial displays permanent home time at 9:00 and a second time zone with patented quickset on the main dial, while the oversized double window displays the date at 2:00.

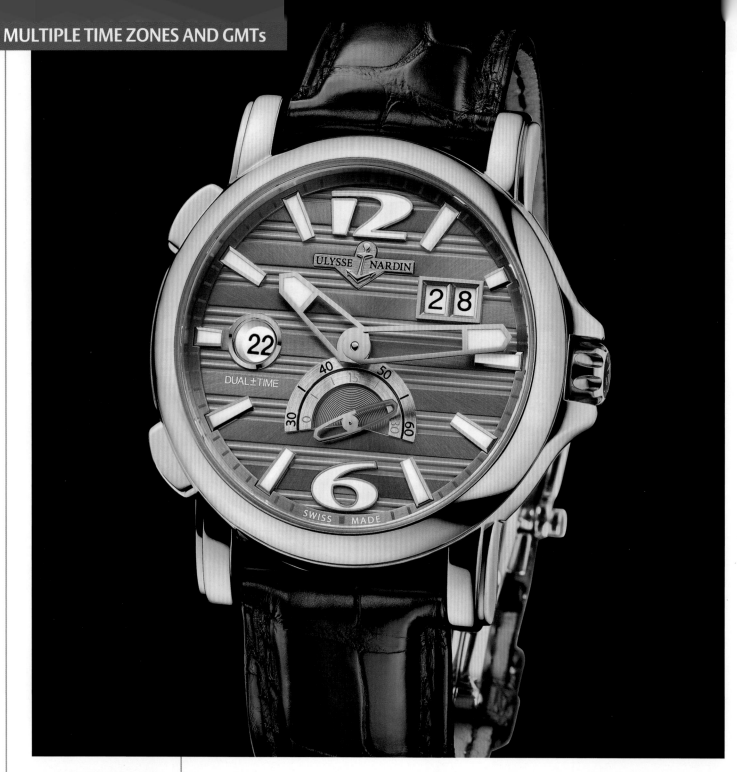

ULYSSE NARDIN

DUAL TIME – REF. 246-55/69

The 42mm Dual Time features an exhibition caseback, a second time zone with patented quickset on the main dial, and permanent home time in the window at 9:00. The date is displayed in large digits through the double window. This Dual Time is presented in 18K rose gold and powered by the UN-24 caliber.

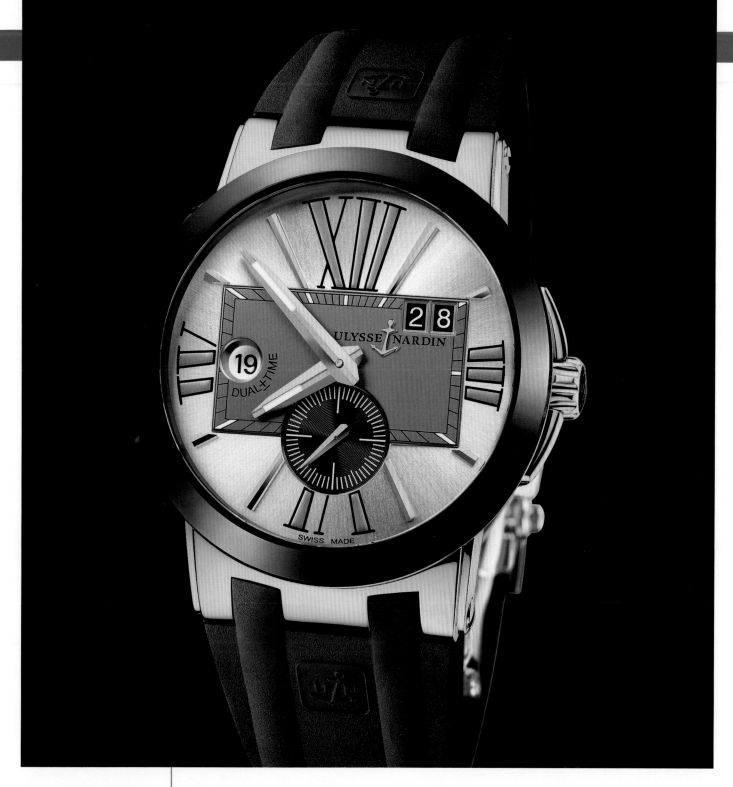

ULYSSE NARDIN

EXECUTIVE DUAL TIME – REF. 246-00-3/421

Driven by its UN-24 caliber, the Executive Dual Time is presented in a 43mm 18K gold case. This fine timepiece offers an exhibition caseback and ceramic bezel and pushers. Additional features include a second time zone with patented quickset on the main dial and permanent home time in the window at 9:00. The Executive Dual Time is also available in stainless steel on a rubber strap with ceramic clasp.

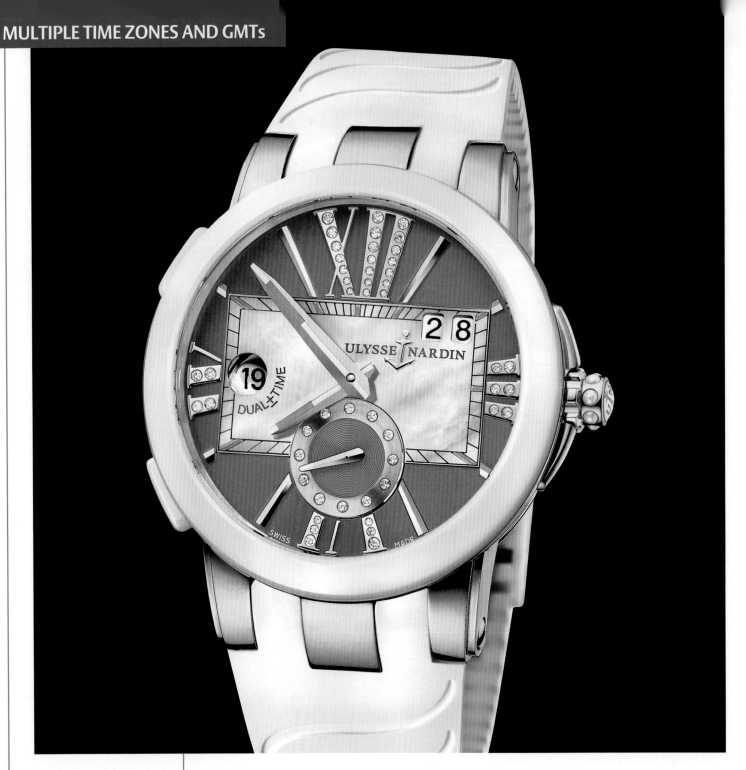

ULYSSE NARDIN

EXECUTIVE LADY – REF. 243-10/30-07

The dial of the Executive Lady displays a second time zone with patented quickset and permanent home time in the window at 9:00. This timepiece offers an exhibition caseback that reveals its UN-24 caliber. The 40mm case is crafted in stainless steel, and the bezel and pushers are fashioned from ceramic.

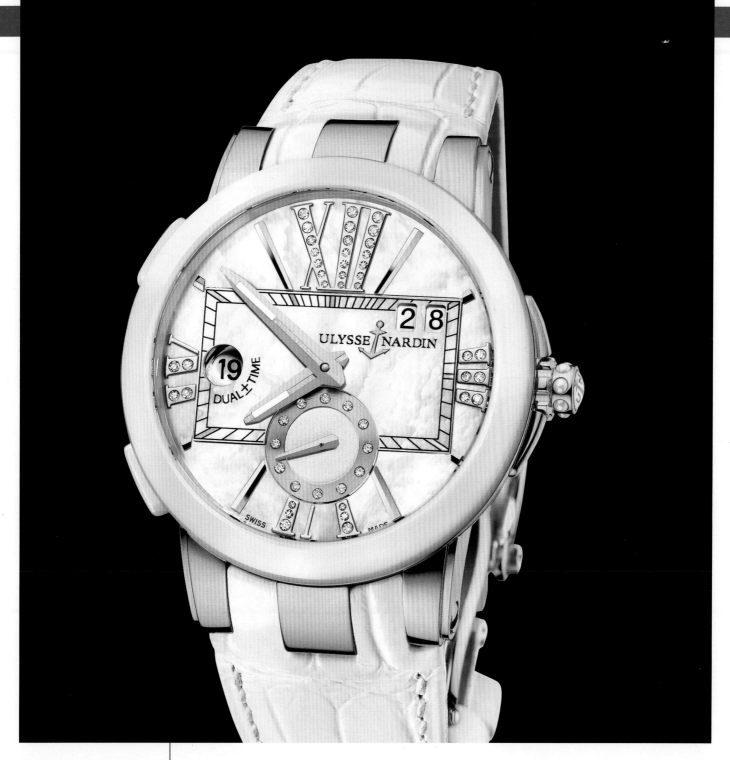

ULYSSE NARDIN

EXECUTIVE LADY – REF. 246-10/391

Powered by the UN-24 caliber, this 40mm Executive Lady in 18K rose gold features an exhibition caseback, a second time zone with patented quickset on the main dial, and permanent home time in the window at 9:00. Ceramic bezel and pushers complete the Executive Lady.

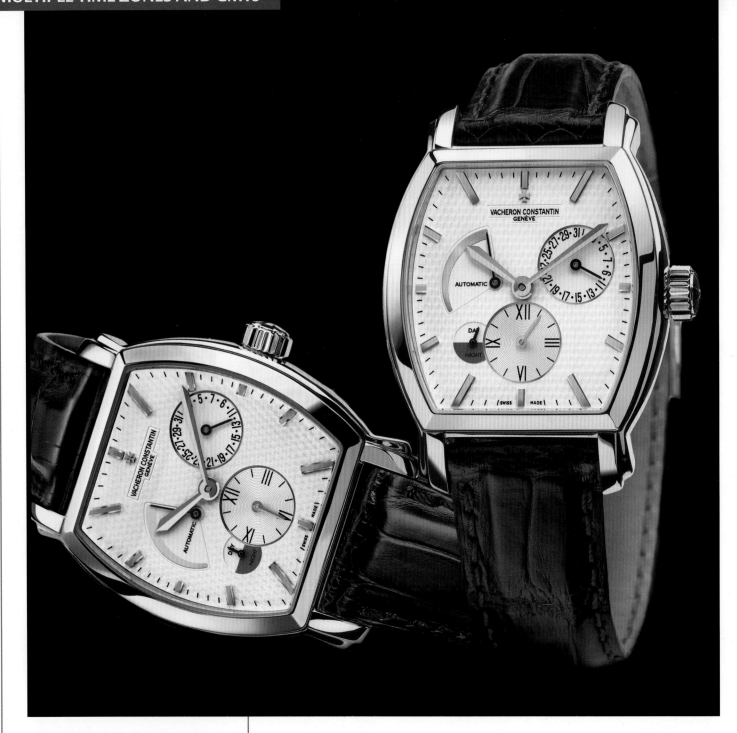

VACHERON CONSTANTIN

MALTE DUAL TIME – REF. 47400

This self-winding Malte Dual Time houses the Caliber 1222 and is available in 18K white or rose gold. It offers hours, minutes, date, power reserve, and second time-zone indication with day/night readout. The movement beats at 28,800 vph and the watch is water resistant to 3atm.

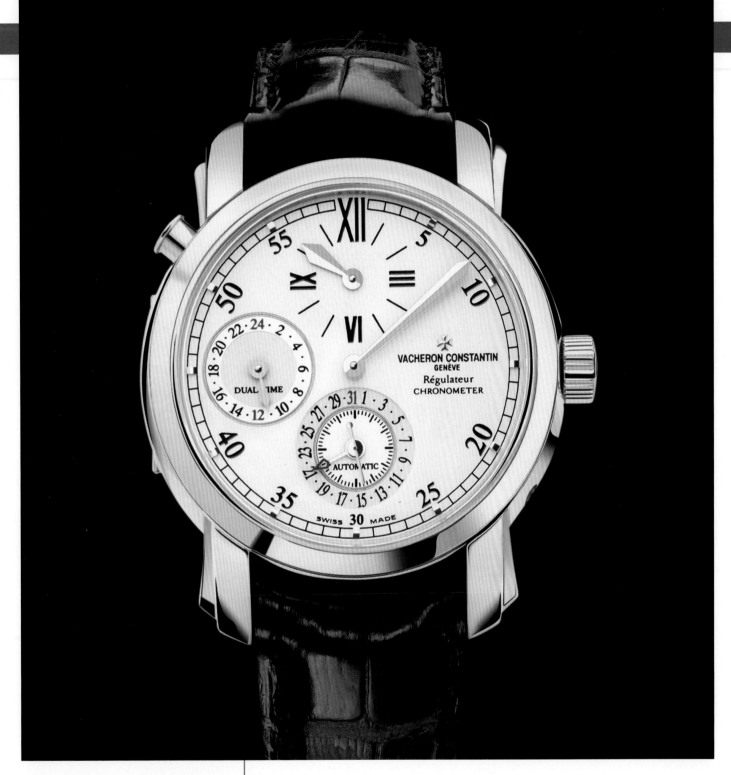

VACHERON CONSTANTIN

MALTE DUAL TIME REGULATOR – REF. 42005

This Malte Dual Time Regulator is presented in an 18K pink-gold half-hunter case with back lid, and houses the COSC-certified chronometer Vacheron Constantin Caliber 1206 RDT. The manually wound movement offers hours, minutes, date calendar at 6:00 and second time zone indicator at 9:00 via a 24-hour subdial.

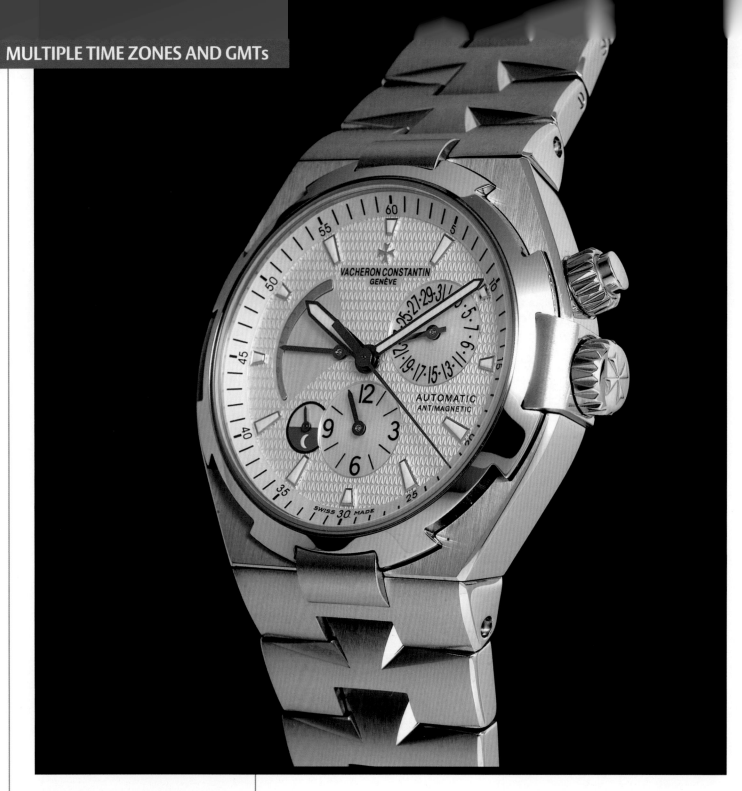

VACHERON CONSTANTIN

OVERSEAS DUAL TIME – REF. 47450/B01A

Encased in 316L surgical-grade steel on a steel bracelet, this Overseas Dual Time watch is powered by the mechanical automatic-winding Vacheron Constantin Caliber 1122 with 40 hours of power reserve. The 34-jeweled movement beats at 28,800 vph, and is protected against magnetic fields by a soft inner iron case. The watch offers hours, minutes, seconds, date, and dual-time readout with day/night indication. Eight screws fasten the bezel and the sapphire crystal is antireflective. Water resistant to 15atm, Overseas Dual Time features a silvered dial with applied, luminescent gold trapezoid markers and luminescent hands.

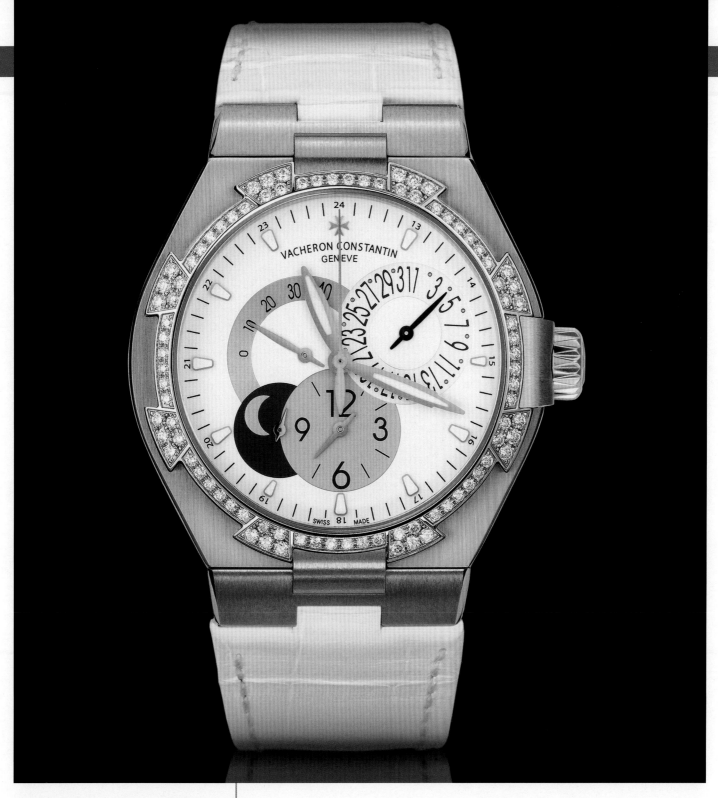

VACHERON CONSTANTIN

OVERSEAS DUAL TIME – REF. 47751

The Overseas Dual Time features the date, a second time zone, and a power reserve. Its 18K pink- or white-gold 42mm case with clear-cut, harmonious lines gives this timepiece a very strong character. The white-gold bezel shimmers with 88 brilliant-cut diamonds and the matte-white varnished dial, with its luminescent, pink-gold leaf-shaped hands, provides perfect legibility for reading the various indications. This watch also has a solid caseback stamped with the Overseas medallion, a two-masted sailboat. Thanks to its screw-down crown, water resistance is guaranteed to a depth of 15atm, or approximately 500 feet. Each Overseas model features an antimagnetic shield that was researched and developed by Vacheron Constantin. Diamonds sparkle at their brightest when they come together with luminous materials, one of the reasons why the brand paired the Overseas Dual Time with a white vulcarbonized rubber strap in addition to the white alligator leather that features a triple-folding clasp.

Retrograde Mechanisms and Jumping Hours

The choice of the direction in which watch hands turn goes back to the dawn of time. It is in fact based on the sundial, the oldest time-measuring instrument. In the Northern Hemisphere, the shadow cast by a rod on a horizontal dial points to the north and follows the opposite path to that of the sun, meaning that of the hands on a watch. But while this endless rotation around an axis appears natural, there are many other devices serving to indicate the passing of time—for example, a retrograde display, in which a hand moves over the arc of a circle before returning to its starting point. In an ironical twist of history, the first retrograde display can also be regarded as that of the horizontal sundial. The shadow cast by the rod starts at sunrise (close to the 9 o'clock position) and disappears at sunset (close to the 3 o'clock position), before reappearing the following morning in its initial position. In addition to the retrograde function, watchmakers have in recent years begun enhancing dials with various discs, cylinders, rotating cubes and even colored segments.

Nicolas Beau

*International
Director of
Chanel Horlogerie*

"We are the very opposite of a fashion brand!"

Though they have their roots in haute couture, Chanel watches are by no means mere fashion accessories. The extensive activities deployed by the brand over the last more than 20 years in the watchmaking field have earned it a place among the most prestigious. The key resides in certain pieces that have left indelible marks on the industry, such as the J12, launched in 2000, which was the first timepiece to be encased in black ceramic.

Gabrielle Bonheur Chasnel, better known as Coco Chanel, was born August 19, 1883, in Saumur, in France's Pays de la Loire department. In 1910, she realized her dream of becoming a fashion designer, and it didn't take long for her style and materials to become a sensation. In 1921 her company launched Chanel No. 5, a global success that is still a popular emblem of the brand. Three years later appeared the costume jewelry, and in 1929, with the help of some well-chosen accessories, the Chanel "total look" was born: a revolution in fashion. From this impressive heritage, in 1987, sprang La Première, the first watch by Chanel. In 2000 came the J12, which rapidly became iconic. Today, fine watchmaking is the third area of expertise for the House with over a century of history.

What are the main markets for Chanel Horlogerie?
Europe, and in particular France, is extremely important for us. Tourism has contributed greatly to the growth in France. Then there's the United States, which has been one of Chanel's biggest markets since the 1930s. We had quite a bit of worldwide growth in 2010.

What explains this keen interest?
It's the result of a lot of foundational work: Chanel has been investing in haute horology for more than 20 years, and our mythic J12 watch was released 10 years ago. All of the work we've done in terms of distribution and research and development is now paying off! It's a reward for our serious reputation and for quality.

The J12 is the model that made your name in the watch industry...
That watch marked the beginning of the 21st century. Nobody before we did so in 2000 had ever thought to release a watch that was entirely black. After we showed the way, the rest of the world followed. In 2003, Chanel presented an all-white version of the J12 Ceramic, which was also a huge success. The J12 is said to be the first icon of the 21st century.

How do things look in 2011?
It has started with a blast, the same as 2010! Considering what our industry went through in 2009, we must keep our feet on the ground. However, with our new J12, which is clothed in an entirely new material, we are confident.

Chanel's J12 Tourbillon Rétrograde Mystérieuse boasts a number of complications within its sleek black ceramic case.

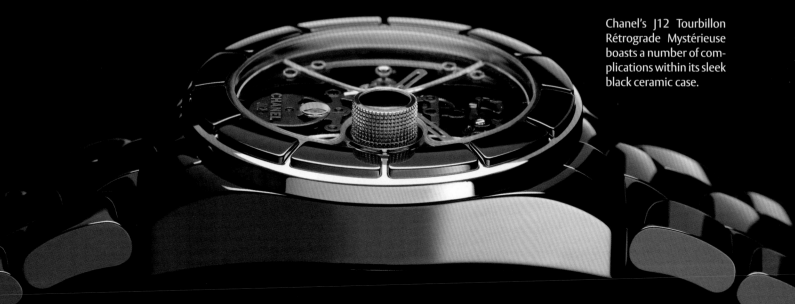

What other new products are you launching this year?

We are paying tribute to La Première, our historic watch. When it was released in 1987, Chanel was one of the first Houses to get involved in Swiss Made watchmaking. The piece was very innovative at the time, combining elements from the world of accessories, fashion and horology. And it's still here! This year we are proposing a "Vintage 1987" series in gold, equipped with a quartz movement.

So you were one of the first fashion brands...

We are the very opposite of a "fashion" brand, which changes with every trend. On the contrary, we create the trends! We have an exclusively "Swiss Made" approach, for the long term—and we have never abandoned a product. It's a very thorough, in-depth approach. Around 230 people work at our office in La Chaux-de-Fonds in Switzerland, and horology is the third domain of Chanel, after fashion and fragrances.

What goes on at your branch in La Chaux-de-Fonds?

That was the site of the Châtelain business, which was acquired by Chanel in 1995. It created cases, buckles and bracelets. Since the acquisition, we have been utilizing it for all of our horological operations besides the production of the movements themselves: mounting, encasing, setting, etc. We also do work in ceramic, gold, steel and titanium there. The business has remained autonomous, and Chanel is one client of Châtelain, among others.

For watch movements, you are currently working with ETA (Swatch Group) for La Première and some of the J12 models, and with Audemars Piguet (Renaud & Papi) for the grand complications. Do you foresee other partnerships in your future?

No, we prefer to work with the fewest number of partners possible. It's important to work with just a few people, but over the long term, if only to facilitate the logistics of after-sale service.

Are you planning on going the other way entirely and vertically integrating all of your watch production at Chanel?

For Chanel, a watch is a creation, and creation must have the fewest number of constraints possible! If we started to make movements, we would have to talk dimensions, lines, proportions, etc, and we would run the risk of making watches just for the movements within. We don't want to be influenced in that way. In 2008, we created a small version of the Première, and ETA offered us a small quartz movement that was perfect for the piece. We work with consummate professionals and that has served us quite well.

Out of your entire watch production, what is the division between quartz and mechanical movements?

The split is about 40 percent quartz, 60 percent mechanical. But it's not a conflict for us: Swiss Made quartz movements work very well. Occasionally, certain women even ask us to replace their automatic movement with a quartz one!

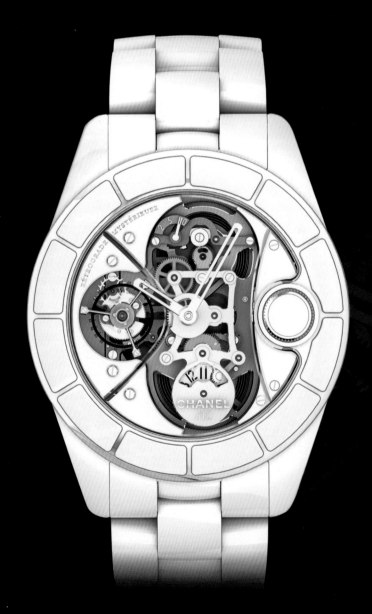

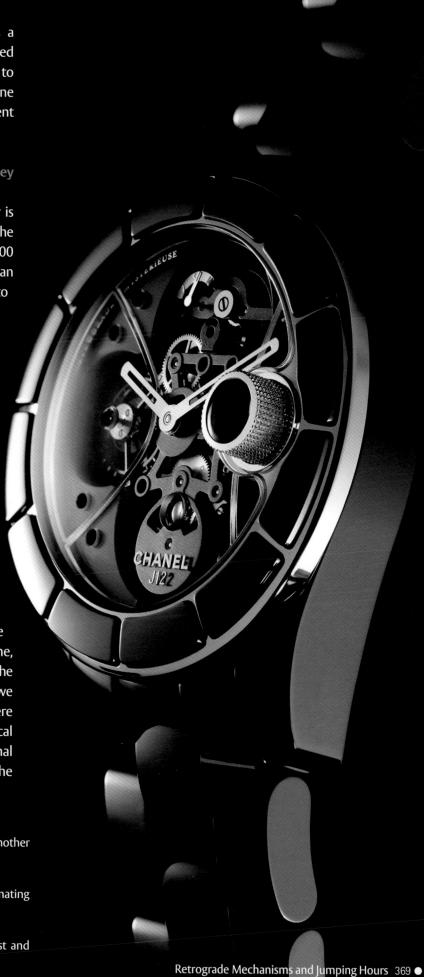

What is your target clientele?

Chanel has a very feminine image. La Première is a women's model, but the J12 is clearly for a mixed audience. We have pieces in all diameters, from 29 to 42mm. Those who are buying the 42mm J12 Marine are 90 percent men. Overall, I would say that 60 percent of our clients are women, and 40 percent are men.

Is your clientele passionate about horology, or do they mostly buy for the Chanel name?

Women are more likely to fall in love with whatever is beautiful. The brand is there to reassure them about the quality. But when one is spending 210,000 € ($285,000 in US dollars) for a J12 Rétrograde Mystérieuse, it's an entirely different approach. We limited the model to two series of ten pieces, and all of them were sold! It is one of our great successes: women are already faithful to Chanel watches, and with time we have succeeded in winning men over too.

Is it an advantage or a disadvantage to have the Chanel name for a watch company?

It is an unquestionable advantage. Knowing our creativity and our quality, our women clients were already quite taken with the idea of watches. That is the advantage of belonging to a larger company.

What is the common denominator of Chanel products?

Innovation and the idea of daring. Gabrielle Chanel was the first to use tweed and fashion in high fashion; in 1921, when she launched Chanel No. 5, she was the first to truly create a fragrance, since at the time, perfumes just reproduced natural flower scents and the now-iconic J12 follows that same dynamic. When we came up with ceramics, the world thought we were crazy. Rado was using ceramics, but as a technological material. We transformed it into a traditional material that is now part of Chanel's identity in the watch industry.

FACING PAGE
TOP LEFT
Chanel's first watch, aptly named La Première, has become another Chanel icon, and is still being released in new versions.

BOTTOM RIGHT
In addition to a tourbillon, the new J12 features a fascinating retrograde minute display.

THIS PAGE
The J12's vertical crown ensures perfect comfort on the wrist and a simple press on the face releases the crown for winding.

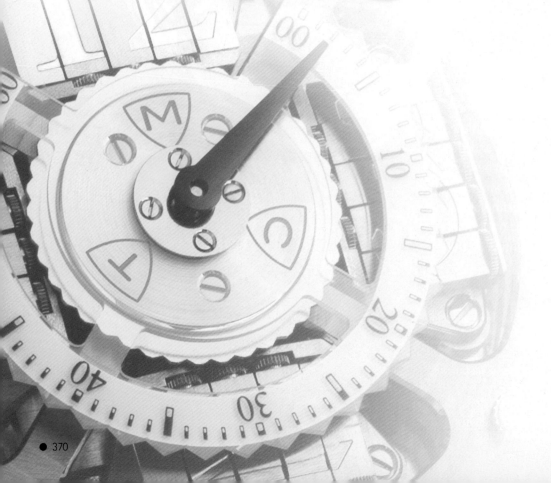

Retrograde Mechanisms and Jumping Hours

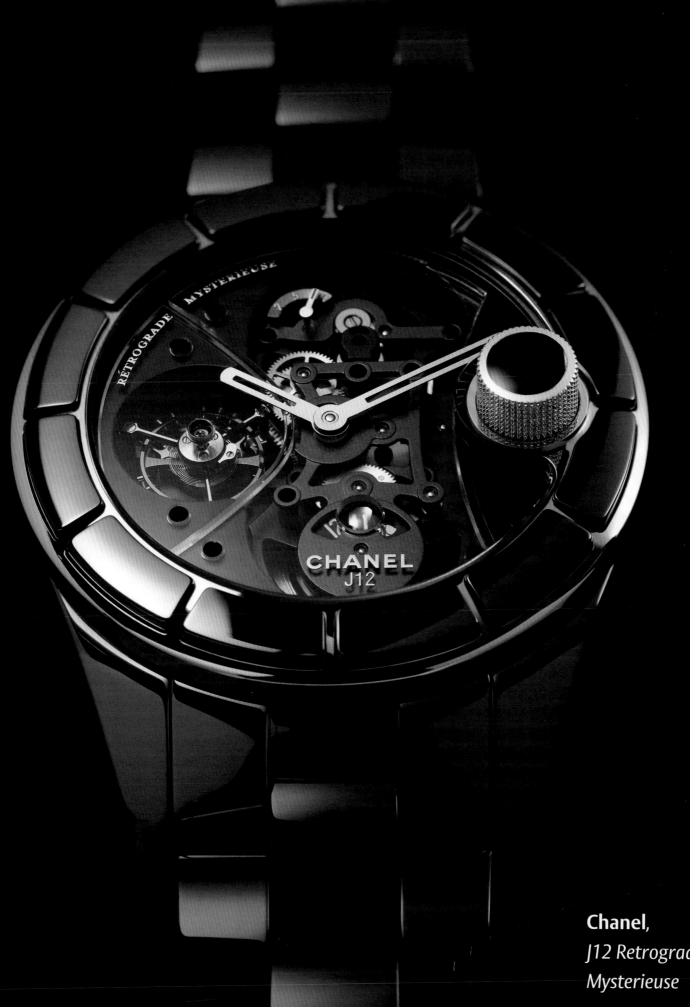

Chanel,
J12 Retrograde
Mysterieuse

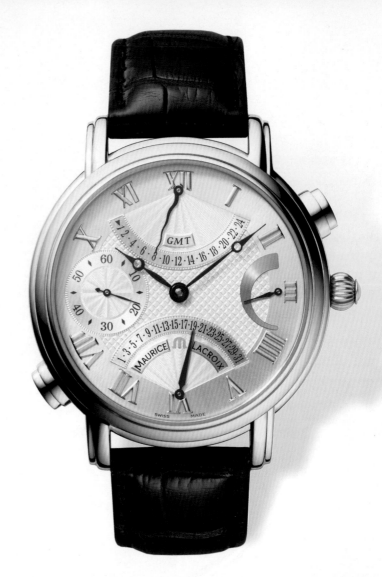

Things that appear frozen in time generally end up being challenged in the world of horology. For centuries, the path traveled by watch hands has remained rigorously consistent. While watchmakers have long since decided to diversify display modes, this field has in recent years become a favorite playground for demonstrating boundlessly inventive approaches. Horologers began by inventing the "retrograde" system, based on a hand traveling over the arc of a circle and then returning instantly to its point of departure before starting off again along the same path. Retrograde displays are very much in vogue, and provide a basis for creating dials with original and "animated" designs. Witness the GrandCliff Skyscrapers by Pierre DeRoche, with two half-moon vertical counters, as well as

the extremely original Tempus Vivendi by Thomas Prescher: interpreted in several different versions (eagles, dragons, samurai warriors, Qatar), the latter features hour and minute hands running over fan-shaped counters on either side of the dial. Retrograde mechanisms may also be used for displays other than time indications. In addition to the traditional hours/minutes/seconds, the Double Rétrograde II by Maurice Lacroix offers retrograde date and 24-hour indications, while the Lange 1 Daymatic by A. Lange & Söhne features a hand showing the days of the week on the arc of a circle between 9 and 11 o'clock.

TOP LEFT
Thomas Prescher, *Tempus Vivendi*
LEFT CENTER
A. Lange & Söhne , *Lange 1 Daymatic*
ABOVE
Maurice Lacroix, *Double Rétrograde II*
LEFT
Pierre DeRoche, *GrandCliff Skyscrapers*

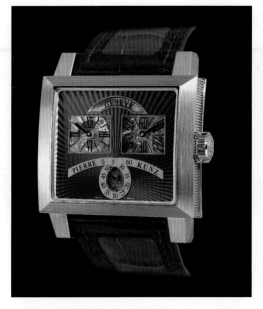
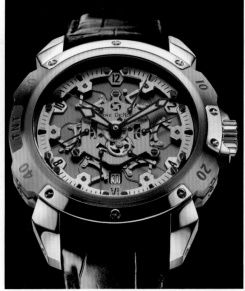
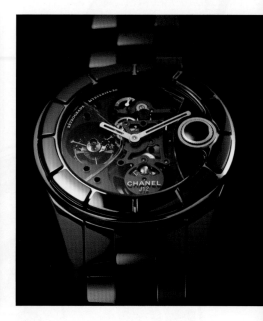

A STUNNING VISION

The dance of the hands leaping back to their initial position tends to make retrograde timepieces a spectacular experience, especially when certain dials combine two, three or even four indications of this type, or when watchmakers have fun creating complicated "figures." On the Seconde Virevoltante Rétrograde, Pierre Kunz offers an amazing show of aerial acrobatics with a hand dipping and swooping around a 470° loop before returning to its initial position in 5/100ths of a second and starting all over again. The new Tirion Triretrograde Minute Repeater by Milus features a retrograde seconds display based on three 20-second segments placed at 6, 10 and 2 o'clock. The first hand moves across its arc of a circle before jumping back to its starting point, while the second hand takes over, and then in turn passes the baton on to the third. Pierre DeRoche went even further in 2009 by unveiling the GrandCliff TNT Royal Retro, equipped with an exclusive Dubois Dépraz mechanism. The seconds are indicated by a succession of six retrograde displays driven by gear and strip-spring systems that are visible on the dial. In a slower yet equally spectacular model, the central minutes hand of Chanel's J12 Rétrograde Mystérieuse runs in a traditional manner for the first ten minutes, before bumping up against the retractable crown appearing on the dial at 3 o'clock. This sets off a retrograde motion that takes another ten minutes to bring the hand to the other side of the crown, on the 20th minute. During this retrograding period, a disc-type digital display appearing in a magnified window between 5 and 6 o'clock takes over counting the minutes. After the ten-minute retrograde episode, the time indication continues in the customary way.

TOP LEFT
Pierre Kunz, *Seconde Virevoltante Rétrograde*

TOP CENTER
Pierre DeRoche, *GrandCliff TNT Royal Retro*

TOP RIGHT
Chanel, *J12 Rétrograde Mystérieuse*

BELOW
Milus, *Tirion Triretrograde Minute Repeater*

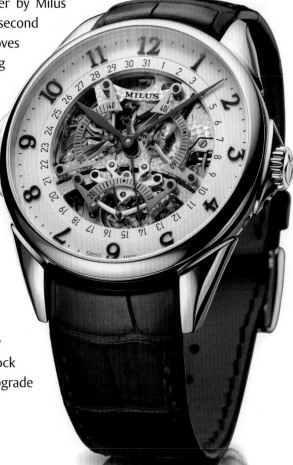

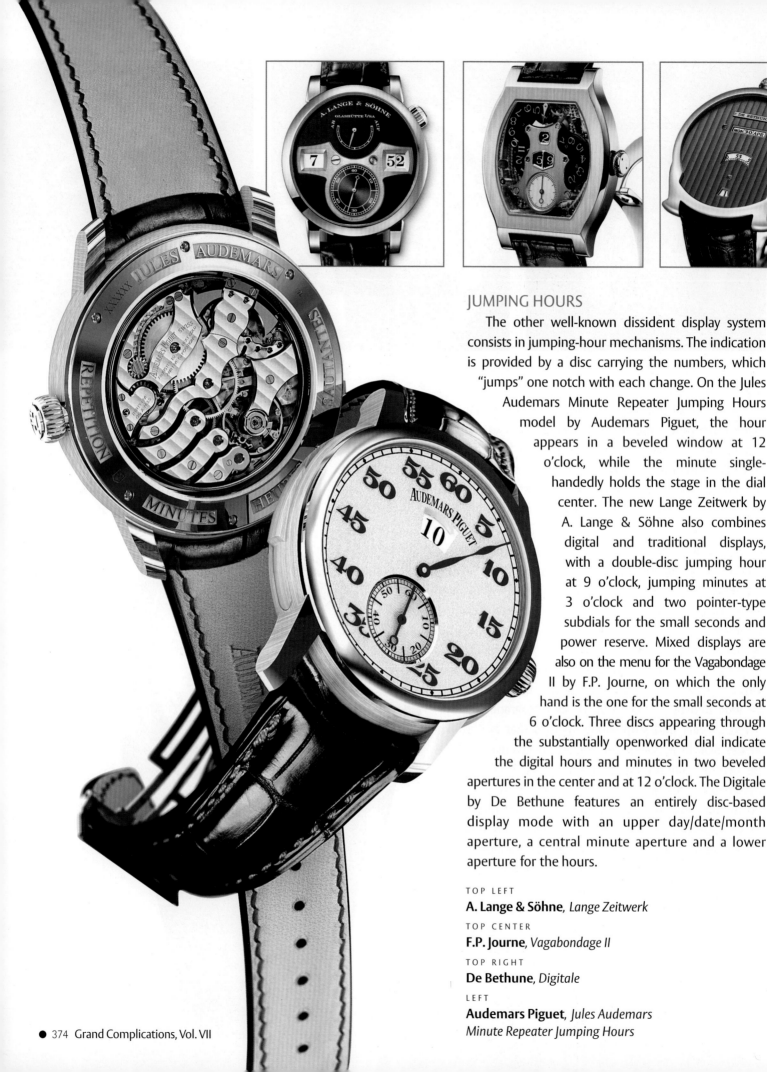

JUMPING HOURS

The other well-known dissident display system consists in jumping-hour mechanisms. The indication is provided by a disc carrying the numbers, which "jumps" one notch with each change. On the Jules Audemars Minute Repeater Jumping Hours model by Audemars Piguet, the hour appears in a beveled window at 12 o'clock, while the minute single-handedly holds the stage in the dial center. The new Lange Zeitwerk by A. Lange & Söhne also combines digital and traditional displays, with a double-disc jumping hour at 9 o'clock, jumping minutes at 3 o'clock and two pointer-type subdials for the small seconds and power reserve. Mixed displays are also on the menu for the Vagabondage II by F.P. Journe, on which the only hand is the one for the small seconds at 6 o'clock. Three discs appearing through the substantially openworked dial indicate the digital hours and minutes in two beveled apertures in the center and at 12 o'clock. The Digitale by De Bethune features an entirely disc-based display mode with an upper day/date/month aperture, a central minute aperture and a lower aperture for the hours.

TOP LEFT
A. Lange & Söhne, *Lange Zeitwerk*

TOP CENTER
F.P. Journe, *Vagabondage II*

TOP RIGHT
De Bethune, *Digitale*

LEFT
Audemars Piguet, *Jules Audemars Minute Repeater Jumping Hours*

A GREAT TEAM

Jumping hours are often associated with retrograde minutes. On its HLq03, the youthful Hautlence brand has devised an innovative jumping hours and retrograde minutes device—based on a connecting-rod system ensuring the transmission of energy—combined with small seconds and a date window. The Horological Machine N° 2 by MB&F associates a resolutely original appearance with a double dial display that draws upon ultra-sophisticated techniques, particularly in terms of the energy supply. The right-hand dial displays jumping hours (with a visible disc) and retrograde concentric minutes (with an arrow pointer running over the arc of a circle), while the left-hand provides retrograde date as well as twin-hemisphere moonphase displays.

RIGHT
Hautlence, *HLq03*
BELOW
MB&F, *Horological Machine N° 2*

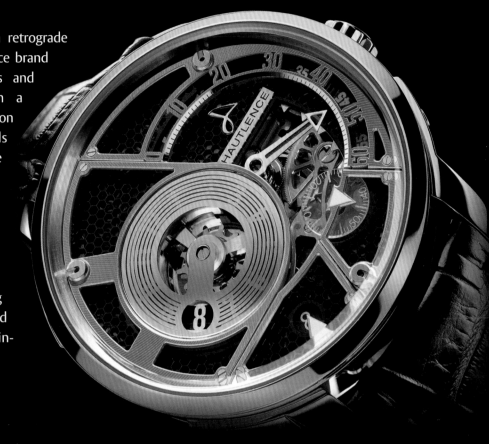

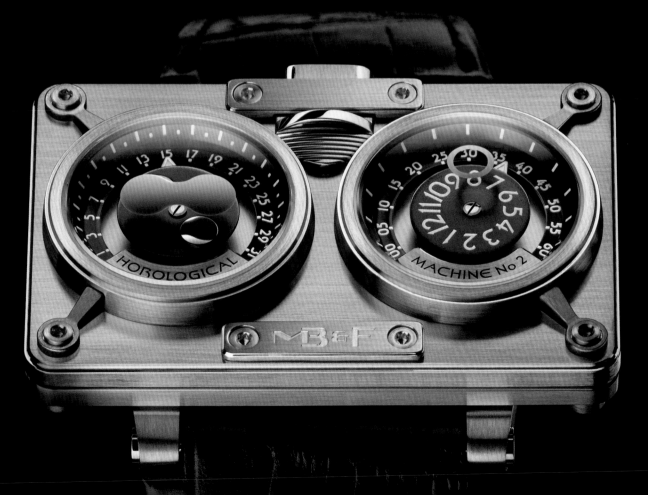

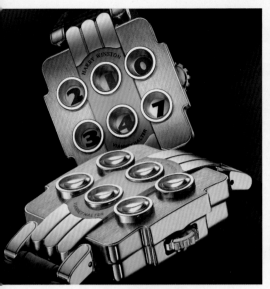

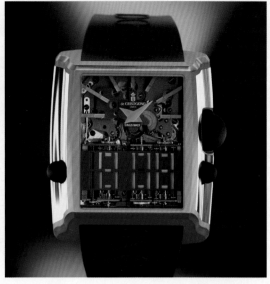

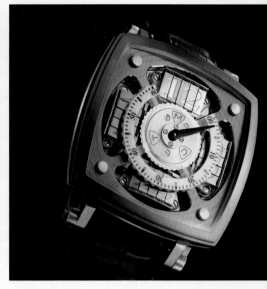

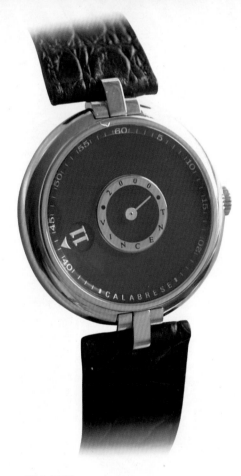

TICKING TO DIGITAL TIME

"Digital" mechanical displays are currently much in favor among watchmakers, who find great scope for their imagination in such models. With his Baladin model, Vincent Calabrese offers an unusual read-off mode by displaying the jumping hour in a small round window that marks off the minutes by rotating around the dial. For the Opus 3 by Harry Winston, Vianney Halter created an all-digital display with jumping hours, minutes, seconds and date appearing in six separate "portholes", and ten independently rotating discs driven by two mechanisms totaling 250 parts. Also for Harry Winston, in the Opus 7, the young Swiss German watchmaker created an "alternating display." A first press on the crown guard turns the disc to bring the correct figure opposite the marker at 10 o'clock, a second press displays the minutes, and a third the power reserve. The Meccanico dG dual time zone watch by de Grisogono combines an analog display of the first time zone with a digital display of the second, with both driven by a completely mechanical movement comprising 651 parts. The digital second time zone indication, which is reminiscent of old airport display panels, is composed of mobile micro-segments driven by a set of 23 cams.

TOP LEFT
Harry Winston, *Opus 3*

TOP CENTER
de Grisogono, *Meccanico dG*

TOP RIGHT
MCT, *Sequential One*

ABOVE
Vincent Calabrese, *Baladin*

RIGHT
Hamilton, *Pulsomatic*

FAR RIGHT
Harry Winston, *Opus 8*

Harry Winston, *Opus 7*

For the Opus 8 by Harry Winston, Frédéric Garinaud devised a digital hours and minutes display system inspired by pin art games. Activating a bolt on the side of the case causes the digits corresponding to the time to "rise up" from the dial, while the minutes are marked off on a vertical scale. Another model providing a great show is the Sequential One by MCT (Manufacture Contemporaine du Temps). The hour appears in turn in one of the four display zones on the dial by means of an original system of triangular prisms closely resembling animated advertising panels. The minutes appear over a 270° arc, but there is no backward jump: at each change of hour, the mobile minute ring makes a one-quarter turn to the left to reveal the following hour (and hide the three others), leaving the minute hand to pursue its continuous circular path. The new Pulsomatic by Hamilton appears at first glance to feature a straightforward electronic liquid crystal display … except that it isn't at all electronic, but in fact equipped with the mechanical automatic-winding Caliber H1970.

THE THIRD DIMENSION

Another innovative approach takes the form of three-dimensional displays. In this particular category, the Tambour Spin Time GMT by Louis Vuitton offers a decidedly original twist. While the minutes are shown by an extremely classic central hand, the hours are a whole different story. Twelve rotating rods are arranged in a star shape, each tipped with a small cube. Every time the minutes move from 59 to 00, one of the cubes pivots to reveal the following hour, while the cube displaying the previous hour also makes a quarter-turn to reveal its neutral face. An additional yellow hand serves to provide a dual time zone display. But the undisputed star of three-dimensional watches has got to be Urwerk, a youthful brand renowned for its futuristic timepieces,

with their "satellite" system. On its UR-201, the time is read off three satellites spinning around a central carrousel. Each satellite rotates once every 12 hours, successively revealing its four sides (1-4-7-10 / 2-5-8-11 / 3-6-9-12). The three satellites carry tiny telescopic hands that extend or retract to follow the minutes scale appearing along the bottom of the dial. On the caseback, a "control board" inspired by racing car gauges enables the owner to check whether his watch is running smoothly thanks to three complementary functions. The same principle governs the UR-103 Mexican Fireleg, the latest addition to the 103 collection, on which four satellites replace the classic hour hand.

TOP CENTER
Louis Vuitton, *Tambour Spin Time GMT*
BELOW
Urwerk, *UR-201*
RIGHT
Urwerk, *UR-103 Mexican Fireleg*

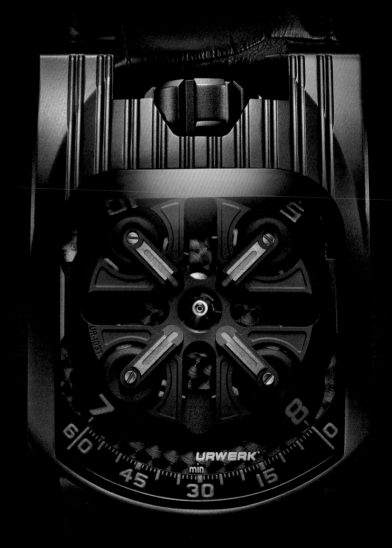

LINEAR DISPLAYS

The latest trend, confirmed by several noteworthy creations introduced in 2010, is that of linear displays, making an even cleaner break (at least visually speaking) with our traditional vision of time as a circle. These straight-line displays are sometimes based on retrograde systems, as on the Vertigo by Pierre Kunz, with an hour hand that rises vertically like the mercury in old-time thermometers, before dropping down again in a flash once it reaches 12 o'clock. But other models use different systems. On his DualTow watch created to celebrate the 20th anniversary of his Manufacture (see the Chronographs chapter), Christophe Claret presents an hour and minute display with notched rubber belts inspired by caterpillar-track vehicles. For Jean Dunand and its Palace model, the same watchmaker created the CLA02CMP flying tourbillon movement. In addition to the hours, minutes, seconds and chronograph functions, this caliber drives a dual time zone display and a power reserve indication appearing in two oval circuits covered by an arrow-style capsule. The Opus 9 by Harry Winston, developed by design engineer Eric Giroud and watchmaker Jean-Marc Wiederrecht, features a linear display of the hours and minutes by means of two small brass chains set with emerald-cut diamonds, along with vivid mandarin garnets serving as hour-markers. As for the Urwerk brand, it introduced its first departure from its satellite concept in 2009 in the shape of the UR-CC1 inspired by the speedometers on certain 1950s cars. This model returned in 2010 in an all-black version. On this UR-CC1 Black Cobra watch, the linear display of the hours and minutes is still based on two cylinders. Upon reaching the far end of its trajectory, the minute cylinder returns to its initial position in one tenth of a second, and this retrograde movement pushes the hour cylinder one unit forward. A disc-based double linear and world-premiere digital seconds display is visible in the upper section of the dial.

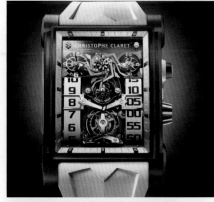

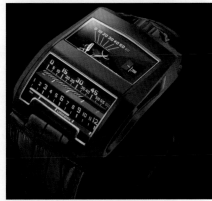

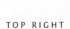

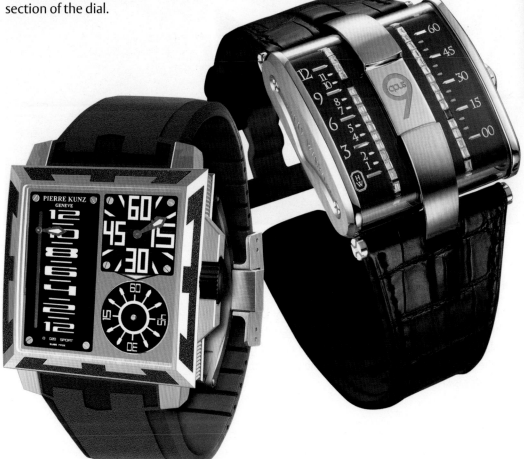

TOP RIGHT
Christophe Claret, *DualTow*
RIGHT CENTER
Jean Dunand, *Palace*
ABOVE
Urwerk, *UR-CC1 Black Cobra*
LEFT
Harry Winston, *Opus 9*
FAR LEFT
Pierre Kunz, *Vertigo*

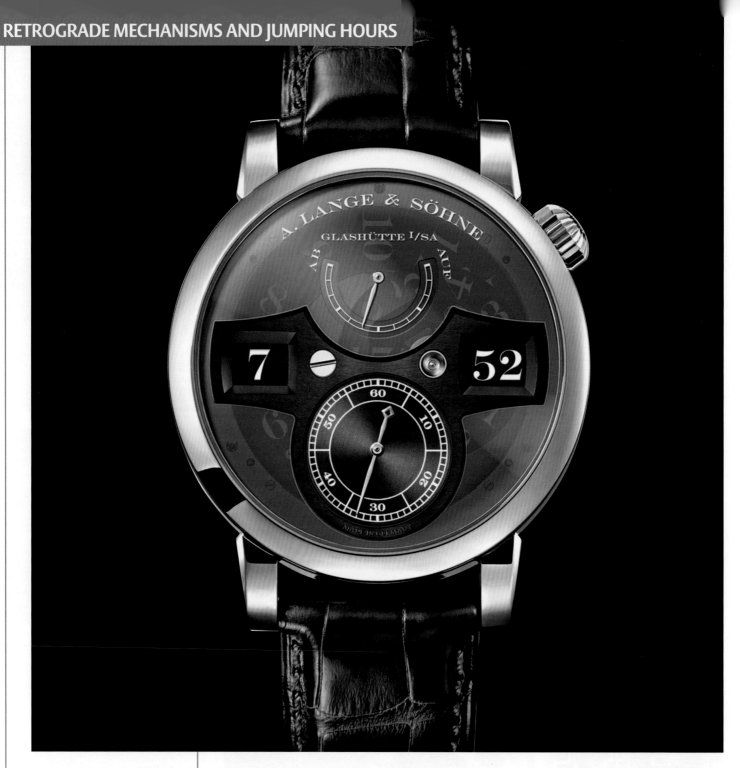

A. LANGE & SÖHNE

LANGE ZEITWERK LUMINOUS – REF. 140.035

The Zeitwerk Luminous is powered by the manual-winding Lange proprietary L043.1 caliber, which contains 388 components and 68 jewels. Decorated and assembled by hand, the movement beats at 18,000 vph and possesses a precision beat-adjustment system with lateral setscrew and whiplash spring. The dark tinted sapphire crystal glass has a special UV-transparent PVD coating that permits light to enter and charge the numerals with enough photonic energy to reliably emit the time for several hours during the night. The case is platinum and the series is limited to 100 pieces.

AUDEMARS PIGUET

JULES AUDEMARS SKELETON MINUTE REPEATER WITH JUMPING HOUR AND SMALL SECONDS
REF. 26356PT.OO.D028CR.01

Housed in a 950 platinum case fitted with a sapphire caseback and an opaline openworked dial with black printed numerals and a skeleton jumping hour disc, this Jules Audemars model marries two great horological specialties: the minute repeater and the jumping hour. This marvel of precision and harmony extends Audemars Piguet's savoir-faire in the realm of complicated watches. With its classically reinvented case and dial, the watch is a fresh addition to the Jules Audemars collection.

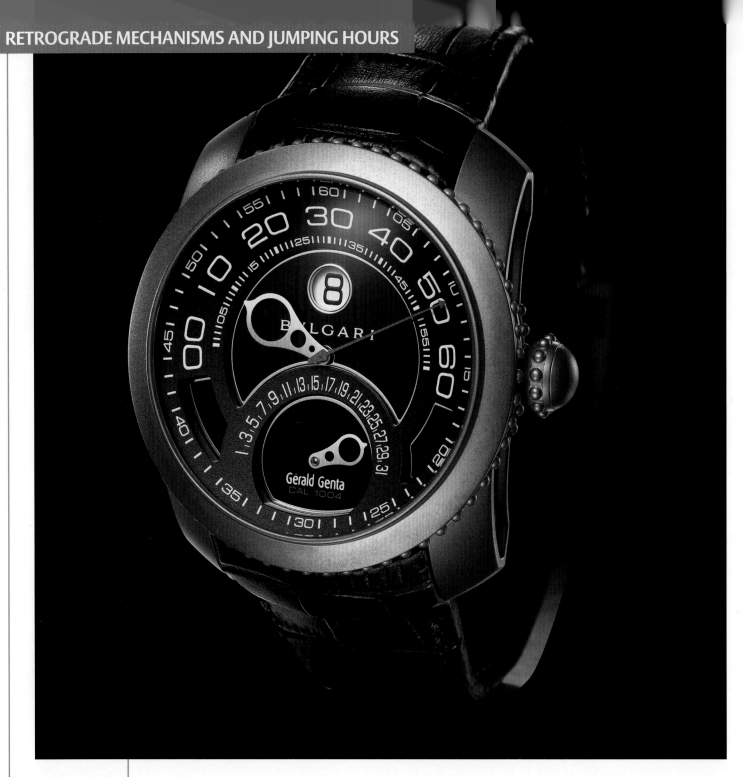

BVLGARI

GEFICA BI-RETRO – REF. BGF47BBLDBR

The Gefica Bi-Retro features retrograde minutes and date displays, as well as a jumping hour positioned at 12:00. The 46mm case is crafted in sand-blasted bronze and satin-finished titanium, providing a sturdy and chic home for the automatic-winding Calibre GG 1004 within, which beats at 28,800 vph and provides a 45-hour power reserve. Its black dial matches the black alligator strap, which bears a three-blade titanium folding buckle.

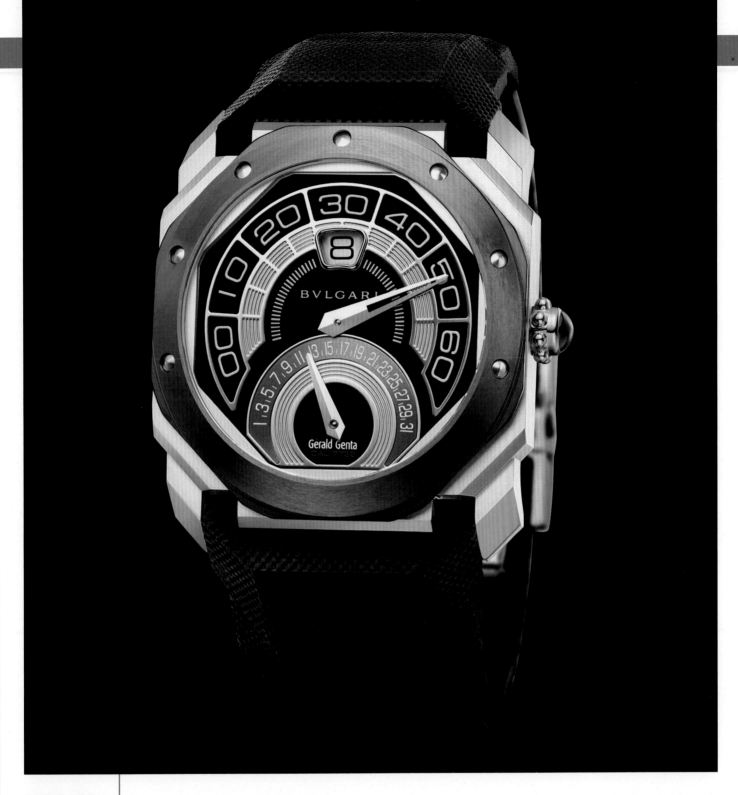

BVLGARI

OCTO BI-RETRO – REF. BGO43BSCVDBR

This decidedly sporty model houses a sophisticated movement powering a jumping date window, as well as retrograde minute and date indications via superimposed hands. The Octo Bi-Retro is driven by in-house made Calibre GG 7722, an automatic-winding movement that beats at 28,800 vph. The jumping hour, visible through a wide aperture at 12:00, is a perfect match for the retrograde minute indication provided by a hand running over a 210° arc featuring a graduated scale divided into 10-minute zones. The date can be read off a 180° segment at the bottom of the dial. The Octo Bi-Retro is housed in a 43mm steel case with a black ceramic bezel and sapphire crystal caseback.

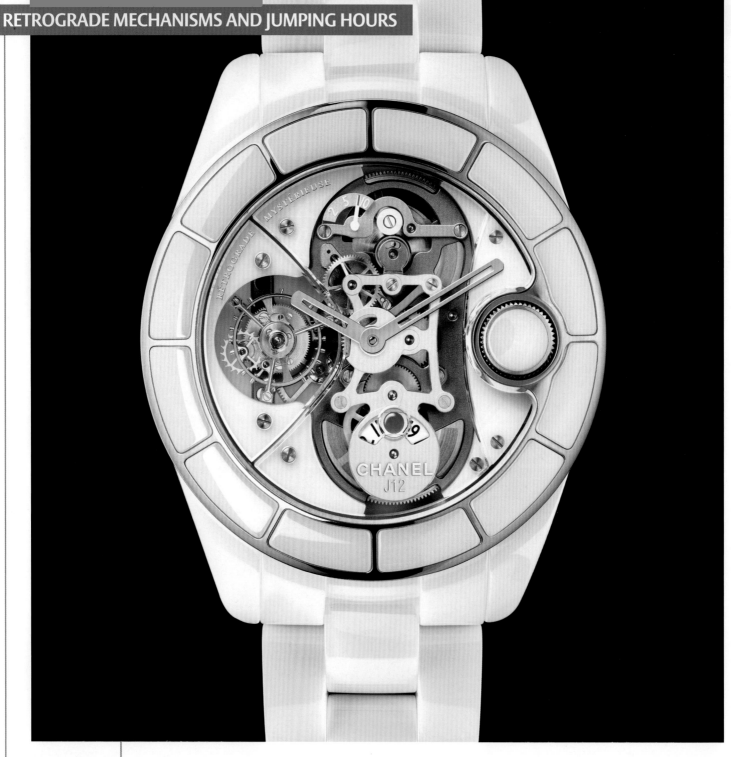

CHANEL

J12 RETROGRADE MYSTERIEUSE – WHITE CERAMIC

When technical prowess compliments the aesthetics
CHANEL RMT-10 Calibre
- R for Retrograde
- M for Mysterious
- T for Tourbillon

After introducing the first tourbillon featuring a highly innovative high-tech ceramic bottom-plate, CHANEL confirmed its status as a pioneer of contemporary watchmaking by creating the J12 Rétrograde Mystérieuse. The Rétrograde Mystérieuse is the embodiment of innovation and includes 5 complications:

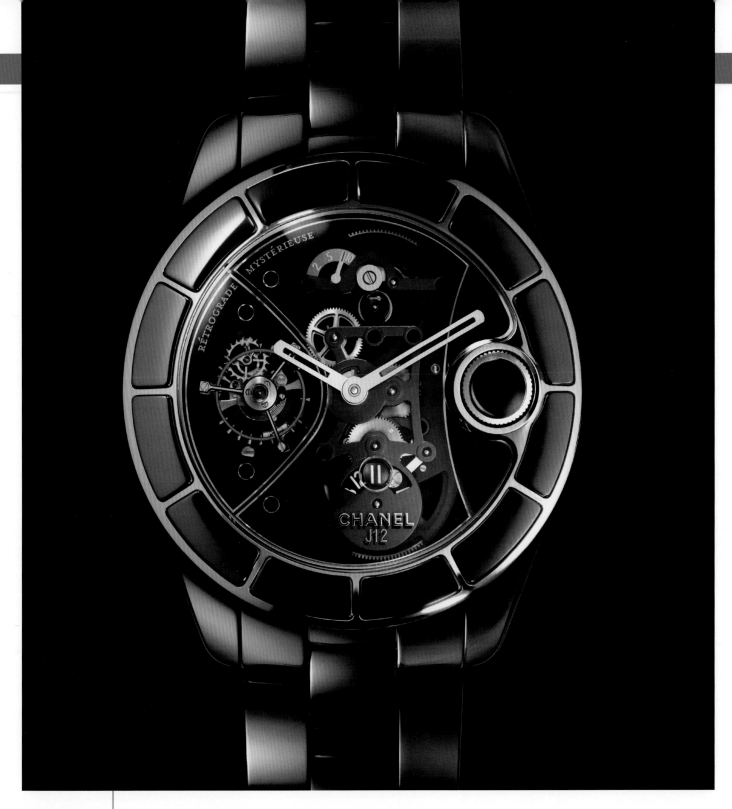

CHANEL

J12 RETROGRADE MYSTERIEUSE – BLACK CERAMIC

1. A tourbillon
2. A retractable vertical crown
3. A retrograde minutes hand
4. A 10-day power reserve
5. A digital minutes display

This perfectly round watch with a 47mm diameter has been designed without a side crown to ensure optimum comfort on the wrist. The work on this complication was entrusted to one of the most "state-of-the-art" watchmaking design/construction workshops: the Giulio Papi team (APRP SA).

Limited and numbered edition of ten pieces in black high-tech ceramic and 18K white gold or ten pieces in black high-tech ceramic and 18K pink gold.

The white ceramic edition is a unique piece.

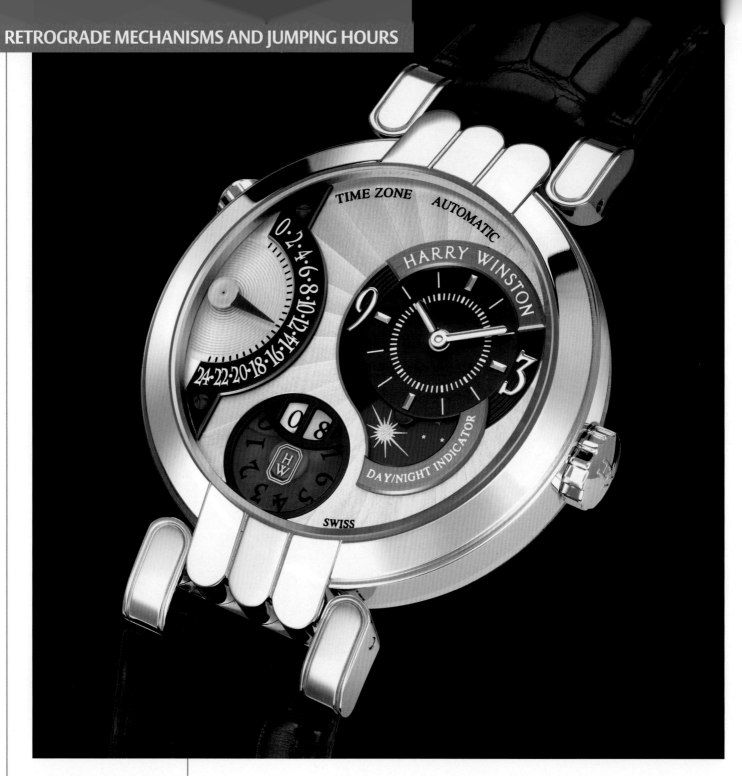

HARRY WINSTON

PREMIER EXCENTER® TIMEZONE – REF. 200/MATZ41WL.W

The Premier Excenter Timezone, powered by an automatic-winding movement with a five-day power reserve, displays a second time zone on a retrograde 24-hour counter. This technological feat is enhanced by a day/night indicator indexed to the first time zone and the display of a magnified date at 6:00. The hours and minutes tick by in an off-center subdial at 2:00. The watch is housed in a 41mm case in 18K white gold that displays the movement through a sapphire crystal caseback.

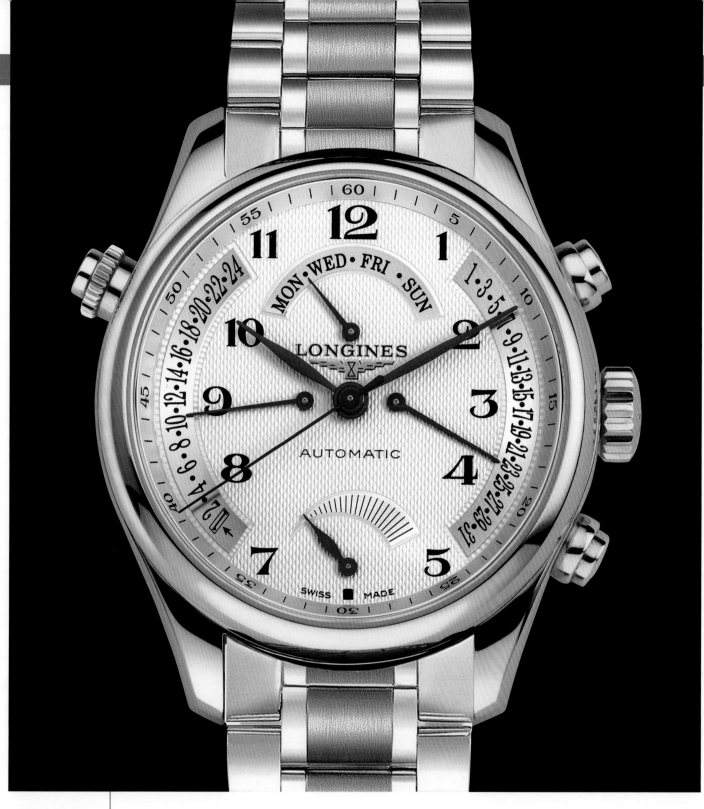

LONGINES

THE LONGINES MASTER COLLECTION RETROGRADE – REF. L2.715.4.78.X

Powered by its L698 caliber, the Longines Master Collection Retrograde offers four retrograde functions: day, date, seconds and second time zone on a 24-hour scale. The stainless steel case is available in both 41mm and 44mm sizes. The timepiece is available on the wearer's choice of stainless steel bracelet with pushpiece-operated triple-folding clasp or genuine alligator strap with triple-safety folding clasp.

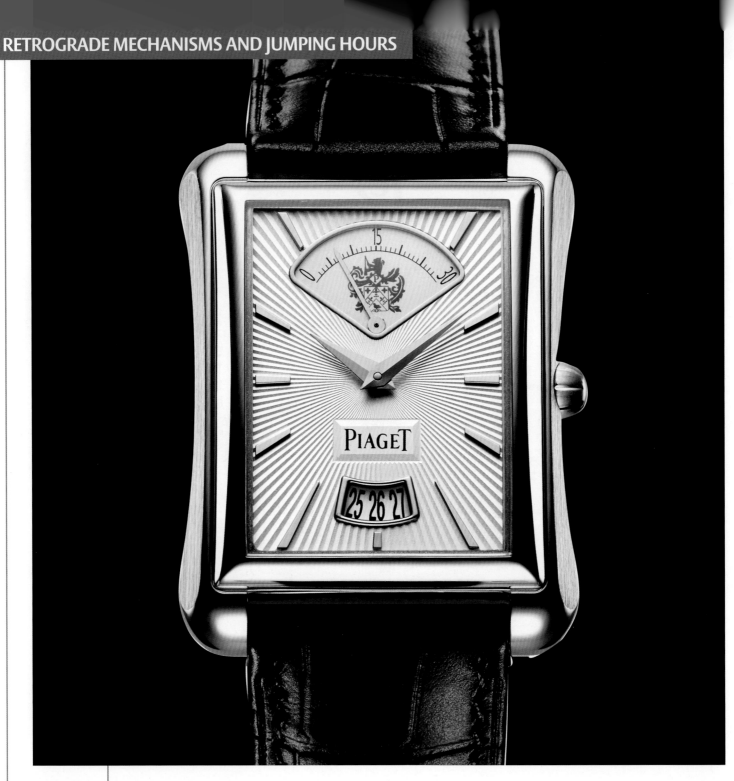

PIAGET

PIAGET EMPERADOR – REF. G0A33072

The large size of this Piaget Emperador model particularly accentuates the design of the rectangular case with its subtle blend of straight lines and curves. The warm shade of the 18K white gold further enhances its aura of harmony and strength. The silver-colored dial provides a highly contemporary reinterpretation of classicism by combining a sunburst guilloché motif with slender baton-shaped applied hour markers and the historical Piaget coat-of-arms in white gold. Beneath this supremely distinguished face lies a self-winding Manufacture-made Calibre 560P with large date display at 6:00 and retrograde seconds at 12:00—the flagship movement within the new Piaget collection of ultra-thin mechanisms.

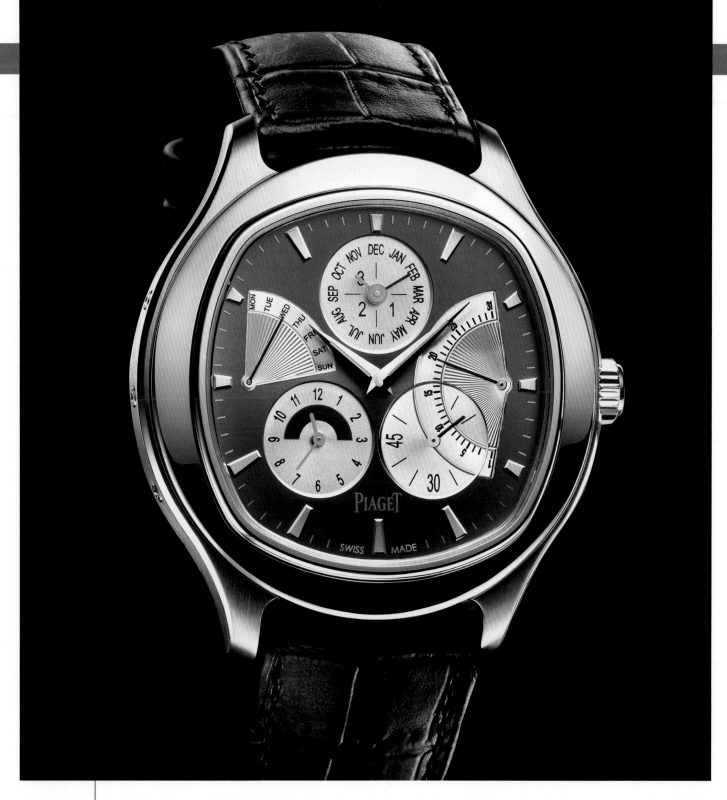

PIAGET

PIAGET EMPERADOR COUSSIN PERPETUAL CALENDAR IN WHITE GOLD – REF. G0A33018

This watch is equipped with a Piaget Calibre 855P self-winding movement, designed, developed and produced entirely in-house. It displays the hours, minutes, small seconds at 4:00 and months and leap years at 12:00, along with retrograde day of the week and date displays at 9:00 and 3:00 respectively. The case middle actually carries a mention of the function of each of the four correctors for the month, date, day of the week and second time zone. Subtly alternating polished and satin-brushed surfaces on the case middle, bezel and inner bezel ring, the case of the Piaget Emperador Coussin Perpetual Calendar is fitted with a sapphire crystal caseback that provides admirable views of the movement finishings.

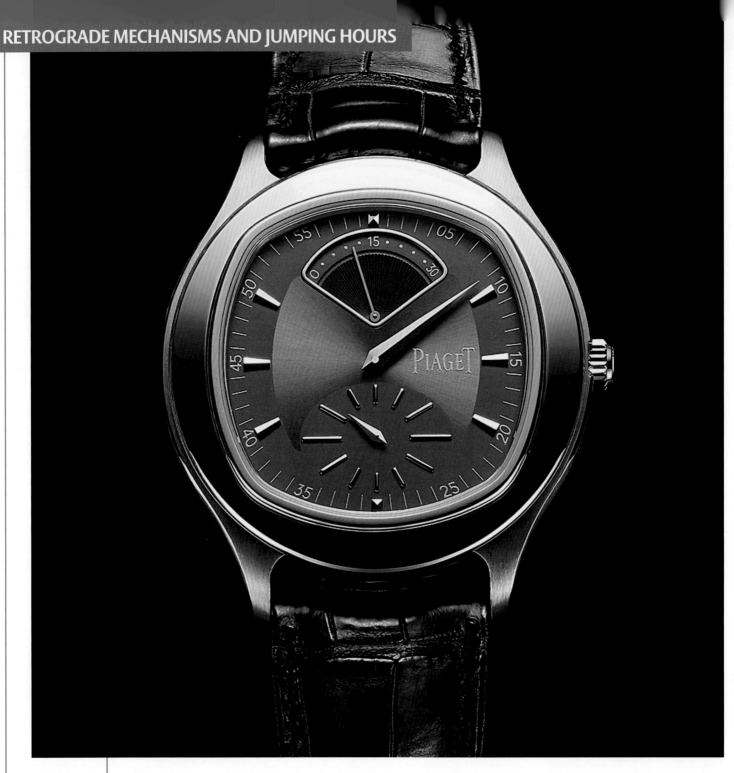

PIAGET

PIAGET EMPERADOR COUSSIN REGULATOR – REF. G0A34024

This Piaget Emperador Coussin Regulator is driven by the Calibre 835P, an ultra-thin mechanical handwound movement measuring 3.92mm thick. This caliber is equipped with a large balance with screws and a large barrel providing a power reserve of around 60 hours. Like all movements by the Manufacture, the Calibre 835P is graced with extremely meticulous finishes. The mainplate is circular-grained and bridges are beveled, while the decorative elements such as circular Côtes de Genève and blued screws are in line with the brand's aesthetic codes. Its case measures 42.5mm in diameter and is fitted with a sapphire crystal caseback. A finely satin-brushed charcoal gray dial is guilloché-worked at 12:00 for the retrograde seconds.

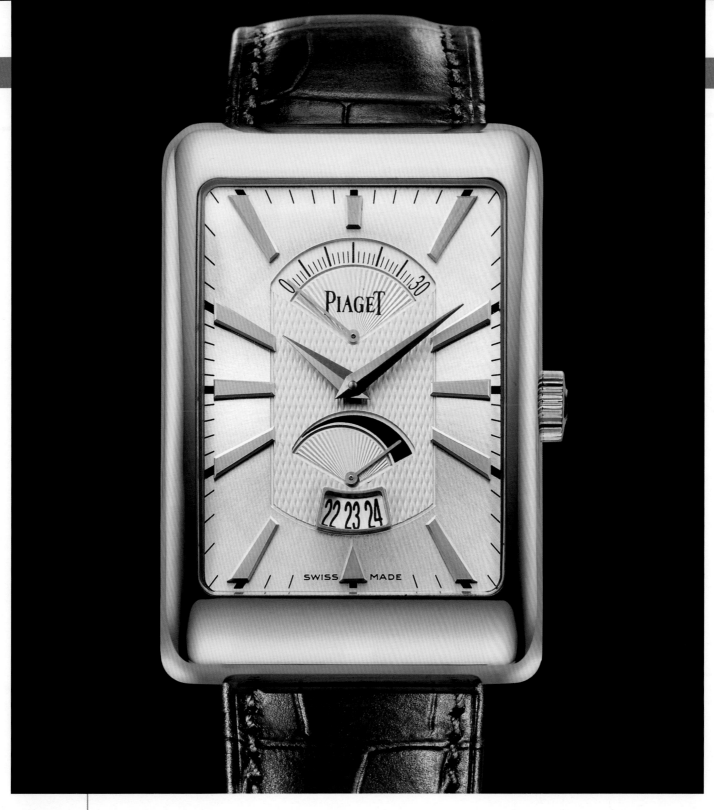

PIAGET

PIAGET RECTANGLE A L'ANCIENNE – REF. G0A33061

This powerful and extremely masculine watch, with its oversized white-gold case housing a 561P movement driving the retrograde seconds and power reserve displays, is intended for men with a taste for distinctive design and fine watchmaking. This model is equipped with an ultra-thin mechanical hand-wound movement endowed with superlative finishing including circular Côtes de Genève, a circular-grained mainplate, beveled and hand-drawn bridges, as well as blued screws. Piaget thereby confirms its longstanding tradition and undeniable know-how in the field of exceptional Haute Horlogerie.

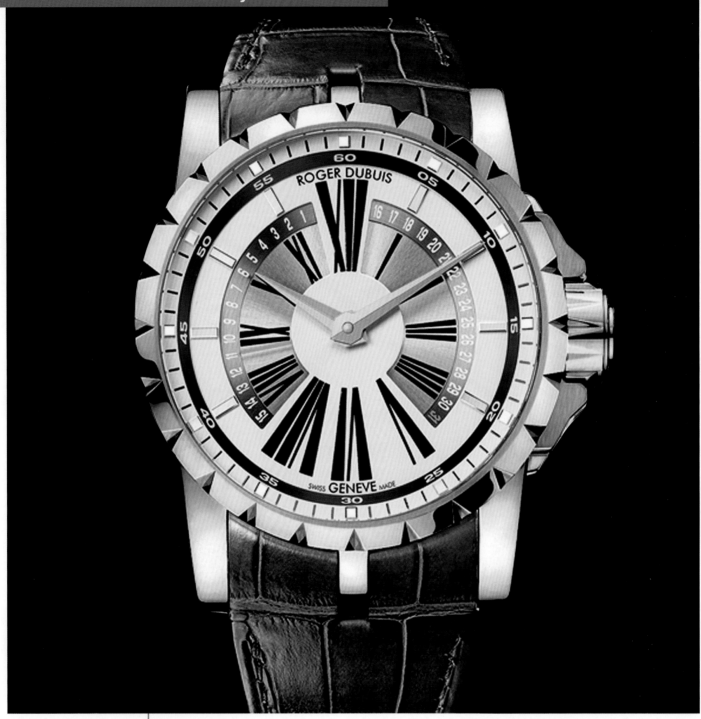

ROGER DUBUIS

EXCALIBUR BI-RETROGRADE JUMPING DATE – REF. EX45-14B-20-00/01R00/B

This bi-retrograde timepiece offers automatic winding and a 48-hour power reserve. Finely adjusted to five positions, this Excalibur is powered by the RD 14B movement and housed in a 45mm white-gold case. The bi-retrograde jumping date is situated at the center, and the date corrector is at 2:00. The fully adjustable, hand-stitched alligator strap is outfitted with a white-gold adjustable buckle. The Excalibur Bi-Retrograde Jumping Date is part of a limited edition of 88 pieces.

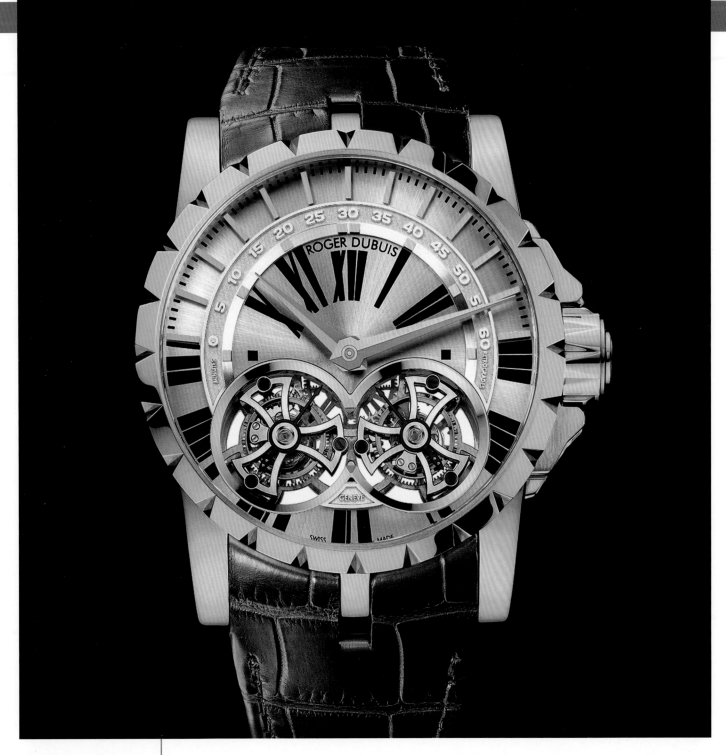

ROGER DUBUIS

EXCALIBUR DOUBLE TOURBILLON WITH JUMPING HOURS AND RETROGRADE MINUTES
REF. EX45-015-00-00/RR00/B

Powered by its RD 01 caliber, this double flying tourbillon with differential gear luxuriates within a 45mm rose-gold case. The Excalibur Double Tourbillon offers a 360° jumping-hour display, retrograde dragging minutes between 9:00 and 3:00 (180°), and a power reserve indicator on the caseback. Finely adjusted to six positions, this timepiece also features a 48-hour power reserve. The tourbillon carriages are shaped like a Celtic cross and the fully adjustable, hand-stitched strap is crafted from genuine alligator skin. The Excalibur Double Tourbillon with Jumping Hours and Retrograde Minutes is part of a limited edition of 28 pieces.

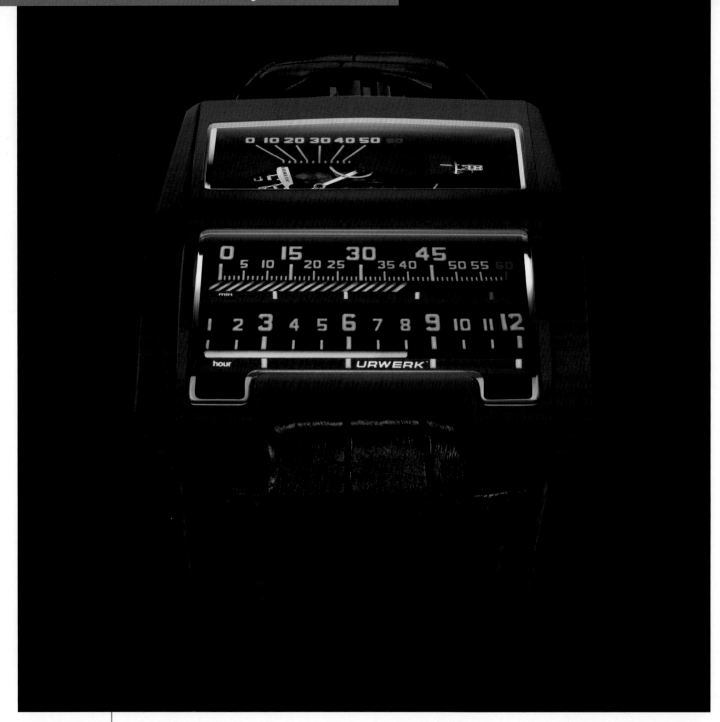

URWERK

UR-CC1

The UR-CC1, also known as "the Black Cobra," does away with time-telling convention altogether, using exclusively linear displays for jumping hours and retrograde minutes. The model's white-gold case, 53.9x42.6x15.4mm, is treated with aluminum titanium nitride to create a sleek black look. A sapphire crystal embedded in the case provides a view of the bronze beryllium cam, whose constant rotation powers a toothed lever that rotates the retrograde minutes cylinder. When the minutes go back to zero, the change also advances the jumping hours. The digital seconds display on the right shows even numbers from 2 to 60, alongside a spiral that moves as the seconds wheel spins to indicate the seconds in a linear display as well.

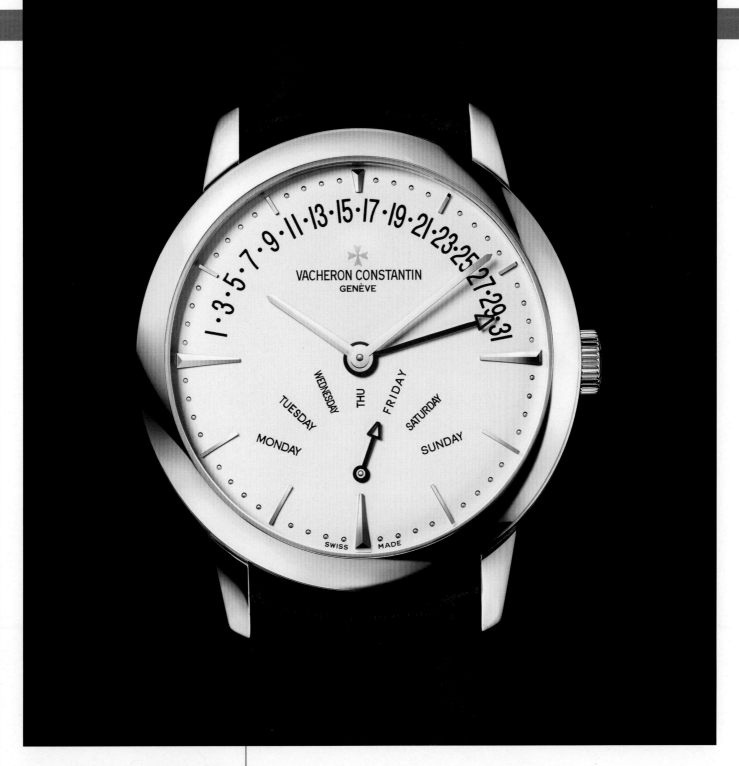

VACHERON CONSTANTIN

PATRIMONY CONTEMPORAINE RETROGRADE – REF. 86020

Powered by the mechanical automatic-winding Vacheron Constantin Caliber 2460 R31 R7, this Patrimony Bi-Retrograde is hallmarked with the Geneva Seal. Beating at 28,800 vph and offering 43 hours of power reserve, the 27-jeweled movement is equipped with a guilloché rotor. Retrograde day is provided at 6:00 and retrograde date is shown at 12:00. The three-piece case is polished and water resistant to 3atm. The sapphire caseback reveals the exquisite movement.

Equations
of Time

Human time is not the same as that of nature! The latter is intrinsically variable and seems to delight in slowing down or accelerating the pace of successive days. The inclined position of the Earth's axis and its elliptical path around the sun lead to irregular diurnal and nocturnal periods that vary according to the time of year. Nonetheless, society has come to need fixed temporal points of reference, which is why we initiated the convention of mean time. The discrepancy between solar (or "natural" time) and civil, standard (or "artificial") time varies over the months and is known as the equation of time. The year 2009, which was designated as the Year of Astronomy by the United Nations Assembly, appears to have sparked the renewal of astronomical horological functions, including the launch of new wristwatches with so-called "running" equations of time. They serve as eloquent reminders that time can never be truly disconnected from the movement of the stars.

ELLIPTICAL THEORY

If the Earth's axis were perfectly perpendicular to its orbit, and if its path around the sun were totally circular, there would be no such thing as the equation of time. But because nature is irregular, mathematics was invented to remedy the resulting issues. The Earth in fact describes an ellipse in turning around the sun, and its axis is inclined in relation to its orbit. This means that the lapse of time between two passages of the sun through its highest point in the sky (noon) is not the same length year-round. It actually lasts 24 hours only four times a year: on April 15th, June 14th, September 1st and December 24th. Otherwise, it is sometimes longer and sometimes shorter, following an immutable curve. This difference ranges from 16 minutes and 23 seconds, on November 4th, to 12 minutes and 22 seconds, on February 11th. It is real or true time, as shown on sundials, that corresponds to the rhythms of nature. Mean solar time (also called civil time), as displayed on our watches, is a convention based on the average of all days in a year. The variable gap between solar time and civil time is what astronomers have called the "equation of time."

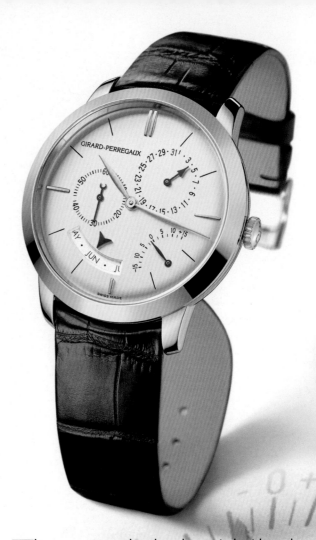

The greatest watchmakers have vied with each other in developing ingenious systems serving to reproduce the variations of the equation of time—an indispensable feature of all ultra-complicated astronomical watches. Since the variable lengths of true solar days are identically repeated on the same days, they can be "programmed" by means of a so-called "equation" cam that performs one full rotation per year. Its profile resembles that of an "analemma," representing the figure traced in the sky by the sun's various positions as recorded each day at the same time and from the same place throughout the calendar year. The extreme precision of this shape, resembling that of a figure 8, determines the accuracy of the equation of time.

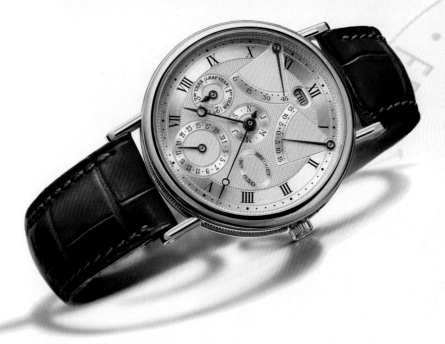

TOP
Girard-Perregaux, 1966 *Calendrier annuel et équation du temps*

LEFT
Breguet, *Equation du temps*

NEVER-ENDING STORY

The equation of time display may be presented in various ways. Most watches are equipped with a subdial or auxiliary segment swept over by a hand running from -16 to + 14 minutes (sometimes from -15 to +15); to know true time, the user must then do a mental addition or subtraction of this difference in relation to mean time. Such is the case for example on the Breguet Equation du temps model with perpetual calendar, and on the new 1966 Calendrier annuel et équation du temps by Girard-Perregaux, presented in spring 2009, available this year in white gold and also equipped with an annual calendar requiring only one correction per year (see Calendars chapter). On this dial, an extremely original configuration features the date in a small subdial at 1:30, the equation of time on the arc of a circle at 4:30, the month in a panoramic window at 7 o'clock and the small seconds at 9 o'clock. The new in-house automatic-winding movement that drives this watch is equipped with a variable-inertia balance that enhances the precision and the stability of the rating. Clearly greatly inspired by the equation of time, Girard-Perregaux also offers this complication on a sophisticated version of its rectangular 1945 Vintage model, in this case combined with a perpetual calendar; the equation of time segment-type display appears in the corner of the dial at 10:30, just next to the astronomical moonphase (see Moonphase chapter). Meanwhile, the Vacheron Constantin Patrimony Traditionnelle Calibre 2253 Collection Excellence Platine is endowed with a tourbillon movement powering indications of the perpetual calendar and times of sunrise and sunset, as well as the equation of time on the arc of a circle at 10:30.

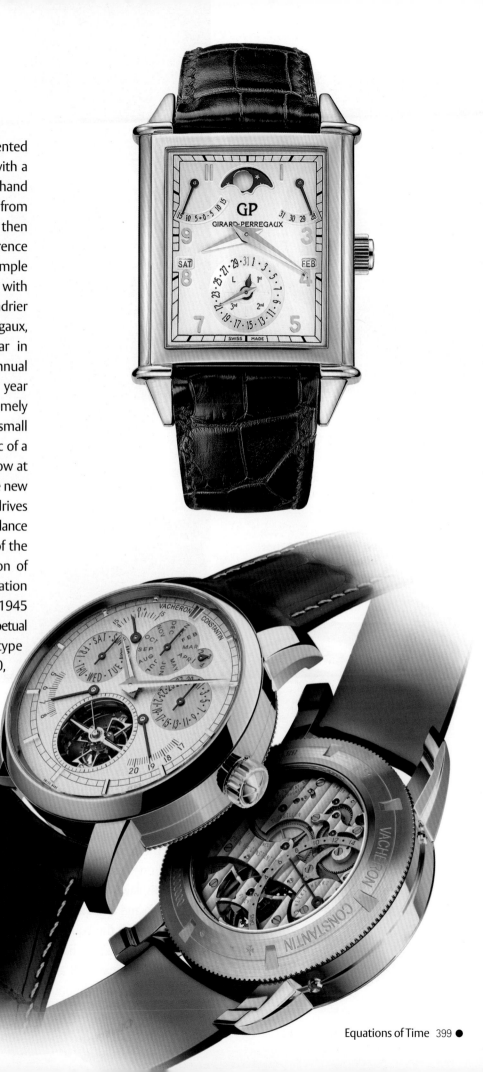

TOP
Girard-Perregaux, *1945 Vintage*

RIGHT
Vacheron Constantin , *Patrimony Traditionnelle Calibre 2253 Collection Excellence Platine*

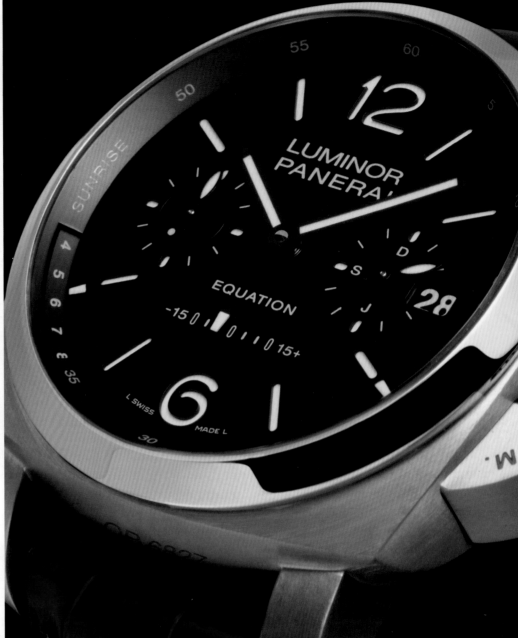

ABOVE
Chopard, *L.U.C 150 "all in one"*

RIGHT
Panerai, *Luminor 1950 Equation of time Tourbillon Titanio 50 mm L'Astronomo*

BELOW
Jaquet Droz, *Equation du temps*

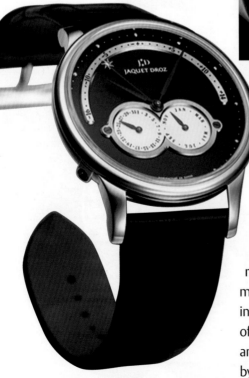

While most watches adopt this kind of display on the dial, certain brands prefer to do things differently, such as Panerai with its Luminor 1950 Equation of time Tourbillon Titanio 50 mm L'Astronomo. This model, the most sophisticated ever developed by Panerai, provides a linear display of the equation of time at 6 o'clock. The caseback bears a depiction of the night sky as seen from a city chosen by the client. The same city also serves as a reference for the sunrise and sunset indication. Chopard also uses the back of the L.U.C 150 "all in one" as a second dial: it features a guilloché gold plate bearing the power reserve display, 24-hour night and day indication, sunrise and sunset times, an orbital moonphase and an equation of time—all set to correspond to what may be observed in Geneva. As for the Equation du temps by Jaquet Droz, it actually gives the equation of time a starring role to thanks to a large hand tipped with a sun and running over a 180° arc stretching between 9 and 3 o'clock. This unusual arrangement is complemented by twin date and month subdials in the lower half of the dial.

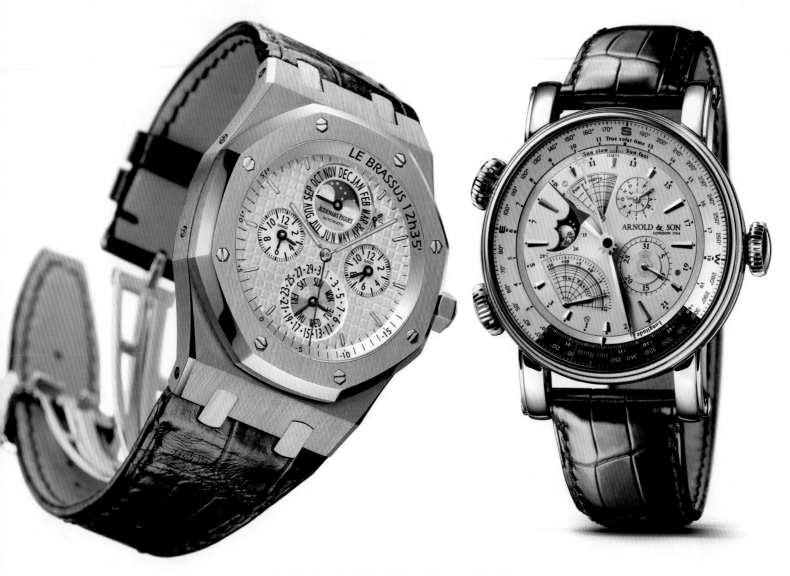

TAKING LONGITUDE INTO ACCOUNT

Audemars Piguet also chose to indicate the equation of time with a large central hand in offering this complication for the very first time on a Royal Oak watch: a blued steel equation of time hand sweeps over a scale graduated from -15 to +15 and engraved on the inner bezel ring. The name of the city chosen by the customer as a point of reference is engraved on the other side of the inner bezel ring, along with the time when the sun reaches its highest point in that location. In 2005, Audemars Piguet was the first brand to have developed an equation of time indication system adjusted to the exact degree of longitude, and no longer merely to the entire time zone—thereby ensuring a far more accurate and realistic display. The zero of the equation of time graduation is thus positioned exactly at the average time when the sun reaches its culminating point in the chosen place. When the hour hand corresponds to the hour indicated on the inner bezel ring, the owner of the watch knows that the sun is exactly at its

zenith. This Royal Oak Equation of time is also one of the rare wristwatches to display sunrise and sunset times while taking into account three parameters: date, longitude and latitude. The Arnold & Son watch brand, the spiritual heir to the famous British horologer John Arnold, drew inspiration from his work to create an equation of time watch that also takes account of longitude, thanks to a dial featuring two mobile rings. This True North Perpetual features another unprecedented characteristic: when the 24-hour solar hand indicates the true solar noon, the wearer need only point it towards the sun for the mobile outer dial to indicate true geographical North.

TOP LEFT
Audemars Piguet , *Royal Oak Equation of time*
TOP RIGHT
Arnold & Son, *True North Perpetual*

RUNNING EQUATION OF TIME MODELS

Distinctly more user-friendly yet far more complex in terms of their construction, "running" equation of time watches have two hands fitted coaxially with the minute hand, respectively indicating mean time and true time. They require no mental arithmetic, since true time is continuously displayed directly on the dial. This system, which had long been regarded as the exclusive preserve of pocket-watches, first appeared on wristwatches in 2004 and represents a genuine feat in terms of miniaturization. The Gyrotourbillon 1 by Jaeger-LeCoultre, which caused a sensation mainly because of its spherical tourbillon (see Tourbillon chapter), also features an offset hour/minute subdial bearing a running equation of time displayed by an additional minute hand adorned with a tiny golden sun. The Equation marchante "Le Brassus" by Blancpain is also distinguished by its double equation of time display: the running equation of time itself appears in the center with an additional central minute hand tipped with a golden sun; and a subdial at 2 o'clock boasts a retrograde hand indicating the number of minutes of difference. This sophisticated device is combined with an ultra-thin perpetual calendar. Blancpain has also associated a running equation of time display and a perpetual calendar in a model from the Villeret collection named "Equation marchante pure," but without any additional segment-type display.

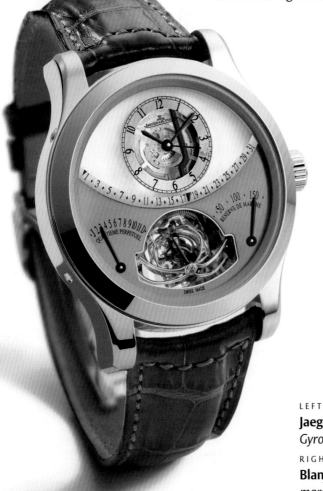

LEFT
Jaeger-LeCoultre,
Gyrotourbillon 1

RIGHT
Blancpain, *Equation marchante "Le Brassus"*

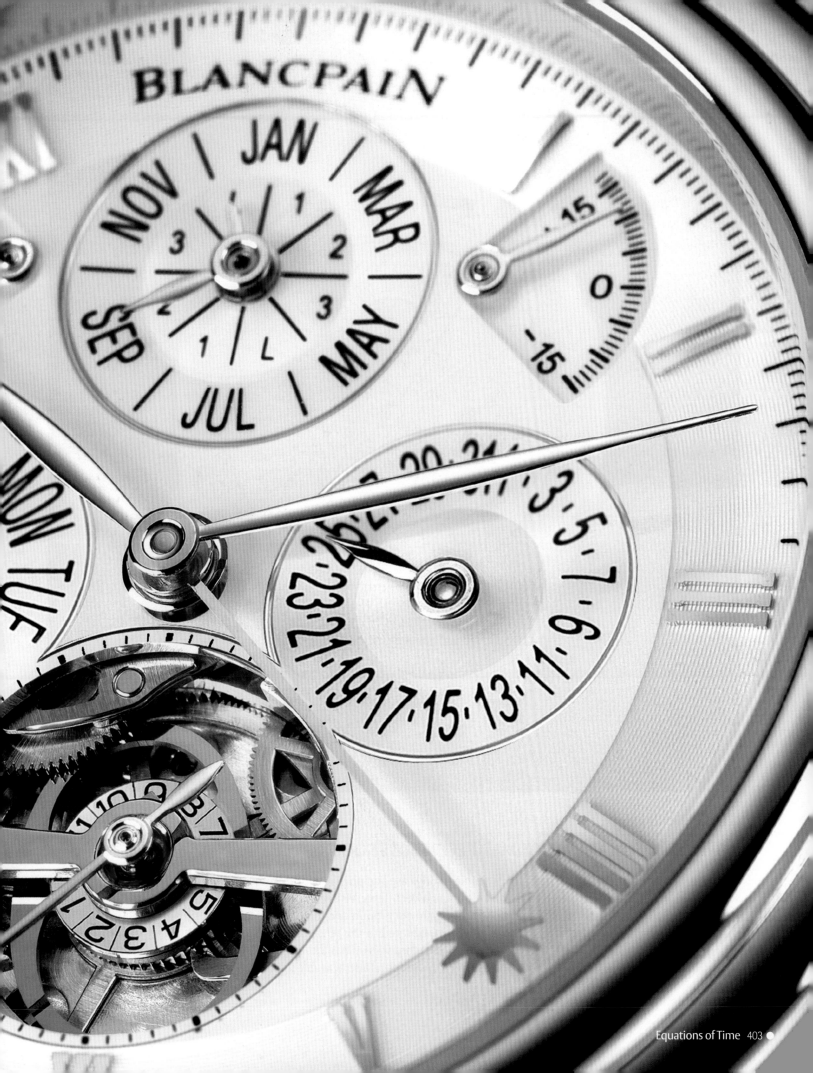

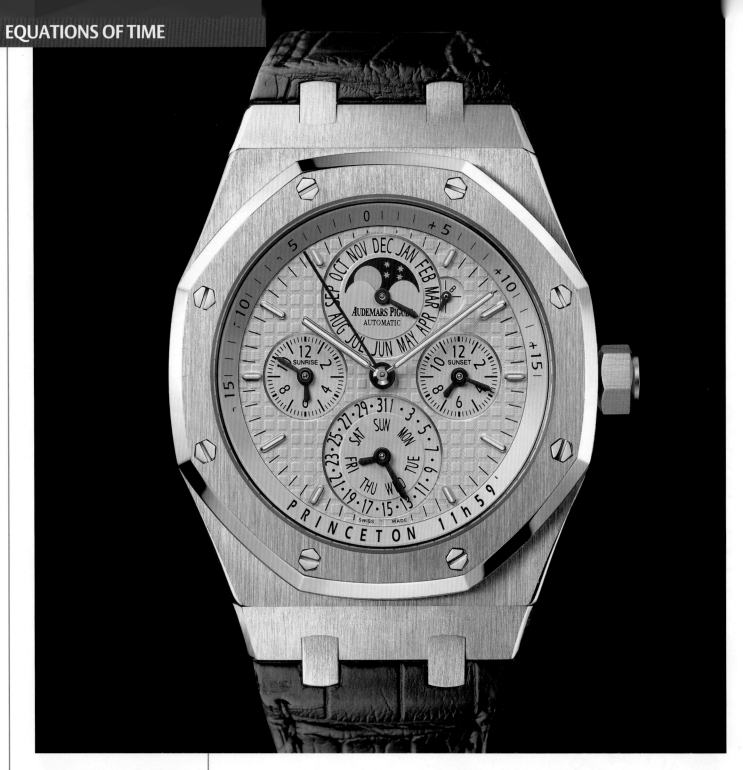

AUDEMARS PIGUET

ROYAL OAK EQUATION OF TIME – REF. 26603ST.OO.D092CR.02

The Royal Oak Equation of Time is housed in a stainless steel case and powered by an automatic-winding 2120/2808 movement, which beats at 19,800 vph and is endowed with a 42-hour power reserve. Visible through the sapphire crystal caseback, the 41-jewel movement depicts conventional time and real solar time and offers hours and minutes, sunrise and sunset times, equation of time, perpetual calendar and moonphase. The solar zenith is calibrated to the reference city chosen by the owner. The openworked oscillating weight may be personalized on request (the standard version has the "AP" logo). Mounted on a large scale hand-sewn crocodile leather with AP folding clasp in stainless steel, this model is also available in 18K pink gold.

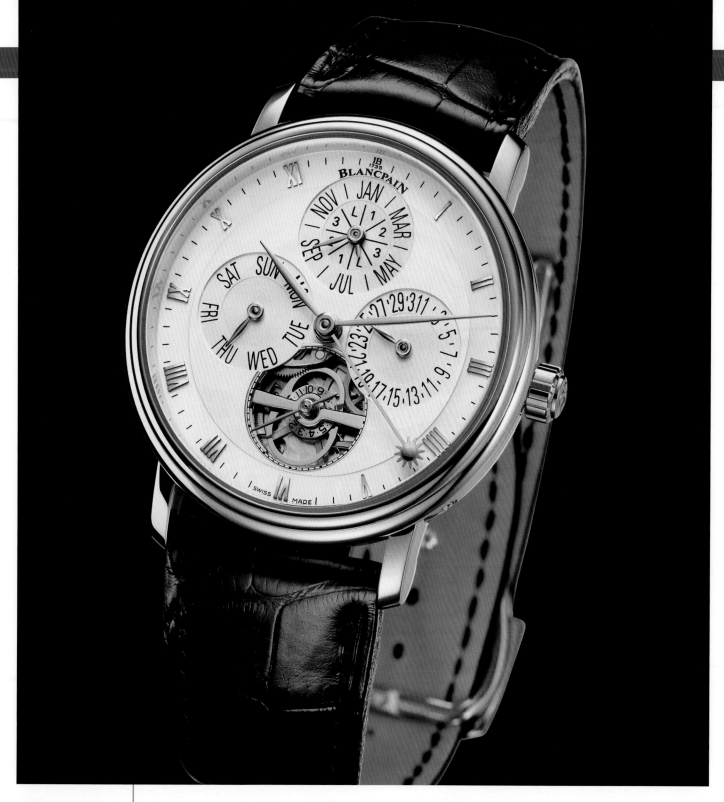

BLANCPAIN

VILLERET EQUATION MARCHANTE PURE – REF. 6038-3442-55B

The Equation Marchante Pure, based on the Le Brassus model that was the first wristwatch capable of displaying the separate solar and civil times by two minute hands, was launched in 2005 as part of the Villeret collection characterized by its pure lines and formal beauty. This limited edition of 50 pieces is crafted in platinum and houses the 364-part caliber 3863A, equipped with 72 hours of power reserve.

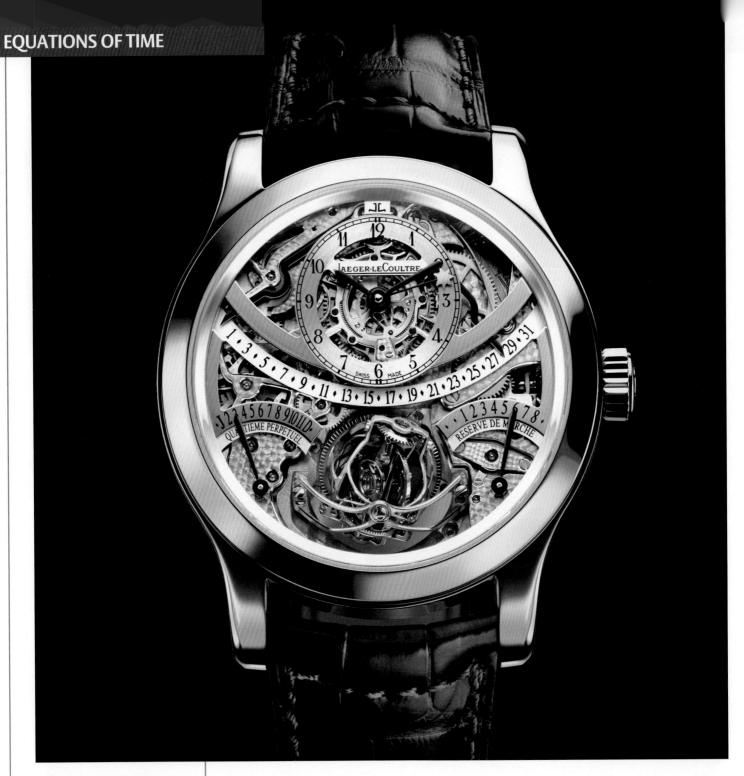

JAEGER-LeCOULTRE

HYBRIS MECHANICA GYROTOURBILLON 1 – REF. 232.34.25

In Jaeger-LeCoultre's 177 caliber, which powers the Hybris Mechanica Gyrotourbillon 1, the three-dimensional rotations of the balance-wheel are at the very heart of an extraordinary horological invention. The ultra-light outer carriage makes a complete turn about its axis every sixty seconds. The inner carriage rotates far more rapidly, completing 2.5 turns per minute. Beside the remarkable three-dimensional tourbillon, this timepiece also displays hours, minutes, perpetual date and month with retrograde displays. Far from being satisfied with these accomplishments, the master watchmakers also decided to add an equation of time, one of the most challenging of complications. For an extra challenge, the display is of a "running" equation of time, displaying civil time with thicker blue hands and true solar time with a thinner, star-tipped dial.

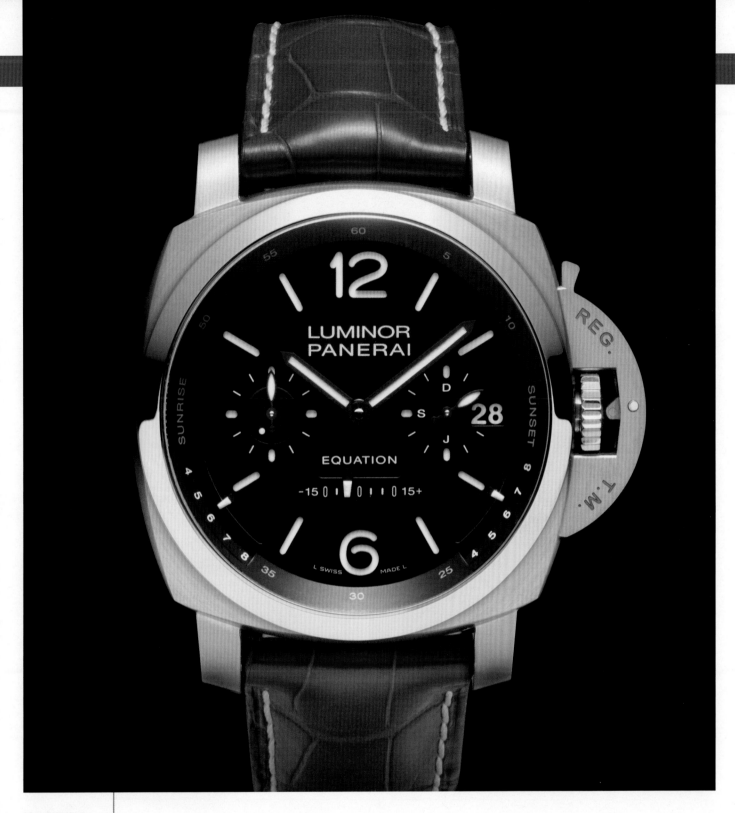

PANERAI

LUMINOR 1950 EQUATION OF TIME TOURBILLON TITANIO, 50MM – REF. PAM00365

Continuously introducing innovations that surpass all expectations—especially for a relatively new movement manufacturer—Officine Panerai's approach to the most complicated of all grand complications, the equation of time, has set a new industry standard. The Luminor 1950 Equation of Time Tourbillon Titanio, also called L'Astronomo, is the ultimate tribute to the genius of Galileo Galilei and showcases some of the rarest, most exclusive and fascinating specialties in watch-making. Completely customized for the owner, L'Astronomo showcases a tourbillon with equation of time functionality, sunrise/sunset times for the city chosen by the wearer, and depiction of the star map of the night sky for that locality on the back plate. All of these functions are powered by the hand-wound, 375-component Panerai P.2005/G caliber, which also features a 4-day power reserve and Panerai tourbillon regulator, and housed inside a 50mm titanium case that is water resistant to 10 bar (100m), thanks to its patented crown-protecting device. Produced in just 30 examples, it is the most technically sophisticated timepiece ever produced by Officine Panerai.

Minute Repeaters and Sonneries

The audible indication of the time is undoubtedly the most ancient of the horological complications. In an age when the darkness of the night was lit only by candles, some of the most talented watchmakers set about making timepieces talk. The first to be introduced were striking pocket-watches, which initially chimed the hours "in passing"—like church bells—and then progressively came to strike the hours, quarter-hours and minutes on demand, simply by pressing a dedicated button. Today, many connoisseurs consider these mechanisms to be the most sophisticated complication, since it takes extreme technical and musical skills to guarantee the optimal functioning and sound. In recent years, a handful of manufacturers have ventured to create such mechanical masterpieces, vying with each other in devoting extensive research and ingenuity to giving this complication a whole new lease on life.

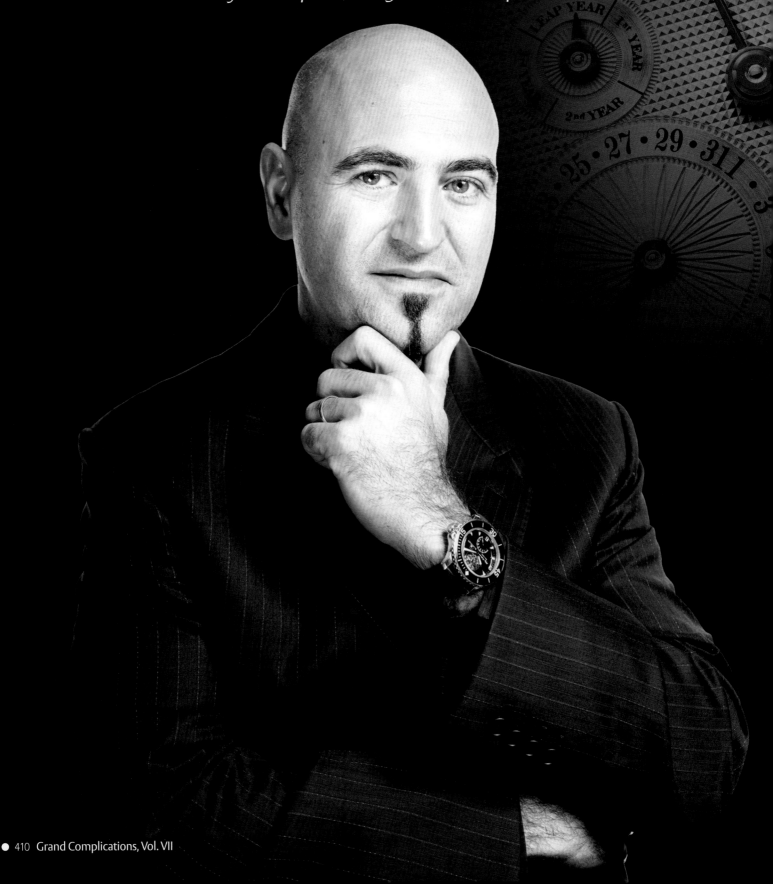

Marc A. Hayek

Member of the Executive Group Management Board of Swatch Group, CEO of Blancpain, Breguet and Jaquet Droz

"The watch industry is experiencing some fascinating times"

Marc Alexandre Hayek is the new strongman of the Swatch Group high-end sector. The death of his grandfather Nicolas G. Hayek last year led to a reshuffle within the group. Alongside his mother Nayla, appointed Chairwoman of the Board of Directors, and his uncle Nick, President of the Executive Group Management Board, Marc Hayek now wears a number of hats. After the passing of his grandfather in the summer of 2010, he was appointed CEO of Breguet and of Jaquet Droz, in addition to his role as CEO of Blancpain, a position he has held since 2002. He also became a member of the Board of Directors of Tiffany & Co and continues to sit on that of Glashütte Original—all of which clearly confirms his position as the leading figure in the group's high-end segment. These new responsibilities have not surprised observers, as Nicolas G. Hayek had clearly designated his grandson as his heir in this segment and had groomed him for the task. Marc Hayek explains the reality of the brands he is currently heading and of the future he has in store for them.

Since succeeding your grandfather as CEO of Breguet, you have had an opportunity to discover the brand from within: what do you think of it?

Breguet is certainly a fascinating brand. While it definitely has an undisputed historical dimension, it has nonetheless managed to remain in the vanguard of progress. This is exceptional and is notably due to the vision of my grandfather Nicolas G. Hayek, who gave of his very best in order to restore this brand to the place it deserves, at the very pinnacle of the watchmaking art.

Was there one element that particularly touched you?

To be quite honest, what most surprised me was the brand's strength in the area of research and development. My grandfather was a visionary and he succeeded in endowing Breguet with this dimension. Research on new materials in particular has enabled Breguet to move up several levels, and the silicon escapement is a fine example of this approach. But many other developments are in the pipeline and will be presented over the coming years, all of which began under the aegis of Nicolas G. Hayek.

Should we expect any significant innovations?

The entire watch industry is experiencing some fascinating times, with numerous innovations that are transforming the watch, its construction and its reliability in fairly fundamental ways. Taboos are being lifted and this period is definitely interesting and will mark a turning point for watchmaking. And what really pleases me is that Breguet is on the cutting edge in this domain and that the brand is successfully rounding the corner and beginning to write the future of fine watchmaking.

Based on Breguet's new 777 movement, the Réveil Musical incorporates a silicon escapement and a Breguet balance-spring.

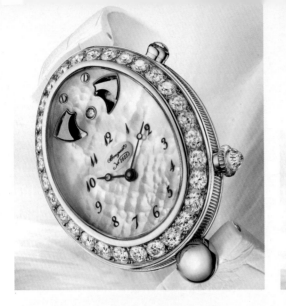

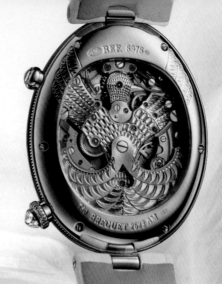

Breguet is a competitor of Blancpain, which you have been leading since 2002: how will the competition between the two brands develop in the future?

It is notably thanks to the spirit of rivalry that has always existed between Breguet and Blancpain—each of which have around a 700-strong staff—that the two brands have achieved regular progress. This rivalry—whether internally within the Swatch Group or with other competitors—is an excellent stimulus. Breguet and Blancpain are of course sister brands, but have always vied with each other on the markets. This competition has been beneficial to both brands in the past, and still is today. It has in particular enabled each to distinguish itself and to establish its own personality.

How would you describe these personalities?

Their common core lies in their mastery of mechanical watchmaking and their undeniable know-how. But this core is interpreted in very different ways at Blancpain and Breguet. Blancpain embodies a more youthful, sometimes sporty and more conventional spirit, an extremely Swiss brand strongly rooted in the Vallée de Joux and brimming with new projects. Breguet is a slightly more stolid brand endowed with a Gallic spirit, impeccable and rigorous styling, a brand bound up with history through the destiny of certain famous figures, and which bears the name of the man who is acknowledged as the greatest horologer of all time. It is also characterized by a will to move ahead, driven by an extremely effective R&D department. As I mentioned before, my grandfather was a true visionary, as is powerfully confirmed by the legacy he left me in Breguet.

How can this healthy emulation between the two brands be maintained? What is your perception of and your own position in relation to each of them?

Blancpain has been my baby since 2002, so I obviously feel a special attachment to this brand; the renewal of Breguet epitomizes the work of my grandfather, and possesses an incredible history that he has taken far beyond what we could ever have imagined—to where it belongs, at the very peak of the art. Both have been the object of substantial investments in recent years in terms of both production facilities and personnel, and are thus perfectly well armed for the future. At Blancpain, there is an extremely loyal team of staff with whom I have been working for many years and who are well acquainted with the brand, my ambitions for it, and my demands. At Breguet, there was naturally a vacuum to be filled, a spirit to be honored and an exceptional heritage, as well as a competent and highly motivated team. The CEO of both brands can thus build on excellent foundations!

TOP

The first Grande Complication in the collection, this Reine de Naples features a *sonnerie au passage*, meaning a striking mechanism that chimes automatically or in passing.

ABOVE

The Type XXII chronograph is equipped with an escapement and a flat balance-spring in silicon beating at 72,000 vibrations per hour, meaning 10 Hertz—a world first!

How about Jaquet Droz, which you are now also heading?

Jaquet Droz can be regarded as a start-up which has its place within the group but which could do with certain adjustments. Its identity must be reinforced, but this brand's vocation is not to be a movement manufacturer, and it will thus be repositioned below Breguet and Blancpain, with more affordable entry prices than those applied in recent years. Jaquet Droz could moreover source its mechanical movements from Blancpain.

And on an economic level, how are these brands doing?

Last year was one of consolidation for Jaquet Droz. But the weight of this brand is fairly minimal within the overall group results. However, as far as Breguet and Blancpain are concerned, the two brands are moving ahead in an extremely favorable way and achieved very similar results last year in terms of growth. There is genuine competition between the two brands and I regard this as something very positive.

You have just inaugurated a new Breguet boutique and museum in Zurich. Are there other such projects on the horizon?

Created at my grandfather's initiative, this Breguet boutique in Zurich—which features a museum on the upper floor—is undoubtedly the brand's finest showcase anywhere in the world. But we have other plans for boutique openings.

Are there any projects for the United States?

Yes, we are opening a second Breguet boutique in New York. This will contribute to further energizing the brand in the United States, because we have to admit that in terms of image, recognition, awareness and distribution, neither Blancpain nor Breguet are where they deserve to be on the American market. The very fact that we are somewhat lagging behind on this territory means the prospects are all the more exciting!

And are other openings planned elsewhere?

Naturally, we will be pursuing our efforts in Asia, and particularly in China. We will take all necessary measures to achieve large growth for Breguet in China over the coming years. But it will take Breguet at least two to three years to catch up with Blancpain in China, since the latter brand is especially well established there.

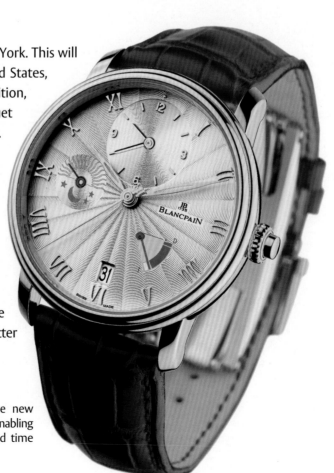

Blancpain has presented the new Villeret Demi-Fuseau Horaire enabling the user to adjust the second time zone in half-hour increments.

Christophe Claret

CEO of Christophe Claret

"Creating my own brand was the obvious choice"

After the DualTow in 2009, Christophe Claret launched the Adagio collection at the beginning of 2011, thereby firmly establishing the eponymous brand among the exclusive circle of fine watchmaking names.

It started with an anniversary. To celebrate the 20 years of the company that bears his name, Claret created the DualTow in 2009. A concentrated example of his manufacture's expertise, this single-pusher planetary-gear chronograph with striking mechanism and tourbillon soon caused a stir among the most devoted collectors. The piece's popularity was such that these collectors, suddenly discovering a watch creator and not just a high-end movement designer, clamored for more. Thus encouraged, Claret decided that the DualTow would go from being a one-off piece to the founding model of his own brand. The second collection, Adagio, was presented in Geneva in January of 2011, a presentation to be followed shortly thereafter at BaselWorld 2011 with the brand's third collection.

Some brands start by making watches and then attempt, with varying degrees of success, to become manufactures in the highly specific Swiss watch industry sense of the term. Claret has done the opposite: creator of high-end watch movements for prestigious brands for 20 years, he decided a few months ago to put his name on his creations. Originally from the Lyon region in France, Claret studied watchmaking in Geneva before starting a career as a restorer of antique watches. At BaselWorld 1987, the owner of a large Swiss watch business asked him to develop an exclusive minute repeater movement. To fulfill the order, Claret established a business with two partners in 1989. Three years later, however, feeling the need for his independence, Claret bought up his partners' shares in the company and renamed it: Christophe Claret SA.

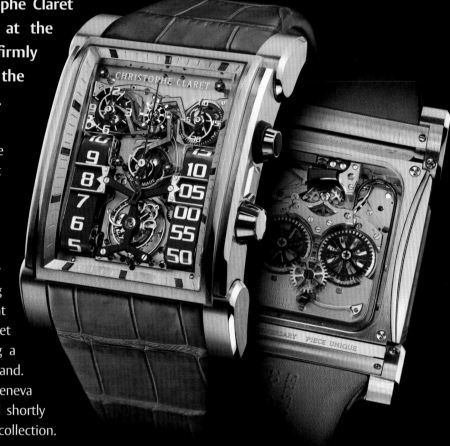

The decade that followed would bring him recognition and a high-end clientele. In 1999, Claret acquired an old manor, le Soleil d'Or (the Golden Sun) in Le Locle. It was the start of a new era: in the next two years, the number of clients exploded, and the staff expanded from 17 to 62. Feeling cramped, the Manufacture Christophe Claret constructed an annex of 500 square meters (5,380 square feet) in 2002, followed by a second of the same size in 2004. Equipped with an expansive and state-of-the-art fleet of machinery, the manufacture, which today employs around 90 people, produces almost all of its movements' components, as well as most of the casing elements.

Among the company's twenty-odd clients are Maitres du Temps, Jean Dunand, Ellicott and Harry Winston. For these brands, the manufacture continues to provide and perfect calibers that are among the most complicated in the world. Few brands will own up to using outside suppliers to create their most complex models; this is why, outside a small circle of connoisseurs, the name of Christophe Claret is little known to the larger public. However, from the minute repeater, the first complication developed by the watchmaker, to the orbital tourbillon and a perpetual calendar with roller displays, the manufacture is one of the most innovative and high-performance companies in the watch industry.

In 2009, the Christophe Claret manufacture celebrated 20 years of service to luxury watch brands. As a nod towards them, the watchmaker created for the very first time a complete watch, a life-size showcase for his abilities. A commemorative timekeeper that is both provocative and without equivalent, the DualTow is by definition available in a limited edition: 68 pieces, all different and thus all unique. The major innovation resides in a patented single-pusher chronograph that functions thanks to three planetary gears, each one with the same structure. But Christophe Claret has chosen to further refine the caliber by adding a striking mechanism that marks the start, stop and reset of the chronograph. An example of the manufacture's expertise in chiming and musical movements, the watch possesses exceptional acoustics. The snail-shaped gong-ring is one of the most accomplished and difficult to perfect.

Carefully working each detail, the watchmaker and his team set the finishing touch to the movement by endowing it with a chronograph function. This way, the wearer can follow its state of functioning from moment to moment. Playing on an effect of perfect symmetry, the mechanism presents the hour and minute counters on a bridge that also plays the role of a sapphire crystal dial. Respectively positioned at 11 and 1 o'clock, they complement the central seconds hand. This extremely forceful and technical stage-setting frees up enough space to reveal the entire system driving the chronograph at 12 o'clock, and a one-minute tourbillon at 6 o'clock. Finally, two notched belt-type displays, specially developed for Christophe Claret and placed on either side of the watch are driven by cylinders placed at each end. They respectively indicate the hours and the minutes in five-minute increments.

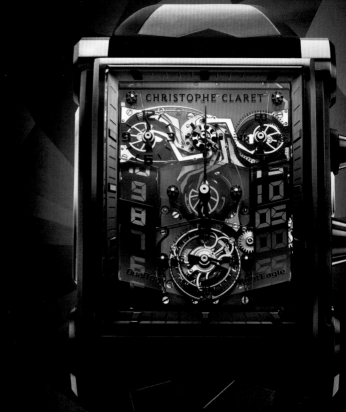

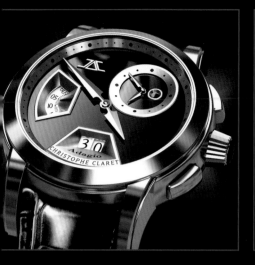

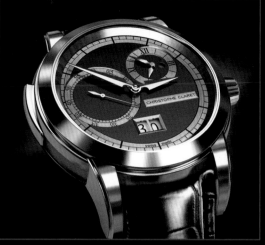

However, in unveiling his horological talents in this way, Claret found himself becoming a watchmaking celebrity. Hailed by collectors and watch lovers all over the world, who recognize his distinctive "touch," he has aroused the desire for more. "Some of them already owned a watch with a Claret movement without even realizing it," explains the watchmaker. "The DualTow allowed them to discover the rest of my work." Establishing a Christophe Claret watch brand emerged as the obvious path.

The second Christophe Claret collection was presented at Geneva at the same time as the Salon International de la Haute Horlogerie, in January 2011. Inviting his guests to a suite at an upscale Geneva hotel, the watchmaker unveiled the Adagio collection. A classical beauty embodying the purest horological tradition in both its movement and its exterior, this exceptional piece is equipped with the SLB88 caliber—naturally made in the Manufacture Christophe Claret. Incorporating 455 components, it offers central hours and minutes, small seconds at 9 o'clock—in a subdial or a window, depending on the version—large date at 6 o'clock and a second time zone (hours and minutes) with day/night indication in a subdial at 2 o'clock.

As an allusion to the order that allowed him to found his business more than 20 years ago, Claret also wanted to equip the timepiece with a minute repeater, a major complication in the world of haute horology. Striking the hours, quarter-hours and minutes on demand, the "cathedral" gongs of the striking mechanism are endowed with a patented device, preventing them from hitting each other as they vibrate beneath the hammers' blows. The crown also possesses a security system: when the barrel's spring is extended to its maximum, a declutching mechanism kicks in, thus preventing any damage due to overwinding. Available in three materials—rose gold, white gold or platinum—the 44mm case is water resistant to 30 meters. It has two pushbuttons at 2 and 4 o'clock to set the large date and second time zone, as well as a strike slide at 9 o'clock. As for the dial, it is also available in three versions—hand-guilloché, made from a gemstone (black onyx, ruby, jade, opal or lapis lazuli), or in anthracite rhodium-plated gold punctuated with stamped subdials. All models come on an alligator strap and each combination of dial and case is limited to just eight pieces. Just released, this timepiece already hints at more to come.

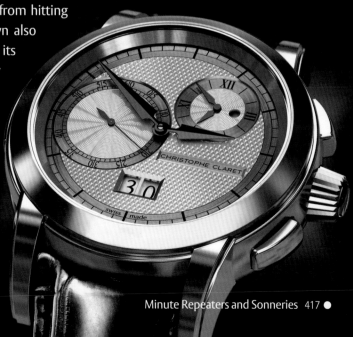

Minute Repeaters and Sonneries

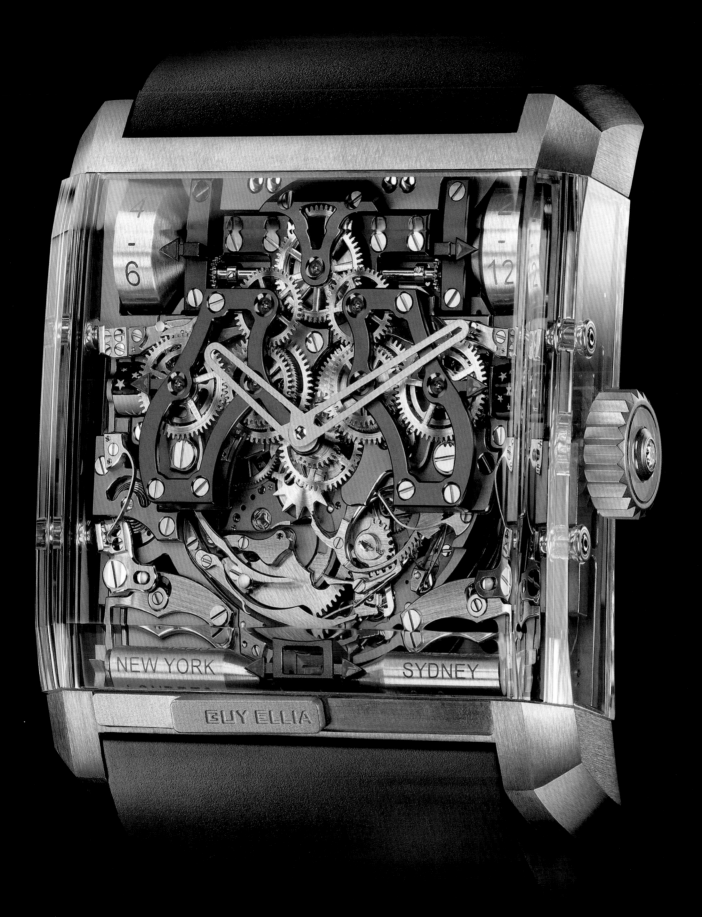

Guy Ellia,
Répétition Minute Zephyr

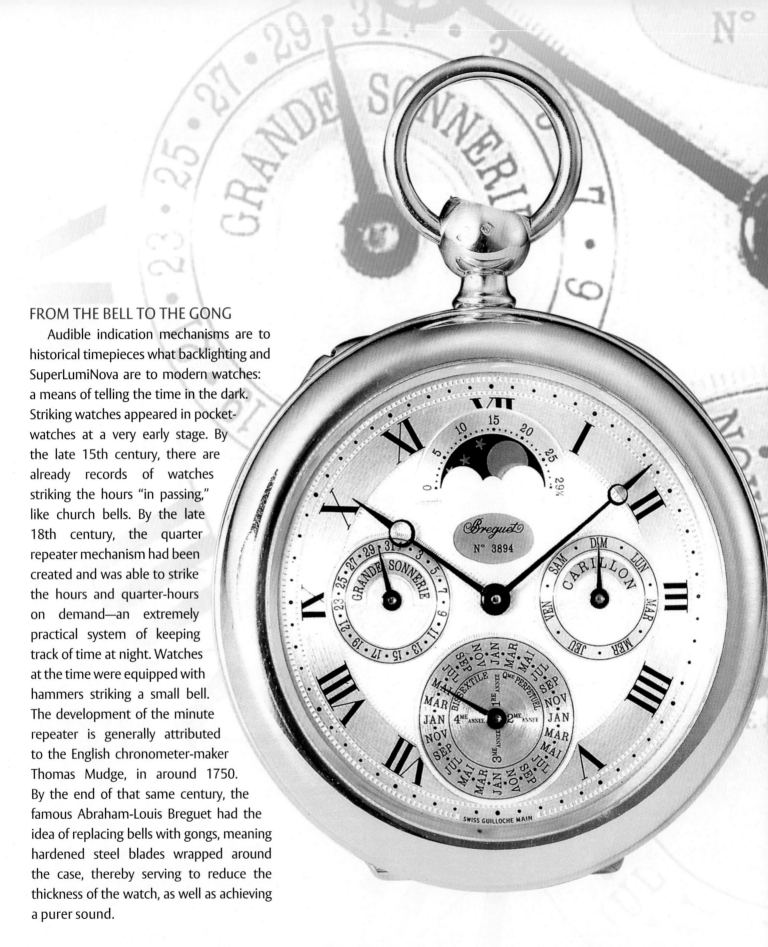

FROM THE BELL TO THE GONG

Audible indication mechanisms are to historical timepieces what backlighting and SuperLumiNova are to modern watches: a means of telling the time in the dark. Striking watches appeared in pocket-watches at a very early stage. By the late 15th century, there are already records of watches striking the hours "in passing," like church bells. By the late 18th century, the quarter repeater mechanism had been created and was able to strike the hours and quarter-hours on demand—an extremely practical system of keeping track of time at night. Watches at the time were equipped with hammers striking a small bell. The development of the minute repeater is generally attributed to the English chronometer-maker Thomas Mudge, in around 1750. By the end of that same century, the famous Abraham-Louis Breguet had the idea of replacing bells with gongs, meaning hardened steel blades wrapped around the case, thereby serving to reduce the thickness of the watch, as well as achieving a purer sound.

Pocket watch in 18K yellow gold. Its hand-wound movement drives a perpetual calendar showing the day, date, month and leap-years, as well as the phases and the age of the moon. Its "Grande Sonnerie" chimes the hours, quarter hours and minutes with three different gongs. This piece is unique.

Omega has the distinction of introducing what may be the world's first minute-repeater wristwatch. Created by Louis Brandt in 1892, the watch features a striking mechanism that chimes on demand the hours, quarter-hours and minutes.

LIKE A MUSICAL INSTRUMENT

In the 20th century, in the miniaturized form of wristwatches, watches providing audible indications of the time established themselves as one of the most eloquent demonstrations of watchmaking know-how. It takes exceptional skill to make this complex system of "mechanical" memory, based on "feeler-spindles" picking up the information from the hour, quarter-hour and minute "snails", and then passing it on to "gathering-pallets" that raise the hammers. It takes an extremely sensitive musical ear to adjust the gongs as one would a musical instrument, especially in the case of a so-called "cathedral" chiming mechanism that strikes on three or four gongs. There are two main types of audible indication: striking "in passing" or automatically (grand and small strike) and striking on demand (repeater mechanisms). Grand strike (grande sonnerie) means that the watch repeats the hours every quarter-hour, and small strike (petite sonnerie) that it merely signals either the full hours or the quarter-hours. Meanwhile, a minute repeater mechanism is generally fitted with two gongs: a low-pitched one for the hours, a high-pitched one for the minutes, and the quarter-hours on alternating high- and low-pitched tones.

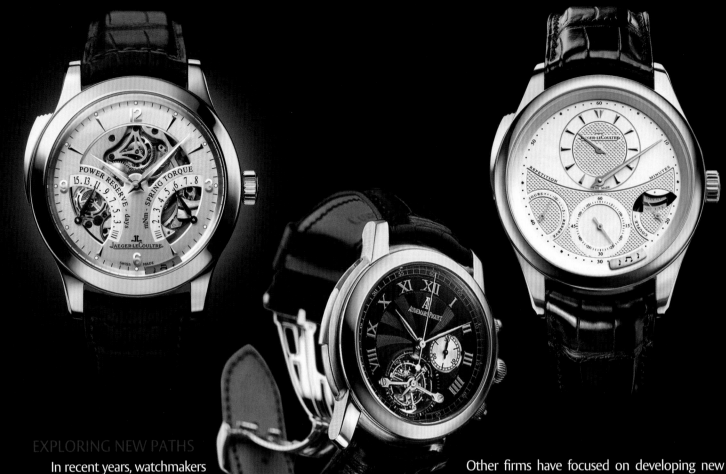

EXPLORING NEW PATHS

In recent years, watchmakers seem determined to revive interest in minute repeater models by exploring new technical and aesthetic paths. In 2005, Jaeger-LeCoultre launched the Master Minute Repeater, equipped with an original sound transmission system: the latter is transmitted directly outward by the sapphire crystal of the watch to which the gong-heels are welded, and the gongs themselves are made from a material featuring a secret and exclusive composition. The result is a sound of peerless power, richness and purity. The Master Grande Tradition à Répétition Minutes, unveiled in 2009, is based on the same principle of transmission through the watch crystal, but the gongs feature a square section that is tapered towards the tip, thereby increasing the volume and the duration of the sound. In this model, the minute repeater is associated with a regulator-type display with central minutes and hours on a small offset dial at 12 o'clock. The watch also has an exceptional 14-day power reserve.

Other firms have focused on developing new striking systems, such as Audemars Piguet with its Jules Audemars Tourbillon Minute Repeater Chronograph, or new function-starting devices such as Roger Dubuis with its Excalibur Minute Repeater, in which the striking mechanism of Caliber RD08 is activated by rotating the turning bezel. Not forgetting the Classique 5447 Minute Repeater and Perpetual Calendar by Breguet, endowed with several technical developments, for some of which patents have been registered. Blancpain has opted to tackle one of the trickiest issues with minute repeater watches: the Achilles' heel in their water resistance represented by the slide-piece, which can prove fatal in damp climates. With the Léman Minute Repeater Aqua Lung, the brand offers a minute repeater model that is water resistant to 100 meters. To achieve this, it has devised an ingenious liaison device between the external slide-piece and the internal arming lever, via a set of racks, intermediate wheels and gaskets. The minute repeater is also designed to be the thinnest in the world and the thinnest in diameter.

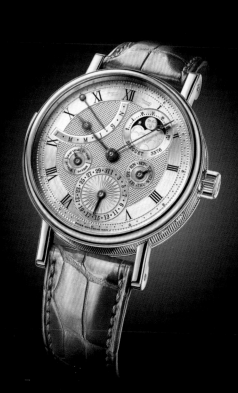

The Challenge RMT-S by the Geneva-based Cvstos brand, with anti-shock tourbillon carriage, combines a minute repeater with water resistance to 100 meters—but in a distinctly more futuristic manner. And while on the topic of technical innovations, and at the risk of shocking purists, it is also worth mentioning the association between a quartz movement and a minute repeater in the Eco-Drive Minute Repeater Perpetual by the Japanese brand Citizen, featuring the battery-free Eco-Drive system powered exclusively by natural or artificial light.

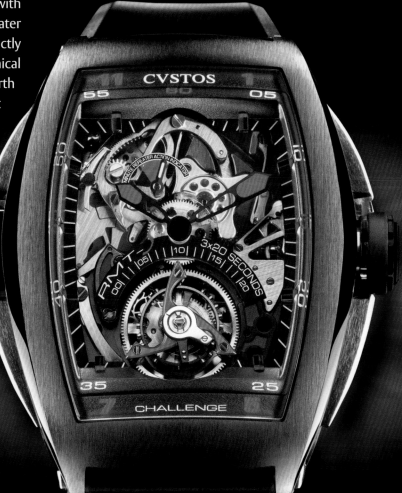

FACING PAGE
TOP FROM LEFT TO RIGHT
Jaeger-LeCoultre, *Master Minute Repeater*
Audemars Piguet, *Jules Audemars Minute Repeater Tourbillon Chronograph*
Jaeger-LeCoultre, *Master Grande Tradition Minute Repeater*
BOTTOM
Roger Dubuis, *Excalibur Minute Repeater*

THIS PAGE
TOP FROM LEFT TO RIGHT
Breguet, *Classique 5447 Minite Repeater and Perpetual Calendar*
Blancpain, *Léman Minute Repeater Aqua Lung*
Citizen, *Eco-Drive Minute Repeater Perpetual*
BOTTOM
Cvstos, *Challenge RMT-S*

UNVEILING THE MECHANISM

In classic minute repeater watches, nothing signals the presence of this sophisticated complication like the presence of a small slide-piece or bolt on the side of the case, such as on the Bulgari Minute Repeater equipped with a Parmigiani Fleurier movement, or the new Portugaise Minute Repeater by IWC, with a large case and hand-wound pocket-watch movement. However, many watchmakers prefer to show the mechanism by openworking the dials. Such is the case of the Midnight Minute Repeater by Harry Winston, on which a tiny porthole at 10 o'clock serves to observe the engraved striking mechanism. Vacheron Constantin also aims for maximum transparency—and slenderness—with its Répétition Minutes Squelette Maîtres Cabinotiers. The 3.3mm-thick movement comprises over 330 parts, most of them openworked, decorated and chased. The equally finely worked skeletonized movement of the Amadeo Fleurier 46 Minute Repeater Tourbillon Reversed Hand-Fitting by Bovet Fleurier looks every inch a work of art. In addition to displaying the hours and minutes, the reversed hand-fitting bearing a single hand makes it possible to read off the hours, half-hours and quarter-hours on the other side of the caliber.

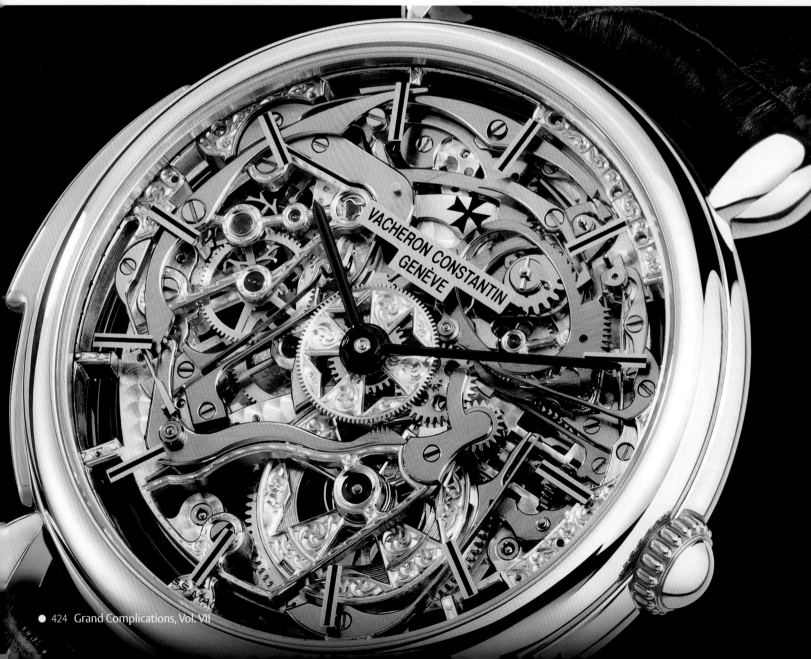

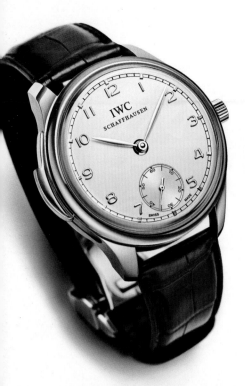

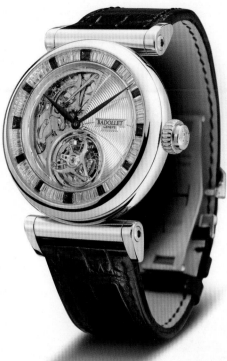

FACING PAGE
TOP
Bulgari, *Minute Repeater*
BOTTOM
Vacheron Constantin, *Répétition Minutes Squelette Maîtres Cabinotiers*

THIS PAGE
TOP LEFT
IWC, *Portugaise Minute Repeater*
TOP RIGHT
Badollet, *Observatoire 1872 Répétition Minutes*
BOTTOM LEFT
Harry Winston, *Midnight Minute Repeater*
BELOW
de Grisogono, *Occhio Ripetizione Minuti*

This type of display is particularly appropriate on a model that converts quickly and easily from wristwatch to pocket-watch or table clock. Another timepiece with a pocket-watch look, the Observatoire 1872 Minute Repeater by Badollet provides ample views of its hammers, gongs and inertial flywheel through an opaline openworked dial. Finally, de Grisogono plays the iconoclast with its Occhio Ripetizione Minuti. Based on the principle of reflex cameras, the watch features an aperture in place of a dial; when the minute repeater is activated, the twelve ceramic shutters open to reveal the movement and remain open while the cathedral chime is sounding.

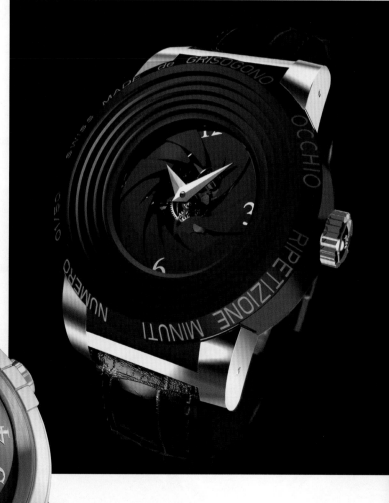

Yet other watchmakers offer variations on the type and frequency of the striking mode. On its L.U.C Strike One, Chopard presents a mechanism striking each hour with a single blow (hence its name), and an opening in the dial serves to reveal a small hammer at work. On his one-of-a-kind Masterpiece N°7 model, Finnish-born watchmaker Kari Voutilainen offers a minute repeater striking not only hours/quarter-hours/minutes, but also hours/ten minutes/minutes, a system designed to enable a more intuitive division of time. Edox also offers an hours/minutes indication on its Classe Royale Répétiion 5 Minutes, featuring a square case and striking mechanism visible through an openworked dial. The Japanese brand Seiko has revived the antique hour repeater mechanism in a high-end model named Credo Spring Drive Sonnerie. The mechanism strikes in three modes: the number of hours on each hour; three strikes every three hours (3, 6, 9 and 12 o'clock); and silent mode. Thanks to the exclusive Seiko Spring Drive technology, the hands move "as regularly and silently as time itself."

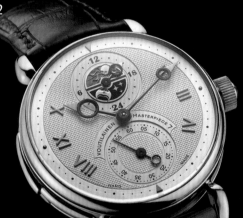

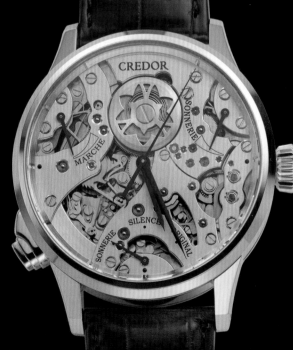

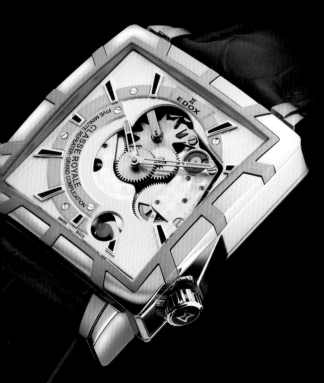

TOP
Chopard, *L.U.C Strike One*
ABOVE
Kari Voutilainen, *Masterpiece N° 7*
LEFT
Edox, *Classe Royale Répétition 5 minutes*
RIGHT
Seiko, *Credor Spring Drive Sonnerie*

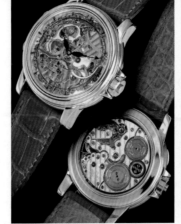
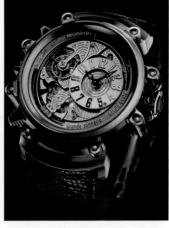

THE ULTIMATE SOUND EXPERIENCE

Undoubtedly the ultimate achievement in terms of audible time indications is to combine "in passing" and "on demand" striking mechanisms within the same movement. In 1992, Philippe Dufour, one of the greatest current artisan watchmakers, created his Grande Sonnerie, the first ever minute repeater wristwatch with grand and small strike. François-Paul Journe, another top-flight inventor, followed suit with the Sonnerie souveraine. This wristwatch, which took almost six years to create and fine-tune, is distinguished by its extreme functionality. The watchmaker has developed several systems serving to facilitate and secure the functional use of the watch, including in particular an activation device based on several watertight pushers. He also sought to reduce the energy required for the striking mechanism. This model gave rise to ten patent requests. Another of its distinctive features lies in the fact that Journe opted for a steel case—a first in his collections—in order to guarantee perfect sound. A superb example of an audible watch, and indeed of a complication watch in general, the Grande Sonnerie Moon Phase by Daniel Roth combines a tourbillon, a minute repeater, small and grand strike, a four-hammer Westminster chime, a double display of the movement and striking mechanism power reserves, as well as a large moonphase and a pointer-type date indication.

When it comes to absolute masterpieces in this field, several models are destined to leave an indelible sound imprint on the history of striking watches. The first, the Hybris Mechanica à Grande Sonnerie, is part of the Hybris Mechanica trilogy of ultra-complicated watches presented by Jaeger-LeCoultre (see Multi-Complications chapter). Its movement, comprising over 1,300 parts, incorporates—in addition to a flying tourbillon, a perpetual calendar and various jumping or retrograde displays—a grand and small strike as well as a minute repeater, along with a Westminster chime that sounds a tune that lasts much longer than normal.

To further enhance the operation and the quality of the sound, the watchmakers devised new hammers with an articulated head, ensuring enhanced energy efficiency. The second bears the signature of the Gérald Genta company, now part of the Bulgari group, and which has an exclusive software program enabling it to measure the sounds of its striking watches in terms of their intensity, their accuracy and their cadence. The Arena Metasonic, unveiled in autumn 2009, fully benefits from all of these high-tech breakthroughs. Thanks to another program capable of analyzing various types of material, the brand has also developed a new patented alloy for the case middle, named Magsonic, featuring a secret composition guaranteeing the best possible outward transmission of the sound. The case construction is inspired by the "side drums" on drum kits, with a titanium bezel and back secured on the outside by dedicated pillars.

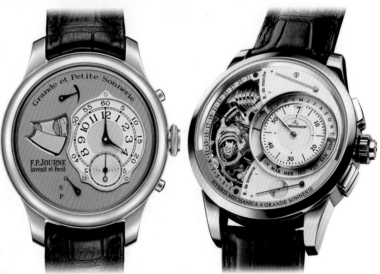

TOP LEFT
Philippe Dufour, *Grande Sonnerie*

TOP RIGHT
Gérald Genta, *Arena Metasonic*

LEFT
Daniel Roth, *Grande Sonnerie Moon Phase*

ABOVE LEFT
F.P.Journe, *Sonnerie souveraine*

ABOVE RIGHT
Jaeger-LeCoultre, *Hybris Mechanica à Grande Sonnerie*

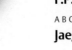

A WORLD OF AUTOMATONS

When it comes to providing a grand visual and acoustic show, automaton watches hold a place of their own despite their extreme rarity. Ulysse Nardin is pursuing this tradition with several noteworthy creations, including the Genghis Khan watch, the first minute repeater tourbillon model with jacks to be equipped with a Westminster chime. The 18-karat gold case houses four gongs sounding different notes (E-C-D-G). It sounds the hour by a G, the minutes by an E, and indicates the quarter-hours on all four gongs by means of three different sound sequences. The black onyx dial is adorned with hand-engraved gold figurines that spring to life when the striking mechanism is activated, and are perfectly synchronized with the sound of the gongs. Inspired by a painting by Caravaggio, the Il Giocatore Veneziano from Daniel Roth associates a minute repeater mechanism (with cathedral chime) with an automaton that throws two dice according to seven different cycles with 72 combinations each, meaning a total of 504 possibilities. The automaton movement operates independently of the minute repeater mechanism, and may thus be activated either at the same time as the striking mechanism, or on demand. As for the Amadeo Fleurier 44 Minute Repeater Tourbillon Triple Time Zone Automaton watch by Bovet Fleurier, its dial features an automaton with bells reminiscent of the first jack mechanisms.

THIS PAGE
ABOVE
Ulysse Nardin, *Genghis Khan*
LEFT
Daniel Roth, *Il Giocatore Veneziano*

FACING PAGE
Ellicott, *Lady Tuxedo Midnight*

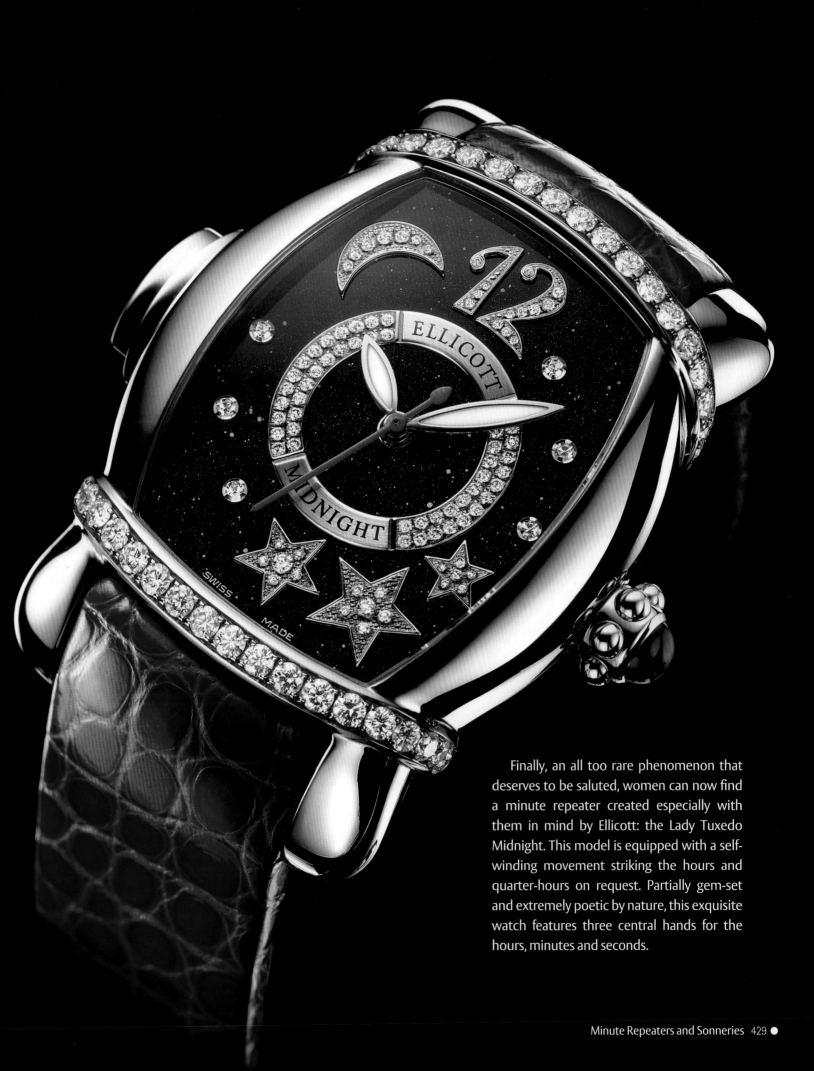

Finally, an all too rare phenomenon that deserves to be saluted, women can now find a minute repeater created especially with them in mind by Ellicott: the Lady Tuxedo Midnight. This model is equipped with a self-winding movement striking the hours and quarter-hours on request. Partially gem-set and extremely poetic by nature, this exquisite watch features three central hands for the hours, minutes and seconds.

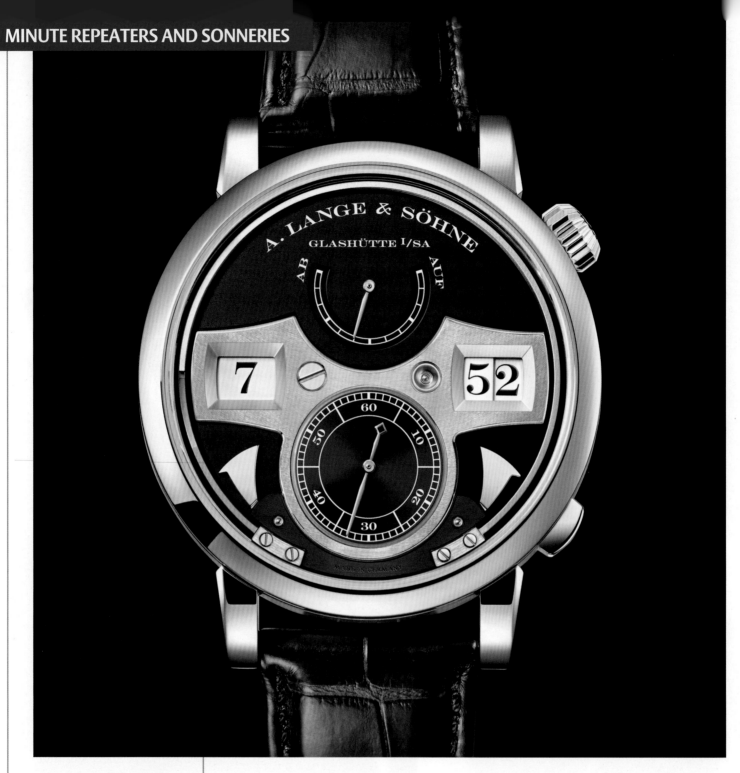

A. LANGE & SÖHNE

LANGE ZEITWERK STRIKING TIME – REF. 145.029

The most recent addition to the Lange Zeitwerk family is endowed with a chiming mechanism that is visible on its dial. The Lange Zeitwerk Striking Time is the first Lange wristwatch with an acoustic signature. It strikes the quarter-hours with high-pitched tones and the full hours at a lower pitch. The chiming mechanism consists of two black polished steel hammers that are integrated in the dial layout on either side of the subsidiary seconds. The manually wound L043.2 caliber is crafted to the most exacting Lange quality standards and largely decorated and assembled by hand. The sonorous timepiece comes in a 44.2mm white-gold case with a black dial or in a limited edition of 100 pieces with platinum cases and rhodium-plated dials.

AUDEMARS PIGUET

MILLENARY HAND-WOUND MINUTE REPEATER WITH AP ESCAPEMENT

REF. 26371TI.OO.D002CR.01

The Millenary Minute Repeater is a concentrated blend of expertise, technical sophistication and innovative materials. Its titanium oval case provides an atypical setting for a truly magnificent sight featuring offset gold subdials. The AP escapement and the double balance-spring, as well as the hammers and the striking gongs, all become key players in a truly three-dimensional creation. Conceived, developed and produced by Audemars Piguet, the new hand-wound 2910 caliber driving the Millenary Minute Repeater is also distinguished by the atypical construction of the regulating organ. The oval Millenary case in brushed titanium—a material featuring exceptional acoustic qualities—is framed by a polished titanium bezel. The various organs within are barely concealed by the anthracite gray hours and minutes subdial offset at 3:00, and by the small seconds at 7:00. Limited edition of eight pieces.

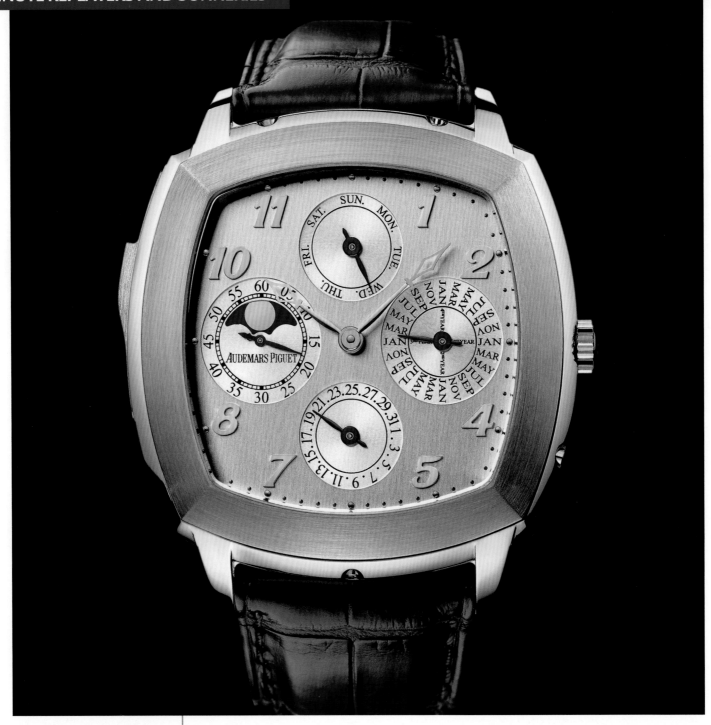

AUDEMARS PIGUET

TRADITION MINUTE REPEATER PERPETUAL CALENDAR – REF. 26052BC.OO.D092CR.01

This exceptional timepiece is inspired by a Lépine pocket-watch created in 1923 by Audemars Piguet. The 50x50mm 18K white-gold case houses the manual-winding 2855 movement, whose minute repeater movement chimes the hours, quarter-hours and minutes upon request. The piece's opaline dial with applied Roman numerals and "cathédrale" hands in pink gold offers perfect readability of the day, date, month, leap year and moonphase indications provided by the perpetual calendar module. The manual-winding movement is decorated with Côtes de Genève and circular graining, which can be admired through the sapphire crystal caseback.

BLANCPAIN

CARROUSEL REPETITION MINUTES LE BRASSUS – REF. 0233-3634-55B

Blancpain's Carrousel Répétition Minutes Le Brassus is powered by the 1736 caliber residing in its 18K red-gold 45mm case, and features a flying one-minute carrousel. A slide lever operates the minute repeater and a cathedral gong sounds the hour. The skeletonized and openworked dial reveals the BLANCPAIN movement. The Carrousel Répétition Minutes Le Brassus is available in a limited edition of 10 pieces.

BVLGARI

OCTO GRANDE SONNERIE TOURBILLON – REF. BGOW44BGLTBGS

The Octo Grande Sonnerie Tourbillon is the ultimate embodiment of horological complexity, especially since the automatic-winding movement that powers it is equipped with a tourbillon, retrograde hour display and power reserve indicators for the movement and striking mechanism. The four gongs are made from a special steel alloy, and are suspended between the movement and the inner surface of the case. Each one has a different length to produce its own specific sound, and each corresponds to a hammer that strikes a specific spot on the gong. The minute repeater mechanism is capable of both grand and small strike, as well as sounding the time in passing and on demand. Retrograde hours and a disc minute display complete this exceptional piece.

BVLGARI

OCTO REPETITION MINUTES RETRO – REF. BGOP43BGLMR

Within the Gérald Genta collection, the Octo Répétition Minutes Retro is distinguished by a combination of a minute repeater mechanism with a jumping hour display and retrograde minutes indication. The piece features an exquisitely crafted dial with a guilloché and cloisonné decoration, featuring a retrograde minute hand running across a 180° arc on the right-hand side of the dial, while the jumping hour window is located in the traditional position at 9:00. The 43mm white-gold case of the Octo Répétition Minutes Retro is adorned with two beaded crowns. The one at 3:00 serves to adjust the usual time functions, and the second to activate the repeater mechanism.

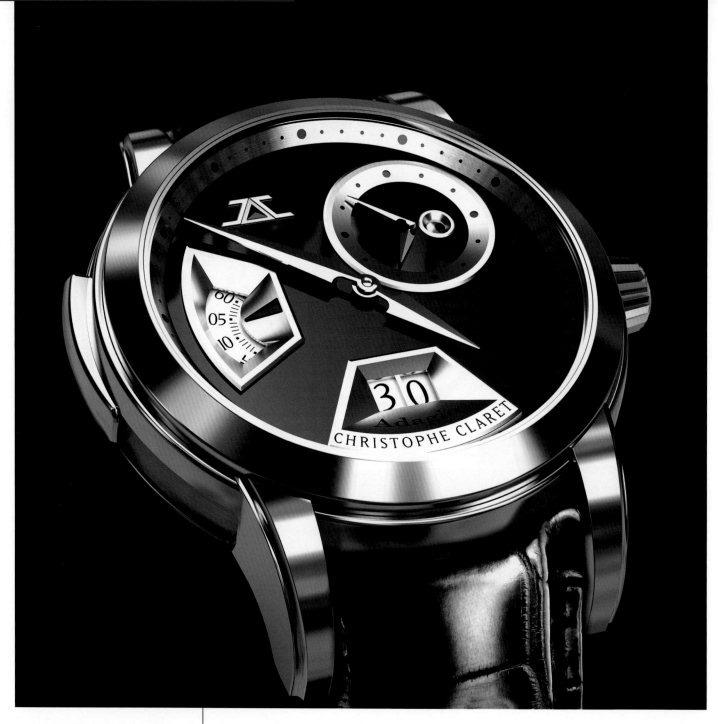

CHRISTOPHE CLARET

ADAGIO – REF. MTR.SLB88.002

Considering each of his timepieces as a work of art, Christophe Claret creates highly innovative models combining avant-garde technologies and time-honored expertise. He offers only the most exceptional and intricate timepieces, achieved by relentlessly pushing the known limits of originality and mechanical complexity. The newest revelation of the prestigious Christophe Claret brand is the Adagio. The Adagio features an hour, quarter-hour and minute repeater on cathedral gongs, a grand date and a GMT with day and night indication. The mechanical hand-wound movement is made up of 455 components and 46 jewels, and has a 48-hour power reserve. The Adagio is available in 18K white gold, 18K rose gold and platinum. The timepiece will be created with dials featuring hand-guilloché, semi-precious stones (lapis lazuli, black onyx, ruby, jade and opal) and black rhodium-plated gold. Each dial configuration of the Adagio will be produced in a limited edition of eight pieces.

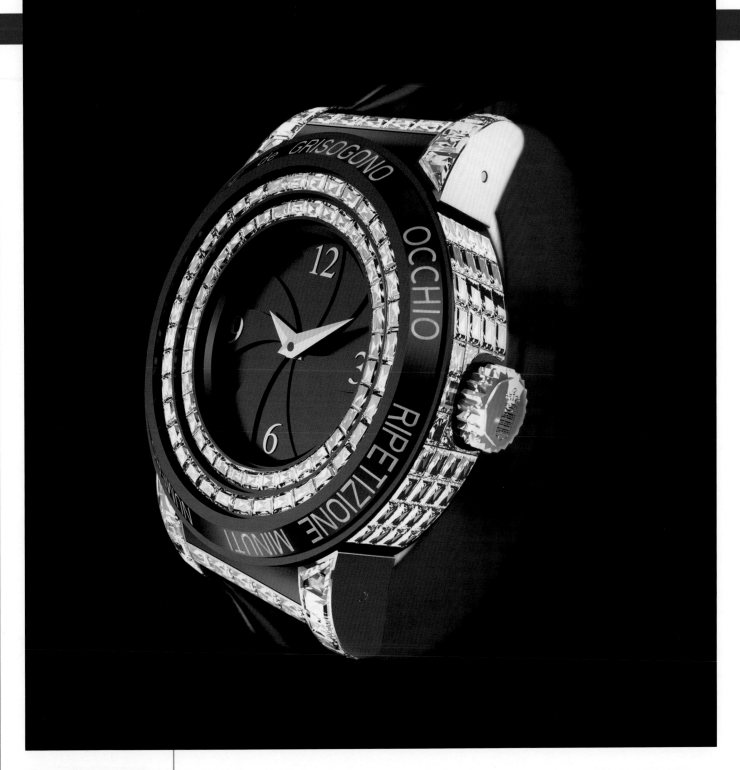

de GRISOGONO

OCCHIO RIPETIZIONE MINUTI TITANIUM

The exceptional Occhio Ripetizione Minuti boasts a mechanism very similar to the one found in a reflex camera. Comprising 12 titanium blades, the diaphragm opens to reveal the movement as the mechanism chimes. The watch's sapphire crystal caseback reveals the movement of the three hammers (to strike the hours, quarter-hours, and minutes) on the gongs, as well as the movement's signature decorative finishing. Originally released in a more sedate version, this model is now available in a spectacular diamond-set version, which features 154 baguette-cut diamonds (18 carats in total) on the bezel, case flanks and lugs.

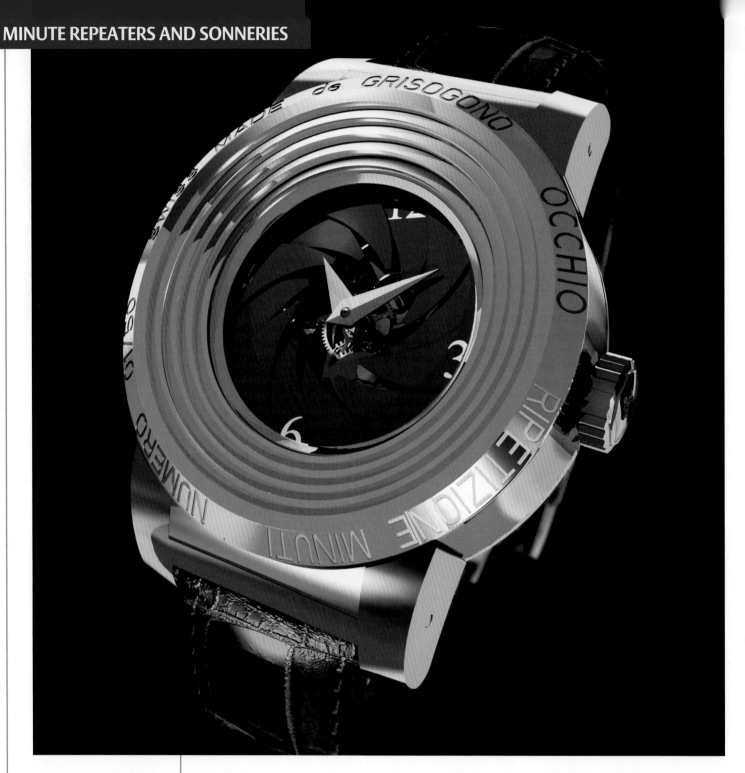

de GRISOGONO

OCCHIO RIPETIZIONE MINUTI ROSE GOLD CLOSED

The Occhio Ripetizione Minuti more than holds its own as a minute repeater, striking the hours, quarter-hours and minutes. At first glance, it looks like any other beautifully designed watch. However, its dial holds a secret: it is made of twelve titanium blades that open to reveal the movement underneath. As the three hammers inside strike the gongs to sound the time, the dial reveals the delightful play inside; the sapphire crystal caseback shows off the movement of the hammers and the trademark de GRISOGONO finishing on the movement.

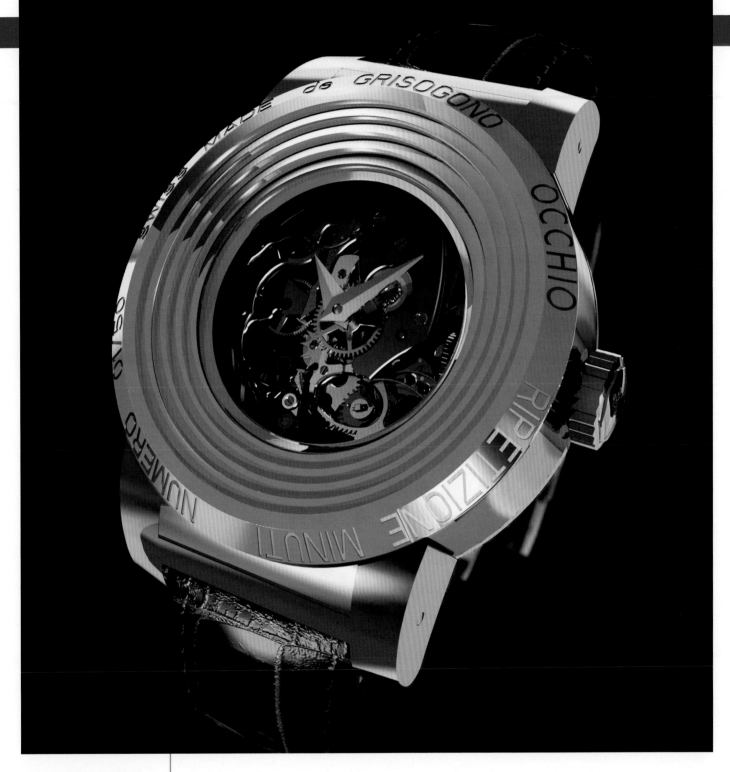

de GRISOGONO

OCCHIO RIPETIZIONE MINUTI ROSE GOLD OPEN

The exceptional Occhio Ripetizione Minuti boasts a mechanism very similar to the one found in a reflex camera. Comprising 12 titanium blades, the dial is actually a diaphragm that opens to reveal the movement as the mechanism chimes. The wearer can either enjoy the spectacle on the front of the watch, or the one on the back, as the watch's sapphire crystal caseback reveals the movement of the three hammers on the gongs, as well as the movement's signature decorative finishing.

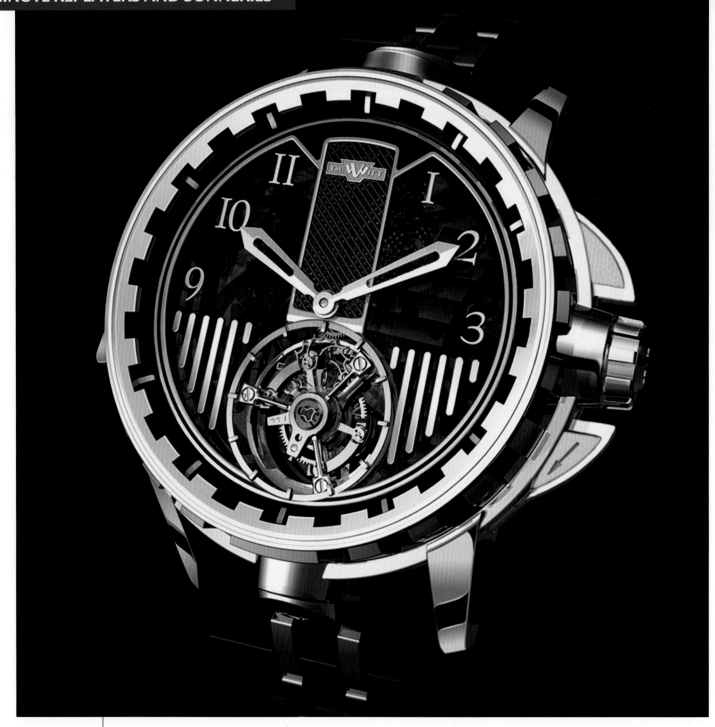

DEWITT

REPETITION MINUTES TOURBILLON GMT ANTIPODE – REF. AC.8900.38.M060

Resplendent in the technological breakthroughs of the 21st century, the Répétition Minutes Tourbillon GMT Antipode offers three complications—tourbillon, minute repeater and GMT—within a pivoting double-sided case. The front side reveals the tourbillon carriage, local hours and minutes and the minute repeater. The local time striking mechanism is triggered by a pushbutton located at 9:00. The reverse side of the watch displays the GMT function, with hours and minutes of the second time zone. The wearer can activate the local minute repeater mechanism while reading the time for the second time zone. The hand-winding mechanical movement is finished in elegant black-gold Côtes de Genève, while the grade 5 titanium and white-gold case houses the exceptional DW8900 caliber.

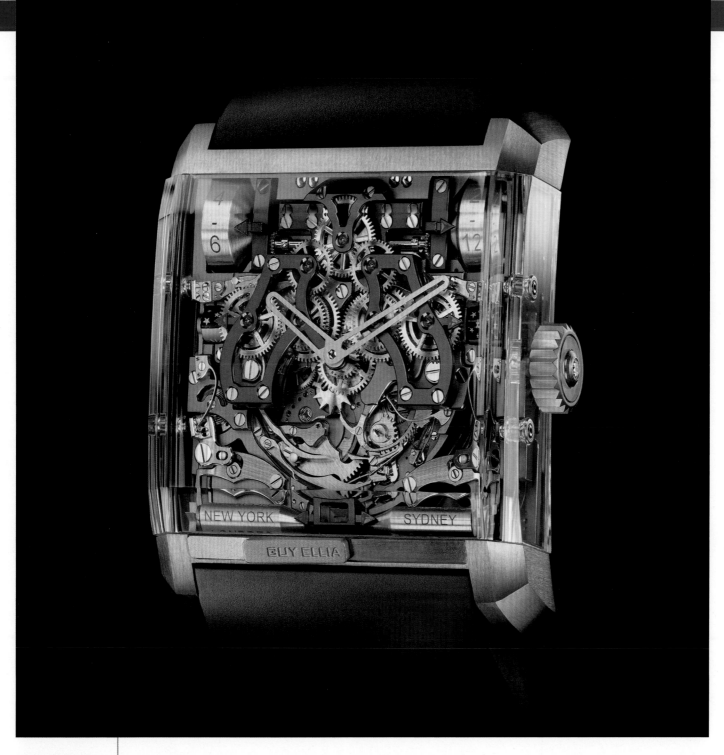

GUY ELLIA

REPETITION MINUTE ZEPHYR

The ambassador of Guy Ellia's complicated timekeeper, the Repetition Minute Zephyr with its complications and intricate manufacturing process, is considered a particularly exceptional piece. The Caliber GEC 88 was created by Swiss manufacture Christophe Claret and features a power reserve indicator, minute-repeater function and five time zones with day/night indication. The movement beats at 18,000 vph in a solid, convex, high-resonance sapphire crystal case of impressive proportions (53.6x43.7x14.8mm). Mounted on an alligator strap with a folding buckle, this model is also available in pink gold or titanium.

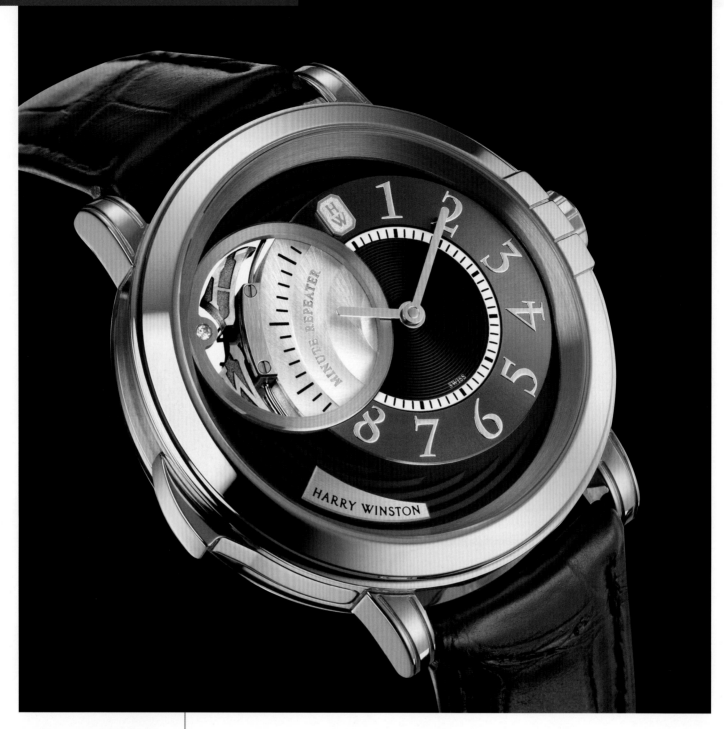

HARRY WINSTON

MIDNIGHT MINUTE REPEATER – REF. 450/MMMR42RL.K

Sleek and sophisticated, the round 42mm case of the Midnight Minute Repeater is fitted with an automatic-winding mechanical movement. An open dial design allows for a unique view of the minute repeater mechanism that can be activated by pressing the pushpiece situated at 8:00. Surrounded by a gold ring, a hollowed window brings emphasis to the technical innovation: two hammers gracefully engraved with Harry Winston's initials, located on the exterior of the movement. The edition is limited to 40 pieces in rose gold and 40 pieces in white gold with the option of a silver or dark dial.

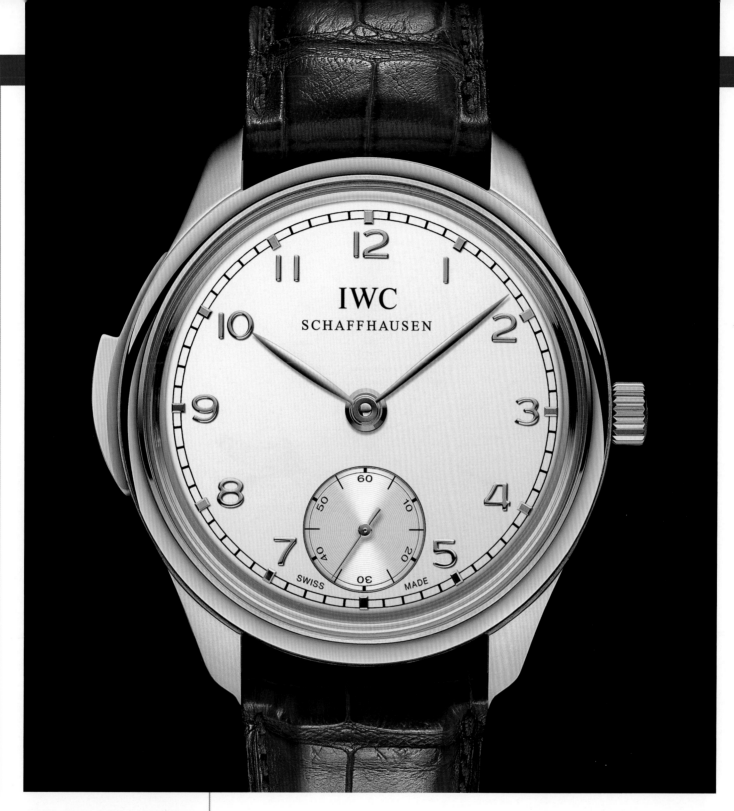

IWC SCHAFFHAUSEN

PORTUGUESE MINUTE REPEATER – REF. IW544905

For Portuguese explorers out on the open sea, timekeeping was of crucial importance. Using a log line together with a special sandglass—the log glass—they were able to measure the vessel's speed. The ship's bell clock, on the other hand, was used to signal the beginning and end of sailors' watches: the bell would be struck once every half-hour and twice every full hour, with four double strikes signaling the end of a watch. The abstract concept of time was thus being converted into acoustic tones even back then. In the Portuguese Minute Repeater, depressing the slide causes a delicate strike train to sound the time out audibly in hours, quarters and minutes. In 2009, the case was increased by 1.7mm in height and 1mm in diameter, but in a move destined to appeal to fans of classic dial design, the small seconds display was shifted from 9:00 to 6:00. To achieve this, the original 95-calibre Lépine open-face movement was replaced by a 98950-calibre hunter pocket-watch movement and some of the stylish elements of the early Jones calibers were adopted. A number of these, such as the elongated index, the balance with its high-precision adjustment cam and the distinctively decorated nickel-silver plate and bridge with gold-plated engravings, can be seen through the transparent sapphire crystal caseback. Both versions are limited to 500 watches.

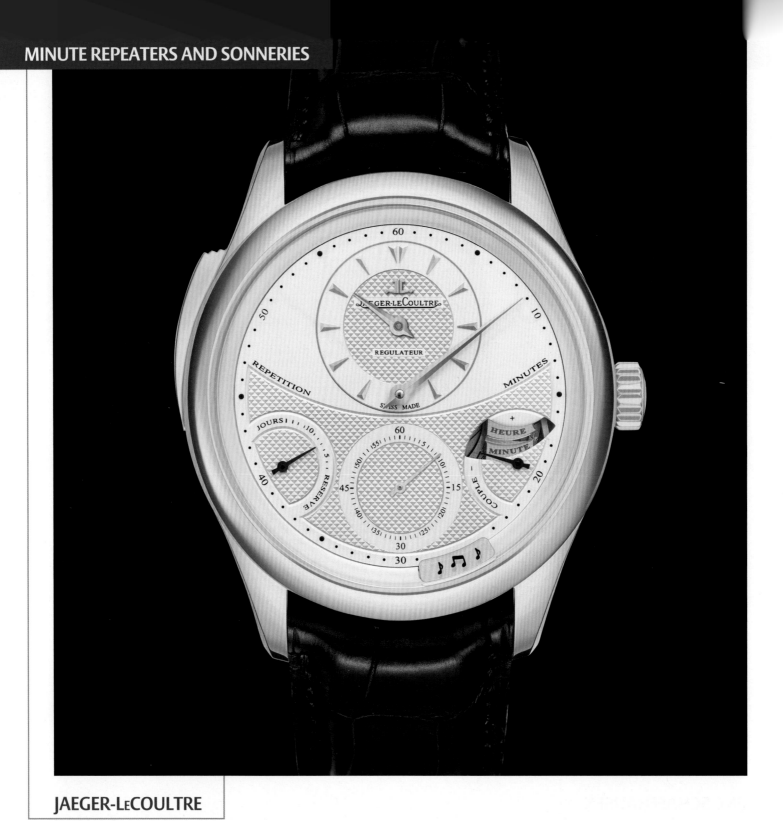

JAEGER-LeCOULTRE

MASTER GRANDE TRADITION MINUTE REPEATER – REF. 501.14.10

The new 947R caliber builds on its exceptional predecessor, 947. The 947 innovated a patented crystal gong, whose heel was welded to the sapphire crystal, increasing the intensity and purity of the sound. Among other changes, the section of the gongs has since adopted a progressive shape, tapered towards the end in order to increase the duration of the sound. The display is in the regulator style, which remains to this day a complication reserved for particularly high-precision watches. This Master Grande Tradition is the only watch to combine a minute repeater with a two-week power reserve and a crystal gong. In an ultimate touch of sophistication, the two minute repeater hammers are visible through a dial opening at 4:00, each bearing the inscription "MINUTE" or "HEURE," depending on which gong they strike.

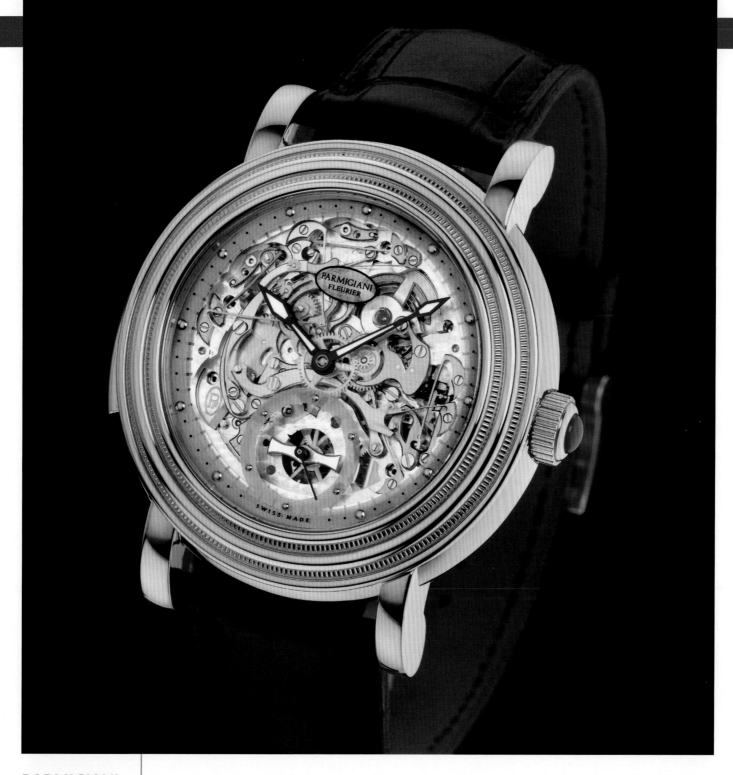

PARMIGIANI

TORIC QUAESTOR SKELETON – REF. PFH437-1002800

Parmigiani's Toric Quaestor Skeleton is powered by the PF355 caliber residing in its 46mm case, which is crafted in 18K rose gold and adorned with a ruby cabochon on the crown. The minute repeater chimes on two cathedral gongs with a chime rhythm regulator flywheel, and the piece possesses a device that disconnects time-setting while the chime is operating. The openworked dial possesses a sapphire crystal base. The piece is mounted on a Hermès alligator strap with a knurled rose-gold ardillon buckle.

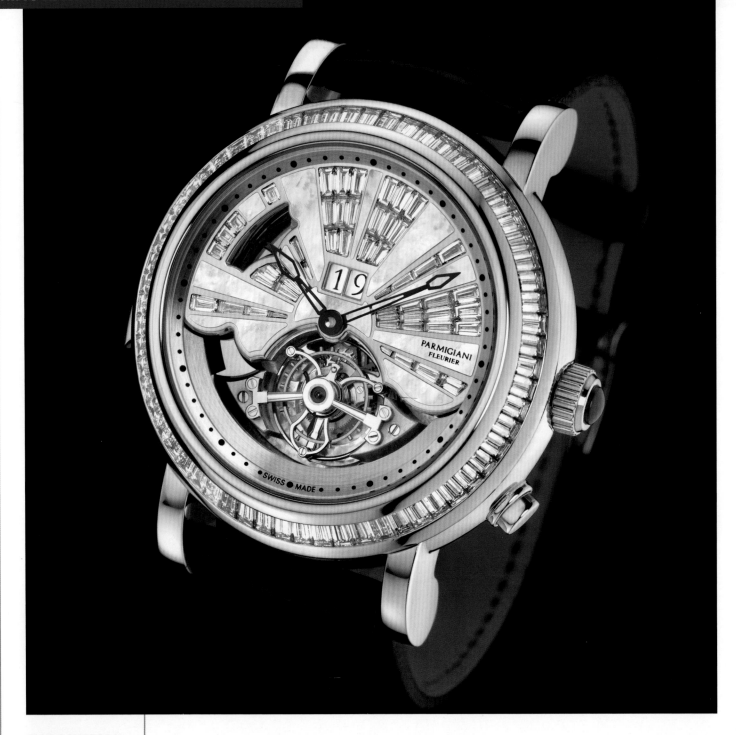

PARMIGIANI

TORIC WESTMINSTER LARGE DATE – REF. PFH412-2065200

Parmigiani's Toric Westminster Large Date is named for its Westminster chime, which sounds the hours, quarter-hours and minutes on four cathedral gongs. The watch displays hours, minutes and a large date, and a tourbillon resides on the lower half of the diamond-adorned dial. The piece's polished 950 platinum 46mm case houses a PF256 movement, and its bezel is set with 60 baguette-cut diamonds, totaling approximately 5.7 carats. The watch is mounted on an Hermès alligator leather strap with a platinum ardillon buckle.

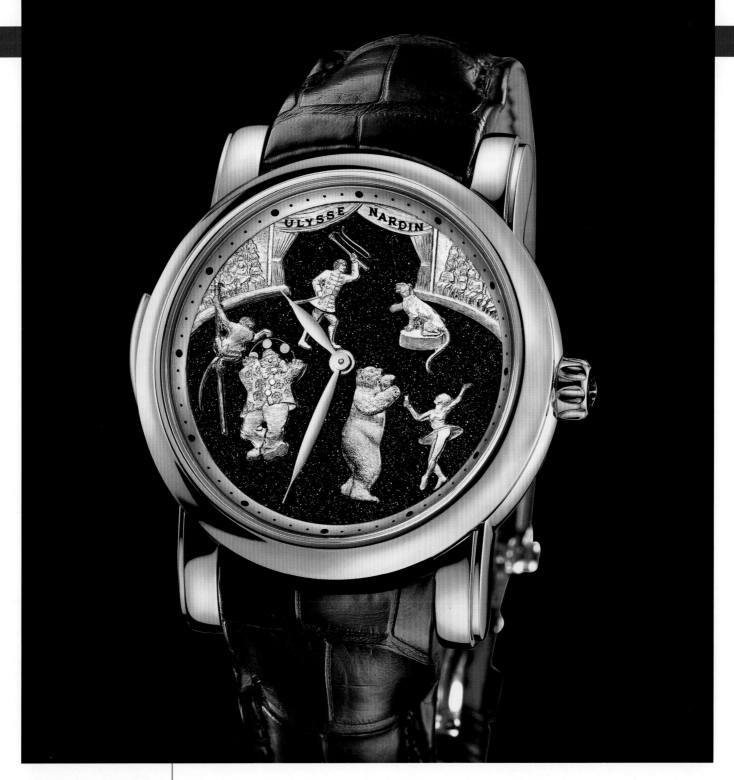

ULYSSE NARDIN

CIRCUS – REF. 740-88

The Circus parades four animated Jaquemarts in 18K white gold, as well as two distinct gongs for the minute repeater complication. An exhibition caseback reveals the UN-74 caliber and an aventurine dial further distinguishes this festive complicated piece. The Circus is available in a limited edition of 30 pieces.

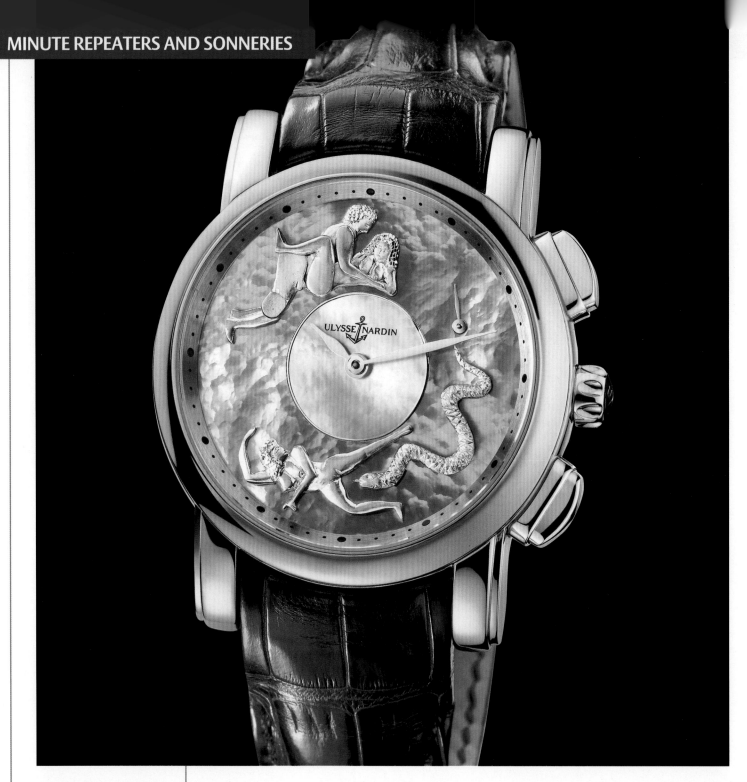

ULYSSE NARDIN

EROTICA – REF. 6119-103/P0-P2

Playful and provocative, the Erotica boasts automatic chime activation and utilizes platinum for its animated Jaquemarts and 42mm case. Powered by the UN-611 caliber, the Erotica is fitted with an exhibition caseback and is also available in 18K rose gold.

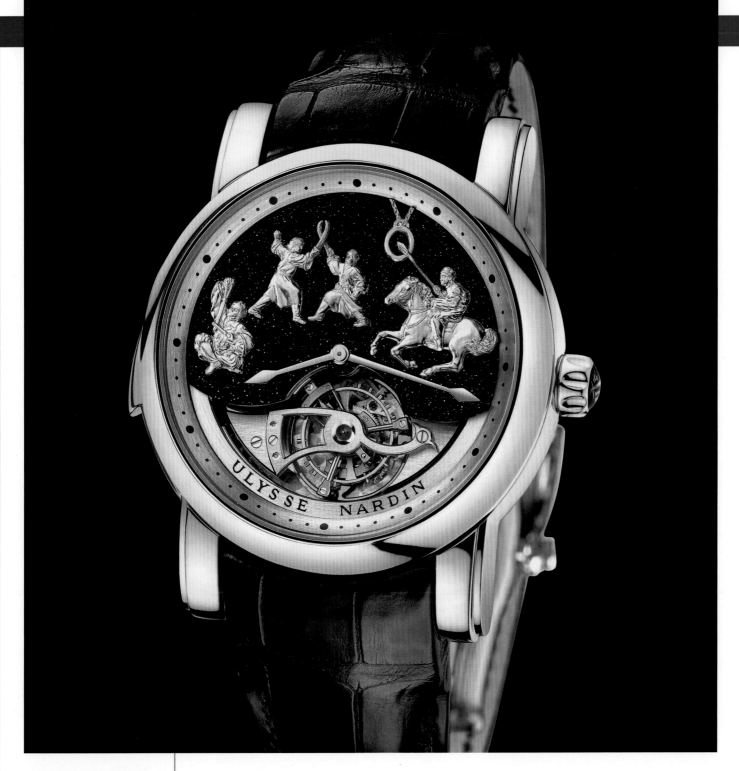

ULYSSE NARDIN

GENGHIS KHAN – REF. 789-80

The 42mm Genghis Khan Westminster Minute Repeater Carillon Tourbillon luxuriates in a platinum case. Powered by the UN-78 caliber, animated Jaquemarts battle on the aventurine dial. This minute repeater is available in a limited edition of 30 pieces.

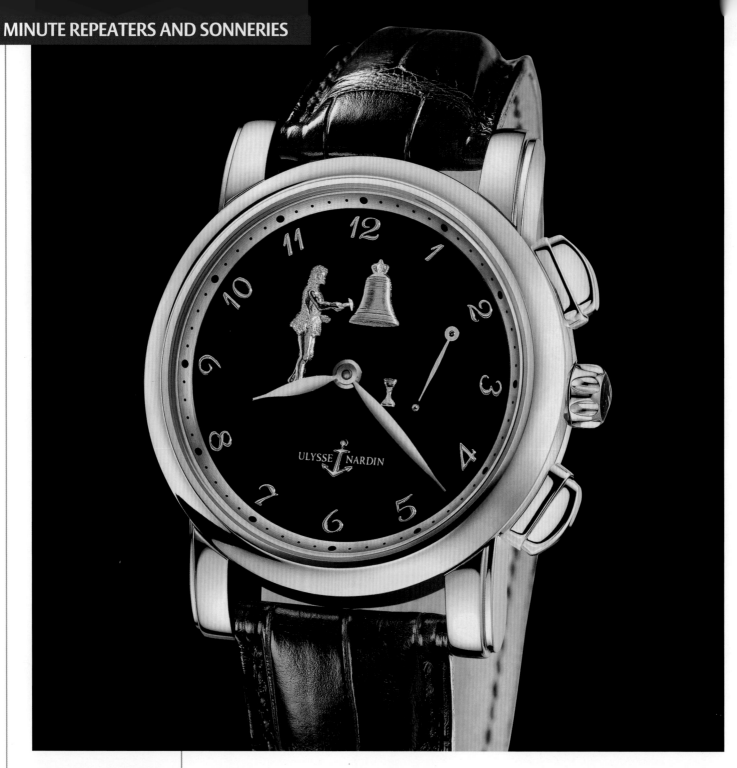

ULYSSE NARDIN

HOUR STRIKER – REF. 6106-103/E2

Ulysse Nardin's Hour Striker minute repeater features automatic chime activation and elegantly animated Jaquemarts. The UN-611 caliber is housed in a 42mm 18K rose-gold case, which is also available in platinum.

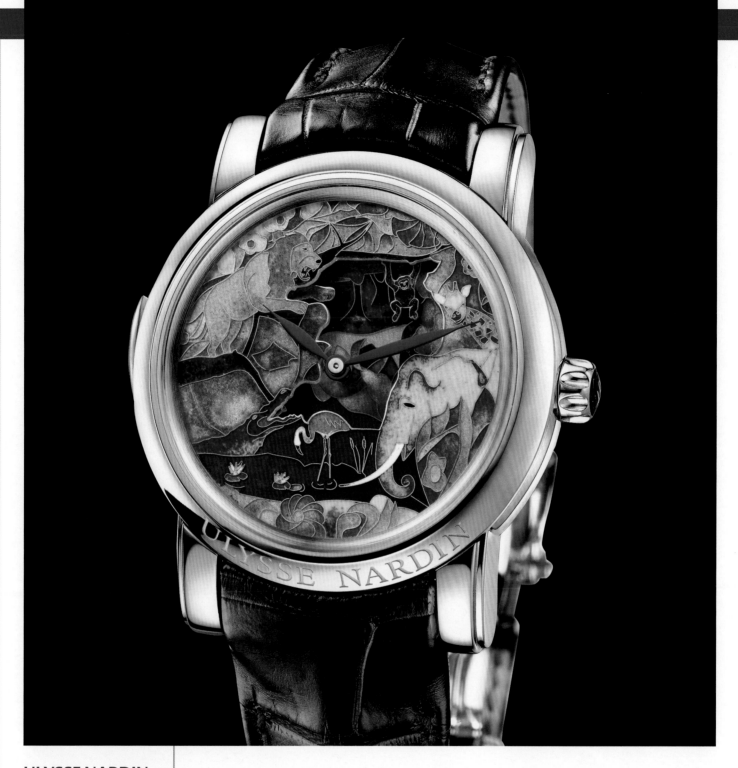

ULYSSE NARDIN

SAFARI – REF. 729-61

Wild as a jungle frolic, the Safari Minute Repeater is ornamented with two animated Jaquemarts on its cloisonné enamel dial. Bearing a UN-72 caliber movement, the Safari offers two distinct chimes and an exhibition caseback. The platinum 42mm case is also available in rose gold. This model is available in a limited edition of 50 pieces.

Moonphases

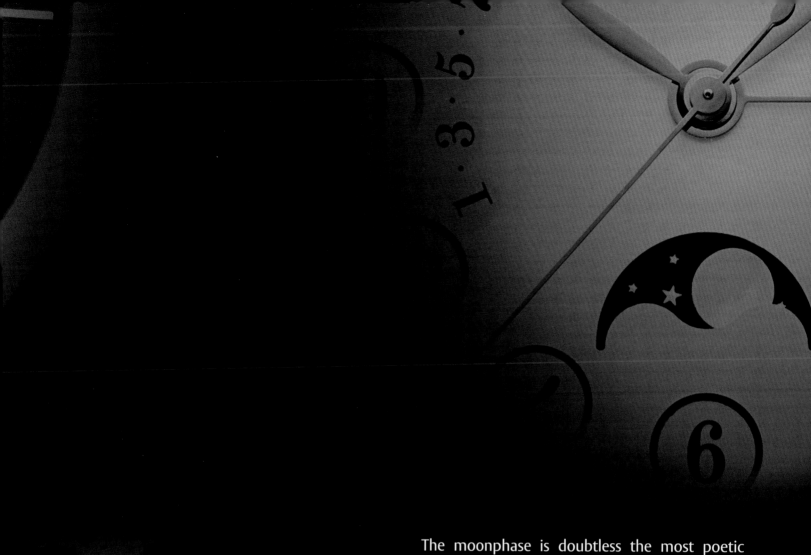

The moonphase is doubtless the most poetic of all complications. Together with the sun, it has inspired numerous calendar systems and was already featured on the first medieval mechanical clocks. The moonphase display is currently back in favor, and is indeed asserting itself as a full-fledged complication. New moon, first quarter, full moon, last quarter: the displays serve to depict the changing faces of the heavenly body throughout its 29.5-day cycle. Like an open window on the sky, it reminds us that our time is inextricably entwined with the great natural cycles.

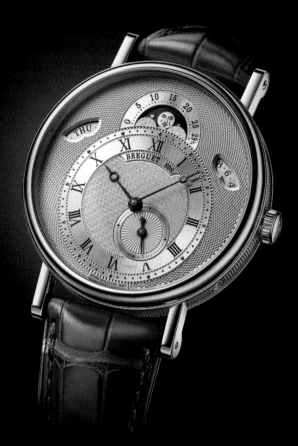

The movement of time has always been measured against the cadence of the seasons, and the path of the sun and moon. The first calendars were based on the straightforward observation of nature and stars, a technique that was gradually refined and perfected over time, to the point where Egyptians inferred from it a division of the year into twelve months, which we have inherited via the Greeks and the Romans. This organization probably in turn inspired the division of the days and nights into two sets of 12 hours. Despite the almost universal adoption of the Gregorian calendar, essentially based on the path of the sun, ancient lunar or lunisolar calendars (based on both the sun and the moon) remain extremely important in certain cultures, particularly in determining the date of traditional feast days and religious events, or for astrological calculations. Such is the case for example of the Chinese and Jewish lunisolar calendars. It also applies to the Muslin lunar calendar, in which the year is composed of 12 lunar months of 29.53059 solar days each—meaning 11 days fewer than the Gregorian calendar, which explains why the annual Ramadan period always begins ten days earlier than the previous year. The exact start of Ramadan is still determined in many countries by local observation of the first moon crescent. The moon also plays a role in the Christian religion, within which the mobile Easter date is traditionally set as the first Sunday after the first full moon following the spring equinox.

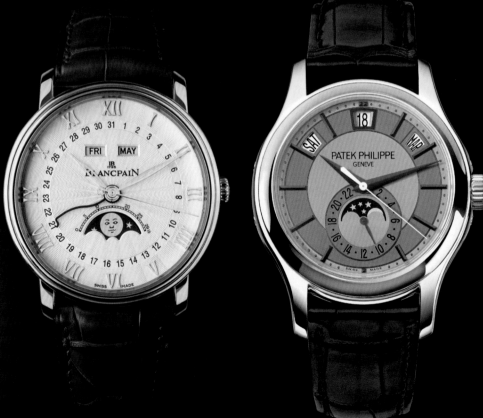

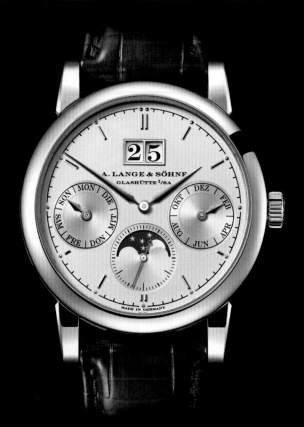

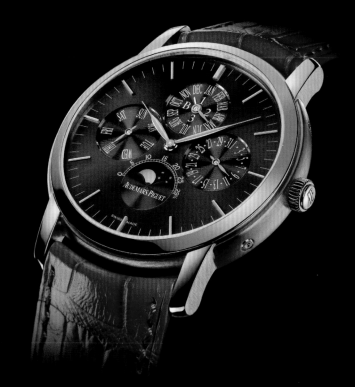

A WINDOW ON THE STARS

In Western civilization, the moonphase display is an essential part of the first large medieval clocks. It appears on the dials of the first pocket-watches in the 14th century, alongside other astronomical and astrological indications, and well before horologers were able to measure the minutes and later, the seconds. In the late 18th century, the great Abraham-Louis Breguet made ample use of it on various use of it on watches featuring various complications by creating pure and refined dials of a nature echoed by the recent Breguet Classique 7337, a wristwatch with an offset chapter ring, asymmetrical small seconds, moonphase and day of the week and date appearing in two windows at 10 and 2 o'clock. In 2010, Blancpain provided a masterful reinterpretation of the classic moonphase calendar tradition introduced in its Villeret collection and named Phase de Lune Demi-Savonnette. Il comprises a fully secured calendar mechanism with under-lug correctors and a red-gold half-hunter type case. In its Annual Calendar Ref. 5205 model, Patek Philippe chose a calendar requiring just one correction per year, at the end of February. The moonphase aperture at 6 o'clock is rimmed by a counter for the 24-hour indication. Meanwhile, A. Lange & Söhne and Audemars Piguet have opted to associate the moonphase with a traditional perpetual calendar on the Saxonia Annual calendar and Jules Audemars Perpetual Calendar, while Vacheron Constantin has done likewise and also added a column-wheel chronograph in its Patrimony Traditionnelle Perpetual Calendar Chronograph.

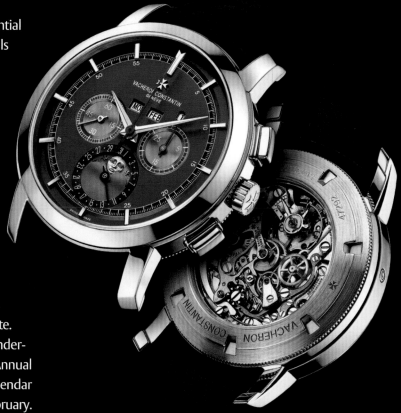

TOP LEFT
A. Lange & Söhne, *Saxonia Annual calendar*
TOP RIGHT
Audemars Piguet, *Jules Audemars Perpetual Calendar*
ABOVE
Vacheron Constantin, *Patrimony Traditionnelle Perpetual Calendar Chronograph*

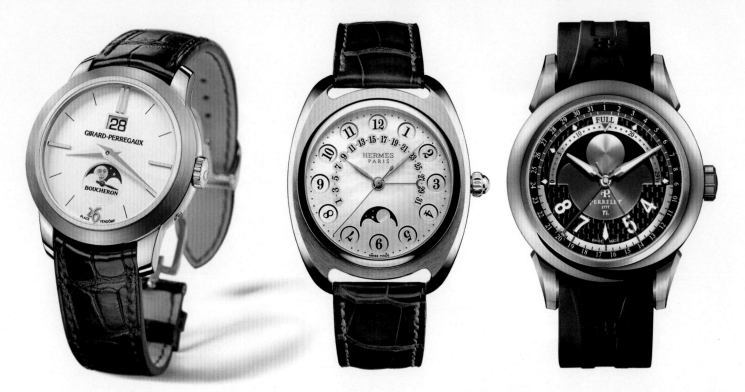

A GROWING ROLE

Nonetheless, in recent years the moonphase seems to have broken free of the "straitjacket" of the perpetual or complete calendar, and of its role as an indispensable accessory, instead establishing itself as a full-fledged complication in its own right. While maintaining its traditional position at 6 o'clock, some watchmakers have chosen to give it a higher-profile role by combining it with a simple date display. This is the path chosen by Girard-Perregaux pour Boucheron, a limited edition developed by the Swiss watchmaker for the Parisian jeweler, in which the small seconds merges with the moonphase in a

single subdial at 6 o'clock. The date display—in a large window at 12 o'clock on this particular model—can also be treated to an original stage setting. On the Dressage Platinum Moon Phase model by Hermès, for example, the retrograde pointer-type date display moves across the arc of a circle between 8 and 4 o'clock, surrounding the moonphase aperture at 6 o'clock.

In leaving its conventional central position in the lower part of the dial, the moonphase sometimes moves firmly up to a highly visible location at 12 o'clock. The Geneva-based brand Frédérique Constant has enriched its range of proprietary movements by launching the Heart Beat Manufacture Automatic Moon Phases & Date watch, notably issued in a version featuring a silicon escape-wheel; the moonphase aperture at 12 o'clock, at the very center of a pointer-type date display, overarches the "heartbeat" opening serving to admire the balance. Perrelet gives pride of place to the night orb in its Grande Phase de Lune centrale, featuring an aperture occupying the entire upper half of the dial. This watch, with its titanium case, carbon-pattern dial and pointer-type date display, is also equipped with an "age of the moon" display showing the number of days that have elapsed since the last new moon.

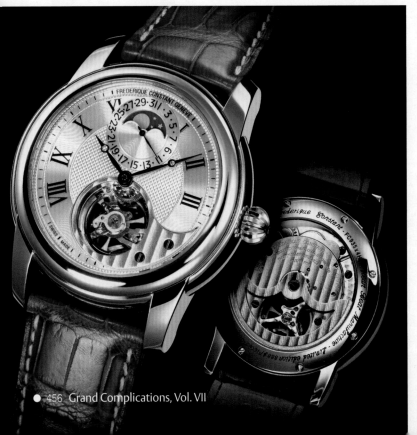

TOP LEFT
Girard-Perregaux, *pour Boucheron*

TOP CENTER
Hermès, *Dressage Platinum Moon Phase*

TOP RIGHT
Perrelet , *Grande Phase de Lune centrale*

LEFT
Frédérique Constant, *Heart Beat Manufacture Automatic Moon Phases & Date*

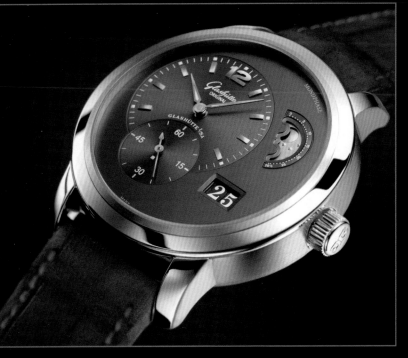

MOONSTRUCK

Another notable current trend is for the moonphase to leave its symmetrical position along the vertical axis of the dial in order to take up an offset position that enables the creation of timepieces with resolutely original and dynamic faces. Glashütte Original provides a refined example with its PanoMaticLunar XL: the moonphase display through an aperture at 2 o'clock serves to punctuate an asymmetrical dial face composed of an off-set hour, minute and small seconds display on the left, and a large date on the right, all appearing against an elegantly restrained galvanic-coated gray dial. Zenith's Grande Class Tourbillon Moonphase combines the proprietary El Primero chronograph caliber with a moonphase appearing through a window at 9 o'clock, thus leaving space for an offset left-hand hour, minute and seconds display. On the Premier Perpetual Calendar, Harry Winston has chosen to reveal the moonphase through a small minimalist opening in the offset hour, minute and seconds display, echoing the leap-year indication on the other side of the dial.

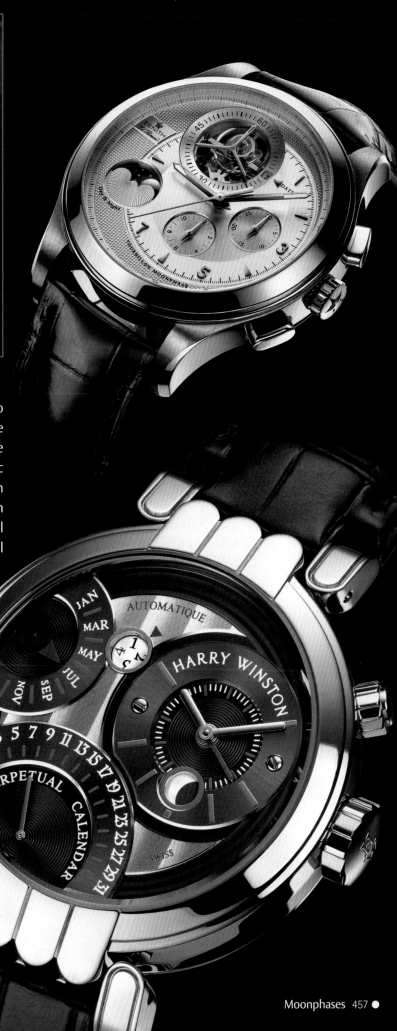

TOP LEFT
Glashütte Original, *PanoMaticLunar XL*
TOP RIGHT
Zenith, *Grande Class Tourbillon Moonphase*
RIGHT
Harry Winston , *Premier Perpetual Calendar*

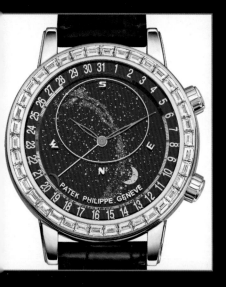

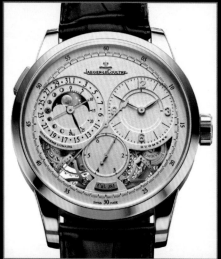

VARIATIONS ON A THEME

The disc/aperture system can give rise to various technical and aesthetic variations, often yielding exquisitely poetic results. Equipped with a mobile sky chart, the extremely complex Celestial by Patek Philippe provides a perpetual view of the exact configuration of the night sky as viewed from the Northern Hemisphere, complete with the visible movement of the stars and the moonphases, as well as the moon's position in the sky. A golden ellipse placed beneath the sapphire crystal serves to delineate the portion of the sky visible above Geneva and of all cities located along the same latitude—a stunning heavenly vision on the wrist. Representing another spectacular showcase for such horological achievements, the Pontos Décentrique Phases de Lune by Maurice Lacroix features a broad opening between 2 and 5 o'clock, where two superimposed disks reveal the moonphases and the day/night indication. Several recent timepieces also distinguish themselves by providing simultaneous displays of the moonphases in both hemispheres. While this is not a major technical feat in itself, since it simply involves revealing both moons which are in any case present on most mobile discs, it certainly adds an original touch to a dial. The same applies to Duomètre à Quantième Lunaire by Jaeger-LeCoultre, which is equipped with a Dual-Wing movement based on two independent energy sources—one for precision and the other for the functions—displays the moonphase in both the Southern and Northern Hemispheres. A double moon also appears on the Horological Machine n° 2-SV by MB&F, which features a rectangular case with two separate dials: the right-hand one for jumping hours and retrograde concentric minutes; and the left-hand one for the retrograde date as well as the moonphases in both hemispheres.

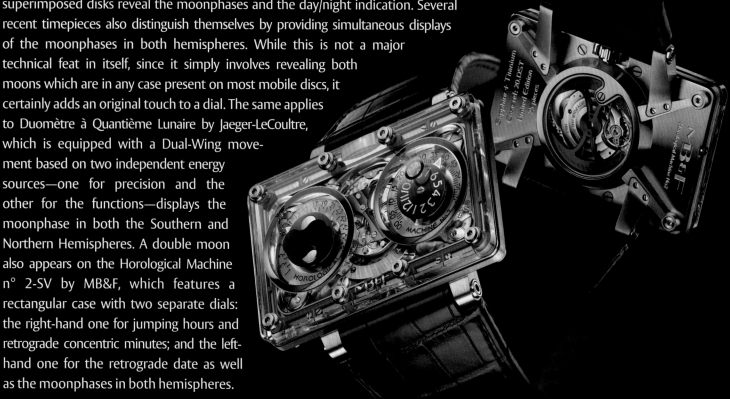

A STARRING ROLE

Alongside apertures cut out to form a traditional "double-axe" motif, there are also some that are as round as the full moon; these systems are generally fitted with a mobile cover acting like the shadow the Earth casts on the moon and thus serving to represent its changing faces throughout the synodical revolution. These round apertures are increasingly used on large displays that make the moon the star of the dial's show, such as L'Eclipse by Jaquet Droz, on which the moon, with a smiling face inspired by 19th-century engravings, is alternately hidden or revealed behind a matte black mobile disc that makes a striking contrast with the glossy absolute black of the grand feu enamel dial.

Other brands, albeit very few, prefer to give free rein to their imagination and invent new ways of depicting the lunar cycle. On the latest models in its B25 collection, De Bethune has chosen a three-dimensional approach with a patented "spherical" indication system. At 12 o'clock, two half-spheres—one in steel and the other in platinum—are nested, polished and flame-blued by hand. Steel is naturally colored by oxidation, while platinum retains its natural color. Thomas Prescher has also adopted the "ball-type" approach in his Mystérieux Tourbillon Double Axe Automatique. Enthroned at the top of an almost square case revealing only the tourbillon—the rest of the movement remaining hidden beneath the bezel—sits a three-dimensional moon framed by two hour and minute drums.

FAR LEFT TOP
Jaquet Droz, *L'Eclipse*
FAR LEFT BOTTOM
Thomas Prescher, *Tourbillon Double Axe Automatique*
LEFT
De Béthune , *DB25 Ciel étoilé*

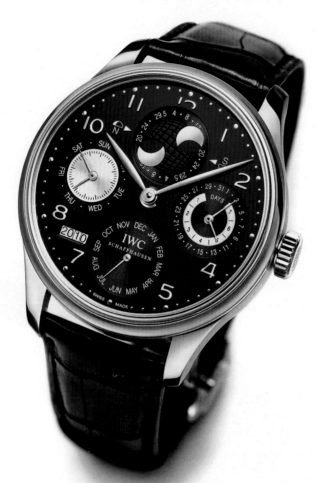

EXTREMELY VARIABLE PRECISION

Even though they are all based on an identical principle, not all aperture-type moonphase displays show the same degree of accuracy. On an ordinary moonphase, the disc bearing the two moons is driven by a 59-toothed wheel corresponding to two lunar cycles (2 x 29.5 days). This system results in a discrepancy of 44 minutes and 2.8 seconds per month, corresponding to one full day every 2 years, 7 months and 20 days, approximately. High-end watches are equipped with a far more complex and accurate device called "astronomical moon" comprising a 135-toothed wheel. The difference between the mechanism and the real lunar cycle amounts to one day in 122 years and 44 days. But on its Portuguese Perpetual Calendar, IWC has further enhanced this degree of precision thanks to an innovative system comprising three toothed wheels and reducing the gap to one day in 577 years! This quest for precision has also been taken up by A. Lange & Söhne on its 1815 Phases de Lune, for which it has developed a gear train fitted with a particular gear ratio serving to guarantee a one-day difference in 1,058 years! Only H. Moser & Cie has so far matched this performance with its Moser Perpetual Moon. As for the True Moon by Arnold & Son, it claims to provide a precise reproduction of the waning and waxing phases of the moon while following the exact duration of synodical periods.

TOP LEFT
IWC, *Portuguese Perpetual Calendar*

TOP RIGHT
Arnold & Son, *True Moon*

RIGHT
A. Lange & Söhne, *1815 Phases de Lune*

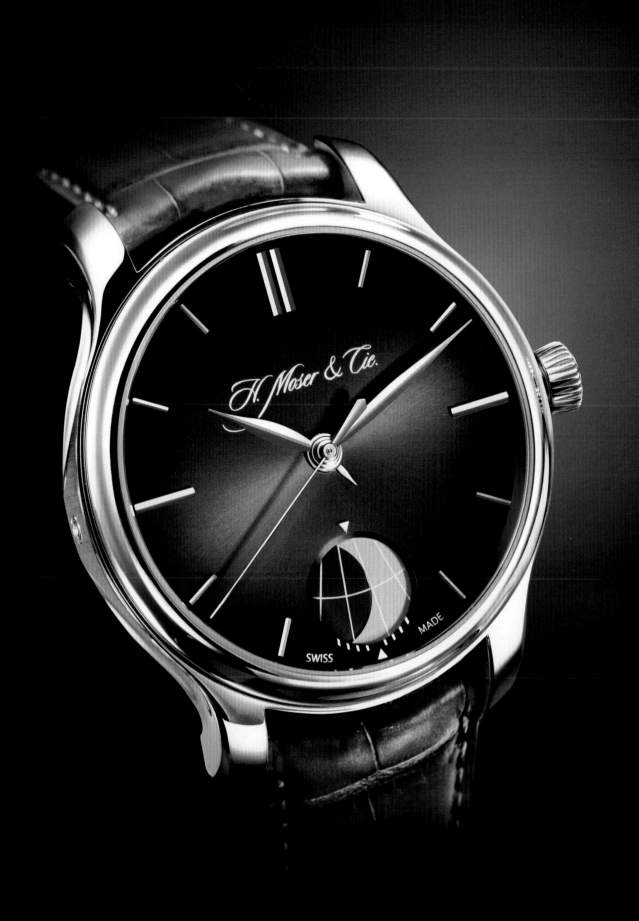

H. Moser & Cie , *Moser Perpetual Moon*

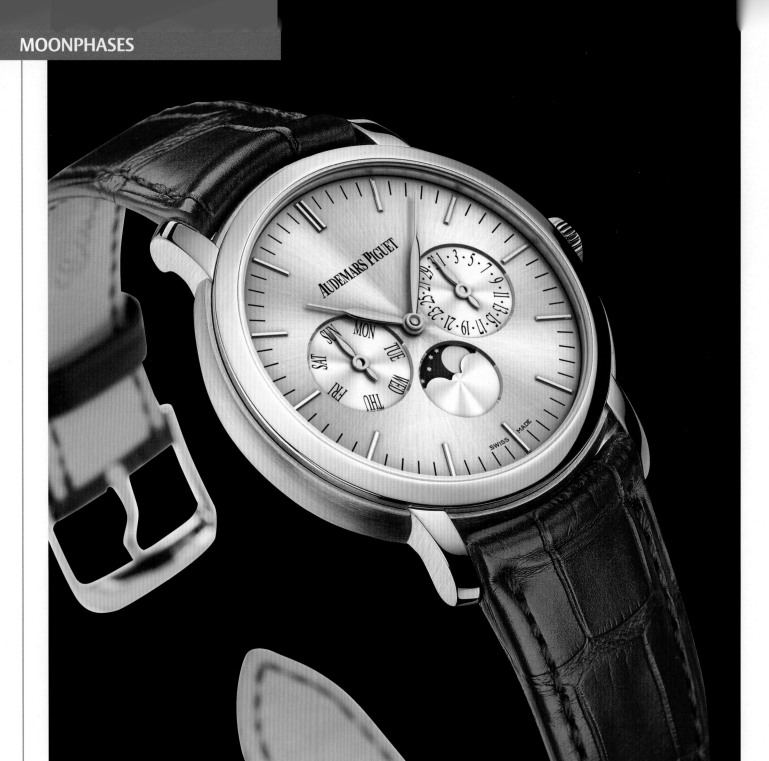

AUDEMARS PIGUET

JULES AUDEMARS MOON-PHASE CALENDAR – REF. 26385OR.OO.A088CR.01

The Jules Audemars Moon-Phase Calendar watch reveals the full measure of this pure form. The pink-gold case and slender bezel ensure maximum dial opening and thus enhance readability. The date and moonphase displays are surrounded by a decorative fillet highlighting the snailed inner decoration. The date, day and moonphase are some of the most useful watch functions in daily life. In this model, beauty also lies beneath the dial. All the bridges are beveled, polished and adorned with Côtes de Genève, and the mainplate is circular-grained.

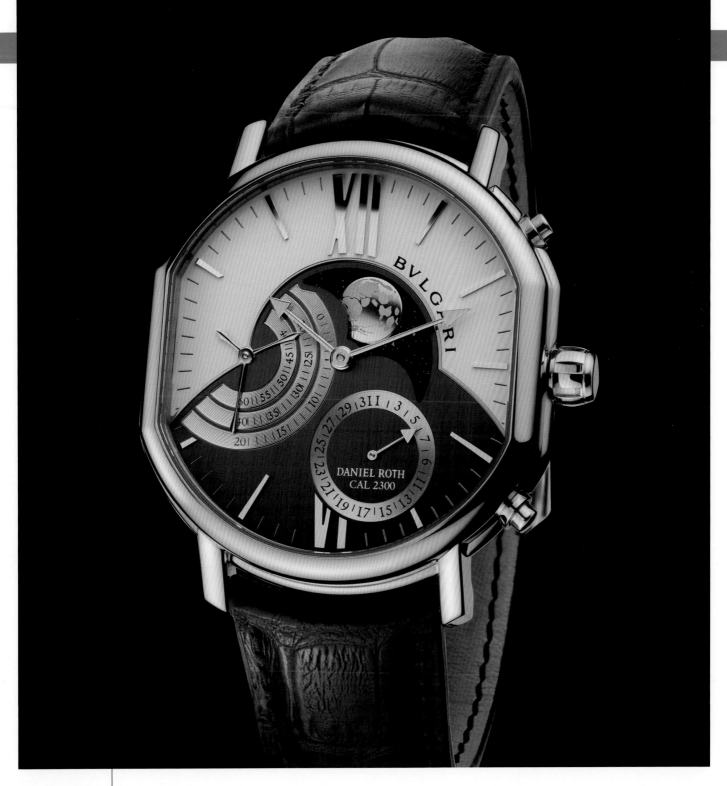

BVLGARI

GRANDE LUNE – REF. BRRP46C14GLDMP

Positioned on a depiction of the night sky, the central gold-coated moon is revealed through an asymmetrical opening topping the extremely original seconds indication, which is composed of three arms of varying lengths spinning on a single axis and respectively covering three 30-second segments. The dial displays the date on a graduated circle subdial, and the lunar cycle and date functions are easily adjusted using the two corrector pushpieces on the side of the slender elliptical rose-gold case. The entire set of functions is driven by the generously sized DR Calibre 2300, a Lépine-type mechanical manual-winding Frédéric Piguet movement enriched with an exclusive Daniel Roth complication.

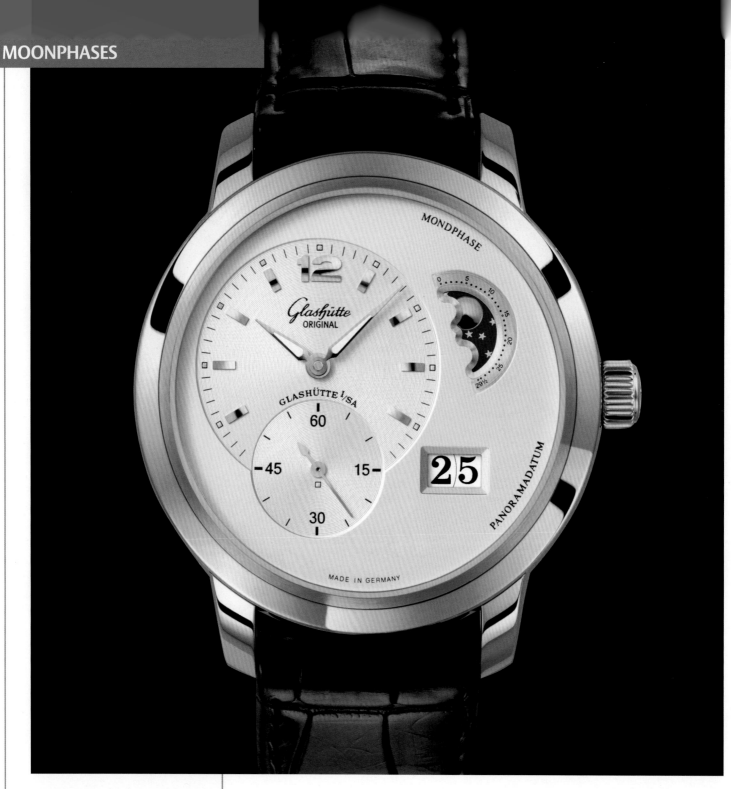

GLASHÜTTE ORIGINAL

PANOMATICLUNAR XL – REF. 90.02.34.11.05

The PanoMaticLunar XL presents the classic lines and look of the PanoMatic XL models in an understated, eloquent form. Set within the galvanized matte gray dial are the characteristic off-center hour/minute and small seconds subdials, finely milled and galvanized in the same dark gray hue. The elegant moonphase display presents a silver moon and stars against a fine-grained silver sky. The 42mm stainless steel case offers both polished and satin-finished surfaces and is held securely in place by a gray alligator strap. At the heart of the new PanoMaticLunar XL is the Caliber 90-02 automatic movement with its off-center skeletonized rotor. Its finely finished elements—the three-quarter plate, duplex swan-neck fine adjustment, Glashütte ribbing and sunburst decoration—are clearly visible through a sapphire crystal caseback.

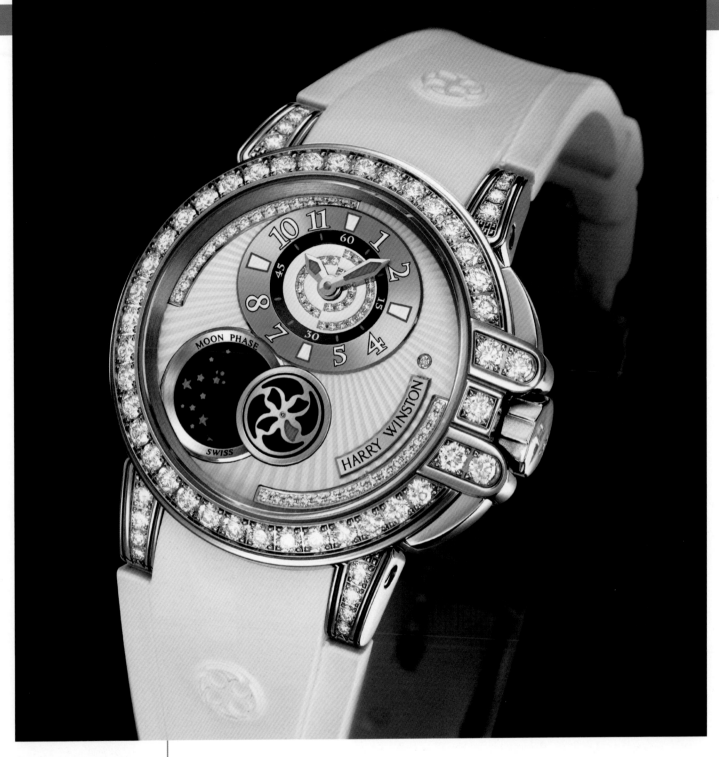

HARRY WINSTON

LADY Z – REF. 400/UAMP36ZL.WDC/D3.1

Clothed in Zalium® that is both gem-set and polished, a first for this metal with its distinctive sheen, this feminine interpretation of time is sprinkled with diamonds forming parentheses on either side of the dial and highlighting the time indications. Around the off-center hour at 12:00, precious stones form a sparkling target from which everything else seems to radiate. The sunburst guilloché silvered dial features the contemporary moonphase display beneath a matte black mask that progressively reveals a constellation of stars. Available in coral, lilac, fuchsia or turquoise variations, the watch is driven by a self-winding movement with a 42-hour power reserve and delicate finishing that may be admired through the sapphire crystal caseback.

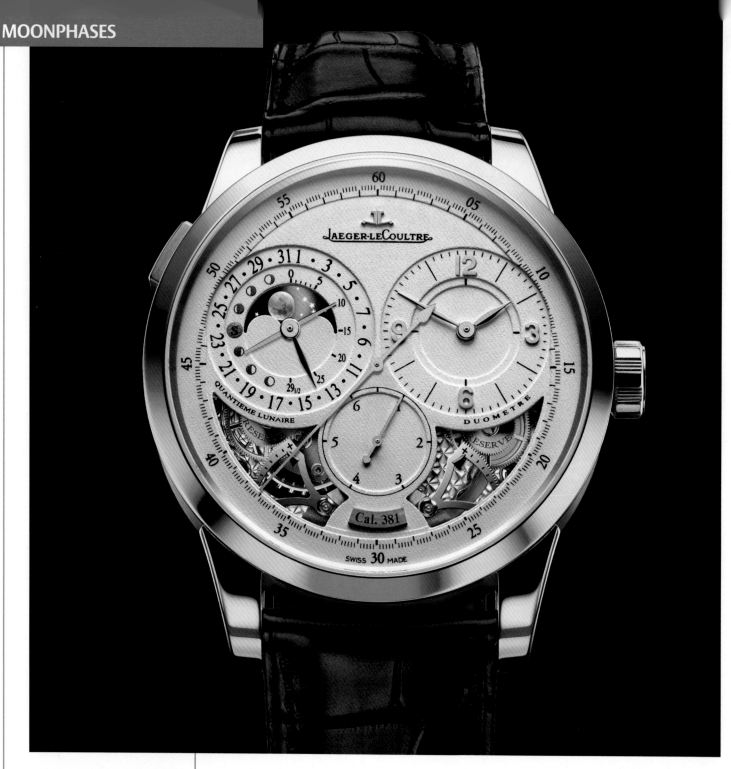

JAEGER-LeCOULTRE

DUOMETRE A QUANTIEME LUNAIRE – REF. 604.24.20

The partially openworked dial of the Duomètre à Quantième Lunaire allows a peek at its exceptional manual-winding Jaeger-LeCoultre 381 caliber, which comprises 369 components and provides 50 hours of power reserve. Hours and minutes are displayed in a subdial at 2:30, and jumping seconds complete the time indication. A subdial at 9:30 indicates the date, as well as the moonphase in the North and South Hemispheres. The 42mm pink-gold case reveals the movement through a sapphire crystal caseback and is water resistant to 50m. A chocolate brown alligator strap completes the ensemble.

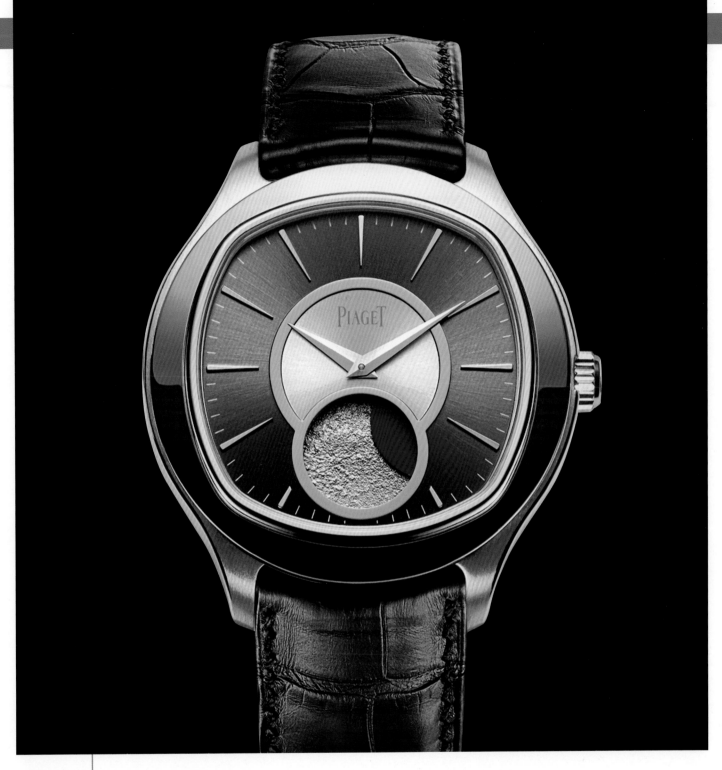

PIAGET

PIAGET EMPERADOR COUSSIN MOON PHASE – REF. G0A34022

This model is a paragon of purity and understatement, featuring a generous 46.5mm case with an original and attractive moonphase display at 6:00. With its broad opening measuring 12mm in diameter, this large moon reveals a wealth of subtle craftsmanship exercised on a heated gold plate featuring reflections symbolizing moon craters. The moonphase indication is provided by a mobile mask that gradually uncovers the white-gold moon disc, before covering it up again. This complication beats to the rhythm of the new Calibre 860P, a self-winding movement. In addition to its approximately 72-hour power reserve, it features Piaget's signature finishes such as circular Côtes de Genève motifs, a circular-grained mainplate, beveled bridges, and blued screws.

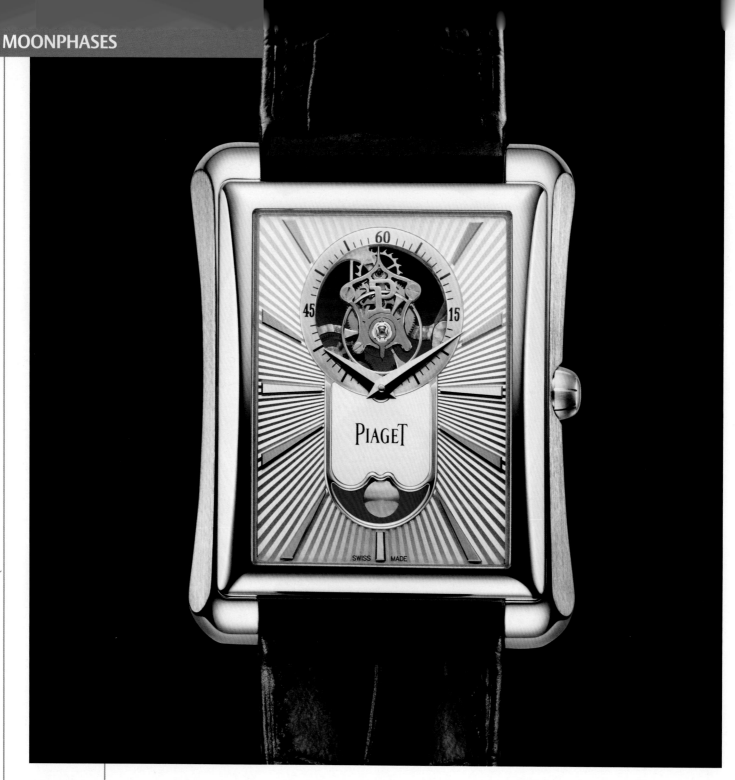

PIAGET

PIAGET EMPERADOR TOURBILLON MOON PHASE – REF. G0A35121

The Piaget Emperador Tourbillon Moonphase houses a Calibre 640P, an ultra-thin hand-wound mechanical tourbillon measuring 3.5mm. This tourbillon maintains the sophisticated lines and finishings of the Piaget Emperador watches, but offers a more powerful and masculine size. The movement was created at the Piaget manufacture, and the carriage of this tourbillon—visible through a dial opening at 9:00—consists of 42 parts and weighs a mere 0.2g. A moonphase display appears at 6:00 on a sunburst guilloché dial, with 18K white-gold appliqués. The lapis lazuli moonphase disc is enhanced by a golden moon and a pyrite star-studded dial.

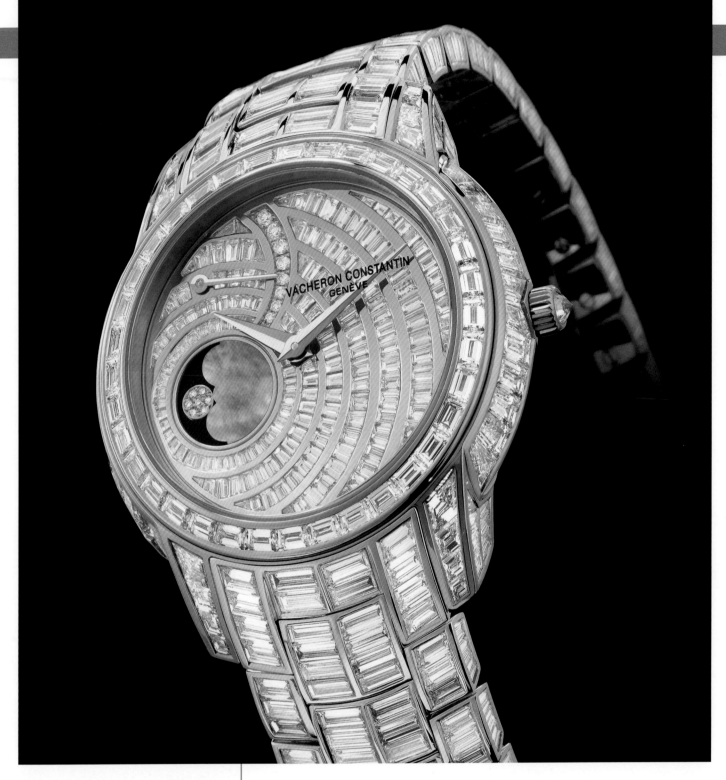

VACHERON CONSTANTIN

KALLA LUNE – REF. 83630

The newest addition to the Kalla collection is the Kalla Lune complication. Its hand-wound mechanical movement, Caliber 1410, bears the prestigious Hallmark of Geneva. On the dial is the power reserve display and moonphase display set with 14 diamonds (0.03 carat). The case is set with 158 baguette-cut diamonds (13.6 carats), and its winding crown is set with one diamond (0.1 carat). The dial is set with 170 baguette-cut diamonds and nine brilliant-cut diamonds (2.82 carats). Kalla Lune's 18K white-gold case measures 40.5mm in diameter, and its deployment clasp is set with eight baguette-cut diamonds (0.38 carat).

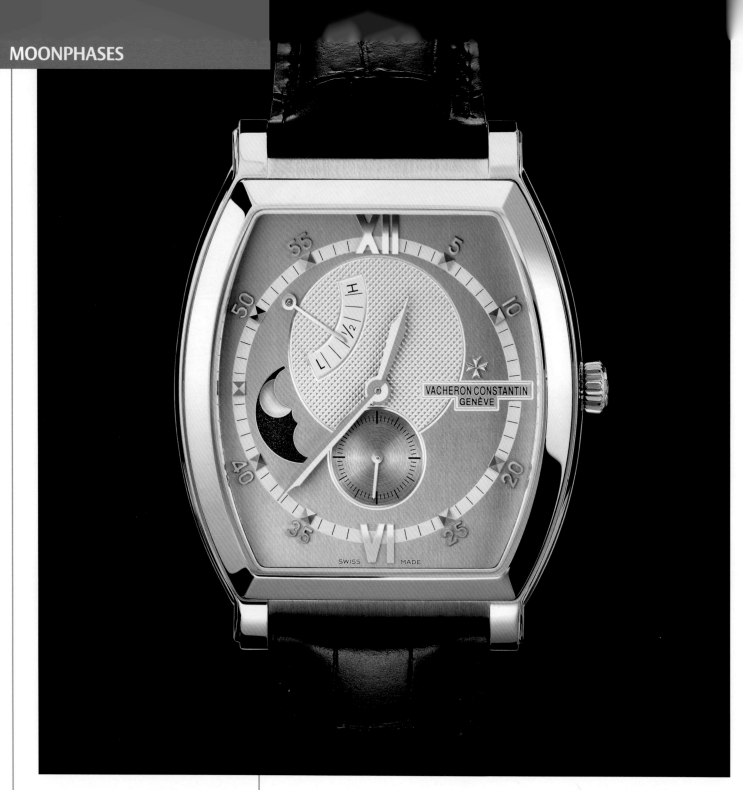

VACHERON CONSTANTIN

MALTE MOON PHASE AND POWER RESERVE – REF. 83080

The Malte Moon Phase and Power Reserve is available in a case of 18K white gold or 5N pink gold. The satin-brushed caseback is secured by screws and the dial is protected by a glareproofed cambered sapphire crystal. Guaranteed water resistant to a depth of 30 meters, this timepiece is fitted with a square-scale alligator-leather strap in black for the white-gold model and chestnut brown for the rose-gold model; each strap is equipped with a gold folding clasp matching the case.

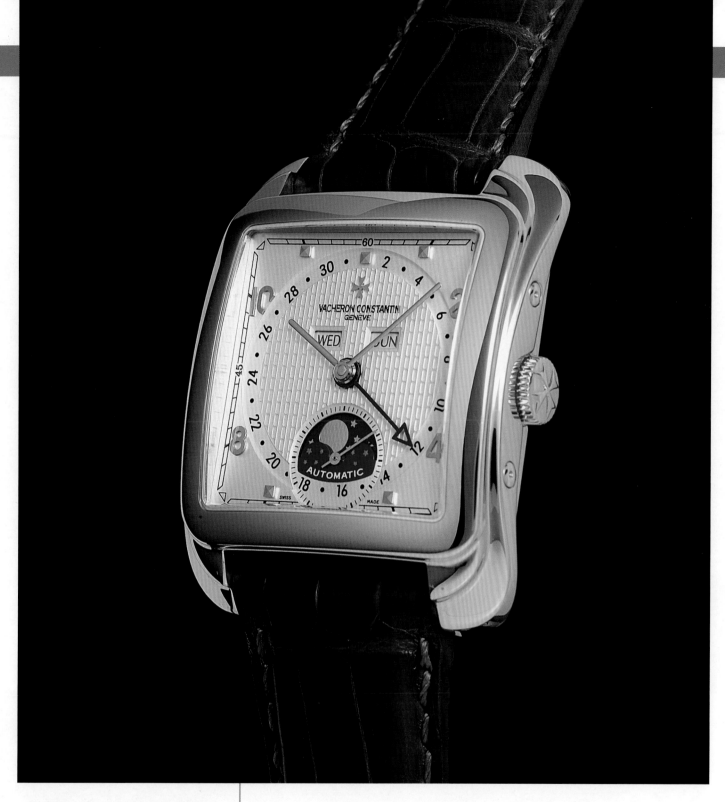

VACHERON CONSTANTIN

TOLEDO 1952 – REF. 47300

This Toledo 1952 is crafted in 18K pink gold and houses the mechanical manual-winding Vacheron Constantin Caliber 1125. Beating at 28,800 vph, the complicated movement is equipped with 36 rubies and offers 40 hours of power reserve. In addition to small seconds, the watch offers a full calendar (date, day, month, moonphase). The three-piece square case is fitted with a curved sapphire crystal, is water resistant to 3atm, and is secured with a hand-stitched alligator strap with pink-gold clasp.

WED 18

CERTIFIED
CHRONOMETER

30

Diving

CHRON...
AUTOMATIC
5000FT/1500M

PROFESSIONAL
500 METERS
HELIUM VALVE
AUTOMATIC

MADE

Since the development of nautical sports in the 1950s, the world's seabeds have inspired an impressive range of innovations developed by watchmakers and engineers. No other field has engendered so many technological breakthroughs in such a short space of time. Contact with water challenges the watch industry in a variety of complex ways: the difficulties involved in guaranteeing water resistance, readability and resistance to pressure, as well as ensuring that divers' timepieces are both functional and secure, have fuelled relentless research that has resulted in solutions that have proven valuable for the entire sector. Today's divers' watches are indeed considered by both professionals and many customers as the epitome of sturdiness and reliability. Even though a majority of them are more regularly subjected to the chlorine in swimming pools than pressure at great depths, they are nonetheless enjoying ever-growing success and pushing brands to ever further extremes.

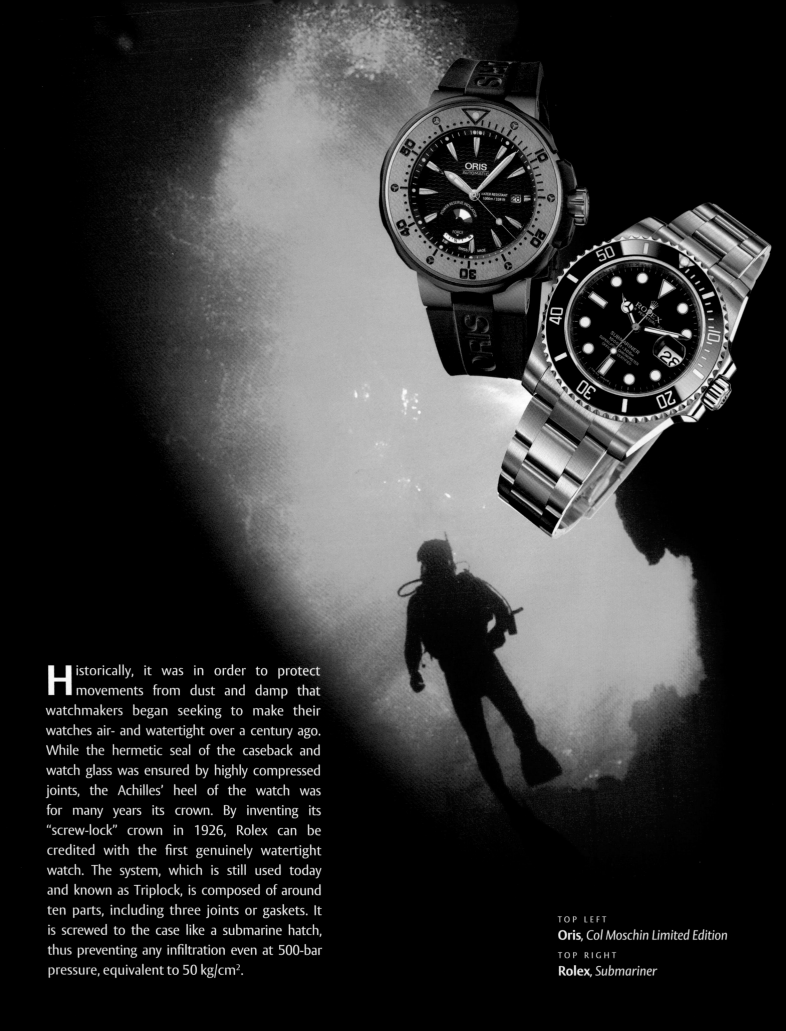

Historically, it was in order to protect movements from dust and damp that watchmakers began seeking to make their watches air- and watertight over a century ago. While the hermetic seal of the caseback and watch glass was ensured by highly compressed joints, the Achilles' heel of the watch was for many years its crown. By inventing its "screw-lock" crown in 1926, Rolex can be credited with the first genuinely watertight watch. The system, which is still used today and known as Triplock, is composed of around ten parts, including three joints or gaskets. It is screwed to the case like a submarine hatch, thus preventing any infiltration even at 500-bar pressure, equivalent to 50 kg/cm^2.

TOP LEFT
Oris, *Col Moschin Limited Edition*
TOP RIGHT
Rolex, *Submariner*

AN OYSTER ON THE WRIST

Rolex named its star collection after the famous mollusk known for its keenly protective role. In 1953, the crowned brand created a watch for Professor Auguste Piccard and which accompanied his bathyscaph, Trieste, to a depth of 3,150 meters. In 1960, the Deep Sea Special even descended to 10,916 meters in the Pacific Ocean Mariana Trench. The latter watch returned to the surface intact after undergoing a pressure of one ton per square centimeter. In addition to equipping explorers and scientists, the first watches were also worn by the armed forces. Such was in particular the case for the Officine Panerai watches of the 1930s and 1940s, intended for the Italian Navy, with their luminescent dial indications and their famous crown system guaranteeing water resistance to 200 meters. The navy divers' watch niche is still exploited by certain brands, including Oris. For example, the watchmaker's new Col Moschin Limited Edition is named after the special Italian forces who tested it in real-life situations. This imposing 49mm-diameter watch is equipped with a graduated tungsten bezel equipped with the Rotation Safety System, which means the user has to lift it up in order to adjust it.

The 1950s witnessed a boom in water sports that led to the emergence of the first series-made divers' watches. Rolex set the tone in 1953 with its famous Submariner, which was water resistant to 100 meters (compared with 300 meters today). That same year, Blancpain launched its Fifty Fathoms, created in cooperation with two French naval officers of the special "combat divers" unit. This watch, initially water resistant to 50 fathoms (91.45m)—hence its name—is distinguished by its black dial, bezel and strap. Blancpain subsequently revisited it by creating a collection including a flyback chronograph with pushpieces that are watertight and operational to a depth of 300 meters. The range has also been extended to include an all-white self-winding model, the 500 Fathoms—water resistant to 1,000 meters—and in 2010, the Fifty Fathoms Flyback Chronograph Complete Calendar and Moon Phase watch in steel.

In 1956, Breitling launched the SuperOcean, a divers' watch with a monohull case and armored glass that was water resistant to 200 meters; and in 2006, the brand celebrated the 50th anniversary of this great sporting model by offering the SuperOcean Héritage watch, also introduced in a chronograph version. In 2010, the SuperOcean, now water resistant to 1,500 meters, made a colorful comeback with a series of five watches featuring blue, yellow, red, silver or black inner bezels. Meanwhile, Rolex has reaffirmed its supremacy in the underwater world by its recent launch of the Sea-Dweller Deepsea, a model water resistant to a mind-boggling 3,900 meters! To withstand such colossal pressures as those exercised at such depths, this exceptional instrument features a new patented case structure named Ringlock, involving a virtually indestructible nitrogen-alloyed stainless steel support ring set inside the case middle, between the glass and the back. The double wristband extension system ensures an extremely comfortable fit over all kinds of diving suits. The chronometer-certified movement is equipped with the Rolex Parachrom balance spring, which is resistant to both shocks and magnetic fields.

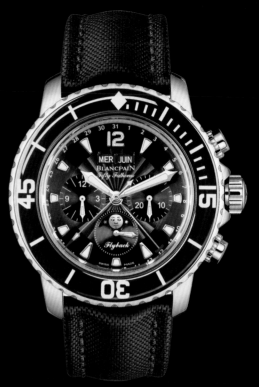

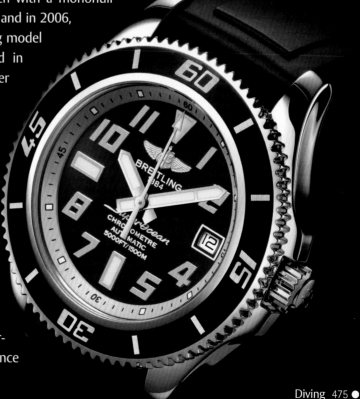

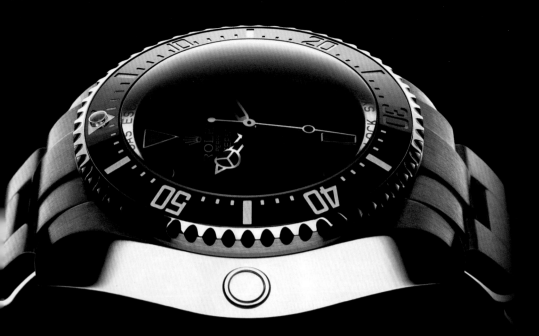

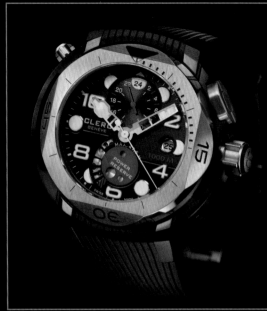

SURVIVAL INSTRUMENTS

To earn the title of divers' watch, not only must a timepiece display well above-average water resistance (minimum 100 meters), generally guaranteed by the screw-lock crown and screw-down caseback, but it must also offer all the indispensable functions for amateur or professional divers. These include a rotating bezel to keep track of immersion times, equipped if possible with a unidirectional rotation system that avoids any accidental deregulation of the programmed time. The dial generally features large numerals and clearly visible hands, abundantly covered with a luminescent substance. The metal bracelet or rubber strap is often fitted with an extension system enabling it to be worn over diving suits. The most high-performance models are equipped with a helium valve. This extremely volatile gas, used to facilitate breathing inside hyperbaric chambers, can easily seep into the cases and must at all costs be vented when the diver returns to the surface so as to avoid any risk of overpressure.

Using these various attributes as a point of departure, brands currently offer a broad choice of divers' watches, ranging from casual chic models mainly intended for cocktails by the swimming pool, to professional models equipped to withstand extreme depths. In a techno-deluxe style, Clerc Genève offers a Hydroscaph model that is water resistant to 1,000 meters.

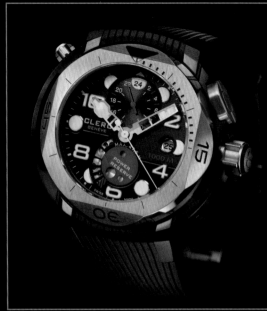

TOP LEFT
Rolex, *Sea-Dweller Deepsea*
TOP RIGHT
Clerc, *Hydroscaph Big Date Power Reserve*
RIGHT
Chanel, *J12 Marine*

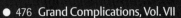

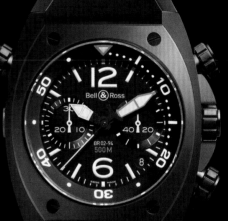

Its 2010 version is housed in a DLC-blackened steel case topped by a brushed titanium bezel, and equipped with an automatic helium valve and a 4mm-thick sapphire crystal, as well as lateral reinforcements. Meanwhile, Chanel has celebrated the 10th anniversary of its J12 model by launching a maritime version for men, complete with a 42mm-diameter black ceramic case with a black or blue dial. The J12 Marine is water resistant to 300 meters and delivered with a rubber strap.

Graham, the brand with British origins and now based in La Chaux-de-Fonds, has introduced an updated version of its Chronofighter, based on a left-hand function activation system initially developed for World War II fighter pilots who found it easier to handle a pusher and crown placed on the left-hand side of the case, due to their cumbersome gloves. In 2010, this divers' chronograph is interpreted in four new versions: the Chronofighter Oversize Diver Deep Black, Deep Purple, Turbo et Turbo Tech. All are water resistant to 330 meters and equipped with a helium valve. The BR 02-94 Carbon Chronograph from Bell & Ross is another example of a divers' model fitted with a decompression valve. Its shot-peened 44mm black steel watch is water resistant to 500 meters. Because of the inherently sporty context, watchmakers often equip divers' timepieces with chronograph functions, but it is nonetheless well worth mentioning that most of these instruments, even perfectly "watertight" ones, cannot be activated while diving, since this might enable water to seep in through the pushers. Breitling has achieved a major breakthrough in this field with the Avenger Seawolf Chrono, introduced in 2010 in a Blacksteel version, and the only chronograph to be fully water resistant and operational at a depth of 1,000 meters. To achieve this, the brand has developed a patented magnetic pushpiece device with controls operating through the metal of the case, thus avoiding any direct contact between the pushpiece and the movement.

TOP LEFT
Graham London, *Chronofighter Oversize Diver Deep Black*

TOP RIGHT
Breitling, *Avenger Seawolf Chrono*

RIGHT
Bell & Ross, *BR 02-94 Carbon Chronograph*

NEW LAUNCHES

While more accustomed to regatta watches such as the famous Admiral's Cup, Corum has now launched its first ever full-fledged divers' watch. Created to mark the 50th anniversary of the collection, the Admiral's Cup Deep Hull 48 is water resistant to 1,000 meters and issued in a 500-piece titanium limited edition, and another 255-piece series in PVD-blackened steel. Speaking of anniversaries, IWC has chosen to create a model in tribute to Jacques-Yves Cousteau, who would have been 100 years old in 2010. A partner of the Cousteau Society since 2003, IWC accordingly launched the Aquatimer Chronograph Jacques-Yves Cousteau Edition, the fifth special edition of this collection. The generously sized 44mm steel case is water resistant to 120 meters and carries Cousteau's signature and portrait on the back. Audemars Piguet has meanwhile also presented its own Self-winding Royal Oak Offshore Diver watch. Driven by Calibre AP 3120, this divers' watch has an antimagnetic steel case that is water resistant to 300 meters and a rotating inner bezel adjustable via a crown at 10 o'clock.

In 2010, Omega, which had revived its iconic 1970s Ploprof watch (designed for professional divers) the previous year, extended the line by introducing an all-white Seamaster Ploprof 1200M model, driven by a movement with a co-axial escapement and a helium valve; a safety pushpiece serves to release the bezel and rotate it in either direction, then lock it into the chosen position, thereby avoiding any accidental handling during the dive itself. In autumn 2009, the brand also presented a new Seamaster Planet Ocean Liquidmetal® Limited Edition, with a bezel combining black ceramics and Liquidmetal®—two ultra-hard materials that are highly resistant to scratching and corrosion. Also in 2009, Richard Mille made a big splash in the underwater world by presenting its first divers' watch, the RM025 with chronograph and tourbillon. The brand now returns to this category with a slightly smaller (47mm) round watch, the RM 028. The latter is equipped with a skeletonized self-winding movement fitted with a variable-geometry rotor that adjusts winding to match the user's degree of activity. Richard Mille has also issued a limited edition engraved with the emblem of the Voiles de St Barth sailing competition.

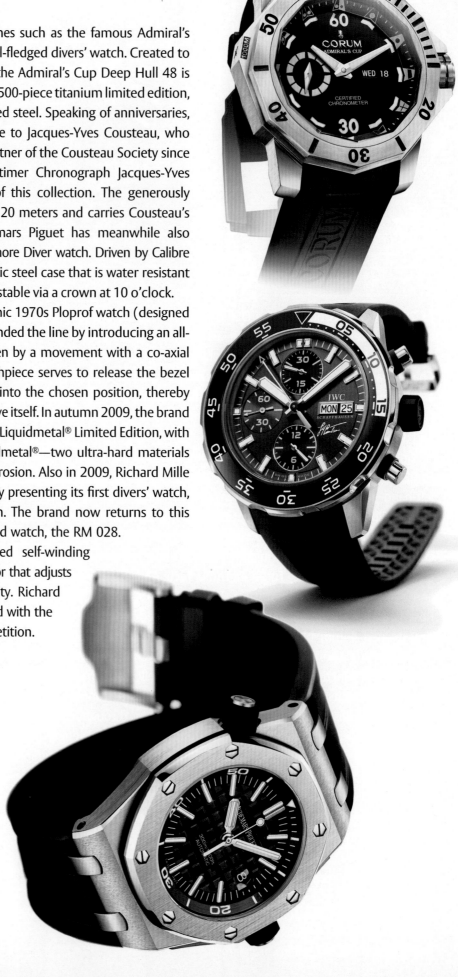

TOP RIGHT
Corum, *Admiral's Cup Deep Hull 48*

RIGHT CENTER
IWC, *Aquatimer Chronograph Jacques-Yves Cousteau Edition*

RIGHT
Audemars Piguet, *Self-winding Royal Oak Offshore Diver*

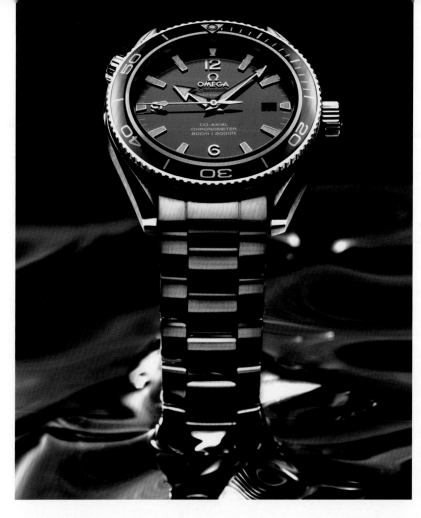

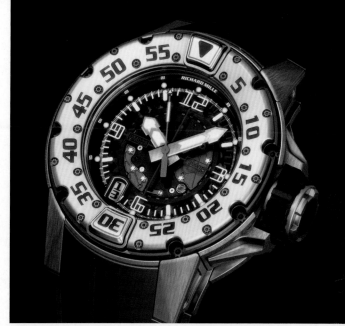

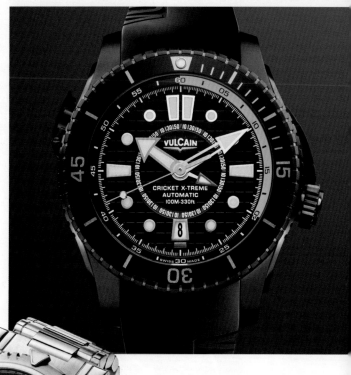

Among divers' watches, there are more and more models equipped with an alarm function serving to provide an audible reminder of the end of a dive time—such as the Cricket X-Treme Automatic by Vulcain, driven by the new Cricket V-21 alarm movement. Another maritime model is the Breguet Marine Royale 5847, which belongs to a line relaunched in 2004 and inspired by the watches that the brand's founder created for the French Royal Navy. Its alarm is operational underwater to a depth of 300 meters.

TOP LEFT
Omega, *Seamaster Planet Ocean Liquidmetal® Limited Edition*

TOP RIGHT
Richard Mille, *RM 028*

ABOVE
Vulcain, *Cricket X-Treme Automatic*

FAR LEFT
Omega, *Seamaster Ploprof 1200M*

LEFT
Breguet, *Marine Royale 5847*

OPTIMAL READABILITY

In recent years, we have been seeing the grand return of a function that is not specifically horological as such, but is nonetheless extremely useful to divers: the depth gauge, or bathymeter. It serves as an alternative to—or rather as complementary to—the electronic wrist chronographs that are pouring onto the market. The Master Compressor Diving Pro Geographic Navy SEALs by Jaeger-LeCoultre is water resistant to 300 meters and distinguished by a mechanical depth gauge located on the left side of the case and fitted with a membrane that expands or contracts according to the degree of water pressure to which it is subjected. The movements of this membrane act on a large arrow-tipped hand by means of a clever transmission system that is partially visible on the dial. The depths measured range from 0 to 80 meters. Jaeger-LeCoultre has also paid tribute to its partnership with the US Navy SEALs—the elite American military combat divers' unit—by creating two other divers' watches in limited series: the Master Compressor Diving Chronograph GMT Navy SEALs, with chronograph and dual time zone display; and the Master Compressor Diving Alarm Navy SEALs with alarm function.

Moreover, certain brands devote particular efforts to the field of visibility. At depth of 75 meters and under, daylight gives way to ever-greater darkness the further one descends. Divers' watches must thus ensure perfect readability by means of large numerals and hour markers, as well as by an effective luminescent substance. For its Engineer Hydrocarbon Spacemaster model, Ball Watch uses micro-tubes of gas guaranteeing 20 years of luminosity one hundred times more intense than other technologies. It is based on cutting-edge Swiss technology consisting of capturing tritium in a gaseous state within tiny glass tubes. Light energy is given off by molecules striking the colorful inner surface of the capsules. For its Deep Dive model, Luminox uses the same micro-tubes tinted in blue, the very last color that the human eye is capable of perceiving from a certain depth downwards.

BELOW LEFT
Jaeger-LeCoultre, *Master Compressor Diving Pro Geographic Navy SEALs*
BELOW RIGHT
Ball Watch , *Engineer Hydrocarbon Spacemaster*

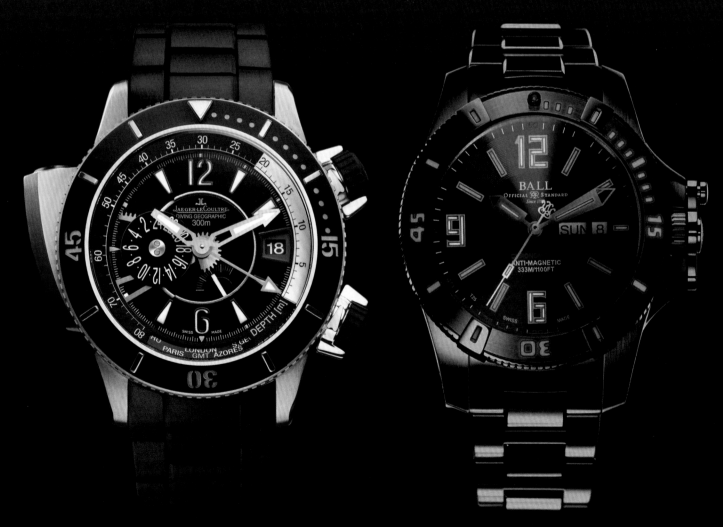

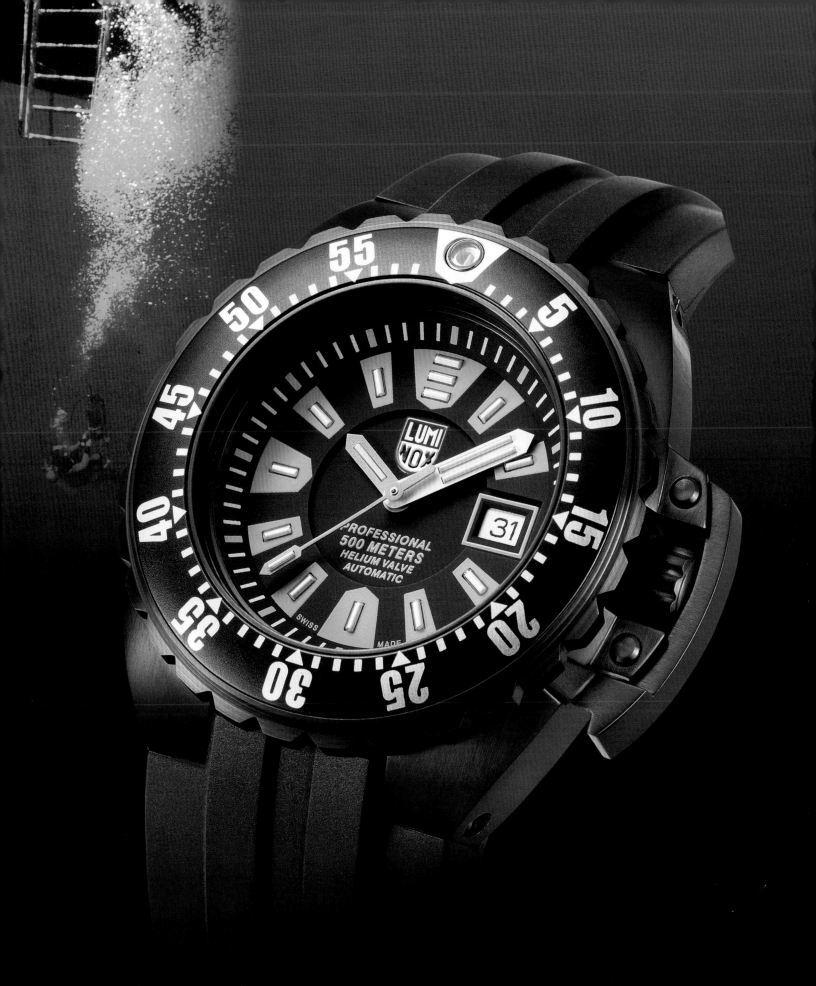

Luminox, *Deep Dive*

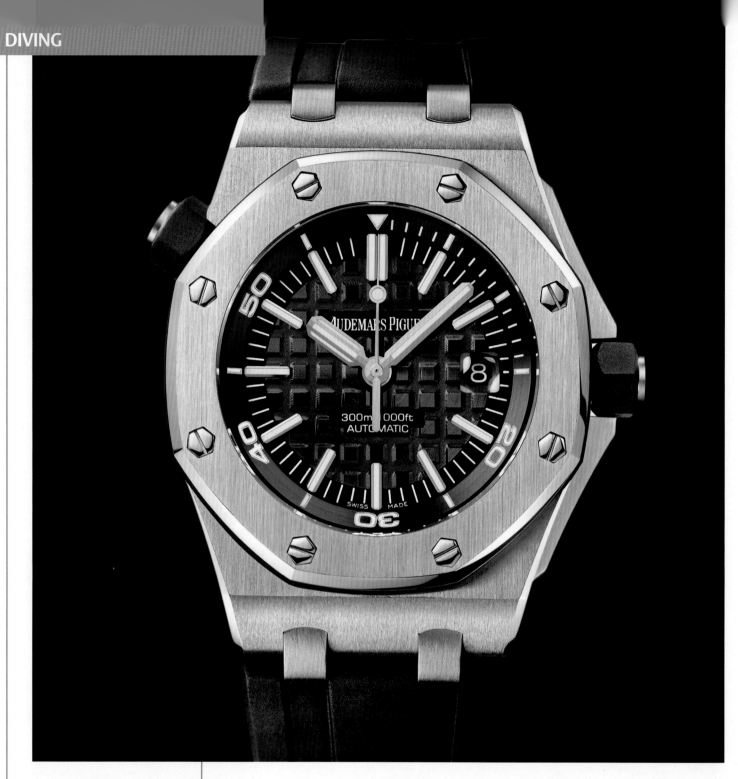

AUDEMARS PIGUET

ROYAL OAK OFFSHORE DIVER – REF. 15703ST.OO.A002CA.01

For its diver's watch, Audemars Piguet has opted for a pared-down approach. The Royal Oak Offshore Diver is equipped with the Manufacture Audemars Piguet automatic 3120 movement with a 22K gold oscillating weight decorated with the Audemars and Piguet family crest. The case components—particularly the gaskets, the thickness of the back and that of the crystals—have been adapted to guarantee water resistance to depths of 300m. Its exclusive black "Mega Tapisserie" dial, which has a inner rotating ring with diving scale, applied luminescent hour markers and hands in white gold, displays hours, minutes, dive-time measurement and date. The model is available on a black rubber strap with oversized stainless steel pin buckle.

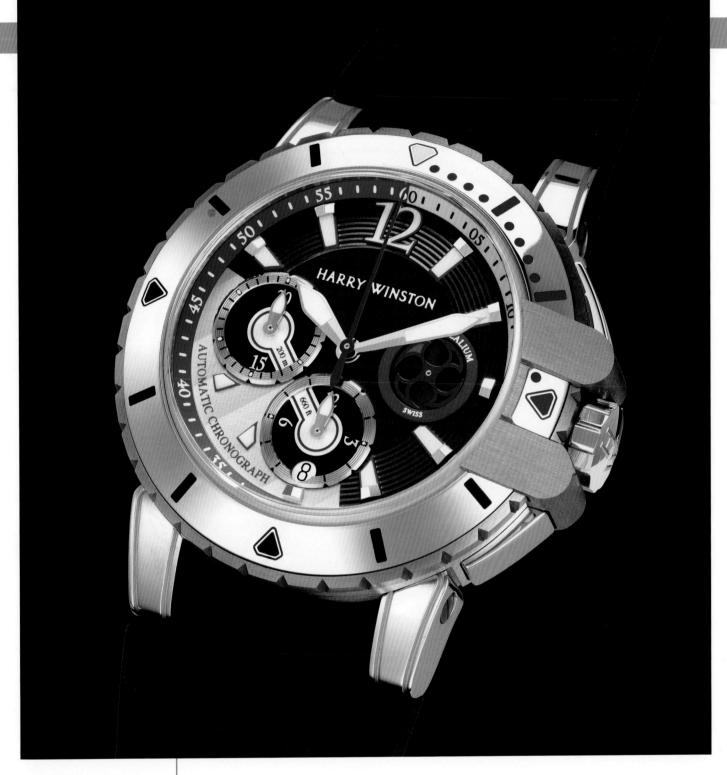

HARRY WINSTON

OCEAN DIVER – REF. 410/MCA44WZBC.KB

The Ocean® collection is designed to host the Harry Winston sport watches featuring radically innovative designs. At 3:00, the shuriken, a little star composed of four branches (rose gold or red) and inspired by martial arts, rotates to the rhythm of the small seconds hand, indicating that the movement is working perfectly. Moreover, the mobile attachment lugs, a hallmark of Harry Winston timepieces, have been developed to tilt to 30° in order to better fit the wrist. For the casing, Harry Winston's craftsmen of the House have once more skillfully combined materials that symbolize the brand: Zalium and white gold for the case, white gold for the pushpieces, crown, bezel and lugs.

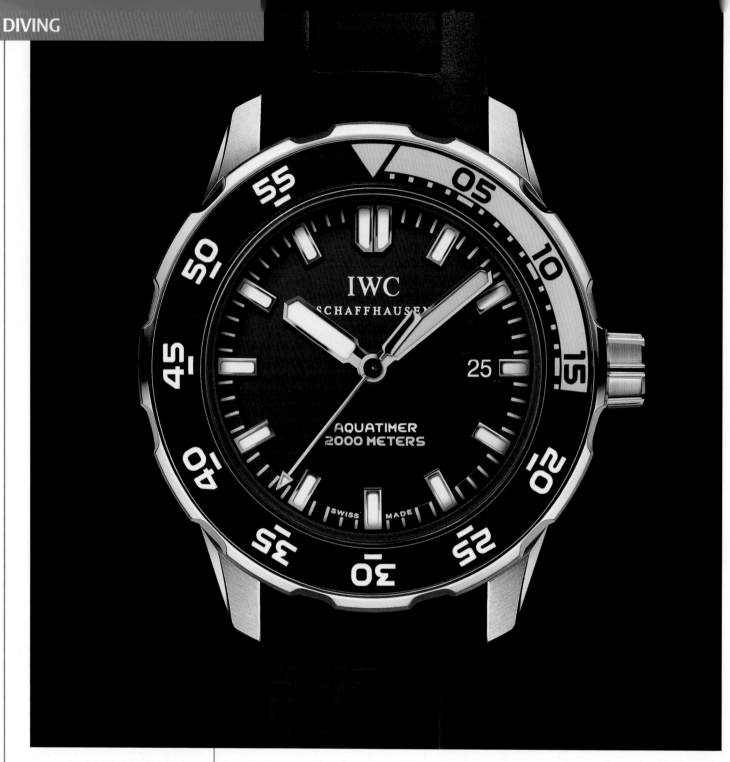

IWC SCHAFFHAUSEN

AQUATIMER AUTOMATIC 2000 – REF. IW356802

The Aquatimer Automatic 2000, with its tested pressure resistance to 200 bar, still holds the horological record for water resistance. Its automatic 30110 caliber contains 40 jewels, beats at 28,800 vph and offers 21 hours of power reserve. The stainless steel watch features a rhodium-plated black dial and a black external mechanical rotating bezel with the familiar luminous yellow 15-minute segment of the previous Aquatimer. Yellow is also used for the minute hand, which indicates the dive time, to ensure a clear distinction. A second variant has a white dial with orange or white numerals on a white or dark blue background on the rotating bezel and an orange hour hand. Shown here on a black rubber strap, the Aquatimer Automatic 2000 is also available on a stainless steel bracelet.

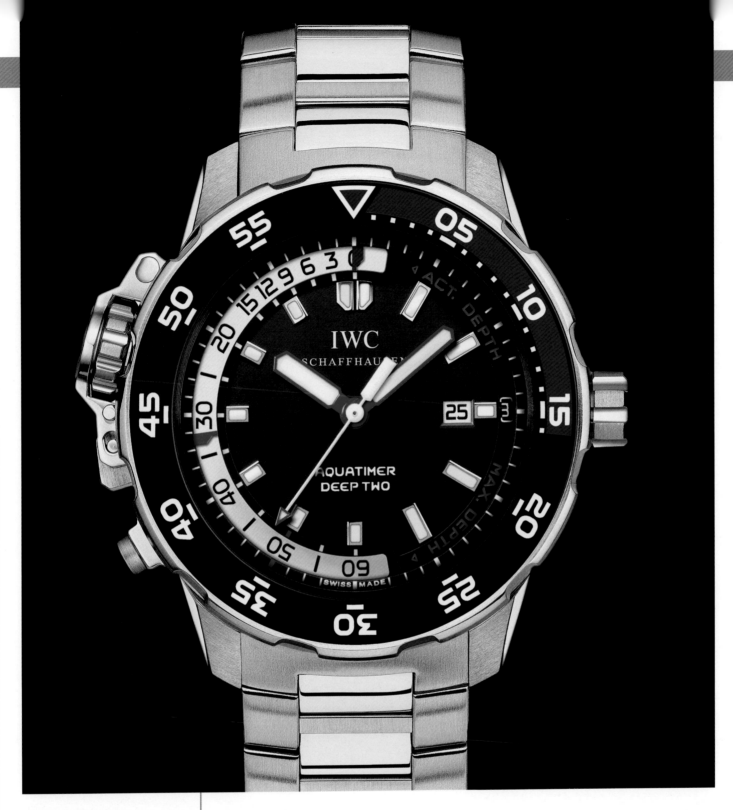

IWC SCHAFFHAUSEN

AQUATIMER DEEP TWO – REF. IW354701

The Aquatimer Deep Two boasts a 46mm case that is pressure resistant to 12 bar. The watch shows not only the actual dive depth, but also the maximum depth reached during a particular dive, doubling as a complete second safety system alongside the dive computer. The Aquatimer Deep Two features a semi-circular indicator on the dial, which records depths down to 50 meters. Its pressure-measurement system is contained in a second large crown on the left side of the case. The water pressure acts directly on a membrane inside this crown and forces a pin into the interior of the case, triggering a system that results in the depth indicator (blue) moving over the white measuring field as the depth of water increases or decreases. The maximum depth indicator (red) always remains at the greatest depth reached. It can be released by a button underneath the depth-gauge sensor crown on the left side of the case.

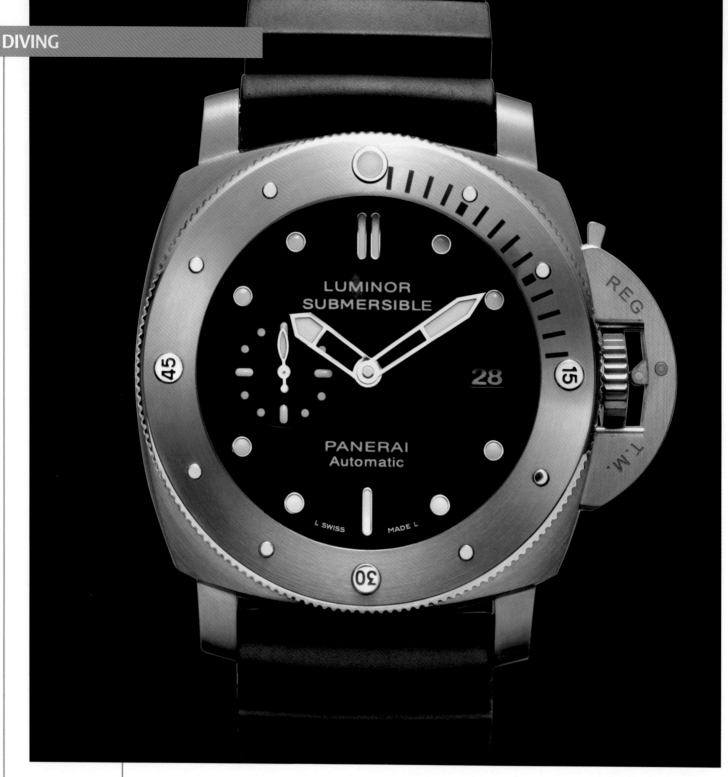

PANERAI

LUMINOR 1950 SUBMERSIBLE 3 DAYS AUTOMATIC TITANIO – REF. PAM00305

The latest version of the Luminor Submersible is now for the very first time powered by an exclusively in-house movement, the Panerai P.9000 Calibre. This recently launched automatic-winding caliber's 197 component parts and two-barrel system guarantee 72 hours of power reserve. With a 47mm diameter titanium case, it is a professional underwater model, watertight in depths of up to 300m (30 bar). Distinctive features, in addition to its size, include a substantial counterclockwise, unidirectional bezel with stud and relief markers, as well as a dial with wide baton hands—a design inspiration from historic models. The Luminor 1950 Submersible 3 Days Automatic Titanio comes complete with a natural rubber strap.

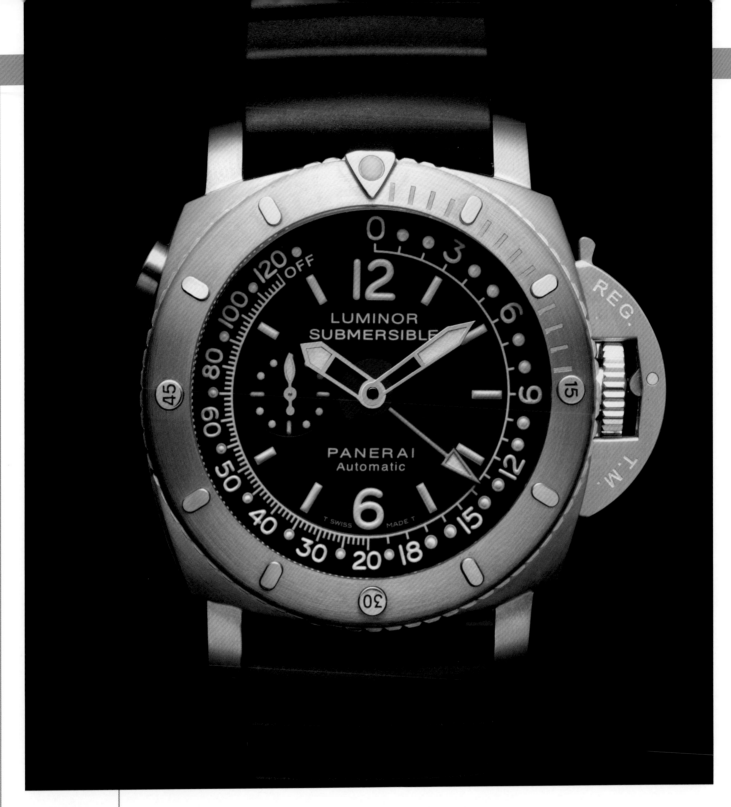

PANERAI

LUMINOR 1950 SUBMERSIBLE DEPTH GAUGE FOR THE PANGAEA EXPEDITION

REF. PAM00307

Recognized for creating the first professional divers' watches in history and supplying them—along with wrist depth gauges—to the Royal Italian Navy in the first half of the 20th century, Officine Panerai reaffirmed its tradition in the field of professional precision instruments with the combination of these two indispensable measuring devices in a single instrument: the Luminor 1950 Submersible Depth Gauge. Unlike historic wrist depth gauges, which were functional to 30m, this innovative device can measure depths to 120m and record the greatest depth encountered in the course of a dive. This is achieved by an independent, sophisticated electronic device fitted within the 47mm titanium case. In a numbered limited edition, the caseback is engraved in celebration of famous explorer Mike Horn's Pangaea Expedition.

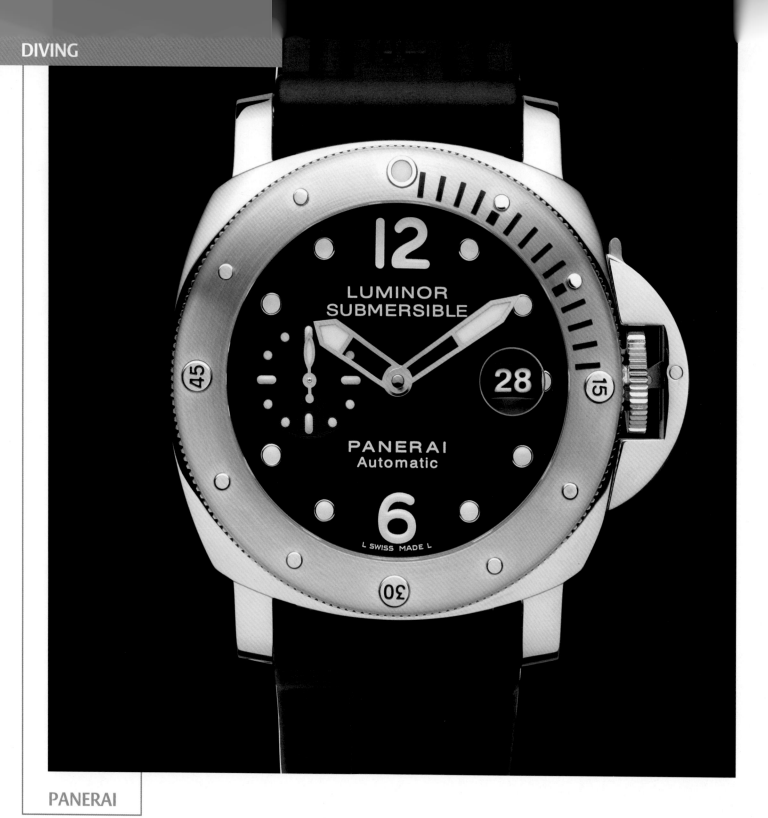

PANERAI

LUMINOR SUBMERSIBLE – REF. PAM00024

Inspired by the model designed for the Egyptian Navy in 1956, the Luminor Submersible inherits the historic version's striking personality through its characteristic rotating bezel (which enables the duration of a dive to be read quickly) and its reliability under extreme conditions. The addition of an automatic mechanical movement enhances the great functionality of its predecessor, a testimony to Panerai's constant dedication to technical development and quality standards. This 44mm model is water resistant to 30 bar (300m).

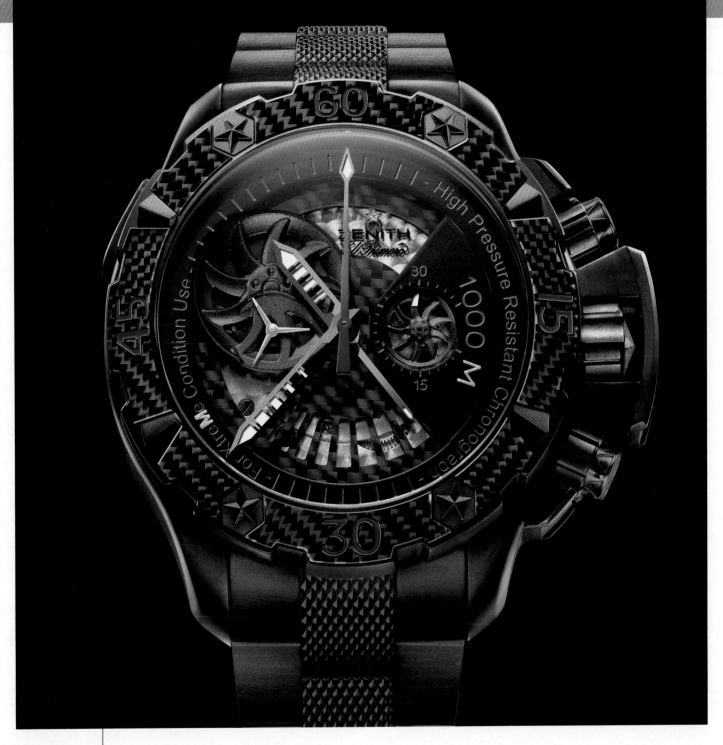

ZENITH

DEFY XTREME SEA OPEN

Cased in 46.5mm of black titanium with graduated unidirectional rotating bezel in black titanium, fitted with carbon-fiber inserts, the Defy Xtreme Sea Open is powered by the El Primero 4021 SX automatic chronograph movement with harmonic plate. The caliber consists of 248 parts and 39 jewels. The balance, chronograph and pallet bridges are built of shock-absorbing Zenithium Z+. It has a 30-minute counter at 3:00, small seconds at 9:00, power reserve indicator from the hour axis, and central seconds blue varnished hand. Water resistant to 1,000 meters, the high-tech case features a helium valve at 10:00 and black titanium screw-in pushbuttons with carbon-fiber guilloché patterns and protective crown device. The carbon-fiber dial is a multi-layered construction with shock-resistant Hesalite glass. Composite lateral inserts reinforce the black titanium bracelet with blue-tinted central links.

Alarms

Measuring the passing of time is not an innate ability of the human brain. Without any outside reference, in fact, it is very difficult to "remember" the length of a minute, half an hour, or an hour. This is why throughout history we have invented ways to remind us, and watchmaking has been a crucial aid in this matter. Already, by the Middle Ages, before the invention of clock hands, church bells let monks know when it was time to kneel in prayer. Today, the alarm watch always accompanies the businessman or the traveler. Thanks to various innovations introduced over the last few years, divers have also been able to benefit from such mechanisms, whose sound travels faster under water than out of it. This complication is rarely offered by itself, usually teaming up with GMT, chronograph or calendar functions.

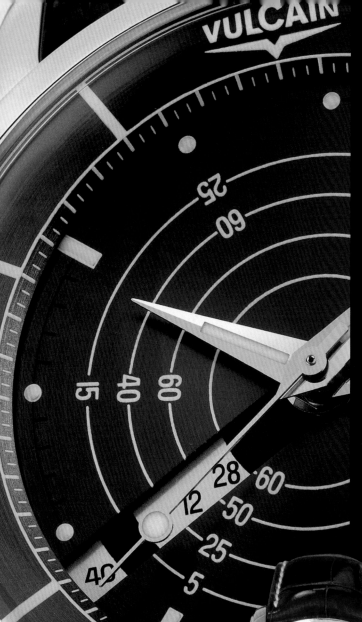

MORNING BELLS

The alarm is undoubtedly one of the oldest horological complications. In the 12th century, clocks in monasteries were already ringing out the times of the services—before dial hands had even been invented. In the 15th century, table clocks were often equipped with an alarm mechanism that rang on a small bell; in 1601, the Corporation des Horlogers de Genève required that anyone who wanted to become a "maître" had to produce a small alarm clock. In the 16th century, alarm pocket-watches appeared with openworked cases that facilitated the passage of sound. In the 17th century, watchmakers also created large "carriage watches," with mechanisms to wake travelers who might otherwise miss their connections.

WRISTWATCH ALARM SYSTEMS

Eterna introduced the first alarm wristwatch in 1914. Its sole barrel powered both the movement and the alarm. In 1920, Zenith also created an alarm movement, this one equipped with two barrels. But these mechanisms were not yet ideal. The vibrations of the alarm tended to interfere with the precision of the watch, and the sound was not loud enough to wake anyone up. In 1947, Vulcain launched the first truly functional alarm wristwatch, Cricket. This famous manual-winding caliber possessed two barrels, one for the movement and the other for the alarm, equipped with a strike, or sonnerie, that lasted close to 25 seconds. Using a system with a membrane and a double back pierced with holes, it emitted a strident sound capable of waking the soundest sleeper. The Vulcain Cricket attracted not only the masses, but also the most powerful men in the world—Truman, Eisenhower, Johnson, and Nixon—and thus came to be nicknamed "the Presidents' watch".

In the 1950s, the mechanical alarm experienced its golden age. Many manufacturers were intrigued by this increasingly popular complication. In 1950, Jaeger-LeCoultre presented the famous Memovox, which allowed two different alarms: a loud one to wake up to, and a more discreet ring for meetings during the day. The hammer struck the perforated back directly for the louder ring; when the watch was worn, the caseback was in contact with the wrist, muffling the sound. In 1958, Jaeger-LeCoultre presented the Mémovox Parking, contemporaneous with the first appearance of parking meters; in 1959, the brand followed up with the Memovox Deep Sea, a diving watch. In 1961, Vulcain launched the Cricket Nautical, water resistant to 300 meters, the first alarm watch with an alarm perfectly audible under water. However, in the 1970s, the arrival of quartz movements and electric clock radios seemed to sound the death knell for mechanical alarm watches.

OFF ON

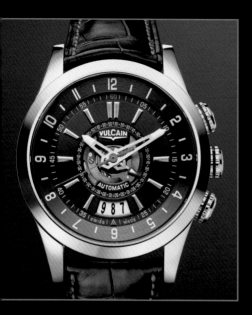

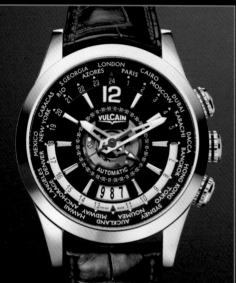

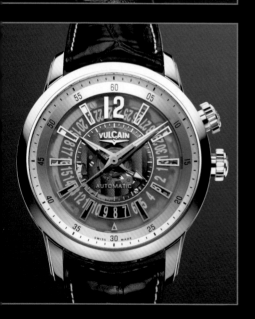

RINGING BEAUTY

The renaissance of mechanical horology at the end of the 1980s led to the triumphant return of the alarm watch. In 1989, Jaeger-LeCoultre released the first alarm wristwatch with perpetual calendar: the famous Grand Réveil. In 1994, the Sentier manufacture launched the Master Réveil, descendant of the Memovox. The Cricket caliber also returned to center stage. Vulcain, relaunched in 2002, is set on taking advantage of its rich past, both by developing the movement and by adding other useful complications. Notably, Vulcain has reissued its famous Nautical, with a central rotating dial displaying the stages of decompression, and a triple-backed case that acts as a resonance chamber. In 2005, the brand scored a coup by presenting the Imperial Gong, the first wristwatch with a movement-alarm and tourbillon, equipped with a cathedral chime worthy of the finest minute repeaters. In 2006, Vulcain launched a new collection called Golden Voice, with a soft, discreet sound, closer to a vibrating alarm than an alarm as such. In 2009, Vulcain began a new chapter in the Cricket saga by presenting an automatic-winding version. The Cricket V-21 caliber, composed of 257 pieces, is equipped with a rotor mounted on ceramic ball bearings and a double barrel—one for the movement, the other for the striking mechanism. It is also equipped, like its predecessor, with the Exactomatic system—a patented Vulcain invention—ensuring the watch's regularity. The new movement debuted in two new travel watches: the Revolution Dual-Time, with two time zone indications, and the Revolution GMT, with universal or "world" time (see GMT and Multiple Time Zones chapter). In 2010, the Le Locle watchmaker released a model inspired by the famous "Presidents' watch" model, called the 50s Presidents' Watch. It also launched the Anniversary Heart Automatic Calendar, equipped with the automatic caliber Cricket V-22, a sequel to the V-21. Available in steel or gold, it flirts with transparency by having a dial in metallic or sandblasted sapphire crystal.

LEFT FROM TOP TO BOTTOM
Vulcain, *Revolution Dual-Time*
Vulcain, *Revolution GMT*
Vulcain, *Anniversary Heart Automatic Calendar*
TOP RIGHT
Vulcain, *Golden Voice*
RIGHT
Vulcain, *50s Presidents' Watch*

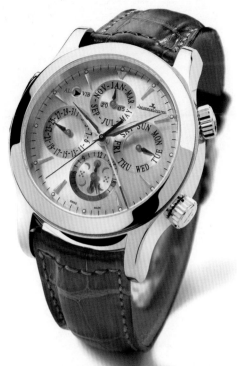

STRIKING INNOVATIONS

Jaeger-LeCoultre, another traditional pillar of the alarm watch field, is not resting on its laurels. In 2005, the brand launched the Master Grand Réveil, with a perpetual calendar. The alarm mechanism includes a barrel and a lever that are independent from the main movement, as well as a hammer that strikes a bell suspended in the caseback. The alarm can be set to striking or vibration mode. In a sportier tone, Jaeger-LeCoultre solidified its partnership with Aston Martin by creating the AMVOX1 R-Alarm, featuring a design evoking automobile dashboard counters. Jaeger-LeCoultre has also presented the Master Compressor Extreme W-Alarm. Besides its shock-resistant case, this ultra-sturdy model features several patented innovations in the field of alarm watches. Instead of being fixed to the case (which renders the striking less audible when the wrist is being worn), the chime surrounds the movement and is fixed to the case middle with two pins. Moreover, the hammer strikes the chime at a precise point, close to where it is fixed. The result is a powerful sound and an optimal resonance, whether the watch is on the wrist or the night table. The alarm time is selected in a highly precise, very original manner, using a double hour/minute disc in a window at 9 o'clock. To the great joy of the brand's devoted public, in 2010 Jaeger-LeCoultre launched a new interpretation of its historic Memovox model. Called Master Memovox, it is equipped with the 956 caliber, direct descendant of the first movement in history equipped with an alarm function, which was presented by the Sentier watchmaker in 1956. This same movement animates the Master Memovox International version, which was inspired by the model presented on the occasion of the brand's 125th anniversary in 1958, then known by the name of Memovox Worldtimer. The alarm disc bears the names of cities and regions of the world.

TOP LEFT
Jaeger-LeCoultre,
Master Grand Réveil

TOP RIGHT
Jaeger-LeCoultre,
AMVOX1 R-Alarm

BOTTOM LEFT
Jaeger-LeCoultre,
Master Memovox

BOTTOM RIGHT
Jaeger-LeCoultre,
Master Memovox International

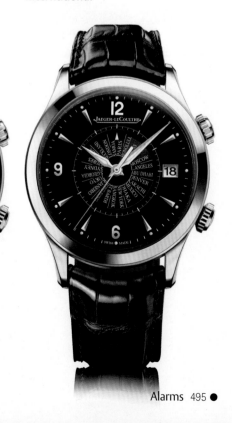

THE DAWN OF A NEW ERA

Vulcain and Jaeger-LeCoultre are not the only ones to work in the alarm-watch field. For the last few years, this horological classic has been enjoying a return to popularity among brands and customers alike. In 2008, Oris—known in the 1940s for its small alarm clocks—launched the Artelier Alarm wristwatch. In 2009, Alfex—a brand based in the Ticino region of Switzerland that is known for its prizewinning designs—celebrated its 60th anniversary by presenting the Pazzola Giant Alarm. The piece is technically and aesthetically innovative: setting the time of the alarm is done with a disc that is incorporated into a mechanism under the dial. Two years earlier, Ulysse Nardin garnered acclaim with its very avant-garde Sonata Silicium Limited Edition. Endowed with a silicon lever and escapement wheel, this timepiece was the first watch in a collection to utilize several technical innovations introduced in 2007 within the framework of the InnoVision program. By using two cams (one for the 24-hour indication, the other for the minutes), the alarm mechanism—equipped with cathedral gongs—could be programmed with great precision up to 24 hours in advance.

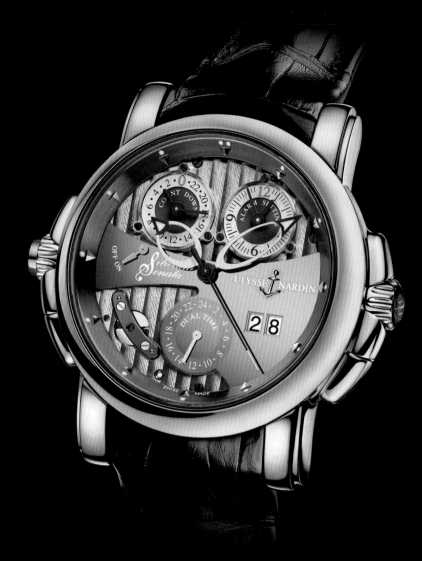

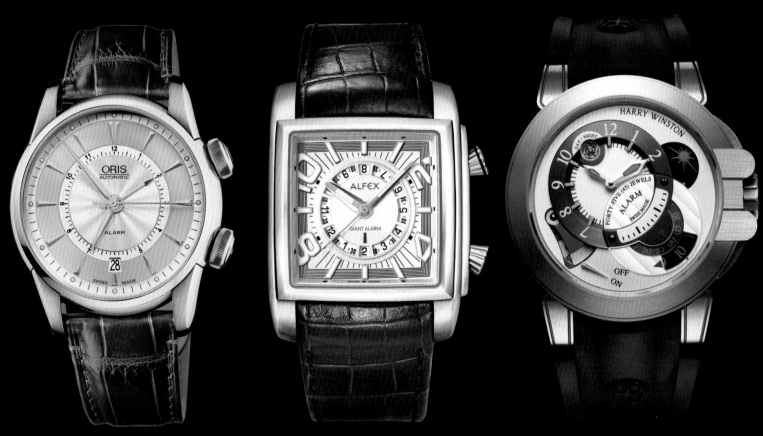

Since then other brands have followed suit, such as Harry Winston and its Project Z6. Equipped with a manual-winding movement that has a 24-hour alarm, this piece uses a gong cast in one piece, with a triangular section for better sound amplitude. But it is a German brand that has introduced what is doubtless the most useful accomplishment. Glashütte Original, a Swatch Group company, wowed observers at BaselWorld 2010 with its Senator Diary, the first watch in the world that allows the wearer to set the alarm 30 days in advance. A pusher at 8 o'clock allows the wearer to select the desired setting, with "d" for the date, "h" for the hour and a drawing of a clock to activate the striking mechanism, all in a window at 10 o'clock. Once the choice is made, the crown at 10 o'clock can activate the red pointer that indicates the date of the alarm in a subdial, or the window at 6 o'clock indicating the time of the alarm, in 15-minute increments from 12:15 am to midnight.

FACING PAGE
TOP RIGHT
Ulysse Nardin, *Sonata Silicium Limited Edition*
BOTTOM LEFT
Oris, *Artelier Alarm*
BOTTOM CENTER
Alfex, *Pazzola Giant Alarm*
BOTTOM RIGHT
Harry Winston, *Project Z6*

THIS PAGE
Glashütte Original, *Senator Diary*

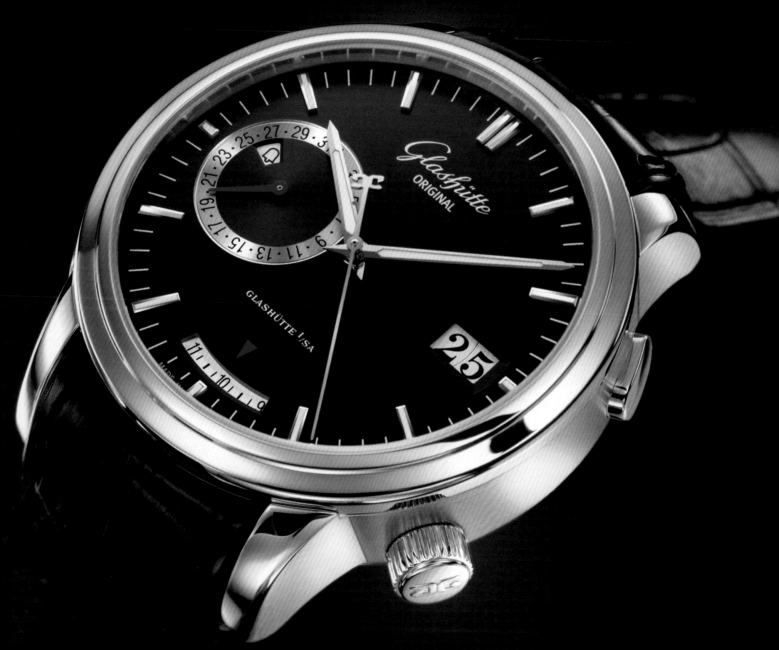

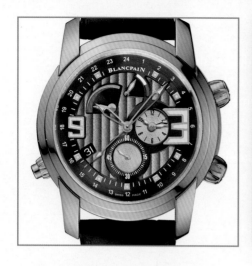
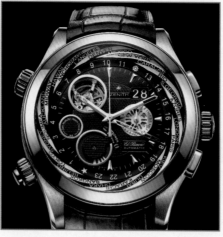
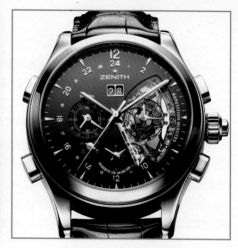

ALL THE WORLD'S MORNINGS

The alarm can also join forces with other complications. Useful for travelers, it comes in particularly handy on watches with multiple time zones, such as in many Vulcain models. In its Léman Réveil GMT Anniversaire 1735-2005 (see also the Multiple Time Zones and GMT chapter), Blancpain has joined these two functions in an unusual way: the alarm hand is connected to the second time zone display, which shows local time with the large hour and minute hands. Another practical innovation: the movement's automatic-winding mechanism allows the wearer to build up the power reserve for the movement and the striking mechanism at the same time. Blancpain lost no momentum in 2009, presenting the L-evolution Réveil GMT, with a new proprietary movement that also possesses two barrels (one for the watch, the other for the alarm) that are both recharged by the automatic-winding system, as well as an alarm hand linked to the local time.

Breguet's Réveil du Tsar enjoys more or less similar functions, with an indicator that indicates the activation of the striking mechanism in a small window at 12 o'clock. The Grande Class Traveller Répétition Minutes El Primero by Zenith (see Multi-Complications chapter) presents, among other functions, an alarm with two-tone striking or vibrating mode, as well as two power-reserve indicators, one for the movement and one for the strike. In 2009, Zenith also came out with a new Class Traveler Open Multicity Alarm, whose automatic chronograph El Primero movement also powers an alarm and universal time.

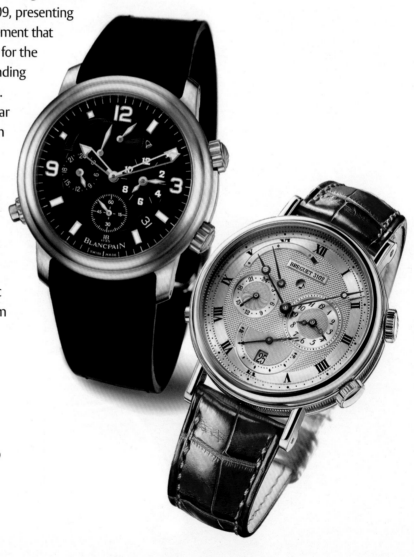

TOP LEFT
Blancpain, *L-evolution Réveil GMT*

TOP CENTER
Zenith, *Class Traveler Open Multicity Alarm*

TOP RIGHT
Zenith, *Grande Class Traveller Répétition Minutes El Primero*

BOTTOM LEFT
Blancpain, *Léman Réveil GMT Anniversaire 1735-2005*

BOTTOM RIGHT
Breguet, *Réveil du Tsar*

UNDERWATER SOUNDS

We are also seeing more and more diving watches equipped with an alarm. It might seem a strange combination at first, as the watery depths are not the ideal place to spend the night, or even take a nap. But the diving alarm is used to mark a specific event, for example, the end of a dive—and sound carries much better in water than in air. Following its legendary Nautical model, Vulcain has developed several diving alarm watches, such as the Diver X-Treme Automatic, powered by the new V-21 caliber, with a ribbed rotating bezel and water resistance to 100 meters. Breguet has added to its sporty Marine Royale collection a new alarm model. Water resistant to 300 meters, the piece's modern design combines rose gold and rubber. Still in the military, seagoing vein, Jaeger-LeCoultre celebrated its partnership with the US Navy SEALs with its 2009 release of the Master Compressor Diving Alarm Navy SEALs, a limited edition with a case in grade 5 titanium and a ceramic bezel that is water resistant to 300 meters.

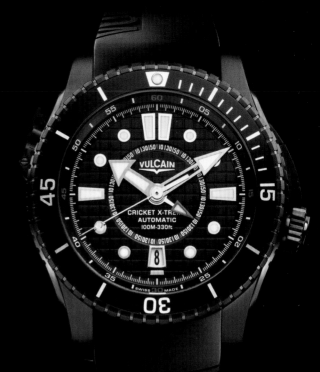

TOP RIGHT
Vulcain, *Diver X-Treme Automatic*

BELOW LEFT
Jaeger-LeCoultre, *Master Compressor Diving Alarm Navy SEALs*

BELOW RIGHT
Breguet, *Marine Royale*

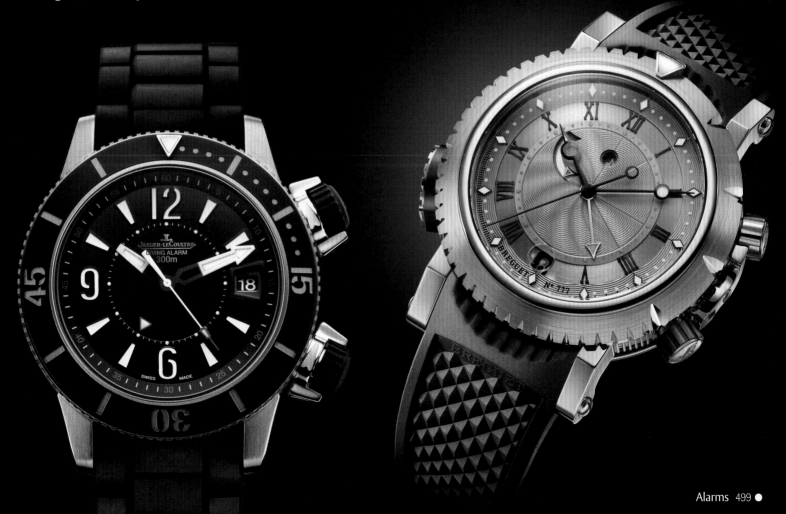

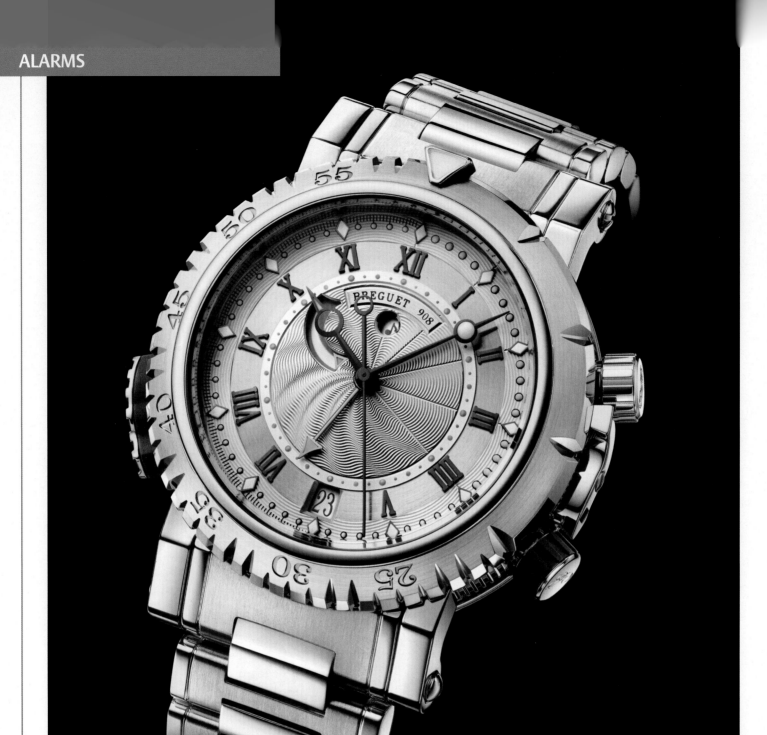

BREGUET

MARINE ROYALE – REF. 5847BB

The Marine Royale is powered by an automatic-winding 519R caliber that boasts a 45-hour power reserve. The dial displays hours, minutes, seconds, date at 6:00, the alarm power reserve between 9:00 and 11:00 and the alarm on/off indicator at 12:00. The 45mm 18K white-gold case possesses many notable characteristics, including a unidirectional rotating bezel with luminous markers, a wave-shaped ratchet at 3 to ensure the bezel's one-way rotation, a hand-guilloché sapphire crystal caseback, and rubber-covered alarm on/off pushpieces at 3:00. The 18K gold silvered dial also features hand-guilloché decoration, as well as a chapter ring with applied blued Roman numerals and luminous dots for nighttime readability.

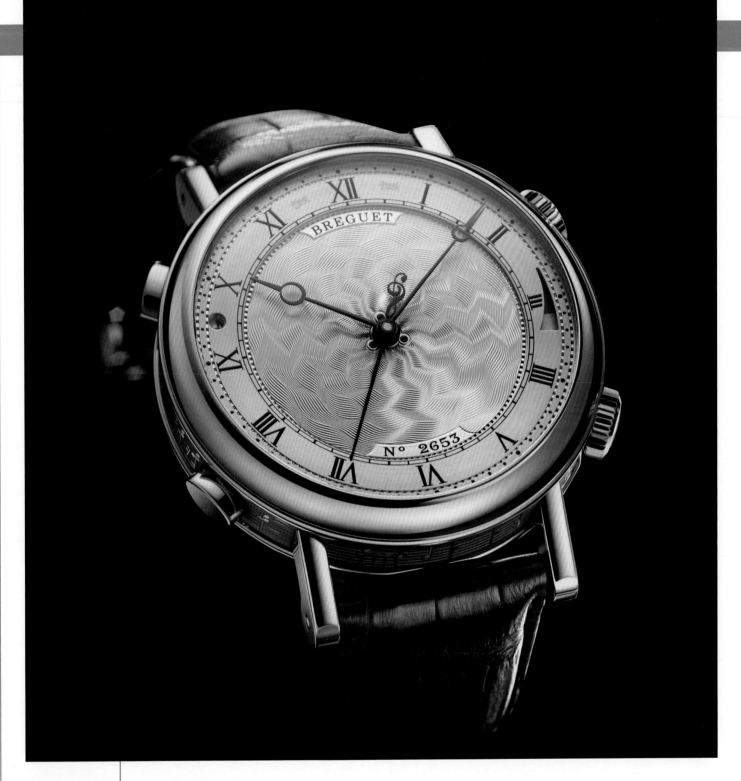

BREGUET

REVEIL MUSICAL – REF. 7800BA

Breguet presents the melodious Réveil Musical. This alarm watch is powered by an automatic-winding 777M caliber housed within an 18K yellow-gold 48mm case. Endowed with a straight-line lever escapement, Breguet balance wheel and overcoil, and 55 jewels, the piece also possesses a dial that features a guilloché rotating bridge with platinum effects and blued-steel hands. Musical notes adorn the caseband. The Réveil Musical is also available in a white-gold case.

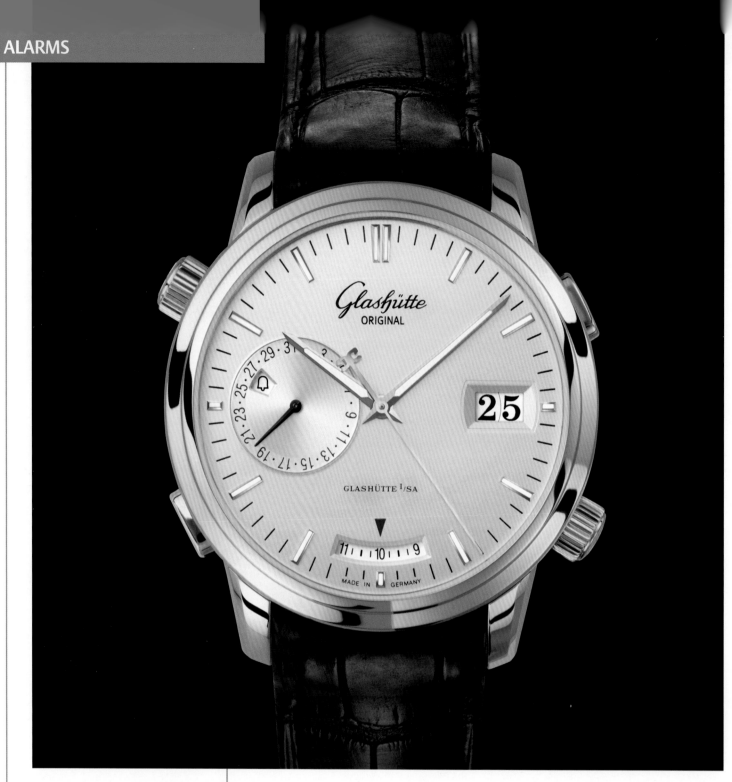

GLASHÜTTE ORIGINAL

SENATOR DIARY – REF. 100.13.01.01.04

The Senator Diary is beautifully balanced, with two crowns positioned directly opposite each other on either side of the rose-gold case, each flanked by a pusher. The crown and pusher on the right operate the panorama date display at 3:00. Rose-gold hour, minute and sweep seconds hands enhance the elegance of the design. The Caliber 100-13 automatic movement boasts beautifully finished components, including a three-quarter plate with Glashütte ribbing, polished steel components, beveled edges and blued screws. The date indicator on the diary alarm subdial is in blue, as is the small arrow indicating the diary alarm time aperture at 6:00. The Senator Diary is also available in a stainless steel version.

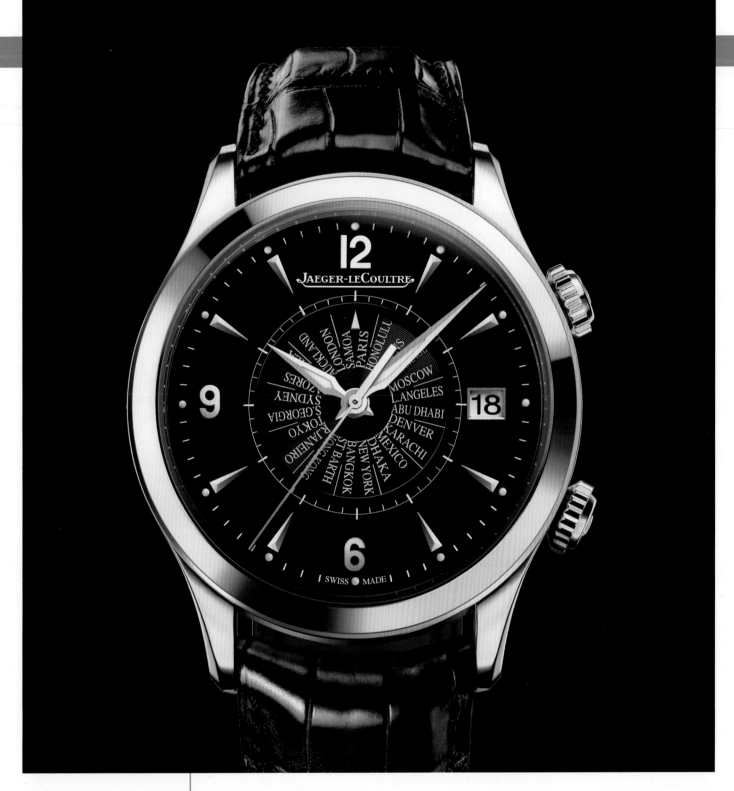

JAEGER-LeCOULTRE

MASTER MEMOVOX INTERNATIONAL – REF. 141.84.71

Released as a tribute to the historic 1958 model, the Master Memovox International also shows the world time zones on its central alarm disc, which is inscribed with the names of 24 cities. Each represents a different time zone, which allows the traveller to instantly tell the time anywhere in the world, a feature that nicely complements the indispensable alarm function. Powered by the automatic-winding Jaeger-LeCoultre 956, the Master Memovox International is housed in a stainless steel case that is water resistant to 50m.

Brand Directory

A. LANGE & SÖHNE
Altenberger Strasse 15
01768 Glashütte
Germany
Tel: 49 35053 440
USA: 800 408 8147

AUDEMARS PIGUET
1348 Le Brassus
Switzerland
Tel: 41 21 845 14 00
USA: 212 758 8400

BELL & ROSS
8 Rue Copernic
75016 Paris
France
Tel: 33 1 73 73 93 00
USA: 888 307 7887

BLANCPAIN
Le Rocher 12
1348 Le Brassus
Switzerland
Tel: 41 21 796 36 36
USA: 877 520 1735

BREGUET
1344 L'Abbaye
Switzerland
Tel: 41 21 841 90 90
USA: 866 458 7488

BVLGARI
Rue de Monruz 34
2000 Neuchâtel
Switzerland
Tel: 41 32 722 78 78
USA: 212 315 9700

CHANEL
25 Place du Marché St. Honoré
75001 Paris
France
Tel: 33 1 55 35 50 00
USA: 212 688 5055

CHRISTOPHE CLARET
Route du Soleil d'Or 2
2400 Le Locle
Switzerland
Tel: 41 32 933 80 80
USA: 954 610 2234

de GRISOGONO
176 bis Route de St. Julien
1228 Plan-les-Ouates
Switzerland
Tel: 41 22 817 81 00
USA: 212 439 4220

DeWITT
Rue du Pré de la Fontaine 2
Satigny 1217 Meyrin 2
Switzerland
Tel: 41 22 750 97 97
USA: 305 572 9812

DIOR HORLOGERIE
44 Rue François 1er
75008 Paris
France
Tel: 33 1 40 73 54 44
USA: 212 931 2700

FRANCK MULLER
22 Route de Malagny
1294 Genthod
Switzerland
Tel: 41 22 959 88 88
France: 33 1 53 67 44 39

FRÉDÉRIQUE CONSTANT SA
Chemin du Champ des Filles 32
1228 Plan-les-Ouates
Switzerland
Tel: 41 22 860 04 40
USA: 877 619 2824

GLASHÜTTE ORIGINAL
112, Av. Kleber
75116 Paris
France
Tel: 33 1 53 81 22 68
USA: 866 382 9486

GUY ELLIA
21 Rue de la Paix
75002 Paris
France
Tel: 33 1 53 30 25 25
CA: 310 470 1388
NY: 212 888 0505

HARRY WINSTON SA
8 Chemin du Tourbillon
1228 Plan-les-Ouates
Switzerland
Tel: 41 22 716 29 00
USA: 212 245 2000

HUBLOT
Route de Divonne, 14
1260 Nyon 2
Switzerland
Tel: 41 22 990 90 00
USA: 800 536 0636

IWC SCHAFFHAUSEN
Baumgartenstrasse 15
8201 Schaffhausen
Switzerland
Tel: 41 52 635 62 37
USA: 800 492 6755

JACOB & CO
Route de Thonon 146
1222 Vésenaz
Switzerland
Tel: 41 22 752 49 40
USA: 212 888 2330

JAEGER-LeCOULTRE
Rue de la Golisse, 8
1347 Le Sentier
Switzerland
Tel: 41 21 845 02 02
USA: 212 308 2525

JEAN DUNAND
Chemin Pré-Fleuri 31
1228 Plan-les-Ouates
Switzerland
Tel: 41 22 706 19 60
USA: 570 270 6160

LONGINES
Saint-Imier 2610
Switzerland
Tel: 41 32 942 54 25
USA: 201 271 1400

PANERAI
Via Ludovico di Breme 44/45
20156 Milan
Italy
Tel: 39 02 363138
USA: 212 888 8788

PARMIGIANI
Rue du Temple 11
2114 Fleurier
Switzerland
Tel: 41 32 862 66 30
USA: 305 260 7770

PATEK PHILIPPE
Chemin du Pont du Centenaire 141
1228 Plan-les-Ouates
Switzerland
Tel: 41 22 884 20 20
USA: 800 628 4344

PIAGET
37 Chemin du Champ-des-Filles
1228 Plan-les-Ouates
Switzerland
Tel: 41 22 884 48 44
USA: 800 628 4344

REBELLION TIMEPIECES
Chemin du Bief
1027 Lonay
Switzerland
Tel: 41 21 802 33 04

RICHARD MILLE
11 rue du Jura
2345 Les Breuleux Jura
Switzerland
Tel: 41 32 959 43 53
USA: 310 205 5555

ROGER DUBUIS
1217 Meyrin 2 Geneva
Switzerland
Tel: 41 22 783 28 28
USA: 888 738 2847

STÜHRLING ORIGINAL
449 20th Street
Brooklyn, NY 11215
USA: 718 840 5760

TAG HEUER
Louis-Joseph Chevrolet 6A
2300 La Chaux-de-Fonds
Switzerland
Tel: 41 32 919 80 00
USA: 973 467 1890

ULYSSE NARDIN
3 Rue du Jardin
2400 Le Locle
Switzerland
Tel: 41 32 930 74 00
USA: 561 988 8600

URWERK
34 rue des Noirettes
1227 Carouge-Geneva
Switzerland
Tel: 41 21 900 20 25
USA: 310 205 5555

VACHERON CONSTANTIN
Rue des Moulins 1
1204 Geneva
Switzerland
Tel: 41 22 930 20 05
USA: 212 713 0707

ZENITH
2400 Le Locle
Switzerland
Tel: 41 32 930 62 62
USA: 973 467 1890